Rogues' Gallery

BROADWAY BOOKS ■ *New York*

The Secret History of

ROGUES'

the Moguls and the Money

GALLERY

That Made the Metropolitan Museum

Michael Gross

Copyright © 2009 by Idee Fixe Ltd.

All Rights Reserved

Published in the United States by Broadway Books,
an imprint of the Crown Publishing Group,
a division of Random House, Inc., New York.
www.broadwaybooks.com

BROADWAY BOOKS and its logo, a letter B bisected on the diagonal,
are trademarks of Random House, Inc.

Book design by Maria Carella
Photo on section openings courtesy Andrew Prokos Photography

Library of Congress Cataloging-in-Publication Data
Gross, Michael, 1952–
Rogues' gallery : the secret history of the moguls and the money that
made the Metropolitan Museum / Michael Gross. — 1st ed.
p. cm.
1. Metropolitan Museum of Art (New York, N.Y.)—History.
2. Art—Collectors and collecting—United States—Biography. I. Title.
N610.G76 2009
708.147109—dc22 2008041480

ISBN 978-0-7679-2488-7

PRINTED IN THE UNITED STATES OF AMERICA

1 3 5 7 9 10 8 6 4 2

First Edition

In memory of Mallory G. B. H. Kean

I hear you laughing still

Private Vices by the dextrous Management
of a skillful Politician may be turned into Publick Benefits.

BERNARD MANDEVILLE, *The Fable of the Bees*

Contents

Leaders of the Metropolitan Museum

DIRECTORS

Luigi Palma di Cesnola, 1879–1904
Caspar Purdon Clarke, 1905–1910
Edward Robinson, 1910–1931
Herbert Winlock, 1932–1939
Francis Henry Taylor, 1940–1955
James Rorimer, 1955–1966
Thomas Hoving, 1967–1977
Philippe de Montebello, 1977–2008
Thomas P. Campbell, 2009–

PRESIDENTS

John Taylor Johnston, 1870–1889
Henry Marquand, 1889–1902
Frederick Rhinelander, 1902–1904
John Pierpont Morgan, 1904–1913
Robert de Forest, 1913–1931
William Sloane Coffin, 1931 1933
George Blumenthal, 1934–1941
William Church Osborn, 1941–1946
Roland Redmond, 1947–1964
Arthur Houghton, 1964–1969

C. Douglas Dillon, 1969–1978
William Butts Macomber Jr., 1978–1986
William Henry Luers, 1986–1998
David E. McKinney, 1998–2005
Emily Rafferty, 2005–

Chairmen

Robert Lehman, 1967–1969
Arthur Houghton, 1969–1972
C. Douglas Dillon, 1972–1983
J. Richardson Dilworth, 1983–1987
Arthur Ochs Sulzberger, 1987–1998
James Houghton, 1998–

Rogues' Gallery

Introduction

ON A CHILLY WINTER DAY, EARLY IN 2006, I SAT IN THE OFFICE of Philippe de Montebello, then director of the Metropolitan Museum of Art (he would announce his retirement two years later). Montebello is generally considered, even by his most fervent admirers, a little arrogant, a touch on the pompous side, and his mid-Atlantic Voice of God (well-known from his Acoustiguide tours of exhibitions) does nothing to dispel the impression of a healthy self-regard. So I was nervous; I was there to discuss my plan to write an unauthorized book about the museum and to ask for his support, or at least his neutrality.

He wasn't happy to see me.

My brief conversation with the museum administration, then racing to an abrupt conclusion, had actually begun in the fall of 2005, when I called Harold Holzer, the senior vice president for external affairs, and told him my plans. His reaction was quick and negative.

"Nobody here is ever of a mind" to cooperate with an author, he said. "The only kind of books we find even vaguely palatable are those we control." Nonetheless, the museum had just "broken precedent" to cooperate with another author writing about the museum. It was "vaguely palatable" because it was "a controlled entity." Once it was published, I'd see there was no point in my writing another. "If we tell you we won't cooperate, will you go away?"

Until now, there have been only two kinds of books on the museum. Some have had agendas, whether personal (the former Met director

Thomas Hoving's memoir, *Making the Mummies Dance*, was a score-settling romp; John L. Hess covered Hoving as a journalist for the *New York Times,* came to hate him, and explained why in *The Grand Acquisitors*) or political (Debora Silverman disdained the upper classes of the 1980s, the way they disregarded history and merchandised high culture, and explained why in *Selling Culture: Bloomingdale's, Diana Vreeland, and the New Aristocracy of Taste in Reagan's America*).

The other kind of Met book was commissioned, authorized, published, or otherwise sanctioned by the museum. The first among those, appearing in two volumes in 1913 and 1946, was by Winifred E. Howe, the museum's publications editor and in-house historian. They are, to be kind, dutiful. Two later, somewhat juicier histories were commissioned by Hoving and published to coincide with the museum's 1970 centennial, one a coffee-table book called *The Museum* by the late Condé Nast magazine writer Leo Lerman, the other, *Merchants and Masterpieces,* a narrative history by Calvin Tomkins, a writer for *The New Yorker.* Though *Merchants* is an "independent view of the museum's history," as Tomkins wrote in his acknowledgments, the book was conceived by and for the museum, he used museum-paid researchers, and he submitted his manuscript to museum officials for comment.

Danny Danziger, author of the 2007 book *Museum: Behind the Scenes at the Metropolitan Museum of Art* (the one I was supposed to wait for), had changes forced on him. Early that year Viking Press distributed advance proofs of the book, made up of a series of edited interviews with museum employees, friends, and trustees, which was to be published that May. But then *Museum* didn't appear as scheduled. What did was a brief *New York* magazine article revealing that it had been delayed so it could be expurgated.

The publisher said the changes were "run-of-the-mill," and Harold Holzer said they were "a matter of fact-checking," with no "wild-eyed running around to get things changed."[1] But a side-by-side comparison of the proofs with the book that was finally published suggests that a few of the Met's most powerful demanded and won changes. Cutting remarks made by the vice chairman Annette de la Renta, a list of paintings owned by the trustee Henry Kravis, and an entire section on the trustee emerita Jayne Wrightsman all vanished. And their words aren't the only ones that the mu-

seum has tried to erase. Simultaneously, *The Clarks of Cooperstown* by Nicholas Fox Weber, a book about the family that produced two of America's greatest modern art collectors, Stephen and Sterling Clark, the former another Met trustee, was banned from the museum's bookshop, even though it had been rushed into print to coincide with a Met exhibition of the Clark brothers' collections and the museum promised to "aggressively sell the book in its stores." *Publishers Weekly* noted that the book portrayed Alfred Clark (Stephen and Sterling's father) as leading a double homosexual life, and mentioned Sterling Clark's involvement in a plot to overthrow FDR.

Ever since its founding, the Metropolitan has bred arrogance, hauteur, hubris, vanity, and even madness in those who live in proximity to its multitude of treasures and who have come to feel not just protective but possessive of them. "Being involved with it made you special to the outside world," says Stuart Silver, for years the museum's chief exhibition designer. "It was a narcotic. You were high all the time."

The Metropolitan is more than a mere drug, though. It is a huge alchemical experiment, turning the worst of man's attributes—extravagance, lust, gluttony, acquisitiveness, envy, avarice, greed, egotism, and pride—into the very best, transmuting deadly sins into priceless treasure. So the museum must be seen as something separate from the often-imperfect individuals who created it, who sustained it, and who run it today, something greater than the sum of their myriad flaws.

Without taking anything away from the Louvre or the Orsay in Paris, Madrid's Prado, St. Petersburg's Hermitage, the British Museum (which has no pictures), Britain's National Gallery (which has only pictures and sculpture), the Vatican in Rome, the Uffizi in Florence, Vienna's Kunsthistorisches Museum, the Art Institute of Chicago, Berlin's Pergamon, Amsterdam's Rijksmuseum, the Smithsonian Institution, the National Gallery of Art, the Museum of Fine Arts in Boston, the Getty in Malibu, or other vital New York museums like the Whitney, the Guggenheim, and the Museum of Modern Art, the Metropolitan is simply (and at the same time not at all simply) the most encyclopedic, universal art museum in the world.

In Montebello's office that day, he'd been slumped sullenly in his chair as I made my pitch, but straightened up defensively as I finished. "You are laboring under a misimpression," he told me. "The museum has no secrets."

✧

ITS SCOPE IS MIND-BOGGLING. THE METROPOLITAN MUSEUM OF
Art is a repository for more than two million art objects created over the
course of five thousand years. Its more than two million square feet occu-
pying thirteen acres of New York's Central Park, and encompassing power
and fire stations, an infirmary, and an armory with a forge, make it the
largest museum in the Western Hemisphere.

The Met portrays itself as a collection of separate but integrated mu-
seums, "each of which ranks in its category among the finest in the world."
Its seventeen curatorial departments cover the waterfront of artistic cre-
ation: separate staffs are dedicated to American, Asian, Islamic, Egyptian,
medieval, Greek and Roman, ancient Near Eastern, and what was once
known as primitive art but is now described with the more politically cor-
rect name Arts of Africa, Oceania, and the Americas. European art is so vast
it gets two departments, one for paintings, another for sculpture and deco-
rative objects. Additional departments are devoted to arms and armor, cos-
tumes (which includes both high fashion and everyday clothing), drawings
and prints, musical instruments, and photographs. Modern art has its own
curatorial department and is housed in its own wing.

The collections are almost all contained in a building that has grown
in fits and starts since it first opened in 1880 to contain the then-ten-year-
old museum. In the years since, it has nearly filled the five-block-long plot
of Central Park set aside for it by the New York State legislature in 1871.
The first redbrick Gothic Revival building, which opened into Central
Park, was designed by Calvert Vaux and Jacob Wrey Mould, the park's
structural architect, and was leased, rent- and real-estate-tax-free, in per-
petuity to the museum's trustees by New York City, appropriately enough
on Christmas Eve 1878. That first structure has since been almost entirely
enveloped by additions. Only a few hints of the redbrick original remain, a
bit of its southern facade and the undersides of staircases.

Today's imperial neoclassical facade and entrance opened on Fifth Av-
enue in 1926; they were conceived by Richard Morris Hunt, one of the
founding trustees. Hunt not only designed the museum's familiar face; he

also created its first comprehensive master plan, but wouldn't live to see the only part of his plan that was fully realized, the monumental Great Hall through which most visitors enter.

The famous firm of McKim, Mead & White signed on two years later to complete Hunt's unfinished business. Over the next quarter century, their work resulted in the opening of a new library in 1910 and northern and southern wings through the following decade, and after an interregnum for war, into 1926. Yet another wing was posthumously named for John Pierpont Morgan, the industrial-era financier. Morgan served first as a trustee and then as the museum's president from 1904 until his death in 1913. The Morgan Wing, which now contains the popular arms and armor collection, opened in 1910 as a home to the museum's decorative arts collection.

The American Wing, built onto the museum's northwest corner in 1924, was inspired and paid for by its then president Robert de Forest, the museum's first great champion of American art. His wing grew further in 1931 with the addition of the Van Rensselaer period room, the grand entrance hall of a manor house built near Albany, New York, in the 1760s. The museum itself would later call the wing "awkwardly placed" and that period room a "haphazard appendage."[2] Later in that decade, a more successful appendage, the Cloisters, a branch of the museum dedicated to medieval art and architecture, opened about seven miles away in Fort Tryon Park at the northern tip of Manhattan, paid for in its entirety by John D. Rockefeller Jr., who, though he never joined the board of trustees, was as decisive a force in the museum's history as Morgan.

During World War II, the Metropolitan's fifth chief, Francis Henry Taylor, who created the model of director as populist, reconceived the museum as a collection of smaller ones defined by civilizations and cultures, and started planning to modernize and expand the building. He managed to build a gallery connecting the Morgan Wing to the Fifth Avenue building, but frustrated in turn by war, financial shortfalls, the Whitney Museum of American Art, which briefly toyed with a merger with the Metropolitan, and a hidebound board of trustees, an exhausted Taylor produced no more buildings before he quit his job in 1955. His successor, a medievalist named James Rorimer who'd befriended Rockefeller, shouldered the burden of

modernization but got little credit, as upgrading electricity, lighting, and air-conditioning was hardly as glamorous as erecting new brick and mortar.

In September 1967, after New York City, long at odds with the museum, refused to pay for any new buildings until a comprehensive master plan was created, Tom Hoving commissioned one from the young firm of Kevin Roche John Dinkeloo and Associates. Unveiled in 1970 during the museum's eighteen-month centennial celebration, it proved to be as controversial as it was ambitious. Roche's park-side wings (the Temple of Dendur on the north, the modern and European art galleries and Lehman pavilion to the west, and the Michael Rockefeller primitive art wing on the south), all wrapped in glass and limestone, weren't completed until 1992; the interior the plan envisioned was finally finished fifteen years later with the restoration of the Greek and Roman galleries in the museum's southeast corner, where they had been before Taylor replaced them with a restaurant.

By that time, work had already begun on the next great museum expansion, this one created by the Montebello regime and dubbed the Twenty-first Century Met. Hemmed in by the promise the museum was forced to make to the city to win approval for the Roche expansion—which forever set the building's outer limits—it has ever since engaged in what it calls "building-from-within," revamping underused areas, turning air shafts and empty space into exhibition galleries and offices, and even excavating beneath the building, as it was doing beneath the Charles Engelhard Court as this book was being written. The story of the Metropolitan's ceaseless expansion is as fascinating as that of the evolution of its collections and of the cast of characters that created and sustains it all.

VISITED BY ABOUT 4.6 MILLION PEOPLE A YEAR, MORE THAN A third of them from other countries, the Metropolitan styles itself the premier tourist attraction in New York City. More than a mere museum, it is also a food and drink purveyor in its employee and public cafeterias and six other dining venues (the Petrie Court Café, the Trustees Dining Room for

members only, the Iris and B. Gerald Cantor Roof Garden Café, the Great Hall Balcony Bar, and an under-construction café in the latest iteration of the American Wing). It is a concert and lecture hall, a catering facility and event space, a vast retail and wholesale operation (with thirteen separate shops inside the main museum and another thirty-nine around the world), a scholarly center and library, an educational resource offering worldwide tours and travel programs, lectures, symposia, films, and workshops (20,773 events in all in the year ending June 30, 2006, that attracted 830,607 people), as well as reference services, apprentice and fellowship programs, and a publishing house employing some two thousand people.

Less tangibly, it is a repository of desire, and not just for the art objects on display. Unlike its peers in Paris, Madrid, and St. Petersburg, and countless other museums around the world, the Metropolitan was started from scratch by self-made men rather than springing full-blown from a noble collection. Yet acceptance by the museum—whether as an employee, a scholar, a donor, a trader or seller of art, a member of one of its many groups and committees, or, best of all, a member of its ruling board of trustees—is a version of ennoblement, the ultimate affirmation of success, material and *d'estime* that our democracy has to offer.

The museum repays its supporters with social prestige and affirmation of their cultivation. Of course, what you get depends on what you give. And the price is always rising. A seat on the board of trustees will set you back in excess of $10 million. The price of being a benefactor, which chisels your name into the marble plaques beside its Great Hall staircase, is $2.5 million. There are only 267 living benefactors. But for a mere $95 annual membership (up from $10 in 1880), almost anyone can get free admission, use of the Trustees Dining Room in summertime (when the trustees are mostly out of town), a couple of exhibition previews and magazines, and a 10 percent discount at the Met Store. And $65 of that is tax deductible.

In the American social firmament, the Metropolitan looms as more than a museum. "In the status-driven world of upper-income New York," the New York Times has said, "one sure route to social stardom is a seat on the board of a prominent arts institution. A savvy player will aim for the top: the Metropolitan Museum of Art."

"No club, church, philanthropy, or fraternal order in New York enjoys quite the same prominence or confers quite the same radiant status," *New York* magazine agreed.

"Sitting on its board is arrival reaffirmed, the ultimate compliment from the ultimate peers," wrote the social observer David Patrick Columbia. The art dealer Richard Feigen has called the board of the Met "the most exclusive club in the world." But Feigen has also compared the museum to a nice girl "who just once in a while goes out and turns tricks for pocket change."[3] And in recent years, as costs have escalated and government support of the arts has shrunk, she's grown promiscuous, creating councils and committees, stepping out with big corporations, even tying her fortunes to fashion magazines, all for one purpose: to generate cash.

The Met offers memberships ranging from $50 national associates, who live outside New York (there were 42,167 in 2007), to annual fellows in the President's Circle, 25 in all, paying $20,000 a year for membership. There are dozens of ways to get your name in the back of the annual report. You can donate to the annual appeal to members; join the President's Circle or the Patron Circle; make your company a corporate patron; sponsor an exhibition like Balenciaga, Condé Nast, and Party Rental Ltd. all did in 2007; donate art or funds to acquire art; make plans for a charitable annuity; join the Pooled Income Fund or a Friends Group (the Alfred Stieglitz Society, Amati, and Philodoroi, the Friends of the various curatorial departments, the Friends of Concerts and Lectures, of Inanna, of Isis, of the Thomas J. Watson Library); become a William Cullen Bryant Fellow; give a memorial gift; donate to the Christmas Tree Fund or the Fund for the Met ($5 million or more gets you top billing); or join the Chairman's Council, the Met Family Circle, the Apollo Circle for young donors in training, the Real Estate Council, the Professional Advisory Council, the Multicultural Audience Development Advisory Committee, or one of the visiting committees, where devotees of one department or another get to rub shoulders and share special privileges with curators and trustees. All it takes is interest, and the willingness to cough up coin.

In America, state-owned museums are the exception, and most, though founded by public-spirited citizens, were nurtured in the soil of private enterprise and live in a complex environment, "expected to be as cost-

effective as a business while serving as an educational resource, a civic institution and a community partner—usually on the same day," the museographer Marjorie Schwarzer wrote. Like Feigen's well-bred whore, "the contemporary museum has had to embrace some apparent contradictions as it attempts to define itself for its many publics: being a charitable nonprofit organization in a marketplace culture, being a place of memory, reflection and learning in a nation that stresses action and immediacy, being a champion of tradition in a land of ceaseless innovation."

The Metropolitan occupies a state-owned building sitting on public land; has its heat and light bills, about half the costs of maintenance and security, and many capital expenditures paid for by New York City; receives direct grants of taxpayer dollars from local, state, and national governments; and for most of its existence has indirectly benefited from laws that allow, and even incentivize, private financial support in exchange for generous tax deductions. So it is clearly a public institution. But even though New York State has statutory authority to supervise the assets of charities— a vague but powerful standard—over the years the Met's board has considered itself beholden to no one. It has functioned as a private society.

In the Metropolitan's early days, that meant its wealthy and powerful trustees took a straightforward attitude of "the public be damned," closing the museum on Sundays, for instance, even though it was the only day that the working class had free for leisure pursuits (and even though the trustees would sometimes unlock the place, Sabbath notwithstanding, for themselves and their friends). Over the years, that arrogance has been toned down, but it has never been entirely abandoned. Today the museum shames visitors into paying a $20 admission fee, even though its lease says it must be open free five days and two nights a week and its own official policy is that anyone can enter for a contribution of as little as a penny. And although it promised, as part of the 1971 agreement with the city that implemented the Hoving master plan, to create open and direct access to the building from Central Park through two courtyards, those entrances, now named the Carroll and Milton Petrie European Sculpture Court and the Charles Engelhard Court, remain shuttered to this day.

Some neighbors argue that Philippe de Montebello's building-from-within policy also violates the museum's 1971 agreement by altering the

three-dimensional silhouette of the building, which they consider sacrosanct. One protesting group, the Metropolitan Museum Historic District Coalition, was recently able to stop a plan to excavate more space beneath the museum's front apron, its fountains, and Fifth Avenue. Some residents of apartment houses across Fifth Avenue suspect that the museum is still up to something underground, pointing to cracked foundations as evidence.

❖

THE METROPOLITAN MUSEUM IS A NOT-FOR-PROFIT PARTNERship between the city of New York and the museum's trustees. While the charitable corporation owns the art in the museum, some argue that it really holds its treasures in "trust," as first defined by the courts of fifteenth-century England. "The board doesn't own the art; it simply manages the corporation," says Ronald D. Spencer, an art law specialist. "The corporation functions as a caretaker for the public," which makes the trustees the stewards of those priceless assets, obliged to protect them and to manage the institution that contains them. The people are the beneficiaries of that trust.

The museum's board must raise funds for acquisitions, exhibitions, conservation, education, and other costs not covered by the public's contributions, which have, over the years, ebbed and flowed with the currents of economic and political change. Though much is opaque about the Met's operations and finances, its scope can be gleaned from its tax return and annual reports, which are available for public scrutiny: in the year that ended on June 30, 2007, the Met had $299.5 million in revenue, $50 million of which came from public contributions, gifts, and grants, $27 million from the city (which included $12 million worth of gas and electricity, provided for free), almost $24 million from fees paid by its 134,291 members, and just under $26 million from the voluntary admission fees it requests at its entrances.[4]

Auxiliary activities and other income brought in more than $113 million. In 2006, the Met earned $10.6 million from entry fees for lectures and concerts, $8.6 million from major fund-raising parties (including two for the Costume Institute, which alone brought in $4.5 million), and $2.5 mil-

lion from its parking garage. It also netted $26.8 million selling art (the proceeds restricted to acquiring more), almost $4 million from its restaurant, and $41 million selling merchandise, most of which went untaxed because the museum claims that the goods, ranging from scholarly books to reproductions of art on ties and Christmas cards, are "related to the museum's charitable function" as an educational organization.

That's just the beginning. As of June 30, 2007, the museum's assets (*not* including its art) were valued at $3.6 billion, representing a 21.7 percent increase over 2006. Of that increase, $573.2 million came from dividends, interest, and capital gains on its $2.96 billion investment portfolio (which includes stocks, bonds, investment and hedge funds, and private equity and real estate investments). Of that, $69 million was transferred from the museum's endowment to its operating budget. The endowment contributed 30 percent of the museum's revenues that year, gifts from the public 26 percent, New York City 14 percent, admission contributions and membership fees 13 percent each, leaving an operating surplus of $2 million (compared with a $3 million deficit in 2006).

That money paid for the museum's seventeen curatorial departments and eighteen hundred employees (whose efforts are augmented by about nine hundred volunteers) as well as its ancillary activities. Its payroll—or at least the paychecks of its top officers—reflects its status as a huge and hugely successful business. Montebello's total compensation topped $5 million in 2006; six other officers, including the PR man Holzer, were paid in excess of $300,000, and five more received only slightly less. Raking in well-earned big bucks were its chief investment officer (about $1.2 million), deputy chief investment officer ($700,000-plus), and senior investment officer ($337,000), as well as a computer operations manager (just under $400,000), registrar (about $375,000), and technology chief (about $327,000). Outside law firms earned $1 million from the museum in 2006, outside accountants almost $800,000, a human resources consultant almost $400,000, architects almost $6 million, construction contractors the same amount, and shipping and customs brokers almost $3.7 million.

The museum also spent almost $35 million on art that year; $63 million to operate its curatorial, conservation, cataloging, and scholarly publishing departments; $47.3 million on guards; $40 million on its merchandise

operations; $27 million on its galleries; $11 million on education and community services; the same to mount special exhibitions; almost $4 million for public relations; $3.8 million to run its restaurants; $3.4 million for its auditorium; $3 million on member services; $1.4 million to operate its garage; $712,000 on corporate events; $182,000 on government lobbying; $2 million on advertising; $4.3 million on repairs and maintenance; $3.7 million on insurance; almost $2 million on bank and credit card services; $1 million on reference and research materials; $1.3 million on its various programs; $1.8 million for catering; and more than $500,000 on interns and honoraria.

In the two years ending June 30, 2007, the museum also made significant capital improvements, spending some $240 million renovating its Greek and Roman wing and the Ruth and Harold D. Uris Center for Education, $22 million to renovate the wing housing its African, Oceania, and Central and South American collections, almost $17 million to begin remaking the American Wing, $4.2 million to reinstall the Wrightsman Galleries, and about $27 million on other projects. About $61 million in contracts for capital improvements were in the pipeline. Also outstanding were bond liabilities of about $163 million, and a debt of $85 million on a $100 million line of credit from the JPMorgan Chase bank. All of this earned the Met the No. 36 spot on the 2007 *NonProfit Times* list of America's largest nonprofit organizations (the Red Cross was No. 1, the New York Public Library, No. 42).

And that doesn't count the value of the art. "There is no way to calculate it," says the dealer Richard Feigen. "Most of the items are beyond prices realized in the market because the quality is generally beyond anything that has appeared. Think of all the departments . . . Asian, Egyptian, classical . . . it's billions and billions and billions."

Consider that a Jackson Pollock painting sold in 2006 for $140 million. The Met owns at least two, forty Pollock drawings, and three sketchbooks. That same year, a de Kooning painting sold for $137.5 million (the Met owns four and four drawings), and a Klimt painting for $135 million (the Met has two, although they are not as valuable). In 1990, van Gogh's *Portrait of Dr. Gachet* sold for $82.5 million and a Renoir, *Bal au Moulin de la*

Galette, Montmartre, for $78.1 million. Ten years later, the Met owned twenty-seven Renoirs, and "they have over a billion dollars' worth of van Goghs alone," including at least eighteen paintings, another one of New York's top dealers says. Exact numbers are hard to come by. The Met's Web site refers to only seventeen van Gogh paintings and three drawings. The central catalog, a card file of museum holdings that was once open to the public, "is no longer updated," a member of that department e-mails in response to a request for information, so "is now rather incomplete." And the various curatorial departments have grown so territorial and secretive that they will not even share their records of departmental holdings with the museum's own Thomas J. Watson Library, as I learned when I called to confirm the numbers I *could* find.

Michael Botwinick, director of New York's Hudson River Museum, formerly the assistant curator in chief of the Met, points out that it owns more—lots more—than paintings. What's it all worth? It's priceless, of course, since the Met will never sell its collection. But here's a ballpark estimate. "Consider today's art market," Botwinick says. "Twenty-five million dollars is not an unusual price for 'sought after' objects, $50 million is not an unusual price for 'important objects,' masterpieces are certainly going to fetch $100 million, and then there are the touchstone pieces [that are worth] let's say $250 million. Let's say there are a thousand in the $25 million sought-after category, five hundred in the $50 million important category, a hundred in the $100 million masterpiece category, and ten in the $250 million touchstone category. That alone is over $60 billion.

"Add to that all of the harder-to-figure things like the Cuxa Cloister, the Wrightsman period rooms, and the Temple of Dendur. Add to that the high-volume collections. I have little trouble thinking you could argue $100 billion easily."

Harry S. Parker III, a former vice director of the Met and later director of San Francisco's Fine Arts Museums, goes even higher. "I'd take a guess at $300 to $400 billion."

FROM ITS INCEPTION, OVERSIZED PERSONALITIES HAVE DOMI-
nated the Metropolitan; many loom large in American history, too. John Jay,
grandson of the first chief justice of the Supreme Court, conceived of it.
William Cullen Bryant, the orator, poet, journalist, publisher, and clubman,
was one of the most eloquent advocates of the museum's creation. In recent
times, its board heads have been some of America's most powerful busi-
nessmen: in the 1930s, George Blumenthal, who headed Lazard Frères; in
the 1960s, Robert Lehman, the head of Lehman Brothers; in the 1970s,
C. Douglas Dillon, John F. Kennedy's secretary of the Treasury; and in the
1990s, Arthur Ochs "Punch" Sulzberger, the chairman of the *New York Times*.

Some of these characters defined distinct eras in the museum's color-
ful history. Luigi Palma di Cesnola, named the first director by the mostly
self-made founders, was an Italian count, a Civil War veteran given to in-
flating his rank, an American diplomat, and an amateur archaeologist, some
of whose finds from Cyprus remain treasures in the museum's collections
today; his excesses mark it still. J. Pierpont Morgan is credited with turning
the Met from a semiprivate clubhouse for the trustees into a professional
operation.

Following Morgan and dominating throughout the mid-twentieth
century, though never serving as a trustee or officer, John D. Rockefeller Jr.
was quietly its greatest benefactor, and his relationship with James Rorimer,
the sixth director, was a model for the symbiosis between the rich and the
scholarly that made the Met blossom even more after Morgan. Thomas
Hoving, a scholar but also a showman like Cesnola, was appointed by a
board of trustees led by a group of gunslinging veterans of John F.
Kennedy's New Frontier administration; at their urging, he reinvented the
Met, and in the process redefined all museums during his mere ten years as
director, beginning in 1967.

IN 1920, AT THE MUSEUM'S FIFTIETH BIRTHDAY CELEBRATION,
the former secretary of state and Met trustee Elihu Root unveiled two mar-
ble slabs carved with benefactors' names in the Great Hall. Among the first
names to be added were those of Rockefeller (who later contributed his

collection of medieval art and the Cloisters to house it); the banker George Baker, who started what's now called Citibank and gave the museum an unrestricted seven-figure gift; and Frank Munsey, known as the most hated newspaper publisher in New York, who handed over an amazing $20 million in 1925—then the largest cash gift ever given to a museum—making the Met the wealthiest museum in the world.

Ever since, the Met has been a political, cultural, and social spectacle, especially when all three come together in the cauldron of fund-raising. Then the fun really begins. You can get a seat on the board by wielding power (like Henry Kissinger, who was recruited to lend geopolitical savvy), or waving your family bloodline or corporate flag (among the Met's brandname trustee dynasties have been Morgans, Astors, Whitneys, Rockefellers, Annenbergs, Houghtons, and various representatives of the Lazard Frères investment bank), or possessing a useful skill or connections (like any number of financiers, developers, and media titans such as Mrs. Ogden Reid, Henry R. Luce, and Sulzberger). But money counts most of all: a commitment to donate six-figure sums every year, or to twist the arms of other potential givers. "Give, get, or get out" is the rule.

Committee membership can cost even more, particularly if one lands a coveted seat on the acquisitions committee, where you're expected to cough up cash to buy treasures. The only exceptions are those who are rich in art and are wooed in the hope that those riches will one day be donated to the museum. Like the wine committee in a social club, acquisitions is the most fun, but not the most powerful, sinecure. That honor goes to executive, which really runs the show. As recently as thirty years ago, the museum's board actually functioned like one, arguing about issues, making a difference. Nowadays, it simply serves as an applauding claque for the smaller group that actually makes the decisions.

To oversimplify only somewhat, the Metropolitan Museum has always swung between two poles, two kinds of directors, revolutionaries and reactionaries, change agents and consolidators. Bomb throwers like Hoving and Francis Henry Taylor have wanted to open the museum up to the people, while the knee-jerk reflex of the trustees is to disdain the clamoring hordes. Montebello, almost all agree, was a brilliant example of the elitist director—the type that tends to be favored by executive trustees—but he was also a

consummate bureaucrat, which may well explain how he lasted thirty years in his job. A distinguished success, well paid and highly respected, he was neither exciting nor adventurous—nor was he loved. He was hired to be exactly what he became: the keeper of a great tradition. Under Montebello, as in the heyday of the Brahmins, the museum—behind a curtain of secrecy— could do what it wanted.

BACK IN PHILIPPE DE MONTEBELLO'S OFFICE, I WOUND UP MY pitch for the museum's cooperation by gently telling him and Emily Kernan Rafferty, the museum's president, that I was aware that some months before the curatorial staff had been ordered not to speak to me. "Well," huffed Montebello, "we wouldn't do that! That would violate the principles of the museum. It would be wrong." Then he said it again. "It would be wrong." Out of the corner of my eye, I noticed Rafferty trying to signal him, first subtly, then broadly, until finally she spoke up. "Uh," she interrupted, "Philippe . . . ?"

She had in fact told her senior staff not to speak to me if I called them, she said.

"Well, that was wrong," Montebello huffed, but his heart was no longer in it. I left the room shortly after that with the distinct feeling that I was on my own. For I already knew that a curtain of secrecy had been hung over the museum long before Montebello's time. With the stakes so high and the money and egos involved so big, the Met has always had to operate in the shade, whether it was acquiring art under questionable circumstances, dealing with donors hoping to launder very sketchy reputations, or merely trying to appear above reproach in a world where behind almost every painting is a fortune and behind that a sin or a crime. So I was disappointed but unsurprised when, a few days later, a letter arrived, confirming that the museum, its staff, and supporters would not cooperate.

But that wasn't my last encounter with the top of the museum's organizational chart.

Dietrich von Bothmer, the museum's then eighty-nine-year-old curator emeritus of Greek and Roman art, was, I was told, close to death. "Get

him now," more than one person urged. "He ought to have a lot to say." It was just at the moment when the heat was being turned up on antiquities in American museums. Bothmer's counterpart at the J. Paul Getty Museum in Los Angeles, Marion True, was going on trial for acquiring and smuggling illegally looted antiquities in Italy (she would later face charges in Greece as well). Its government was pressuring the Met to return the greatest prize Bothmer ever brought home, the so-called Euphronios or Sarpedon krater, a huge vessel originally used to mix water with wine, painted with a scene of the death of Sarpedon, Zeus's son, by the Greek master Euphronios in about 515 B.C. At the time, Montebello was digging in his heels; he didn't want to give it back.

When he'd bought the krater from True's co-defendant in Rome, a dealer named Robert Hecht Jr., Bothmer was hailed a hero—it was the finest of twenty-seven surviving vases by the painter—but he was also condemned by archaeologists who insisted that he had to have known it had just been dug from Italian soil. Surely, Bothmer had stories to tell. Maybe he would tell them. Maybe he hadn't gotten Rafferty's memo. Maybe he was too old to care.

So I wrote him a letter, and a few days later his wife, the former Joyce Blaffer, a Texas oil heiress, called and said that she would arrange with Miles, the nurse's aide who accompanied Bothmer to the museum each day, for me to interview him. Miles and I arranged to meet at the Met on February 1, 2007. Greeting me at the security desk, he said that after I spoke to Dr. Bothmer, the curator wanted me to read "his memoirs."

Upstairs, in one of the hidden warrens where the museum's staff works, Bothmer was sitting in a wheelchair, holding a wooden walking stick in his left hand, in the small windowless office the museum had assigned him in retirement. He was sharply dressed in a black jacket and black sweater, his museum ID on a chain around his neck. He has straight white hair, a large, jutting face with a strong square chin, and searching eyes behind rectangular glasses. Clearly, he'd once been quite handsome. He was still imposing. I spent a pleasant hour chatting about everything from his family's background to his first days at the museum in the 1940s.

While we were talking, two curators, James C. Y. Watt, the Brooke Russell Astor Chairman of the museum's Department of Asian Art, and his

wife, Sabine Rewald, the Jacques and Natasha Gelman Curator in the Department of Nineteenth-Century, Modern, and Contemporary Art, stopped in. I was introduced to Rewald, who asked what I was doing. I explained I was interviewing Bothmer for a book on the museum, and she asked if I'd been "sent" by the museum's Communications Department. I said no, I was an independent author and hoped to interview her, too. Later that day, I would innocently call and leave her a message. She never replied.

Though Bothmer's recollections sometimes got what I'd call "stuck"—he would elaborate on stories we'd already covered as I tried to move the conversation forward—those moments were brief, and mostly he was engaged and engaging. Still, at the end of an hour, he was clearly tiring, so I suggested we continue the next day. At that, he was wheeled home, but not before Bothmer, his aide, and his assistant, Elizabeth, all urged me to stay and read his book, pointing to a large manuscript box sitting on Bothmer's desk.

The "book" turned out to be one of a series of oral history interviews with the museum's top trustees and staff, this one conducted in 1994 for the Archives of American Art at the Smithsonian Institution. I had asked to read them, but I'd been told I needed the permission of the interviewees to see them and that had to come via the museum, so I was out of luck. Thrilled to finally be seeing one, I began by reading a cover letter from Ashton Hawkins, the museum's secretary and chief counsel from 1969 to 2001. It said, "We want to leave it up to you to decide whether to restrict access to the interview during your lifetime."

I got through about a third of the book that day, then left when Elizabeth had to go home. We discussed a plan for the next day and decided that I would return at 9:45 a.m. and continue reading until Bothmer joined me at 11:45 to resume the interview. Sometime after 10:00 the next morning, Elizabeth excused herself briefly. The day before, Miles had asked me to pick up the phone if it rang, so when it did, I answered without thinking. A mistake.

The caller identified herself as Sharon Cott, Ashton Hawkins's successor, the museum's senior vice president, secretary, and general counsel. "Is Miles there?"

I explained that he had not arrived and Elizabeth had stepped out. With a sinking feeling—I'd been busted!—I asked to take a message.

"Who is this?" she asked.

"Just a visitor." Why in God's name had I picked up the phone? Had Rewald called Cott instead of returning my call?

Elizabeth appeared, and I went back to reading while she returned Cott's call, instantly turning guarded. Elizabeth referred her to Miles. The phone rang again. Elizabeth listened and turned. "They"—Miles and Bothmer? Cott?—didn't want me to read the oral history, she said. But then she turned away and let me keep reading.

I started skimming, skipping ahead to the pages on more recent events.

Elizabeth's cell phone rang, and she left the room just as I reached a page that warned that what followed was not to be released until years after Bothmer's death. I stared at that page, wondering what lay beyond it, until Elizabeth returned. Now she said she really did have to take the pages away. But Bothmer would be there any minute.

Soon, Miles pushed Bothmer into the office, apologizing. With a glance, I tried to tell him no explanation was necessary. But explain, he did, in a rush. He had to take Bothmer "to therapy," an appointment he'd just remembered and that could not be switched.

"You've got five minutes," he said. "Make the most of it."

Less than three minutes later, Miles was back. He seemed embarrassed and confused when I suggested we continue another day as Bothmer was clearly enjoying himself. He'd even said so. Then Miles and I stepped into the hall outside, where he said that "the museum" felt Bothmer was "doddering" and "senile" and because of "his condition" didn't want him speaking to me. He added something about having to stop me because we were on museum property. Anticipating that problem, I had originally suggested to Joyce Bothmer that I interview him at home. Miles promised to speak to "Madam" about that. When we returned to the office, Bothmer was upset at the abrupt end of our conversation.

I suggested that I walk Miles and Bothmer out of the museum. Miles was buttoning Bothmer's coat when Sharon Cott appeared, grinning stiffly,

saying nothing, arms tightly wound. Miles pushed Bothmer into the hall, where an awkward pas de quatre took place—no one acknowledging what was going on. Cott finally said she wanted to talk to Bothmer. He asked, "Is this a conspiracy?" I'd decided I liked him. "Several," I said.

"I don't know what you mean," Cott reprimanded me. I wondered, is this what you learn in law school? I told her we were all leaving. Did she want me to leave alone? She did. As I walked down the hall, Miles pushed a slightly bewildered Bothmer back into his office.

Perhaps Bothmer knows no secrets. But Tom Hoving told me that's not what the Italian government believed; he says the Euphronios krater was only returned after Italy threatened to indict Bothmer as it did Marion True and drag him into court.

With their curator emeritus confined to a wheelchair and, in the museum's estimation, doddering and senile, perhaps the museum's leaders were worried for his health. Or perhaps their concern was what he might say if questioned.

Regardless, he will take his secrets to the grave—at least until his full oral history emerges, if it ever does. The Metropolitan Museum is a storehouse of human memory. But it appeared, that day at least, it would just as soon its own be erased.

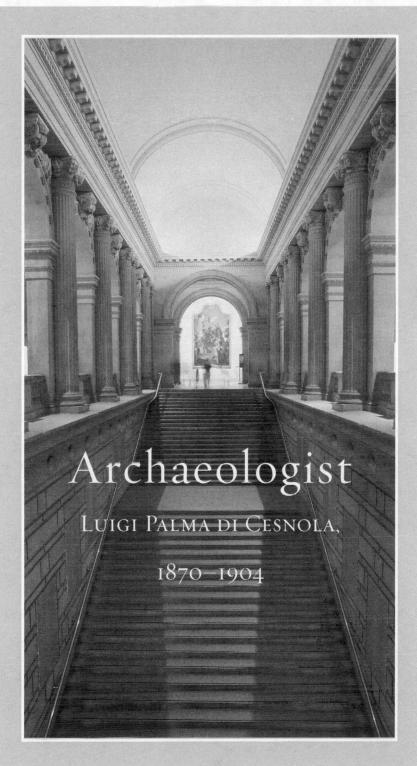

Archaeologist

LUIGI PALMA DI CESNOLA,

1870–1904

In August 1865, just after the end of the Civil War, President Andrew Johnson named a new American consul to the scrubby island of Cyprus, an outpost of the Ottoman Empire in the eastern Mediterranean Sea. The lucky appointee was an expatriate Italian, a minor aristocrat, and a soldier of fortune who'd survived the Austrian and Crimean wars, a passage by ship to New York, years in poverty, and a suicide attempt before distinguishing himself as a Union officer in the Civil War. Wounded in action, he was held prisoner, oddly enough by both his own side and the Confederacy. After winning his consulship, he became an American citizen and began an eleven-year career in archaeology that would win him the riches and fame he dearly craved, but not the respect that he finally wanted more.

Cesnola was sometimes called a count (or *conte* in Italian), a title he technically didn't hold before he renounced it on becoming a U.S. citizen.[1] That wasn't Cesnola's only upgrade. Though he'd risen only to the rank of colonel in the army, once appointed consul, he also promptly took to

calling himself general, claiming, without any supporting evidence, that his commission was awaiting Abraham Lincoln's signature on the night of the president's assassination. New York's newspapers and official museum publications would later call him that regularly, as if he'd been one. But no matter. Though his route to his fate was anything but direct, Nobile Emmanuele Pietro Paolo Maria Luigi Palma di Conti di Cesnola was a man of destiny, and he was on course to become the first potentate of the Metropolitan Museum of Art and a model, for both good and ill, for those who followed him.

The museum's first acquisition with a dubious title, he would not be the last.

THE MET DIDN'T EXIST WHEN CESNOLA WENT TO CYPRUS. BUT a year after his appointment as consul, a group of Americans spending the summer of 1866 in Europe came together for an all-day, all-night Fourth of July party at Le Pré Catelan, a restaurant in the Bois de Boulogne outside Paris, where two tents were set up for dining, another for dancing, and a fourth as a coat check, all decorated with French and American flags and portraits of George Washington and the reigning emperor, Louis Napoleon, who called himself Napoleon III.

Addressing the gathering, John Jay, a lawyer, abolitionist, and founder of the Republican Party, as well as the grandson of the first chief justice of the Supreme Court, gave what an observer called "a most lively and amusing speech on the American Invasion of the Old World," during which he suggested that America needed an art museum of its own and that Americans like his fellow guests, who had experience abroad and the taste to appreciate Europe's treasures, were the ideal candidates to start it.[2]

Back in New York, Jay was a founder and the president of the civic-minded Union League Club, a group of pro-Union, antislavery entrepreneurs in a city generally known for pro-Confederacy sentiments. So besides wealth, a certain boldness characterized its early members. Soon, the club's art committee, headed by the magazine and book publisher George Palmer Putnam (whose authors included William Cullen Bryant, Nathaniel

Hawthorne, Washington Irving, James Fenimore Cooper, and Edgar Allan Poe), was charged with making something of Jay's idea.

Museums were a European invention. In the early sixteenth century, Pope Julius II bought the *Laocoön,* a marble sculpture that had been found buried in a Roman vineyard. A month after it was dug up, he put it on display, and the Vatican Museum was effectively born.[3] In his history of the American museum, *Palaces for the People,* Nathaniel Burt says that artistically aware post-Renaissance Europeans didn't need museums because "they lived in them . . . the Roman palazzo, German schloss, French chateau or English great house." Europe's museums grew out of those private treasure troves. The very first, in Basel, Switzerland, began as the private collection of Hans and Bonifacius Amerbach, friends of Hans Holbein the Younger's. In 1743, Anna Maria Ludovica, a Medici, gave her family collections to Florence on condition they never be removed and "should be for the benefit of the public of all nations." Similarly, the British Museum, chartered in 1753, was founded on the private collections of Sir Robert Cotton and his son Thomas, Robert Harley, and Hans Sloane (namesake of Sloane Street, Sloane Square, and Hans Crescent), who called his treasure house a museum because it contained objects for study, not pictures for mere enjoyment.

The Louvre, too, began as a private art collection, formed by François I and Louis XIV. Just after the French Revolution, the onetime Royal Palace was renovated and reopened for the public. But it was Napoleon who laid the foundation for the encyclopedic Louvre we know today, systematically looting treasures from the countries he conquered and bringing the spoils back to Paris. His brothers, whom he put in charge of nations he conquered, followed suit, helping to establish the Rijksmuseum in Amsterdam, the Museo Nazionale in Naples, and the Prado in Madrid.[4]

Burt says the first museum in America was the one opened by the painter Charles Willson Peale, who exhibited his portraits of heroes of the Revolution in Philadelphia in 1786. His sons later founded Baltimore's Peale Museum in 1814. Another artist, John Trumbull, was involved with the American Academy in New York, which opened and closed repeatedly at the start of the nineteenth century, and planted seeds from which sprang America's first true art museums—though they were really just galleries—

in Connecticut, at Yale in New Haven, in 1832, and the Wadsworth Atheneum in Hartford, which opened in 1844. But neither these museums, nor the several fledgling art societies and academies founded in New York, nor the New-York Historical Society, formed by families of the Dutch and English landed gentry in 1804, had the breadth to be considered in the same league as the museums of the Old World.[5]

The New-York Historical Society did have ambitions, though, so in 1856 it decided to expand its art holdings, swallowed up several more collections in the ensuing years, and in the summer of 1860 declared its intention to "establish a museum and art gallery for the public in Central Park."[6] The historical society set its eye on the Arsenal, a former munitions-storage facility at Fifth Avenue and Sixty-fourth Street.

In the spring of 1862, the state legislature gave the Arsenal and some acreage surrounding it to the historical society for "a museum of antiquities and science and a gallery of art." But the society, whose members were wealthy but limited in number, couldn't raise the money to make it happen. Then, in 1866, after receiving a gift of 250 European paintings, it tried again, petitioning for another, larger site on higher ground (the Arsenal was below grade) and winning the right to build on the plot of land where the Metropolitan now stands. Richard Morris Hunt, brother of a painter and an architect who'd built palaces in Newport and New York for families with great names like Goelet, Vanderbilt, Astor, and Belmont, had been hired to design a grand building for the Arsenal site; now it was to be built farther uptown, and a committee was formed to raise money to do so.[7] The historical society's idea was to erect "an appropriate and beautiful edifice" that could be "indefinitely enlarged and extended, without the least detriment to its symmetry, as the future exigencies of the Museum may require."[8] Such a building would indeed be erected, but not by the historical society and not before a seismic shift in New York society changed the lay of the land.

Until the Civil War, most wealth in New York belonged to a landed gentry in the form of real estate. But in the mid-nineteenth century, self-made businessmen and financiers began printing money at such a rate that there was enough left over for hobbies. The American art collector was born. In New York, a group of nouveau riche magnates; the gold-rush-era merchant and shipbuilder William H. Aspinwall; John Taylor Johnston, a

railroad tycoon; August Belmont, the American representative of the Rothschild family bank in Frankfurt, Germany; William Tilden Blodgett, a varnish millionaire and real estate investor who co-founded the *Nation* magazine in 1865; and the retailer Alexander T. Stewart began amassing significant art collections. Where their forebears had fled Europe, they now turned back to it as a source of high culture. And on April 4, 1864, some of them helped organize and many more attended the opening of the Metropolitan Fair Picture Gallery, an exhibition and auction of hundreds of paintings at the Fourteenth Street Armory to benefit the Union's wounded soldiers.

Among the paintings on display were works by Frederic E. Church, John Frederick Kensett, Albert Bierstadt, Daniel Huntington, Asher Durand, and several by Emanuel Leutze (including *George Washington Crossing the Delaware*, which would eventually end up in the Metropolitan). Aspinwall, whose collection was full of old masters, Belmont, and others opened their private galleries to the public to coincide with the fair.[9] Later that month, the *New York Times* picked up the drumbeat, editorializing that the fair "suggested to many for the first time, and renewed in other minds more emphatically, the need, desirableness and practicability of a permanent and free gallery of art in this city . . . The time has come."[10]

Unfortunately, the time was already past for the patricians who controlled the New-York Historical Society; though they tried for the next two years, they could raise neither the money nor the will to follow through on their plans for a museum. Its leaders also feared that building on public land would invite "control by the hoi polloi," says the society's current historian Kathleen Hulser. Eventually, and not without considerable pain, the Metropolitan would prove that fear unfounded.

Back at the Union League Club, things had moved forward—albeit at a glacial pace. It took three years before George Putnam's art committee (which included Kensett and another landscape painter, Thomas Worthington Whittredge, as well as Samuel P. Avery, the art dealer who'd advised August Belmont on his collection) decided that an art museum was indeed worthwhile, and then invited three hundred of the city's most powerful, rich, and cultured citizens to a meeting in the league's auditorium on East Twenty-sixth Street, where William Cullen Bryant presided and spoke

with his usual eloquence. The city needed a museum worthy of its new status as the third "great city of the civilized world," he began.

Next up to the podium was a young Princeton lecturer on art, George Fisk Comfort, who agreed that the American deficiency in the formative arts of painting, sculpture, and architecture could best be cured by the establishment of free museums. "It was impossible to tell how much America had lost by not having such a museum," a newspaper account of Comfort's speech continued, "not only in the lack of improvement in the public taste for art, but in the loss of opportunities to purchase valuable collections" that were "rapidly passing away." Even now, he warned, a classicist from a Berlin museum was en route to Cyprus to examine a collection of works owned by the American consul there, "a collection that ought by all means to be secured for *this* country." Even though he was unknown and thousands of miles away, Luigi di Cesnola was in that crowded room.

Before the end of the evening, and even though, in the words of the future trustee Elihu Root, "there were many faint hearts in that group," those assembled resolved to establish an art museum in New York and named fifty "gentlemen" to make the necessary legal preparations and get the project off the ground. Thomas Worthington Whittredge wrote that he and the other artists on the arts committee "modestly left our names out, and the matter [then] took such a worldly turn that it was a long time before we were mentioned as ever having had anything at all to do with the inception of the Metropolitan Museum."[11] Their modesty was a mistake; though Kensett, Church, the genre artist and society portraitist Eastman Johnson, and the sculptor J. Q. A. Ward would be among the Met's first officers, artists would never again play a significant role at the museum, and though works from their Hudson River school did enter the museum as gifts and bequests, for the next hundred years neither living nor American artists would feel welcome there.[12] Artists were apparently not gentlemen.

Nathaniel Burt characterized the resulting Committee of Fifty as "a rather odd list" that boasted "very few immediately recognizable names," aside from the painter Church and the Central Park architects Frederick Law Olmsted and Calvert Vaux. The presence of the bibliophile and philanthropist James Lenox, the bankers Henry G. Marquand and Anson Phelps Stokes, and the influential lawyer Joseph H. Choate notwithstand-

ing, it "seems like a collection of second-string worthies, chosen as substitutes for bigger fish who got away."

This was the new, meritocratic New York; the fifty were successful businessmen, either self-made or merely of the second generation, all of them respectable but not yet prestigious, who had emerged from the Civil War into civic pride, political reform, and cultural ambition. They were the "strange weeds pushing up between the ordered rows of social vegetables" that so distressed Newland Archer's mother in Edith Wharton's *The Age of Innocence,* and they had more in common than their love of art and their disdain for New York's corrupt Democratic political culture. Many were close friends, so right from the beginning they formed a like-minded group.

Though they lacked the status of the Knickerbocracy, they had their own elite clubs that defined the culture they sprang from. Two-thirds of their number belonged to the civic-minded Union League, and forty of them to the culturally disposed Century Association, which had been formed twelve years earlier "for the purpose of promoting the advancement of art and literature."[13] Though they'd gotten off to a slow start, they now began to move forward with a keen sense of purpose and destiny. Choate drafted the legal documents, and two months later the first board of trustees was appointed, and, putting first things first, they elected officers and began raising funds.

LONG BEFORE HE'D ARRIVED ON CYPRUS AND REINVENTED himself—again—as an archaeologist, Luigi Palma di Cesnola's life was already an opéra bouffe, a wild blend of adventure and farce, of opportunism awaiting only opportunity. He was born in June 1832, the second son of an impoverished absentee father whose noble family traced its origins to medieval Spain and a wellborn, much younger mother whose family had been ennobled only four decades before but was far wealthier than the Cesnolas. Several Cesnolas had fought for the revolutionary cause of Italian unification, a history that infected young Luigi with a desire for glory and mixed feelings toward authority. The family crest carried the motto *"Oppressa resurgit,"* or "Oppressed, he rises again."

Expelled from his first school, Luigi left his second, a military academy, at fifteen to become a Sardinian soldier and for the next seven years fought the losing battle against Austrian domination of northern Italy but won fast promotions and a medal for bravery. After another stint in a military academy, Cesnola was promoted to lieutenant and became secretary to a general. Just weeks later, he was discharged from the army for reasons unknown. Undeterred, he became a soldier of fortune and won a commission in a joint British-Turkish army, serving as a general's aide in the battle of Sevastopol during the Crimean War. Then, choosing not to live off his mother's fortune, he followed his own star, first to Turkey and finally, at age twenty-six in 1858, to New York City.

For the next few years, he lived in boardinghouses, "in poverty and solitude . . . unemployed and probably hungry," his biographer wrote, failing to find work as a translator and composer and then, according to his late granddaughter, attempting suicide.[14] Finally, in 1859, he found work teaching Italian and French to young women seeking to better themselves. One of them was Mary Jennings Reid, daughter of Samuel Chester Reid, a hero of the War of 1812, the designer of the Stars and Bars version of the American flag, and later harbormaster of the Port of New York (the predecessor of today's Port Authority). A few weeks after Abraham Lincoln's inauguration, Cesnola proposed to Mary by letter, and they wed, over the objection of her friends and family, in June 1861.

By then, the War Between the States had begun. Early in 1862, Cesnola enlisted and was made a major in the Eleventh New York Cavalry Regiment, but within a few months, bored by tedious duty far from the front and chafing at having to report to an officer he felt was inferior, Cesnola resigned. Less than a month after that, he was arrested for promoting mutiny among his former regiment's troops by trying to lure them away to fight under him. Unbowed, he wrote from prison to George McClellan, the Union's top general, complaining about his former superior and asking for his own command.

His audacity paid off. By year's end, he was leading five cavalry regiments of the Army of the Potomac into skirmishes against Confederate troops in Virginia. But early in 1863, trouble came again when he was charged with stealing public property, mailing six Remington cavalry pistols

home to his wife. Though he insisted his aim was pure—he'd sent the guns for guards trying to stem desertions—he was worried enough to pointedly inform his accuser that he had friends in high places and mention all the good press he'd been getting. To no avail. He was cashiered out of the army with a dishonorable discharge.

Cesnola began a letter-writing campaign, peppering Lincoln's assistant secretary of war with press clippings, personal recommendations, legal arguments, and affidavits indicating he hadn't actually stolen the pistols, and finally, after a month, was reinstated as a colonel. After being discharged and reinstated again, Cesnola was wounded in battle, lost his mount, and ended up in Libby Prison, a converted tobacco warehouse in Virginia, where his pride and contempt for his captors ensured that he was passed over whenever prisoner exchanges were arranged. Finally, in March 1864, his wife, Mary, and his best friend in New York, Hiram Hitchcock, a co-owner of the Fifth Avenue Hotel, induced the general in charge of exchanges for the Union to make an offer the Confederates could not refuse, and Cesnola won his freedom. He returned to New York briefly as preparations were under way for the Metropolitan Fair, but a month later he was back in uniform, back in combat, and soon enough back in trouble, accused of various failures and transgressions and accusing fellow officers of their own, before prevailing in one final skirmish with the rebels and mustering out of the army forever in September 1864.

Age thirty-two, with a wife and by then a daughter as well, Cesnola faced an uncertain future. He was penniless, and had no ready means of support. Using what he knew, he opened a military school. But that did not suit his ambitions. So after the South surrendered on April 9, 1865, and Abe Lincoln was shot and died a mere six days later, the soldier of fortune let it be known that he'd been fortunate enough to receive a promise from the president, just days before his death, of a general's rank and a consular post. He demanded that Lincoln's successors make good on that promise.

He got a consular job with the help of New York's two senators, who successfully lobbied the secretary of state on his behalf; Cesnola became the $1,000-a-year U.S. consul to Cyprus that August. Even before he left for Europe, he began calling himself General Cesnola.

Being a consul quickly proved dull as well as insufficiently rewarding.

Mostly, his consular reports were filled with complaints about money, but he also griped regularly about his posting to the "barbaric," "uncivilized" Cyprus, the "cunning, deceitful," "unappreciative race" that occupied it, and the "lazy, indolent" Turks who ran it.[15] He tried to augment his income by importing sewing machines. When that failed, he hired himself out as a sort of rent-a-consul to Greece and Russia and tried exporting Cypriot wine via his friend Hitchcock in New York. But then he met England's consul and learned that valuable ancient relics were everywhere for the taking on the island—Cyprus had been conquered by Greeks, Egyptians, Persians, and Arabs before falling to the Ottoman Turks—and that many in the local diplomatic corps had gone into the antiquities business. Overnight, he became a dedicated amateur archaeologist, and soon a very professional dealer in antiquities.

By the summer of 1866, he'd begun digging up tombs outside the city, and then, after acquiring a Turkish permit, or *firman,* through the American envoy in Constantinople, he branched out around the island, eventually claiming to have visited some three thousand tombs himself. Truth be told, he hired local laborers to do his digging and kept no diary, notes, or records whatsoever about the dates or locations of his finds. Modern archaeologists are horrified by his lack of scientific method, care, technique, discernment, and finesse as well as his disrespect for the culture of the land where he spent a decade, but at the time these were nonissues. What mattered was raw accumulation—and at that, Cesnola excelled. He turned tomb robbing into a proto-industrial operation—and displayed its fruits in his home in the port of Larnaca, which he turned into a small museum.[16] That his carelessness damaged many objects and caused others to disintegrate mattered not; there were more where those came from.

In 1868, still trawling for money, he began selling pieces of his collection to tourists; one visitor was Frederic Church, another, Henry Hulbert, a millionaire paper manufacturer, who said he would put in a good word about Cesnola with the founders of the New York museum.

But when Cesnola's diggers excavated their greatest find yet, a huge limestone head, the following spring, the Turkish authorities took notice and became alarmed. Greek and Roman objects were highly prized in Eu-

rope. Cesnola had to move with speed and assurance if he was to keep his edge and maximize the profits of his good luck and hard labors. He'd known the Turks since living in their country after the Crimean War. He was certain that though they ruled Cyprus, he could handle them. He even concocted a new scheme to excavate the entire island.[17]

Cesnola's egotism knew no limits. Ever hungry for money, and seeking career advancement and a better posting, perhaps as the American consul in Turin or the Italian consul in New York (his wife longed to return home), he'd already commissioned two biographies of himself in Italy (by the end of his career, he would be the subject of five) and sent boxes of antiquities off to anyone he thought might help him. Cesnola had dug up so many objects so indiscriminately that he sometimes sent dirt-encrusted finds to Hitchcock by the basketful, accompanied by instructions on how to clean them. Cesnola saw a bright future. Museums were a growth industry; he started sending gifts to them, too.

In 1870, with twelve thousand objects on hand, Cesnola auctioned hundreds in Paris and contacted the British Museum, the Louvre, and the Hermitage, hoping one of them would buy his collection en masse and label it with his name forever. None of them bit.

Undeterred by the snubs, Cesnola approached the fledgling Metropolitan. In August 1870, he wrote to John Taylor Johnston, who'd just been named its first president. Cesnola, to his lasting credit, didn't want to break up his collection and sell his finds piecemeal, even though that would likely make him more money; he wanted his collection to remain intact. And if he also got a bag of money for it and a big job and salary at the museum that housed the Cesnola collection, well, so much the better.

IN MID-JANUARY 1870, THE COMMITTEE OF FIFTY ADOPTED A preliminary constitution for an association called the Metropolitan Museum of Art, formed to encourage "the cultivation of pure taste" and "the application of art to manufactures and to practical life." Two days later, a meeting was scheduled at the Century Association to elect the museum's

first officers, but the election was abruptly postponed. At what was apparently a contentious meeting, a first slate of candidates was "not approved." A question was raised as to whether the meeting had a quorum. And objections were also raised to both the name of the museum and the description of its purpose in the constitution.

Whatever issues caused the postponement of the election, they were swept away on the last night of January, when twenty-seven men were elected the first officers of the museum. Johnston was named president, William Cullen Bryant a vice president, William J. Hoppin of the New-York Historical Society and the socially connected Hudson River school painter John Frederick Kensett were among eight trustees, and Comfort, Choate, Church, Hunt, Olmsted, and Putnam were elected to the thirteen-man executive committee with the varnish king Blodgett at its head. Johnston was sailing the Nile at the time, but cabled his acceptance and rushed home.[18] The state legislature made it official on April 13, 1870, approving the new corporation the very same week that the New-York Historical Society announced *its* plan to raise funds on its own to build a museum in Central Park. It was a museum moment all along the eastern seaboard. The American Museum of Natural History, Boston's Museum of Fine Arts, and Washington's Corcoran Gallery were also all born nearly simultaneously.

The Met's ambitious executive committee immediately raised the stakes, declaring its intention to eventually create "a more or less complete" collection of art "from the earliest beginnings to the present time," to sponsor a drawing program in public schools, to immediately begin acquiring plaster casts and models of great sculpture and architecture, to begin an art library, and to prepare an exhibition of loaned artworks meant to quickly be replaced by purchases and gifts. It also decided to offer 250 voting memberships in the association and to charge $1,000 to become a museum patron, $500 to become a fellow in perpetuity (that is, with the right to bequeath that status at death), and $200 to become a fellow for life, and it recommended the appointment of a building committee to figure out how, and how much it was going to cost, to house it all. Finally, the committee declared that "the Central Park would be a good location for such an edi-

fice," adding, "Let us have the building and objects of art to fill it will be forthcoming."

On the morning of May 24, the *Times* announced that the historical society had requested a site for its "very extensive monument" from the state legislature. At the Metropolitan's first annual meeting, held that night at Johnston's home, an all-marble palace on lower Fifth Avenue, a permanent constitution was adopted and the board of trustees grew to twenty-one members and was divided by lot into classes, allowing the reelection or replacement of three members per year. (At various times New York's governor and the city's mayor and public works and parks commissioners have served ex officio.) The executive committee shrank to five members: its chairman, Blodgett, Hoppin, Kensett, the financier Robert Gordon, and the architect Lucius Tuckerman. Most important, the founders got serious about raising money, appointing finance and audit committees and deciding on a first fund-raising drive with a goal of $250,000.

The Metropolitan's founders had more going for them than money. They and their kind were vocal opponents of "Boss" William Magear Tweed, then a state senator, but he pushed their interests in Albany, New York's capital, because he hoped to get a big cut of any money spent building museums in Central Park, and to win the favor of the powerful culturati. He'd lately bribed, cajoled, and engineered the passage of a new city charter, which, among other things, wrested control of the park from state officials and put its acres of fresh fields for graft into the hands of Tweed's legendarily corrupt political machine. Estimates of the Tweed Ring's total thefts from the city's coffers would ultimately range from $30 million to $200 million.

The patricians of the historical society had made it quite clear that they did not want the public paying for its planned park home, precisely because they hoped to avoid entanglement with city officials. The Met's founders proved less finicky. Samuel Tilden, a railroad lawyer, introduced Tweed to Albert Bickmore of the American Museum of Natural History, and he and Choate (who was on both boards) went to Albany to show Tweed a proposed museum charter. Tweed and his henchman Peter Sweeney, the head of the city's Department of Public Works, promptly in-

troduced museum bills in the state legislature, incorporating first the American Museum of Natural History and then the Met.* Choate cleverly inserted language stressing the art museum's plans to furnish popular instruction, to ease its passage down the throats of the Tammany officials who supposedly represented the interests of the city's swelling population of Catholic immigrants and working poor.[19]

Like many of the museum presidents who would follow him, John Taylor Johnston was a wellborn collector. The son of Margaret Taylor, whose father had come to New York from Glasgow in the 1770s, and John Johnston, a Scottish shipping mogul and banker, young Johnston took his first trip to Europe at age thirteen, visiting Rome, Venice, and Florence, where his father bought copies of old masters, and decided that the mosaics in St. Mark's Square were "frightfully ugly." Johnston went to high school in Scotland and then enrolled at NYU, finally graduating from Yale College law school in 1841. Two years later, bored by the law, he toured Europe again, where his father bought more old masters "for a mere song" and he walked through the Louvre with his mother, comparing its pictures with ones they'd seen in other collections.[20] On that trip, Johnston met his wife, Frances, whose father, James Colles, was a broker for plantation owners in New Orleans and later a tastemaker whose collection of what is now known as Fine French Furniture is renowned to this day.

In 1848, the bewhiskered Johnston became president of a twenty-five-mile-long local railroad and quickly built it up into the four-hundred-mile Central Railroad of New Jersey, a giant shipper of anthracite coal. He also developed suburban communities along its route. In the following decade, he began accumulating an art collection and built the first marble mansion in New York to house it and his family at 8 Fifth Avenue, a block north of his parents' house. It had a checkered black and white marble hall and a grand staircase with a wide mahogany banister, perfect for his grand-

* A year·later, Choate would join the Committee of Seventy, which broke up the Tweed Ring, and give an indignant speech condemning Tammany and its boss. Shortly afterward, in October 1871, Tweed was arrested. Two years later, he would be convicted on more than two hundred counts of fraud and larceny and then, after an escape that lasted almost a year, die in prison in 1878.

children to slide down.[21] Enormous bronze elephants guarded the entry to his galleries in a rear stable house that he opened to the public once a week.

Johnston's collection included works by Corot, Meissonier, Church, Johnson, Durand, Kensett, Thomas Cole, Gilbert Stuart, and his greatest acquisition, J. M. W. Turner's *Slave Ship*. He was in the right place at the right time; central Greenwich Village was an artistic hothouse. The National Academy of Design was nearby, as was the Century Association. And in 1857, Johnston's brother commissioned the neighboring Tenth Street Studio Building, America's first building for artists' studios arrayed around a domed gallery. Richard Morris Hunt designed it, and Frederic Church, Winslow Homer, and William Merritt Chase would all be tenants.[22] The Johnston home, says a descendant, "was ground zero for everything going on in New York for fifty years."

It was certainly ground zero two nights before Christmas 1870, when dozens of art-minded gentlemen of New York assembled chez Johnston—among them Henry Marquand, Frederick Rhinelander, and J. Pierpont Morgan, who would in turn become the next three presidents of the Met—for an hour-long tour of his gallery followed by a meeting to begin raising funds for their museum. By the end of it, $45,000 had been pledged toward the $250,000 goal. Until the larger amount was promised, no pledges would be called in.

The museum trustees met on March 3, 1871, to review the lack of progress of the subscription drive and consider a broader appeal to the public. The museum was nowhere near its initial fund-raising goal. Only Johnston had proved willing to commit more than a four-figure sum, and he'd given only $10,000.[23] A year later, only $106,000 had been raised from 106 donors.

The trustees' "Appeal to the Public" cited many of the same arguments first made by John Jay in Paris: a museum represented "an essential means of high cultivation." Money was needed soon because "there is now an opportunity, made by the political and social changes in Europe, to buy works of art of all kinds and at low rates." In fact, Europe's misfortunes had already created the opportunity for the museum's very first purchase, for which it would agree to spend more money than it had.

That transaction was set in motion by Blodgett, a relatively unedu-

cated self-made man who made a fortune before becoming a political reformer and abolitionist. Blodgett gained attention in art circles in 1859 by spending $10,000 on a painting, *Heart of the Andes,* by Frederic Church, the highest price paid until then for a work by a living American artist. The wealth of the mutton-chopped, dark-haired Blodgett had allowed him to accumulate a gallery of art, including works by Asher Durand, Kensett, Jasper Cropsey, Whittredge, Théodore Rousseau, Thomas Gainsborough, Joshua Reynolds, John Constable, Jean-Louis-Ernest Meissonier, Rosa Bonheur, and William Bouguereau.[24] It all led to an invitation to join the Century Association, a charter membership in the Union League Club in 1863, and a year later a leading role organizing the Metropolitan Fair.

The museum's well-polished legend has it that while visiting Brussels, Blodgett discovered and bought on its behalf 174 European paintings, mostly Flemish and Dutch, encompassing works attributed to Rubens, Hals, Van Dyck, Goya, Velázquez, Sir Joshua Reynolds, Guardi, Tiepolo, Poussin, and Greuze. In its official histories, Blodgett is portrayed as a discerning hero for this "timely and disinterested effort," despite its having been "severely criticized at the time as an act in excess of Mr. Blodgett's authority."[25] In the museum's first official telling, he bought two collections, one from "a well-known citizen of Brussels" and the other from "a distinguished Parisian gentleman," which had suddenly come up for sale in the prelude to the Franco-Prussian War in 1870. Half a century later, Calvin Tomkins would write that they came from three collections. In fact, the paintings seem to have had even more sources than that, one possibly being a Belgian art dealer in Paris, one Léon Gauchez, who has been described as a "slightly shady character" by Oxford's *Journal of the History of Collections* and seems to have acquired Blodgett paintings from several different individuals and at estate sales and auctions.[26] Gauchez was among the first of many European art dealers who, over the years, have hooked wealthy, naive American clients and even made a fool of the museum.

The museum says that Blodgett paid $116,180.27 (a bit over $1.9 million in 2007 dollars) for the 174 pictures and wrote to his fellow trustees to offer them to the museum at his cost with a money-back guarantee of authenticity. Although he, too, found the purchase "somewhat rash," Johnston

had assumed responsibility for half the cost, and they'd jointly borrowed $100,000 from the Bank of America to seal the deal.[27] At an eventful March 1871 board meeting, the Met accepted Blodgett's offer and acquired its first holdings. Fortunately, within two months, subscriptions reached $250,000, so it could pay for them.

But Samuel Avery, the art dealer who'd also become a trustee, believed Blodgett was worse than rash, and shared those sentiments with Johnston. While in Paris a year later, shopping for the museum, Avery wrote Johnston expressing his unease about Blodgett's ever-closer relationship with Gauchez, who'd just bid at another auction, apparently on Blodgett's sole say-so, and allegedly on behalf of the museum, for pictures that the museum didn't want and wouldn't pay for in the end.

Avery wrote sarcastically of "the wonderful doings of Mr. Blodgett" and his "wholesale way" of buying that seems to promote "the well known liberality (or folly) of the Americans as a class," making things far harder for Avery when "competing with the old fossils of Europe *for* the fossils of all time." He'd been branded a gilded goose ripe for slaughter, Avery complained, and the museum had become "the great hope of every art operator in Europe." Most of what he'd been offered on his trip was worthless, the rest vastly overpriced—and all due to Blodgett and his Svengali, Gauchez. Avery had been reduced to telling dealers and impoverished nobles selling art "that I don't talk French, that I don't buy old masters—that I don't belong to the museum, that they have no money, that it is a myth, that Mr. Blodgett is dead & etc. . . .

"It is no joke to have an ex-countess of 250 lbs weight pressing you with warm admiration (therm 90) against a freshly varnished *Susanna and the Elders!*" he cried, only half-joking. The one time he'd encountered Blodgett, he was with Gauchez of course. "I saw I was not wanted and so beat a retreat."[28]

Gauchez's judgments have not stood the test of time. In a museum *Bulletin* published to coincide with a recent show of its Dutch paintings, the Metropolitan admitted that only 64 of the 174 Blodgett paintings are still in its collection, the rest deaccessioned (museum-ese for disposed of) as copies, authentic works in bad condition, or simply second-rate. Luckily, Blodgett was also the museum's foremost early fund-raiser, securing "from

others the largest contributions that were collected by any single individual," as the future museum president Robert de Forest would later recall, ensuring the museum's perpetual gratitude despite its hero's folly.

<div align="center">❖</div>

BACK IN NEW YORK, THE QUESTION OF WHERE TO HOUSE BLODgett's pictures was being addressed, and the varnish king had a hand in that, too. Home from Europe, Blodgett was "instrumental" in the negotiation for a permanent home, de Forest would report a few years later. In the spring of 1871, Professor Comfort had led a joint committee of representatives of the Metropolitan and American museums to Albany, where they'd presented petitions signed by forty thousand citizens asking the legislature to issue bonds to raise money to build homes for the two museums. Among the signers, Comfort would later relate, were the "owners of more than one-half of the real estate of New York City." They brought the petitions to Tweed, who handed them off to Sweeney, who declared that once "two or three details" were ironed out, "this will go through."

Those details? How much would the museums cost? Typically, Tweed was looking to make a killing; the museum men pressed for a frugal course, asking for only $500,000 each to build a wing at a time as needed. And could the museums own those buildings themselves, please? When Sweeney insisted that the public had to own them, "our Committee turned and conceded that point and the statute was passed," Comfort said.[29]

In fact, it was the brilliant lawyer Choate who'd crafted the pact with the comptroller of Central Park in a conversation that had begun in 1868, when the founders of the American Museum of Natural History (a group that included the future Met trustees Choate and Blodgett) first approached the parks commissioners about placing their establishment in Central Park.[30]

Joseph Hodges Choate, the son of a doctor from a Colonial family in Salem, Massachusetts, had graduated from Harvard and started his career as a $500-a-year clerk in a law firm, quickly rising to partner. Representing clients like Standard Oil, American Tobacco, and the Bell Telephone System, he was soon considered the greatest corporate lawyer of his age and one of

the city's best-loved after-dinner orators and clubmen, at a time when both attributes were highly regarded. Though he was known as a master of the jury trial, an arena in which his command of rhetoric and legal strategy was unparalleled, his most significant accomplishment may have come in 1895, when he persuaded the Supreme Court to declare the income tax unconstitutional; it remained so until the Sixteenth Amendment passed in 1913.

So by the time he got involved with the museum, the tall and handsome Choate, who had a huge head dominated by flashing dark eyes, was already a figure of renown in New York. His client list was studded with millionaires, and with his reputation for informality, humor, and charm he was a fixture on the city's A-list party circuit.

On his death at age eighty-five in 1917, after a second and equally distinguished career as a diplomat, the trustees of the Metropolitan said they owed Choate a great debt. "To him, in large degree, the Museum owed the breadth of its original scope . . . and the form of its relation to the city of New York, which has made it essentially a public institution, a museum of the people, sustained largely by the people, and administered by the people," they wrote.[31] In truth, the astonishing Choate, then only thirty-nine years old, had done something even more remarkable, conjuring up a brilliant illusion of public accountability, one that persists to the present day.

Under the agreement passed into law on April 5, 1871, and later used as a model by many American cities, the museums would acquire collections, which would belong to them, and employ curators to care for them, while the city would build and maintain "suitable fireproof building[s]." The actual locations of those buildings were still up in the air. Initially, it was believed that both would share what was then called Manhattan Square, just to the west of Central Park between Seventy-seventh and Eighty-first streets, sitting in "side by side buildings which together will form a great central home of artistic and scientific knowledge," according to the *Times*. Meanwhile, the American Museum of Natural History had set itself up in the Arsenal, the proposed home of the historical society until it decided to try to build uptown.

Late in 1871, the Met's trustees finally leased its first home, a brownstone on Fifth Avenue between Fifty-third and Fifty-fourth streets that had formerly housed Dodworth's Dancing Academy, for two years at $9,000 a

year. Although slow in opening its new doors to the public, the Metropolitan felt real enough to a former U.S. consul general in Beirut, who gave it its first donation, a sculptured marble sarcophagus. Then William Backhouse Astor gave the museum its first sculpture, *California* by Hiram Powers, early in 1872. Astor was likely inspired by the opening of the temporary museum that February.

Johnston wrote to Blodgett, telling him of "the stir and bustle" of preparations, most of which involved hanging Blodgett's purchases in "the best place in the rooms." Even as the hanging committee "worked like beavers," Johnston was considering whether to follow Blodgett's advice to concentrate on Dutch pictures and make "the Gallery strong in one thing" or "to branch out in some other line before going deeper into pictures . . . as our space is so limited." So were funds. The museum still owed him and Blodgett $15,000 from the original purchase.

Ten days later, Johnston wrote Blodgett again, this time reporting on the openings. He happily announced that his apprehension over inviting "the disaffected artist element and the gentlemen of the Press" to the new museum had been misplaced. Even an artist who'd declared the Met "damned humbug" beforehand had been won over by a preview. The public opening three nights later went even better, so well in fact "that I was afraid the mouths of the Trustees would become chronically and permanently fixed in a broad grin," Johnston wrote. Before closing, he added the news that the Met was now being offered what would eventually become the New York Public Library's site in today's Bryant Park, greatly disappointing "Church and myself, who are 'Central Parkers.' "[32]

In reporting on the opening, the *New York Times* noted that for the moment, admission was limited to members and their friends, but hoped that would change "within a few days" when "the location of a temporary Museum in the Central Park will be decided on." It wasn't, but in March students were admitted, and at last, in May, the doors were opened to all—at least until August, when the place was shut down for the hot summer month.

LUIGI PALMA DI CESNOLA ALREADY HAD HIS NOSE IN THE DOOR. On March 25, his friend Hiram Hitchcock of the Fifth Avenue Hotel gave the museum's first lecture on the discoveries the American consul had made on Cyprus. They'd known each other since 1859, and Hitchcock, whose wealth came from mining, eventually became Cesnola's best friend, chief adviser, financier, business agent, and editor; he was about to become Cesnola's promotional megaphone, too, charged with hyping him into not just a sale of antiquities to the museum but also a permanent foothold in New York.

The timing of Hitchcock's lecture was anything but coincidental. Cyprus's Ottoman rulers had decided to establish a museum in Constantinople—and demanded all of Cesnola's duplicates. When Cesnola told them that there were none, they demanded half his collection instead and ordered the governor of Cyprus to halt all antiquities exports until he complied. Luckily, the governor, whom he'd cultivated, warned him instead.

Cesnola went berserk, writing letters full of bile and exclamation points to his friend Hitchcock and asking the State Department to send a warship to get his loot off the island. He also got to work, shipping two hundred cases of his best finds off the island in the next two weeks; the ban was against the American consul, so he sent them to London as the Russian consul. He also kept digging and shipping as he jousted with Constantinople by mail.[33]

That June, he sent another three cases, earmarked for the Smithsonian Institution, to Hitchcock in New York on an American frigate, but it sank; a second boat was blocked by a Turkish warship. An impressive batch of finds was soon dispatched to a museum in Constantinople (and remains in the Archaeological Museum in Istanbul today). Whether they were seized or given freely by Cesnola in exchange for a renewal of his permission to dig is a matter of interpretation. Finally, in September 1871, the rest of his objects left Cyprus; 5,756 went to his Paris dealer, and another 7,354 objects—many of them earmarked as "gifts" for influential citizens and important museums—went to Hitchcock in New York.

Hitchcock got busy promoting the collection, attempting to force it on the new Metropolitan by giving talks praising Cesnola's finds and then turning those lectures into what his biographer would describe as a "rhapsodic" illustrated article for *Harper's Weekly*.

That February, Johnston had pressed the Met's trustees to buy the collection quickly, and the next month, at a meeting at Kensett's studio, he told them Cesnola was insistent on selling it intact—even though he'd been selling bits and pieces for years—so perhaps the Met still had a chance to get it, as all of its competitors were demanding the right to select the best pieces and leave the rest.

Johnston was on a winning streak. At the end of March, the Parks Commission had suddenly changed its mind and decided to give the Metropolitan its present plot in Central Park, instead of land farther downtown. The trustees promptly ratified that plan and hired Calvert Vaux to begin thinking about what to build there. And now, their permanent location finally settled, they began to think in earnest about what their new building would hold. After the usual summer hiatus, which saw Hitchcock's panegyric published in *Harper's* accompanied by a half-page illustration of Cesnola in a brigadier general's uniform and a plea to America to find a home for his loot, Johnston asked Junius Morgan, J. Pierpont's banker father, who lived in London, to arrange an inspection of Cesnola's material.

The "general" had been busy that summer, traveling from Turin to Paris to London, attempting to sell his finds while also trying to secure a new diplomatic post in Turkey, where he hoped to dig up even more treasures. But determined to sell what he had on hand, he'd rented a house in London and mounted an exhibition of his best pieces in a private gallery near the British Museum. Morgan visited and then returned in September, joined (as Morgan feared his expertise was insufficient) by Blodgett, who rushed from New York to vet the collection on behalf of the executive committee, which was running the museum in the absence of curators.

Blodgett liked what he saw—and probably liked Cesnola, whose interests in art and commerce seemed neatly balanced—and suggested the museum buy the collection in toto. But some trustees still had their doubts, until good old Hiram Hitchcock again vouched for his friend. Finally, the museum offered to give Cesnola $15,000 as an advance, show the collection in New York, and only then make a final decision about buying it. Cesnola said no. He wanted more than that. So he sent copies of Hitchcock's article all over Europe. By November he had a better offer from the Met: it would pay a total of $50,000 in three annual installments—and possibly also offer

Cesnola an appointment as the museum's first director—but only if he agreed that the Met could renege if it wasn't completely satisfied. Cesnola accepted and promptly booked passage for his family and 275 chests of artifacts to America.

Cesnola was feted on arrival as a general and a great archaeologist, although neither his methods nor his finds put him on a par with Heinrich Schliemann, who was simultaneously excavating Troy, a fact that made Cesnola seethe with jealousy. Taken up by Johnston, he was introduced to the trustees and their circles and hired, for the moment, for $500 a month, to unpack, inventory, clean, repair, and arrange his collection, which had sustained significant damage between Cyprus and New York. He immediately abandoned his diplomatic ambitions and began plotting a return to Cyprus to dig up yet another collection, which he announced he would bring home to his adopted America.

In the meantime, the trustees rented a large mansion at 128 West Fourteenth Street from a family named Douglas to house their suddenly growing collection. The two leases overlapped, and money was still tight, so they asked the park commissioners for $15,000 toward their rent and expenses. The city agreed to appropriate that sum annually for rent and other expenses. It looked like a good investment.

Cesnola started unpacking in March, and by the end of May his collection was on display. When the new building containing not just the Cesnola objects but also the Blodgett paintings and a loan exhibition finally opened to the general public in October 1873, the trustees charged admission (initially fifty cents, promptly lowered to twenty-five) except on Mondays, when it was open free. In the spring of 1874, a show of John Kensett's final paintings opened; he'd died in December 1872. By August, when the museum shut down for the summer, its collection was valued by the *Times* at $400,000, and it had again outgrown its quarters; luckily, ground was broken that month in Central Park. At last, the founders were going to have a real home.

But Cesnola didn't have what he really wanted—a job. And he'd no doubt read the *Times* on July 6, when it generally praised the museum but faulted it for failing to produce a catalog of its holdings and hire a director.

In the fall of 1873, a frustrated Cesnola decided he had to show the

trustees his worth by returning to Cyprus to dig some more, proposing that the museum cover his expenses, take and value his finds, and pay him accordingly. He was so eager he didn't even wait for them to approve the deal. And this time, he planned to head off not only unfavorable comparisons to his more scholarly colleague Schliemann but also inquiries into his methods. His critics had inspired him to write a book, *Cyprus: Its Ancient Cities, Tombs, and Temples,* that he would publish in 1878 as a preemptory bid to silence them. He would note in its preface that scholars worried—legitimately, it would later turn out—about his, or rather his diggers', excavation techniques, which were presumed to be violent and destructive, and his utter failure to document his finds.[34] Indeed, his only "scholarship" or "documentation" before his first big sale to the Metropolitan had been purely commercial publications: two catalogs had been created to sell his objects. This time, he would be more careful. He even had Hitchcock draft a detailed afterword to the book, to be signed by John Taylor Johnston, describing his finds and including an inventory of the objects. But most important of all was his claim to have discovered, in September 1874, what he called the "Treasure of Curium."

"Under the temple of Kurium [*sic*]," the Met's trustees would soon announce, "he discovered what were undoubtedly the treasure vaults of the temple . . . a series of four rooms excavated in the solid rock [containing] over fifteen hundred objects in gold, silver, gems, bronze, alabaster and terracotta . . . left by the priests, when obliged from some cause to make a hasty departure." It was as great a find as Schliemann's. Greater. "My digging at Curium," Cesnola wrote to Hitchcock, "will throw forever into shade those of Schliemann."[35] He thought it was the crowning achievement of an eleven-year career in archaeology. It would certainly prove to be the defining one.

"The only trouble was that the treasure, as such, never existed," his biographer Elizabeth McFadden wrote. Short of funds, as always, Cesnola had ginned it up out of unconnected material, some dug up by workers in his employ, some purchased all over the island. And instead of documenting the archaeological context of the alleged treasure, he faked the provenance in an effort to present it—and himself—as more significant than it really

was. In truth, he'd only taken quick tours of the island. It was all, McFadden wrote, "an invention of his fertile and desperate mind."

What drove Cesnola to such an extreme? A likely explanation was the Panic of 1873. The economic contraction lasted four years and affected the Metropolitan in myriad ways. For Cesnola, the most significant were its postponement of the final payment for his original collection and its decision to leave unsigned his contract for more finds and funds. He was a free agent.

The Curium ruse was a patch over his latest troubles. In 1875, he shipped a hundred boxes to the museum in New York, and the rest followed in May 1876. But the trustees still wouldn't commit to buying, leaving Cesnola fuming, calling the trustees donkeys in a letter to Hitchcock: "There is no real entrust in them." He griped to Johnston, too, ordering that his boxes be returned "without taking them out of the Custom House . . . What an expense I have incurred . . . and to no purpose."[36]

But in fact, the Met's problem was not a lack of trust but rather its own lack of funds. In the summer of 1874, while Cesnola was concocting the fable of his Curium finds, the Metropolitan's trustees had totted up their achievements in its latest annual report. They said that only $207,000 had been collected from the original subscription drive, along with $47,000 worth of donated art and another $30,000 in subsidies from the Department of Parks. That was not insignificant and was only the first installment on $145 million in public money over the next hundred years, covering between 25 and 44 percent of annual operating expenses.[37] But the museum still owed $15,000 for the first Cesnola purchase (whether to Johnston, Junius Morgan, whose J. S. Morgan & Co. had financed the deal, or Cesnola is unclear), which it had decided required another fresh fund-raising drive.

Yet another appeal would be announced in November 1876 after the British Museum got wind of the Curium treasure and started a bidding war the Met was intent on winning. To do that, it had to raise $40,000, two-thirds of the total purchase price. It vowed to also pay for shipping and to hire Cesnola to arrange both his collections in its new Central Park home. Two-thirds of the sum was raised almost immediately; the rest two weeks after the public appeal was made.[38] "All right!" Cesnola exulted in a cable to

Johnston. "Three hearty cheers for our dear New York Museum."[39] Back
in New York in May, he was named the museum's secretary, albeit for no
pay. Still hoping he'd be named director, and with bright commercial
prospects—for his book on Cyprus would soon be published, and Tiffany &
Co. would begin selling facsimiles of his finds—he agreed.

Though increasingly intertwined, Cesnola's and Johnston's fortunes
were on opposing trajectories. Johnston had held on to two million shares
of his Central Railroad in New Jersey as it dropped from $120 a share to
$23, losing his fortune "without flinching," observed Chicago's *Tribune,*
which dubbed him "a man who has gone to ruin, honestly and bravely." In
the summer of 1876, Johnston was chairman of a giant loan-art exhibition
for America's centennial, attended by 154,000 people, which raised $40,000
to pay off accumulated debts of the Metropolitan and the National Acad-
emy of Design. Of 580 pictures loaned from five dozen private collections,
98 came from Johnston's. Yet that same academy of design charged him
$500 a week plus expenses to exhibit his paintings when they were put up
for auction later that year. The *Tribune* judged this a "disgusting affair" and
an act of "monumental meanness." Blodgett's death in 1875, followed by
Johnston's financial ruination, had been, *Harper's Weekly* editorialized, "seri-
ous blows . . . a kind of public misfortune."

"CAN YOU BELIEVE IT?" ONE METROPOLITAN TRUSTEE EXULTED
to another, punctuating his question with a sharp slap on the back. "Can you
realize that the thing really exists?"[40] It was March 30, 1880, and the per-
manent Metropolitan Museum was finally opening—albeit unfinished—in
Central Park. Two Decembers earlier the legislature had finally approved
the leases that Choate had drafted. New clauses had been added obligating
the museums to be open free of charge, four days a week, and on all holi-
days except Sundays. Although the two other days a week were reserved for
members only, the Met was to be, Winifred Howe would later write in her
history, "a free public institution."

Valentine's Day 1879 was the museum's last day on Fourteenth Street.
Two months later, the board issued its latest appeal for funds, another

$150,000 to buy collections of Chinese porcelain, gems, antiquities, fabrics, and casts and to begin an education program, award medals, and pay for lectures. The appeal noted that the citizens of Philadelphia and Boston had been so generous with their museums that objects offered for sale in New York, "which ought to have become our own," left town instead. Money was also needed for a salary for Luigi di Cesnola, who was finally named the museum's paid director that May (after he'd extracted a promise that he'd have the job for life). He was still owed $17,000 for his Cypriot artifacts.

Through the rest of the year, Cesnola, two newly hired assistants, and several trustees did much of the heavy lifting in the move to the new building, packing and unpacking their precious objects themselves. The Cesnola collection ended up occupying about 60 percent of the main floor and a large balcony overlooking the main hall. By comparison, old masters, modern paintings, and modern sculpture each got less than a quarter of a floor. Finally, the following spring, it was time to open the doors and celebrate. Though few would have bet on it, they'd managed to build a collection and a museum that had, they would say themselves, "real artistic merit."

The opening festivities began with lunch for 150 at Johnston's home followed by a 3:30 p.m. ceremony to which 3,500 worthies had been invited. Despite the cold day, arriving carriages disgorged a fashion parade of ladies "in gay colors," said the *Times*. It was "one of the most magnificent social pageants the city has ever known," added the *Washington Post*. "Every station of society life was represented." A bishop offered a prayer, the head of Parks formally delivered the building, and then the ever-eloquent Choate stepped up to speak.

Looking back at the decade of effort that had led to this great day, Choate praised those trustees who "have poured out their money like water." Though he touched on the notion that the museum was for "the working millions" and not "the favored few," Choate aimed most of his oration at the latter, his eye focused like a laser on the "gigantic fortunes [they'd] accumulated out of nothing . . . within the last five years." Out of nothing, that is, except the "toiling people . . . out of whom they have made their millions."

Art, Choate repeated, "belongs to the people," but the rich would have to pay for it out of their "distended and apoplectic pockets."

Think of it, ye millionaires of many markets, what glory may yet be
yours if you only listen to our advice, to convert pork into porcelain,
grain and produce into priceless pottery, the rude ores of commerce
into sculptured marble, and railroad shares and mining stocks—things
which perish without the using, and which in the next financial panic
shall surely shrivel like parched scrolls—into the glorified canvases of
the world's masters, that shall adorn these walls for centuries. The
rage of Wall Street is to hunt the Philosopher's Stone, to convert all
base things into gold, which is but dross; but ours is the higher ambi-
tion to convert your useless gold into things of living beauty that shall
be a joy to a whole people for a thousand years.

Rutherford B. Hayes, president of the United States, was up next. He
stuck to the script, declared the museum officially open, and, as a band
played excerpts from the opera *Carmen*, left the stage with Johnston and
Cesnola. After returning to his rooms at the Fifth Avenue Hotel, the pres-
ident headed off to a dinner at the home of John Jacob Astor. From Europe,
William Henry "Billy" Vanderbilt cabled the trustees to say they could have
any ten pictures from his house. A few months later, Vanderbilt's son Cor-
nelius II, a museum trustee since 1878, outdid his father, buying a collec-
tion of 690 old master drawings and giving them to the Met. The toiling
masses had been forgotten.

By then, the growing museum (hailed as a "stark cathedral-like edi-
fice . . . a big, gambrel-roofed, lavishly skylighted, gas-lighted, chimney-
studded, ruddy-stoned structure" by Leo Lerman ninety years later[41]) had
already begun agitating for the state to build a new wing. And why not? The
Panic of 1873 was past. The museum sat in an unwelcoming dirt field, with
a boardwalk leading from Fifth Avenue to the basement entrance used by
employees and trustees and the main entrance facing a reservoir in the park
that would be turned into today's Great Lawn only in the 1930s. It was a
firetrap with shellacked floors and walls covered with red billiard cloth.[42]
Meanwhile, at the start of the extravagant Gilded Age, driven by industrial
fortunes like the Vanderbilts', New York was truly coming into its own and
would soon be the home not only of several new museums but also of St.

Patrick's Cathedral (1878), the Brooklyn Bridge and the Metropolitan Opera House (1883), the Dakota (1884) and Chelsea apartments (1885), and the Statue of Liberty (1886).[43] It was an epochal, triumphant moment.

Alas, for Luigi Palma di Cesnola, that was as good as it would ever get.

※

SHORTLY AFTER THE NEW MUSEUM OPENED, THE PLACE BEGAN to leak. On stormy days, display cases were covered with rubber mats. "During one snowstorm in 1880," Calvin Tomkins wrote, "Cesnola counted forty-two leaks in the center of the hall and thirty-seven more in a gallery at the north end." He put out buckets to catch the water.[44]

The museum's own *Review of Fifty Years' Development,* published in 1920, shows precious few significant developments in the five years after its opening in 1880. The trustees certainly didn't want to call attention to the two simultaneous wars the Met was fighting, one of which threatened its image and the other its very existence. Luigi di Cesnola, soldier of fortune, was in the front lines of both.

The troubles began even before the new building opened, when Georges Perrot, a French scholar, published an attack on Cesnola. His excavations "were brutal and destructive," Perrot wrote. "He sacrifices everything to the loot that follows." Then a mere two months after the museum opened in Central Park, a man who had briefly been Cesnola's dealer, the well-respected Gaston Feuardent, wrote to the new director to question the authenticity of one of the objects on display. When Cesnola brushed him off, Feuardent published an article in a magazine called the *Art Amateur* questioning seven pieces Cesnola had sold to the Met, particularly one statuette, allegedly of Aphrodite, a goddess popular with the masses. Feuardent said it wasn't Aphrodite! Cesnola began calling the magazine the *Art Defamateur.*[45]

"Unfortunately," one history says, "once the initial euphoria of bringing the collection to New York wore off and Feuardent began to seriously study some of the pieces, he discovered that a number of the sculptural works had been modified and that Cesnola's remarks concerning find spots were contradictory." His "deceptive alterations or restorations ... can only

be called miscalculation, a profanation, or a fraud," Feuardent wrote. A fraud the museum had paid $121,866.95 for.

Though aware that Feuardent's doubts had first been raised nine years earlier, Cesnola ignored the trustees' request that he keep quiet. First, he cast the accusations as an attack on the museum caused by "envy, jealousy and rage on the part of the dealers [that is, Feuardent] who cannot sell to us the rejected trash brought from Europe." Then he slammed his accuser in a letter to Johnston (whose illness had finally caused him to unofficially hand the museum presidency to the museum's treasurer, Henry Marquand), deriding Feuardent as a "French Jew dealer" writing for "an obscure monthly paper edited by a Jew." It would not be the last time anti-Semitism raised its head in the highest councils of the Metropolitan Museum.

A committee was appointed to investigate late in 1880. When Cesnola appeared before it, he called Feuardent "thoroughly dishonest, ignorant and reckless." He did admit to repairing statues that had been broken, but insisted any reconstructions matched like with like. Then he threatened to quit if the trustees didn't back him with a vote of confidence. They did, declaring Cesnola completely vindicated at the end of January.

But newspapers took up the fight—the *Times* demanded that the museum either sue Feuardent or disown Cesnola. The trustees William C. Prime and Choate agreed. Cesnola hired Choate to defend him and sailed to Europe. Thanks to some adroit legal maneuvers, it would be two years before a libel trial began.

In the meantime, farce. Though they wished the whole thing would just go away, the trustees realized they had to do *something* and so set up two of the disputed statues in the Great Hall and invited the public in to test them and make up its own mind about Cesnola. Test they did, washing the statues, cutting them with knives, and chopping them with chisels before the trustees called a halt to that. Disgusted, the sculptor Augustus Saint-Gaudens begged the trustees to allow an impartial expert investigation. Cesnola's assistant resigned and told the *Times* that Cesnola attached false noses to statues.

The trial lasted almost three months, stretching through the entire winter of 1883–1884. The expert testimony was interminable. The jury's eyes glazed over. Satirists had a field day. With his dramatic mustache,

pince-nez, and authoritarian air, Cesnola was custom-made for the new editorial cartoonists, whose work had already helped bring down Boss Tweed. Cesnola was on the stand for more than a week. His attorneys had already admitted that he'd restored many objects in the museum. He sought refuge in the semantic difference between repair and restoration. And the repairs, as he preferred to say, had been "made without my knowledge," or else he'd "forgotten all about them," or else he didn't know anything about them until Feuardent published, or else the repaired items had been "exhibited without my knowledge that the repairs exist," without his approval, *and* in great haste. Discrepancies in his statements about the sources of his finds simply didn't matter.

By the end of January, tempers were testy. "I won't be blackguarded!" Cesnola snapped at Feuardent's lawyer when he was called back to the stand for the third time. In his eleventh-hour summation, Choate managed to jolly the jury when he said the trial had lasted so long they were all in danger of becoming antiquities. On February 3, after twenty-eight hours of deliberation, the haggard jury decided in Cesnola's favor on two counts, and failed to decide a third. Cesnola and the trustees declared victory. "The genuineness of a collection of antiquities ought to be above suspicion," the *Times* declared, "and the management of this collection has given rise to suspicions which the result of the trial will not dispel."

Although the museum picked up two-thirds of Choate's $32,000 legal bill ($697,680 in 2007 dollars), the ever-broke Cesnola couldn't pay the balance atop the expenses of his East Fifty-seventh Street town house and weekend home in Westchester. And the attacks on him didn't stop. The Numismatic Society published a defense of Feuardent in the *New York Times* in 1884, and in 1885 the journalist William J. Stillman, a member of the Society, published a thirty-nine-page indictment of the Cesnola collection that clearly struck home. Cesnola would later call him "a nasty envious dog" and a "spiteful malicious" "mortal enemy," but over time Stillman's criticisms would be repeated and elaborated on by scholars and archaeologists digging in Cyprus and confirmed by some of those who'd dug objects up on his behalf.[46] The trial may have acquitted him, but the consensus was that the director of the Metropolitan was a fraud.

In all, Cesnola claimed to have found and identified 16 ancient cities,

15 temples, 65 necropoli, and almost 61,000 individual tombs and taken 35,573 objects away from Cyprus.⁴⁷ But after the Feuardent trial, the luster was off his treasure. In his early years, the Cesnola collection was the museum's centerpiece. Uninterested in paintings, he hung them in ranks on the museum's high walls while lavishing the utmost care on his own finds. But in Edith Wharton's *The Age of Innocence,* a scene set in the early 1880s places the protagonist Newland Archer and his wife's cousin Ellen Olenska in the "wilderness of cast-iron and encaustic tiles known as the Metropolitan Museum," where the two would-be lovers meet in "the room where the 'Cesnola antiquities' mouldered in unvisited loveliness. They had this melancholy retreat to themselves."⁴⁸

Small wonder then that in 1887, the museum sold five thousand Cesnola objects to Leland Stanford, president of the Southern Pacific Railroad, for $10,000 and used the proceeds to buy a collection of Egyptian antiquities. More Cesnola objects were sold in 1925, and finally, in 1928, after hiding the "Curium" pieces in its vault for decades, the Met auctioned off about five thousand pieces, keeping only the most authentic.⁴⁹ In each case, the trustees claimed they were only selling duplicates to other museums that lacked such treasures. Fittingly, John Ringling, the circus owner, bought twenty-three hundred of them for a museum he'd started in Florida. Only in the year 2000 did the Met "come clean," as the *Times* put it, about Cesnola, when it put a mere six hundred of the finds on display in four new galleries, giving them visibility for the first time in half a century.

Anna Marangou, a Cypriot archaeologist, published a scholarly book about Cesnola and his collection to coincide with the opening of those galleries. She did research in U.S. government archives, Cesnola's correspondence with Hitchcock, the British Museum, the Louvre, Istanbul's Archaeological Museum, Vienna's Kunsthistorisches, and archives on Cyprus. But what of the Metropolitan? "They were hostile to me from the very beginning," she explains. "When I requested to work with the archives of the Museum the answer was blatantly no without any explanation. They pretended I did not exist and, of course, neither did my book."

FEUARDENT V. CESNOLA WAS A PUBLIC RELATIONS DISASTER OF epic proportions. But worse, it distracted the trustees from seeing a bigger storm on the horizon. The admission figures from the first month of operation in Central Park hinted at the problem. There were 145,118 visitors that month, the museum claimed, 2,768 of whom paid.[50] A year later, the museum said it had attracted 1.2 million visitors in its first thirteen months, 9,000 of whom paid. Immediately, a public clamor began, not only deriding those figures as "monstrous official lying," as a letter writer to the *Times* put it, but also calling for both the natural history and the art museums to open free on the one day of the week that the working millions could actually visit—Sunday.

Immediately and flatly, the mostly Presbyterian trustees refused; their religion forbade entertainment on Sundays. John Taylor Johnston's father had been so strict on the subject his family did nothing but go to church two or three times on the Sabbath. He'd even refused to meet the pope in Rome when his audience was scheduled on a Sunday.[51] No matter that hypocrisy was the rule in New York, where the front doors of saloons were closed on Sundays but side doors were open—and busy. The museums would not open.

After piling scorn on the Met over Feuardent, the newspapers decided that the Sunday closings proved that the museums were in fact for the favored few and not the working millions. Even before the Met's move to the park, the *New York Tribune* had called it "an exclusive social toy, not a great instrument of education."[52] It also called the Met "merely the delightful lounging place of the rich," and *Scribner's Monthly* chimed in to deride it as "a mere extension of [the trustees'] parlor."

The Sunday issue had come up during the first fund-raising drive in 1871. In an interview with the *Hartford Daily Times,* Cesnola claimed that some museum contributors had put a no-Sundays condition on their donations, and the museums had issued a written pledge agreeing to it. Shortly after the Met moved to Central Park, the city elected its first Irish mayor, and public outrage over the Sunday closings rose up again. The museums already felt hard-pressed financially by the requirement that they offer free admission four days a week. They dug in their heels and refused, but sought ways to soothe the public without violating the sanctity of the Sabbath.

Their first thought was to open the museums certain evenings. In 1872, the Met tried that on weeknights and then on Saturday nights, and in 1874 it tried evening hours again, but attendance was always low, so the trustees balked at the cost of additional salaries for longer hours.

Prime and Cesnola had long since gone public with their opposition. Cesnola insisted that the Met was "a private corporation," and Prime threatened to take it out of the park altogether if forced to open on Sundays, reminding the city that the museum could pull out on three months' notice and calling the public's failure to adequately fund it embarrassing.

A month later, a group of German-Americans presented the parks commissioners with a petition signed by ten thousand demanding Sunday openings. In May, the *New York Times* asked if any public money at all should be spent on private institutions that show "silly irritation when their judgment has been called in question" and "turn a deaf ear" to "such a popular demand, for example, as opening on Sundays." For the next decade, inaction and delay would be the museums' main weapons in their fight against Sunday openings. In December 1882, a Baltimore collector sent Johnston $10,000 to pay for two years' worth of open Sundays. Months later, his money was returned.

The summer after the 1884 Feuardent verdict, the issue heated up again when the parks commissioners allowed a Sunday concert in Central Park for the first time. Sabbatarian preachers railed, and the devout quaked, but the city survived this unprecedented mash-up of the masses and the classes, and the clamor for open museums on Sundays rose again.

Some Metropolitan trustees knew that the museums were on the wrong side of history. When Samuel Putnam of the American Secular Union delivered yet another Sunday petition in March 1886, this one signed by 9,000 citizens and endorsed by 120 labor organizations representing 50,000 workers, Choate hoped it might win the day, but Marquand, the treasurer, felt the petition lacked prominent names. Regardless, the politicians noticed. In April, in a lopsided 2-to-1 vote, the state legislature authorized the city to give each museum $10,000 a year to pay for Sundays if the city's Board of Estimate agreed. Marquand aired his fear for the safety of the Met's treasures in the presence of the Sunday hordes.

Nonetheless, in December the Board of Estimate approved the expenditure and directed the museums to open their doors.

Luigi Palma di Cesnola likely sneered at that. When he'd been named director, Cesnola had been handed an institution worth $390,000 with $60,000 in debts. He'd decided years before that the museum needed to pay off those debts and embarked on a personal campaign to see that it did. On Christmas Eve 1881, he'd written a letter to J. Pierpont Morgan. "I wish you with all my heart the merriest of Christmas possible," he began, "and I am sure you will have it. I made my mind up to pay off the only debt of the Museum and keep it forever so. I have in three weeks raised among my friends nearly two thirds of the whole debt. Will you give me like H. R. Bishop did $3,000? If not so much give me at least half or one third, will you? You will enjoy your Christmas much better if you grant my request which after all it is not for me but for the public. Believe me."[53]

Now, years later, the museum's holdings were worth a million dollars, and it was debt-free.[54] Which meant that Cesnola didn't need to listen to the public any more than he needed to listen to his friends. He'd even ended his friendship with the loyal Hiram Hitchcock when his former supporter, recently widowed, had the audacity to propose to one of Cesnola's daughters.[55] And he was just as brutal in informing the unwashed masses where they stood with him. In an interview in January 1887, he let loose, calling the Sunday wannabes "loafers, scum." To allow in "people who would peel bananas, eat lunches, even spit, would be simply unthinkable." Perspiring, his pince-nez slipping off his nose, he even quoted William H. Vanderbilt's infamous line, "The public be damned."

"The erroneous idea has gained some currency that the museum is a public institution," he fumed. "The public has no claim on it at all." If forced to open, Cesnola said, he would stop heating the building. "Let the public go there and freeze. When they had become stiff I would set them up among the other groups of statuary."

Unfortunately for Cesnola, a Parks Department commissioner had spotted people entering the museum on a Sunday and tried to get in himself. That embarrassing fact was confirmed by Cesnola, who admitted that special friends of his and of the trustees were sometimes admitted on Sun-

days, though he rationalized that such passes were rare. The parks commissioner, no special friend, had been turned away. Which may explain why the department now demanded an answer about Sundays before finalizing its budgets. But the museum was about to get a pass. The city's latest mayor, Abram Hewitt, though a Democrat, was also a wealthy iron manufacturer and a friend of many trustees, and he wanted to give the museums money without conditions, even though he, too, favored Sunday openings. Early in March 1887, the museum's latest expansion was approved.

Hewitt got further by offering that carrot than his predecessors had by beating the museums with sticks. A few weeks later, the trustees of both the Met and the natural history museum met at the mayor's home. After failing to win motions approving Sunday openings, even as an experiment, Choate suggested that an informal, nonbinding vote be taken, simply recommending the idea to the two museum boards, and the motion passed. But when those boards still refused to act, Hewitt threatened to cut them off forever. The tide had begun to turn—in Philadelphia and Boston, the museums gave in and opened, and one potential donor was said to have spurned the Met because it *wouldn't* open on the Sabbath—but Sunday openings were still a long way off.

THE SIZE OF THE MUSEUM MORE THAN DOUBLED WHEN IT opened its new south wing on December 18, 1888, with a ceremony that began with a reverend's prayer that the museum devote itself to the happiness and improvement of all classes of people in New York. Marquand, the treasurer and acting president, then thanked the public but even more so the city, for its dedication to the museum as a place of instruction for its people. Next up was Vice President Prime, who detailed who had paid for what, concluding that even though the museum's members had contributed two times what the city had, "artist and student and workingman will all find here rest, refreshment and recreation." Mayor Hewitt then stepped forward to declare the wing open. He pointedly added his hope that "the time will come when on no day, the people shall be excluded."

The people clearly had the sense that this was now inevitable, and the

New York Times review of the new wing reflected that. The Met "is now rid-ing on the crest of the wave of popularity," it said, thanks in no small part to a vastly increased collection, highlighted by an 1887 bequest of more than 140 then-modern paintings by Catharine Lorillard Wolfe. A wealthy, phil-anthropic spinster, Wolfe had taken up collecting on the advice of her doc-tor. She also left the museum an unprecedented $200,000 endowment for the care of her pictures and the purchase of more—a gift that keeps giving today. The gift, mostly then-trendy contemporary art, included Goya's *Bull-fight,* Delacroix's *Abduction of Rebecca,* Cézanne's *View of the Domaine Saint-Joseph,* and Daumier's *Don Quixote*—and was one of the first of the museum's con-ditional bequests; the Met agreed to be bound to keep her paintings to-gether and separate from the main collection. Those and loan exhibitions of dozens of old masters by Marquand and Henry O. Havemeyer, a sugar merchant, spoke clearly of the growing wealth, taste, and power of Ameri-can art collectors.

Nine days later, Mayor Hewitt and the Board of Estimate blinked—again—and agreed to an additional $10,000-a-year subsidy (atop the $15,000 already appropriated) if the museums would agree to open not on Sundays but on Tuesday and Saturday nights. They did. It was a holding ac-tion that would hold for another two years. In the meantime, control of the Met's board slowly shifted away from its older members, an inevitable process spotlighted when John Taylor Johnston stepped down as president and was replaced by the treasurer, Henry Gurdon Marquand, just a few weeks after it was revealed that Marquand was going to give a group of thirty-seven old masters—including works by Vermeer, Constable, Gains-borough, Velázquez, Van Dyck, Rubens, Rembrandt, Hals, and da Vinci—to the museum. Fifteen more paintings followed. Many would later be reattributed to lesser artists, but Marquand's gift, which he'd consciously gathered to be given away, raised the standard of the museum while raising the bar for generous donors first set by Blodgett and Johnston.

Marquand had grown up working for his father, a prominent jeweler and silversmith whose two sons took over the business before branching out into real estate investment and banking. Henry then became a banker and railroad man, doing well enough to retire at the age of sixty-two in 1881 and devote himself to art, which he kept in a gallery in his riotously

overdecorated five-story home at Madison Avenue and Sixty-eighth Street designed by Richard Morris Hunt. It featured a three-story interior court-yard with a skylight roof, a Japanese room with embroidered silk walls, a Moorish smoking room, an English Renaissance dining room hung with sixteenth-century Flemish tapestries, a marble-floored hall with an oak staircase, a bronze fountain, mosaic walls and windows by Louis Comfort Tiffany, and a stone fireplace topped with a copy of a terra-cotta altarpiece he gave to the museum in 1882.[56] He gave the museum not only art and his time but also large amounts of money.

Although Nathaniel Burt describes him as "sensitive, withdrawn and sternly melancholic," Marquand bought art "like an Italian prince of the Renaissance," the critic Russell Sturgis wrote in a posthumous auction cat-alog of his collection. The *Times* of London called Marquand "the Provi-dence of the museum" thanks to his gifts of paintings, ceramics, ancient glass, medieval ironwork, and, in 1886, the funds to add to its sculptural and architectural cast collection, to quickly establish a time line of three-dimensional artworks in the fledgling museum.[57]

John Taylor Johnston would die in his own bed at home in 1893 after sixteen years of progressive infirmity, leaving a fortune of $1.5 million. He gave another $10,000 to the museum, and a quarter of his remaining estate to each of four children, including Emily Johnston de Forest, whose hus-band was named an executor. Robert de Forest came from an accomplished family whose New World lineage dated back to pre-Revolution Connecti-cut, where they were "substantial citizens, office bearers . . . minor offi-cials . . . soldiers in the Revolution."[58] "Blue blood and a big bank account gave de Forest a comfortable head start in life," wrote James A. Hijiya in a lengthy study of his career as a philanthropist.[59] He was a student at Yale in 1870 when he proposed marriage to John Taylor Johnston's daughter on the same day, or so he would later claim, that the museum was founded. "I mar-ried her as soon as I could," he said, shortly after earning a law degree from Columbia.[60]

De Forest inherited his father-in-law's Metropolitan board seat and was named the board's secretary at the same trustees' meeting where Mar-quand was anointed. Also that night, a special committee deciding how to

light the museum at night indicated that it might prefer the new Edison electric system to gaslight. A new day really was dawning.

It just wasn't dawning on Sundays. Marquand was no more interested in forcing the issue as president than he had been as treasurer. At the museum's annual meeting that February, the topic didn't even come up. That spring, when the appropriation for the north wing reached the legislature in Albany, an attempt to link it to Sunday openings failed. When that Baltimore collector's offer of money for Sundays was finally revealed that spring, Charles Dana, the editor and part owner of the *New York Sun*, tripled it, offering $30,000 to the museum if it would only open on Sundays. His offer, too, was spurned.

A year later, electric lights at last installed, the museum opened two nights a week, but when attendance proved sparse, the newspapers took up the Sunday cry again. This time they were joined by a group of women led by Minna Chapman, the wife of a lawyer and anti-Tammany political reformer whose father headed the New York Stock Exchange. Chapman's husband was also descended from John Jay. In a mere five days, she gathered five thousand names on a Sunday-opening petition, and in the resulting public uproar yet another petition attracted an additional thirty thousand signatures, including Andrew Carnegie, Jacob Schiff, August Belmont, Theodore Roosevelt, William K. Vanderbilt, J. Pierpont Morgan, who'd previously been opposed, Elihu Root, Augustus Saint-Gaudens, and Louis Tiffany, and pledges of $10,000 from Henry O. Havemeyer and $1,000 from another collector, Benjamin Altman, to pay for it.

On May 18, 1889, at the end of a three-hour meeting of eighteen trustees, Choate made a motion for Sunday openings. Choate and Rutherford Stuyvesant were among the twelve ayes, Hiram Hitchcock among the four nays. The ayes prevailed, and the next day a headline in the *New York World* said it all: "The People Triumph." Within days, Vice President Prime resigned, and one wealthy widow revoked a promised $50,000 bequest. About 340 of the museum's 1,900 members stopped paying their dues, and 115 of them quit. Nonetheless, a year later the American Museum of Natural History opened on Sundays as well.

A few weeks after the fateful vote, more than twelve thousand visitors

crowded the first Sunday at the Met. They found the gallery with the Curium treasures closed, many paintings hurriedly covered with glass, eighteen guards on duty instead of the customary eleven, and the director nowhere to be found—Cesnola had battened down the hatches and left the premises. But the biggest problem turned out to be an absence of spittoons.

"Many visitors took the liberty of handling every object within reach; some went to the length of marring, scratching, and breaking articles unprotected by glass; a few proved to be pickpockets, and others brought with them peculiar habits which were repulsive and unclean," said the next annual report.[61]

LUIGI DI CESNOLA AND HENRY MARQUAND SAW EYE TO EYE ON most things, and Cesnola worked hard to keep it that way. Despite all the controversies, the building kept growing; the north wing opened in November 1894, increasing exhibition space by about a third to 103,000 square feet. So, too, the collections, which now, thanks in part to the lifting of what Marquand called a disgraceful, "odious and invidious tax on art," included musical instruments, gems, fans, Eastern art and porcelains, embroideries, and Assyrian, Babylonian, and Egyptian antiquities. And attendance was rising; more than half a million visitors came in 1894, almost a third of them on Sundays.

At the annual meeting in 1895, the trustees celebrated the museum's twenty-fifth year, but behind the scenes the board had grown restive. The day of that meeting, seven trustees presented a petition demanding Cesnola's removal. A special meeting of the trustees followed. Only Hitchcock and one other defended Cesnola. De Forest ran the prosecution, which, Hitchcock remembered, said Cesnola was "not the man for the place, hindered progress, prevented gifts, was deceptive, brusque, insulting, domineering, unjust to subordinates, not a good manager, not in touch with art here and in Europe, does not fairly represent us, is a martinet, owns the Museum, controlled Mr. Johnston and now controls Mr. Marquand."[62]

With the backing of Cornelius Vanderbilt and J. Pierpont Morgan,

who'd joined the board in 1888, Marquand took a stand, threatening to quit if Cesnola was fired; he beat back the revolt by a vote of 11 to 7. Choate accused Marquand of bulldozing the board, and another trustee came away sure that de Forest had really hoped to overthrow Marquand, not Cesnola. Inevitably, a story leaked to the press that the director had recently gotten a $3,000 raise to $15,000 a year, and the *Times* dubbed Cesnola's tenure "a continuing scandal."

Out of the woodwork came his old enemies, pointing to the "obnoxious" Cesnola's "surliness of demeanor . . . snappishness . . . repellant ways" and the lack of artistic or archaeological credentials that had "brought the institution into contempt and ridicule." Into the fray the old soldier galloped. "I have no fears," he told the world. His old friend Hitchcock, remarried to a cousin and back in favor again, wrote to say, "You must now *laugh* at anything that comes up to annoy you."[63]

To an extent, Cesnola was right not to worry. He had won his last battle, and hung on. At the next board meeting that spring, Marquand ensured that the director's status was never even mentioned. Instead, the trustees changed the subject, announcing another expansion, this time a million-dollar facade to face Fifth Avenue.

There was no more talk of firing Cesnola; for the next few years, trustees' meetings were airtight, leak-free affairs; the only news they made concerned how much money the trustees were paying personally to meet the museum's expenses and how loudly they chose to gripe about it. In 1890, for instance, the trustees were forced to ante up $52,000 to cover operating expenses; the city had given only $25,000 that year (atop the $360,000 it agreed to pay for the third wing). Though the city's appropriation was subsequently increased to $70,000, the trustees announced they would leave repairs of their building up to the parks commissioners, who could either keep it in good repair "or become responsible to the people for its gradual decay."

That was neither the first nor the last time the trustees were disingenuous. The city was, at that moment, erecting the Beaux Arts wing with its Romanesque facade made of Indiana limestone that has ever since been the visual image of the Metropolitan Museum. "The public will be astonished," the *Times* predicted when given a tour of the work site in the fall of

1899 by Cesnola, who confidently predicted that the museum would eventually fill its thirteen-acre site.

Cesnola would hold on for another five years, and the museum would keep its promise to employ him until the day he died. Flailing against the past, he defended his finds again and again and kept trying to have his title made official; he came away at last with a congressional medal for gallantry thirty-four years before. He continued to call himself general.

All that remained was waiting. Hitchcock died in 1900. Marquand followed in 1902, as did Cesnola's wife, Mary. Finally, in November 1904, Cesnola went to bed one night and never got up again.

He would have liked the headline in the *Boston Globe* announcing his death. "Gen di Cesnola Dead—Breveted Brigadier General by Lincoln," it read. The *Times,* the *Wall Street Journal,* and the *Washington Post* let him keep his military title as well. J. P. Morgan, who'd replaced Rhinelander as the museum president, was one of his pallbearers. A few days after his funeral, the trustees issued a memorial resolution. It acknowledged that he was martial, restive, and "somewhat impetuous in speech and action."[64] His career-defining finds in Cyprus went unmentioned.

Today, Cesnola is remembered, if at all, as a cultural criminal who looted and pillaged and stole not just objects but an irreplaceable opportunity to learn about the past. On Cyprus, he is considered a rapist who thought his victims lesser beings who didn't appreciate their own culture and so had no right to keep its artifacts close to home. Instead, their historic bounty had to be carried off and cared for by people with the taste, education, and breeding to protect and understand it. People like Nobile Luigi Palma di Cesnola and the trustees of the Metropolitan Museum of Art.

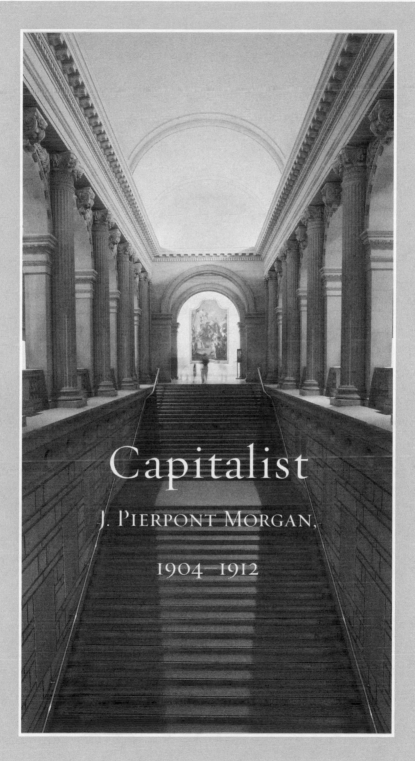

Capitalist

J. PIERPONT MORGAN,

1904–1912

Early in April 1890, Junius Spencer Morgan, seventy-six, the semiretired head of J. S. Morgan & Co., an international investment bank, left his rented villa on a hillside above Monte Carlo in an elegant four-wheeled open carriage. He was en route to nearby Beaulieu-sur-Mer when a train startled his horses, which shied and broke into a run. Morgan stood up to ask his coachman, perched on a raised seat in front of him, what was going on. Just then, the victoria hit a pile of stones, throwing Morgan to the ground. Knocked out, he lingered for three days before dying without regaining consciousness. His son Pierpont, fifty-two, who was sailing across the Atlantic to meet his father before going on to Aix-les-Bains, where he would treat his gout in the town's famous hot sulfur springs—he'd suffered myriad ailments of mind and body since his youth—got the tragic news the day his father died, when his steamship, the White Star Line's *Teutonic,* reached the Irish port of Queenstown.

Twelve days later, his father's embalmed remains were on their way back to his home of Hartford, Connecticut, when Pierpont formally took

over the family firm and his father's position at the pinnacle of American finance. Already a trustee of the Metropolitan Museum, the shrewd, brusque, and confident Morgan was about to emerge as the dominant capitalist of the Gilded Age, reshaping America's economy by guiding the creation of such industrial giants as General Electric, International Harvester, and United States Steel and forcing New York's most important bankers to work together to avert economic collapse in the wake of the Panic of 1907.

Just as important, for the Metropolitan at least, Morgan, the ruthless quintessential American capitalist, was about to launch a second career as the greatest art collector of his, and arguably any, time. He was certainly well prepared for the role. Scion of a family that had farmed the Connecticut River valley since Colonial times, and son of a dry-goods merchant turned international banker, Pierpont Morgan went on his first grand tour of Europe in 1853, at sixteen, visiting Dover, Calais, Brussels, Cologne, Berlin, Leipzig, Koblenz, Kassel, Frankfurt, Baden-Baden, Strasbourg, and Paris before returning to the Duke of Devonshire's house Chatsworth, in Derbyshire, England, where he saw the duke's private library, which was said to be the greatest in the world.[1]

After finishing his studies, Morgan toured Europe again, visiting Paris, Lyon, Marseille, Hyères, Toulon, Rome, Naples, and Florence. Though he'd collected the autographs of Episcopal bishops as a boy, like John Taylor Johnston before him, he made his first purchases of art in Italy, and continued buying here and there, but according to the future Met director Francis Henry Taylor, who would write a posthumous tribute to Morgan as a collector, he didn't pursue art passionately at first, feeling that serious collecting was his father's prerogative. Neither lacked the funds to indulge. Junius was left $1 million when his father died and would leave a far greater sum—$3 million outright and another $7.5 million in capital he'd invested in his firm, as well as real property worth millions more (totaling more than $320 million in 2007 dollars)—to Pierpont on *his* death.

Pierpont was not uninvolved with American high culture. He'd been a founder of the American Museum of Natural History and one of the first subscribers to the Met, and in 1877 was named a patron for his contribution to the fund that bought Cesnola's antiquities.[2] In 1888, Cesnola tried to get him to quit the American Museum of Natural History's board and join the

Met's instead, arguing that his tastes were more geared toward art and that the art museum was "progressing at the rate of a thousand and one compared with the other Museum." When Morgan refused out of loyalty ("I have been connected to that institution from the beginning," he wrote[3]), the Met named him a trustee anyway.[4] Morgan, coincidentally, had lately been having an affair with Adelaide Townsend Douglas, whose husband's family had leased the Met its second home on Fourteenth Street. A pious, long-married Episcopalian, he had a taste for other women.

Morgan was a huge man with white hair, a thick black mustache, wide shoulders, gray eyes like lasers, and a grotesque purple nose caused by a skin disease. He was as intimidating to art dealers as he was to financial supplicants. "I felt dwarfed," Germain Seligman, son of the Parisian dealer Jacques Seligmann, recalled of meeting Morgan. "It was not only his actual height and bulk, but his piercing, flashing eyes, his strong, set face, and, above all, his tremendous, radiating vitality."[5] Morgan stood out, even among the new class of industrially fortunate collectors, oversized personalities like William Henry Vanderbilt and Henry Frick, all of whom began to bid against one another for the spoils of European civilization in a passionate quest to demonstrate not just America's wealth but also its increasing cultivation. "Rich Americans spent more money on art during the thirty years from 1880 to 1910 than had ever been spent by a similar group in the world's history," the curator Albert Ten Eyck Gardner observed.[6]

The fortunes of old Europe fell into steep decline just as America emerged from depression in the 1880s and began making unprecedented sums of money in new industries, railroads, banking, and trade, the era's equivalent of this century's Internet gold rush. Just as America began flexing its wallets, the great estates that had sustained Europe's old nobility were finally coming to the end of their economic utility, as were many of the aristocrats themselves. Across Europe, families that had rarely sold or auctioned their heirlooms were forced to as great fortunes vaporized. It was that or lose their lands. So treasures unseen outside private homes in centuries like Lord Lansdowne's *Portrait of a Man,* the first Rembrandt van Rijn in America, were coming to market to be snapped up by the newly empowered American nobility.

"Collecting gave a feeling of power and exclusive possession," wrote

William G. Constable in his history of American collecting, "contemplation of their acquisitions provided a refuge from the cut-throat competition and remorseless pressures of business life."[7]

Their collections were also a pathway to social acceptance for men of sometimes humble origin and allowed America's new rich to associate themselves and American wealth with the past greatness of Europe. "For the rich and for the powerful one of the things that society in a sense expects them to do is to collect," Philippe de Montebello once said. "It is a way in which the rich can show that they are cultivated as well as wealthy."

The Metropolitan was begun by men who collected then-contemporary art. Like John Taylor Johnston, they began by buying French "Salon," or conservative academic history, paintings and then, urged on by artist-advisers like William Morris Hunt, an American painter who was a brother of the Metropolitan trustee and architect Richard Morris Hunt, moved into collecting what was then modern art: naturalist Barbizon painters like Théodore Rousseau, Millet, Courbet, Corot, and Romantic paintings by Delacroix. But as the nineteenth century ended, mega-wealthy members of the American industrial elite weren't ready to buy from contemporary artists.

Americans like Morgan, Frederick Lewis Allen wrote in *The Great Pierpont Morgan,* sought out well-established art to feed their "romantic reverence for the archaic, the traditional, the remote, for things whose beauty took them far away from prosaic, industrial America." High-end dealers appeared on the New York scene, eager to take their cut of this unprecedented transfer of art from one continent to another.

The first important art dealers in New York were Europeans who began opening galleries even before the Civil War. Knoedler & Co. opened in lower Manhattan in 1846, selling prints and art supplies. The pace picked up after the war. The Duveen family, which started out dealing antiques in Holland early in the nineteenth century and then expanded to London, sent one of its younger members, Henry Duveen, to America in 1876 to seek out wealthy clients. Within a year, he had opened a salesroom, too, although it was another ten years before he hooked his first whale, a retailer named Benjamin Altman.[8] Gimpel & Wildenstein of Paris soon followed. New York had enough millionaires in need of guidance to keep them—and a

trailing pack of scholars and experts, all eager to advise, to vouch for works of art, and to profit—busy. And best yet, this new clientele proved willing to move beyond what was fashionable and take up more adventurous pursuits.

For Henry Marquand, that meant buying up old masters, which had previously scared Americans, who were afraid of fakes. Altman, a reclusive bachelor, also formed a collection of old masters, and bought Chinese porcelain, gold, crystals, tapestries, carpets, and sculpture through dealers like Duveen and Seligmann.[9] The Duveens were so swamped with fine home furnishings and bibelots they began what amounted to a side business in interior decoration, becoming one-stop instant-aristocracy shops.[10]

In 1886, the next great movement in French art, Impressionism, came to America when Paul Durand-Ruel showed three hundred of these fashionable new paintings in New York, and the following year set up shop there. A few adventurous American collectors had begun buying the Impressionists. First among them was Louisine Waldron Elder. A sugar heiress, just twenty years old, she was advised by a family friend, an artist in Paris named Mary Cassatt, who like Louisine was a wealthy, unmarried American. On Cassatt's advice, Louisine bought her very first picture, a Degas pastel, in 1876.[11] Her next purchase was a Monet, and the dealer Eugene V. Thaw has speculated that each was the first painting by those artists to come to America. Louisine's collecting would take on a new dimension when she became the second wife of Henry Osborne Havemeyer, better known as Harry, the head of the Sugar Trust, a monopoly he'd formed by combining fifteen refineries.

The first Havemeyer had come to America from Germany in 1798 as a baker and seven years later opened a sugar refinery that would eventually become Domino Sugar. Harry had been the center of a scandal when he left his wife for her niece, and he and Louisine shunned society, their grandson J. Watson Webb has said, so it could not shun them.[12] At first, they focused on building a family, and then, after the birth of their child in 1889, they focused increasingly on their art collection. Brought up with wealth (he inherited millions when his father died in 1891) but with no more than a high school education, Harry Havemeyer was initially impulsive and promiscuous in his purchases of art. He began collecting at the Philadelphia centennial in 1876, buying large quantities of Japanese lacquer boxes, textiles,

sword guards, and ivory, then moved on to auctions, where his competitive business instincts served him well. He bought art in bulk, just as he did sugar.

His tastes evolved, moving from volume to quality and from objects to paintings after he married Louisine, who'd led a privileged childhood in Philadelphia and Europe, before her first $100 purchase from the unknown and financially strapped Degas, who, legend has it, was about to quit painting when she came along.

While his wife continued buying what was then modern art, Havemeyer began collecting old masters and American paintings. He'd already given the Metropolitan a Gilbert Stuart portrait of George Washington when he bought two Rembrandts and a Delacroix in 1888 and loaned them with a promise to ultimately give them to the museum as well.[13] Havemeyer eventually bought eight paintings attributed to Rembrandt and gave them their own room in his Fifth Avenue mansion, which had over-the-top exotic, international interior decor by Louis Comfort Tiffany. The Rembrandts were hung on the pale olive walls of Harry's study, the rest in a two-story gallery reached by a spectacular gilded-metal "flying" staircase suspended from a curved piece of cast iron. As the Havemeyers' purchases increased in tempo and quality, they built a second gallery in their backyard.[14]

Slowly but steadily, Louisine and her friend Cassatt changed Harry's taste, moving him from fashionable Salon and Barbizon paintings to the Dutch masters, and then on to Courbet (whose work Louisine had first encountered in 1881) and Manet. Louisine called Cassatt "the fairy godmother" of the collection.[15] In her history of art collecting, Aline Saarinen tells the story of a Courbet nude Louisine fell in love with that Harry quietly bought for her, despite their prior agreement that with young children in their home nudes should be forbidden. But there were still limits. A later acquisition, a Courbet nude called *Woman with a Parrot*, was considered so risqué it was first kept in a closet and then loaned to the Metropolitan.

In 1901, the Havemeyers went to Italy, where they bought more than two dozen works from an impoverished German, most of which proved to be fakes. They had more luck in Spain, where they discovered El Greco and Goya. Searching Toledo for a painting billed as El Greco's greatest work, they got lost. "Why don't they hang pictures where people can find them?"

Harry complained. When Louisine finally asked directions and found it, Harry decided it was perhaps the greatest picture he had ever seen, and they began buying as many El Grecos and Goyas as they could find.[16] Alas, eleven of their fifteen Goyas would eventually be reattributed, and they never bought a verifiable Velázquez. But several of their El Grecos and Bronzino's *Portrait of a Young Man* are still considered masterpieces, nicely balancing their judgment and taste against their occasional, and all-too-typical, mistakes.

In 1908, Louisine decided to buy the museum a Goya and to leave it many of her pictures, but Mary Cassatt advised against it, writing that "until the Directors of the Metropolitan show more judgment and taste it is better not to give."[17]

Cassatt's ill opinion may have been formed a few years earlier, when Luigi di Cesnola agreed to exhibit *Saturnalia,* a huge group of bronze figures representing a Roman orgy by a modern Italian sculptor, Ernesto Biondi. Set up in the new Great Hall just before it opened, it was soon removed after it offended several trustees (de Forest called it "revolting"). Reporters, too, condemned it as "uncommonly offensive . . . and so disgusting in subject that one stands appalled at the abyss to which modern Italian sculpture has sunk," as the *New York Times* put it.

Biondi sued to force the Met to put it on display and vented his wrath at American artists, calling them "canvas daubers, home builders . . . all of them business men and nothing but business men" and their works "ice-cold, affected, clumsy, dead—they smell business thousands of miles away." In its defense, the Met blamed Cesnola and said he'd had no right to make a deal with Biondi. Biondi lost, but the museum was ordered to pay to ship *Saturnalia* back to Italy. The affair caused a minor international incident, since the trustee Elihu Root, then serving as secretary of state, represented the museum in court—causing the Italian ambassador to the United States to resign. The sculpture ended up in the Botanical Garden in Buenos Aires.

As Havemeyer and the Morgans, Vanderbilts, and Astors became the Met's chief benefactors, buying and loaning and giving it more pictures and objects, the museum's importance increased geometrically,

confirming their wisdom in buying and loaning and giving even more. As early as 1888, the museum collection was valued at $2.25 million.

Though they are often lumped together in both art and financial histories, the industrialists and robber barons of the late nineteenth century were hardly a tight group of friends. And now that the museum was growing into a force all its own, its roof sometimes covered bitter enmity. Havemeyer and Marquand were thought to be developing good taste. When J. P. Morgan dove into the art market after the death of his father, he was often compared unfavorably to them: as voracious instead of perspicacious, with a preference for objects (books, manuscripts, portrait miniatures, porcelains, candlesticks, armchairs) over paintings. The director of one Berlin museum thought him "arrogant, brash and indiscreet."[18] And like many arrogant men, he could be fooled. In 1909, he sent a box of gems to the Met to be evaluated. A curator wrote back that few were antique and even those were inferior examples, "of a kind which one picks up every day in the shops of the Piazza di Spagna or the Ponte Vecchio," though he added, "I never saw so many of them together before."[19]

Yet he was also capable of buying a masterpiece without blinking, indeed with a sure inner compass. In 1901, he bought an early Raphael altarpiece, the *Colonna Madonna,* painted in 1505 for the nuns of the Convent of Sant'Antonio da Padova at Perugia, who sold it in 1678. In 1802 it passed to the king of Naples and the Two Sicilies, whose descendant Francis II sold it to a Paris dealer for $200,000. Morgan bought it for $386,473.[20] Soon enough, a Hals, Hogarths, and Fragonards would come to him as if by divine right. At the end of each year, his partners would wait in fear to hear what he'd spent on art.

Morgan learned to play tough. In 1899, Joseph Duveen asked his father to let him try to sell a collection of miniature portraits in bulk to Morgan, though only six out of thirty had significant value. Morgan calmly looked them over, asked the price, divided by thirty, and then put just the six in his pocket, telling young Duveen that he'd take them, at the prorated price of course.[21]

Havemeyer was opinionated, driven, cocky, and tough, too, and that had made him some powerful enemies. In 1882, when one of his sugar refineries burned down, Morgan pledged to loan him $1 million on payment

of a $60,000 fee, then kept the fee when the loan proved unnecessary. Havemeyer never forgave him. Morgan didn't care much for Harry either. Most likely that was because some of Havemeyer's outlandish comments ("I don't care two cents for ethics," he once said) stirred up already-simmering public resentment against the sorts of trusts, monopolies, and industrial behemoths that were Morgan's specialty, too.

Morgan, who was named to the Metropolitan's executive committee in 1892, wasn't Harry's only problem. Havemeyer was battling with trust-busters and garnered unwanted attention between 1888 and 1891, when it was first suggested that he join the museum's board. He was "a hard man to get along with!" Henry Marquand warned Cesnola. "I fear he won't do."[22]

Havemeyer kept buying art. But no matter how much of it he gave or loaned (as in 1903, with Manet's *Dead Christ with Angels*) or offered (in 1904 Harry financed Durand-Ruel's purchase of El Greco's *Assumption of the Virgin* so the Met could buy it at a good price, but Cesnola turned him down, and the painting ended up at the Art Institute of Chicago), Havemeyer would never make it onto the board.[23]

In 1907, just after American Sugar was sued for $30 million in an antitrust action, Havemeyer finally died as he lived, in abundant luxury, of heart failure following a weeklong attack of indigestion brought on by a hearty Thanksgiving dinner. He left his wife and children an estate valued at $60 million. At the memorial service held three days later in the art gallery of his city mansion, Choate and Morgan headed a delegation from the museum. Havemeyer's immediate family chose to stay in their rooms throughout the service.

IT WAS THE BEST OF TIMES FOR THE METROPOLITAN. WITH THE museum open on Sundays, the trustees no longer fought with the city over money. In 1893, the annual maintenance subsidy rose from $70,000 to $95,000, and two years later the city appropriated $1 million to build Hunt's eastern wing and its centerpiece, the Great Hall. In 1899, the museum would show an operating surplus of more than $5,000. Donated art and money were flowing in, allowing the museum to enrich its exhibits and,

despite Cesnola's continuing stranglehold, begin to strengthen its staff, hiring its first two curators. No donation was more important than the entirely unexpected one the museum learned about in 1901 and finally received almost three years later.

Jacob Rogers was a true eccentric whose neighbors in Paterson, New Jersey, thought he was the richest man in the state, but weren't sure; all they knew for certain was that his wealth came from building locomotives, that he kept collies and a herd of live deer as well as a stuffed one on his veranda and stuffed swans on his lawn; he had a dairy farm where he produced and sold butter; he refused to allow his biography to be published, and was so afraid of fresh air he stuffed paper around his windows and doors and in the walls wherever he slept.[24] People said he had $7 million; he said he wished they would show it to him as he'd never seen it. They also said he hated women. The last claim proved untrue. The $7 million figure wasn't far off.

Rogers's locomotives were the best there were, and Rogers himself was the opposite, a miserable, reclusive, miserly, aggressively uncharitable, antisocial misanthrope. "Why should I give people money who never have given me any?" he once barked. "He never showed any public spirit, and would recognize no motive that was not based on dollars and cents," said the *Paterson Guardian* on his death. "He would step out of his way to avoid treading on a worm, but would crush an unfortunate business rival without compunction . . . He always lived up to his own motto: 'Never do or give anything for nothing.' "[25]

It was said he'd been embittered by a youthful love affair gone wrong; ever after, he never allowed women near his house, and wouldn't employ them either, even as servants. He had a Swiss majordomo "whose chief duty seemed to be to be rude to persons who, for any reason, had occasion to call," said the *Washington Post*.[26] He hated his hometown for stopping him from buying land near his factory and never let the city forget it. In the Panic of 1873, he simply shut his factory down and went off to party in Paris and laze on the Riviera, where he was said to have had a love affair and a daughter, later awarded to its mother by French courts. Ultimately, it was thought that he may have had love affairs with three "certain women" mentioned but left unnamed in his will; he posthumously canceled any debts they owed him.

In the last year of his life, Rogers tried to shut down his company despite the best efforts of his fifteen hundred workers and Paterson officials to keep the city's oldest and largest industry alive. In early 1901, the works were declared insolvent and were sold; when a lawsuit was brought that June attempting to overturn the sale, Rogers filed an affidavit disclaiming responsibility due to deafness and enfeeblement. He died a week later during a vicious heat wave that killed hundreds in the New York area. His undressed body was found sitting on the floor of a room at the Union League Club, his legal residence, his head resting against the bed. "Jacob S. Rogers died as he had lived—alone," said the *Washington Post.* "If his often expressed wishes are followed, there will be no funeral ceremony. Having few intimate friends and fewer relatives, he felt that any show of grief because of his death would be hypocritical, and he despised hypocrisy."[27]

But it turned out that there were relatives and they were angry, not grieving, when it emerged that he'd disinherited a half sister and left nine nieces and nephews a pittance—a total of $175,000—and the rest, more than $5.5 million, to the Metropolitan. They found that out at the reading of his will in a dingy parlor next to the room where his body lay at his home in Paterson. The heirs "looked at each other in astonishment," said the *Boston Globe,* and sat in dead silence, "which continued for some time," according to the *Chicago Tribune,* and then "left the house indignant," said the *Times.* Rogers's executor predicted that the relatives would contest the will. "There is no doubt that an attempt will be made to prove that Mr. Rogers was insane," said the *Times.* A $20,000 dinner he'd hosted in Paris on his last trip there ($503,000 in 2007 dollars) would be exhibit No. 1.

But more than whether he was insane (for it was generally assumed that he was at least a little tetched), what everyone wanted to know was, why the museum? Rogers owned no art except a few miniatures and, as far as anyone knew, had no interest in it. Luigi di Cesnola had no answers either, although Rogers had been a $10-a-year member of the museum since 1883 and popped into Cesnola's office every so often, paying his dues in person and peppering the director with questions, not about the art, but about the trustees and the business of the museum. Cesnola claimed he had no idea who Rogers was and considered him something of a pest. "Had I known even that he was a rich man I might have treated him more diplo-

matically than I did," he said. "I never had an inkling of his vast wealth." Cesnola also didn't know if Rogers ever visited the galleries, and recalled that during a chat about why the trustees felt they couldn't afford to open the museum on Sundays, he'd hinted he might leave the museum some money. "I figured we might receive something like $2,000 and dismissed the matter from my mind," Cesnola told the *New York Herald.*

So the Rogers bequest came as quite a shock. It "astonished us," the mining mogul William Dodge wrote to Marquand. "It seems like a golden dream."[28] All previous gifts to the museum had taken the form of conditional or special funds, so its endowment to date was a meager $700,000. The British Museum, by comparison, had $22 million, Cesnola said, and spent about $300,000 a year on acquisitions compared with $4,000 a year spent by the Met. And the trustees were still reaching into their own pockets to pay for operating costs, kicking in $44,000 that year. The Rogers bequest would throw off about $250,000 in annual income and allow the Met to compete with older, richer European museums. If the museum won the will contest, Cesnola concluded, "there will be no more stinting." With trustee-attorneys like de Forest, Choate, and Elihu Root, then America's secretary of war, on board, Cesnola had reason for optimism.

Ten days after Rogers's death, one of his lawyers revealed that Rogers had been inspired by Andrew Carnegie's gift that same year of $5.2 million to build branch libraries all over the city, and wanted to do something of equal import for "the educational plant" of greater New York. That same day, his disinherited half sister challenged his will—beginning a legal farce that would last almost three years. The relatives named in the will eventually settled for an additional $250,000 and withdrew their objections, though some of them did ask for jobs at the museum. New York, New Jersey, and the museum tussled over whether either state could tax the windfall (New Jersey did, New York did not).

Finally, late in 1903, the museum got its inheritance. Over the next seventeen years, the money threw off about $4.25 million in income, allowing the museum to buy art without loans from trustees or subscription appeals. By 1931, the Rogers Fund had paid for purchases of Egyptian and Greek objects, armor, and such paintings as Brueghel the Elder's *Harvesters* and Cranach the Elder's *Judgment of Paris.*[29] Rogers money still funds signifi-

cant purchases to this day, paying a portion of the record-setting $45 million price for Duccio's *Madonna and Child* as recently as 2004.

Jacob Rogers's death wasn't the only one to change the museum's course. At the turn of the new century, nine trustees died: first Cornelius Vanderbilt, followed hard by the banker James Garland and Hiram Hitchcock in 1900, and in 1902 Salem H. Wales, the longtime publisher and editor of *Scientific American* and father-in-law of Elihu Root (who'd replaced Vanderbilt on the board), the self-made railroad investor Heber R. Bishop (who gave the museum his collection of one thousand Chinese jades and $55,000 to build a gallery for them that duplicated his ballroom), and, most significant, Henry Marquand, whose collection went to an auction at which a dealer representing J. P. Morgan was among the bidders. Marquand was replaced as president by Frederick William Rhinelander.

The Rhinelanders started their fortune with a sugar refinery and were among the earliest shipbuilders in the American colonies. By 1776, they were rich enough that an early Frederick Rhinelander was, the *New York Times* said in 1878, "disinclined to encourage the agitation" of the American Revolution, but hung around afterward and either bought or acquired through marriage large tracts of land all around the city, catapulting the family into the top ranks of the local Knickerbocker gentry. Two generations later, Frederick W. Rhinelander was one of about forty members of his family living off a fortune estimated to be as high as $100 million. A bald man with a bushy muttonchops mustache and piercing eyes, Rhinelander had been the museum's treasurer for years and was a member of the inner circle of trustees who actually did all the work; he appears to have had no other profession. Rhinelander's thirty-month presidency would be the last stand of the original incorporators.

IN 1898, THE FIVE BOROUGHS THAT NOW MAKE UP NEW YORK merged into the second-biggest city in the world behind London, reinforcing its growing importance in both finance and culture. J. P. Morgan, who played no small part in all that, had started giving art to the museum the year before—beginning with a silver and enamel altarpiece. His great gifts

wouldn't come until later, though, since he did most of his buying in Europe, and the Dingley Tariff Act of 1897 had reimposed the 20 percent duty on imported art that had been lifted in 1890.[30] Though museums could import art they owned without taxes, individual Americans could do so only at great expense. Morgan called the law "idiotically barbarous" and threatened to give whatever he henceforth bought abroad to London's South Kensington Museum if it wasn't repealed.

There was a lot of buying. By the turn of the century, Morgan had begun to withdraw from business and concentrate on the acquisition of books and art, motivated, Jean Strouse has written, by "his cultural nationalism, interest in history, sensuous response to beauty, and love of acquisition. Operating on an imperial scale in the early twentieth century, he seemed to want all the beautiful things in the world."[31]

Morgan relied on experts, but he also believed in both his own eye and his fierce reputation. He would never pay for objects until he'd taken possession and displayed them in his own home. He also paid retail—rarely bargaining. Canny dealers realized that it would be foolhardy to try to cheat him. Yet both he and his favorite museum could be fooled. Cesnola had tentatively attributed Morgan's first gift, that enameled shrine, to Benvenuto Cellini. Over the following years, it was steadily downgraded to the status of a fake and then disposed of entirely.[32]

One Friday in the fall of 1900, Cesnola was summoned by Morgan, who surprised him with the gift of a group of eight Greek ornaments made of gold that he'd just bought from a dealer in London for $150,000, outbidding a member of the Rothschild family. Their arrival in the museum led Cesnola to publicize the security system the trustees had recently installed in its Gold Room, which had only one door; it was wired to slam closed and lock itself—and ring an alarm in Cesnola's office—if any of the objects or cases in the room were touched. Cesnola told how only a few days before, the alarm went off, and he'd found two frightened women cowering in the locked room. Convinced they'd merely tried to open a case, he let them go. A half hour later, his phone rang; it was the police, "telling me to be on the lookout for two female thieves that were known to be working the museums."

It was said that in the preceding two years alone, Morgan had spent

$10 million on artworks, including a series of decorative panels by Jean-Honoré Fragonard, *The Progress of Love*, commissioned for Madame du Barry by Louis XV, for which Morgan spent about $300,000. In the spring of 1901, he added Gainsborough's portrait of Georgiana, the Duchess of Devonshire, to his collection. It had been stolen a quarter century earlier just as his father was about to buy it. Two weeks later in Paris, he bought Raphael's *Colonna Madonna* and a Rubens and Titian besides. In 1902, he gobbled up a rare eighteenth-century clock, a collection of gold seventeenth-century objects from Germany, a tapestry that had once belonged to Cardinal Mazarin (which he later loaned to England's royal family for a coronation), snuffboxes, Dresden china, another Gainsborough, some bronzes, a Dürer drawing, and a $700,000 library.[33] Some conjectured the purchases were motivated by a fierce desire for publicity. Others said he simply planned to build a museum of his own.

More likely, Morgan's gifts, which continued like a steady drumbeat, were motivated by his desire to see the Metropolitan become the world's greatest museum because of his wealth and taste. Francis Henry Taylor went so far as to compare him to Lorenzo de' Medici. "Each in his own way broke with his inherited tradition, and both men looked upon money as a source of maximum power and infallibility—never as an end in itself," he wrote. "And both induced in their contemporaries a new attitude toward the significance of works of art."[34]

When the Paris dealer Arnold Seligmann was asked about Morgan's collection in 1903, he declared it "absolutely genuine," but then, somewhat gratuitously, added his opinion of the Met. "There is a lot of trash in the building," he said. "Aside from the paintings and one or two rare pieces of tapestry, the contents of the Metropolitan Museum in New York might be destroyed by fire and the world not be the loser."[35]

"Inflamed by a grand design for the artistic enrichment of his native country," Morgan was determined to cleanse the museum of the lingering taint of the Cesnola scandal.[36] That wouldn't be easy. In 2007, over a century after the museum's 1903 purchase of its famous Etruscan chariot, or *biga*, its provenance, its legitimacy, and Morgan's role in its acquisition were still subject to questions just like those that plagued the Cesnola collection.

According to the museum, the bronze parade chariot dating back to

the sixth century B.C., inlaid with ivory and decorated with scenes of the life of Achilles, was dug up by a landowner who found it, some ancient utensils, and "other grave goods" in an underground tomb on his land in a small mountain village, Monteleone di Spoleto, in Umbria, in 1902. After passing "through the hands of several Italian owners and dealers, who were responsible for the appearance of the chariot . . . on the Paris art market," the museum's official version says, it was bought by Cesnola, brought to New York, assembled, and put on view for almost ninety years. It was then removed and reconstructed before coming back into public view as a centerpiece of the museum's new Greek and Roman galleries in 2007.

Two years before that, though, the Italian village had begun a campaign to pressure the museum to return it, hiring Tito Mazzetta, a former Italian air force officer who'd become a lawyer in America, to press its case. Mazzetta says he is a distant relative of the farmer Isidoro Vannozzi, who found the chariot and those other grave goods, which turned out to be human remains and two drinking cups. Vannozzi dismantled it, hid it briefly, then sold it to a scrap metal merchant for, depending on the account, two cows or a small sum that he used to buy thirty terra-cotta roof tiles. The chariot was allegedly moved to the back room of a Roman pharmacy where, Mazzetta believes, the omnivorous Morgan somehow became aware of it and arranged for it to be smuggled to Paris in barrels of grain and secreted in a bank vault until an intermediary was able to arrange its sale in 1903 to Cesnola, who paid for it with moneys from the new Rogers Fund.[37] Mazzetta claims such a sale was barred by a law passed in 1821, when Umbria was a papal state, and another from 1903, after the unification of Italy.

When the chariot first went on display in New York in 1903, there was an uproar in Italian government circles significant enough that it was covered in the *New York Times,* which reported that after an American "manufacturer" had bought the chariot for $50,000 and surreptitiously exported it, a government inspector was dismissed for negligence. In 1905, in a letter to the *New York Times,* one Attilio Caccini called the chariot "a corpse" and "artistic plunder."[38]

To Mazzetta, the smoking gun in the case is another, unconnected object that left Italy around the same time under equally mysterious circumstances, and ended up in Morgan's hands: the Ascoli Cope, a

thirteenth-century liturgical cope made for a Roman Catholic clergyman. The parallels are, at least, curious.

In the summer of 1904, a Roman Catholic cardinal, Vincenzo Vannutelli, was walking through London's South Kensington Museum (now the V&A) when he saw the cope, which was on loan from Morgan, whose London house at Princes Gate was full of treasure. Vannutelli recognized it as one that had been stolen in 1902 from the Cathedral of Ascoli Piceno in Italy, which had received it about six hundred years earlier from Pope Nicholas IV. It was likely made in England but had ended up in Rome. Morgan, reported the *New York World,* "did not know the vestment's history, and, of course, was ignorant of the circumstances under which it was offered him." In fact, questions about those circumstances would remain open for years.

The church had been unaware of its loss until Vannutelli's sighting, allowing the possibility that, as the *New York Times* put it in 1907, it had been "clandestinely sold" by a church insider—a not-uncommon occurrence. In 1905, an Italian prosecutor boarded Morgan's steam-driven yacht, the *Corsair,* anchored off Taormina in Sicily, to ask how he came to own the cope. An indignant Morgan insisted he couldn't remember, but refused to sign a statement to that effect since it was written in Italian.

Several priests had been arrested following the revelation of the theft, and a Florentine photographer who had pictures of the cope was also jailed, but he hung himself twelve days later in his cell in Ascoli. He left behind a note written with a match head that said, "I am innocent. Search for the guilty but when he is found he will be too powerful to be touched." The prosecution went nowhere.

By November, the Italian ambassador in London had contacted Morgan through Cesnola and arranged for the return of the cope to Italy, apparently with no questions asked. As the *Times* noted, "Of the history of the cope after it was stolen the public remains utterly in ignorance." In gratitude, Pope Pius X gave Morgan a private audience, and the king of Italy gave a dinner in his honor at which he conferred on Morgan the Great Cordon of Saints Mauritius and Lazarus, which gave the American the rank of relative of the monarch. He also got a gold medal decorated with his own image. Powerful, indeed.[39]

So it should come as no surprise that in 2004, Sharon Cott, the museum's lawyer, "respectfully decline[d]" to return the Etruscan chariot "long after any legal claim could be timely brought," but told Mazzetta of her hope that representatives of the Italian government might consecrate the opening of the new Greek and Roman galleries with their presence and take part in some simultaneous unspecified event to "highlight the contributions of the Umbrian region to Etruscan art."

Unfortunately, that opening was shadowed by ongoing controversy instead: latter-day expressions of the same sort of national pride and questions of provenance that had motivated the angry Italians a century earlier—concerning not only the controversial chariot but also a wide variety of other items in the galleries, as well as the collecting practices of American museums and some of their highest-profile donors.

And then there were the questions about its authenticity.

Writing in *Minerva,* an ancient art review, its founder and editor, Jerome Eisenberg, an antiquities expert and dealer, called the chariot "a pastiche of ancient and modern elements," the latter forged "between about 1890 and 1902." Eisenberg wrote that he first studied the *biga* and told the Met of his concerns in 1968, was allowed to examine the chariot closely for three days in 1971, and eighteen years later, in 1989, presented a paper about it at a meeting of the Archaeological Institute of America, which published a synopsis the following year. Eisenberg returned to the subject after the chariot reappeared in public that spring. The museum's public relations man responded that it was a "ludicrous" rehash of a "discredited" argument made "from a distance" and insisted that "its age and authenticity are not in question."

MORGAN DIDN'T LET QUESTIONS ABOUT HIS ACQUISITIONS SLOW him down. In March 1904, New York City authorized the expenditure of $1.25 million on a new northern wing for the museum to be designed by McKim, Mead & White—creating room for more art. Almost simultaneously, in London, the trustee Rutherfurd Stuyvesant was offered the chance to buy what was alleged to be the world's most important collection of arms

and armor, which belonged to the Duc de Dino, a descendant of the famous French diplomat Talleyrand. The Dino collection included helmets worn by Henry II and Henry IV of France and Vasco da Gama, Philip II of Spain's armor, a cutlass owned by Louis XIV, and a helmet said to have been worn by Joan of Arc. Stuyvesant wrote a bad check for $240,000 to pre-empt an auction of the armor, then rushed a cable to Morgan, who gathered his fellow trustees to browbeat them into coughing up ample funds to cover the check. Morgan was good at spending other people's money as well as his own and later the Rogers Fund paid them all back. In April, the grateful trustees elected Morgan a vice president of the museum.[40]

Just in time, it turned out; in September, Rhinelander, who had seemed to be in good health, was felled by a heart attack at the Red Lion Inn in Stockbridge, Massachusetts, and was promptly replaced by Morgan. From then on, Morgan dominated the board. His ascension greatly worried the cultural guardians of Europe. Between Jacob Rogers's fortune and Morgan's, and with the iron will and voracious appetites of the fearsome finan-cier behind it, the Metropolitan Museum of Art was about to enter its second era *and* the top tier of the world's museums. No object or painting, however precious, would ever again be safe.

With the unanimous election of Morgan as president on November 21, 1904, the board of trustees no longer had to suffer an inferiority com-plex. Morgan's family was old enough, to be sure, to be considered above the salt by all but the most snobbishly European Americans, but more im-portant, the wealth and power he'd earned on top of what he'd inherited were thought to be so great that he gave the museum and its trustees a se-curity and prestige that had thus far eluded them. Morgan was, *McClure's Magazine* wrote in 1901, a remarkable combination of the sort of old money that is surrounded in youth "by evidences of culture, and carefully edu-cated," and that is augmented by "bold, active, fearless . . . forceful and orig-inal" new money.[41]

Making the moment strangely sweeter, the evening before that crucial board meeting, Luigi di Cesnola had finally died. It was said he'd caught a cold at his last meal, suffered an acute asthma attack the next morning, and succumbed a day after that. It was too late to cancel the board meeting, so it went ahead, and Morgan promptly took a chair at the head of the table

and started giving orders. Before he was through, the great reorganizer of corporations would reorganize the museum, too. George H. Story, who'd been the paintings curator for fifteen years, was named temporary director. But who would replace Cesnola? After a respectful but brief pause to honor Cesnola, the changes came in a cascade, all summarized in November 1905 in the debut issue of the museum *Bulletin,* published by Henry W. Kent, who'd been hired as Robert de Forest's assistant secretary. In short order, Kent would modernize the museum's security and firefighting operations and establish a printing shop, a shooting range in the basement for the guards, an employees' association, a room for the intake of new accessions, and the post of registrar to keep track of them all. He would also install the museum's first electric elevators, a fireproof storeroom, a typewriter, and telephones and allow the hiring of women.

Kent's first bulletin promised to serve as an "information bureau" for members, listing all acquisitions and publicizing any and all changes affecting the museum. Conceived as a quarterly, it was so successful it immediately began publishing monthly; otherwise, the lengthy lists of new acquisitions alone might have strained Kent's new printing presses. But the biggest announcement in the first issue was the appointment, approved at a meeting at Morgan's home in January 1905, of Sir Caspar Purdon Clarke as Cesnola's permanent successor, and his assumption of the job that same October. Previously the director of the South Kensington Museum in London, where he'd come to know Morgan, who spent much of his time in the British capital, Clarke gave up a pension to accept the job because he considered the Met's prospects "unrivaled," he said. "No other museum in the world can show such liberal support from private sources."[42] A well-traveled Irishman, Purdon Clarke, fifty-eight, had been with the South Kensington Museum for forty years and had run it for a decade. A trained architect, he'd planned the heating and ventilation system for London's Houses of Parliament earlier in his career. Perhaps to assuage Americans, who may finally have had a world-class museum but had yet to have it run by a native son, Purdon Clarke was described in the *Bulletin* as "a self-made man," "in appearance and manner ... more American than English," "a man of the people," and "thoroughly democratic and approachable." He promptly announced that he would become an American citizen.

There was upset over Morgan's raid in England; Clarke's "defection is regarded as a national loss," reported the *Los Angeles Times*. When the South Kensington Museum's secretary came back after a hiatus that winter and asked about some porcelains the museum had wanted, he was told Morgan had bought them. A set of tapestries, similarly desired? Morgan had gotten them, too.

"Good God," the secretary gasped. "I must talk to Sir Purdon."

"Sorry, sir," the clerk allegedly said. "Mr. Morgan bought him also."[43]

At the end of that year, the thirty-fifth annual report detailed Morgan's and Clarke's vision of the museum. They planned to create new departments, each with its own curator (the first would focus on Egyptian art and soon begin a series of excavations that would continue until 1936), and shift the focus of the museum's collecting energies to the rounding out of the collection and the acquisition of masterpieces, as Clarke put it, so that "art students of Europe will have to come to America to complete their education." Up to that point, the Met had still been buying copies and casts and accepting random gifts of questionable quality. No more. Particular stress was also placed on the need to acquire paintings by Americans (albeit only dead ones), and a wish list of fifty-seven such artists whose works were inadequately represented in the collection was appended to the report.

Despite that renewed focus on American art, and the tariffs that made it excruciatingly expensive to bring Europe's treasures to the United States, Europeans worried that marauding Americans would now strip the Old World bare of art. Within days of Morgan's ascension, an art critic in Berlin raised the alarm among European museum directors, agitating for laws barring art exports. There was reason to worry. American "wealth drew a seemingly unending stream of works of art across the Atlantic," the National Gallery's director in the twentieth century John Walker would say of the moment.[44]

As for the museum's new director, that other import from the Old World, despite the grumbling from both sides of the Atlantic he was greeted warmly by the American press. But he took issue with its reporting. After speaking to him in London, the *Washington Post* had quoted him promising, "There shall be no cliques and no fossils in the Metropolitan management if I can prevent it," and describing how "honorary committees,"

presumably consisting of trustees, had hampered the museum's staff. Both he and his supporters quickly claimed he'd been misquoted. Then he sailed to France to meet Morgan at Aix-les-Bains to discuss potential acquisitions that he refused to specify "for fear of running up prices." Later, he predicted it would take "at least twenty years and cost between $3 million and $5 million to complete the Metropolitan Museum and to put it in first place as a repository of art treasures." But he had no doubt that day would come. "The amassing of immense fortunes is a main avenue, a highway, toward a splendid future for art and a higher civilization in every way," he said, then aimed some deft flattery at his patron, Morgan. "I have not found any wealthy Europeans who spend their money so intelligently."

In mid-November, the Great Hall was thrown open for Purdon Clarke's meet and greet, which featured the New York Symphony Orchestra. Morgan, Sir Caspar, and the executive committee clustered beneath the grand stair greeting their six thousand guests as carriage lines stretched four blocks along Fifth Avenue and up and down all the side streets until long past midnight.

Then Purdon Clarke got to work. In rapid succession, he threw the museum's doors open to art students, removed all restrictions on copying, and hired a curator from the Boston Museum of Fine Arts, Albert Lythgoe, to head the new Egyptian Art Department. Lythgoe promptly hired a student he'd taught, Herbert Winlock, fresh out of Harvard, to assist him. With the kick start of a $16,000 dig fund from Morgan, over the next decade they would excavate the pyramids at Lisht near Memphis, the royal tombs at Luxor (the former Thebes), and what became Morgan's favorite dig spot, the Oasis of Kharga with its Hibis Temple built by the Persian ruler Darius in the sixth century B.C.[45]

Long a source for Cesnola-style plunder and one of the stations of the cross of the Victorian-era grand tours that were part of the education of the worldly and the wealthy, Egypt had, in the previous fifty years, become something different—the focus of scientific explorations into ancient civilization. Though America had missed out on much of the bounty of Greece, particularly after England's Lord Elgin made off with his marbles from the Parthenon on the Acropolis between 1801 and 1812, Egypt proved willing

to cooperate with classical scholars in exchange for a share of their finds. The project would bear a lot of fruit for the museum.

Another new hire was Edward Robinson, who was brought in as Clarke's assistant after leaving his post as director of the Museum of Fine Arts in Boston. The net effect of these and other hires was to greatly strengthen the museum's back bench. Robinson would eventually build up the Met's antiquities collection and replace Sir Caspar, and Winlock would succeed Lythgoe atop the Egyptian Department in 1929 and then, in 1932, follow Robinson as director.

After a five-month sojourn in Europe in mid-1907, Morgan sailed home in August to put the final touches on his financial legend by effectively playing the role of America's central banker and rescuing the economy during the latest financial panic, brought on by collapsing banks. Morgan bore up the system by keeping wounded banks alive, summoning the nation's leading bankers and financiers to his library, where, beneath his priceless artworks, he forced them to work together to keep money flowing, credit lines open, and stock prices from collapsing.

After that, the seventy-year-old Morgan effectively retired from business, at "the zenith of his influence," as Ron Chernow puts it in *The House of Morgan,* "not a pirate but a sage," and as fearsome as ever, for now some believed that financiers like Morgan created panics to increase their profits and power at the expense of the public. Out of those fears grew the progressive movement that played the same reformer role nationally in its time that the Union League Club had occupied in New York City fifty years before, but in this case with a strong antibusiness bias. Morgan also found the successor that his business needed in the bankers' meetings during the panic, Henry Pomeroy Davison, whom he hired away from the First National Bank.

Now Morgan became even more involved with the museum. In 1906, his giving accelerated, high tariffs notwithstanding. Besides Lythgoe's excavation fund, his most significant gift that year was a collection of seventeenth- and eighteenth-century French decorative arts objects and paintings he bought from Georges Hoentschel, a Parisian architect. The *Bulletin* described it as "by far the most important acquisition this year." In order to

deal with the $1.5 million gift and loan, Morgan summoned into being the museum's Decorative Arts Department and hired William R. Valentiner as its first curator. He'd also bought and loaned to the museum Hoentschel's medieval collection ranging from Gothic sculptures to choir stalls. The Gothic style was very much in vogue among the Old New York/Hudson River valley society that ran the museum. As Valentiner installed the collection in 1908, Morgan would sometimes come by to watch. "I don't think I am betraying confidences when I place the amount of his assistance to this institution for the last year alone at more than $1 million," Clarke said in March 1909.

Morgan had also hired Bashford Dean, an independently wealthy and wildly erudite descendant of a Revolutionary War hero, to head up the fledgling Arms and Armor Department. Though he was primarily a biologist and zoologist, and the honorary curator of reptiles and fishes at the Museum of Natural History, Dean had had a childhood fascination with armor that was rekindled by his studies of naturally armored creatures. In 1910, he curated a loan exhibit at the Met. "Practically every amateur of *a. & a.* [arms and armor] in this country has consented to allow me to take the best pieces from his collection," he wrote to Morgan, asking for the loan of his "marvelous Negroli *casque*," a Milanese helmet from 1543.

They would also work together to get an old boarding school friend of Morgan's, William Henry Riggs, to donate his collection of armor to the Met; it was six years before Riggs finally succumbed. In the process, Morgan bought a French hotel Riggs owned that was losing money (eventually getting the museum to repay him for it), made Riggs an honorary trustee, and even offered him one of those named galleries the museum wasn't giving away quite so promiscuously anymore. During World War I, Dean's department made armor for the military; soldiers didn't like it very much when they field-tested it. Dean, who'd been commissioned as a major for the project, said, "Perhaps had the war lasted longer, some of the defenses which originated in the Museum would have demonstrated their merit and been used extensively."

The same year that Dean reeled in Riggs, Morgan made Arms and Armor a full department of the museum. But it would be 1925 before the last cases of Riggs's armor finally made it to New York. To note the occa-

sion, Dean wrote to Morgan's son, Jack: *"My conviction is positive that we owe this entire collection (as a princely donation) to your father as much as to Mr. Riggs himself!"*

Dean resigned in 1927 and died a year later, and most of his personal collection went to the Met, which named its armor wing in his honor. And finally, in World War II, the U.S. Army and Air Force began issuing helmets developed from one of Dean's World War I designs.[46] The museum's armor workshop also created body armor for the air force based on a fifteenth-century Italian brigandine, an armored vest given to the museum in 1929 in Dean's honor.

MORGAN'S PRESENCE AS THE DOMINATING PERSONALITY ALSO contributed greatly to the warming relations between the museum and New York City. He made the mayor an ex officio trustee alongside his comptroller and parks commissioner and, in thanks, won a raise in the annual appropriation to $160,000 and another $2 million to build new wings, a carpentry shop, and a power station. In 1910, two wings invisible from the exterior, one just north of the 1894 wing designed by Charles McKim to house some of the Hoentschel collection and one just to the south of the grand stair built to house the art library, both opened, and wings designated E and H completed the Fifth Avenue facade north of the main entrance, opening in 1911 and 1913, respectively.

Poor Sir Caspar Purdon Clarke wouldn't see any of these improvements. New York's climate seriously disagreed with him, and his health failed soon after he settled in. Though he was quite active his first year in office, railing against art tariffs, fighting with competitors, buying art, advising Morgan, and predicting a twenty-six-acre museum six times its current size, by 1909 he was back in England and Robinson was provisionally in charge. That summer, Morgan summoned Clarke to his house in London. A Morgan art adviser's report on that meeting is Sir Caspar's professional obituary.

"Sir Purdon Clarke's condition denoted serious physical debility," it says. He could no longer "discharge his functions as Director," so Morgan had suggested "a long rest and entire cessation from Museum routine."

They offered Clarke a year off with full pay to regain his health.[47] Not long afterward, Morgan learned that Clarke was continuing to use a letter of credit issued to him to purchase art for the museum—and wrote to ask if he would "be good enough to convert the balance of your letter of credit into cash and apply it upon your salary account?"[48] In June 1910, Clarke officially resigned, and that fall Edward Robinson became the first American-born director of the Metropolitan Museum.

Clarke never recovered and died in March 1911.

THE LAST TIME SIR CASPAR PURDON CLARKE MADE THE AMERI-can papers, just before Robinson's confirmation as his permanent replacement, he finally admitted he would never return to America. He also bore both good and bad news. The former was that thanks to recent donations by Jacob Rogers, the upstate New York banking heir Frederick Cooper Hewitt, and the financier John Stewart Kennedy, the Met's endowment was big enough to "stagger humanity." The bad news? That J. P. Morgan's staggering collection would never make it to the Met. "I do not think Mr. Morgan will ever take his collection to America," he said. "His prices make the market and he can always sell at a profit."

Clarke could not have been more wrong. Morgan had no intention of selling, and at last the way had been cleared for him to bring his treasures home. In February 1909, he'd gone to Egypt for the second time (the first had been in 1877) to visit the two expedition sites, rented a houseboat called a *dahabiyeh* to sail the Nile, learned about the objects that had been found so far, and fell in love with the world he found there. Not that you would have known it. An anonymous Englishman who worked on the special train that conveyed him 120 miles across the desert to the Great Oasis reported that all he did en route was sit and think, eat "a solitary egg and a piece of bread," and then go think some more, even at the dig site, "smoking his big cigars and immersed in his own thoughts," appearing like a Brahmin or a Buddha. "There was the same rapt contemplation and the same air of utter indifference to the outside world."[49] Yet Morgan wasn't unaware. "I

never imagined I would see so many interesting things in my life," he told Lythgoe as they left.[50]

While Morgan was in Egypt, Senator Nelson Aldrich of Rhode Island co-sponsored a bill to remove the tariff on most imported art. Aldrich was considered the senator of the plutocrats, the best friend in government of men like Morgan. Aldrich's daughter Abby was married to John D. Rockefeller Jr., the son of America's greatest monopolist. He was backed up by a brand-new senator from New York, the Metropolitan Museum trustee Elihu Root, who had co-founded the American Federation of Arts to lobby for the museum and against the tariff. Morgan had made it clear that he wanted to give his art to the Metropolitan, but wouldn't so long as the act of shipping it home would cost him $1.5 million. Even populists agreed with the plutocrats and supported the Payne-Aldrich Act since, as "Pitchfork" Ben Tillman of South Carolina put it, "an art gallery will become, in all probability, the legatee of their collection[s]." The bill passed that August and four years later was amended to include works of art less than twenty years old.[51] In the next five months, an estimated $50 million worth of art poured into America.

It was all more proof, if any was needed, of the increasing sophistication of Morgan's Metropolitan. Robinson had prospered, running the museum first in fact, then in name after Clarke's death. Morgan also refilled the board of trustees to his tastes, appointing tycoon friends such as the millionaire lawyer John Cadwalader, the politician and *New York Tribune* editor Whitelaw Reid, and a co-founder of First National Bank, Harris Fahnestock, all in 1901; Morgan's architect Charles McKim in 1904; in 1909 Henry Frick; another First National founder, George F. Baker, a director of forty companies whose ability to keep secrets won him the nickname the Sphinx of Wall Street; the first Jewish trustee, George Blumenthal, the head of the Lazard Frères investment bank (and a future museum president); Morgan's lawyer John G. Johnson and his son, J. P. Morgan Jr., in 1910; Edward S. Harkness, a Standard Oil heir, in 1912; and along the way such notables as the artist Daniel Chester French, the lawyer-collector and museum treasurer Howard Mansfield, and the lawyer and railroad heir (and future museum president) William Church Osborn. With rich friends

like these in place, it was easy for Morgan to also establish an informal system for balancing the museum's operating budget—which annually fell into the red. Each year, Morgan passed the hat, and the trustees coughed up the necessary cash.

They saw it as money well spent. The 1911 annual report crowed that the museum "no longer appeals merely to the 'upper classes,' " but had entered the lives of the many, that the museum's growth had become "symmetrical," encompassing "all art of all periods," and that the staff was at last well organized. "We are not depending on any single man," the report went on, dispensing with bad memories of Cesnola in a single sentence. Behind the scenes, by that year, the museum would have shops for making exhibit cases, for carpentry, painting, gilding, repair, roofing, hand lettering, printing, photography, a tank room to soak ancient sculpture, and a separate lunchroom for a growing cadre of female employees. More important to the public, perhaps, by that time the Metropolitan had also invented the blockbuster exhibit.

IT WAS THE TERCENTENARY OF HENRY HUDSON'S 1609 VOYAGE in his ship *Half Moon* up the river that would be named for him, and the centenary of Robert Fulton's first steamship ride along the same route aboard the *Clermont* in 1807. A sprawling celebration was planned, complete with replicas of the two ships re-creating their historic journeys in a naval parade, the unveiling of statues, monuments, and memorials all along the way, a parade, fireworks, musical festivals, and exhibitions at many of New York's museums. J. P. Morgan and Robert de Forest, who was named a vice president of the museum that year, headed planning committees for the event. The Metropolitan's contributions would be a show of 143 Dutch old master paintings from American collections, all dating from the era of Hudson's explorations, and work by American artists before 1815, when Fulton died, including furniture, decorative arts, and three hundred examples of Colonial-era American silver, among them twenty pieces made by the father-and-son Boston silversmiths named Paul Revere. De Forest would call the exhibition a test of "whether American domestic art was worthy of a place in an art museum."[52]

In July 1909, Morgan sailed from London to New York, bringing with him $30,000 in art that he'd bought for the exhibit and then planned to leave in the museum on permanent loan. Wearing a Panama hat and a gray suit and carrying a cane, he answered questions from reporters and was the first passenger to disembark the steamship *Majestic,* looking "much younger than he normally appears," a reporter observed, as he took a cigar from a colleague ("I had some with me on the boat but they got damp," he said) and strolled to his yacht, which had met the *Majestic* at quarantine and then followed it to pick up its owner on the pier at Christopher Street.

The unprecedented Hudson-Fulton show, which included thirty-seven Rembrandts, twenty-one works by Hals, twelve by Ruisdael, and six Vermeers, and the museum's first use of period interiors (inspired by those in the Essex Institute in Salem, Massachusetts, and the Swiss National Museum in Zurich), ran from September through November and attracted nearly 300,000 visitors.[53] It also changed the course of the museum and national collecting habits; with a nucleus of American art and objects finally in its possession, the Met moved steadily toward the creation of what would be called the American Wing, a museum within the museum, fifteen years later. And it made American antiques chic for the first time.

J. P. Morgan understood that this show was one of the most significant in the museum's first forty years. He personally ordered 255 copies of the deluxe edition of the Hudson-Fulton exhibition catalog and ten more copies printed on vellum.[54]

With the tariff on art abolished, Morgan's buying continued apace, and his loans to the Met increased. In 1910, he bought two significant collections, one of about two hundred pieces of French faience and also a collection of Russo-Byzantine enamels. But that November, he failed to bid on one of the famous Seven Deadly Sins tapestries from Hampton Court Palace at an auction in London, even though Robinson entreated him to, wiring Morgan's curator, Belle Greene, to say, "I fear the Museum is too poor at present, after its recent purchases, to do anything," and hoping Morgan would. He would not. But in 1911, he did send several paintings, including a Rubens, from his London home to the museum and gave it the loan of a van der Weyden *Annunciation,* a Cellini bronze, and a Vivarini panel and also gave as gifts six tapestries depicting the life of the Lord; portraits

of Queen Elizabeth I and of a British admiral and his wife; an Assyrian sword, two knives, and a lance; a prehistoric flint knife and a funeral dagger; more paintings by Carolus-Duran, Memling, Terborch, David, and Holbein, among others; another Rubens, this time a panel; a coffer, a cross, and an ivory plaque; antiquities from the Roman emperor Hadrian's villa; a Limoges clasp and various pieces of gold.

But as he headed back to England in 1911, Morgan's art-buying spree was winding down. "He wrote me the other day that he had not seen anything (except a couple of dames) that interested him," Belle Greene told the American scholar of Italian paintings and art adviser to the rich Bernard Berenson that spring. "I wrote him in reply to stick to the dames and avoid the masterpieces of art."55 That proved impossible, as Morgan's lust for fine art had simply been replaced by an enthusiasm for archaeology that would occupy his remaining days. The pharaoh of finance was attracted to his predecessors.

That fall, after an inventory was prepared of works he'd loaned to the museum, he asked Lythgoe to return twenty-two Egyptian items, *after* the museum shops had mounted them for him. The rest were unveiled for the public on the rainy night of November 6, when Morgan presided over the opening of ten new Egyptian galleries. He also kept giving, agreeing to loan $10,000 to cover the museum's half of the cost of a dig at Sardis in Turkey, about to begin under the auspices of the explorer Howard Crosby Butler, who had studied under Henry Marquand's son Allan, a professor of archaeology at Princeton. If Butler's finds ended up in the museum, Morgan expected to be repaid, but he offered to absorb the cost if nothing of value came of the dig.56

Back in the Nile valley he rented another *dahabiyeh* and with the Egyptologist Herbert Winlock as his not entirely willing accomplice returned to hunting antiquities. When Winlock argued against purchases, as he often did, or insisted that a dealer's asking prices were too high, Morgan went along with his expert but sulked miserably. And when Winlock found out that Morgan was enjoying himself so much he'd decided to build his own *dahabiyeh*, the curator threatened to quit the museum.

Finally, Morgan gave the Met many of the finest things he did manage to buy, and Winlock—whose love of Egyptology began in childhood, when

he mummified a mouse and made a set of coffins for it—wisely decided to stay.[57] A year later, he'd be amply rewarded when Morgan paid for and even helped design a house at Luxor for Winlock, Lythgoe, and their crew. Morgan, Harkness, and the Robinsons, de Forests, and Blumenthals sometimes stayed there. Originally called Morgan House, it was renamed American House after the Egyptologists discovered that Morgan had repaid himself the cost of building it out of the profits the museum made by quietly selling superfluous and duplicate finds to other institutions.[58]

BACK IN AMERICA, PLUTOCRATS WERE NOW LINING UP TO GIVE money to the Metropolitan. Gifts of money weren't "casual," Robinson would later say, but "they are usual." On his death in 1911, the newspaper publisher Joseph Pulitzer left the museum an amount variously reported to be between $500,000 and $900,000. And in February 1912, Francis L. Leland, a bank president, gave an unconditional $1 million in shares of his bank's stock, on condition that the stock never be sold. Unfortunately, when the bank failed a few years later, the gift became worthless.[59] But those gifts paled next to the one Robinson hoped to get from Morgan, who was teasing the museum with the prospect that it might get more—much more—from him. He was all too aware that he was approaching the end of his life and was appalled by the prospect of new death duties enacted in England in 1910. Freed to do so by the Payne-Aldrich Act, Morgan finally decided to ship the treasures he'd stockpiled in Europe to America, addressed to the Metropolitan, even though its president had yet to decide what he was going to do with them. The museum, which hoped the city would pay for yet another wing to house the collection, was willing to store it all, display it all, really do anything it could to convince Morgan that it was where the loot belonged.

To ensure against loss or damage to his precious property, Morgan threw his considerable weight behind a request to the U.S. customs service that it send an inspector to London at his expense to watch over the packing so as to avoid the potentially damaging and delaying customs process upon arrival. "This collection is really a matter of great public and educa-

tional interest," he wrote to the chief customs officer, "and the Metropolitan Museum of Art, which is specially concerned in having the arrangement, is a public institution upon which many millions of dollars have been spent by the city Government." The Treasury Department quickly agreed and sent a representative.[60]

Jacques Seligmann began shipping the collection, in 351 containers, on Valentine's Day 1912. It would take eleven months to get it all to the States. There were no hitches until April 15, when the *Titanic* (a ship owned by a Morgan-sponsored monopoly) hit an iceberg and sank. Germain Seligman would later reveal that a Morgan shipment had been scheduled to be on board the ill-fated vessel but wasn't packed in time.[61] The tragedy barely slowed the shipments. With military precision, a cable flew to London from New York announcing the arrival of each precious cargo. On Christmas Eve, Seligmann announced that he was finished. "With the above lots my tasks as regards the forwarding of Mr. Morgan's European collections is so far ended," he wrote, "and I trust that the contents of all the cases will be found in good condition, when opened." Little did he know how long it would be before that day came.[62]

How much stuff was there altogether? On January 4, 1913, Lorenzo W. Chance, the confidential agent in the U.S. Treasury Department who had supervised the packing and shipping, wrote a personal letter to Morgan, enclosing a copy of his report on the shipments, noting, "The valuations, as well as other details, have been regarded as confidential by this office and will, no doubt, be so regarded at Washington." Chance counted 44 paintings (worth £696,072.20 in 1913), 48 marbles (£200,841.12), 163 Greco-Roman bronzes (£120,000), 231 Renaissance bronzes (£286,496.10), 50 tapestries (£276,189.10), 79 pieces of furniture (£372,794.17), 375 pieces of Dresden china (£242,780.30), 334 pieces of Sevres (£388,132.68), 17 pieces of Chinese porcelain (£43,014.10), 162 additional pieces of earthenware (£271,340), 842 miniatures (£673,613), 150 snuffboxes (£265,293), 155 *carnets de bal* (£87,102), 248 watches (£108,712), 18 clocks (£90,388), 97 jewels and pieces of jewelry (£283,771), 103 pieces of silver (£100,014), 252 pieces of ivory (£369,850), 484 enamels (£928,232), and 455 miscellaneous items (valued at £603,857), for a total of 4,307 pieces worth a bit more than £6.4 million (or about $32 million).[63] But of course, this was

only part of Morgan's art holdings, and valuations are notoriously plastic. In his lifetime, Morgan spent about $60 million on art, the equivalent of about $1.2 billion today.

In the meantime, there was run-of-the-mill museum business to attend to, and as usual with Morgan that meant mixing business with pleasure. He'd begun a romance with Lady Victoria Sackville, the illegitimate daughter of the Honorable Lionel Sackville-West and Pepita, a Spanish dancer. Lady Sackville, who ran her family's estate, Knole, was also affected by England's tax increases, only in her case that meant selling art instead of getting it out of the country. Morgan bought two carpets and twenty-nine tapestries from her for $325,000, sending the former to the museum and the latter to Seligmann in Paris, who put them on display that fall for the benefit of the Louvre.[64]

In November, there was new excitement at the Met when Princeton's Howard Crosby Butler wrote Robinson to say that since the Balkan Wars had brought the Ottoman Empire to its knees, "this would be the time for a representative of the museum to be in Constantinople on the chance of the Turks deciding to withdraw and wishing to part with heavy luggage."

Robinson sent Butler's letter to Morgan along with an unsigned handwritten note: "It is reported that contents of Constantinople museum may soon be for sale. Very important to me to know facts and possibilities and to be in position to act if desirable. Put matter in [the Egyptologist Howard] Carter's hands." Two weeks later, Morgan cabled his London partner, Edward Grenfell, that he had "reason to believe" the Turks would sell their archaeological museum "with all its contents" and wondered if it was safe for Carter to go to Constantinople, today's Istanbul. "This is for the Metropolitan Museum of Art, New York, but I want no names used at present," Morgan wrote. "It is quite important that we should accomplish this if possible." Grenfell rained on Morgan's enthusiasm, reporting that Carter had up and left for Cairo and his own digs; the prospect faded.[65]

But Constantinople had no monopoly on art. Almost simultaneously, Benjamin Altman, the retailer, began secret negotiations with Edward Robinson to leave his collection to the museum—a gift that would dwarf even Jacob Rogers's. A son of Bavarian Jews who'd come to America in 1835, Altman began his career as an after-school clerk in his father's store, then

got a job at Bettlebeck & Co., a dry-goods shop in Newark, New Jersey,
working alongside Abraham Abraham, who would co-found Abraham &
Straus, and Lyman Gustave Bloomingdale of Bloomingdale's.[66] Altman
opened his own dry-goods emporium in 1865 at age twenty-five and
merged with a larger one founded by his older brother Morris to form Alt-
man Brothers, housed in several adjacent storefronts on Sixth Avenue at
Nineteenth Street. By 1876, it was the second-largest retail store in the city.

Altman left few records, and never married or had children, so he has
remained something of a cipher in the history of the Metropolitan, but his
life was considerably more interesting than is known. He and Morris had a
sister, Sophia, who married a Sam Fleishmann and moved to the Florida
Panhandle, where Sam opened a branch of Altman Brothers during the
Civil War, says the historian Daniel Weinfeld. After the Civil War, Fleish-
mann, a Republican, began serving freed slaves in his store, and in retalia-
tion he was ambushed and murdered by the Ku Klux Klan in 1869.
Altman's sister and her six children moved north and were supported by
Benjamin for the rest of their lives, as were Morris Altman's four children
after he died suddenly at age thirty-nine, followed immediately by his wife.
"Beneath a stern exterior there was a heart as sensitive as that of a woman
and as kindly as that of a child," a friend said at Benjamin's funeral.

Altman was a retail pioneer who introduced new women's fashions,
home delivery, and employee benefits; he also quietly adopted his brother-
in-law's progressive politics, becoming an early supporter of what would
later become known as civil rights organizations. He was said to consider
his employees his children. But he also had an eye for fine things and was
paternal toward his collections, which he began in 1882 with the purchase
of a pair of Oriental vases for $35 from Henry Duveen, who agreed to reg-
ularly open his gallery on Saturday nights to accommodate the busy retailer.
He soon became the first American Jew to form a world-class art collection.
Though he visited Europe and bought art there, Duveen was his primary
source, and their relationship continued until Altman's death. Wilhelm von
Bode, a renowned German curator, would ultimately judge his collection
better, if smaller, than Morgan's.

In 1906, after several years of quietly accumulating real estate, Altman
sold his old store (it is now home to a branch of the Container Store) and

moved his retail operation to a French limestone palace he'd built at Fifth Avenue and Thirty-fourth Street (just up the street from the former site of Henry O. Havemeyer's mansion, which Altman also bought). He renamed the store B. Altman & Co. and turned it into the first department store on Fifth Avenue.

Like so many American collectors, Altman began with Barbizon painters, but Duveen edged him toward old masters. In 1901, Joseph Duveen paid the then-record-setting sum for an English painting of £14,752, buying a John Hoppner portrait for Altman, who decided he didn't like it and turned it down. Nonetheless, the expensive gesture put Duveen on the map.[67] By 1905, he'd sold Altman his first Hals and Rembrandt.[68] Many more would follow in just a few years, as the Duveens shed their interior decoration business to concentrate on selling art.

Luckily for Altman, his deliberate decision-making process also included consultations with experts like Berenson, who tutored him about Italian painting, ensured he only bought the best, and collected a secret kickback from Duveen on every sale.[69] In 1909, Duveen sold Altman three Rembrandts for $250,000 each. Unfortunately for Duveen Brothers, the highly visible competition for paintings among men like Altman, Morgan, Frick, and Henry and Collis Huntington had driven prices so high that the government started paying attention. In 1910, Benjamin and Henry Duveen (who'd advised U.S. customs on art appraisals) were arrested for defrauding the government out of duties with false invoices.[70] A number of members of the Duveen family pleaded guilty and ended up paying $1.2 million in penalties and duties.

Altman "was probably the most fastidious collector who ever lived," the *Times* wrote on his death. "He was satisfied with nothing less than perfection." Altman had three secretaries to help him buy, care for, and catalog his treasures, and his galleries "expressed an individuality, and a unique aesthetic consistency and exhibition style," wrote the unknown author of a pamphlet about him published by the New York Community Trust, which later managed his foundation. "His intimate friends will never forget the many rare evenings in that gallery when, after the cares of a busy day were laid aside, Benjamin Altman sat there, surrounded by the treasures nearest to his heart; never boastful but intensely happy that he could give pleasure

and instruction to those genuinely interested in art," said a friend. "The love of art brightened his life."

Altman, though not the work-obsessed recluse he was made out to be, pulled the shade on notoriety, however. Petrified of publicity, he never let strangers see his collection. When he died, there were no known photographs of him to run with his obituaries, and it was said that fewer than a hundred people "even knew him by sight."[71] He considered Duveen's public profile "outrageous and inexcusable." Before the Hudson-Fulton show, he initially refused to loan any pictures to the exhibition. "People say I'm the meanest man in New York," he quipped, "and I want to live up to my reputation."[72] In the end, though, he not only loaned six paintings, including three Rembrandts and his Vermeer, *A Maid Asleep,* but simultaneously made a deal to give the Met everything outright, all of his fifty paintings, 429 Chinese porcelains, enamels, rugs, tapestries, furniture, and sculpture—more than a thousand pieces in all, valued at $20 million ($432 million in 2006).

It wasn't an easy deal to make. Altman wanted his collection to remain intact and together forever and was put off by a new museum policy against accepting conditional gifts; Robinson assured him that an exception could be made for his exceptional taste. Robinson also wrote to Morgan, swearing him to secrecy and asking him to confirm the terms of Altman's bequest. Morgan cabled back from Cairo that he agreed so long as Altman's "requirements [are] not too minute." After another month of reconsidering, Altman ordered his lawyer (Joseph Choate, conveniently enough) to draw up a will leaving everything to the museum, and on June 21, 1912, Robinson sent Morgan the news that it was signed.

A separate sixteen-page contract, revised right until Altman's death, spelled out the conditions the museum accepted, including a requirement that the collection be exhibited as a single entity in adjoining rooms, with paintings hung "in a single line, and not one above the other," just as Altman liked, and permanent employment for his personal curator and another young man who'd been Altman's secretary.[73] A few days after Altman's death from kidney failure in October 1913, the magnificent gift was revealed and hailed as the greatest the museum had ever received. Altman's curator remained with the Met as keeper of his former boss's collection until his death in 1958.

THE EXCEPTION HE'D MADE TO SNARE THE ALTMAN COLLECTION was very much on Pierpont Morgan's mind in December 1912 as he prepared to return to Egypt. He'd just finished testifying in Washington before the House Banking and Currency Committee, which was investigating whether a "money trust," a cabal of financiers led by Morgan, ran American finance and was abusing the public. With him were his son, J. P. "Jack" Morgan Jr., his partners Thomas Lamont and Henry Davison, and a pack of lawyers, including Joseph Choate; together they faced the committee counsel, Samuel Untermyer, a Democrat, a corporate lawyer, and an implacable enemy of financial tycoons like Morgan, and battled him to a draw. Morgan refused to be cornered, and his explanation that character, not connections, determined whom he did business with was roundly praised. But the experience drained him.

In January 1913, some of Morgan's drawings went on exhibit for the first time at the Metropolitan. But though he would walk through the show with Belle Greene while it was still being hung, he would miss the opening of the first major show of twenty-nine of the paintings he'd bought in Europe. A few days before they were unveiled, he and Albert Lythgoe embarked on the White Star Line's *Adriatic,* en route to Egypt, Rome, and Morgan's annual taking of the waters at Aix-les-Bains. He left considerable uneasiness behind him—Edward Robinson was no longer sure Morgan was going to give his collection to the museum.

Late in November 1912, Morgan had summoned Robinson to a meeting in his library and told him bluntly that "he wishes it distinctly understood," the director would later recall, "that he had no intention of giving or bequeathing his collections to the Metropolitan." He'd obviously faced his mortality and was thinking about his estate. His art, he'd realized, was too valuable an asset to simply give away without lots of thought and planning. And under no circumstances did he want the city to appropriate funds for a new building on the assumption that it would necessarily house his collection.

That assumption was already widespread. In 1907, New York's Board

of Estimate had voted to appropriate $750,000 a year for ten years to fin-
ish the museum buildings designed by Charles McKim. But in recent
months, the process had stalled before any money was authorized to build
a double wing to the south on Fifth Avenue. Prompted by several indiscreet
comments from de Forest, many assumed those wings had been designed to
house the Morgan collections. Some in city government felt that if that was
the case, Morgan should pay for the wing himself. In response, he vehe-
mently gave Robinson an order that nothing else should be unpacked.[74]
Morgan's patience had come to an end.

On January 7, he sailed to Egypt. Exhausted by his ordeal in Washing-
ton, "agitated and depressed" on his Atlantic crossing, and aggrieved by
news of the ongoing money-trust hearings, he became suicidal and para-
noid after his party boarded his boat the *Khargeh* to sail up the Nile on Jan-
uary 31, Jean Strouse wrote, refusing to eat, unable to sleep, sure he was
about to die or be murdered. After a brief visit to the new expedition house,
Morgan's companions insisted they cut their trip short and return to Cairo,
and a doctor was summoned from New York. Through February, Morgan
rested in Cairo as his daily activities were chronicled in newspapers back
home. When his doctor arrived in early March, he found the patient para-
noid, delusional, and convinced he was dying.

A few days later his party left for Rome, where art dealers filled the
lobby of the Grand Hotel, but were kept far from the great man, who spent
his days lying on a sofa, smoking cigars. After collapsing during a trip to
church on Easter Sunday, Morgan was confined to his bed. He never rose
again, dying at age seventy-five on March 31. In a private conversation, his
doctor blamed his collapse on the money-trust-committee lawyer Un-
termyer, calling him "that horrid Jew." Though the cause of death remains
uncertain, Strouse believes he'd suffered a series of small strokes and was
felled by a final massive one.[75]

Morgan's body was deposited in a wooden coffin, which was enclosed
in a second of hermetically sealed lead, which was itself enclosed in a third
walnut coffin with yellow metal handles and a yellow metal plate inscribed
with his name and birth and death dates. The body was transported to
Rome's train station, where it was enclosed in another wooden case ini-
tialed JPM, which was screwed closed, strapped in iron bands, and sealed

with tape and the seal of the U.S. consul. From there, it traveled to Le Havre, France, where it was put on board the *France* in the presence of a vice-consul and locked in the ship's mortuary room. The ship docked in New York on April 11, and Morgan's body was taken to his library, where it remained until his funeral and burial in Hartford.[76]

The New York Stock Exchange closed for the funeral on April 14; among the honorary pallbearers were the present and future museum trustees George Baker, Elihu Root, Morgan's personal lawyer, Lewis Cass Ledyard (who would be elected to the board that year), de Forest, and Choate. Newspapers noted the fact that no city officials attended. And a week later, when his will was read, the museum got some bad news: he'd left his entire art collection along with most of his estate to his forty-five-year-old son, Jack, who was also named one of his executors. His wife got $1 million and his homes, Jack his wines, his three daughters each received $3 million trust funds and their husbands $1 million outright. Amounts ranging from $1,000 to $250,000 went to dozens of distant relatives, friends, and servants, and every employee of J. P. Morgan & Co. and J. S. Morgan & Co. in London got a year's salary. The museum wasn't even mentioned.

What was mentioned as a potential beneficiary was the Wadsworth Atheneum in Hartford, to which he'd given $1 million in 1901 to build a wing named for his father on land he'd bought and donated. The context was a clause in which he expressed his desire to "render [his collections] permanently available for the instruction and pleasure of the American people." He blamed his failure to do that on lack of time, and left the final decision about the collections entirely in Jack's hands.

Presumably hoping Jack would forgive or ignore their delay, on the day after Morgan's death a committee of the city's Board of Estimate finally authorized the expenditure of $750,000 to build the new south wing to house his treasures, despite his warning that it shouldn't. The full board approved the proposal on May 1, as the city's comptroller immediately reported to Robert de Forest. He also explained—too little too late—that the matter had been delayed while the city's method of financing its obligations was overhauled.[77]

The museum had already launched a concerted effort to ensure that the new Mr. Morgan left his father's art, or at least as much of it as was

already housed at the Met, right where it was—it was a sometimes awkward effort that would continue for four years. On April 21, the board voted to create a Morgan memorial. Jack, who'd been a patron since 1903, as well as a trustee, hated the first drawings by Daniel Chester French, calling the proposed monument "somewhat clumsy and meaningless."[78] Jack wouldn't see a model he liked until 1918, and it would be 1920 before the memorial (now on the south wall of the main entrance foyer) would be put in place.

A long, awkward dance had begun. Three days after the vote on the memorial, Robinson sent Jack an eight-page inventory of every item Morgan had loaned to the Met, noting carefully, "About many things which he sent here your father was vague as to whether he intended to make them a gift or a loan, and his instructions to me were always to enter any things about which I was doubtful as loans until he had decided. This, of course was done, but I have indicated by a query on the accompanying list such objects as I think—from remarks which he made to me—it was in his mind to give sooner or later, though I never had a final word from him." A hand-written note scrawled on Robinson's letter indicates that Jack saw it and decided that "as the items were not definitely given this 'query' should be disregarded."

Jack spent the next few months finding out what his father owned, what he'd paid for it, what it was worth, where it was (for some was on loan, some still in the hands of dealers), and who owned what: museum purchases and gifts were commingled with Morgan's property. Jack found that his father's treasures were scattered among his various homes and offices in New York, London, and Paris; his Adirondack Mountains retreat, Camp Uncas; his son-in-law Herbert Satterlee's law office; the Met, the Wadsworth Atheneum in Hartford, the V&A, and the British Museum; the Jekyll Island Club (a private island club for plutocrats in Georgia); and even a cigar vault on Wall Street.[79] He also researched what taxes might be due on the estate, and to what countries they might be owed. Lucky for Pierpont, he'd died before a federal estate tax was enacted in 1916. But the New York State transfer tax came to $2.1 million, and New York City's bill was another $3.6 million.

Throughout the process, the ultimate disposition of his father's art

was never far from Jack's mind. "It is my desire that the objects of art left by my Father should be exhibited for the benefit of the public as soon as may be," he wrote his fellow trustees in May. "I know that it was in my Father's mind to make a loan exhibition of them in the new south wing which is to be built, for which I understand an appropriation has been assured by the Board of Estimate. A long time, however, must necessarily elapse before the construction of the new wing makes such an exhibition possible." Robinson offered a temporary exhibit in the meantime, to enable "the people of New York . . . to see the things and get the benefit of them pending such final disposition as may be made of the objects under Mr. Morgan's will." Jack agreed, and asked that it be planned to fill the museum's new northeastern wing (dubbed Wing H).[80] "A temporary quietus at least is thus given to the fears that the collection would be sent to Hartford or elsewhere," a relieved *New York Times* noted on May 29.

In June 1913, the city turned over Wing H, and de Forest wrote Jack that the installation of his father's art could begin. Before sailing for Europe that fall, Jack asked that each item be checked against an inventory list as it came out of the cases.[81] (A final typed inventory of Morgan family loans to the museum from 1912 to 1916 would run 315 pages.[82]) Jack also turned down his father's post as museum president, as did Joseph Choate. Finally, that fall de Forest was elected the museum's new president.

In December, de Forest hit Jack up for his share of the annual operating deficit, including with his plea a list of who'd paid what lately: Henry Frick and Morgan had given $5,000 in 1912; George Baker $3,000; Henry Walters and Edward Harkness $2,500; George Blumenthal $2,000; while most of the others gave $1,000 or less. In 1913, Frick had raised his ante to $7,500. Jack ponied up $1,000, but declined the invitation issued to him and his sisters to attend the Morgan loan collection opening, explaining that they preferred to avoid "conspicuous social appearances."[83]

Jack finally saw the exhibit after a board meeting in February 1914 and declared the chronological display, with separate rooms dedicated to ancient, Gothic, and Renaissance art, the sixteenth and seventeenth centuries, English art, French eighteenth-century pieces, Fragonard, French porcelains, watches, German porcelains, and miniatures, "splendidly done."[84] In

the process of preparing it, the museum reported, it had weeded out six objects curators felt were in poor condition, forty thought to be fakes, thirty-three it lacked room to show, and twenty reliquaries. Museum attendance soared as the Morgan, Altman, and Riggs collections went on display that year.

The next year, after he heard that the museum's operating deficit of $162,000 was "considerably greater" than it had been in 1913, Jack not only sent in his usual $1,000 but also offered to reimburse the museum for the cost of installing the loan collection. Robinson assured him that all the cases and decorations could be reused and that the opportunity to show the collection was ample repayment for what it had spent, but Morgan, perhaps feeling guilty, would keep trying to pay for it. "I should feel much freer and more comfortable in paying," he would write in 1916 to de Forest. Jack finally prevailed and handed over $16,216.81, paying for everything but the cases the museum planned to reuse. He clearly didn't want to feel any obligation to the museum as far as his father's collection went.[85]

Indeed, Jack had already begun selling off his father's treasures in mid-1914. It would soon emerge that Morgan wasn't as rich as people suspected, or very liquid, either; he had about $19 million in securities and little cash; the majority of his $69 million in assets was invested in real estate and art, and his cupboard was bare enough that John D. Rockefeller would quip, "And to think, he isn't even a rich man."[86] The cost of settling the estate, closing out his father's accounts, and ensuring the future of the house of Morgan on Wall Street was more than Jack could bear. As Bertie Forbes, the founder of the eponymous magazine wrote, Jack's selling spree was "prompted more by necessity than choice." Besides art, Morgan sold thousands of shares of railroad stock and his father's controlling interest in the Equitable Life Assurance Society, purchased by a member of the du Pont family for $4 million. "It seems," Belle Greene commented drily, "we need the money."[87]

Jack's copious records of the sell-off note sales continuing into 1915 to Henry Frick and Duveen Brothers, among other eager buyers. Throughout that year, Morgan or his father's curator, Belle Greene, would send formal requests, and Robinson would be forced to disgorge more and more Morgan treasure—royal furniture, clocks, a thermometer, vases, a marble Venus

and a Hercules, Sèvres plaques, Louis XVI and Marie Antoinette medallions, and bronzes. The process was relentless.[88]

Simultaneously, Jack was having everything carefully appraised. Knoedler valued the paintings at the Met, for instance, at $3,637,200; the most valuable single canvas was Raphael's *Madonna and Child Enthroned with Saints* at $300,000; the least valuable, an unsigned portrait of Lady Jane Grey worth a mere $100.[89] And after the loan exhibition closed in late May 1916, the pace increased as Jack started sending the museum lists of what should be transmitted to the Morgan Memorial Building at the Wadsworth Atheneum in Hartford. By September, Hartford had received 1,571 objects. A few weeks later de Forest wrote Jack to grovel and explain a quotation he'd given a newspaper attributing declining museum attendance to the "loss of the Morgan collection." There was also the small matter of World War I, de Forest noted, adding that he knew full well the museum couldn't " 'lose' what it never had."[90]

Not even an assassination could slow the inexorable winding-up of the Morgan estate. On July 2, 1915, one Frank Holt, a troubled German-born accountant, already wanted for murdering his wife, had set off a bomb in the U.S. Capitol, hopped a train to New York, and the next day shot Jack Morgan twice in a misguided protest against US loans to Europe to buy arms for World War I. Arrested immediately, Holt committed suicide in his jail cell.

At year's end, Robinson finally showed his anxiety. "Much as your kindness is appreciated in continuing this long the loans made by your father, the removal of any of the objects in his collections is a distinct loss," he wrote Jack on December 31 after getting the latest return requests, "and the list which you now send includes some of the most important—as well as attractive and popular—pieces which we owe to him and you."

"I am very sorry that there should be anything in what I do to make the Museum unhappy," Jack responded a few days later, "and very much regret that you should have been made unhappy too. You must realize, however, that, as I told you before, the collection will be reduced and probably very materially reduced: that I am glad to have the things in the Museum as long as they are not wanted elsewhere, if it suits the Museum to have them, but I am sure that you will realize the difference between loans and gifts."[91]

He wasn't giving an inch, but he had reason. That same day, the trusts were formally created for descendants, some lucky in-laws, friends, and employees.[92] The money had to come from somewhere.

Briefly, in 1916, de Forest worried that Jack would also quit the board and told him point-blank that "would be a serious blow and it would fall very hard on those members of the Board nearest to you and who were nearest to your father—Choate, Walters and myself. I need not name others." But he had nothing to fear. In late January, four days after everything in the loan exhibition was formally transferred back to Jack and three days after Henry Kent acknowledged Jack's check to pay for the show, he gave the museum the Raphael altarpiece, two sculptures, depicting the entombment and the Pietà from the Château de Biron, and more than thirteen hundred pieces of the Hoentschel Gothic collection, worth a total of about $1.75 million. "The announcement of the gift," said the *Christian Science Monitor,* "came as a complete surprise."

De Forest sent a pack of newspaper clippings to show the universal acclaim that had greeted the gifts, the board named Jack a benefactor, and the Raphael was hung at the top of the grand stair, "where we could see it from the great hall," de Forest wrote.[93] The Hoentschel material took longer to return to view, since the factory making the cases had retooled to produce ammunition after the United States declared war against Germany, and one of the curators installing the material had been called to fight.

"Don't shoot the director," Robinson quipped to Jack. "He's doing his best."

In December 1917, the museum's efforts paid off when it announced that Jack was giving it seventy-five hundred more objects, though it would be another year before the exact status of every item was clarified. The suddenly grateful press made a point of stressing that the museum had gotten much of what it really wanted, though claims that Jack had only sold replaceable items were overstated.

Finally, in June 1918, Jack's gift got a permanent home, although not in a new building but in the former decorative arts wing. Originally built at Morgan's request to house the Hoentschel collection, it was quite appropriately renamed in his honor when it became the home of his collections. The development pleased Jack no end. So in February 1920, when the dec-

orative arts curator, Joseph Breck, cabled him to say that a sculpted-wood Louis XVI storefront was on the market for F35,000 (or $2,046, or $21,168 in 2007), Jack agreed to buy it as a gift for the Morgan Wing, where his father's china would be displayed in its shopwindows. And a week later, Jack agreed to pay for a complete Louis XV–era interior Breck had found to provide a backdrop for the Hoentschel French objects. Jack paid another F105,000 (about $63,527 in 2007) for that.[94]

In the meantime, ground had been broken in 1914 for Wings J and K, completing the Fifth Avenue facade to the south of the Great Hall, but, delayed by war, the smaller wing didn't open until December 1917, and Wing K, then as now the home of the Greek and Roman Art Department, wouldn't open until 1926. The transformation of the Metropolitan into a national treasure and museum of international stature was complete.

THROUGH THE 1920S, JACK MORGAN'S RELATIONS WITH THE museum grew routine; he gave gifts, went to board meetings, and served on the purchasing, finance, and executive committees. In 1927, he tried to leave the board, and Root wrote him to say, "I can understand the feeling of a man struggling to escape the practical slavery imposed by the multitude of obligations which crowd upon a man who tries to be a good citizen . . . The Museum, however, is plainly about to face a very critical situation, both as to personnel and policy," and so he begged Jack to stick around. Though Root didn't say so outright, de Forest and Robinson were at odds.

In her autobiography, *A Backward Glance*, Edith Wharton would later praise Robinson's "quiet twinkle perceptible behind his eyeglasses," his "extremely delicate sense of humor combined with the boyish love of pure nonsense only to be found in Anglo-Saxons," "the dry pedantic manner in which he poked fun at pedantry," and "the fun, the irony, the gentle malice" of his character, but also made him sound, at best, a little scary: "Edward Robinson, tall, spare and pale, with his blond hair cut short 'en brosse,' bore the physical imprint of his German University formation, and might almost have sat for the portrait of a Teutonic *Gelehrter*." Nathaniel Burt agreed with the last, calling Robinson "a slim, grim elegant martinet."[95]

What came between the aloof, formal Germanic director and his president was not recorded, but in another letter to Morgan, Root alluded to a classic conflict. "De Forest will be eighty in April; Robinson is an art director, not an administrator," he wrote. "I am inclined to think that no man who is one can also be the other. The antagonisms, of which we are conscious, are ready to flare up whenever an important change is to be made . . . At eighty-three, I cannot expect to be available for any useful service, but for the Lord's sake, my dear boy, don't get into a position where you cannot put your hand on the situation just as your father did after the death of Chesnola [sic]."[96]

A year later, although de Forest was still in place, he'd begun to curtail his professional activities; Morgan felt he was being maneuvered into the presidency and didn't want any part of it. "As I understand it, the difficulty, after the death of Cesnola, was solved by Father becoming President himself, but that would be impossible for me."[97] Morgan quit all his museum committees, but agreed to remain on the board for the sake of appearances. When the nominating committee named him to the executive committee anyway, he declined. But his son Henry Sturgis Morgan joined him on the board in 1930, and a few years later briefly served as acting president, and thus did his part to sustain family tradition.

In November 1942, four months before his death, Jack did the same when he sent for the then-new museum director, Francis Henry Taylor. "I am in complete sympathy with your plans for revamping the collections of the museum and for presenting them in a more logical fashion," Morgan said. "The stipulation which I made many years ago"—that the Morgan collections had to be displayed together—"would prevent your accomplishing this end. I do not wish to stand in your way." With that, he handed the director a formal letter addressed to the board releasing it from any restrictions as regarded his father's collection.[98]

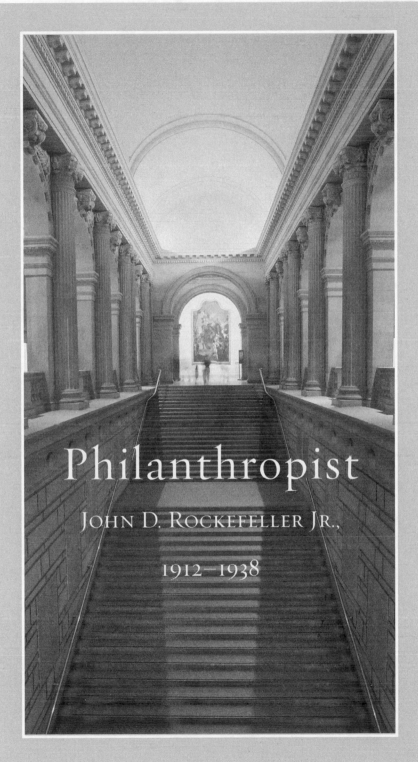

Philanthropist

JOHN D. ROCKEFELLER JR.,

1912–1938

John Davison Rockefeller Jr. was the son of

a myth.

Rockefeller senior, the organizer of the Standard Oil monopoly, was a
hard act to follow, particularly for his only son, who grew up a sensitive soul
with a dour, square face, plagued by a pervasive spiritual malaise, likely
brought on by the hatred his father had aroused in the public. It caused him
to find what comfort he could in domestic order. As an adult, he would al-
ways carry a four-foot folding ruler with him for those times when, as he of-
ten chose to, he would immerse himself in the minutiae of building plans.
On a grand scale, he built Rockefeller Center, the Art Deco masterpiece in
central Manhattan. For the Metropolitan Museum, he chose to build some-
thing far more personal and intimate, its only external branch, the Clois-
ters. Creating Rockefeller Center was a very public act. He chose to keep
his involvement in the Met more private. Junior, as he was known, refused
any official connection to the museum, even the honor of a seat on its
board. Quietly, however, he would become its next J. P. Morgan, wielding

extraordinary influence, albeit behind the scenes, until and even beyond his death in 1960.

Rockefeller junior first paid $10 to become an annual member of the Metropolitan at age twenty-three in March 1897, the same year he went to work for his father. Four years later, he married Abigail Aldrich, daughter of the Rhode Island senator who'd sponsored the bill that did away with the tariff on imported art, after a seven-year courtship begun at college. And just after that, he bested Pierpont Morgan in their first business encounter, when Morgan's U.S. Steel was trying to buy the Mesabi iron ore mine from Senior. When the great man kept young Rockefeller waiting, and then brusquely demanded to know his selling price for the mine, Junior responded that there'd obviously been a mistake. "I did not come here to sell. I understood that you wished to buy." He ultimately made a $55 million profit for his father on the deal.[1]

In 1902, Rockefeller senior's home in Pocantico Hills, on the east bank of the Hudson River in Westchester, New York, burned down, and what had been a vague plan to replace it with a great house nearby suddenly seemed more pressing—to Junior at least. He hired Chester Aldrich of Delano & Aldrich, a distant relation of his wife's, to start planning the stately granite home on three thousand acres that would eventually be called Kykuit (pronounced *kye-cut*).

Junior's motive may have been to counter the simultaneous exposé of Senior's predatory business practices by the muckraking journalist Ida Tarbell in *McClure's Magazine* and the antitrust investigation and breakup of Standard Oil by the Supreme Court that followed in 1911. He wanted "to prove that [his father] was not in fact a doomed soul, driven by nothing more than greed and love of power," wrote Kykuit's biographers Robert and Lee Baldwin Dalzell. "The man who appreciated beauty could never be such an individual." He knew his father was more complicated than the vampire portrayed by journalists and editorial cartoonists.

It took some convincing, but Senior finally agreed to let his son build him a new home. Consistent with his meticulous approach, after deciding on the house itself, Junior began researching landscape architects to create Kykuit's gardens and, through some artist friends of Abby's, was introduced to William Welles Bosworth in 1907.

A *Mayflower* descendant, Bosworth had impeccable professional credentials and an aesthete's sophistication. As he was also to the manor born, he knew how to deal with the wealthy and rapidly became one of Junior's closest friends and advisers on matters aesthetic. After Rockefeller senior moved into Kykuit in 1909, Junior hired Bosworth to design a nine-story Manhattan town house for his growing family, and their collaboration on the Kykuit gardens would continue until 1915.[2] Eventually, Bosworth moved to France in 1922 to supervise the Rockefeller-financed restorations of the châteaus of Versailles and Fontainebleau and of Rheims Cathedral.

But back in 1910, under Bosworth's tutelage, Junior began buying art, concentrating initially on early Italian and eighteenth-century French works. Bosworth took him to the Duveens, who sold him his first seventeenth-century Polonaise rugs from Persia and ten eighteenth-century Gobelin tapestries, most of a series representing the months of the year, created for the Count of Toulouse, the favorite son of Louis XIV. In 1913, Duveen sold Junior the best of the Garland–J. P. Morgan Chinese porcelain collection—objects perfectly suited for a man with a passion for order and meticulous detail—for $3 million, payable over three years. He had to go to his father, who had never collected art, for a loan to get them, justifying the request by pointing out that he'd never been extravagant and considered collecting porcelains, their price notwithstanding, an unostentatious hobby. His father loaned him the money and later made it a gift.[3]

It was a pregnant moment, the end of a generational era. The great industrial collectors were passing from the scene. And thanks to the introduction of a federal income tax after the passage of the Sixteenth Amendment in 1913, the Clayton Antitrust Act in 1914, and the estate tax in 1916, the accumulation of fortunes as big as theirs had been would be halted for almost a century. But Junior represented a new generation of inherited wealth that was already positioned to take the place of the Gilded Age greats and, in some cases, take over their prized possessions as well.

Ironically, Bosworth's greatest contribution to that process, and to the Metropolitan Museum, began not with one of the ancient objects Junior adored but with his convincing his client, at the very end of the landscaping operation at Kykuit, to buy a sculpture for the grounds from a rugged, eccentric Midwestern artist, George Grey Barnard. The son of a clergyman

and a pioneer's daughter, Barnard was born during the Civil War. A bushy-haired, strong-featured, self-assured type, he thought he resembled Abraham Lincoln, one of his favorite subjects. He had first shown his artistic inclinations when he dabbled with taxidermy and clay modeling as a teenager, and after a brief detour into jewelry engraving he entered the Art Institute of Chicago at nineteen, quickly earning enough making portrait busts to finance a four-year stay at the École des Beaux-Arts in Paris. Barnard's first patron was Alfred Corning Clark, son of the founder of the Singer sewing machine fortune, who commissioned Barnard's first monumental sculptures, inspired by Michelangelo, after an impressive debut at the 1894 Salon show in Paris. Clark's family donated the key work from that show, *The Struggle of the Two Natures in Man,* to the Metropolitan in 1896.

After several years of struggle following Clark's death, in 1902 William Clifford, the Met's librarian, urged Barnard to offer his services to the state of Pennsylvania to create two groups of huge sculptures to decorate its new capitol in Harrisburg. At a cost of $700,000, it was reputedly the largest commission ever given to an American artist. Barnard returned to Paris to begin work on the dozens of figures he'd promised, but his advances didn't cover his expenses for raw materials, so he had to find additional sources of income.

In 1906, while in France negotiating the purchase of the Rodolphe Kann collection, Joseph Duveen heard a fascinating story. The French government had recently passed an anticlerical law restricting the sale of religious objects and authorizing the state to catalog and seize church property. In response, local nobles and priests began selling original sculptures from churches in return for cash and copies of the artworks. Through an agent he'd hired to buy such bits and pieces, Duveen learned that Barnard had turned this into a lucrative business; he was selling the genuine medieval antiquities to rich Americans while also building up a collection of his own, including everything from statues and fragments to stonework he scavenged from ruined churches and fields; for centuries, old cloisters had served as quarries, and their cut stones as building materials for local farmhouses.

Duveen sought out Barnard, who proposed they work together on a grand scheme to buy entire buildings, ship them back to America, and sell

them to Pierpont Morgan for the Metropolitan. Barnard told Duveen he already had the partial cloisters of three monasteries—Saint-Guilhem-le-Désert, Trie-en-Bigorre, and Bonnefont-en-Comminges—hidden in plain sight in his garden and a fourth, from the twelfth-century Abbey of Saint-Michel-de-Cuxa, tucked away in a neighbor's barn. His plan was to "restore" them with bits and pieces of other buildings and sell them for $100,000 each. Like Cesnola before him, he was compromising the authenticity of his finds and embroidering tales of their provenance, assuming buyers either wouldn't care or would be none the wiser. Indeed, he claimed to Duveen that Sir Caspar Purdon Clarke was poised to broker a sale on behalf of Morgan and the Met. Unwilling to share a prized client with Barnard, or see Morgan cheated, Duveen queered the deal, but also kept Barnard in the fold by helping him raise the money to finish his Pennsylvania commission. The Met officials never came to see the cloisters, and Barnard went back to finding and selling stone where he could, finally finishing the statehouse statues in 1910.

In the meantime, Duveen became a partner in the conspiracy and through the next decade shipped hundreds of objects to America for Barnard, including some that ended up in the Metropolitan. Barnard agreed that he would only sell masonry while Duveen handled works of art and interior furnishings to complement the stonework. Gothic mansions were the latest decorating trend among the rich, and all concerned prospered. Even museum curators. In *Artful Partners*, his exposé of Duveen's similarly shadowy relationship with his paintings authenticator Bernard Berenson, the author Colin Simpson writes that Paris police files show that Joseph Breck—the Met's assistant curator of decorative arts from 1909 to 1914 and William Valentiner's replacement atop that department after 1917—earned kickbacks from those sales, which totaled F3 million.

In December 1913, French officials got wind of Barnard's plan to send twelve Romanesque arches from the Cuxa Cloister to America and vowed to stop him. Learning of their plan, Barnard protested it while packing identical crates with material of far less value from his garden and then gave in and presented them to France as the Cuxa arches while Duveen secretly shipped the real ones out. Mere days after the last crate left for America, France passed a law forbidding the export of any more historic architectural

fragments.⁴ Out of business, Barnard went home and began building a private museum next to his studio at the northern tip of Manhattan to show his scavenged Gothic finds. Shortly after his Cloisters Museum opened in December 1914, Bosworth turned up with Rockefeller, who bought a hundred items for $100,000. They were taken to Kykuit.⁵

On May 24, 1915, Barnard and Bosworth went to Kykuit to view in situ the two sculptures Barnard proposed to sell to Junior, *The Hewer* and *Prodigal Son.* Barnard pronounced himself entranced. Bosworth then showed the sculptor a niche with a fountain in the gardens, and Barnard immediately proposed another sculpture of Adam and Eve for the spot. Junior liked that idea, but not *Prodigal Son,* which he ordered banished as soon as possible, asking Barnard to sketch a female companion piece for the male figure in *The Hewer* instead. By June, he'd agreed to commission the sculpture, to be called *Primitive Woman.*⁶

As far as Barnard was concerned, he'd found a fatted calf, and henceforth he would do all he could to take nourishment from it. But instead of working on his commissions, he dreamed of how to get even more money out of Junior and within a year came up with a plan to have Rockefeller finance a museum to sit next to his cloister on an adjacent piece of land that was up for sale.

"In this piece of land standing separate as an island," Barnard wrote in 1916, "I could place small chapel towers, gothic doors in stone, marvelous statues and make of this spot a unique sacred place of Beauty and peace for artists poets and people." If Junior would consider creating such a museum, Barnard would offer his "knowledge and guidance and time." But Junior had to hurry. Within six months, he warned, all the hidden art would be "separated and lost as a unit." He had no material interest in the project at all, he stressed, adding that it could all be done "at the cost of what some pay for one picture or two."⁷

Barnard's timing could not have been better. In 1910, Junior had cut his ties with Standard Oil, and devoted himself to philanthropy and defending his father's reputation. But three years later, he was dragged back into the family business when a mine workers' union went on strike against the family's Colorado Fuel and Iron Company. In 1914, the National Guard attacked a tent colony of strikers in a town called Ludlow, killing a number

of women and children, union leaders effectively declared war, and many more deaths followed. After Junior sided with management, he found himself blamed for what has henceforth been known as the Ludlow Massacre. Picket lines were thrown up outside his homes and office, a bomber plotted to blow up his Manhattan residence (failing only because the bomb went off prematurely). Junior, seeing the error of his ways, studied the plight of labor and developed vastly more liberal views and sympathy for his workers, becoming their unlikely advocate. His visits to the coal mines were still fresh in his mind when Barnard made his appeal.

An excited Junior asked Bosworth his opinion. Barnard was right, said the architect. With the Great War in Europe still raging, medieval treasures could be found "among the heaps of ruins all over Northern France and Belgium," he wrote. "I am certain that it would be a substantial revelation to the public of a side of your nature which many have not yet given you credit for." More than that, he predicted, if Junior went ahead and created the museum, it might provide a permanent solution to the family's image problem.

"If you do this," Bosworth exclaimed, "you will have cleared your skirts forever!"

It only took a few days for Rockefeller to agree and ask Bosworth to represent him with Barnard. Soon enough, the sculptor came back with a proposal. If Junior would buy that piece of land for $70,000, Barnard would point him to the owners of two hundred Gothic objects; he claimed to already have the French government's export approval and predicted that they both would win the Legion of Honor for their effort. Junior was interested, but being perceptive, he was also cautious. Barnard, it emerged, wanted only Junior's money; Junior wanted creative input. He also wanted his museum to have a view, and the plot Barnard wanted him to buy lacked one. Barnard refused to even consider moving elsewhere.

Meanwhile, Bosworth had begun to sniff around and had learned that there were other routes to the same destination. There were some truly extraordinary plots of land for sale both above and below Barnard's. One, belonging to a C. K. G. Billings, a wealthy horse breeder and racer, had just what Junior wanted: on the site of the Revolutionary-era Fort Washington, it and two adjacent estates, totaling forty acres high on a ridge in Washing-

ton Heights, offered regal views all the way from the Statue of Liberty to the Hudson valley and across the river to the sheer, dramatic Palisades cliffs. The development of that eleven-mile-long tract had been stopped a few years earlier in large part due to donations from the Rockefellers, J. P. Morgan, and some other wealthy landholders, seeking to preserve its natural beauty (and, not coincidentally, their own panoramic views).

Perhaps, Bosworth suggested, Junior could start from scratch, buying and building his own cloisters without the man who'd thought them up. But Barnard wasn't easily foiled. He kept pushing for a sale of *his* land and his objects, though always weakening his case by adding more conditions. Writing directly to Junior, Barnard insisted that if they went shopping together, he had to have first dibs on anything they saw. Junior responded through Bosworth with a draft of a letter he wanted Barnard to sign, offering his curatorial and restoration services for free, giving up all claims on any works he assembled, and giving Junior the right to terminate their relationship at will.[8] Barnard didn't sign, instead complaining to Junior that Bosworth was envisioning a grandiose St. Peter's Basilica in upper Manhattan, not the quiet monastic retreat he assumed Junior wanted, too.

Barnard was insistent on cutting out the middleman, Junior on keeping Bosworth as a buffer. When another Rockefeller factotum told Barnard that Junior wasn't going to buy his land after all, he wrote again, ominously warning Junior that his plans might become known if they went their separate ways. Junior threatened to walk away unless Barnard left him alone for the summer and sent the sketch he'd promised, but had not yet delivered, of *Primitive Woman*. For the month of August 1916 at least, Barnard wisely kept silent.

By Labor Day, though, he could contain himself no longer and wrote a letter in pencil, addressed "Dear Bosworth, Strictly private," dropping all of his conditions, "if Mr. R will give me the price I have been offered twice for the Cloister collection." Bosworth forwarded it to Junior, noting another "flux of bird-like words" from Barnard. But the artist was canny as well as crazy; somehow he knew he had a whale hooked and had to hold on, even if that meant a little capitulation. In October, Junior signed a contract for *Primitive Woman*. And in January, he bought his plots of land with river views high over northern Manhattan.

Barnard knew full well how he wanted to fill them. A few days later, he began offering Junior individual objects from his own collection while also asking for a loan to buy the land nearer to his that Junior had refused. Rockefeller sent his regrets through his personal secretary and then had Bosworth reinforce the message. He would buy nothing more from or for Barnard.

Infinitely adaptable, Barnard returned with an offer to buy back the one hundred Gothic pieces he'd already sold Rockefeller. Junior told Bosworth he'd agree only if Barnard would do so at the same price he'd paid. But Barnard "is too restless a character to accept anything as final," Bosworth rightly warned his client. "His egotism also makes him feel that he must keep bobbing up." Again, he promised to handle the sculptor, whom he considered useful if not indispensable.

Petrified of exposure, Junior agreed to let things stand as they were, and for several months, as Barnard struggled to buy the adjacent lot, he let Rockefeller alone.[9] In the meantime, not knowing what to do with the Billings land now that he was on the outs with Barnard, Junior offered it to the city for a public park and was turned down because of the war. For the next dozen years he would lease out the Billings estate while adding to his holdings until they reached fifty-seven acres. Each time a new mayor was elected, he'd renew his offer of a park to the city. He'd be spurned every time.[10]

Meanwhile, though, time healed the wounds in Junior's relationship with George Grey Barnard. It helped that his father had finally approved sketches for *Adam and Eve* after Barnard accepted some changes suggested by John Singer Sargent, the society portraitist who'd just painted Senior. Barnard, in turn, accepted a three-year limit on producing the work.[11] But by December, he and Junior were again at odds after Barnard allowed *Primitive Woman* to be photographed. The publicity-shy Rockefeller declared himself "quite aghast," and Bosworth chastised the sculptor for his "great lack of courtesy." Barnard apologized, blaming the press.[12]

In January 1918, with war raging, Rockefeller wrote to Bosworth, suggesting they try to recoup what he'd spent on his Gothic objects by selling them to a dealer who was known to be buying them, Dikran Kelekian. But Bosworth had a better idea. He'd just had lunch with the museum trustee

George Blumenthal, who had built a new home, a huge mansion on Park Avenue at Seventieth Street, and was turning it into a private gallery of ancient art; he offered to take the objects off Junior's hands. Describing the house as "the latest sensation in this country," Bosworth said it proved that decorating with ancient art was a trend. The value of the Gothic stones was bound to pick up again.

❖

BORN IN FRANKFURT AM MAIN IN GERMANY IN 1858, GEORGE Blumenthal had come to America as a child and joined Lazard Frères, an investment bank run by the French-Jewish siblings who gave it their name. By the time he lunched with Bosworth, Blumenthal had been Lazard's senior partner in New York for fourteen years and had begun collecting art under the influence of David David-Weill, a cousin of the Lazards'. Morgan put Blumenthal on the Met board in 1909. Not long after that, the patrician trustee William Church Osborn urged the Met to give "at least one young Jew" a seat on the board. Osborn wrote to de Forest that "about a quarter of the people of the city are Jews and a large proportion of the art treasures of the city are in Jewish hands."[13] (His older brother, Henry Fairfield Osborn, president of the American Museum of Natural History, would soon say that the time had come to put "an agreeable Hebrew" on its board, too.[14])

It is telling that Osborn was unaware of Blumenthal's religion. Like the several Jewish trustees who followed him, Blumenthal was typical of the German Jews who arrived in America early in the nineteenth century and became what some refer to as WASHes, or White Anglo-Saxon Hebrews, the assimilated-Jew version of WASPs. Some even thought him an anti-Semite himself as he often argued against the election of other Jewish trustees. The cultured Blumenthal fit right in at the Met, quickly joined its executive committee, and built his mansion on Park Avenue around the nucleus of a two-story marble Spanish Renaissance patio from an early sixteenth-century palace.

Though he wasn't as rich, Blumenthal's spending rivaled Rockefeller's. When he bought a pair of sixteenth-century Venetian andirons for

$48,300 at a London auction, the world stopped and noticed. But Junior didn't take Blumenthal up on his offer to buy those Gothic objects. His attachment to them, to Barnard's idea of a cloisters museum, and to Bosworth's suggestion that his taste for the Gothic might improve his family's image proved stronger than his urge to be rid of his old stones.

❖

WORLD WAR I WASN'T KIND TO THE MUSEUM, BUT OTHERS WERE in the four-plus years that laid waste to Europe. The war began a month after the assassination of the Austro-Hungarian archduke Franz Ferdinand and his wife in Sarajevo in June 1914, and had a chilling effect on the American "takeover" of the art trade, freezing the European market and causing prices to rise. With transportation disrupted at best and dangerous at worst, particularly after Germany began attacking transatlantic shipping with its submarine fleet, the war slowed the influx of art into the museum. With industrial resources diverted to war production even before the United States entered the conflict in 1917, museum construction slowed, too, until after the armistice of November 1918.

That didn't stop the collection from growing, of course. Edward Harkness paid for innumerable Egyptian objects, including the blue-green faience hippopotamus that remains one of the museum's most beloved objects and unofficial mascot; the widow of the American Museum of Natural History's Morris K. Jesup gave his Hudson River school paintings; Ogden Mills gave bronzes; Harris Brisbane Dick, a publisher, gave prints and drawings worth $170,000, several paintings, including two Whistlers and a Sargent, and $1.3 million to open a new print department and hire William Mills Ivins Jr., a lawyer and prints collector, as its first curator; Junius Morgan gave Dürer etchings and woodcuts; and the de Forest family gave an Indian temple made of carved wood (which became the centerpiece of the new Indian galleries) and 217 pieces of Mexican majolica.

Bequests from Amos Eno, a Civil War veteran and merchant who became a wealthy real estate investor, and Theodore Davis, a lawyer, mine owner, and noted Egyptologist, both got bogged down in litigation over their estates. Relatives challenged Eno's bequests of $8 million from his $12

million estate to museums, universities, and an antipoverty group, claiming that he had gone insane in his old age. Various witnesses also said that he was violently opposed to everything from trade unions and woman's suffrage to the telephone, automobiles, and colleges. Courts first set the will aside and then reversed that decision in what would become the most expensive will contest in New York history. Finally, the Met gave up a fifth of its bequest and received $200,000 in 1923.

Davis was "a nervous little man with marked mannerisms, self-centered but generous."[15] He left the museum a collection of eleven hundred finds from private digs he'd financed in the Valley of the Kings, including the mummy of Amenhotep IV, as well as a number of valuable objects and paintings by Monet, Manet, and Goya (and a later-downgraded Rembrandt) when he died. But his wife challenged the will, demanding the collection be sold to pay for promises Davis made, although she offered to give the museum $50,000 out of her share to pay for the best items and an option to buy the rest. While the museum fought in Newport, where Davis had lived in a seaside "cottage" known as the Reef on the famous millionaires' row Cliff Walk, his treasures were on loan to the museum. Even after the widow herself died and the U.S. circuit court ruled against the museum, de Forest and Robinson vowed to fight on and, fifteen years after Davis's death, finally prevailed in a federal appeals court. By that time, the collection's value had quadrupled to $1 million.

In the meantime, two other huge bequests had come to the museum without much fuss or bother. Isaac Dudley Fletcher controlled the coal-tar trust, a monopoly on roofing tar and other coal by-products that was broken up by the federal government in 1913. When he died four years later, it was revealed that he'd done more than collect coal companies; his French château-style mansion at Fifth Avenue and Seventy-ninth Street contained statues, jewelry, rugs, tapestries, antiquities, stained glass, and paintings, including works by Rubens, Gainsborough, Millet, and Rembrandt, purchased on annual trips to Europe, and estimated to be worth anywhere from $2 million to $8 million, and about $3.4 million in cash, the second-largest fund for purchases in the museum's history.

So concerned was Fletcher with his legacy that he had his lawyer draft his will in collaboration with de Forest. The museum got thirty-seven

paintings, ten statues, and about two hundred other objects, as well as his mansion, which it would sell. And late that year, de Forest returned the favor, praising Fletcher as a model donor in the *Bulletin* for expressing his "very natural and proper desire" "to form a permanent memorial collection, shown separately from other museum exhibits," but leaving the museum free to choose what it would accept and demanding only that those objects be exhibited together for a year. Though de Forest added that the museum would continue to make exceptions, his praise of Fletcher for drawing a "delicate line . . . between his strong desire" and the museum's responsibilities made it abundantly clear to future donors that the trustees would no longer dance to their tune.

It wasn't quite that easy for the museum to get its fifth-largest gift, the $1 million bequest of John Hoge, an Ohio manufacturer of soap and tile, but in that case luck was on its side. Having made a fortune promoting soap with then-novel techniques like billboard coaches and premiums, Hoge became a director of Procter & Gamble, financed banks in Ohio, Seattle, and Alaska, and invested his fortune in real estate—including a number of valuable Manhattan properties.

Shortly before his death, Hoge drafted a codicil to his will in his own hand, leaving one of those properties to the museum, but never informed it he'd done so. Edward Robinson only learned of it when he read a tiny item in the *New York Times* in June 1917 revealing that Hoge had left money to the Met and to the Actors' Fund of America. When the two organizations contacted Hoge's executors in Ohio, they got no reply, so they sent a lawyer to Zanesville, where he learned that the codicil had been set aside when Hoge's primary beneficiary, a nephew who lived in Seattle, alleged that his uncle was not of sound mind. The nephew, who'd been left $2 million, made it known that if he got the extra money, he would use some of it to pay for a park in Zanesville, so no local lawyers would represent the museum; the savvy New Yorkers found one in another town and on August 1 sued for a determination of the validity of the bequest. When the nephew and his sister learned that Hoge had made a fortune in the stock market just before his death, and, more significant, that under the terms of the will they would be disinherited if they pushed their challenge to the codicil, they backed off, and in November the will was admitted to probate. In January 1918, the

museum became the owner of 481, 483, and 485 Fifth Avenue and 3 East Forty-first Street.

Another huge purchase fund was endowed by George A. Hearn, a retailer and trustee who gave the museum dozens of paintings by living American artists and $200,000 to buy more; it paid for Sargent's *Madame X* and Thomas Eakins's *Pushing for Rail*, among the few purchases in that decade. The museum's annual reports tell of stagnation and retreat. Membership and attendance dropped due to the "state of the times," the "interruption of intercourse" with Europe, an "absorbing interest in the war," which caused "unprecedented demand . . . for labor," the loss of staff and members to the military, the unprecedented "demands upon sympathy and time" war deaths caused, and, finally, "increased income in many directions allowing other, more expensive forms of amusement." What little the museum could acquire was being "left abroad" due to "the danger of shipment."

Many of those factors affected attendance, which began at 913,230 in 1914, the largest number of visitors to the museum since the Hudson-Fulton exhibit, but dropped to just below 700,000 the next three years, and finally plummeted to 635,000 in 1918 after America entered the war, driving down auxiliary revenue from the museum bookstore. Despite all of that, the museum kept growing, with exhibition space increasing from 151,000 square feet in 1909 to 267,000 in 1915. Largely as a result of the increased cost of running a larger museum, the same period saw the operating deficit climb from a low of $112,000 in 1916 to $230,000 in 1918. The problem was that the city's contributions weren't rising along with expenses, and the percentage of expenses its appropriation covered kept falling.

Whenever they needed something from the city, the trustees would raise the banner of education. In those years, the annual reports hit that bell over and over, mentioning "greater opportunities for service to the community than ever before" (in 1915), "the enlarging value of the Museum as an educational factor in . . . civic life," and "educational opportunities" mentioned three times in a single concluding paragraph in 1916, and describing the Met as an "indispensable adjunct to the schools" in 1917. Finally, in 1918, the city raised its appropriation from $200,000 to $233,000 but simultaneously announced that it would drop to $175,000 in 1919, a decision the

trustees called "lamentable," threatening that they would either divert purchase funds to operations or curtail programs. After 139,000 education-related admissions were tallied and publicized in 1919, the city appropriation was raised to $312,000 in 1920, but still the deficit covered by the trustees grew to $273,000.[16]

Like its role in education, pleas of poverty were a regular motif in the museum's fund-raising appeals. In 1920, when he relaunched an endowment drive he'd been forced to drop for the duration of the war, de Forest even managed to make the Met's success (its endowment had reached $16 million) sound like failure. "Relatively to other art museums, our Museum is rich, but relatively to its opportunities, it is poor," he said.[17]

That fund-raising drive coincided with the Met's fiftieth anniversary, a somewhat muted affair highlighted by a rearrangement of the permanent collection, loans from dozens of prominent New York collectors, and the debut of the Egyptian objects that had remained in Cairo during the war. The anniversary celebration culminated with the unveiling in May 1920 of the first two tablets on the grand staircase naming the founders and benefactors of the museum followed by a dinner at the University Club. But the tone of the event was set by Robert de Forest. Though he said that the museum had grown "far beyond [the founders'] most extravagant expectation," he also pointed again to its annual deficits and the failure of the city to find the money to complete the wing running south on Fifth Avenue.

Adding to the vague sense of postwar malaise, despite the museum's new riches, there were few new faces and no new fortunes coming onto the board of trustees. Only four trustees were added during the war, and none of them was a J. P. Morgan. So it's hardly surprising that in 1921, John D. Rockefeller Jr. was asked to take a seat on the board. What is surprising, though, is that he was elected first and only then asked if he'd be willing to serve.

The offer was prompted by expressions of interest in the museum from Junior. He'd been kicking its tires for two years. In 1919, he'd asked Edward Harkness to slip him a copy of the museum's financial statement on the sly.[18] That December, he offered Robinson a loan of the Months tapestries and Pierpont Morgan's tapestry furniture, purchased from Duveen, and asked the dealer to ensure that "they would be adequately shown."[19]

When Duveen found out that the museum was going to break them up in two disconnected rooms, Rockefeller withdrew the loan offer.

Undeterred, Robinson asked for a loan for the fiftieth anniversary exhibit. Rockefeller agreed to send the Morgan furniture (two settees and twelve chairs), the ten Months tapestries, and sixteen pieces of Chinese porcelain requested by Benjamin Altman's curator, Theodore Hobby. He got a calligraphed certificate upon their return to him, expressing the museum's gratitude, along with a note from Henry Kent asking if he wanted to be anonymous in the record of the event. Rockefeller agreed to be named so long as he was not identified as the owner.[20] Shortly after that, he was named a fellow in perpetuity.

In February 1921, he began asking the museum's financial officers lots of detailed questions about its lease, the nature and size of the city's contributions, the size of the deficit, and the various types of memberships. Alert to the possibilities, de Forest answered many of the queries personally, even though he was on vacation on Jekyll Island, explaining, for instance, that the city was obliged to keep the museum buildings in repair, but the trustees never asked for extra money, that the city set salaries for maintenance and security staff, and that the museum felt it did not need insurance because it was isolated, fireproof, and well guarded.

Then, apparently without advance warning, Rockefeller was unanimously elected to the board on April 19. "I think I should say," de Forest wrote in a letter to Junior in Hot Springs, Virginia, "that you were not elected because of your wealth (though that is no disqualification), or because of any expected financial help (though help of this kind is not unwelcome), but because we want the benefit of your judgment and experience in executing an important public trust." Junior declined ("I must deny myself," he wrote) on May 11, again on May 13, and, after a personal appeal from Robinson, for a third time on May 16.[21] But when de Forest tried again, Junior made it clear that despite his policy against board service, he was interested "in what is being done there" and genuinely sympathetic "with the idea of popularizing it." It would be several years before de Forest and Robinson learned just how interested and sympathetic Junior really was.

⚙

GEORGE GREY BARNARD'S GROVELING HAD DONE THE TRICK, and he'd remained in favor with the Rockefellers, even as he kept nagging Bosworth for more money. Much to Rockefeller's delight, Barnard had finally begun delivering the Kykuit sculptures in 1919, though they still needed pedestals and finishing.[22] He immediately started operating again, writing Junior's secretary to say that de Forest's assistant, Henry Kent, who'd recently bought a cast of Junior's *Primitive Woman* for the museum, had valued the Barnard cloisters at $1 million. So Barnard now proposed that Junior pay him in full for *Adam and Eve*—$50,000—not as an advance but as a loan with the cloisters as security. Bosworth soon got to the bottom of his urgency. Barnard was a year behind on his mortgage, owed $13,000 in back taxes, and had come down with rheumatic fever. Without ready cash, *Adam and Eve* would never make it to Kykuit's garden. A battered Junior finally offered to loan Barnard $1,500 a month for three months.

Typically, once he got that money, Barnard frittered it away and came asking for more.[23] This time, he wanted Junior's help and a piece of the Billings land to fulfill a vision he'd had for a memorial to peace and American industry, an arch, 120 feet in height, surrounded by (depending on Barnard's mood) anywhere from twenty-nine to six hundred separate sculpted nudes, all reaching through clouds of war toward a mosaic rainbow hovering over it all, to honor those who died in the war. He would later describe it as an American Parthenon. Yet somehow, despite all his overblown importuning, he managed to keep his hooks in Rockefeller, borrowing a garage on the Billings estate as a studio (where he would create his *Adam and Eve*) and continuing to profit from Junior's mixed feelings about laundering his reputation by building a medieval museum.[24] The next time Barnard pleaded poverty, Junior agreed to up his fee for the statue by $15,000.[25] But four days after he turned down a Met board seat, Junior also turned down Barnard's latest plea for more funds and in August, when Barnard claimed he couldn't finish *Adam and Eve* without selling his cloisters, reiterated that there would be no further payments.[26]

Junior's battle with Barnard over *Adam and Eve* continued for another eighteen months. Even Barnard's wife joined the fray, claiming that the Rockefellers were underpaying for the statue, causing her poor husband to take to bed from the strain of financing his rich patron. "Art can't be hurried any more than a child's growth," she wrote, threatening to go to the press before exhorting Junior to "clear yourself . . . all this is greatly to your discredit."[27]

Meanwhile, the sculptor was fending off the city's attempt to seize his land for nonpayment of back taxes, negotiating with Breck and Robinson to sell them his Cloisters Museum, trying to induce Junior to buy Chinese and Japanese temples he claimed he'd been offered, and considering auctioning his unwanted strip of land. Why did Junior put up with Barnard's chaotic presence in his life? One reason came that November, when Barnard informed him that a dealer named Edouard Larcade had appraised his cloisters at more than $1 million. In the process, he'd discovered that Larcade was selling a set of Gothic tapestries from a great French family's château. He thought Junior ought to see them. He expected, of course, a finder's fee.

Those tapestries, woven in Brussels of silk, wool, and metal threads in the late Middle Ages, possibly for the wedding of Anne of Brittany to Louis XII, and depicting a unicorn hunt, had long been owned by the aristocratic La Rochefoucauld family. Rockefeller snapped them up, paying $1.15 million for six of them, although the buyer's name was kept secret for months as controversy raged in Paris over the departure of these art treasures from France.[28] Also secret, the reason for the sale: the current Count Rochefoucauld wanted to build a golf course at his château.[29]

In December, Junior learned Barnard was getting his $50,000 after all, as a kickback. Resisting the urge to cancel the deal altogether, Junior had his lawyer ask the sculptor to repay $17,000 loaned to him over the years he'd been working on *Adam and Eve*. But when Barnard refused, Junior backed down again, explaining to his staff, "This is a delicate situation and I want to do what is wise, and of course our ultimate desire is to get the statue as soon as possible, satisfactorily completed. At the same time, I dislike to be used and put upon in this way."[30] He was at a loss what to do.

The next few months would make the weight of that decision seem

insignificant. Late in April, an unkempt stranger began following Junior from his home to his office, demanding a job. After a few weeks of that, the stranger tried to push his way into the house on Fifty-fourth Street. A police guard was posted at the door, but on May 2 the stranger appeared again armed with a stiletto and two long needles and rushed at Junior, shouting, "You and the Bolsheviks are responsible for all the trouble in the world!"

Fortunately, Junior evaded the attacker, and the police clubbed him into submission and hauled him off to Bellevue Hospital. He'd soon be identified as a Syrian silk weaver from Canada. Rockefeller declined to press charges. The next day Barnard wrote that he was thrilled to hear of "your escape from death and the maniac."[31] Then, three days after that, Junior's sister-in-law Lucy Aldrich was on a Chinese train when it was seized by bandits; forced to sleep in a dog kennel for a night, she was quickly released, but the story made headlines for a week. Small wonder then that Junior was unavailable when Barnard insisted he had to come see *Adam and Eve* and decide whether to "leave the clouds on Adam's loins as now is, or discover more of Adam's male attributes, giving more punch to the creation."[32] Adam's penis was not a priority.

Then, a few days later, scandal. George Grey Barnard's former partner in his Gothic ruins business in France, George Joseph Demotte, sued Joseph Duveen for slander after Duveen was asked by the executors of the estate of a New York jeweler to put a value on a Gothic statue Demotte had sold him (which he'd left to the Metropolitan), and declared it a fake. Duveen, who was hypercompetitive, had been lying in wait for a chance to damage Demotte, who had opened a rival gallery in New York. Two years earlier, he'd had its manager, Jean Vigoroux, arrested for stealing money and some Persian manuscripts that later turned up, still in Demotte's possession. According to Colin Simpson, Vigoroux had been slipping information about his boss to Duveen, who passed it on to American tax authorities hoping they would shut Demotte down. He fired Vigoroux and brought charges against him instead.

But once Demotte sued Duveen, too, countercharges of fraud came fast and furious, with French nobles and art experts declaring Demotte had sold scores of fakes and overly restored statues to American museums and collectors, eventually naming both the Metropolitan and Junior among his

victims. One expert said 20 percent of the Met's Gothic holdings were Cesnola-style fakes. "That man would put arms on the Venus de Milo," he said of Demotte. Meanwhile, with Demotte's embezzlement charges against him slowly wending their way to court, Vigoroux chimed in with the claim that three-quarters of Rockefeller's objects were spurious, too.[33] For all of them, art had become a very ugly business.

Edward Robinson stepped forward to defend both the Met's purchases and Demotte. And so did George Grey Barnard, who came out to defend his former business partner and to vouch for the authenticity of the pieces he and Demotte had sold to Junior.[34] Awaiting trial in Paris, Vigoroux sought help from Duveen, who decided to air the matter of Demotte's forgeries in the press. A few days later, George Blumenthal, who sat on the purchasing committee that had approved the Met's buys, vowed that it would investigate. That same day Demotte's charges against Vigoroux came up before a tribunal in Paris. As it took evidence, Duveen and Demotte kept slinging mud at each other across the Atlantic.

At least some truth came out in the Paris courtroom, where "evidence most of the time was totally irrelevant to the case," the *New York Times* wrote with a snicker, leaving out the detail that some of that evidence was of kickbacks paid to Met curators. Vigoroux's first defense against the charge that he'd stolen from Demotte was simple, and likely true: the missing money had gone as payoffs to society figures in New York who'd facilitated sales. He refused to name names, but another Frenchman testified that such under-the-table arrangements were common. And in pretrial affidavits, Demotte admitted as much, noting payments to Met officials, Barnard, and Berenson among others, and claiming that Duveen himself had knowingly bought and sold a forgery. Vigoroux even blamed his misappropriation of funds on Junior, claiming Rockefeller had held on to a Chinese statue for eight days while deciding whether to buy it.

The Metropolitan got dirtied, too. Duveen's manager in New York, Edward Fowles (whose papers were a primary source for Colin Simpson's exposé), urged his boss to settle the case, warning that his enemies in New York, including the museum trustees Henry Walters and George Blumenthal, were financing Demotte's suit. De Forest and Robinson confirmed this when they announced they weren't going to investigate their Gothic

objects after all, but would wait for a verdict, hoping for Demotte's vindi-
cation.

Before that could happen, though, Demotte was killed by another art
dealer, allegedly by accident while hunting in France, although it wasn't
hunting season. Simpson noted that the shooting came just three days after
Demotte and Duveen were served with demands for testimony in the in-
vestigation of yet another suspicious death, that of Emile Boutron, another
former associate of Barnard's and Demotte's, who may have been ready to
sell the dealer down the river.[35] Duveen "could barely contain his glee at the
news that he no longer had to prove anything," wrote his biographer Meryle
Secrest.[36] On the same day, separate magistrates ruled Boutron's death a
suicide and Demotte's an accident. The dealer who shot Demotte was
found not guilty of homicide but fined F500 and ordered to pay F100,000
to compensate the dead man's family.

Vigoroux was found guilty—but was sentenced to a slap on the wrist:
a month in jail, a payment of $3,775 to Demotte's widow, and a fine of F25.
The museum declared victory and didn't investigate further. Only Henry
Walters, the museum's latest vice president and along with Blumenthal a
key member of the purchasing committee, was candid enough to admit that
he'd bought fakes. "The danger of spurious art," he admitted, "is constant."[37]

ADAM AND EVE, ALL 125 TONS OF IT, TWENTY-FIVE FEET HIGH IN
white Carrara marble, finally made it to Kykuit's gardens in September
1923. In October, Barnard offered Junior the *Prodigal Son* sculpture again in
payment of his debt. Junior's secretary pointed out it had been rejected
eight years earlier.[38] A few weeks later, Barnard returned to the subject of
Adam's missing genitalia, suggesting adding it along with a fig leaf. A grate-
ful Junior said he wasn't so sure, but that he loved the piece, though he
asked Barnard to add some charm to Eve's face. And two weeks later, he
wrote again to remind Barnard that he was still owed $11,268.85, but within
days was offering to forgive the loan and pay Barnard an additional
$8,731.15 outright, so long as he agreed to finish the statue to Junior's satis-
faction and promise never to sue the family.

Barnard ultimately signed the releases, took the money, and promptly fell off the Rockefeller radar for a year, despite Junior's aides urging him to live up to his end of the contract and finish *Adam and Eve*. In October, he returned to his idea of placing his Peace Arch on Junior's land and began working on full-scale plaster models of it in the building Junior had loaned him on the former Billings estate. Advised again that his patron wasn't interested, Barnard insisted that it would be finished if it took the rest of his life. A few years later, he'd describe his quest for that grail as "an endless crucifixion." He would never return to the *Adam and Eve* statue. Instead, he'd finally subcontract out the finishing touches in 1928 and argue with Junior about its completion until 1933.[39]

Even as he kept Barnard close, Junior had begun looking into other ways to contribute to the Met. In 1922, the Laura Spelman Rockefeller Memorial Fund, created by John D. Rockefeller Sr. in his late wife's name to contribute to the public welfare, hired Beardsley Ruml, a statistician and economist, as its director, and one of his first tasks was to study the Metropolitan Museum in order to find a suitable purpose for "a gift of considerable magnitude."

The resulting sixty-two-page report provides a snapshot of the museum at age fifty. After describing its charter and lease, Ruml notes that the average sitting trustee had served for just over eleven years, while the average term of trustees over the life of the museum had been fourteen years, with a fifth of them serving for twenty-five years or more. Joseph Choate held the record, having served forty-seven years. Ruml noted presciently that if trustee seats were rotated more often, the museum would widen its circle of influence and awareness of change. "There is danger that the Board may become insensitive and inflexible," he wrote.

In 1921, the museum made almost $1 million on its endowment, which had largely been invested in government bonds during the war. George Baker's unrestricted gift the next year of $1 million in Victory bonds pushed that income even higher. New York, which had lifted its charter restriction on annual contributions to the museum in 1915, had upped its appropriation to $325,000 that year. Salaries ate up $500,000 a year, and almost as much was spent on art in 1921. Ruml said he found the museum in "an excellent financial position," though that wasn't obvious, since the trustees did all they

could to obscure its finances. Ruml judged their annual report "almost a perfunctory document" and their constant moaning about deficits disingenuous. He predicted increased public scrutiny.

The staff had grown considerably. The secretary's office had grown from four to ten employees in four years. There were now seven curatorial departments, several with five in staff. In all, the museum employed 273 people, up 47 since 1915. The city set the wages of the low-end employees. Department head and assistant curator salaries were $5,250 and $2,651, respectively. Raises were skimpy at best, causing "a certain amount of dissatisfaction."

The collections were uneven, Ruml found; some, like the plaster casts (which had once been highlights of the young museum and remained a favorite of de Forest's), were languishing in "dismal unfrequented galleries," and he felt that both the musical instrument and Cesnola collections were "yielding an inadequate return." The building was in excellent condition, but its storage area was outdated. Attendance had broken one million for the first time, and the museum's image was good, even if it fell short in "increasing public interest and . . . rendering greater public service."[40]

What did the museum need in order to do that? Ruml suggested more galleries for temporary exhibits, an art school within the museum, and more connection to modern industry. He met with de Forest, who felt a school might be a good idea. But Junior had different notions and seemed to prefer keeping them to himself. De Forest asked for a personal meeting, but Rockefeller wriggled out of it. Junior confided to an aide, Raymond Fosdick, that his was a "somewhat intricate problem," and as he wanted to "act intelligently," he saw no point in rushing matters.

Neither did de Forest, who was busy completing his greatest contribution to the museum he ran for eighteen years, the American Wing. Its genesis was the Hudson-Fulton exhibition, which first brought together the three museum officials who would become the Metropolitan's champions of American art, de Forest, Kent, and Richard Townley Haines Halsey. The last, a banking heir, stockbroker, and inveterate collector whose forebears had come to America in 1630, began donating to the museum in 1906, became a trustee, and in 1923 would retire from Wall Street to become its de facto first curator of American decorative arts.[41] Peter M. Kenny, a curator

at the museum, has compared the trio to the teams that make Hollywood movies: "De Forest, who paid for the project, would fit the role of the powerful studio mogul; Kent [who had been consumed by American decorative arts since the late nineteenth century, when he ran a small Connecticut museum], the savvy producer; and Halsey, the artistic director."[42]

De Forest's interest in American antiques had been sparked by his wife, who'd begun buying old objects from people's attics one summer out of boredom and had since made it a hobby. Her finds would eventually fill every nook, corner, and stable of their Long Island summer home. Emily de Forest's unpublished memoir of the time omits the date, but just after the Hudson-Fulton exhibition she began buying for what would become the American Wing. Her husband, "who had gradually become very sympathetic with my hobby," had suggested that the museum needed a home for its rapidly expanding holdings in early American furniture, silver, brass, glass, and china. "We have more means now," he'd said, "than when you began to find such things. How would you like it if we gave to the Museum an American Wing?"[43] Robinson was opposed, feeling Americana was "unworthy of exhibition in a museum," but eventually the de Forests, Halsey, and Kent overcame his objections.[44]

Henry Kent had already envisioned the look of the wing when he installed the Met's first period rooms in the Hudson-Fulton show. In 1910, Emily de Forest bought the first of the new wing's rooms, complete with cupboards, doors, and a fireplace, from a Colonial-era farmhouse in Woodbury, New York, shortly before it was demolished. Then Halsey, Kent, and another curator began combing the original thirteen colonies, looking for more, and found, among others, the ballroom from an Alexandria, Virginia, tavern a few miles from Mount Vernon, where George Washington had celebrated his last birthdays in 1798 and 1799, and a parlor from the Philadelphia home of one of the city's early mayors, which served as Washington's headquarters there.

In 1915, when the Branch Bank of the United States on Wall Street, built in 1822–1824 and also known as the Assay Office, was torn down, de Forest donned his hat as the president of the New York Art Commission and arranged for the neoclassical facade to be salvaged, and then, as mu-

seum president, ensured that the marble was stored on a museum-owned vacant lot. It would become the new wing's facade.

At first, Kent would write in his memoirs, the museum asked its architects at McKim, Mead & White to design the new wing, but they turned down the job, likely because the building had to be designed to both fit and suit the preexisting architectural elements of fifteen period rooms and two reproductions, and not vice versa. Priscilla de Forest Williams, a grandchild, later surmised that they felt "a building to house American crafts was beneath them."[45] So in 1919, the de Forests approached Grosvenor Atterbury, the architect of their summer house. In her recollections, Emily de Forest insisted that was the idea all along, "to build it according to our wishes and let us use our own architect."

What is indisputable is that when the $2 million gift was announced in November 1922, Atterbury's plans were already well developed for a three-story freestanding building that would eventually be connected to the rest of the museum via a passageway at the north end of the Morgan Wing. A Colonial-style garden was planted in what would become, about fifty years later, an interior courtyard.

The newspapers, noting that the de Forests had been married for fifty years, called the American Wing their golden-anniversary present to the city. But their gift to themselves was an around-the-world second honeymoon, highlighted by a visit to the Valley of the Kings, where George Edward Stanhope Molyneux Herbert, the 5th Earl of Carnarvon, and the archaeologists Albert Lythgoe and Howard Carter gave them a sneak preview of their latest and greatest find, the tomb of Tutankhamen. Though they only had three days to spend in Egypt, "we decided to give them entirely to 'The Tomb,' " wrote Emily, who lunched at the expedition house and then took a "rickety little vehicle" to "a kind of shallow pit, from which led downward a flight of stone steps, steps cut in the solid rock but oh, so shallow and so steep. We scrambled down and at the last step looked into a room not very large, low ceilinged, but brilliantly illuminated by electricity. What a sight met our eyes!"

In that room sat three gold couches, but it was the next room that drew them, beyond a walled-up doorway and two jet-black statues repre-

senting the tomb's guardians, "gold kilted, gold sandaled, armed with maces and staffs and the protective sacred cobra upon their foreheads," de Forest recalled.

"If I were you," she said to Lord Carnarvon, the financier of the expedition, "I could not sleep nights until I saw what is on the other side of that opening."

"I don't sleep nights," he replied.

The American Wing (which was briefly called the de Forest Wing) opened two years later, on November 10, 1924. In his speech that day, de Forest noted the prevalent disdain toward American art, quoting the trustee John Cadwalader: "What do you mean, de Forest, by American art? Do you mean English or French or what? There is nothing American worth notice." He also addressed the inevitable controversy that found the museum accused of vandalizing historical homes. "We have given them a refuge," he countered. "We have saved them from destruction." De Forest joked about the new vogue for antiques, which had driven up prices for the best pieces. "Perhaps we had a good deal to do with it, to our destruction," he said, then nodded toward the ancestor worship that also drove the wing's founders. "We shall be satisfied if we have helped to rescue the modest art of our forefathers from undeserved oblivion and have proved that their zeal for liberty did not obscure their sense of beauty." As staunch advocates of museum outreach, both he and Halsey thought the wing would communicate American values, uphold the country's traditions, and "fight the influx of foreign ideas utterly at variance with those held by the men who gave us the Republic."[46]

To commemorate the occasion, the de Forests gave another gift, a stained-glass window called *Autumn Landscape,* created by their neighbor, friend, and relative by marriage, Louis Comfort Tiffany. The difficulties inherent in working with living artists were made plain when Tiffany got into a fierce row with curators over its placement. The curators eventually won.[47]

So did commerce, because thanks to the American Wing, the museum finally attained another of its long-stated goals, influencing industrial production. Having set off a craze for early American antiques, the Met now dipped its beak into the business. In 1924, William Sloane Coffin was elected to the board. He was a vice president of W. & J. Sloane, his family's Fifth Avenue home-furnishings store, which evolved into a pacesetter in

interior decor for the wealthy and a manufacturer of reproductions of antique furniture. Two years after he joined the board, Coffin went into business with Halsey making reproductions of early American furniture, which Sloane would market for years to come as line-for-line copies of pieces from both the museum's and Halsey's own collections.[48]

The American Wing—the first museum building paid for with private funds—was significant, but it was hardly the only magnificent gift to come to the museum in the mid-1920s. Collis P. Huntington, the railroad king who'd built the Central Pacific line, had died in 1900 and left his art to the Met, but only on the passing of his wife, Arabella, and their son, Archer. But when she died in 1924, Archer waived his life interest and gave the museum dozens of pictures, including Vermeer's *Woman with a Lute* and works by Hals, Rembrandt, Joshua Reynolds, and Thomas Lawrence. But he held on to the greatest Huntington prize, Rembrandt's *Aristotle with a Bust of Homer,* which his mother had bought from the Rodolphe Kann collection via Duveen. Archer sold it back to Duveen a few years later, and Duveen sold it on to the advertising legend Alfred Erickson, who sold it back to Duveen during the 1929 Wall Street crash, then bought it back again. The Met would finally buy it from Erickson's widow's estate after she died.

The newspaper publisher Frank A. Munsey was about to write the museum *out* of his will when he died of peritonitis after an emergency appendectomy late in 1925. "He was an irascible character—impossible, arrogant, awful," says Peter Dooney, whose wife's father took over Munsey's newspapers. But Dooney says Munsey's plan was to give the bulk of his estate, including his newspapers, to his employees. "He had no children, no family," he explains. "His family was the newspapers. But unfortunately, before ink was put on paper, he died."

Ironically, Munsey was an expert at putting ink on paper. A bookish farm boy from Maine, he made enough money in an early job running a Western Union telegraph office to go to business school, then made a deal with a stockbroker friend to start a magazine and moved to New York "not to enter journalism," he wrote, "but to succeed in journalism."[49] Legend has it he came with $40, vague promises of backing, and a batch of manuscripts for which he'd paid $450. The backing quickly dried up, but Munsey talked a publisher into printing the first issue of the *Golden Argosy*. A couple of maga-

zines later, he cut their price from twenty-five to ten cents and began using high-speed presses and cheap pulp paper, putting out magazines targeted to the working class. Those innovations made him rich. When his publications failed, he changed their names or started new ones. In 1891, he bought his first newspaper, but shut it down when it didn't click with the public.

But he didn't give up. After a profitable hiatus as a real estate, hotel, grocery, and stock market investor, he began buying newspapers again in 1912 and threw their weight behind Theodore Roosevelt, who had just bolted the Republican Party to run for president as the candidate of the new Progressive (or Bull Moose) Party. Munsey helped finance his ultimately unsuccessful run. He then went on a spree of buying, closing, and merging newspapers to make the survivors more financially viable. He bought the New York and Paris editions of the *Herald,* for instance, merged them with his *Tribune,* and then sold them for $4 million to Ogden Mills Reid, whose wife would end up a Metropolitan trustee. Having owned seventeen different papers in his life, Munsey ended up with only two, the *Sun* and the *Evening Telegram.* Proving his prescience, they would later merge again and again, until dying in 1967 as the *World Journal Tribune*, a consolidation of seven separate newspapers.

"As a journalist, he was a force; to some he seemed titanic, irresponsible and sometimes ruinous; yet he regarded himself as a constructive, not a destructive, agent," the *World* editorialized on his death. Said the *Evening Post,* "Mr. Munsey's career has the dramatic appeal which we like to think of as peculiarly American."[50]

Munsey's estate was at first thought to be as large as $40 million, and five-sixths of that was left to the museum, then the largest gift to any museum in history. Though he'd been a member since 1916, this came as a surprise to the trustees. When he'd drawn up his will in June 1921, his lawyer asked the childless bachelor who should get the bulk of his estate. "Oh, well, give it to the Metropolitan Museum," he allegedly said.[51] One of his eulogists later claimed that Munsey wanted to have the same impact on art that Andrew Carnegie had on libraries and the Rockefellers on medical research.

Robert de Forest's first reaction on hearing the news was relief that he could meet the next year's deficit. But within a month, he'd come to under-

stand that Munsey's real estate was heavily mortgaged, and under the terms of his will his newspapers could not be sold immediately, and he got back to worrying about deficits again.

In 1926, William Dewart, a longtime friend and Munsey's executor, bought the newspapers and some real estate from the estate on behalf of their employees in a deal valued at $13 million, but de Forest announced that the money wouldn't meet the estate's immediate debts, so the museum would not see any immediate benefit.

Within a year, the museum started spending its anticipated haul anyway, buying a previously unknown Titian portrait of Lucrezia Borgia's husband, Alfonso d'Este, the Duke of Ferrara, for $125,000, and, at the museum's urging, Dewart sold the *Telegram* and announced that Munsey's 660-acre estate in Manhasset, Long Island, would be subdivided and sold. A few months later, a previous owner of the Titian, the Comtesse de Vogüé, said she was sure it was just a copy. "How she regarded it or what she was paid for it are matters with which we had nothing to do," sniffed Edward Robinson. Today, it remains in the museum collection, labeled as a copy.

The museum essentially entered the real estate business in the long and drawn-out process of realizing the funds Munsey had bequeathed, selling off his property bit by bit, and even dabbling in building development when it looked like that might be more profitable. In April 1929, the estate was finally settled, with the museum's share valued at $17,305,594. The detailed account of Munsey's holdings went on for many pages. But after the stock market crashed that fall, the valuations and the museum's plans for the rest of Munsey's land were both downsized. It took the museum twenty years to get rid of the land. That was only revealed in 1950 when the *Sun* was finally sold to the *World-Telegram* and the museum announced that in the end it realized only $10 million from the estate. It turned out that in his skepticism about the windfall, Robert de Forest had been prescient, too.

THOUGH GEORGE GREY BARNARD DROPPED HIS PRICE TO $700,000, the museum declined, early in 1925, to buy the Cloisters Museum, and a dealer named Jackson Higgs, who was helping the sculptor,

wrote Junior to ask if he wouldn't reconsider buying it. Higgs, who wanted Junior's favor more than a commission, offered to waive his fee and suggested that $1.12 million would seal the deal—and be a bargain. But he was also talking to the decorative arts curator, Joseph Breck, who wanted the Cloisters but couldn't pay for it and wouldn't ask Rockefeller, either.[52]

Junior had been generous enough lately. After mulling Ruml's study and the museum's response, he'd decided to give the museum $1 million in the form of sixteen thousand shares of Standard Oil stock with no restrictions except a suggestion that it be used for current needs, the most unglamorous but important kind of gift, until 80 percent of the trustees agreed on how to spend it. "If only every giver of large gifts were as wise as you," de Forest responded.[53] Junior's conditions were released to the press verbatim, likely as a lesson to less cooperative donors. Edward Robinson was so out of favor he only learned of the gift at the trustees' meeting where it was announced.

Four months later, in April 1925, Junior suddenly informed Robinson he'd buy Barnard's Cloisters for $500,000 and give the museum another $300,000 to maintain it, but only if it could be moved to the Billings estate, which he still hoped to give to the city. Breck and de Forest started negotiating with Barnard. His price came down to $750,000. Junior hired an appraiser to put a value on Barnard's land minus the sculptor's house, which he wanted to keep. Barnard threatened to sell his objects piecemeal. Then John Gellatly inserted himself into the negotiation.[54]

Gellatly was an art student turned businessman who'd married an heiress who'd died and left him everything—except for a trust fund to care for her horses and dogs. But everything turned out not to be enough. He spent it all on art. And though he had astute taste, he didn't have much sense. He'd decided to buy some land between Barnard's and the Billings estate so Barnard could expand his Cloisters and Gellatly could build a home. But Gellatly would only do all that if Junior would buy the Cloisters, agree never to move it, and allow the erection on *his* land not just of the Asian temples Barnard had been offered—apparently through Gellatly, who also collected Asian art—but of a museum of modern American art to hold Gellatly's collection.[55] "You will note that . . . I did not suggest any contribution on Junior's part," he wrote to de Forest, "but perhaps between the

lines I told him that my plan would add millions of value to his property. He may not see it but I know that you can."

De Forest and Junior were way ahead of him. The museum president did want Barnard's Cloisters Museum and assured Junior that the board might kick in another $200,000 to get it—and he signed on to Rockefeller's plan to move it. Junior wanted both Gellatly and Barnard out of the way, sure they were plotting to drive the price higher. It wasn't news that people liked to try to get one over on the Rockefellers. He agreed to pay $600,000 and, if absolutely necessary, the additional $50,000 it would take to keep Gellatly on the sidelines. And in the end, he was even more generous than that, turning over a second batch of stock worth just over $1 million to the Met to buy the Cloisters and create a Gothic Fund to buy more art for it in the future. Skirt cleaning was quite expensive.

In mid-May, de Forest made Barnard an offer in writing, without reference to Junior. The Met would pay $600,000 provided it could move the collection, and Barnard could buy back his land as long as he paid the back taxes on it. But de Forest also made it clear he wanted nothing to do with "your friend Gellatly." Sounding impatient, he gave the sculptor a few days to respond. But Barnard played coy, and Gellatly kept trying to insert himself, flattering de Forest about the American Wing. Finally, de Forest admitted to Junior, "I shall not be sure of anything until it is done, and I shall not think it done until title passes to the Museum; nor do I suppose, in dealing with a gentleman of such poetic instincts as Barnard, that even then it will be what a friend of mine calls 'done finished.' "

In fact, he was almost there. The deal was made on May 22 and closed in early June, and the purchase of the Cloisters was announced. A press release had been drafted and shown to Junior that said it was sold for a confidential sum donated anonymously and that it was assumed the Cloisters would remain in place. On Rockefeller's copy, someone added the words "at least for the present." Though that was what the press was finally told, one headline still read, "It Is Not to Be Changed." Junior also gave in and let the museum say how much it cost and who'd paid for it. Finally, he also offered to donate the Gothic pieces he'd bought from Barnard himself.[56] In the *Herald Tribune*, Barnard said the museum had gotten a bargain, citing Demotte's $2.5 million valuation.

Barnard's Cloisters reopened in May 1926 as a museum branch, but Junior was already planning to move it to "a more suitable site . . . the high rocky wooded point which I own north beyond the greenhouses" bought "some years before," just north of the Billings estate. He authorized Bosworth to talk to the museum about how to make that happen.

Rockefeller's relationship with the museum deepened quickly. Like the museum's officials, curators treated him with rare deference, and he was soon involved on many levels. When Robinson asked to borrow two portraits of his father for a special John Singer Sargent exhibit in 1925, Junior consented immediately. In 1927, he also loaned a portrait of Antoine Lavoisier by Jacques-Louis David to the paintings curator, Bryson Burroughs, who rearranged the museum's French gallery around it. Two years later, he loaned Breck one of his Polonaise carpets. De Forest offered Winlock's services when he heard that Junior was off to Luxor. Shortly after the stock market crash, at the request of the rector of the Episcopal Church of the Heavenly Rest, Junior even tried to get a guard a promotion. Robinson wrote to say the hapless fellow had already risen to the level of his competence, "though I admit this with regret especially because of the interest you have taken."

The attention paid off in spades. That April, de Forest and Breck looked at some of Barnard's latest offerings and wrote their new patron that they'd be interested, "if and when Barnard comes down from the skies and gets to earth" on his prices. Within days, Junior offered more donations in the event that happened. Two months later, Barnard offered de Forest a Romanesque facade, though at first he wouldn't set a price. "You are living in the poetic atmosphere of the skies," de Forest wrote him. "I envy you your freedom from mundane questions. I should like to try floating myself but . . . we must observe business methods." In a snippy reply, Barnard asked for $150,000, claiming the Philadelphia Museum of Art had offered $100,000. In a note to Junior saying that $100,000 seemed fair, de Forest noted his amazement that Barnard could get such material out of France, and worried that it might never happen again. In response to a request for "full information" about the provenance and authenticity of the facade, Barnard demanded a $20,000 deposit, $20,000 more by October, and $60,000 by December, leading de Forest to call him "the most delightfully

and charmingly unbusinesslike person I ever ran across" and refusing to proceed. On learning that Barnard needed money to pay a debt, de Forest did an about-face and loaned him $10,000 out of his own funds. Junior complimented him on his patience.

Patience was certainly one of Rockefeller's virtues. It would be almost four years before he finally managed to give Fort Tryon Park to the city and make his plan to move the Cloisters real. In the meantime, the maneuvering continued. Junior hired the landscape firm of Frederick Law Olmsted, now run by his sons, to study the possibilities and the architect John Russell Pope to think about a building; the museum flailed, unsure where the Cloisters would end up; Barnard alternately operated, fumed, and lusted to build his Peace Arch on "the great stone prow" of Junior's high point, sometimes called God's Thumb, often aloud and to the press, much to Rockefeller's distress. And the Demotte gallery popped up again, when the dealer's son Lucien offered Junior the tomb of Count Armengol VII for the Cloisters, asking price $175,000. Cleverly, the museum sent George Blumenthal—rich but no Rockefeller—to negotiate for it instead and managed to get it for $82,000. Just after Junior paid for it and gave it to the museum, young Demotte wrote him to say how disappointed he was that it had gone to Blumenthal.[57] Not to be outdone, in October 1928, shortly after he was elected to the executive committee and the purchasing committee and named head of the finance committee that spring, Blumenthal created a $1 million fund for the museum, with the principal to be invested by him, and all the income he earned added to it until he and his wife died. By 1940, its balance would reach $1.5 million.[58]

Though de Forest favored moving the Cloisters, as long as it remained where it was, the museum had to protect and maintain it, so early in 1928 Junior agreed to buy a strip of adjacent land for $300,000 to buffer it from possible encroachment by new buildings. At the same time, the museum evicted Barnard from a studio in one of the buildings on what was now its land. Though Junior still seemed attached to him, a fed-up de Forest just wanted him gone.[59] Typically, Barnard responded by going to the press, pressuring the museum to buy more stonework from him and create a sculpture school, housed in a new wing connecting his home to the existing Cloisters. He couldn't let go.

✻

WAS IT MODERN ART PUSHING JUNIOR TO CREATE HIS MEDIEVAL museum? By 1929, the avant-garde had inevitably moved from the edges to the center of action in the art world. Nothing showed that more clearly than the career of Louisine Havemeyer, who gave her collection to the museum that year, though she named it for her husband, Harry. After Harry's death, Louisine had continued buying art, though initially the lingering bad feelings over the way the museum had snubbed Harry kept her from giving gifts.

Over time, though, her hard feelings dissipated as the museum's taste and judgment seemed to improve. First came the famous Armory Show of modern art in 1913, a survey of the Impressionists, Symbolists, Postimpressionists, Fauves, and Cubists. Many were outraged by what they saw there— Matisse and Brancusi were hung in effigy by some art students. Though Robinson was less than enthused, Bryson Burroughs convinced the trustees to spend some of Catharine Lorillard Wolfe's bequest to buy Paul Cézanne's *View of the Domaine Saint-Joseph* for $18,000, and almost lost his job in the process.[60]

But in 1914, Samuel T. Peters, who was married to Louisine's sister, was named a trustee and introduced her to the new president, de Forest, whose public spirit and social engagement she admired; with her husband's nemesis Morgan gone, she began to deal with the museum again. In 1919, she loaned Burroughs more than a dozen Courbets for a show honoring the artist's hundredth birthday, and also made loans to William Ivins, the prints curator, whom she'd met when she loaned him works for a show at the Grolier Club.[61] And she likely attended the 1919 loan exhibition of modern French art, sent to America by a grateful French government for its help during the war; it opened late that year and featured artists like Renoir, Monet, Bonnard, and Signac, though many of the paintings were, as one critic put it, "middle-aged" and hardly modern.[62] Encouraged nonetheless by what she saw, Havemeyer added a codicil to her will to put into place the plan she'd first cooked up in 1908 to give a major gift—113 works of art—to the museum.[63]

Two years later, urged on by art critics and modern collectors like Havemeyer, Gertrude Vanderbilt Whitney, the lawyer John Quinn, and Lillie Bliss, the daughter of President McKinley's interior secretary, the Metropolitan mounted a loan exhibit of Impressionist and Postimpressionist paintings from private collections, including paintings by Cézanne, Gauguin, Daumier, Manet, Seurat, and Degas. Many of the more modern canvases, Havemeyer's among them, were loaned anonymously. The show was condemned as shocking, degenerate, corrupting, and dangerous, comments the outspoken Quinn dismissed as "Ku Klux art criticism."[64] After the show, the Met even accepted a Whitney gift of four paintings by living artists. Less than impressed, Quinn left his Seurat, *Le Cirque,* to the Louvre on his death.

In 1921, Louisine changed her will again, adding twenty-nine more paintings to her gift, including six old masters and eight Monets, and authorizing her son, Horace, to give the museum even more, so long as they would be on permanent view and credited to her late husband's collection. Three years later, at age sixty-nine, she began marking her collection with tags indicating which pictures she thought the museum might want. Though the gift was kept secret from the public, the museum was informed and named her a benefactor.

The rest of the world learned of her stunning generosity in January 1929, after she died. The bequest included four paintings attributed to Veronese, a Bronzino, a Fra Filippo Lippi, seven paintings thought to be by Rembrandt, two small Hals portraits, two Rubens, two El Grecos, five Goyas, a Millet, eight Monets, innumerable works by Manet and Degas, a Renoir, a Pissarro, two Corots, two Poussins, an Ingres, four Cézannes, and four Cassatts—a total of 1,972 objects appraised at $3.5 million. Though some of the trustees preferred the old masters to the modern French paintings, Robinson called it "one of the most magnificent gifts of works of art ever made to a museum." By that time, of course, Havemeyer's taste was no longer outré. De Forest used the gift as an opportunity to push the city for another wing, and to cover up the tensions that had for so long defined the museum's relationship with the Havemeyers.[65]

A six-gallery show of the entire Havemeyer collection opened the next year, attracting a quarter-million visitors in eight months, and then the bounty was dispersed throughout the collection, where it all remains today,

a testament to the couple's taste and Louisine's generosity. Harry Havemeyer had been avenged. And beginning with their son, Horace, who joined the board in 1930, descendants of the Havemeyer family have held prominent positions in the museum hierarchy ever since.

But its acceptance of the Havemeyer collection did not mean the museum was now open to any and all modern art. After George Hearn had died in 1913, the trustees decided that his fund should be spent not on works by living artists, as he'd intended, but on works by artists who'd been alive in 1906, when the gift was established. "Many artists were under the impression that the Hearn income was irregularly deflected to the purchase of coal, boilers, and paper towels," *The New Yorker* would report. In fact, though now and then a living artist entered the collection, the Hearn Fund mainly sat accruing interest until 1927, when an art magazine revealed the surplus and de Forest and Robinson agreed to buy another Sargent portrait, painted in 1900, for $90,000. After it was pointed out that Sargent had died in 1925, the museum changed the credit on the painting to the Wolfe Fund and bought six others with the Hearn income instead.[66]

Gertrude Vanderbilt Whitney rediscovered the Met's ingrained bias against living artists, especially American ones, the same year as Havemeyer left her gift. "The New York establishment liked other cultures and didn't respond to their own," says Tom Armstrong, who would direct the Whitney Museum years later. Gertrude was different. A great-granddaughter of Commodore Vanderbilt, and the wife of Harry Payne Whitney, the grandson of a Standard Oil founder, Whitney had a loveless marriage and filled the void in her life with art, opening a series of studios, artists' clubs, and galleries in Greenwich Village with a partner, Juliana Force, just a few doors away from the Johnston and de Forest homes, all dedicated to supporting living American artists both psychically and financially.

Her penultimate creation, the Whitney Studio Club, founded in 1918, became a showplace for the artists she championed, and the pictures she bought from every show formed an unprecedented collection. Finally, in 1929, when they "threatened to overwhelm the gallery," as Force's biographer Avis Berman has written, "the necessity of a museum became apparent." First, though, Whitney decided to offer it all to the Met, along with $5 million to build a wing to house it, sending Force to make the offer. The art

critic Forbes Watson, a friend of Whitney's, was skeptical. He considered Edward Robinson a classical, orthodox autocrat, "not a modern director but a guardian of sacred premises," with a "pontifical manner" and "schoolmaster methods." Before Force "could get that far" in her pitch, says Flora Biddle, Whitney's granddaughter, "Edward Robinson said, 'No! Not that!' "

"What will we do with them, my dear lady?" the condescending director asked Force of Whitney's paintings. "We have a cellar full of those things already."[67]

"He was really angry," Biddle continues. So was Force, who returned to Whitney's studio on MacDougal Alley alternating between rage and joy, for now Whitney would have to open her own museum. "And that's how the Whitney Museum came into being," says Biddle.[68] It was announced in January 1930 and opened in November 1931.

Something must have been in the air, for almost simultaneously Lillie Bliss, Mary Quinn Sullivan, an artist and teacher, and Abby Aldrich Rockefeller were conceiving of the Museum of Modern Art as a home for European modernist art and an inspiration for American artists. As a girl, Abby had collected drawings and watercolors by Edgar Degas, but early in her marriage she'd subsumed her more adventurous tastes and joined with Junior to collect conservative old masters, Italian primitive paintings, a Goya, a Chardin, Sir Thomas Lawrence's full-length portrait of Lady Dysart, and some Asian art. But eventually, drawn back to the avant-garde, she struck out on her own again. Junior objected; he detested modern art. So she used her Aldrich fortune to indulge her taste for German Expressionists, Postimpressionists, American folk art, and modern woodcuts. In order to avoid ever having to see them, Junior gave her an entire floor of their Fifty-fourth Street town house to use as a private gallery. But he was a loyal husband. A week after the stock market crash in October 1929, he escorted Abby to the opening of her museum in a six-room office suite on Fifth Avenue. Lacking funds, it would move several times over the next decade, but eventually the museum that would be known as the Modern moved to a permanent home on land Junior gave it on Fifty-third Street, a block from their longtime home.

That didn't mean Junior was going modern himself. Earlier that year he bought a Piero della Francesca *Crucifixion* from Duveen, who'd bought it

at auction for $375,000, earning himself a lawsuit from the seller, who accused Duveen of cheating him by suppressing bids.[69] Then Junior bought an extraordinary set of colossal bas-relief sculptures from Nimrud in ancient Assyria, a series with a provenance so rich and complex it is the subject of an entire book, *From Nineveh to New York*. Uncovered by an English adventurer digging just south of today's Mosul in 1845, they ended up as interior decor in a private manor house. But in about 1919, they were sold to pay inheritance taxes, and the buyer, Dikran Kelekian, then tried and failed to sell them to Robinson. In 1927, with the sculptures on loan to a Philadelphia museum that couldn't afford them, Kelekian went hunting for another museum or a millionaire willing to buy and donate them.

Late that year, after negotiating the price down by $50,000, Rockefeller agreed to buy sixteen bas-reliefs and two monumental winged bull statues for $300,000. For the next two years, he mulled over what to do with them, considering leaving them in Philadelphia, moving them to a planned Oriental museum in Chicago, or giving them to the Met. The latter was already bursting at the seams. Fifteen years earlier, its "congestion of art objects" had led the *Times* to say that the treasures in its cellar "almost rival in their profusion of precious things the galleries to which the public is admitted."[70] Now, with the addition of the Havemeyer bequest, and despite the auctioning off in 1929 of lesser, surplus, and duplicate objects, the situation had grown critical.

With its principals all dead, the museum no longer felt tied to McKim, Mead & White and in the fall of 1929 chose John Russell Pope, already working for Junior on the Cloisters, to design a new wing to fill in the northwest corner of the museum connecting the Morgan Wing to McKim's northern wing on Fifth Avenue, and applied for a $3 million appropriation from the city. The stock market crash intervened.

But before it was clear that the Depression would stop the museum from further expansion (until 1954, as it would turn out), another of the Morgan-era trustees, Valentine Everit Macy, a philanthropist whose family had been involved in the purchase of Nantucket island from its Native American inhabitants and later the founding of Standard Oil, approached Junior and convinced him to donate the Assyrian pieces as a centerpiece of Pope's new wing. In January 1930, Junior gave them to the Met and began

a quiet effort to bring together some of the thirty-eight additional pieces from the same temple that were scattered around the United States.[71] By 1943, he'd purchase two additional pieces from Union College (for $22,536) and one from the Auburn Theological Seminary (for $11,200). In the meantime, the Near Eastern Art Department had been established and a curator hired.

<center>❖</center>

That deal was simple compared with the Cloisters. In March 1930, John Gellatly turned up again, demanding the $50,000 he now claimed to have loaned to Barnard. In letter after letter, each artfully swatted off by a Rockefeller aide, it emerged that Gellatly considered himself the sole agent of the sale of the Cloisters but, more important, that some of the art he'd given to the nascent National Gallery of Art (after being spurned by de Forest) had not yet been paid for, and he expected Junior to help him meet his obligations. This time, even Barnard was outraged. "I refuse to have anything to do with it," he wrote. After reiterating that he wouldn't pay Gellatly, Junior ordered any further letters from him filed without response.

Gellatly's last letter was sent in October 1930, less than a month after he married for a second time, at age seventy-eight, to a "spectacularly beautiful" actress-producer forty-two years his junior, who was apparently unaware that he'd run through his fortune until the night after they wed, when he offered to give her some shabby furniture he had in storage in lieu of a wedding present. They immediately separated. In September 1931, Gellatly was sued for $660 in back rent on her apartment. He died two months later, leaving her $79, an umbrella, and an empty suitcase.[72] His widow quickly sued to recover his art—an effort that would finally fail on appeal in 1948. Six years after Gellatly died, she, too, started writing to Junior, still trying to collect that $50,000, hoping that Junior would pay the "debt" in order to forestall a lawsuit she threatened to bring against Barnard and the Met that "will more or less involve you and will cause a lot of publicity," she wrote. She added that in exchange for the money, she'd give Junior all the documentation in her possession "so that there will never be any chance of this

unfortunate matter being made public." Almost as an aside she added that she'd been forced to ask because she had "an invalid daughter." When Junior's aides decided not to reply, she wrote again . . . and again. Finally, an aide replied, "It seems to us further discussion would accomplish nothing."[73] From his files, it appears that Junior never even heard about this latest gentle attempt at blackmail.

When Gellatly first began peppering him with letters, Junior had other things on his mind; the latest mayor was finally talking to him seriously about what would become Fort Tryon Park, while he simultaneously finalized a deal with de Forest to pay for new quarters for the Cloisters.[74] In mid-February 1930, Rockefeller formally offered the museum six acres in the future park, commanding the highest point on Manhattan Island, as well as the cost of dismantling Barnard's museum, building a new one, and moving the collection there. Ever hopeful, de Forest offered to name the new building for him, adding, "Moreover and parenthetically, you declined some years ago your election as a trustee of the Museum. Are you not willing to reconsider this decision and become at some future time not only giver but receiver?" Junior politely declined again. De Forest, wiser now about the ways of his newest benefactor, responded, "In your place, I should feel the same way."

Now a new phase began in the relationship between donor and museum. For Junior, this was an opportunity to indulge, albeit in a pious and monastic creation that fit well with his self-image. For the rest of his life, he would micromanage the Cloisters, and the museum would, quite correctly, indulge him in this, consulting him on its shopping sprees with his money and heeding his advice on negotiations while keeping his role secret to avoid paying Rockefeller-sized markups, and keeping new objects and architectural elements he paid for under wraps until he gave his okay to reveal them. For though he refused to have it named for him, the Cloisters was, without question, Rockefeller's museum—and his gift earned him a singular place among the museum's donors.

Junior's generous gestures were revealed to a nervous nation in June 1930. Not only would he give the city a park and the Met a new museum, but he also intended to pay for landscaping all sixty acres of his gift, for a total cost estimated at $13 million. He simultaneously agreed to rehabilitate

another park surrounding Grant's Tomb, and the city, in return, agreed to close several streets running through what would soon become the Rockefeller Institute. Though objections would still be raised and the approval process would take another nine months, Junior's argument that he was creating jobs at a time of unemployment eventually won the day.

Predictably, the only person unhappy with it was George Grey Barnard, a further indication, if any was needed, of why the Metropolitan preferred not to deal with living artists. Once again enlisting others as proxies, he had the Columbia University economist Edwin Seligman write to Junior to say Barnard was (quite correctly) fearful of eviction from his studio within the boundaries of the new park. Barnard was in debt and in despair, and his pleas for Junior's continued patronage became increasingly shrill. Faced with the expiration of his studio lease and an order to vacate in November, Barnard went to the newspapers again and again, announcing he would refuse to leave and demanding "three or four more years in the present studio" to complete his Peace Arch. It had already taken him so long, he said, because he'd been experimenting to find "perfect light."[75] A month later, he changed his mind and told the papers he would get out, but would leave his statues behind. Let them be Junior's problem!

Rockefeller was in Europe, on a two-month drive through France and Spain. On his return for Thanksgiving in Kykuit with his father, he pledged to give the sculptor every consideration. Asked for comment on the trembling economy, he added, "I have no message except that I am very hopeful, as always. There are many problems, grave and difficult ones . . . but they will be solved ultimately. That I believe." His immediate problem with Barnard would be solved within a year; after the sculptor was ordered to vacate and went to the press yet again (the *Chicago Tribune* called the eviction "a figurative boot in the seat of art's baggy pants"[76]), he moved back into his former studio on the land the museum had bought near the old Cloisters, expanded at Junior's expense. Lucky Junior would soon buy it and become Barnard's landlord again.

But some other problems were just beginning, both for the world and for the Metropolitan Museum. As Junior set to work planning the new Cloisters, and the curators set out to find more material for it, the hard times in the country worsened and took a toll—in lives. The first in the

museum's upper echelon to go was George Blumenthal's wife, Florence, in September 1930. After moving into their mansion in 1916, Blumenthal had returned to Lazard Frères after a ten-year absence, but in 1925, at age sixty-seven, he retired to devote more time to the museum and his other favorite cause, Mount Sinai Hospital.

Their home became one of New York's showplaces. There was a dining room that seated twenty-five. "The service was partly gold, partly silver," recalled Joseph Turner, Mount Sinai's director. "The menus were always written on china in front of every plate. His office was on the third floor. I dreaded walking over these wonderful carpets that were on the floor, and I sat on a 15th or 16th century Spanish chair that creaked every time I moved."[77] But after his wife died, George seemed inclined to withdraw from the art world, selling his house in Paris and later the paintings, furniture, and objets d'art he kept there at auction for $350,000, and returning to New York, where the trustees of Mount Sinai gave a dinner in his honor that sounded more like a farewell than a welcome home.

Edward Robinson, seventy-two, had died as well, in April 1931 after a long illness, during which Breck had served as acting director. Quiet, scholarly, and steady, he'd been a perfect antidote to the chaos wrought by Cesnola, and the presence of the entire hierarchy of the museum in the front pews of St. Bartholomew's Church, and among the ranks of his pallbearers (who included Blumenthal, Breck, Osborn, Coffin, and Junior), was a testament to the esteem in which he was held, even if it wasn't accompanied by much affection.

Robinson's stealth antagonist, de Forest, had been ailing, too. Though his eightieth birthday was celebrated by 250 friends at a party where he was declared the Abou Ben Adhem of New York (after a poem about a Sufi mystic whose "name led all the rest"), his eighty-first in 1929 found him confined to bed, never to recover. A few months later he resigned as chairman of the American Federation of Arts and increasingly worked from home, rarely going to his law office. Though he attended a museum board meeting in March 1931 and was reported to have hosted a family party on the night of his eighty-third birthday, he died of heart failure eleven days later on May 7, 1931.

As befit his status as a civic leader, the news made the front page of the

New York Times, and the museum was closed the day of his funeral. He left it an endowment of $100,000 to pay for the free concerts he'd loved, and the rest of his millions went to his family. Unfortunately for them, the estate's value would shortly plunge along with the American economy, its value dropping from more than $6.5 million to $4 million in a year. The contents of his house were sold at auction in 1935 for $60,000, but Emily de Forest gave her children four paintings each and enough money that they were able to buy back some of their favorite pieces. In 1940, the museum would finally receive a bit less than $16,000, its proportionate share of the remaining estate. Emily Johnston de Forest lived on until 1942, when she died at Wawapek Farm at age ninety-one.*

In a matter of days, speculation began about who would now run the museum. Jack Morgan's name was the first mentioned to replace de Forest, and several museum directors were said to be in the running for Robinson's job. But that December, the presidency went to William Sloane Coffin, fifty-two, who'd been serving as acting president, indicating, as Coffin himself put it, that there would be "no break with the established policy of the past." A month later, the Egyptologist Herbert Winlock, forty-seven, was named the Met's fourth director.

Winlock, who had been in effective charge of the museum's Egyptian excavations since 1919 and who had kept a steady flow of objects coming to New York, despite increasing clampdowns by the Egyptian government, was considered a breath of fresh air on arrival. Art dealers said that once he replaced the starchy Robinson, laughing and joking were again allowed within the museum. Before that, they said, curators had "had to cross Fifth Avenue before they dared to smile."[78] Breck, who was passed over because like

* The Johnston—de Forest connection to the museum would, of course, live on. For years, the museum's legal work was done by Lord Day & Lord, co-founded in 1848 by one of de Forest's uncles and one of his cousins. Howard Mansfield, a trustee since 1909 and the museum's longtime treasurer, was a Lord Day partner, and another partner and de Forest descendant, Sherman Baldwin, would serve both as the museum's general counsel and later as a trustee in the mid-1960s. Baldwin's daughter-in-law worked as the assistant to the museum's first development (or fund-raising) director in those same years, and in 1995 many Johnstons and de Forests attended a founders' ball celebrating the museum's 125th birthday.

Robinson he was more admired than liked, was named director of the Cloisters. At the same time, the board was decimated; seven trustees died within two years. In Winifred Howe's words, it was "the end of an epoch," the passing of "the second generation of Museum administrators."[79] Between 1930 and 1932, a dozen new trustees, all younger men, came onto the board.

Junior's son Nelson Aldrich Rockefeller got involved with the museum when he started working with his father on the new Cloisters. Early in 1931, Junior decided to switch architects and hired the Boston-based Charles Collens, who'd just completed another of Junior's great philanthropic commissions, the Gothic interdenominational cathedral Riverside Church. "You are designing and building this building for me," Junior wrote in a later letter confirming the commission. "I am giving it to the Metropolitan Museum." Though Collens was instructed to work directly with the museum, he was to inform Junior of any problems through Nelson. Meetings began in November, with Collens ordered to proceed as soon as possible "because of the general condition of unemployment," Junior wrote him, though "on the other hand, because of the uncertainty of the financial outlook, it may seem wise to complete the plans . . . and then let the matter rest for a few months." Collens replied with his sincere hope "that the present unnatural situation may clear up."[80] It would be a long time before that happened. The stock market had lost a third of its value in 1929. By the time Junior wrote that letter, the Bank of the United States had closed, setting off a wave of eight hundred bank failures.

In September 1931, as the stock market swooned for the eighth time in two years, Breck added another member to the Cloisters team, James Rorimer, a Paris- and Harvard-trained curator, who would spend the rest of his life at the museum, the last eleven years as its director. Rorimer's father, Louis Rohrheimer, a prominent interior decorator, architect, and furniture designer in Cleveland, had changed his name after World War I and, like many assimilated Jews, raised his son with "no religion," says his daughter Anne.

At Harvard, Rorimer took the famous museum course run by Paul Sachs, a descendant of founders of the Goldman Sachs investment bank who trained several generations of museum professionals; he was already a nascent connoisseur, and something of a careerist. He won a job at the Met

as an assistant in the Decorative Arts Department before he graduated, and was doing pioneering research on the use of ultraviolet light in the examination and authentication of art when he was sent to Austria in 1930 to examine and negotiate for a rare fifteenth-century stained-glass window for the Cloisters. Rorimer decided it was the ninth-most-important work of art in Austria, negotiated the price down from $75,000 to $35,000, and launched what would grow into the most important relationship of his life; he and Junior would eventually come to exemplify the perfect relationship between curator and donor.

The flirtation continued at their next meeting at Junior's home, when Rockefeller praised an article Rorimer had written and the young curator caught his first thrilling sight of the Unicorn tapestries. As he was leaving, Junior pulled him aside and told the baby-faced Rorimer that he should go to Fort Tryon Park himself and put up stakes and string to show where the building would go. Rorimer impressed him by mocking up walls and ramparts with wood and burlap instead.[81]

In April 1932, the stock market sank again, finally settling 84 percent below its value before the 1929 crash. Even Rockefellers and Morgans were stunned, but for them, at least, life went on as before. Jack Morgan asked Junior if Nelson would join the museum's board. "He is just the kind of young man that we older members want to see in that position, and your kindness to the Museum, which has been so great, gives us, I think, the right to ask you to go still further with it, and let us have the privilege of a member of your family on the board," he wrote on April 8, adding that he "was humiliated to find," after a dinner at Junior's, "that I had been inadvertently pilfering" a linen with Abby's initials on it. "I hope that you will not think that the habit of kleptomania is coming on me in these hard times . . . It was a delightful dinner and . . . I think you deserve a better reward than being stolen from."

Three days later, Nelson met with Coffin and agreed to join the board, but only on condition it was understood he was his own man, not his father's representative, that their tastes in art did not coincide, and that if push came to shove, his first loyalty would go to his mother's museum—not the Metropolitan. The same day, Junior wrote Jack Morgan to say that his wife was pleased he'd liked her napkins so much he'd taken one, and that

he was absolved.[82] A few days after that, the board met, elected Nelson a trustee and a fellow for life, named him head of the trustees' committee on Near Eastern art, and approved Collens's plans for the Cloisters. Two weeks later, Junior committed to spending "at least a couple of million dollars" on it, but warned that given the economy, "it may be that I shall think it best to defer" finishing it immediately.[83] Nonetheless, everyone wanted to get in on the act. Junior was really the only game in town, the only man standing who could make Pierpont Morgan look like a piker. In April 1933, George Blumenthal even offered Breck his Paris music room for the Cloisters if the museum would pay for its removal and transport. This apparently surprised Junior, who wrote Breck to say he would pay for it, even though he added cryptically that "the situation is somewhat delicate as between Mr. Blumenthal and myself." What delicate situation goes unremarked. But he considered the bill for $2,500 "a matter of no consequence." The room was worth $25,000.[84]

Charles Collens's plans for the new Cloisters were approved on May 23, 1933, and on June 21 Coffin, Winlock, Breck, and Nelson Rockefeller agreed to proceed to working drawings. Then Breck left for Europe on his annual summer scouting expedition. In early August, he was out walking in a resort town in the Swiss Alps when he had a heart attack and died. In a letter to Junior the next day, Coffin called Breck's death "a very severe blow to the museum," but progress on the Cloisters hardly slowed at all. Within days, Junior approved the choice of James Rorimer as Breck's replacement as director of the Cloisters, and the rest of Breck's fief was split into two new departments, Renaissance and Modern Art, and the American Wing.[85]

A quick study who could be inarticulate in a crowd but was masterful one-on-one, Rorimer immediately read up on Rockefeller and his Baptist psyche. They were already alike in their circumspection, thrift, and modesty. Rorimer was also a wise judge of character; he came to the conclusion he should never ask Junior for anything, particularly money, and always be exacting and account for every penny when Junior entrusted him with some. Some of his colleagues decided he saw Rockefeller's patronage as a stepping-stone to a bigger job.

William Sloane Coffin's term as the Met's president was short: he died a week before his second anniversary in office. Only fifty-four, he'd

gone to work as usual on a cold December day and had lunch at the long oval table in the director's dining room in the museum basement, but on exiting with Winlock, Coffin fell on the icy steps and had to be helped to his car; it drove him home, where he lay down without saying hello to his wife and had a fatal heart attack.

Battered by the Depression and death, Coffin never got the chance to fulfill his dream of extending the reach of the museum, expressed just a few months earlier in a speech on Park Avenue. Among his suggestions were some that would eventually be realized—teaching teachers and branch museums—but not by Coffin. "The museum started out as a rich man's club," he said, "where art patrons could keep their collections, but with the passage of years, the conception of the museum has changed, and now it is doing its best to serve the city." When Junior wrote his widow a condolence note, it reflected that, hailing the promise of "the new era in the history of the museum which his administration had ushered in."

Once again, the trustees and curators filled a church, Brick Presbyterian this time. And once again, a museum president's estate was dissected in the papers. Only this time, what was most apparent was the damage being done by the Depression. Though Coffin left his widow and children (including William Sloane Coffin Jr., who would gain fame in the 1960s as the antiwar chaplain at Yale) about $400,000, by the time his fortune was distributed, his real estate and investments had shrunk in value to only $240,000.

Given the grim economic climate, it is hardly surprising that at the next trustees' meeting in January, they unexpectedly chose to make the generous financier-collector George Blumenthal the museum's seventh president, his religion notwithstanding. Robert Moses, a city official who would shortly join the board as an ex officio member, would later write that Blumenthal's ascension to the museum's top job was as likely as his swimming up Niagara Falls.[86] But it was a wise choice—and not only because he'd hinted that he would give his art to the Met. According to Calvin Tomkins, though he had been "autocratic and secretive" and "defensive rather than brilliant" in investing the museum's endowment, keeping all of it in preferred stock, Blumenthal had "kept the Metropolitan afloat" when all around it institutions were sinking in the Depression.[87] "He ran the Met

with an iron fist," says the author William Cohan of Blumenthal's ultra-conservative investments. "He was afraid President [Franklin Delano] Roosevelt would drive America into bankruptcy."

His new post also saw him functioning as a quasi-director; unfortunately, Herbert Winlock's constitution had proved better suited to digs in Egypt than a New York office job, and like Sir Caspar Purdon Clarke before him, he withered in the job. Blumenthal, on the other hand, was revived by the new challenge.

What was the delicate situation between him and Rockefeller? It could have been Rockefeller's association with John B. Trevor, an anti-immigration lawyer, lobbyist, and founder of the American Coalition of Patriotic Societies. Though he was a descendant of a signer of the Declaration of Independence, Trevor's well-known pro-Nazi, anti-Jewish sentiments could easily have offended the German-Jewish Blumenthal.[88] In 1931, when the Met was looking for new trustees, Junior had sought suggestions from Trevor. But as likely, the "situation" with Blumenthal was just reflective of human nature. Although Junior wasn't a trustee, the museum now danced to his tune. Blumenthal may have been the museum's dedicated president. He may have had exquisite taste. He was certainly very, very rich, even in the midst of a Depression. But he wasn't John D. Rockefeller's only son.

EVEN ROCKEFELLER JR. FELT THE DEPRESSION. IN DECEMBER 1933, a dealer of medieval art, Joseph Brummer, wrote to say that Breck had "reserved" a doorway and window at $11,000. Junior replied that he wasn't buying just now, unless of course he could get "depression prices." Brummer took $7,500.[89] With an empty nest, Junior and Abby also began thinking about downsizing, and in 1936 they sublet a thirty-seven-room duplex apartment with a servant's mezzanine between floors at 740 Park Avenue and began preparing to get rid of their big house. The Met's Altman curator, Ted Hobby, helped him inventory his art. The resulting list ran fourteen pages, with sections "arranged according to their desirability as Museum acquisitions" and grouped by department. Curatorial desire must have been aroused even further when the gifts and loans started coming in almost im-

mediately: Rakka pottery, Roman amphorae, Corinthian jugs, Sultanabad vases, Chinese garden seats.[90]

But Rockefeller's beneficence notwithstanding, the Depression was depressing the museum's activities. In 1933, Henry Kent wrote to Ivins that there was "a very general intention not to buy anything." Four years later, things were worse. After a budget meeting with the trustees, Ivins wrote to Kent, "It was decided from now on to cut down drastically on all requisitions for money and labor . . . I'm hoarding even the smallest change in the museum's administrative pocket."[91]

John Russell Pope's new northern wing was put on hold, and Blumenthal and Winlock felt they'd be lucky if they could get enough money simply to repair leaking roofs and modernize their oldest structures. They also hoped to move their newly expanded armor collection into the original Vaux building, to open up space for the discoveries of the Egyptian expeditions. Finally, with its champion de Forest gone, they hoped to get rid of the plaster cast collection. The new armor hall, designed by the office of the ailing Pope, would open in 1939.[92] The Board of Estimate wavered, but approved a $10,000 emergency roof-repair fund in 1934; simultaneously, and quite out of the blue, a Parks Department official offered to complete Hunt's main entrance.

Back in 1895, Hunt had planned to decorate that facade with thirty-one sculptures, including four monumental groups above each of the pairs of columns framing the entrance, but the money ran out and the plan languished. In June 1934, Aymar Embury II, the consulting architect of New York's parks, wrote Winlock suggesting that a team of sculptors already working for the Depression-era Works Progress Administration complete the entrance sculptures to the original designs. Deeming the project "undesirable," the trustees declined, and the unfinished limestone remains there today, a visible if unintended symbol of the perpetually unfinished museum.[93]

In the summer of 1934, with no end to the economic downturn in sight, Junior briefly lost faith and drafted a letter to Winlock asking if the Cloisters construction should be downsized or delayed, but he never sent it.[94] Blumenthal was thinking along the same lines and that fall suggested saving money by buying more Gothic doors, rooms, and windows than orig-

inally planned as they would cost less than new construction. Junior deemed the suggestion "wise and proper," and all concerned agreed to move forward.[95]

It's said that James Rorimer sealed the deal when he had WPA artists build a mock-up of the Cloisters and set it up in the museum basement for a 9:00 a.m. meeting. "Is this the way The Cloisters are going to look?" Junior asked, peering through a Romanesque portal toward a mock-up of a Moutiers-Saint-Jean doorway.

"No, Mr. Rockefeller," Rorimer replied. "This is the way they could look if you wished them to."[96] He did.

In January, Junior celebrated his decision by giving the museum his Unicorn and Months tapestry sets and fourteen pieces of Beauvais furniture, worth $2.65 million. A few weeks later, he transferred thirty-eight thousand shares of Standard Oil of California (worth $1.16 million) and seventy thousand shares of Socony-Vacuum Oil (worth $905,000) to the museum to pay for the building fund.[97] Then, in mid-March, he gave Blumenthal permission to start construction and announce the gift.

When Blumenthal sent him a draft of the museum's 1934 annual report to review a few days later, it said the museum's general funds were "only just sufficient" to balance its budget. Junior's lawyer wrote back that he was worried there would not be money enough to maintain and operate the Cloisters. Blumenthal's rapid response showed that the museum could still be opaque about its financial plight. He had only been trying to counter the impression "that the Munsey bequest had made the Museum a very rich institution."[98]

The Cloisters, at least, was a rich institution—and now it went shopping for a Gothic chapel to be incorporated into the new museum. A dealer in France had just bought an abandoned one attached to a farm building in the ruined Château La Serre in Chauvirey-le-Châtel; it was named the Chapel of St. Hubert after the patron saint of hunters. But from France, William Welles Bosworth warned that even though the fifteenth-century structure was mentioned in no guidebooks and rarely visited even by the most intrepid of tourists, and despite the fact that Junior had paid a bundle to help restore Versailles and Rheims Cathedral, France's Ministry of Fine Arts was afraid of bad publicity if it allowed the chapel out of the country.

Laws had been passed "with the especial view of preventing just what we wish to do," Bosworth told Junior, adding that French farmers were known to turn up with pitchforks to protest the removal of even minor monuments.[99] One of Bosworth's colleagues suggested that it first be sold to a Frenchman and then disappear. After months passed without any positive word, Winlock wrote Junior to say, "Chapel buying is a slower business than I thought it would be."

Finally, in July 1936, the French government presented a bill to authorize a gift of the chapel to Rockefeller. But immediately a firestorm of criticism broke out on both sides of the Atlantic, petitions were signed, and letters of protest poured into Junior's office, each one filed but not acknowledged. Junior did respond to a letter of support from George Grey Barnard and called some of the protests "fanatical."

Fanatical, perhaps, but also effective. The approval process stalled, and by November the *Herald Tribune* was reporting that "grimly serious . . . indignant" peasants were guarding the chapel, threatening "to beat off intruders with clubs" after seeing a "mysterious" man taking measurements. "The chapel is our only claim to fame," one of them said. "Let them give him Notre Dame."

On further investigation, Bosworth learned that a disaffected architect whose desire for a post as an inspector of historic monuments was behind the protests and that—shades of Barnard!—the dealer who'd bought the chapel had paid next to nothing for it to a farmer who was behind on his mortgage. Junior, in consultation with Rorimer, decided to set a deadline of the following March. Blumenthal, who had friends in high places in France, tried to intervene, but by February, Junior had had enough and instructed Bosworth to abandon the effort and say nothing more about it, leaving any comment to Blumenthal, who "has for some time past been quite anxious to handle this whole matter himself." (The delicate situation being, apparently, as yet unresolved.)

When Bosworth kept trying anyway, Junior finally told him to stop; Rorimer had come up with an alternate plan to create a chapel using six important stained-glass windows he'd been offered by Jacques Seligmann for $30,000. With Junior operating behind the scenes, Rorimer won them for $27,500.[100] Though the attempt to buy a complete chapel was dropped,

Rorimer would never forget it and would finally succeed in 1957, when he acquired the apse from the Church of San Martín at Fuentidueña in Segovia, Spain, that had first come to the museum's attention in 1935, but then slipped from its grasp during the abortive negotiations with the French. It turned out to be a national monument, which slowed Rorimer down, as did the Spanish civil war and World War II.

As construction proceeded and the planned opening in the spring of 1938 neared, Rorimer's immersion in the Cloisters was total; he traveled through Europe scouting finds while keeping a close eye on spending at home and staying in close touch with his powerful patron, at one point writing to praise Junior for his "great vision and planning" in fulfilling "the spirit of your gift."[101] Rorimer even hired his father back home in Cleveland to make furniture for a boardroom they were building in the tower that would crown the Cloisters. Junior was equally pleased with Rorimer, and generous in telling him so. After he found some additional fragments of the Unicorn tapestries, Rorimer arranged a purchase and trade for objects "of no particular value." "I hardly dared believe" you could pull this off, Junior exulted, calling it "most gratifying and extraordinary."[102]

The excitement was shared with Winlock, who could barely contain himself throughout 1937; as Junior's move to 740 Park neared, his house on Fifty-fourth Street was slowly dismantled, and he peppered the museum with gifts and loans at an ever-increasing rate, offering rugs, Gobelin tapestries, Chinese sculptures, tables, chairs, books, and a fifteenth-century fireplace.[103] By November, as the final touches were applied to the building, Junior was toting up numbers, learning to his pleasure that there was still money left in his Gothic Fund, so he could buy a statue of Jesus and Mary from Joseph Brummer.[104]

Finally, in March 1938, the building was finished, the collection was installed, and opening day was nearing. The board met and sent its thanks. Nine new members had joined as the Cloisters was rising and brought down the average age of the trustees considerably (sixty was young at the Met).[105] They weren't all rich: Arnold Whitridge taught history at Yale. But most were. Thomas Lamont was a partner in J. P. Morgan; Harry Payne Bingham was a tobacco and banking heir; Samuel Kress was the founder of

S. H. Kress, the five-and-ten-cent store chain; Arthur W. Page was the head of public relations for American Telephone and Telegraph; Thomas J. Watson was the president of IBM; Vanderbilt Webb was a Vanderbilt heir and Rockefeller lawyer.

Most significant of all was the handsome, tweedy Roland Livingston Redmond, an imposing man at five feet eleven inches, with blue eyes and an aquiline nose. If Redmond was inclined toward ancestor worship, it was understandable. On one side, he was a grandson of the founder of a forerunner of Wells Fargo and American Express. On the other, he descended from the Livingstons, who arrived in America in 1673, married into one of the richest Dutch Colonial families, and by 1715 owned Livingston Manor, more than 250 square miles along the Hudson River. Livingstons signed the Declaration of Independence, backed Robert Fulton's development of the steamboat, and negotiated the Louisiana Purchase. Johnston Livingston, Roland's grandfather, was one of the bankers who convened in Pierpont Morgan's library to stem the Panic of 1907.

Redmond was the perfect evocation of the American aristocrat. He'd grown up in a house on the Livingston property on the Hudson. In 1915, he married Sara Delano, a second cousin of the future president Franklin Delano Roosevelt. Four years later, he joined the law firm of Carter Ledyard & Milburn, where Roosevelt and Lewis Cass Ledyard, another associate of Morgan's, had once worked. The New York Stock Exchange was Redmond's first significant client following the great Crash of 1929, and he became close friends with Richard Whitney, its patrician head, who was subsequently convicted of stock fraud and embezzlement—a scandal that spelled the end of WASP primacy on Wall Street. Though he wasn't an art collector, Redmond had every other quality needed in a trustee.

George Grey Barnard died two weeks before the new Cloisters opened. It's unclear if he'd been invited. Memos in Rockefeller and Parks Department files indicate that Winlock asked the trustees, the mayor, the comptroller, and the parks commissioner and their wives, the governor, the City Council and borough presidents, local legislators, the department heads of the museum, the builder, and the architects. Junior asked his kids, his sister and her husband, someone from Olmsted's office, one of his aides,

and "your people on the landscaping, traffic problems etc." Admission was limited to museum members for three days before the doors were opened to the general public. Nobody mentioned Barnard.[106]

The great sculptor's last few years had been played to type. He'd badgered Junior to build a museum for American sculpture on the site of the old Cloisters, and tried to sell him his own collection again to get out of debt (to the tune of $100,000) and get back to work on his Peace Arch. "It is destined that we shall go down in history together on this Acropolis," he wrote.

They ran into each other at the opening of Fort Tryon Park. Then a Dr. Seligman of Harvard called to say Barnard had had a stroke—and to ask Rockefeller to buy his Peace Arch for the nation. Barnard's last few letters to Junior were spiritual, nostalgic, and a little mad. He asked if it was true that the "Standard Oil Co. possess[es] millions of harmonicas and wants them given as prizes to boys and girls who can imitate the songs of birds." Rockefeller was disturbed by the correspondence.[107]

In the spring of 1937, Barnard announced he'd given the property that held his Cloisters to the government; the problem was the museum owned it. That summer he tried again, saying he'd given it to the Gold Star Mothers charity. "Fortunately for Mr. Rockefeller he cannot be made a party to any controversy which may arise," one of his lawyers assured.[108]

Before his death, Barnard sent some of the plaster models of his Peace Arch to the city of Kankakee, Illinois, and to the University of Delaware. "They just showed up in about 1934," says Norman Stevens, executive director of the Kankakee County Museum. But because they included breasts and genitals, they were hidden away in storage, where they crumbled to dust. Barnard had spent $1 million on his quixotic dream.

Barnard's obituary said he suffered a heart attack "while working on what was to have become a giant statue of Abel, depicting him as he realized the treachery of Cain."[109]

AT THE CLOISTERS' OPENING ON MAY 10, 1938, JUNIOR overcame his shyness and gave a speech after Mayor La Guardia, the parks commissioner, and George Blumenthal all praised him. "I was told the other day

that the first perquisite [*sic*] for a successful funeral is a willing corpse," he began with an awkward joke. "This looks to me like a very successful funeral, but I can assure you that I am a very unwilling corpse." Noting that the day was the culmination of twenty years' work, he recalled how he'd waited through four mayors to make the park and museum a reality, then disclaimed credit for it, saying his contribution had only been financial. He singled out Breck; "his brilliant successor," Rorimer, who "with rare taste and infinite patience has brooded over every detail"; the planners, architect, and builder; and the parks commissioner. And then he proposed that beauty surrounded by nature could solve a problem confronting Americans: how to use leisure.

"If what has been created here helps to interpret beauty as one of the great spiritual and inspirational forces of life, having the power to transform drab duty into radiant living; if those who come under the influence of this place go out to face life with new courage and restored faith because of the peace, the calm, the loveliness they have found here; if the many who thirst for beauty are refreshed and gladdened as they drink deeply from this well of beauty, those who have builded here will not have built in vain," he concluded. In months to come, Junior and Rorimer would strive to top each other in their expressions of mutual appreciation.

Three years later, an out-of-town visitor wrote to Junior's lawyer, reporting his shock and disappointment that Barnard's name was nowhere to be found on the building. The lawyer wrote Junior, drily noting that neither the land, the building, nor the Cloisters collection was donated by Barnard, and that his original property had reverted to him when the collection was moved.[110] In 1943, a vegetarian society offered to pay for a plaque in Barnard's honor on what would have been his eightieth birthday. The offer was refused. He finally got some credit twenty-three years later, when a plaque was placed just inside one entrance to the museum branch by a local landmarks group.

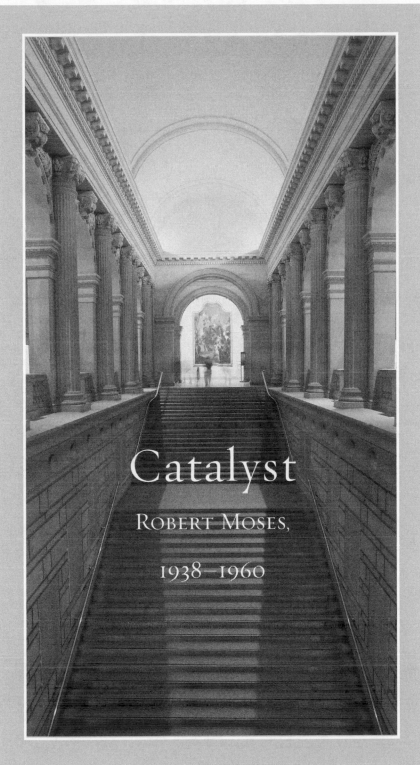

Catalyst

ROBERT MOSES,

1938–1960

The parks commissioner who spoke at the opening of the Cloisters would pose the biggest challenge to the Metropolitan Museum's trustees since the Sunday-closing controversy. Robert Moses would fight a multifront war against the increasingly imperial museum that would continue well beyond his thirty-year tenure at Parks. New York's legendary urban planner, a twentieth-century czar of the city, Moses reshaped the metropolitan area, creating parks and parkways and cloverleaf overpasses, destroying, transforming, and creating neighborhoods, and literally redrawing the map of New York, first as a state official working for Governor Alfred E. Smith, beginning in 1919, and then, after a losing run for Smith's job in 1934, as the city parks commissioner and head of the Triborough Bridge and Tunnel Authority. A revolutionary often criticized for caring more about big pictures than little people, Moses was an imperial populist whose dreams transformed the urban area as much as skyscrapers redefined its skyline. New York's modern infrastructure was approved with his signature. He also transformed the Met.

Moses was appointed parks commissioner by Mayor Fiorello La Guardia, replacing five men with one and totally revamping the department's structure. His job gave Moses ex officio trustee privileges. But despite their right to attend, the city officials on the Met's board almost never did. And overwhelmed with more urgent problems, Moses did not object—at first. That year, the only big issue was an old request to fix the roof and move the water mains beneath the building, vestigial remains of an old water system that threatened the excess art stored in the basement.[1]

In 1939, as the world warily watched Germany and Europe barrel toward war, it was oddly appropriate that the new Arms and Armor Hall opened. The biggest museum news of the year, though, was Herbert Winlock's resignation in April due to ill health. Appointed director emeritus, he would move to Maine and live on ten more years in relative obscurity. At Winlock's insistence, William Ivins, the prints curator, had been named acting director in the fall of 1938 after the director had a stroke.

Ivins, whose family was accomplished but not socially distinguished, wanted Winlock's job. Though he had no training in art, he'd been collecting prints since his student days. He had the intellectual and aesthetic skills for the job, and friends in high finance whom he could tap for funds. But his personality got in his way. Though quick-witted and full of ideas, "he had a terrible temper," said A. Hyatt Mayor, his assistant and eventual successor, "absolutely ungovernable; a mad temper" that made him enemies from the lowest ranks of curatorial assistants to the board of trustees.[2] Roland Redmond found him "sarcastic and impish" and, though brilliant, lacking in administrative ability and tact. His two stints as acting director caused Blumenthal to reject him for a permanent appointment.[3] They were so bad, in fact, the staff nicknamed the nine months the board spent searching for a replacement as the reign of Ivins the Terrible.

The trustees first approached George Harold Edgell, the director of the Museum of Fine Arts in Boston, but he turned them down. Then two other highly qualified candidates were rejected, one in-house, Harry B. Wehle, a paintings curator since 1918, the department head since the death of Burroughs in 1934, and a nephew of the Supreme Court justice Louis Brandeis, and the other, Wehle's former teacher Paul Sachs, the associate director of Harvard's Fogg Art Museum. Both Calvin Tomkins and George

M. Goodwin, who wrote a study of the role of Jews in American art muse-
ums, say that Blumenthal nixed them both because of their religion, feeling
there were already enough Jews in high positions at the museum, himself
first among them.[4] The search went on and on.

There was "an arid, tomblike calm" that "pervaded the mostly un-
trodden galleries" in Winlock's museum, Karl Meyer wrote.[5] Wags had
taken to calling it the Necropolitan and said it suffered from hardening of
the galleries. *The New Yorker* sniped that the acting director, Ivins, still wrote
with a quill pen and considered theories about the democracy of art to be
"so much parlor Socialism." Some of the younger trustees, the magazine
continued, "felt that their institution might perhaps be run on more pro-
gressive lines."[6]

Robert Moses disdained the old families who'd run the place since its
founding. "The arrogance and conceit of those people were phenomenal,"
he would later say. "They really felt they were the lords of creation and that
nobody had the right even to question what they did."[7] They were particu-
larly arrogant when it came to efforts by the public or its representatives
to exercise any oversight over the museum or its finances. Blumenthal
wouldn't even let his finance committee do an audit of the endowment.[8]

As president, Blumenthal was even more dictatorial than Morgan had
been. He occupied a commanding oak armchair at the head of the board
table, with Henry Kent, who for all intents and purposes ran the museum,
and the senior trustees (average age seventy-five) closest to him, and
younger members like Rockefeller, Henry Morgan, and Redmond at the far
end. Blumenthal would inform the trustees what he wanted done, expected
them to approve, and was rarely disappointed. Discussion was kept to a
minimum. He or his cronies ran all the most important committees. Blu-
menthal brooked no interference, delay, or even interruption. "He was, like
so many men of his kind," Germain Seligman recalled, "difficult to argue
with, and had little inclination to waste time."[9]

It was among those younger board members that Moses found allies,
notably Marshall Field, Van Webb, and Nelson Rockefeller. In the early
1930s, aside from his work on the Cloisters, Nelson's first tentative in-
volvements in the museum had been limited to the areas he knew, Asian
and pre-Columbian art. He certainly had a hand in a secret deal the mu-

seum made with the Modern, which agreed not to show art more than sixty years old.[10] Though he regularly wrote $3,000 checks to cover his share of the annual deficit, so unattuned was the twenty-seven-year-old trustee to the perks he was entitled to that in 1935 he sent the museum a request for one of its books and enclosed a check for it. "Did you not know that a Trustee is entitled to each and every publication free of charge?" came the reply. "I hasten to return your cheque, although I am tempted to keep it in our Museum memorabilia collection."[11]

The next year Nelson was named head of the trustee committee on sculpture, which also included Webb and Field, along with Redmond. That spring Nelson urged the board to accept a Rodin sculpture being offered as a gift, but Winlock disapproved, feeling the subject matter—a man and woman embracing—was inappropriate. In a note to Webb, Nelson said he found that hard to believe. Webb replied puckishly that he hadn't realized the committee would deal with "such interesting problems."[12] In May 1939, after he was named president of his mother's modern art museum, Nelson resigned from all his committees at the Met aside from the one in charge of finding a new director.

This was the museum's most pressing need, as Ivins continued to alienate those around him. Yet he was also as incisive as he was abrasive, as he demonstrated in a memo submitted to the board just *after* he was denied the directorship. In it, he laid out the square footage of each department's gallery space and its proportionate share of administrative costs. The disparities, he concluded, "raise the question whether a number of the Museum's collections do not represent favored fashions in private collecting and personal enthusiasms and dislikes rather than any considered plan for a balanced development of the whole to a cultural end." He proposed that galleries displaying "endless and weary" amounts of everything from Egyptian objects to arms and armor to lace be downsized and that study-storerooms be created to hold "duplicates and quasi-duplicates and . . . art in which the public has little interest," in order to heighten the quality of the art shown in galleries, cut maintenance and security costs, and free up space for what was missing, "the art in which the public is most interested," he wrote, the "living contemporary art the Museum deliberately turns its back upon . . . whether or not it is liked by the Trustees and officials."[13] Some

of the younger trustees secretly agreed with him, feeling the collection did not reflect the breadth of art history, but these were not sentiments calculated to curry favor with the board.

Though he was bitter and disappointed when denied the directorship, Ivins still managed to score two more important career coups. In 1941, he reeled in 228 prints, including 44 by Rembrandt, collected by the investment banker Felix M. Warburg. Five years later, he curated a show celebrating the thirtieth anniversary of the Prints Department, before he was forced to retire at age sixty-five. His parting shot was an article in the *Bulletin* that summer, titled "The Dead Hand," ridiculing those who fought the new and ran the museum. They were "the nice people, the cultured people, the backward-looking people," he wrote. "They withdraw to their ancestral homes and talk shrilly about vulgarity, taste and eternal verities." Ivins died a mostly forgotten man in 1961.

❖

ROBERT MOSES AND NELSON ROCKEFELLER FIRST TEAMED UP IN 1938, when the Dutch Colonial Verplanck family offered the museum the contents of an eighteenth-century drawing room for the American Wing, demanding it all be exhibited together. When the board declined as a matter of policy, Moses engineered the passage of an amendment reaffirming that conditional donations would be refused but giving the board the right to make exceptions.[14]

Then Moses began "studying the relationship" and concluded that "the city's supervision [of museums] . . . should be tightened rather than loosened."[15] Realizing that the various museum boards simply rubber-stamped decisions made by their executive committees, he demanded and won the right to send a representative to the executive meetings at the American Museum of Natural History and, after "a hell of a row," elbowed his way into the inner council of the art museum, too.[16]

Moses soon discovered that he had a real edge over the trustees: due to the Depression, attendance and membership were down (annual dues in 1939 brought in only $38,810 compared with $109,880 in 1929); the museum was desperately short of funds (its 1939 deficit would be $75,000);

the city had cut its subsidies, forcing fifty-three city-paid security and maintenance employees onto the museum payroll and put off repairs and maintenance. Moses had the chance to trade his power to fix things for influence over the museum's affairs.

At first, when Moses pushed, Blumenthal and his trustees pushed back. But it wasn't long before Moses started making his power felt. By December 1939, Moses's pressure had led to the appointment of a special committee to study the museum's finances. Rockefeller and Webb were named to it and immediately decided to use it "as an excuse to have a study of the whole museum made" as they'd done recently at the Modern, where the process led to a total reorganization and a 20 percent cut in the annual budget.[17]

In the meantime, the trustees were squirming to avoid giving Moses the right to oversee their budget requests to the city, and in the process they briefly tied themselves up in a knot, claiming that the museum should by rights deal directly with the city regarding its financial needs and not have to go through the Parks Department—that is, another agency.[18] "If you want a showdown on this question, I am all for having it," Moses told William Church Osborn.[19] He was even more blunt with Blumenthal, calling the proposition preposterous.[20] Finally, Moses went to the city's lawyers, and they agreed that the museum was not an agency and that its budget would have to be presented by Moses. Luckily, Moses was not the enemy the trustees thought he was—when they discovered that a new city administrative law repeated language from 1901 that capped the city's annual appropriation to the museum at $95,000, Moses advised them not to draw attention to it by fighting it, and the much-larger annual subsidies the museum had been getting since the Morgan era ($479,000 in 1929, $508,000 in 1932, $345,700 in 1934, $404,148 in 1939–1940) continued.[21]

But the other thing that made the trustees squirm was Moses's insistence that the museum needed to be more democratic, more entertaining, more popular, more representative of the community, and more responsive to its needs. And he made it clear that the trustees would need to court the general public—not just their own society—if they expected continued financial support from its purse. And this wisdom could have been the de-

ciding factor behind the stellar, if belated, choice the trustees finally made for the museum's next director.

The year before, in *The Museum in America*, a study for the American Association of Museums, Laurence Vail Coleman had written, "A trustee's duty is to have the museum run, not to run it. The director is the museum."[22] If that was the case, then the trustees had decided they needed a man who could wield a new broom and sweep their museum clean of its cobwebs.

THOUGH HE OFFERED THE FAMILIARITY OF A GOOD FAMILY BACK-ground, Francis Henry Taylor was a breath of fresh air. He agreed to replace Winlock (or rather, acting director Ivins) early in 1940 after a six-month courtship that had extended the museum staff's agony. A lot of what Thomas Hoving is credited with doing for the Metropolitan, Taylor actually began, cushioned by the likes of Morgan and Rockefeller and primed by Robert de Forest, the patrician who'd foreseen the need to popularize the museum. But in the ranks of the museum's directors, its fifth was the first revolutionary, combining, one friend said, the administrative skills of a general with "the scheming patience of Machiavelli" in an impressively enormous, surprisingly graceful five-foot eleven-inch, two-hundred-plus-pound body topped by an oversized head with a prominent, beakish nose. (People compared his profile to everything from the British cartoon character Mr. Punch to a bust of Louis XVI.[23])

Witty and articulate, as opposed to his two predecessors, Taylor was able to get away with insulting trustees. He played the part of the Bourbons he was said to resemble, wrote Nathaniel Burt, alternating "captivating charm," "temperamental fury," and an "attitude of casual and caustic superiority," a natural arrogance that "disconcerted the trustees, used as they were to stubborn but still subservient scholars."[24] It was telling that one of Taylor's first acts was to abolish a long-established policy of distributing clothing cast off by the wives of trustees among those of the curators. He was like a hurricane blowing through the museum. "I don't relax," he would say. "I just collapse. It's pretty much of a rat race."[25]

Taylor's parents were modest and unostentatious despite a certain social standing. Raised by French and German governesses in his strict Episcopalian family, and educated in exclusive private schools, Francis spent many summers abroad and developed a taste for fine food and a keen facility for languages. He spoke French, Spanish, and Italian and read medieval French and German.

After an abortive attempt to follow his father into medicine, Taylor turned to art. His interest had been sparked by the erection of a neo-Gothic cathedral near his childhood home. A chronically overweight underachiever, Francis moved to France, where he'd spent summers as a child, to become an English teacher in Chartres, and spent a year studying medieval art at the Sorbonne before finally buckling down and enrolling in graduate school at Princeton. He returned to Europe as a Carnegie fellow in 1926 and two years later got married and dropped out of Princeton to become the medieval curator at the Philadelphia Museum of Art.

Though he clearly had fun there, Taylor found Philadelphia stuffy and got out as soon as he could. He was named, at age twenty-eight, the director of the art museum in Worcester, Massachusetts. "They wouldn't put his age in the paper, because they were embarrassed by how young he was," says his daughter Pamela Taylor Morton. He made only a modest salary (his wife, Pamela, made more than he did as a poetry and fashion editor of the *Ladies' Home Journal*) but made a large reputation as a popularizer and showman. He believed a museum should be a liberal arts university for the common man, not a treasury, a "safety deposit box for archaeological treasures," or "a three-ring circus," he told the *Times* on his arrival at the Met. "His regret at not going into medicine was expressed in his feeling that museums could function as places of healing, places where people could learn about the world," says another daughter, Mary. Though he wasn't rich, she adds, he'd been raised as if he were and thought everyone "should have the opportunities he'd had as a child."

"I give him credit for really making museums audience focused, not mausoleums, but community centers," says Jim Welu, now the Worcester's director. Taylor strengthened Worcester's education and outreach programs, sought to bridge the then-yawning and still-classic divide between arcane art scholars and what they generally derided as a sensation-seeking

public, quadrupled annual attendance, doubled the size of the museum, organized pacesetting loan exhibitions, bought new objects with a strategic eye, and attracted both Carnegie grants and sixth-grade class trips.

"He was famous for saying showmanship shouldn't show, but without it you're dead," says Welu. "We didn't want museums to be stuffy." So unstuffy was he that Welu once saw him pinch a woman's bottom on a Met elevator. "He loved to shock." He also had a biting wit. "He would say, '*Kunstgeschichte Horsegeschichte*,'" the curator Hyatt Mayor recalled.[26] (*Kunstgeschichte* means "history of art," which he equated, phonetically at least, with horse manure.) He also loved Worcester's trustees "because they let him do what he was hired to do," Welu says. Many, including the moguls who ran the Met, were watching.

Taylor was viewed as an innovator who focused like a laser on the museum-going experience and was convinced that if collections were made more entertaining and accessible, the public would respond. He first met with William Church Osborn in the summer of 1939 and by winter had been offered the job. But it is likely that he'd piqued the Met's interest earlier that year, when it started planning a show called Life in America, ordered up by the board of trustees to appeal to the tourists in town for that year's World's Fair.

The influential exhibition of about three hundred pictures—many of them loans—celebrated American life through the centuries. Taylor's Worcester Art Museum had, on loan, an American primitive painting, *Elizabeth Clarke Freake and Baby Mary*, that Hyatt Mayor and William Ivins wanted for the show. "So I was delegated to ask Francis if he would lend it," Mayor recalled. "He said it was on loan to the Worcester Museum but he knew the owners very well and they would do exactly whatever he said to them, so there was no use in the Metropolitan Museum going to them direct; the only way to do it was through him; and he would consent to persuade the owners to lend it *if* the Metropolitan would lend to his Flemish show which he was gathering together the Van Eyck painting of *The Last Judgment and The Crucifixion* and some other great early thing we have . . . In other words, he was wanting to swap [a] Man o' War for a cab horse. And I with complete seriousness said I would relay this proposal at home. And naturally nobody at the Metropolitan Museum had the least interest in the exchange. So we

didn't get *Mrs. Feake* [*sic*] and he didn't get the Van Eyck. He always believed in trying a horse trade like that."[27] His nervy demand may well have been calculated to attract the Met trustees' attention. With uppity newcomers like the Modern and the Whitney nipping at its run-down heels, the Met needed its own upstart.

In June 1939, Taylor spelled out the philosophy that was about to win him the Met in a paper he read at a meeting of the American Association of Museums. It was later expanded into a short book called *Babel's Tower: The Dilemma of the Modern Museum*. For Taylor, the seeds of the modern museum had been planted in the Italy of the Dark Ages. The great Italian collections of the fifteenth century were formed to celebrate "the pleasures of this world" by people who "admired art for its own sake, and more than that ... accepted it as part of ... daily life." Taylor argued that the promise made by the Metropolitan's founders to similarly create "free and ample means for innocent and refined enjoyment" had been betrayed by high-handed scholarship that insulted the intelligence of the general public. "The public are no longer impressed and are frankly bored with museums," he wrote.

Taylor argued that museums could no longer afford to be "remote from life ... Like muscle, taste can be developed only through exercise. The art museum is nothing more than a gymnasium for the development of these muscles of the mind ... Objects which at first appear to be mere curiosities emerge with new meaning, to explain the social and political progress of mankind and to assist us in forming our judgment and in refining our opinions and beliefs ... The museum is no longer, then, the rich man's folly. It is the great free public institution to which the humblest citizen may turn for spiritual regeneration."

Despite that crack about the rich, Taylor's ire focused more on curators than on trustees. He felt most trustees were humble stewards who understood the world in a way that a cloistered curator ("a highly polished introvert who exists only for himself and his own intellectual pretensions") did not. But all of them needed to understand "that we have emerged from the pre-war frenzy of acquisition for acquisition's sake and must digest what we already have." Only if museums could "be articulate without being intentionally obscure" would they justify themselves, he concluded.

It was no wonder that Taylor's arrival set off as many alarm bells as it

did cheers. The board had, in fact, split on the choice. One faction, led by Osborn, wanted someone more staid and scholarly; Osborn actually offered the job to a curator who'd worked with Taylor in Philadelphia, Horace H. F. Jayne, who was a few years older, at the same time Blumenthal approached Taylor.[28] Blumenthal wanted a director who shared his love of medieval art, so the younger man got the top job and Jayne was induced to take a new position as vice director, sharing not just the administrative burden but the need to gain the confidence of a staff bound to be suspicious of the two young outsiders. One of the unhappy staffers was James Rorimer. Having created the Cloisters, he had visions of being director himself.[29] Two days before Taylor's appointment was announced that January, R. T. H. Halsey wrote Nelson Rockefeller worrying correctly that "the appointment of our Philadelphia friend" would adversely affect "the morale of our curatorial staff, some of whom are very able and have given their lives to the museum."[30]

Congratulations poured in, too, though, with some friends expressing the hope that Taylor would breathe fresh life into the Met and others warning that the job, though important, would not be easy. Taylor knew he faced a formidable challenge and would have to make changes, but slowly, so as to cure the patient without harming or killing it. All the same, his humor, youthful vigor, and optimism always showed. He would not be serving tea to visitors, like Herbert Winlock had. He wanted his museum to offer up more potent stuff.

Midway through the four months between the announcement of his hiring and his arrival in New York, Taylor was greeted by a three-part series in *The New Yorker,* a profile of the museum at age seventy that highlighted its quirks as well as its facts: Twenty-three of the twenty-eight elective trustees held about 120 corporate directorships, although their "Metropolitan is inclined to ignore its trustees' ventures into the world of affairs" when discussing them publicly, the magazine said. Beneath the trustees were ten curators, forty associate and assistant curators and curatorial assistants, and a staff of more than five hundred others, including "two hundred and fifty attendants, dozens of secretaries and cataloguers, a chemist, a registrar, a building superintendent, and a head librarian"—not to mention the termites in the basement and moths in the linings of the cases that held the

Crosby Brown Collection of Musical Instruments, about which the current
trustees were said to be somewhat less than enthusiastic. Beneath them all,
in a subbasement, remained the sixty-foot pistol practice range.[31] Though
Winlock had always refused to value the collection, "arbitrary fools in art
circles" had claimed it was then worth more than $2 billion, presumably in-
cluding the "enormous number of Museum articles . . . hidden away in
storerooms in the basement."

Many wondered how Taylor, who was, formally speaking, a medieval-
ist, would deal with modern art. It was known he had his quarrels with it,
but he also admired the Museum of Modern Art's director, Alfred Barr,
who'd supported his candidacy, and he hoped that with Nelson Rocke-
feller's assistance, the two museums would find a way to cooperate more
with each other. Hostility to modern art remained strong at the Met, the
Havemeyer paintings notwithstanding. In 1930, Bryson Burroughs told the
purchasing committee there were no generally agreed-upon living artists
"of outstanding merit." The next year, when Lillie Bliss died and left most
of her art to the Modern and only thirteen works to the Met, one newspa-
per grumbled that instead of making "intelligent use of the millions left to
it," the Metropolitan had "swallowed the millions and gone to sleep again."[32]

In 1933, Harry Wehle had refused a proffered loan of a Picasso and,
when offered a gift of one of Cézanne's *Card Players* paintings, said he'd take
it but wouldn't promise to hang it. In 1934, the Modern's Barr had pointed
out publicly that the Met had no Gauguin, Seurat, Signac, Toulouse-
Lautrec, Rousseau, Matisse, Derain, Picasso, Modigliani, and on and on.
"Do you not think it would be a good idea if we got some?" Winlock wrote
Burroughs, who replied that the trustees were against it and those painters
were already "old hat." Some years, no pictures were purchased. And even
when the Hearn Fund bought seventeen in 1937, Henry Kent wrote that "to
buy the modern in haste is to repent at leisure."

Modernity's fans on the board were no help, either. The trustee
Stephen Clark suggested avoiding "the lunatic fringe," but added that if it
proved politic to buy bad paintings, they could always be given "a decent
burial in the cellar."[33] In that same 1940 *New Yorker* trilogy, the writer Geof-
frey T. Hellman noted drily, "At the present rate, in fifty years several hun-
dred Hearn purchases will be downstairs."[34]

❖

Changes began even before Taylor moved to New York in the summer of 1940. Nelson Rockefeller and his allies agreed they had to immediately commission the study they'd suggested so it wouldn't be delayed or canceled by Taylor's arrival.[35] Moses must have been pleased by this; his 1940 Parks budget included money for museum roof and skylight repair and a new freight elevator, though museum officials would remain unhappy with the slow-moving appropriations process.[36] No wonder; after a decade of neglect, the building was simply obsolete.

Such was the state of things when Taylor, thirty-seven, arrived for his first day at his new job with what should have been a slow summer ahead in which to get his bearings. But immediately demands were made. A purchase of about a dozen paintings by contemporary artists led some to ask why the museum bought so few. Although the Met had hired a consultant, Lloyd Goodrich, in 1937 to work with Stephen Clark and Bryson Burroughs on Hearn Fund purchases, he'd made little difference. The *Times* even printed a list of about four dozen artists with no work in the collection and suggested that Juliana Force and Gertrude Whitney, the former a friend of Taylor's, might be better equipped to spend the Hearn income than the Met's curators.[37] The argument raged in the newspaper's letters column all summer long. Three weeks after Taylor reported to work at the Met, the American modernist Stuart Davis published a blistering attack on the museum, accusing it of "artistic myopia . . . It would seem that the Metropolitan suppresses modern and abstract American art in its policies as effectively as would a totalitarian regime."[38]

Despite his populist urges, Taylor, like every director before him, and like most trustees before Nelson Rockefeller, was skeptical of modern art. In his address to the museum directors he'd mocked those who thought of "joining the chorus boys of surrealism in singing 'My Heart Belongs to Dada' "[39] And in *Babel's Tower* he'd condemn modernism as a "banal" expression of the "chaos of the present time."

A show of twenty-one pictures bought with Hearn funds opened the August after Taylor's arrival and kept the argument alive. The *Times* critic

Howard Devree judged them "trivial, merely decorative, or lacking in any significance for our time," if not "downright immature," but praised a recent decision by the board, prompted by that *New Yorker* series, to make all the Hearn paintings available for loans. "This project will do away with the charge that pictures once bought go largely into the Metropolitan's capacious cellars, where, unlike wine, most of them do not improve with age," Devree said.

Change was in the wind, though. Shortly after he arrived, Taylor impressed Moses by suggesting that the museum needed to do more outreach to the public. Taylor, Moses told an aide, "seems to be an alert, progressive and cooperative fellow. I want to keep the new man in this frame of mind before he gets a chance to settle down and follow in the footsteps of some of his stiff shirt predecessors."

The stiff-shirt era was passing fast. The museum's business manager leaned back in his chair and died of a heart attack in the staff lunchroom in September; Henry Kent retired in October; and a committee headed by William Church Osborn proposed an entire reorganization of the staff that month. A month later, a committee was formed to finally dispose of the unloved plaster casts. (When a proposal was floated that the city provide a building for a museum of these casts, Robert Moses was blunt: "Not on your life."[40]) In December, Taylor proposed to abolish pay days and make admission free whenever the doors were open (museum insiders joked he did so because he was too heavy to pass through the turnstiles), and at his first annual meeting in January 1941 he announced that he would be proposing a reorganization of the collections as well.

But some things stayed the same. The synergy between the museum and New York society for one: the executive committee approved the sale to Mrs. Henry Carnegie Phipps of furniture and furnishings willed to the museum by the banking heir and former Treasury secretary Ogden Mills, with the proceeds going to redecorate the director's lunchroom. Also unchanged was the annual call for the trustees to meet the deficit, even after income from more than twenty endowment funds was diverted to pay operating expenses. Although Nelson Rockefeller had taken a leave from the board to work for President Roosevelt coordinating relations with Latin America (a job he'd stay in through the war), he still wrote his annual check

for $3,000.[41] And on December 3, the museum asked the Parks Department for a special appropriation of $4.8 million over the next six years; they planned to renovate the entire place.[42] Even though they soon cut that request in half, Robert Moses wasn't ready to say yes yet.

Moses's displeasure would be evident in 1941 after Blumenthal asked Lamont, Halsey, and Redmond, who was rapidly emerging as a force on the board, to begin casting about for two new trustees. All through the preceding year, Moses's representatives had pushed for the election of a woman, but each time the issue was raised, the discussion was postponed. Finally, Moses pressed and was "politely informed that it could obviously not elect one until it could elect two, because one would be lonesome, and it was also hinted that the jolly, informal stag atmosphere would never be the same," Moses later recalled. He also wanted to elect a trustee conversant with modern art to replace the absent Rockefeller since "the dictum of George Blumenthal," he continued drily, "that nothing significant has been painted, moulded, or wrought since 1900 is still regarded by some of his associates as a sage observation."

At an executive committee meeting on January 31, Blumenthal made it clear that he would not allow the election of a woman. The battle lines were drawn. Moses asked an aide for a list of second- and third-generation trustees as well as a list of the trustees' addresses, which showed up the group's diversity—all but one of them (Whitridge at Yale) lived within a few blocks of each other on Manhattan's East Side. With that knowledge in hand, Moses drafted an incendiary memo to Mayor Fiorello La Guardia,[43] excoriating the museum leadership for being stuck in an "aristocratic tradition" that was "withering" and exhorting for change that would put "less emphasis on wealth, old family, and big game hunting, and more on representing great masses of people."[44]

Moses soon filled two files with letters of praise of what one fan called his "blast on the decadence of museums." Dorothy Draper, a decorator, praised "the stand that you are taking on the ridiculous pomposity and stuffiness of the City's museums." Adelaide Milton de Groot, just elected a fellow for life, sent a telegram from Palm Beach saying the memo was "splendid" and signed it as a "benefactress of the following institutions: Metropolitan, Natural History, Historical Society, City of New York,

Cooper Union." But his eloquence and passion notwithstanding, Moses would soon find out just how hard a task he'd set for himself.

A few days later, Moses suggested that George Biddle and Joseph Medill Patterson be elected trustees. Patterson, the founder of the tabloid *Daily News,* was a member of the upper class, but also a progressive who wanted to reach the lowest common denominator (art, to the *News,* was comic strips). He "has a very good idea of what people are thinking about in New York," Moses wrote, while Biddle was not only a living American artist but also a champion of artists and a first-name-basis friend of President Roosevelt's. "I have a very real belief that artists should have at least a minority representation in art institutes and art organizations," he told Moses. "I am glad you feel the same." Patterson wrote directly to the museum's new secretary, "to inquire what sort of job I am being nominated for," he reported to Moses. "I am told that is a secret, but, nevertheless, I cannot withdraw my name for nomination. This is, therefore, to notify you that in the unlikely event I should be elected, I will not serve."[45] Incredulous, Moses sent copies of the whole exchange to the president of the City Council, "as an example of the stuffiness of the Metropolitan Board," he wrote. He also complained to each of the trustees, who delayed the election and went looking for more candidates.

Ruminating on a brief vacation about "snooty trustees who do not know and care what the public is thinking," Moses saw an alternative (one it would take the museum decades to see itself): "to get so large a private endowment that an institution can live without recourse to the public treasure," he wrote. "Perhaps in such a case the institution can patronize the public and even tell it to go to hell. Even in this case, I don't think that would be a wise procedure."[46] A few days later, he got a letter from Taylor, saying he was making changes he was certain Moses would like and suggesting they lunch at the museum on a Thursday, "when we have the twenty-two department heads together and none of the trustees."[47] Moses opted instead to lunch alone with Taylor and ask that the museum and the city get off to a fresh start. In response, Taylor performed triage on the Met's outstanding requests and submitted a five-year plan for the most urgent building repairs at a total cost of $849,000. Moses would approve some of them—eventually.

Whether it was the strain of the ongoing argument, old age, or both is unclear, but George Blumenthal chose that moment to end his career at the museum. At the May 1941 board meeting, he revoked all conditions on his gifts to the Met. Though he'd been ailing for some time, Blumenthal rarely missed a board meeting, but he did send his regrets on June 9. After spending the next few weeks semi-comatose, he died on his own silk sheets at age eighty-three. His funeral was conducted by an Episcopalian reverend. Within days, the board unanimously elected William Church Osborn, seventy-eight, its eighth president, signaling that there were limits to its tolerance for change. "Bill didn't know a drawing from a painting," says Redmond's daughter Cynthia Mead. "Art was not his thing. You wanted a well-connected New Yorker to lend importance, credence, to ask for money, to set an example."

John D. Rockefeller Jr. wrote Osborn to express the "hope that, with the efficient new Director of the Museum, the duties of the President can be made as light as possible."[48] But the board still needed new trustees to replace Blumenthal, Harkness, Arthur Curtiss James, and Howard Mansfield, who'd all died in the preceding year.

Though he'd hoped for some time off to edit *Babel's Tower*, Francis Henry Taylor returned to work in August when his new vice director collapsed in the street and was hospitalized. One of Taylor's priorities was to deal with Blumenthal's last gift to the museum, his house. Though at first he'd thought to give it as a branch museum, he'd later reconsidered and suggested the museum take his art, Spanish patio, and other architectural features and then demolish the mansion and sell the land. Taylor disagreed; he wanted to move the Arms and Armor Department there. Moses wrote to Osborn saying he was "emphatically opposed."[49] In November, Blumenthal's wife moved out, but chimed in to ask that the house be left standing and "put to some useful purpose rather than taking it down . . . His desire was always to have it perpetuated."[50] But like a dog with a bone, Moses wouldn't let go. On the same day the Japanese attacked Pearl Harbor, propelling America into World War II, Moses demanded to know why the house had not yet been torn down, considering that wages might go up sharply in wartime. War also meant that the salvage value of the metal in the house would be high.

When the trustees petitioned a court to stall demolition until after the war, Moses realized he'd been licked and helped get the museum a tax exemption (for the Vélez Blanco patio as a cultural relic). By July, the museum had stripped the house of much of its art (which went on display at the museum proper in December 1943) and in its place installed an arms and armor exhibit in the patio and opened it as a branch museum. Taylor had hired a Viennese lawyer, Emanuel Winternitz, as keeper of the musical instruments collection, and he'd won the trustees' favor by arranging concerts using them during the war, attracting crowds to the house and many new members.

The fate of the house remained in question until just after the war. Moses considered a bid of $300,000 made in the fall of 1944 by the builder Sam Minskoff insufficient, but he finally acquiesced. The house was demolished in 1945. An apartment building, 710 Park Avenue, finally went up on the lot in 1947.

Thirty years later, Moses wrote to Thomas Hoving, reminiscing about his days on Blumenthal's board. "I went to see George once at his Gothic mansion on Park Avenue," he wrote.

> A lovely little French maid in a brief, trim, black uniform and a little white apron was sitting on George's lap. She jumped up and discreetly melted away. Said George, "You caught me off guard." George didn't like me among other things because . . . I paid his Museum bills. "No, George," said I, "you remind me of Samuel Johnson, the great lexicographer. In a similar contretemps his indefatigable biographer Boswell said, 'Dr. Johnson, I am surprised.' Said the old curmudgeon, never at a loss for the right word, 'Boswell, you're astonished, *I'm* surprised.' "[51]

LIFE AT THE MUSEUM DID NOT RETURN TO NORMAL AFTER BLU-menthal's death. Instead, Moses kept pushing, and the trustees lacked a strong leader pushing back. Moses knew enough to alternate the carrot and the stick. In 1939, for instance, he'd agreed to have the water mains in the

tunnel beneath the museum removed to create a four-block-long, twenty-six-foot-wide, and ten-foot-high storage space. In mid-1941, with war approaching, Osborn proposed turning some of it into a bomb shelter. After Moses talked them out of "their crazy scheme" to do that, he actually got the funds to remove the mains on the condition that the museum itself would pay to convert the space to storage. A year later, after the tunnel was cleared by WPA workers and the city got the proceeds of the sale of a thousand tons of scrap metal, the trustees appropriated $76,000 to create 160,000 cubic feet of storage rooms that, due to their position, remained at a constant seventy degrees, perfect for storing art.[52] At the same time, Moses was pushing for a far more significant change aboveground.

The idea of a Whitney wing at the Metropolitan had been resurrected by Gertrude Vanderbilt Whitney, when she began anticipating her own death. It would be a solution to any number of problems, for her museum as well as for the Met. She didn't want to pay what it would cost to ensure the Whitney's stand-alone survival, says Avis Berman in her biography of its director Juliana Force, who was kept in the dark while the rich people talked among themselves.[53]

Though there is no record of it, Nelson Rockefeller must have been a factor in the Met-Whitney equation. He had long been concerned with the Met's relations with other museums. Early in 1934, afraid of losing potential donations, Nelson had asked Herbert Winlock to establish ties with the Modern, to cooperate, and to perhaps share trustees to counter an impression "that bad feeling and misunderstanding exists between the two museums and that sooner or later the modern museum will be frozen out by the Metropolitan."[54] That spring, both boards had agreed. Nelson's mother, Abby, joined him on a joint committee along with Osborn, Blumenthal, and others.

Force liked Francis Taylor's charm, wit, naughtiness, and irreverence, but not his attitude toward living artists. She felt he shared the Met's institutional belief that artists were pests, and she knew how catty and clever he could be about modern art.[55] Early in 1941, Rockefeller was putting together a loan exhibit to go to Latin America as a show of solidarity with America's future war allies and forced the Met, the Modern, and the Whitney to work together. That February, Taylor entered into secret negotiations with both

modern museums to loan them paintings bought with the Hearn Fund, in exchange for loans from them to the Metropolitan. By August, the idea of moving the Whitney into a new wing at the Met had been broached.

In September, Gertrude was elected the first female member of the Met's board, along with Devereux Josephs, a descendant via marriage of the inventor of the Colt revolver and financial officer of the philanthropic Carnegie Corporation. Whitney refused. Josephs, who was a neighbor of Roland Redmond's on Long Island, accepted. Josephs would be a key player at the museum for the next three decades; he was immediately named chairman of the finance committee and hired J. P. Morgan & Co. for $18,000 a year to advise the museum on investments. The trustees came up with more names for the other board vacancies, all men. Robert "Bobbie" Lehman of the Lehman Brothers banking family soon became the second-ever Jewish trustee; some think he took the "Jewish" board seat vacated by Blumenthal, even though Blumenthal himself had distrusted him.

Lehman's father, Philip, had been collecting art since World War I, and by the time Bobbie was named to the board, his collection was considered the second best still in private hands in America, with a strong concentration on Italian and Flemish paintings from the fourteenth and fifteenth centuries. It included paintings by El Greco, Goya, Rembrandt, and many more.

The money to buy it all came from the acumen and foresight of the Lehmans. Before Bobbie joined the firm, it had already moved from commodities like cotton, coffee, sugar, and oil into financing big retailers, public utilities, and railroads. Bobbie, a product of Hotchkiss and Yale, spent his first years out of college putting his art education to use, improving his father's collection.

After purchasing "a conventional Rembrandt, a decorative Goya and a superficial Hoppner," his father started listening to him as he nudged their purchases into Italian primitives.[56] But sometimes he went too far. "When he was a young guy," recalls his only son, Robin Lehman, "my dad bought a piece of African art that his dad hated and said, 'Get it out of the house, I never want to see it.' " But instead of turning away from art, Bobbie became dedicated to it. "He would have really liked to have been an art historian," his son continues.

The pull of dynasty was strong, though, and after World War I, Bobbie joined the family firm, becoming a partner in 1921 and taking on more responsibility. Even before the Depression, he was leading the firm, but had the acumen and foresight to bring in nonfamily partners to expand Lehman's possibilities ("I bet on people," he would say), to attract investments from insurance companies and pension funds, to open its own investment fund, and to see that industries like television, motion pictures, and aviation would have a profitable future. Among the companies he started or helped to expand were American Airlines, Pan Am, TWA, Paramount Pictures, and 20th Century Fox.

On Philip Lehman's death in 1947, Bobbie inherited his art collection and position as the senior partner at Lehman. He would continue to tend to both for two decades.[57] Like many of his wealthy peers, he played polo, bred horses, and married several times. Though a small man, five-feet-seven, who dressed casually compared with other bankers, he was known as "the last of the imperiously rich" and "the aristocrat of the autocrats."[58] But contradictions abound in the case of Lehman. Despite his business successes, he was described as pathologically indecisive. Regardless, his election to the museum board confirmed that he was as much a connoisseur as a financial king. Having just lost out on the collection of Samuel Kress, another impressive accumulation, the Met was going to keep a close eye on Lehman. In 1948, he was elected a museum vice president. Six years later, in 1954, he loaned the museum ninety paintings, which were installed in four galleries. Though he was less than thrilled with the installation, especially after it shrank to three galleries, he left them there for seven years.

Seven months after saying no to the Metropolitan, Gertrude Vanderbilt Whitney died, so the Met began courting Flora Miller, Whitney's oldest daughter, and Frank Crocker, the family lawyer and Whitney Museum treasurer. In November, Crocker met with Taylor and agreed to "consolidate," as the newspapers put it, the Whitney into the Metropolitan, build a new $2 million wing for it, place the Whitney collection there, and endow it with another $2.5 million to $3 million so the city would bear no additional burden, all of it paid for by Gertrude's estate.[59] A month later, Force met with Taylor, who casually mentioned the Whitney Wing to her. Though she'd heard about the possibility in September from Moses and

James Dawson, his aide, she apparently did not know a deal had been made.[60] Seeing her expression, Taylor stopped dead. "Good Christ, don't you know?" he asked. "Haven't they told you?" Force, furious, blamed him, and other champions of new art flocked to her side. "The Metropolitan is big enough—too big—and its extremities grow cold already," commiserated the Modern's Alfred Barr.[61]

The Whitney planned to close after a memorial show in early 1943. Gertrude Whitney's son and co-executor, Cornelius Vanderbilt "Sonny" Whitney, was elected to the Met's board as part of the deal that February. But the Whitney side found the formal agreement drawn up by the Met's lawyers vague and insulting, and its architects thought the Met's Whitney Wing concept unappealing; Moses would refer to it as a wart on the face of Central Park.[62] So a final decision on the merger was indefinitely delayed, and the Whitney on Eighth Street reopened.[63] To keep the ties alive, the Met agreed to let Force spend $10,000 a year from the Hearn Fund buying paintings for the Met from Whitney exhibitions. But that arrangement exacerbated the tensions between her and Taylor; asked what his trustees would think of her choices, Taylor quipped, "I think they will puke."[64] The Met's merger with the Whitney would sit in limbo through the war and beyond.

That war, and the looming possibility that New York might be bombed like Pearl Harbor, were very much on the minds of the trustees when they met in January 1942. Ever since Moses had laughed off their request to build a bomb shelter in the basement, they'd been studying what to do in case of war. After the fall of France in the spring of 1940, they'd prepared a plan to close the entire second floor with its vulnerable glass skylights and remove much of the art from the building. Right after Pearl Harbor, they'd decided to lease two bank vaults for the storage of gold, silver, gems, and ivories (the vaults of the Federal Reserve Bank having been deemed inadequate) and a defunct upstate cement mine to keep their most precious and irreplaceable paintings and sculptures safe. They resolved to remain open, though, at least until dusk, and leave less important objects in place behind heavy shutters, muslin, and sandbags to protect glass skylights from bomb concussions.

On December 29, they changed course after they found the upstate

mine had flooded during a rainstorm; after looking over fifty possible alternatives, they leased Whitemarsh Hall, a fireproof and air-conditioned estate on three hundred acres near Philadelphia. They surrounded it with floodlights and steel link fence topped with barbed wire, installed humidity controls, and induced the museum's superintendent and his wife to move there for the duration of the war; he would leave the area only five times in the next twenty-seven months. Over the next four months, some fifteen thousand works of art, including five hundred paintings, were trucked off in convoys complete with armed guards and a curator, with no single truck carrying more than $1 million worth of art. Several other museums, Thomas Lamont, Robert Lehman, Sam Lewisohn, and William Church Osborn stored their art there, too. Three hundred cases of the most precious objects went to the rented bank vaults.

Back on Fifth Avenue, curators armed with pistols, some of them accompanied by their pet dogs, patrolled the place, ready to save the most valuable objects if the city was bombed. Taylor would often join them, sleeping on a cot overnight. With the skylights painted black and white lightbulbs replaced with less noticeable blue ones, it must have been an eerie way to spend the night. Luckily, the worst thing that ever happened was when a skylight blew in during a rainstorm.

Courageously, the trustees agreed to proceed with a major Rembrandt exhibition scheduled to open a mere six weeks after America had entered the war, but Taylor made plans to move all the paintings to the basement in a mere twenty minutes in the event of an emergency.

RIGHT FROM THE START OF FRANCIS HENRY TAYLOR'S REIGN AT the Met, John D. Rockefeller Jr. appeared somewhat less than thrilled with its new director. In October 1940, Charles Collens, the Cloisters architect, wrote to complain that Taylor had installed a temporary exhibit, including some armor that "was so foreign to the spirit of peace" that a recent visit he'd made "was entirely spoiled." Junior summoned James Rorimer to a meeting to discuss it, but for the moment deferred to Taylor. But with Nelson otherwise engaged, his father was Boss Rockefeller again. So the fol-

lowing spring, when Junior asked that his six Polonaise rugs be returned, Taylor wrote personally to beg to buy two of them. Junior, who might well have given them as a gift to Rorimer, agreed to sell them at a one-third discount from what he'd paid, a total of $127,664.[65]

Junior remained totally engaged with the Cloisters, constantly plotting new purchases with Rorimer. Together, they kept Osborn from accepting the gift of an organ that they considered inappropriate. That was just before Pearl Harbor. Just after, Rorimer wrote to report that the Unicorn tapestries and some of the best stained glass had been among the first objects moved to the museum's "house in the country." He'd sealed the box with the tapestries himself.[66] Not long afterward, Rorimer thrilled his patron when he announced his conclusion—which remains in dispute—that those tucked-away tapestries had indeed been made for the marriage of Anne of Brittany.

Eight months later, tapestries were again the subject when the dealer Joseph Brummer wrote to offer Junior ten more, in a package deal with two buildings on Fifty-seventh Street, for $900,000. They were fragments of a set of fourteenth-century masterpieces depicting nine worthies of the ancient world (Alexander the Great, Julius Caesar, David, Joshua, and King Arthur among them) that Brummer had found being used as curtains in a French château; he'd bought all the contents of the room so as not to have to reveal their worth. The Met already owned another panel depicting King Arthur, bought in the 1930s. Junior admitted to Rorimer that he'd long coveted the tapestries—but "in view of the times" was disinclined to buy and donate them, adding that even though he was presently buying and not selling real estate, he wondered how much money was left in the Cloisters fund and whether the museum had any to spare.

After consulting Taylor, Osborn, and a couple of the trustees, Rorimer reported back that although there was only $72,000 left in the fund, everyone was interested, and he'd called the tapestries into the museum in an attempt to make the deal happen. Though he agreed to spend what remained in the fund if the trustees would pay the balance, Junior played typically cagey, telling Brummer he wasn't interested and, even if he was, he wouldn't buy the buildings. When Brummer replied that it was an all-or-nothing deal, Junior urged him to keep talking to Rorimer.[67]

Six days later, on October 22, 1942, Junior wrote to William Church Osborn, seething over a letter he'd received that morning from Francis Henry Taylor. Junior opened with praise of Rorimer, "whom I have found easy to work with . . . wise, diplomatic . . . and a close and unusually skillful negotiator and buyer." But then he segued to Taylor, who'd asked if they could meet to discuss the Worthies tapestries. He'd made his position clear to both Brummer and Rorimer, so could "see no useful purpose to be served by my acceding to Mr. Taylor's request for an interview and, quite frankly," if there were to be more conversations, he preferred to speak only to Rorimer, "who alone and for all these years has been the point of contact."[68] Having put the museum on official notice of whom he liked to deal with, Rockefeller sent a brief note to Taylor saying he was going out of town and was sorry "a conference will not be possible."[69] He already had a medievalist, Rorimer, and had no interest in a second.

Things simmered until December, when Taylor met Arthur Packard, Abby Rockefeller's financial adviser, who warned Junior that Taylor wanted a face-to-face to find out where he stood in the management of the Cloisters and to discuss the "frictions" he thought came from an "incomplete understanding" among Junior, Rorimer, and himself. A few weeks later, Junior wrote Taylor again to say that while he hoped the museum could acquire Brummer's tapestries, he really had no more to do with the Cloisters than "any other contributor," so felt it "inappropriate" to discuss its management "even if I were competent to do so, as I am not." He sent a blind carbon copy to Osborn.[70]

Six fraught weeks passed; in mid-February, Rorimer finished a report on the future of the Cloisters, and Osborn asked him not to show it to Junior, but rather to submit it to Taylor for consideration by a committee of four: Osborn, Lamont, Devereux Josephs, and Nelson. Rorimer agreed but promised to consult Junior before taking "any decisive step, or accept[ing] any imposed Trustee decision."[71]

This was a street fight played in the most cultured tones. Junior quickly tightened his ranks, writing a lengthy background memo to Nelson that spelled out his very strong feelings. Rorimer was brilliant, profound, meticulous, and exceptionally wise and shrewd and had a long relationship with Brummer, whom he always handled masterfully. He and Junior were

working a ploy, perfected over their long association, to win the tapestries for the Cloisters at the lowest possible cost, a charade revolving around expressions of disinterest from Junior. Taylor "appeared to resent Mr. Rorimer's having taken the matter up with me . . . While I am sure he is an able man . . . I have not found myself drawn to him." While Taylor very properly expected the prerogatives due a director, Junior had his own prerogatives and simply didn't want to deal with him or see him. Rorimer was afraid for his job, and since he'd made and loved the Cloisters, Junior wanted him happy. Period. "My fear is that because Mr. Taylor recognizes Mr. Rorimer as a much abler and more scholarly man than himself, he is jealous of him and is apt to so clip his wings that Mr. Rorimer will resign. This I should regard as nothing short of calamity." The letter was signed "Affectionately, Father."[72] Simultaneously, he said as much to Rorimer, making it clear he would find a way to let the trustees know his views. The battle lines were drawn.

Fortunately for all, Rorimer's report coincided with his classification as 1A by his draft board—meaning he'd be called up for duty at any moment. Taylor simply tossed the matter in a drawer and pointedly did not pass the report on to Nelson. Junior advised Rorimer that he was sure time and patience would solve any problems. Soon afterward Rorimer was drafted as an army private and was given a leave of absence to serve. A trusted assistant, Margaret Freeman, was left at the helm of the Cloisters.

She wasn't the only woman Rorimer left behind. He and Katherine Serrell, a descendant of the Plymouth Colony leader William Brewster, had met cute in 1932 in the museum library, where she'd gotten a job three years earlier, after graduating from Wellesley. Most of the other women employees were old. Family legend has it that when Rorimer showed up in the library one day and found a young woman working there, he was so taken aback he fell down a small flight of stairs. They dated others for several years. But in 1936, Rorimer's sister got married, and he suddenly got interested in Kay.

Three years later, after earning a master's degree from the Institute of Fine Arts, New York University's art history graduate school, which had close ties with the museum, and spending time at the Sorbonne on a fellowship, Kay went off to do research in medieval art and architecture at

Princeton. But she came back to work in the library—and to see Rorimer—every summer. The museum had become a much better place for women under Taylor, who let them eat with the men in the staff dining room for the first time. Sometimes curators would even have a glass of wine.[73] Kay and Rorimer married in November 1942 in the Episcopal church in her hometown.

A few months after Rorimer went to war, when the home front looked safe, the Met's art began coming back to New York (miraculously, only a few small items were damaged). By then, Rorimer had finished basic training, been promoted to lieutenant, and studied intelligence, military government, and languages in preparation for a job as a Monuments, Fine Arts, and Archives officer in postwar art preservation in Germany and France. Only then was the source of the friction between him and Taylor finally acknowledged. Taylor, who'd been declared unfit for military service due to his weight and various medical problems, despite a protracted attempt to serve, wanted the Unicorn tapestries moved to the main museum. Even from a distance, he was still trying to clip Lieutenant James Rorimer's wings and, consciously or not, insulting the museum's greatest benefactor. It is likely no coincidence that exactly two months after hearing that news, Junior had a list made of all of his gifts to the Metropolitan. They totaled just under $8 million.

Rorimer and Junior continued a sporadic correspondence when the young curator headed to Europe just after D-day. Junior fretted that the returned tapestries—he'd won, and they'd gone to the Cloisters of course—no longer looked right. Rorimer assured him that was only because the stained glass in the tapestry room hadn't yet been reinstalled. Rorimer's letters home were chatty and informative within the limits imposed by military censorship; much about his work in Europe would remain secret for decades. "Although my main purpose in Paris was to preserve buildings and to protect them and their collections from further abuse," he later wrote in a memoir of his wartime experiences, "it became increasingly apparent that I was in a position to gather intelligence for future operations in Germany in the course of doing my job." Thus, he became an art spy.[74]

Rorimer's key informant was Mlle. Rose Valland, "a rugged, painstaking and deliberate scholar" who was an assistant at the Jeu de Paume when

the Germans turned it into a clearinghouse for their looted art. She some-
how managed to stay at her post and gained vital knowledge about where
the Nazis were stashing looted art. A member of the Resistance, she would
frequently tease American and French officials with that information, but
initially, Rorimer wrote, "withheld her information because she feared that
it might fall into the wrong hands."[75] One of her most enticing leads con-
cerned Hermann Göring's twenty visits to the Jeu de Paume to make selec-
tions for his own private collection.

As the weeks passed, he and Valland began to work together closely;
she directed him to forty-six art-filled train cars the Nazis had left in a Paris
rail yard in their hasty retreat. Though they were mostly filled with "bric-a-
brac," the find proved her value. And she began to trust the American, pre-
senting him with photographs of high-ranking Nazi officers with looted art
and, more important still, revealing the location of their meticulously kept
records.

In April 1945, Rorimer was ordered to go to Germany to investigate
a cache of Nazi loot that had been found in a salt mine in Thuringia, west
of Weimar. Among his finds were windows, two chests of Rothschild-
family jewels, and Rubens's *Three Graces* from the Maurice de Rothschild
collection. Occupied Germany soon became the scene of a free-for-all
treasure hunt. "There were works of art everywhere," Rorimer writes, "and
information poured in faster than our limited personnel (my corporal and
I) could handle it. The lure of discovering hidden art treasures, together
with the desire for the sure-fire attendant publicity, appealed to many com-
mands. For weeks we were swamped with requests for guidance in the han-
dling of newly discovered works of art, and we had to choose among those
requiring immediate action."[76]

In May, Göring was captured by the U.S. Seventh Army, and Rorimer
was surprised to find his request to submit questions to the interrogation of
the SS master granted without hesitation. Göring, who described himself as
an art lover—*"Ich bin nun mal ein Renaissancetyp"* (After all, I'm a Renaissance
type)—gave up the location of his hidden collection within a day, and Ror-
imer sped off to Berchtesgaden, where he found a cargo car full of furniture
on the main tracks of the train yard, and later eight more cars and a two-

story cement bunker, similarly loaded with art, all hidden in the pre-defeat panic by desperate Nazis trying to hold on to their ill-gotten gains.[77]

After sorting through the Göring finds, Rorimer wound up in Munich on May 7, 1945, a few days after the city fell to the Allies. There was more looted art scattered all across the city, and his last job was to visit as many of the 175 repositories as he could and help set up collection points, where the long process of restitution would begin.

In January 1946, he was back in America with a Bronze Star—but with no assurance he would still have a job. He needn't have worried. Just six weeks earlier, Osborn had approached Junior with a plea for a donation toward a seventy-fifth anniversary fund drive meant to pay for his and Taylor's massive plan to rebuild the postwar Metropolitan. Junior demurred, telling Osborn it was "improbable" that he'd take "other than a purely nominal part, if indeed any." He was waiting to learn Rorimer's fate.

In early February, Rorimer went to see Taylor, whose antagonism appeared to have melted, though whether that was a result of the postwar glow or something Junior said is unclear. On hearing that the status quo ante was restored, Junior declared himself delighted and gratified and invited Rorimer to 740 Park to see if there were artworks there he would want for the Cloisters "if they were in the market and [they] had the money." Rorimer played along and chose a van der Weyden, two Duccios, two fifteenth-century Burgundian portraits, and the Piero della Francesca *Crucifixion* and *Deposition,* but advised that the Cloisters could never afford them "unless through your auspices."[78] It was as if their flirtatious collaboration had never been interrupted.

ALTHOUGH THE FIRST MOVE WAS MADE BY NELSON ROCKE-feller, the seventy-fifth anniversary fund-raising campaign, the Metropolitan's first attempt since its initial membership drive to solicit money for its operations, was really inspired by Robert Moses; within eight years of joining the Met board, Moses had succeeded in rewriting the terms of the city's collaboration with the museums that sat within its parks. In the spring of

1942, Moses was collecting proposals for a citywide public works program to provide immediate employment after the war ended, and in response Taylor pressed the trustees to think harder about the future. Besides the Blumenthal house, they had been offered a mansion owned by the Duke family, and Taylor, like most museum directors who followed him, was aching to expand his turf. He called the museum's lack of a master plan a crisis and its current layout "a prodigal waste" of space, pointed out that its heating and electrical systems were virtually obsolete (there were steam radiators in the center of many galleries), and insisted that decisions had to be made before the need to reinstall the collection on its return from wartime storage was upon them. Planning soon began in earnest.

As the collection returned to New York, the curatorial staff finally reconciled itself to Taylor. He'd made a great effort to win them over, inviting them to play a far more active role than they'd previously been allowed in making purchase pitches to the trustees, for example. The purchasing committee often met for dinner at a private club, and curators with objects under consideration were invited and seated among the nabobs, then asked to make a personal pitch and answer any questions. Though Taylor would sometimes second-guess his staff and urge "no" votes once the curators had left the room, he was usually able to blame the trustees and walk away unscathed.

Robert Moses's first impression of the new director was changing, too, however. Never a huge fan, Moses now worried about Taylor's intentions, and so did some trustees, who were against the sort of modernist architects Taylor wanted to consult on the postwar program. A month later, Taylor proved their concerns were real when he threatened to give the museum's building back to the city and floated a plan to knock down Carrère and Hastings's monumental New York Public Library at Fifth Avenue and Forty-second Street and replace it with "a new tall building of the most modern kind" to house both the museum and the library. Moses immediately dropped any pretense of diplomacy and called Taylor "an egotistical crackpot" in a memo to an aide that he copied to half a dozen city officials. "You get a rough idea from this of the sort of fellow we are dealing with, and of the importance of keeping an eye on his moves."[79]

Moses hinted at his next move in another letter to Van Webb, won-

dering if the museum planned to pay for its own reconstruction or would ask for "part of the design money from the city."[80] Unbeknownst to Taylor and the trustees, he'd already decided to demand that the city's wealthier museums cover half the costs of any reconstruction and new construction all by themselves. Its 1941 annual report didn't advance the museum's case. Moses was shocked to "find nothing [in it] to indicate that the city is anything more than an Uncle Sam bank from which the Museum draws its own savings to pay for chewing gum and other accessories," he observed. "They are certainly an arrogant gang!"[81]

In June 1942, with a $4 million reconstruction plan almost finished, Taylor took a two-month leave of absence, ostensibly to make a goodwill tour of Latin America with Nelson Rockefeller to shore up support for the Allies. But his daughters later learned that "he was really following clues he'd been given about Nazis who'd taken art from Paris and was trying to find it," says Pamela Taylor Morton, who adds that both before and during the war her father "helped bring people who were in danger out of Europe." He wasn't going to let Rorimer have all the fun.

In Taylor's absence, Van Webb sought to reassure Moses that the board would not ask for any branch museums in its request. On his return, Taylor proved he could manipulate the board as well as Moses: learning that the commissioner wanted the museum to pick up half the cost of plans and drawings for the postwar work, and would not allow it to use the money appropriated more than a decade earlier for the never-built northwest wing, Taylor pressed Osborn to express official regret that the city wasn't living up to its part of the decades-old bargain with the museum.[82] Osborn agreed that Moses's intractable stance raised a "grave question."[83] But the new reality was dawning on the trustees, and by January the seeds of the seventy-fifth anniversary campaign were planted. Though they clearly preferred the status quo, with the city paying for new buildings, and had decided against dipping into their endowment (which then held about $40 million) to do that themselves, they did agree to try to raise the money elsewhere.[84]

In *Where Is the Metropolitan Museum Going?* a sixty-five-page report issued in January 1943, Taylor painted his vision of the postwar challenge to the Met in a frame of erudition and eloquence. The museum had to be nothing less than a university of civilization, one of the few in the world; Taylor

credited Paris, Rome, London, and Berlin as its only equals, but forcefully reminded the trustees that those cities had been bombed, burned, looted, and demoralized and so would not be up to the job for years. The Met, then, would have to shoulder the burden of restoring the world's spirits and intellectual standards virtually alone. Lucky, then, that before the Depression and the war, the Morgan-era museum had been stuffed to the gills with cultural goodies, "beyond the dreams of avarice," Taylor wrote, as post-tax, postwar generations of the wealthy could and would never again be so grandly beneficent.

Assimilating those treasures was the first priority, and to do that, the museum needed a modernized physical plant and a larger, better-paid staff. The buildings lacked not just creature comforts like air-conditioning but such basics as hot water, proper ventilation, and humidity controls; the coal-burning power plant spewed out soot. Taylor foresaw the need to modernize those systems and dreamed of greatly expanding the museum to the southwest. His idea was to rebuild the museum physically and reinvent it as well, creating five smaller specialty museums within a museum, each with its own entrance, showing respectively paintings and prints and ancient, Oriental, decorative, and American art, all arranged chronologically with an almost purely pedagogical purpose. To serve his goal of broadening the museum's popularity by making it more accessible and entertaining, he also wanted to install escalators; build a new auditorium; rebuild the ground floor to house study-storage rooms, the unloved musical instrument and cast collections, the library, a restaurant, shipping, receiving and cataloging, education and other outreach and community efforts; get the museum involved in the new medium of television, bringing art to those who couldn't get to New York City; and offer tiny radio-operated headsets for private gallery tours. The costs beyond the $4 million the Met had already requested? At least $25 million.[85]

Back from his summer house on the Connecticut shore that fall, Taylor kept up his push for the trustees to make decisions on rebuilding and expanding, insisting that the latest iteration of his plan—which would increase exhibition space by about a third, move the entire American Wing, complete with its courtyard, from one end of the museum to the other, and build the Whitney Wing, auditorium, and new decorative arts galleries—

would cover all the museum's needs for the next fifty years. Finalizing those plans would cost only $180,000, and he wanted the board to pay it. But Roland Redmond, for one, wasn't so sure the trustees should pay for a building the city would own, and Osborn argued that in the end the city might cough up more cash after all.[86]

Unfortunately, Moses wasn't playing ball; the Whitney merger still had not been finalized, and he'd heard from Taylor and Redmond that the real reason for the delay was a family squabble. There was at least some truth to that. Sonny Whitney was angry, felt he'd been cut out of the loop, and "wanted to do a museum of Western art in Cody, Wyoming," says his niece Flora Biddle, Flora Whitney Miller's daughter. "Something with his name on it that he controlled. But it wasn't only Sonny who didn't think [the merger] was appropriate. It was the whole staff, including my mother." Moses wanted a final decision, wanted new plans from the Met that addressed both the Whitney board's objections to the existing ones and the possibility that there would be no Whitney Wing, and also pointedly warned Taylor that the museum's chance of taking more land in Central Park would depend on its "look[ing] like a completed building from the outside, and operat[ing] like one from within."[87]

A WELCOME BREAK FROM ALL THE SQUABBLING CAME THAT November when Jules S. Bache announced his desire to give his art collection to the museum. Bache, the son of a wealthy German-born merchant, owned the brokerage house J. S. Bache & Co., which had been founded by an uncle. He was a corporate director and an antitax activist who was obsessed with European aristocracy. He was also "a well-known man on the town," Tom Hoving says. "I mean really a reprobate," who would eventually die "in the arms of his black mistress on the West Side," Hoving continues. "In those days, it was probably worse to be on the West Side than it was to have a black mistress! On the East Side, it might've been okay!"

But that was known only to a few. Many knew of his collecting, which began with French furniture and before World War I moved into painting, favoring pictures with distinguished provenance. A client of both the un-

scrupulous Joseph Duveen (who served as his decorator as well) and Jacques Seligmann, Bache bought about $6 million worth of works from Duveen, including many that had been misattributed by Bernard Berenson. His fortunes foundered during the Depression, right around the same time that he learned he'd often been snookered, and he stopped buying art. But by 1943, when he was eighty-two years old and stepped back from business, his fortune had been restored along with his reputation for discerning taste. His collection was considered important enough that at a special meeting of the executive committee that November, it reversed an earlier decision to reject his condition that the sixty-three paintings and objets d'art be kept together in contiguous galleries labeled with his name. A threat to give it all to the National Gallery if the trustees refused likely played a part in that decision.

At the same time, Taylor announced that detailed plans had been drawn up "for the radical post-war reconstruction of the museum building . . . though it is not yet wholly clear where funds will come from," the *Times* pointedly added.[88] Though the Whitney merger seemed to be on permanent hold, another collaboration that would provide the museum with a huge future payoff was easily accomplished in 1944, when the seven-year-old Museum of Costume Art agreed to move its operations into the Metropolitan and became the Costume Institute. That museum was founded in 1937, and its first holdings were a group of period garments owned by Lee Simonson, a scenic designer, and another of theatrical costumes collected by Irene Lewisohn, whose cousin Sam was a founding trustee of the Modern. Irene and her sister Alice had founded the Neighborhood Playhouse, one of the first off-Broadway theaters; it evolved into an acting school, and the museum then opened in its premises. The idea of this first fashion museum in New York was not only to collect and protect historic clothing as applied design but also to give New York's fashion industry a patina of art and an inspirational resource center for the study of design and technique.

Initially, the costume museum presented annual shows in Rockefeller Center, curated by a costume designer and featuring talks by experts ranging from textile authorities to executives of what was then called Bergdorf & Goodman, the carriage trade specialty store. Immediately, it became a magnet for donations from social and fashion folk like Mrs. August Bel-

mont and Elsa Schiaparelli. Its second exhibit, in 1938, attracted forty-five hundred visitors. By 1939, it had leased a permanent home in Rockefeller Center. Two years later, Lewisohn invited Robert Moses to visit her "small museum." With war raging in Europe, American communication with the Continent's well-developed fashion business was cut off. Seventh Avenue, as this vitally important New York industry was commonly called, had previously depended on Paris fashion for direction. Now it needed its own lodestar.

In 1943, Lewisohn encountered financial difficulties and formed a committee to keep the Museum of Costume Art alive. Dorothy Shaver, an executive of Lord & Taylor, a fashionable Fifth Avenue department store, became the prime mover in an effort that also included the Central Needle Trades High School and garment workers' unions. Their job became more urgent when Lewisohn died early in 1944. "There were three or four of us who went to [Francis Henry] Taylor and said, 'Couldn't we have a Costume Wing?' since there was a furniture one, an American one," the late fashion publicist Eleanor Lambert recalled to the author Eleanor Dwight. "We said it could be an inspiration."

Taylor, who'd seen at Worcester that clothing exhibits could be popular, told the group that if it would raise "a token fund" to make the institute self-supporting, they could have what they wanted. "So we wrote a letter to people in the industry who were very, very, very rich men in factories rather than designers, and we said, 'Nothing under $10,000,' but if you give this we promise we'll never ask you again." Though Taylor had asked for between $150,000 and $250,000, they raised $350,000 (including a $50,000 bequest from Irene Lewisohn's estate), "and that's what started it," Lambert said.[89] The Metropolitan negotiated the right to run the institute as it wished in consultation with an advisory committee made up of the institute's boards and representatives from the fashion industry. When the takeover was announced in December 1944, Osborn, who'd pushed hard for the deal, stressed its practical and educational advantages for the fashion industry. Shaver was even more direct, saying that the move demonstrated "a desire on the part of a great museum to serve effectively the American fashion industries."

Though the museum took over immediately, a physical merger had to

wait until peace was restored. But a year later, in May 1945, the first exhibit planned under the Met's auspices opened in the Morgan Wing and made it plain that the founders' intention to encourage "the application of art to manufactures and to practical life" was finally being made manifest by Taylor's museum. Fashion and textile designers were asked to choose inspiring objects from the museum's collection and create designs based on them. Designers like Adrian, Adele Simpson, and Norman Norell showed dresses that featured Greek architectural motifs, and fabrics inspired by a necklace worn by a statue of the Egyptian queen Nefertiti.

The Costume Institute, which by then held seven thousand articles of clothing, finally moved into the Metropolitan in the spring of 1946. Originally, it was thought the collection would be moved into a building connecting the museum proper to the planned Whitney Wing. Instead, it went into a basement at the northeast corner of the museum, where it would remain until 1970.

Despite its less than chic quarters, its ties to the fashion industry quickly grew even stronger. Decades later, critics would condemn the commercialization of the museum by its association with the fashion industry, but that horse had long since left the barn. In February 1947, another department store, Bloomingdale's, gave the museum twenty-six outfits from that year's spring collections, the first created since wartime restrictions on fabrics had been lifted, to celebrate the seventy-fifth anniversary of both the store and (belatedly) the Metropolitan. After they were displayed at a lunch where the gift was announced, the outfits went straight into Bloomingdale's windows for a week before arriving at their final home at 1000 Fifth Avenue. What effect the museum's imprimatur had on sales went unrecorded.

Another Costume Institute innovation was its Party of the Year, an annual gala planned by Lambert and Shaver to raise $25,000 a year to add to its endowment and, the board hoped, generate publicity and prestige. The first, held in 1948, honored the designer Norman Norell. The second, a supper dance at the Plaza hotel, featured a show of Belle Epoque fashion. A pageant of wedding gowns was the attraction at the third. At another, the entertainment featured Francis Henry Taylor and a designer competing to see who could transform ten yards of fabric into an evening gown on a model faster; Taylor lost. Though the Party of the Year would eventually

become a social spectacle, in its early days, before designers became known quantities, it was simply an industry event. "It was basically Seventh Avenue, a lot of Jewish people," says an institute staffer. "A rabbi's wife who knew everyone did the seating."

⬥

THE MUSEUM OF THE FUTURE WAS ALREADY TAKING SHAPE, BUT Robert Moses wasn't ready to celebrate. He was still waiting for the trustees to agree to pay half the costs of any postwar reconstruction, and he was getting angrier by the minute at their refusal. Osborn had Moses's demand for answers copied for each of the trustees on attention-getting thick, heavy paper, along with a similarly printed cover letter to the board, alerting it that the museum's sweetheart deal with the city was being threatened, as was its financial viability. Though the eighty-one-year-old president's signature had grown noticeably shaky over the years, this time it was as emphatic as his warning.

The response from Moses was, if anything, even stronger, accusing Osborn of "astonishing misrepresentations," indignantly pointing out that the museum had recently received unexpected gifts totaling more than $3 million, and tackling head-on Osborn's concerns about paying for buildings on city land by noting that the de Forests had done just that with their American Wing and that the Whitney trustees had just offered to do it again assuming they and their Met counterparts could ever agree. He ended by noting that he had supported the Whitney Wing despite the likelihood of "considerable protest" from those "who do not believe in surrendering any more park land" to the museum.[90]

A few days later, when Osborn called a special board meeting, Moses asked his representative to point out to the trustees that the museum president also served as vice president of a city budget commission that had just blasted the city's postwar building plans as extravagant. "I don't know how many shoulders a really talented old gentleman can carry water on," he quipped, "but Mr. Osborn is way up among the record holders."[91] Finally, after that meeting, the battered trustees realized that Moses had painted them into a corner.

Within a month, a revised plan was developed, but the Parks officials judged the whole unwise and impractical and couldn't help but notice that Osborn kept vacillating and the question of financing the work was being "piously avoided."[92] But Osborn was still stuck in the past, railing against the commandment from Moses that the museum had to come up with more money. The planning—and the posturing—continued. Osborn even told the latest man from the Parks Department that he would have to leave the boardroom the next time money was discussed. Instead of rising to the bait, Moses simply stood his ground.

Finally, the new reality sank in, and at the March board meeting Osborn was authorized to appoint a committee to plan a public drive for funds tied to the museum's seventy-fifth anniversary. A month later, Moses appealed to the budget director to give museum employees paid by the city a raise. "How would you like to manicure lions and tigers for 1900 bucks a year?" he wrote. "What about explaining . . . Siamese Madonnas of the 14th century to a bunch of hicks from Medicine Hat?"

Still, Moses wasn't satisfied, since Osborn kept stalling, would not commit to paying for buildings, and never got around to appointing the fund-raising committee. Meanwhile, Moses kept tabs on the museum's investments and was likely delighted to learn that thanks to the economic engine of war, the market value of its endowment had risen $5.6 million in 1943. Much of that fall was spent fending off an attempt to unionize the staffs of all the museums. Once again, behind the scenes, Moses was an unlikely advocate for the museums, urging La Guardia to raise salaries quickly.

Optimism was in the air early in 1945. By May, the war in Europe would be over. Japan would surrender in August. A new spirit had entered the boardroom of the museum, too. Planning for its seventy-fifth birthday and the accompanying $7.5 million fund-raising drive to finish the museum's buildings forever was in the works, the Whitney board had expressed happiness about the latest set of plans for its wing, new trustees were beginning to fill the empty seats on the board, and the executive committee was even beginning to tire of what some members saw as Osborn's obstructiveness.[93] After five years in office, Francis Henry Taylor could finally look forward to a bigger, better museum in years to come. And briefly,

it even appeared that another European war would offer the museum an unprecedented opportunity to acquire a singular masterpiece.

The *Pietà Rondanini,* Michelangelo's last work of art, left unfinished on his death, was owned by an ancient noble Italian family who decided to sell it at the end of the war. Myron Taylor, a trustee then serving as America's envoy to the Vatican, got wind of the fact that it could be had for $700,000. Hypnotized by the idea that they could acquire the first Michelangelo sculpture in the Western Hemisphere, the executive committee decided to pay that price if necessary to get it. As they knew the new National Gallery and other museums, too, would "give several right eyes" to get it, the committee decided to proceed in total secrecy. Though the museum would have had to spend every free penny it had for the next eighteen months to acquire it at that price, Moses declined to interfere, although he did tweak Taylor for crying poverty to him while simultaneously negotiating for the Pietà. But it was not to be. When word of a possible sale leaked in Italy, the government refused an export permit. It was eventually sold to the city of Milan for a third of the $600,000 that the Met finally offered.

In March, the trustees moved to fill four more empty board seats. Initially, Moses was sheepish about making suggestions, even asking Van Webb if there was any sense in trying. "Perhaps the club atmosphere must be maintained," he said with a sigh.[94] But when Webb replied that many of the trustees wanted a more useful and qualified board, and Moses learned that the museum study had suggested filling vacancies with representatives of the press, department stores, and religious groups, he renewed his star-crossed nomination of Joseph M. Patterson, added the name of the Laura Spelman Rockefeller Memorial Fund's director, Beardsley Ruml, and once again noted the absence of women on the board, suggesting Anna Huntington, Archer's wife, and Helen Reid, whose husband, Ogden, owned the *New York Herald Tribune.* The board again snubbed Moses, electing Arthur Hays Sulzberger, publisher of the *New York Times* (and the board's third Jewish trustee), and Walter Gifford, the president of AT&T, instead, proving a prediction Moses had made to Webb: "Art is to continue to be caviar." Out of reach of the public at large.[95]

Gifford, Moses complained, was more of the same, just another cor-

porate officer. And Sulzberger, though a friend, lacked the "ingenuity, force and support" Patterson would have lent to the board, and "has a pedestrian mind . . . and will simply be another fellow who goes along."[96] Webb wrote back that he was disappointed, too, but thought Sulzberger at least to be a good choice (he was right; it would be years before the *Times* was again critical of the museum). Moses copied the whole exchange and forwarded it to Taylor, then dropped Webb one last word on the subject.

If asked for recommendations in the future, he wrote, "I shall offer the social register."[97]

THROUGH THAT SUMMER, MUSEUM PEOPLE, LIKE MOST IN THE world, were consumed with current events, but by the fall normal life was resuming. In the meantime, the seventy-fifth anniversary committee, led by IBM's Thomas Watson, had finally been appointed, budgets and contracts for the building rehabilitation set, a drive to recruit twenty-five thousand new members organized, and the law committee put to work devising justifications for corporate donations to the museum. The Whitney plan seemed to be moving forward, too, with the arrangement of galleries under active discussion. In September, Moses and Osborn agreed that the city would pay about $2.4 million toward the improvement of its existing buildings, and the museum would come up with $1.7 million. At the same meeting that saw that expenditure approved, Dudley Easby, a lawyer who'd worked with Nelson Rockefeller, was named the museum's secretary. Repeating Osborn's description of him as "a work-horse type, lacking the social qualities" of his predecessors, a Moses aide cracked, "The club is sure going to hell."[98]

What was sure was that the club was in the red. The 1946 budget anticipated a $377,000 deficit, half of it due to the costs of fund-raising, the return of employees from the war, and increased costs for just about everything. And then there were the pesky organizers, still trying to unionize the guards; more than half had already signed up. It was against this backdrop that the diamond jubilee campaign was launched in April to "meet the total future requirements of the institution."[99]

At the kickoff on April 2, the war hero and future president General Dwight D. Eisenhower was made an honorary lifetime fellow to recognize his success in protecting and recovering artworks in Europe (a matter the museum knew about quite well through the work of Taylor, Rorimer, and a newly hired associate curator of paintings, Theodore Rousseau, who had worked at the National Gallery before the war and then been a lieutenant commander assigned to the Office of Strategic Services' Arts and Monuments team). The estimated cost of the museum Taylor had envisioned had risen to $10.24 million (and by May the architecture committee would raise that estimate again to $16.6 million).[100] As bait, the elaborate brochure appealing for funds ended with an elegantly typeset list of all the museum's benefactors and an invitation for a new generation to join their ranks.

Unfortunately, the public didn't bite quite as fast as the trustees hoped. Devereux Josephs, the treasurer, had become Taylor's confidant on the board after Taylor moved to a coastal town in Connecticut where Josephs had a summer house. Taylor suggested balancing the budget by, among other things, reinstituting admission charges, creating a permanent fund-raising department, and studying ways to better utilize restricted donations. By the fall, though purchases of art objects had picked up again, he'd also be considering eliminating jobs, nudging aging employees into early retirement, and closing the museum on Mondays. Taylor couldn't catch a break. And his life was about to get vastly more complicated.

The good news was that William Church Osborn, whose wife had died a year before and who'd been hospitalized earlier in the year, had decided to retire, though he would remain a trustee and honorary president until his death at age eighty-eight in 1951. The bad news was that his successor, Roland Redmond, who not only lived near Osborn on the Hudson River but was related to him by marriage, would take after his old family friend J. P. Morgan and be a very active president. His first actions were a sign of things to come, cutting back on full board meetings and giving more power to the executive committee.

Sonny Whitney quit the Met board in February 1947. At the same time, Nelson Rockefeller, who'd tried to quit a year earlier (the board simply ignored his resignation), reopened the conversation between the two museums about how to handle modern art; potential donors to the Modern, where Nelson remained president, had proved unwilling, worried that it would fail. Francis Cormier, a Moses aide, came away from a board meeting worried that Whitney's resignation spelled more delay for the merger with the Whitney. Rockefeller was looking to the middle distance and wanted to end the state of confusion among the three museums.

In April 1947, a working agreement was being hammered out among the three museums to buy works with Met funds but place them in the Modern for about fifty years and then move them to the Met once they were deemed classic, the term agreed upon to describe older art. The Modern committed to sell works it owned that had become classics to the Met, and all three agreed to generally work together more, communicate, cooperate, loan one another objects, and avoid duplication of efforts and conflicting exhibits.[101] The Met would stick to old art, the Whitney to new American art, and the Modern to the modern art of the twentieth century. The Met soon identified Modern works with an agreed-upon value of just over $500,000 for purchase (ten Cézannes, including *The Bather*; six Matisses; two Picassos, including *Woman in White*; two Rousseaus, including *The Sleeping Gypsy*; six Seurats; two Signacs; and van Gogh's *Starry Night*). That figure was cut by more than half before the ten-year deal, known as the Three Museum Agreement, was finally signed. Nelson Rockefeller was in on the negotiation, but the proposed arrangement was a sweetheart deal for the Met, which stood to gain thirty years of modern art with little expense or effort. The Whitney, however, really took it on the chin. It got to disappear into the Met. So it took months of negotiation before a final agreement was hammered out.

Nelson's father remained of two minds about the Met. In the spring of 1946, he'd asked James Rorimer to remove his name from the identifying labels of most of his gifts to the museum. But only a few days later, Devereux Josephs sent him a financial report on the Cloisters so detailed it even included a section on how much clerks and mechanics were paid. The next year the Rockefeller Brothers Fund, a philanthropic organization set

up by Nelson and his brothers, gave the museum $25,000, and after he got a letter asking for suggestions to fill six vacant seats on the board, Nelson wrote Redmond, gently reminding him of his request to be relieved. His "very ambiguous situation" would remain unresolved for four more years, as first Easby and then Redmond asked him to postpone his departure, even though he'd stopped attending board meetings. By January 1951, when he and the board agreed he would become an honorary trustee—that is, one without duties or obligations—Nelson was the fourth-longest-serving trustee after Marshall Field, Elihu Root Jr., and the inactive Osborn.[102]

In the meantime, his father started paying close attention to the Cloisters again. In 1944, Junior reopened his talks with Brummer about the Worthies tapestries that had provoked the rift between Rorimer and Taylor. He still wanted to get them for the Met and asked if they could talk not "as a buyer and a dealer" but as "two citizens."[103] After two meetings, the price remained too high, but still Junior wouldn't give up plotting to get them. In 1946, he gave another thousand shares of Standard Oil of New Jersey to pay to rearrange the tapestry room and buy a mantelpiece from Brummer, and on Rorimer's return to the museum he again tried to get the dealer to lower his price for the tapestries.

Everything changed when Brummer died in April 1947 and his collection of about 150 objects, many never seen before, was offered to the Met. Though the executors were asking more than $2 million, and the museum was offering only half that, Junior was willing to cover $750,000 of the price and was pushing the museum to make a deal for about half the collection (including the tapestries of course). The museum wanted a few other items for the main building. By July, the deal was made for $1.3 million, and the stock Junior handed over—delivered to Roland Redmond in a three-inch-thick stack of certificates—was sold for more than $1 million, more than covering the cost of everything bought for the Cloisters. Though Taylor and Redmond had offered the Brummer estate a show in the main building, Junior objected, not only because he felt Brummer's protracted tease didn't justify it, but also because he wanted the glory for the Cloisters. As always, he got his way.[104]

The Brummer purchase was announced in mid-September, with Rorimer revealing for the first time that the museum already owned other bits

and pieces of the tapestries so the set was nearly complete, a feat Rorimer called "one of the most exciting adventures in reconstruction ever undertaken in the museum."[105] Another exciting and unprecedented adventure—the Three Museum Agreement—had been approved just a day earlier, and it was announced on September 21. Several works of art were immediately transferred, including Picasso's portrait of Gertrude Stein, which she'd left to the Met in 1946; it was loaned to the Modern. Though the agreement referred in passing to the stalled "coalition" with the Whitney, the joint press release didn't mention it at all.

The Whitney had won a few concessions from the Met. But the arrangement was not to last, and the Whitney's management blamed Taylor for its failure. "The crux of it was," says Flora Biddle, "the Metropolitan people didn't care about American art and the Whitney people were very concerned about that."

Though it has been alluded to before, the fullest account of what happened appears in Avis Berman's entertaining biography of Juliana Force, *Rebels on Eighth Street.* It was obvious that the Three Museum Agreement wasn't working, so in February 1948 Redmond invited the top men from the Modern and the Whitney to a dinner at the private Brook Club. Over dessert, Taylor and his vice director turned provocative, claiming the Whitney curators only cared about New York abstract artists and didn't know anything about the rest of America. Taylor sneered that Whitney openings were populated by men in blue jeans.

"Those are the artists," he was told.

Furious, the Modern and Whitney teams went to Force, who was dying of cancer but loved a good fight, and told her what had happened. Convinced that her friend Taylor was an irredeemable reactionary, she resigned as the Met's Hearn adviser and insisted the merger be called off. By May, Flora Miller had met with Redmond and agreed with Force, but they announced only that the deal was postponed. The break was finally made public in October, after Force died. The Whitney's statement cited "serious divergences in the attitude toward contemporary art of the two institutions" that "raised grave doubts" and "outweighed the many advantages of the coalition." The cover story was a thin one. "It was obvious to anyone on the inside of the art world that the target of this statement was Francis

Henry Taylor," wrote *Newsweek,* "a man reputedly cautious—even downright reactionary in his approach to 'modern art.' "[106] Soon, the Whitney moved, first to land donated by the Modern in the old Rockefeller neighborhood of West Fifty-fourth Street, and then to its current location on Madison Avenue.[107] Redmond was convinced the Whitney trustees were simply afraid of losing future bequests to the Met.[108]

Robert Moses was furious when he learned in August that the merger had collapsed. He'd already had his doubts about Redmond, who'd been on the New York City Art Commission the year before when it sued to stop his plan to raze the 1807 Fort Clinton at the tip of lower Manhattan. In retaliation, Moses left the museum out of the 1949 city budget, even though Redmond was pressing to proceed with the rehabilitation of its oldest wings. The Department of Parks instead scheduled that work, which represented about a quarter of Taylor's master plan, for 1953 and 1954, with completion estimated in 1958.

Thus far, the seventy-fifth birthday drive had brought in $1 million; Thomas Lamont had left the Met the same amount when he'd died early in 1948 (and was soon replaced on the board by his son); the Panama Canal promoter William Nelson Cromwell had willed the museum $450,000; and another windfall came with the death that same year of the lumber heiress and portrait painter Catherine Denkman Wentworth, who left the museum almost $4.5 million (along with a renowned collection of French silver and gold snuffboxes). It was more than enough to cover the museum's share of the work, so Redmond pressed for an earlier city appropriation. In response, Moses told him that due to his role in the "futile and basically malicious" Fort Clinton lawsuit, he could not "expect special attention and effort" in solving the museum's problems.[109] By October, the museum had retrenched, abandoned Taylor's building plans, and was asking only for funds to repair and modernize its existing buildings. Unmollified, Moses told them they'd have to start from scratch with new plans and cost estimates.

Briefly, the trustees considered buying 998 Fifth Avenue, a venerable McKim, Mead & White–designed Italian Renaissance–style apartment building across the street from the museum, for its administrative and research offices, some specialized collections like the unwanted musical in-

struments, and the library. Its builder-owner, James T. Lee (grandfather of Jacqueline Bouvier Kennedy), was in deep financial trouble and offered 998 at the bargain price of $900,000. Taylor had plans drawn showing how it could be connected to the museum with a tunnel, but Moses thought it "a thoroughly bad idea," and the executive committee finally decided not to evict the seventeen families renting there, some of them contributors, in order to take it over.

After the 998 deal died, the museum and Moses finally reached an accommodation. The rehab work began, with the museum loaning the city its half share until 1951, when that money would be repaid. Redmond might have been the president, but Robert Moses was the boss, albeit one with a puckish sense of humor. When the museum mailed him a membership appeal that listed all the trustees except the public officials, Moses sent Redmond a note asking if he'd "painlessly got rid of us."[110]

They hadn't, but the trustees did approve a program to get rid of duplicate and secondary art and save on storage bills as galleries were emptied for the impending work. It was the largest sell-off since the Cesnola deaccessioning. Many curators opposed it, though, and Taylor was reluctant, so it stalled for several years.

All the while, Rorimer and Nelson's father were growing closer than they'd been before the war. In November 1947, the curator gave his patron a private tour of a loan exhibition of 175 famous French tapestries, including a dozen from Versailles, that had been delivered to New York on a French battleship—"one of the most important exhibitions ever held in the museum (Taylor's opinion)," according to a Moses aide.[111] Others were rising in the museum hierarchy; Bobbie Lehman was elected a vice president, and Taylor was made a trustee after nearly doubling attendance to more than two million and bringing in a $143,000 surplus (thanks in large part to his greatest innovation, the international loan shows he championed), but Junior's power was undiminished. At seventy-three, he was getting on in years, but he still operated autonomously through Rorimer at their very successful little museum. It seemed to have none of the problems that plagued Taylor and Redmond downtown.

That summer, Rorimer went to Europe to try to find more scraps of

the Worthies tapestries. In May 1949, Junior annoyed Taylor by engineering a promotion for Rorimer; henceforth, he would be known as the director of the Cloisters as well as its curator.[112] In the years to come, they would work together to buy the Antioch Chalice, allegedly the cup used by Christ at the Last Supper, for $125,000, and the so-called *Mérode Altarpiece,* a triptych by Robert Campin of the Annunciation, from a financially strapped Belgian noble family for $778,000. When Ted Rousseau, who'd rapidly become a significant buyer in the European paintings market, heard it was for sale in 1956, he and Rorimer flew to Switzerland to examine it in a bank vault.[113] "The price was negotiated in accordance with our understanding," Rorimer reported to Junior. "I am under obligation to the owner not to reveal the price publicly, either now or in the future . . . The important fact is that we have it." Junior congratulated him on doing the impossible.[114]

"It's a great game," Rorimer once said. "The only way we can win is by getting the pieces we need most."[115] The Rockefellers were, of course, equally adept at the game. When she died in 1948, Abby left two van Gogh drawings to the Metropolitan, but it would get them only after they spent the next fifty years at the Modern. Taylor was one of seven trustees at the meeting of the executive committee where the bequest was accepted without the usual expressions of gratitude.

If foolish consistency is the hobgoblin of small minds, then Taylor's was obviously a large one. Though he sought advice from modern architects, he fought the advocates of modernism in art. Yet he also made one crucial hire that edged the museum into art's present. Late in 1948, he called an art critic, anatomy and drawing lecturer, and former vice president at the distinguished art school the Art Students League and asked him to head a new department of American paintings and sculpture. His taste for modernism aside, Robert Beverly Hale fit perfectly into the patrician precincts of the Metropolitan. He was descended from the brother of Nathan Hale, America's first spy in the Revolution. His grandfather the Reverend Edward Everett Hale was an author, Unitarian minister, and, late in life, chaplain of the U.S. Senate. His father, an architect, died when Hale was just a boy. His mother, Margaret Curzon Marquand Hale, was a distant relative of the Met president Henry Marquand and aunt of the novelist J. P. Marquand.

Hale would refer to his parents as "upper Bohemians," part of the affluent set that supported the early American avant-garde. When he was a teenager, his mother introduced him to Picasso and Matisse.[116]

Taylor's call came "out of the blue," Hale recalled, when he was forty-seven years old. "Francis made it very clear that it was an enormous job."[117] He had to silence the museum's critics, who were aware, even if the museum wasn't, that American art was enjoying its first great flowering since the era of the Met's founding. "There was so much Hearn money left, they had to do something," says Hale's widow, Niké. In his public announcement of Hale's hiring, Taylor pointedly noted that he had "never allied himself with any group or movement."[118] But in fact, Hale saw the importance of the very group and movement—abstraction—that so threatened the trustees.

Right from the start, "it was terrible," says Niké Hale. "The Met really didn't want contemporary art. There was so much animosity, from Roland Redmond particularly. He was wonderful but conservative; he hated abstraction. He just wanted Rembrandts and Vermeers."

"I was in with the last of the Victorians," Hale would recall of the museum, which had "enormous funds . . . but not much taste for contemporary art." Early in his tenure, Taylor had arranged a meal at a midtown club with a group of artists and some trustees who hoped to learn. Asked how to tell a good picture, one artist asked if his questioner had ever walked by the ocean, admired a glistening stone or shell and picked it up to take it home. "I don't believe I ever have," the trustee answered.[119]

Three days after Hale was hired, James Naumburg Rosenberg, a New York lawyer who'd just retired to become an artist, opened a correspondence with Robert Moses about the Metropolitan's attitude toward contemporary art. When Moses expressed interest, Rosenberg warned that he intended to "stir up a hornet's nest." He'd decided the Met was moving backward, despite Hale's arrival, and planned a series of nine daily open letters to Redmond, detailing its sorry track record, hoping the press would pick up on the story. A life member of the museum, he intended to make a fuss at the next annual meeting, too.[120]

In essense, Rosenberg demanded that the Met cancel what at that point had become a two-museum agreement and begin collecting modern art on its own if it was to be the "vital dynamic educational body" demanded

by its charter. How, he asked, could the museum not own a single Seurat, van Gogh, Matisse, Rouault, Modigliani, Braque, Chagall, Bonnard, Vlaminck, or Utrillo? How could it be that its only Picasso was at the Modern? How, now, could they still define those artists as modern and not classic? "How long does the Metropolitan propose to wait before giving full recognition to such modern masters?" he asked. "How can real education in art be given if these artists are omitted? And how much longer must a now living foreign painter wait before his works cross your threshhold? What does such a policy do to the morale of your curators or the reputation of your museum?"

Open letters six through eight were filled with misgivings about Taylor's leadership, and Rosenberg's amazement at his statements, such as one where he said that modern art "announces the sterility and the intellectual vacuum of twentieth century America . . . [the] spiritual breakdown in our Western civilization." In those words, Rosenberg heard "echoes from the Kremlin . . . declarations of contempt and despair." Rosenberg's last letter came three days before the annual meeting set for January 17, 1949, and urged immediate adoption of a program that put current art on a par with past treasures on the museum's walls and in its scholarly estimation. "Art did not come to an end with the advent of the twentieth century," he concluded. "Yours must be an unshackled, forward-looking, educational institution not in one area only, but in the entire field of art." He was even more blunt in a letter sent the same day to each of the ex officio trustees. "Are you of the opinion that Dr. Taylor should be continued as [the museum's] director?" he wrote. "I shall present that question at the meeting."[121]

Vanderbilt Webb, responding privately to Moses, said that Taylor's virtues outweighed his flaws but that Rosenberg had "probably done a real service in stirring up the animals a little."[122] Redmond's reply, sent the day of the annual meeting, reaffirmed the museum's position and supported Taylor's right to his opinions, no matter how controversial or unpopular. "We are not disposed" to censorship, he wrote. Particularly not when he and the rest of the trustees agreed with their director. But the museum had come to a turning point. Taylor and Redmond may have been on top at the moment, but they were on the losing side of a long war.

At the annual meeting, Taylor refused to engage with Rosenberg be-

yond saying his words had been taken out of context. "Mr. Rosenberg did not take the courtesy of discussing this with me in advance," he said, "and I don't see why he should have the courtesy of a further answer." After the meeting, Rosenberg vowed that he'd only just begun to fight.[123] Though it admitted that Taylor's glibness was easily turned against him, that his feelings toward modern art were lukewarm at best, and that his eight-year tenure at the Met had been "difficult," the *Times* approved of Redmond, judging him "calm, judicious and friendly."[124] But others thought Rosenberg's critiques were on target, including George Biddle, whom Moses had proposed as a trustee. He, too, wrote an open letter to Redmond.

Harking back to Artists for Victory, a show of work by living artists that filled the Met's galleries at the end of 1942 after its masterpieces were sent to Whitemarsh, Biddle suggested an annual or biennial exhibit of work by living artists, be they modern or conservative, American or foreign, and two permanent galleries to show the paintings and prints then allegedly stacked up "in the vaults of the Museum." In response, Redmond assured Biddle that Hale was coming up with a plan.[125] And within a week, the purchasing committee had appropriated $94,000 to buy two van Gogh paintings, *Cypresses* and *Sunflowers*, and to hold a large van Gogh exhibit that fall, with sixty-six paintings coming from the Netherlands and another twenty from American collections. After a trustees' meeting in March, Francis Cormier of the Parks Department decided it was likely that Rosenberg's open letter had influenced the decision. Certainly the reaction to the thirteen-week show was a harbinger of things to come. Total attendance exceeded 300,000, making it the most popular in the museum's history. Huge sums were made selling reproductions and catalogs—not a first, but a significant event. And one night, Nelson Rockefeller had the museum to himself for a private evening viewing for forty members of the Modern's board and staff, an experience so positive he wrote Redmond to say it "opens up rather an interesting new possibility for a service which all the museums might render."[126]

The van Gogh blockbuster was exactly what Robert Moses wanted—a return to Hudson-Fulton-style showmanship. "Let's admit the showmen to these exclusive circles," he wrote in a magazine article appraising all the city's museums that year. Though he would force Taylor to reverse course

on his next innovation, hanging banners on the front of the museum to herald its show, Moses was a pretty happy guy, and he'd set the museum on the course it would sail for the next fifty years. He told George Biddle late in March that he and Rosenberg had proved to be "useful catalysts," that now "the Metropolitan is generally moving in the right direction," and that he believed that Thomas Lamont's bequest would soon be used to build a wing for contemporary art.[127] Two out of three of his conclusions were right. The Lamont Wing would turn out to be a pipe dream. The museum simply wasn't yet ready to pay for new wings all by itself.

Yet, like Rosenberg (who kept writing protest letters until 1957), Moses kept at the museum, restating his desire for a female trustee and suggesting that it might also benefit from adding a broadcast executive to the board as well as someone "distinguished in the field of modern art, but a conservative and not a crackpot."[128] The trustees appeared to have reconciled with Moses as well, and at the same board meeting where they approved the first rehabilitation contracts that fall, the board elected the candidate Moses suggested for the latter slot, the copper heir and political progressive Sam A. Lewisohn, a Modern and Brooklyn Museum trustee, modern art collector, author, relative of Bobbie Lehman's by marriage, and the board's fourth Jewish trustee. Sadly, he would only live another sixteen months, but in that time he helped nudge the museum a bit further out of the prison of classicism.

Robert Hale had quickly found that Taylor's backing did not translate into support from the board of trustees. Indeed, they often laughed at works he recommended. They were all so old and repressed that he would joke about wearing a dark suit to work in the hope that he might have to attend one of their funerals: "But that was a slow process and didn't really solve my problem." When he recommended the purchase of three paintings of clowns by Walt Kuhn, one of the organizers of the 1913 Armory Show and an important American modernist, one trustee "flew into a rage," Hale recalled, waving his arms, insisting he could paint better than that. Now Lewisohn, who wasn't afraid to throw his weight or his money around to get his way, was so shocked by the unnamed tycoon's behavior he persuaded the board to buy all three pictures, and before the year was out, Hale and Taylor convinced the trustees to effectively give up their oversight over the Hearn

funds and allow Hale to purchase art in consultation with a special advisory committee of three trustees, Lewisohn, Elihu Root Jr., and Walter Baker, all of whom, Hale would say, "appreciated contemporary American art."[129]

Baker had been elected to the board in 1948 along with General Eisenhower and Henry Luce, the editor-publisher of *Time, Life,* and *Fortune* magazines. A vice president of Guaranty Trust, a large bank (that would merge with J. P. Morgan in December 1958), and the chairman of the board of Union College, Baker collected classical antiquities and drawings. Root, a lawyer who was known as Sec, shorthand for "Second," to distinguish him from his father, the cabinet member, whom the family called Elihu-the-statesman or Elihu-the-famous, had deep links to the museum (his grandfather Salem Wales was a founder) but also to modern art; he'd been a weekend painter since the 1920s, when he joined the art-oriented Century Association, where he began showing his work in 1947.

As important, perhaps, Root's younger brother, Edward, had been teaching art since 1920 at Hamilton College in their hometown in upstate New York while quietly building one of the finest collections extant of early American modernists. In the 1920s, he'd even tried to get the Met to buy an Edward Hopper painting, to no avail. "The average age of the purchasing committee was seventy-two," Edward Root said, "and none of them liked anything more modern than the Barbizon school and certainly nothing American."[130] Some of the museum trustees would likely have been equally negative toward Sec Root's favored subject, female nudes. But that choice probably stood him in good stead with Robert Hale. It is a testament both to the Root family's influence on the board and to Hale's growing effectiveness that in 1953 Edward Root's collection was shown there. It was the first time the museum had ever exhibited a private collection of contemporary art. Family lore has it that Root then offered the collection to the museum.

"They refused it," says Dolores Root, a relative. "They had no vision."

BUT TAYLOR WAS HARDLY A CONSERVATIVE. RATHER, HE WAS AN innovator and something of a showboater. In 1949, for example, he loudly canceled a speaking engagement in the South when he learned black stu-

dents would be banned, and at home experimented with new ways of lighting art, starred in a televised walking tour for CBS, and hired Bradford Kelleher to create the museum store; previously the store had only sold etchings, prints, miniature facsimiles, catalogs, and postcards at its information desk. Kelleher's book and reproduction shops would eventually become a major profit center.

After Redmond's election as president, he and Taylor had gone on a nationwide trip to cultivate the directors of other museums to ensure that the Met could both borrow and loan art more easily. They also met local artists and were shocked to discover their hostility toward New York's art world, which they felt either looked down on them as provincial hicks or tried to take advantage of them. So in 1949, Taylor sent Robert Hale to more than twenty American cities, to meet artists and seek opinions on how the Met should deal with and define "living" American art. A decision was made to hold an open competition, with regional juries leading to a national panel convened in New York.

The result was American Painting Today, opening in winter 1950, just after a summer show of two hundred of those long-unseen Hearn-financed paintings and prints in the cellar. Hale had discovered to his chagrin that the museum owned no Cubist, surrealist, abstract, or Expressionist art, and called what it did have timid. But the retrospective show did include works by Thomas Eakins, Winslow Homer, Mary Cassatt, and Childe Hassam, as well as others from the modernist collection of the photographer and gallerist Alfred Stieglitz; his widow, the painter Georgia O'Keeffe, had just given the museum 589 works of art—including works by herself, Marsden Hartley, John Marin, Charles Demuth, Picasso, and Brancusi—"because Stieglitz was so definitely a New Yorker," she explained.[131]

The idea of successive retrospective and competitive shows—and two more juried exhibits that followed—was to prove that the Metropolitan had been paying attention to living Americans all along, and would continue to do so. Howard Devree of the Times judged the effort courageous. But behind the scenes, Hale mocked his own shows, submitting a prehistoric Japanese sculpture from an Asian art curator's collection to the jury as the work of an invented American Indian named Joseph Kubeb, a.k.a. Chief Laughing Horse. Don Holden, one of Hale's drawing students, was re-

cruited to fill out the form. "I did it with a steel pen that blotted and splat-
tered and tore the paper," he remembers. "There were misspellings and
cross-outs and where it asked me to describe my philosophy of art, Hale
dictated, 'Make true Indian thing.' " The Far Eastern art curator Alan
Priest's Japanese houseboy delivered the package, complete with a photo of
Kubeb, actually a Navajo grocery delivery boy. "The jury called it a piece of
junk and rejected it," Holden says.

Eighteen well-known painters and sculptors, including Robert Moth-
erwell, Louise Bourgeois, David Smith, Hans Hofmann, Barnett Newman,
Clyfford Still, Richard Pousette-Dart, Ad Reinhardt, Jackson Pollock,
Mark Rothko, and Willem de Kooning, felt the same way about the Met's
efforts and in May 1950 announced a boycott, declaring that the jurists
were "notoriously hostile to advanced art," the only creative endeavor "that,
for roughly 100 years . . . has made any consequential contribution to civi-
lization." They also echoed Rosenberg's charge that Taylor held modern art
in contempt, and added that Hale, by accepting the jury, had taken his
"place beside Mr. Taylor." Soon enough, seventy-five more artists, a group
the *Times* described as "equally noted," defended the Met in an open letter,
but history has not been as kind to those signers, who included only a few
still known as first-rank artists today, among them Milton Avery, Reginald
Marsh, Will Barnet, and George Grosz.

The protesters still wanted in, just not via a jury trial; soon enough,
Hale and his trustee-advisers (when Lewisohn died after his sixteen-month
run, he was replaced by Stephen Clark, who was himself replaced by the
progressive publisher and Robert Moses ally Marshall Field) were pulling
off minor miracles, buying works from the living artists on the outer edge
of the avant-garde, New York's Abstract Expressionists. "The argument
about abstraction went back and forth forever," Niké Hale says. "Bobby
wanted those people in the Met, but the trustees didn't like it. In the 1950s,
you bought European paintings," like a Picasso purchased at the end of 1950
for $38,000 (more than half of which was donated by one rich couple in ex-
change for the right to keep the painting in their home eight months a
year). Hale had won one crucial advantage, however. "He needed approval
to spend more than $1,000," says Hale, "but he could spend less than that
on his own." In 1952, he did just that, buying Jackson Pollock's *Number 17*,

1951, one of a series of all-black paintings on unprimed canvas, for a three-figure sum. "No one had heard of Pollock," says Hale's widow. "There was still no money in Abstract Expressionism." Taylor was so furious at him for buying the Pollock, though, he almost fired him.[132]

Five years later, after Pollock's death, Hale made a deal with the trustees to acquire a Pollock masterpiece, *Autumn Rhythm (Number 30, 1950)*, which remains a highlight of the museum collection.* Several trustees hated the huge piece, and confronted with the board's overt hostility, Hale began to cry—amazingly, his tears won the day. "At most, they were only going to have one Pollock in the house," Hale's successor, Henry Geldzahler, would say.[133] So Pollock's dealer, Sidney Janis, took *Number 17* back and gave the museum a $12,000 credit toward the $30,000 price of the much larger *Autumn Rhythm*.** When Hale took Redmond to see it once it was hung, he said, "You know, Bobby, you've ruined my museum."[134]

But there was no turning back now, and the trustees seemed to realize it, eventually allowing Hale to acquire more great work like Willem de Kooning's *Easter Monday*, Arshile Gorky's *Water of the Flowery Mill*, and Isamu Noguchi's marble sculpture *Kouros*.

Perhaps this loosening up inspired Roland Redmond to take his own leap into the unknown; he left his wife, Sara Delano, in the fall of 1952 and took up with Lydia Bodrero Macy di San Faustino. A descendant of an early chief justice of Connecticut and the daughter of an Italian diplomat, she already had one museum connection in her background, having married Valentine Everit Macy Jr. in 1925 and divorced him in Reno seven years later. Macy was the grandson of a Standard Oil official and the son of the Metropolitan trustee and benefactor Valentine Everit Macy. Lydia would loosen Redmond up and introduce him to café society.

As further evidence of the new order, the first women trustees were finally elected in March 1952: Mrs. Ogden Reid; Mrs. Sheldon Whitehouse,

* The Met's first Pollock, *Number 17*, was subsequently owned by the magazine publisher S. I. Newhouse Jr. and the cosmetics heir Ronald Lauder.

** "They hondled over how much they would pay," says the curator Robert Littman, and Pollock's wife, Lee Krasner, "was appalled but told me that after the board meeting she said to herself, 'You fuckers, you've just set the price of a Pollock.'"

the granddaughter of a founder of the Central Pacific Railroad; and the second Mrs. Vincent Astor, Minnie Cushing (Redmond was Vincent Astor's divorce lawyer). Also elected that year were Arthur Amory Houghton Jr., the president of Steuben Glass; and Chester Dale, a collector who'd already favored the National Gallery with many gifts. Dorothy Shaver, the retailer behind the Costume Institute, would shortly join the board, too. And it wasn't just the board that was being renovated. Galleries were closing for repair and reopening; Taylor had taken the Greek and Roman court, which was then seen as out of fashion, and hired the decorator Dorothy Draper to design a new restaurant that would soon be dubbed both the Dorotheum and Café Borgia for its poisonous food.[135] A new auditorium, paid for by the estate of Grace Rainey Rogers, a coal and coke heiress, was in the works, too. And Moses was cooperating, insisting on limiting contractors to ones who were unquestionably competent rather than allowing open bidding because, he told the Board of Estimate, "every conceivable kind of hazard to irreplaceable objects is involved."[136]

AMONG THE FIRST NEW GALLERIES TO OPEN AT THE REFRESHED Metropolitan Museum was the three-room Treasury at the Cloisters, conceived of after the Brummer purchase as a home for the branch museum's most precious possessions, with the Antioch Chalice as its centerpiece. In June 1951, when Rorimer wrote to John D. Rockefeller Jr. in Maine to tell him that it was getting good reviews but had cost $25,000 more than expected, Junior wrote out a check within a week. Although Junior, at seventy-seven, was growing frail, he still wielded great power. C. Douglas Dillon, a Republican investment banker who was close to the Rockefellers, had just been elected to the Met's board. And Junior's sons would shortly decide to add the museum to the annual donations list of their Rockefeller Brothers Fund, even though the Museum of Modern Art had terminated the comatose-on-arrival two-museum agreement early in 1952.

Museums didn't always do what their patrons wanted. In 1954, Nelson Rockefeller, still in thrall to the Latin American cultures he'd been immersed in since before the war, incorporated yet another museum (a dozen

years after the Modern board failed to act on his suggestion that it create a new department to house such art). He tentatively called it the Museum of Indigenous Art. But Junior's commitment to the Cloisters remained focused and unwavering and was about to reach its zenith.

Rorimer was just back from a three-month acquisition spree in Europe that January when Junior surprised him with an envelope containing $500,000 worth of stock to pay for his many new finds. He also hinted at a larger gift to come. By March, a number had been attached to that gift—$5 million, with 70 percent earmarked for acquisitions and the rest to maintain the Cloisters. By June, Junior had upped the ante again, and gave the museum $10 million in Socony-Vacuum and Standard Oil of California stock—the largest donation ever made to the Met, and one that doubled its annual purchasing power.[137] Rorimer family legend has it that Junior decided to double the gift after Rorimer came to a breakfast meeting at his apartment one day carrying an envelope he'd planned to mail to Rockefeller and, as Junior made them tea himself, carefully removed the stamps from it before handing it over in person, greatly impressing the recipient with this latest example of his thriftiness.

"Everyone—Taylor, Redmond, etc. happy about gift," Rorimer wrote in a postcard to his wife. "Roland . . . calls wording a tribute to me. I took Francis & Dudley [Easby] to lunch." He was a hero.[138]

Junior was, too, and filled a file folder with letters of praise, but also some of condemnation. "Has it occurred to you that in supporting the arts—while the world is pitching and tossing in an agony of insecurity and bloodshed, you are writing yourself into the history of this era as one who did not see or think or act wisely in time of crisis [by] subsidizing pictures instead of persons—the image in place of the reality?" wrote one Ada McVicker of Yonkers. Sometimes, even Rockefellers couldn't win.

Part of what had Junior so excited was what Rorimer had done in Spain, reopening negotiations for the roofless, disintegrating Gothic apse, or church vault, that had first crossed their radar in 1935 at the time the French were protesting their government's attempt to give a chapel to Rockefeller. In other corners of his life, Junior was slowing down, even handing off Kykuit to his children in order to retire to Tucson in winter and Williamsburg, Virginia, in summer for the rest of his life. But he would

watch carefully as Rorimer negotiated with the Franco government, the church, and the local authorities to get him one last prize. "The last five percent is what counts," he'd once told his son Nelson.[139] The apse would be that final piece that completed the Cloisters.

Though the stones themselves could be bought for $20,000, Junior and Rorimer decided to offer an additional $100,000 to restore other buildings in Spain, and the purchasing committee authorized $100,000 more than that, just in case. The halo Rorimer had earned with Junior's $10 million gift didn't totally protect him. Looking forward to a purchasing committee dinner at the Union Club where the apse acquisition would be approved in June 1953, Rorimer wrote to his wife that Taylor blamed a recent rise in market prices on the large Rockefeller gift. Redmond, however, was now firmly in his camp.

Rorimer returned to Spain in the fall of 1954 after its foreign minister approved the permanent "loan" of the chapel based on a promise to the bishop of Segovia to restore a church in the town that contained the ruins and buy back some frescoes that had been stolen from Spain for the Prado. Nonetheless, it would take almost three more years to close the deal. In the meantime, the Metropolitan would suffer the shock of losing another director.

Francis Henry Taylor was a mass of contradictions, as John Pope-Hennessy, a sculpture curator at the Victoria and Albert Museum, discovered when they met in London in 1952. Pope-Hennessy judged a lecture Taylor gave as "snobbish and conceited," and his first impression of the Met's director was that he was "an inflated fake," but on close inspection at a dinner thereafter he revised his opinion, finally deciding that Taylor was "warm and natural and cultivated."[140]

Taylor appeared to get along well with his boss, Roland Redmond. "He learned a lot from Francis Taylor," says Redmond's daughter Cynthia. Along with Ted Rousseau, the dashing paintings curator, they took a tour of Europe, even stopping to call on the elderly Bernard Berenson in Florence. But beneath the surface, Taylor was chafing as Redmond, though not a connoisseur, frequently asserted his prerogatives as president, claiming turf Taylor felt was his and overruling his director. And since the rejuvenated

Redmond was only in his early sixties, Taylor could only look forward to more of the same.

His tenure hadn't been easy before that, beginning with high hopes dashed by the war, continuing through the grinding battles with Robert Moses, the failure of the three-museum pact, a second scare when the United States entered the war in Korea, and, most recently, his successful but nonetheless thankless efforts to bring modern art into the Metropolitan. Some of his administrative innovations had stalled, others had proven less than successful; the building reconstruction, though necessary, had closed galleries, halted most other initiatives, and caused considerable inconvenience and stress, and two more vice directors had followed Horace Jayne in quick succession; none gained the confidence of the staff.[141]

Understandably, Taylor felt battered and smothered by his administrative burdens and decided that he'd been sidetracked from his true purpose in life, writing and art scholarship. By the early 1950s, even though he'd managed to strengthen the director's office, attract younger, less obstructive curators, win some measure of control from them over hiring and spending, plan a new junior museum, greatly expand the museum's lecture program, add five smoking lounges, and make the place more female-friendly, he'd begun to doubt the choice he'd made to move to New York. Now and then, he'd get a job offer, and increasingly he was tempted by them. His health, never good, was suffering.

"As soon as Francis came to the Met . . . he lost the bounce and *joie de vivre* that made him such a charmer in Phila [*sic*]. And Worcester," Horace Jayne would recall years later. "It might have been awe of the Met, but I think it went deeper . . . I don't think he really 'grew up' until he came to New York. His buoyancy disappeared and pomposity set in."[142]

In July 1953, Taylor found himself at the barricades again, this time at odds with the museum guards, who earned about $60 a week. When they threatened to strike, Taylor tried to get the city to give them a raise. When a Parks Department underling waffled, Taylor demanded an appointment with Moses and so infuriated the city's Santa Claus that Moses told Redmond he would never do business with Taylor again.[143] Redmond retaliated by refusing a Department of Parks request that it spend more for plants in

front of the museum, pointing out that its paved "apron" belonged to Central Park, not the museum. "If you want to toss the book at us, you will find that our aim is also pretty good," an astonished Moses shot back.[144] "He ended up finding Moses exhausting," says Taylor's daughter Mary. "He loved what he was doing, but he wanted to do some writing. The continual fights with the trustees were exhausting," too. He'd had his fill of them. The days when they met "were always sort of fraught," Mary says.

Taylor wanted out. It should have been a time of triumph. A hundred refurbished galleries, as well as the restaurant and the new auditorium—the last paid for entirely out of museum funds—were set to open in the spring of 1954, at a final cost of $9.6 million.[145] The second phase of his much-revised plan for the museum, including a new library and main entrance, would require more time, planning, and fund-raising. Taylor had projected a reopening celebration he called the Balloon Ascension—inspired by the ceremonial launches of hot-air balloons in the late eighteenth century—to celebrate the reinstallation.[146] But at the end of September, a picket line went up outside the museum, and Taylor again slept there at night, fearful of fires. He had a room adjacent to his office, equipped with a couch, a private telephone line, and a view out over the main entrance. After watching the guards, many of whom he was close to, walking their picket line, he had the cafeteria send them coffee and food.

Thanks to the strike and unforeseen construction delays, Taylor's mood was dark. He was irritated that Redmond was away in Florida and was also fighting with Robert Lehman, who'd just loaned much of his art collection to the Met but wouldn't commit to giving it unless he was given a wing and promised that nothing he gave would ever be sold; after all, the museum had done that for twenty-three donors, among them Altman, Michael Friedsam, Bache, the Havemeyers, and Wentworth—whose names were thus immortal. The fighting was getting to him finally; his letter to members announcing the new galleries was dispirited. Moses, true to form, complained to Redmond that Taylor had failed to thank the city in it.

In January 1954, Taylor's Balloon Ascension began with the opening of forty-four new European paintings galleries, followed by seventeen new medieval and Renaissance galleries in February ("For the first time, you can really see what we've got here," Taylor said) and, a bit later that month, the

opening-night party for the new three-hundred-seat restaurant, where fountains spewed wine and the only vestige of the old Roman court was a mosaic floor (the Greek and Roman Art Department would never forgive Taylor for taking its court away; it would not be returned to the department for more than fifty years). Its dark walls inspired Taylor to quip that the decorator Dorothy Draper had crushed Aubrey, a black waiter in the director's dining room, to create their blackberry shade.

At that same moment, museum directors all over the country began to play a game of musical chairs. The director of the Museum of Fine Arts in Boston died, and the latest director of Taylor's alma mater, the Worcester Art Museum, quit to take over Boston's Isabella Stewart Gardner Museum. That summer, the Worcester board asked Taylor whom they might consider, and he threw his hat into the ring. Having spent his vacation recuperating from his latest bout with ill health, Taylor found himself interested. By fall, he was plotting a return to Worcester. When he finally gave the museum seven months' formal notice in December, acknowledging only the strain of his administrative responsibilities and his desire to return to scholarship and connoisseurship, he was broadly and rightly praised for making the museum vibrant again.[147]

After a three-month trip to Europe, Taylor returned to New York for a farewell dinner at the Century Association in June. In the meantime, James Rorimer, forty-nine, quickly emerged as the leading candidate to succeed him, although a search committee was appointed. Robert Moses had suggested André Malraux, the brilliant French author, who would soon become Charles de Gaulle's culture minister. Told the trustees wanted an American with managerial skills, Moses sneered that that should be the job of "the second man," not the director.[148] The finalists included Perry Rathbone, just named director of the Museum of Fine Arts in Boston; and Froelich Rainey, director of the Museum of Archaeology and Anthropology at the University of Pennsylvania. But the trustees didn't want a repeat of the problems that confronted Taylor when he arrived as an outsider, so in midsummer Rorimer got the job as the Met's sixth director, retaining his title of director of the Cloisters and gaining a seat on the board, the director's office with its Fifth Avenue view on the mezzanine of the museum, furnished with Blumenthal furniture and tapestries, and an annual salary of

$22,500. He got the promotion just six weeks after finally making a deal to acquire his Spanish apse "on our terms," as he'd reported to Junior, after twenty years of trying.

There is disagreement as to whether the trustees were happy with their choice. John Pope-Hennessy would later write that the appointment came only "after a protracted interval in which other candidates were interviewed, and the outside world was left with the impression that he was appointed *faute de mieux*"—for lack of a better alternative—"and did not enjoy the trustees' full confidence."[149] But John D. Rockefeller Jr. thought differently, calling the unanimous decision of the board and the press approbation that followed "most gratifying... That you have been chosen... gives me the greatest satisfaction... It is an honor that you have well-earned and richly deserve; a position which you will fill with both ability and distinction."

In response, Rorimer reminded his patron that it was he who'd convinced him to return after the war. "I see no occasion of failing you now," he wrote. Old habits died hard; beneath his signature, he noted that in the week since he got the big job, 14,568 people had visited the Cloisters while only 4,011 entered the main building.[150] A few days later, Junior's secretary wrote back to say that her boss found his attendance report "as gratifying... as it is difficult to believe."[151] (In fact, due to the strike, the rebuilding, and the discontinuance of music and lecture programs, annual attendance in the main building was down more than 400,000, though those numbers, counted by guards on clickers, were notoriously inaccurate.) Junior was invited to a dinner welcoming Rorimer in the Lansdowne Room, an eighteenth-century dining room that had been brought out of storage and installed in the final stage of the remodeling. He didn't attend—gloating was not his style.

Rorimer took over immediately, and with a passion, waking at six each morning "to throw himself into every detail of the museum's vast activities," as Hyatt Mayor put it. "Even on Saturdays and Sundays, he walked the galleries with the crowds, like a captain inspecting his ship, to make sure that every label told its story, that every floor was waxed."[152] Experienced with trustees and donors, he segued easily into a director's social life as well.

Having served as chairman of the staff's architectural committee (since he could read blueprints and Taylor could not), he was already up on and in complete accord with his predecessor's plans for the museum renovations, and as such there was a degree of continuity—new storage and employee rooms, special exhibition galleries, reinstalled arms and armor, Greek and Roman, and ancient Near Eastern collections, air-conditioned paintings galleries, a new library, and new storage and services building were all on the agenda, along with the ongoing deaccessioning plan to get rid of second-rate material and a revamped salary and retirement policy. But he also made it clear that some things would change. In interviews, he said he would balance the need to humanize the museum with sound scholarship and give recognition to "the work of those who are creating in our midst," mentioning that he owned a large work by the American abstract painter Cleve Gray.

He also hinted that he would be more acquisition minded than Taylor had been. "I'd rather see a masterpiece by an artist already represented in the collection than a second-rate picture by an artist who isn't," he told the *Times* art critic Aline Saarinen. His very first move was a symbolic one, cleaning out the first room visitors entered, the Great Hall, which, under Taylor, had been a cluttered menagerie of suits of armor, Assyrian sculptures, and tapestries.

Francis Henry Taylor died with his boots on not quite three years after quitting the Met, aged fifty-four, of an internal hemorrhage following surgery for kidney stones. The consensus was that he never regained his health after losing it to the Metropolitan Museum. In a memorial written for the museum's *Bulletin,* his longtime friend and adversary Roland Redmond praised him for turning the museum "into a modern and dynamic institution."[153]

The Taylor era was over. But the Rockefeller years had yet to play out. It was another two and a half years before the thirty-three hundred stones weighing 600,000 pounds that made up the Spanish apse made it to New York in more than nine hundred crates. By that time, the cost of setting up the apse, which would open to the public in 1961, had risen to $750,000, which Rorimer paid out of the annual income from Junior's Cloisters en-

dowment. "I've waited thirty years for this," he told Don Holden, Robert Hale's onetime student who'd become the museum's PR man. "You have to be very patient in this business."

Appropriately, one of John D. Rockefeller Jr.'s very first gifts to the Met, those monumental Assyrian relief sculptures, would be reinstalled in the new Near Eastern galleries, just two weeks before he died in Tucson at the age of eighty-six of pneumonia and heart strain on May 11, 1960.[154] Twelve days later, Robert Moses resigned as parks commissioner to become president of the 1964 New York World's Fair. As Moses had been a trustee, his departure was noted in Redmond and Rorimer's review of the significant events of 1959 and 1960 in the *Bulletin*—the sort of recognition he'd long demanded and often been denied. Though the trustees recorded "their sorrow" in meeting minutes, Junior's death went oddly unmentioned in the *Bulletin*. It's quite possible that he would have preferred it that way.

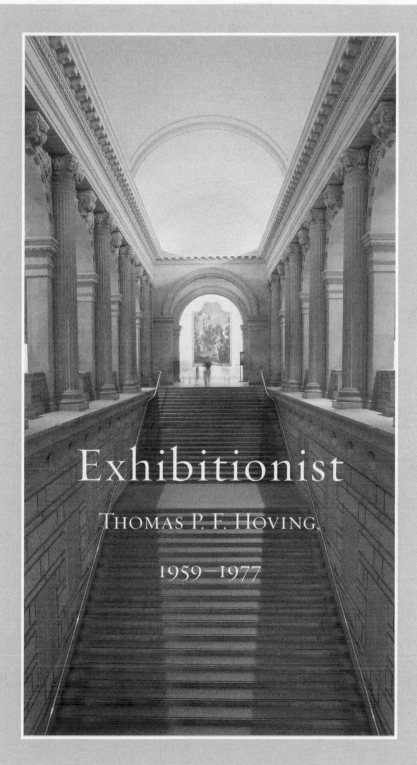

Exhibitionist

Thomas P. F. Hoving,

1959–1977

"I did *not* invite them!" James Rorimer shouted
over the thrumming din of raucous rock music. "Stop them!" The director
of the Metropolitan Museum seemed to vibrate in horror at the frenzy of
torsos, twisting in ways he'd only ever seen rendered by the Cubist artists he
hated. "I was *not* aware of this!"

It was the dawn of the 1960s, the first year of John F. Kennedy's pres-
idency, and, though Rorimer didn't know it, also the end of the moated Met-
ropolitan Museum of Art. Francis Henry Taylor's dream of a broadened,
democratic museum was being realized before Rorimer's startled eyes.

The exact hour of the fusty, dusty old Met's death—9:00 to 10:00
p.m. on November 20, 1961—was noted the next morning in a *New York
Times* article by a young reporter named Gay Talese, who would go on to do
more important things (as would the museum). The old Met would march
on five more years. But at that moment, as a song called "The Peppermint
Twist" echoed through the museum, something changed forever.

"I was a twister," boasts Thomas Pearsall Field Hoving, then as now

an impossibly tall, lean, eagerly friendly sort with a long, patrician face and an oversized yet impish personality. He has described himself as, among other things, aggressive, selfish, solipsistic, boastful, outspoken, blunt, slightly sinful, impatient, angry, disrespectful of danger, intolerant of hypocrisy, a showoff, a publicity addict, and above all controversial. Although none of that was clear yet—he was then only two years into his first job as an assistant curator of medieval art at the Cloisters—his was the spirit of the age.

Rorimer was horrified and tried to stop the music or at least stop the photographers from taking pictures of the people dancing to pop music inside the temple of art, 750 in all, who'd paid $100 apiece to attend the fourteenth annual Party of the Year for the Costume Institute. It was being held for only the second time within the museum. A year earlier, at the same party, there had been sedate fox-trots and waltzes; this time it was Joey Dee and the Starliters whose sound spilled into the Great Hall, where Hoving and his ebullient wife, Nancy, danced.

Hoving came from a family whose social prominence ran through his mother's line, which traced back to John Jay, whose speech in Paris had led to the Met. When Tom was five, his parents divorced. Their parting was bitter; Tom's mother, who got custody of Tom and his sister, never remarried. His father did, again marrying into social connections and money.

Walter Hoving was distant and dominating; when the children visited his River House apartment, he would inspect fingernails and criticize manners. His mother was spontaneous and loving but also lonely, emotional, and demonstrative. Hoving has described himself as a scrawny, uncoordinated, shy and acne-ridden, uncertain, and rebellious boy with a tendency toward pranks that led to expulsions from a series of private schools (Buckley, Eaglebrook, Phillips Exeter). His departure from Exeter was notable: he punched a six-foot-five Latin instructor who'd given him an A minus for bad attitude. At Hotchkiss, his last stop, he buckled down, but was withdrawn and introspective.[1]

While Tom was getting kicked out of schools, his father had become a political and financial force in New York. In 1946, he founded a company that bought first Bonwit Teller and eventually Tiffany & Co., which he ran until 1980. Summers, Tom worked as a newspaper copyboy and then as a floorwalker at his father's stores, where he learned to size up customers,

fold suits, and hate the retail business. In 1949, just before Tom graduated cum laude from Hotchkiss, Walter told his son that the only college he would pay for was Princeton. Luckily, Tom was accepted, but then drifted for three semesters. He was put on academic probation and, in one of several jokey versions of his academic epiphany, went searching for classes where the lights were often off and he could nurse a beer hangover. He settled on a course in medieval art, known as "one of the dullest" at Princeton and taught by Kurt Weitzmann, a "famously demanding" professor.[2] There, he found his raison d'être. He decided to declare a major in art and architecture and in 1953 graduated cum laude.

The same year he met Weitzmann, Tom encountered Nancy Bell at a party. Talking on a staircase, they established that their parents knew each other and were neighbors. That summer, they met up for walks along the East River, and a relationship blossomed. Nancy and Tom graduated in 1953. When he told his father that he was going to graduate school instead of into business, Walter handed him $1,000 and told him that was the last help he would ever get. Though Tom had proposed and Nancy had accepted, she went off on a tour of Europe that summer, and he joined the marines. With the Korean War raging, he figured he'd be better off volunteering to be an officer than getting drafted and serving as an enlisted man. The pair married that October.

After his discharge in 1956, Hoving returned to Princeton as a graduate student in art; though he'd won a fellowship, he refused it when he learned his mother, who had died in a freak accident, had left him a trust that would pay him $5,200 a year. The next summer, Nancy's father sent them to Europe because Tom had never been there. They decided to try living in Rome and spent a year learning languages, visiting museums, even joining in the excavation of an ancient site in Morgantina, Sicily, where Tom met his first antiquities smugglers—an experience he would not forget. Tom earned a master's degree in 1958 and a doctorate a year later and decided to find work as an art dealer, but the powerful gallery owner Georges Wildenstein, who knew Walter, was unimpressed by Tom's zealous pitch for himself and told him he should go to work either for his father or in a museum.

So in the spring of 1959, in a ritual for promising young art historians, Tom appeared at an annual symposium—a sort of hiring bazaaar at the

Frick museum where Ivy League grad students gave talks to museum offi-
cials and gallery directors. According to the Hoving movie as directed by its
self-dramatizing star, a most mysterious, pudgy man plucked him out of the
Frick after his speech and marched him across the street to the Metropoli-
tan Museum for advice about an object.

They looked over a sixteenth-century table in a basement storeroom,
and the man invited Hoving to a bare office where he spotted a piece of pa-
per that identified the mysterious man as James Rorimer. In fact there
wasn't much mystery at all—Walter Hoving had mentioned Tom to his
friend Roland Redmond, and Weitzmann, who was a Cloisters adviser as
well as Tom's, recommended him, too. Rorimer also knew Walter. After a
few more conversations, Rorimer hired Tom, first as a special assistant to
the director with a desk just outside Rorimer's office, then as a Cloisters cu-
rator. The director took a personal interest in young curators, inviting one
or two home for dinner and long talks almost nightly. Hoving quickly
emerged as Rorimer's protégé. The next summer, the Hovings joined the
Rorimers for a summer art tour of Europe in Jim's old green station wagon.
It was an initiation.

Rorimer was notoriously secretive. One of his favorite tricks was to
show impressionable curators a corner of a list of donors or of artworks he
wanted, then tuck it away. A young staffer once snuck a look and found it
was blank. But now he'd decided to share "all his sources—dealers, private
collections, friends, university people," John McPhee wrote. Hoving "got
the feel of Europe as Rorimer knew it, saw the architecture through Ror-
imer's eyes, and, along the way, formed a deep friendship with Rorimer
himself." They even clambered out the window of a Loire château together
to escape a boring tour guide, and climbed a pulpit in Spain to inspect an
enamel Madonna. Through such trials, Rorimer came to feel he'd made the
right choice in Hoving and put him in charge of all medieval acquisitions. A
series of spectacular ones followed, notably the twelfth-century ivory Bury
St. Edmunds Cross, about which Hoving would eventually write a book,
King of the Confessors, the first of the self-aggrandizing post-Met publications
that would infuriate his successors. "Within a month," he said in it, "I had
charted my goals. I would become the curator of the Medieval Department
and The Cloisters. And then, in time, I would succeed Jim Rorimer."[3]

❖

RORIMER'S 1961 SEASON DIDN'T START SMOOTHLY. THAT LABOR
Day weekend, a *Daily Mirror* reporter playing a journalistic prank had em-
barrassed the museum by walking in and out with a small painting stuffed
down his pants, just to prove he could. A month later, there was better
news, though, when the museum showed the remarkable paintings left to it
in the will of the trustee and fan of modern art Stephen Clark; there was
Seurat's *La Parade* and one of Cézanne's *Card Players* series, along with works
by El Greco, Degas, and Renoir. Clark had also left $500,000 to pay for the
long-planned air-conditioning of the paintings galleries, part of the latest
unglamorous phase of the building's rehabilitation, which also included the
construction of a new service building on the site of a former boiler plant
and the library that would be named posthumously for another trustee,
Thomas J. Watson, whose widow and children paid almost half its ultimate
$2.3 million cost.

Glamour roared back in November, and at first at least the glory was
Rorimer's. On November 15, at the Parke-Bernet auction house, he won a
painting the museum had coveted since the days of Arabella Huntington,
Rembrandt's storied *Aristotle with a Bust of Homer*, from the estate of the ad-
vertising man Alfred Erickson's widow for $2.3 million, a record, as were the
$1 million opening bid and the total proceeds of the sale, $4,679,250.

So much had changed in so few years. The art market, which had col-
lapsed during the Depression, and fallen further after 1933, when Ger-
many's Nazi regime sold off what it considered "degenerate" art, didn't rise
from the ashes until the late 1950s. In the 1940s, paintings by modern
artists like Cézanne, once bought for three-figure sums, still sold regularly
for under $20,000. In the following decade, records tumbled. It was the
beginning of the modern art market, says Michael M. Thomas, who joined
the Met as a curatorial assistant in the Paintings Department on the same
day Hoving was hired.

In May 1952, the sale of the Gabriel Cognacq collection in Paris net-
ted $860,000. One Cézanne still life of fourteen apples sold for $82,000,
about $6,000 per apple. In 1957, Basil Goulandris and Stavros Niarchos,

competing Greek shipowners, bid against each other at the sale of Margaret Biddle's art collection in Paris, resulting in the sale of a Gauguin still life for $297,000, a Postimpressionist record. That November, a sale of modern paintings and Fine French Furniture collected by a Paris banker netted more than $2.2 million. A record $1.7 million was spent on the sixty-five paintings alone.

Less than a year later, that record was obliterated in twenty-one minutes when a mere seven paintings by van Gogh, Renoir, Cézanne, and Manet owned by another recently deceased banker, Jakob Goldschmidt, were hammered down for $2,186,800. Cézanne's *Garçon au Gilet Rouge* more than doubled the previous record for that artist, selling for $616,000. A crowd of fifteen hundred ticket holders entered under scarlet awnings and bright movie lights to fill the sale room, two adjacent galleries, and a nearby warehouse. One month later, a hotelier's Postimpressionist collection set more records for Picasso ($152,000 for his *Mother and Child*), Matisse, Utrillo, Rouault, Vlaminck, Modigliani, Bonnard, Pissarro, Signac, and Morisot.

The spending spree continued in 1959, when seventeen paintings collected by the Chrysler heiress Thelma Chrysler Foy were sold by her widower. That night the record belonged to Renoir when his *Daughters of Paul Durand-Ruel* went for $255,000. The buyer was Foy's brother Walter Chrysler Jr. Two months later, he in turn sold twenty-nine paintings, setting a $100,800 record for a canvas by Georges Braque. In the interim, a British businessman set a world record when he bought Rubens's *Adoration of the Magi* from the estate of the Duke of Westminster for $770,000.

This was the context in which Rorimer appeared at Parke-Bernet with a secret plan to win Rembrandt's *Aristotle*. Though it was just one among twenty-four paintings in the sale, which included two more Rembrandts, Van Dyck, Hals, Holbein, Fragonard, Cranach, and Gainsborough, it was the night's prize, with an estimate to match: $1 million. Erickson had first bought it for $750,000, sold it back to Duveen for $500,000, and bought it back for $590,000. After his death in 1936, his widow had kept it until her death. After consulting Redmond and Rorimer, the estate announced an auction.

Museum directors all over America had anticipated the sale, and it was all anyone in the field could talk about, but few knew Rorimer planned on bidding himself. "He loved that nobody knew he was bidding," says his daughter Anne. "It was almost like a heist."

Rorimer, who'd first seen it in Chicago in 1933, "thought about that picture over the years, and the more Mrs. Erickson, who owned it, aged, the more interested I became," he said. "Of course, I had rather hoped that Mrs. Erickson would leave it to us."[4] But that was not to be.

Redmond had already told the trustees about the Erickson auction; he needed the permission of two-thirds of them to raid up to a quarter of the principal of the Isaac Fletcher purchase fund to finance an attempt to acquire it. Though a few trustees opposed the purchase, leading figures like Lehman were for it, and the board authorized Rorimer to spend $2.5 million.[5] Rorimer decided to bid himself to get the most bang for the available bucks. Of the forty-two paintings that have come to the museum attributed to Rembrandt, *Aristotle* would be the only one purchased, and Rorimer's greatest personal triumph.

The Rorimers attended the auction with Charles and Jayne Wrightsman, Charles being one of the newer trustees. The tension in the sale room was palpable. Again, there was an overflow crowd—many dressed in gowns and black tie. Eighteen private detectives were also scattered throughout the crowd of two thousand, which broke into applause when the painting was brought onstage. So when the bidding opened at a record $1 million and Rorimer just sat there slouching with his head down, the Wrightsmans got worried. At one point in the four minutes of bidding, Charlie poked Kay and said, "Jim's asleep." But he wasn't. He'd arranged with Louis Marion, the auctioneer, to bid by winking. One wink: $100,000.

The first bidder, a private collector, dropped out fast, and Rorimer found himself competing with Baron Hans Heinrich von Thyssen-Bornemisza, a Swiss armaments heir and collector, and Rosenberg & Stiebel, the art dealers, bidding for the Cleveland, Rorimer's hometown art museum. He'd somehow learned that $2.2 million was as high as Cleveland's trustees were willing to go, so when Cleveland's agent bid their upper limit, Rorimer was sure he'd won his prize and winked his way to $2.3 million.[6]

Unlike his predecessor, Taylor, Rorimer lived for acquisition—as he'd proved at the Cloisters—and those were his finest four minutes. "I winked to victory," he cabled Redmond, who was in Rome.

A day later, covered with corrugated plastic and quilts and strapped into a moving van, the painting traveled the six blocks to the museum under armed guard. Thanks to Robert Moses, a list of what was paid by donors in the month after the auction is in New York's Municipal Archives, even though official oversight of the board of trustees had waned even before he left his post at the Parks Department. Although it covers only a fraction of the cost, it reveals a lot about the museum's support. Bobbie Lehman, Wrightsman (through his foundation), and Joan Whitney Payson, daughter of the financier Payne Whitney and a cousin of Sonny Whitney's who'd joined the board in 1960 (the same year she co-founded the New York Mets baseball team), each kicked in $25,000.

A few other trustees gave small four-figure sums. But most of the donations were for less than $25. One child gave twenty-five cents. Rorimer admitted that his coup had "pretty-well exhausted" the museum's purchasing funds.[7] *Aristotle* had become the world's costliest painting, exceeding even the biggest known private sale, Andrew Mellon's purchase of a *Madonna* for $1.166 million in 1931. And that record would prove to have value in itself.

Aristotle with a Bust of Homer went on view against a backdrop of red velvet on the northwest wall of the Great Hall two mornings after the auction, protected by a rope line, some potted plants, and guards. On the first day, 42,000 people came to see it, some staring respectfully or studying it through binoculars, others eating pretzels or chewing gum. Reactions ranged from awe to the "persistent feeling of discomfort, even of distaste, with the price," expressed by the editorial board of the *New York Times,* Arthur Hays Sulzberger's trusteeship notwithstanding. Rorimer was unapologetic, and with good reason; the following Sunday, all museum attendance records were broken as 82,679 souls came to see it in the four hours the museum was open. The following Sunday, that record was broken again; with five weeks to go, the museum was on track for 1961 to be its biggest year ever—with almost four million visits. The gossip columnist Dorothy Kilgallen called the Rembrandt "the No. 1 attraction on the current

Gotham scene."[8] Thanks to Rorimer, the empty, echoing Edith Wharton vision of a museum only for connoisseurs was dead, put out of its misery by a very expensive seventeenth-century painting.

❖

RORIMER'S SENSE OF SECURITY WAS EVIDENCE THAT THE MU-seum had changed, too. Late in 1955, Rorimer's first big challenge had been fulfilling a pledge made by Taylor to cull the museum's collections and clear out its attics and storerooms of "surplus and inferior art."[9] Nearly ten thousand objects were identified to be sold at auction or, in the case of fifteen thousand surplus objects from the museum's Egyptian digs, sold directly to the public in the art and book shop (most cost about $10), earning the museum $330,000, which was assigned to curatorial budgets to fill gaps in the collections. Donors were given the chance to buy things back at prices set by an independent appraiser.

With the museum's finances stabilized (there would be an $82,677 surplus in 1957), attendance breaking records, membership rising to new heights, and the endowment nearing $78 million, planning for the continuing renovation of the building had grown more ambitious. At a trustees' meeting in March 1955, the idea had been floated of removing the steep exterior stair to the Great Hall—it led to an ugly, boxy, allegedly temporary structure known as the doghouse—moving the museum entrance, coatroom, information desk, and bookstore to the ground floor, and moving crowds up to the Great Hall on stairs and escalators. That plan would never be realized—the museum's irregular foundation made it too expensive. But it was evidence of the Met's reawakening.

Unburdened by deficits in the booming postwar economy, Redmond had been able to reverse the long-standing policy of having trustees cover them; he'd decided that only the artistically aware, the truly interested, and the potentially helpful would be considered for membership. Vacancies on the board would not be filled immediately. Neither would the post of vice director under Rorimer; instead, in 1956, Redmond hired Joseph Veach Noble, who'd previously worked in the educational film business, to serve as the museum's head of operations and chief administrator. Noble would

promptly prove that his worth went beyond nuts and bolts. He'd come to the museum's attention because of his interest in art. Fascinated with Greek vases, and already building what would become the largest private collection of them in America, he'd contacted a young Greek and Roman curator named Dietrich Felix von Bothmer, one of the museum's most fascinating and controversial characters.

Born to a noble family in Hannover, Germany, in 1918, the young Bothmer had worked for a sculptor as a boy and learned to make lithographs and woodcuts but realized he would never be an artist. "I had the advantage in life of an older brother who had a job in the Berlin Museum," Bothmer says. Bernard von Bothmer, already an Egyptologist, introduced him to the world of museums, one of the few acceptable career paths for young aristocrats. As a teenager, inspired by the opening of a Berlin museum, Dietrich studied Greek and Latin and visited Greece, where, at seventeen, he decided to make antiquities his career.

Back in Germany, he entered the Friedrich Wilhelms University in Berlin, but he detested the new Nazi regime, and soon resolved to leave. "I am a German, but I have always kept my distance from people who were political," he says. Accepted as one of Germany's last Rhodes scholars before the war, he went to Oxford in 1938, where he studied classical archaeology under Sir John Beazley, the world's leading expert on ancient Greek art. "My ultimate goal was America," he says. He visited as a tourist in 1939, and never went home; he was offered a fellowship at the University of California at Berkeley by H. R. W. Smith, another authority on Greek vases; he was still there on a temporary visa when Pearl Harbor was bombed in 1941. He started a doctoral dissertation while on a fellowship at the University of Chicago in 1942 and returned to Berkeley to continue his Ph.D. studies in 1944, but they were interrupted. He'd volunteered to join the American army and that year was sent to the South Pacific.

In April 1945, shortly after his division landed on Mindanao as part of the drive to liberate the Philippines, Bothmer found himself on patrol behind enemy lines. "We were supposed to destroy some enemy bunkers," he says, his eyes filling with tears. "Everybody had run away and they left me behind, wounded, with a man who was crying for his mother. I helped him to safety. I saved a man's life." He was awarded a Bronze Star for gal-

lantry, a Purple Heart, a combat infantry badge, and, eventually, American citizenship. "I was then looked at with more friendly eyes," he says. "I had done my civic duty."

Life still wasn't easy. Bothmer returned to Berkeley in 1945 to complete his Ph.D., but discovered that his prospects had dimmed; under an alien curfew law, he had to leave the library early every night, money was scarce in the academic world, and there were few jobs or research opportunities available, particularly for someone with a German accent. But Bothmer had, in the meantime, repaid his brother Bernard by helping him get to America, too, and through him had begun meeting museum people, including the Met's German-born Greek and Roman curator, Gisela Richter. "She took an interest in me," he says.

In 1946, he walked into the Metropolitan, asked for Richter, and ended up at lunch with several members of the Greek and Roman Art Department, where there happened to be a job opening. Francis Henry Taylor had someone in mind, but Richter and her second-in-command, Christine Alexander, wanted Bothmer, so they gave him a desk and put him to work rearranging their departmental storeroom, "basically as an intern," he says, to show what he could do. A few days later, Richter sent him to meet the trustee Walter Baker. She called it his "Park Avenue test," and he passed with flying colors, identifying one of Baker's antiquities as a partial forgery and winning a meeting with Taylor. Though the director struck him as anti-German, Bothmer's academic credentials and military record stood him in good stead, and he was hired as an assistant curator at $3,000 a year in April 1946 on the same day that another veteran, Lieutenant Commander Ted Rousseau, was named an associate curator earning twice that amount.

Bothmer quickly became a force in the life of the museum. He helped Rorimer with the German words he needed to write his wartime memoir, befriended the eccentric, acid-tongued Asian art curator, Alan Priest, and through him met Josephine Porter Boardman Crane, widow of a paper millionaire and former governor of Massachusetts and a founder of the Museum of Modern Art, who held a weekly salon in her apartment at 820 Fifth Avenue, where he hobnobbed with the likes of Stephen Spender, Jacques Barzun, and Salvador Dalí. As a handsome if severe single man with an aristocratic *von* (which he kept, though his brother dropped it), he became a

popular figure in Manhattan society—in many ways, the quintessentially shrewd and courtly museum curator—though he was never entirely comfortable with the role.

Bothmer learned about the museum, the jealousies and rivalries between and within departments, and the peculiarities of its often peculiar staff. When the Renaissance and modern curator Preston Remington refused him the loan of some objects for an exhibit, Bothmer went behind his back to Taylor to get them; Remington swore eternal vengeance, and Bothmer returned fire, sniping that Remington was so self-involved he preferred looking at himself in the mirror to working. Bothmer was also frequently at odds with Taylor. He was disturbed by Taylor's passionate dislike and glib dismissals of certain kinds of art. Although Richter was unintimidated by him, Bothmer found that other curators would call Taylor's wife to find out his mood before meetings; one senior researcher hid whenever Taylor came her way. Bothmer worried in turn that Taylor disliked him because he was an archaeologist; he'd heard the well-worn tale in which Taylor was turned away from a dig because of his formidable girth. Bothmer would joke that in 1948, when Taylor bought a portrait by Anton Mengs of Johann Joachim Winckelmann, it was because Winckelmann was the only archaeologist who'd ever been assassinated.

Bothmer's keen eye also noted the power of the trustees. At one point, Thomas Watson asked Alan Priest to find a job for a German prince. When Bothmer said in public that the prince was a Nazi (he was), he was taken to the woodshed by Taylor, who, despite his anti-Nazi stance, scolded Bothmer and warned him to never say a word against a potential benefactor.

In 1952, Bothmer got a photograph in the mail of a marble Aphrodite, a Roman copy of a Greek original by the Athenian sculptor Praxiteles that had surfaced in the continuing postwar treasure hunt. Bothmer went home to Germany to buy it and complained that Taylor would only pay part of his fare, since he also went to visit his mother. The museum refused to disclose how it got the statue.

Bothmer and Taylor weren't speaking at all during the final year of the director's reign. Bothmer believed he'd fallen out of favor because he was strong and challenged Taylor, who preferred a staff of cowed weaklings. Bothmer considered Ted Rousseau just such a character, so he wasn't sur-

prised when he heard that the paintings curator wanted Taylor's job. Rousseau had thrived under Taylor, even though (or perhaps because) the director often contradicted him, fought with him, and put him down. But he was something of a lone wolf, without allies outside the Paintings Department, and Bothmer thought him something of a phony and an intriguer, too—but noted that these were unsurprising traits in a former spy.

THEODORE ROUSSEAU JR. WAS BORN IN FREEPORT, LONG ISLAND, in 1912, to a French mother and an American newspaper reporter father who soon quit for a job as a secretary to the mayor of New York. After World War I, Rousseau senior got a job at the Guaranty Trust Bank and was sent to Paris to run its branch there when his son was eight years old. He became one of the leading Americans in Paris before returning home after France fell to Germany in 1940.

Schooled at the Lycée Henri-IV, one of the most demanding public high schools in Paris, and at England's Eton, Ted junior enrolled at Harvard in 1930, but took a leave in 1932, a year after his mother died. Just after finishing his sophomore year, he'd eloped and married Virginia Franck, a Broadway dancer with an infant daughter who had gotten a Mexican divorce a month before from a wealthy polo player. Three days after they were wed, Ted's father yanked his leash and pulled him back to Paris, where he remained, enrolling at the Sorbonne to study art.

Her young husband gone, Franck turned to the newspapers in distress, describing herself as bewildered, yet still having the presence of mind to mention her latest play. "The bride said all the letters from her husband were affectionately couched but extremely vague concerning the future," said the *New York American*, quoting Franck as saying she sympathized with Ted senior. "My parents were not enthusiastic the first time I married," she said. Though they were divorced on grounds of cruelty in November 1933, and she received a lump-sum settlement, three months later Franck told the papers it was news to her; she kept using Ted's name for years.

One year after his marital misstep, Ted junior returned to Harvard and graduated with honors in 1935. Rousseau then flitted through law and

architecture school before landing at the Fogg Museum as a fine arts teacher. In 1938, he won a job at the newly opened National Gallery in Washington, D.C. He had a family connection there; in 1927, its founding donor, the industrialist, banker, and former secretary of the Treasury Andrew Mellon, and Ted's father had been at opposite ends of history's first transatlantic telephone call.

In 1941, Rousseau joined the navy as a lieutenant. Details of his war service are scarce, and in later years he rarely spoke of it. He must have spoken to Tom Hoving about it, though. "He was in Portugal, as a spy," Hoving says. "And he parachuted twice into France during the occupation."

In the early years of the war, thanks to his fluency in several languages, Rousseau served as an assistant naval attaché, doing intelligence work in the American embassies in Lisbon and Madrid. Both of those cities were way stations for the powerful seeking to cross the Atlantic to safety, as well as choke points for those who, *Casablanca*-style, could not find a way out of the war zone. Among those who passed through Lisbon were André Meyer and Pierre David-Weill, partners in Lazard Frères, the investment bank George Blumenthal had run for decades. As prominent Jewish bankers who had helped German Jews escape Hitler's regime, Lazard's partners were, for all intents and purposes, marked for death.

Meyer escaped to New York early in 1940, and Pierre followed two years later, but Pierre's wife, Berthe, and their two children stayed behind because her son by her first marriage had been captured by the Nazis and sent to a concentration camp. They spent the rest of the war in hiding in southern France. She met Rousseau, who was working with the French Resistance, when he was sent to tell her that her son had died in captivity. Though she was much older, they formed a deep bond and would become lifelong lovers.

All of this impressed Hoving, who would cultivate Rousseau and become one of his best friends. He says that as a young man, Ted was so handsome that the debonair leading man Douglas Fairbanks Jr. once remarked, "If I only looked like Ted, I'd really be in business." So it's hardly surprising that by 1945 he was engaged again, this time to the far more acceptable Rosemary Warburton, the stepdaughter of William K. Vanderbilt. She'd made her debut in 1938, alongside the most famous deb of all time, Brenda

Diana Duff Frazier, and regularly hobnobbed with Hearsts and Astors. But again, marital happiness eluded Ted. After a long engagement, during which their wedding was thrice scheduled and postponed, they called the whole thing off in March 1946.

Ted would never dip his toes into matrimonial waters again. "He told me that the only woman he ever loved was a Gypsy girl in Spain," says another of his lovers. Between the engagement and its ignoble end, Rousseau had become one of the key figures in the far more noble Allied effort to find, identify, and return art that had been looted by the Nazis. In 1944, he joined the Office of Strategic Services, forerunner of today's Central Intelligence Agency. Promoted to lieutenant commander, he was assigned to the OSS's Art Looting Investigation Unit as one of three operations officers charged with questioning Nazis and the party members, bankers, and art professionals who'd helped them, focusing on Reichsmarschall Hermann Göring's collection and that taken from the French Rothschild family.

Back in Spain, under the cover of his old navy job, Rousseau met and won the confidence of Göring's banker, Alois Miedl, and over several months gleaned significant information about the looting scheme. After Germany's surrender, Rousseau and his colleagues set up shop in Altaussee, a salt-mining town near Salzburg, Austria, where vast amounts of Nazi loot had been hidden in a mine. They interrogated prisoners of war, including Adolf Hitler's photographer, Göring's curator and private secretary, a Munich dealer who sold art to Hitler even though she had married a Jew and become one, too, and Kajetan Mühlmann, who ran Dienststelle Mühlmann, the agency that organized the Nazi art plunder in Poland and the Netherlands. Though the work was hard, and distasteful, it would also prove rewarding, providing evidence that would be used at the Nuremberg war crimes trials.

When his OSS unit was dissolved in 1946, Rousseau moved on to a five-month tour of duty in Japan, "the nature of which was, and is, secret, beyond the fact that it had nothing to do with art," said *The New Yorker*.[10] Back in America and now a known quantity to the monuments men and fellow art heroes Taylor and Rorimer, Rousseau was named an associate curator of European paintings at the museum, first working under Harry Wehle and then taking his place two years later. Bothmer was convinced

that the Machiavellian Taylor had pushed Wehle out to make room for someone who would be beholden to him—and even better, a golden boy with aristocratic bearing and priceless social-financial connections. Wehle was given the consolation prize of a position as counselor and adviser to the department. Precisely two days later, Rousseau's father was named a commander in the French Legion of Honor.

Not long after that, Rousseau junior set off a furor when he made an intemperate remark to *The New Yorker* for an article that celebrated his promotion. In 1945, without input from the army's arts officers, Lieutenant General Lucius Clay, General Eisenhower's deputy, had floated the idea that some of the art recovered by the Allies should be sent to the United States for safekeeping; the implication was that it might then be available to make reparations to the victims of the Nazis and even as spoils for the victors in the war. Most of the officers involved in the recovery effort protested; Rorimer even submitted his resignation, which was refused. Nonetheless, that December, 202 paintings, mostly from the Kaiser Friedrich Museum, were sent to the National Gallery for storage, and early in 1948 put on display there.

That's when Rousseau spoke out, suggesting that some German art, even looted art, *should* end up in American hands. "America has a chance to get some wonderful things here during the next few years," he told the magazine. "I think it's absurd to let the Germans have paintings the Nazi bigwigs got, often through forced sales, from all over Europe. Some of them ought to come here."[11] Ironically, Rousseau's rash statement probably ensured that the paintings would be returned to Germany—and they were, after a victory lap through American museums in 1949. He would never be so candid again.

Though he did get credit and a write-up in *Time* magazine, early in 1954, for the reinstallation of the forty-four refurbished paintings galleries, Rousseau was still too young and green to get Taylor's job, which pleased Bothmer; he'd been pulling for his friend Rorimer, whose dedication equaled his own—they both often worked on weekends. Rorimer's long daily walks through the galleries, clad in a Brooks Brothers suit and army jump boots (and later, thick-soled orthopedic shoes), trailed by an assistant noting every dust ball, wilted flower, and burned-out bulb, appealed to

Bothmer's authoritarian sense of duty and order. Bothmer probably didn't appreciate another Rorimer habit—walking through new exhibitions in a bathrobe before changing into a tuxedo for openings—quite as much, but as time went by, he and the new director grew closer.

Unlike Taylor, Rorimer shared Bothmer's love of ancient Greek vases, so shortly after the Rorimer ascension Bothmer was able to conclude a deal that he'd dreamed of and schemed for since 1951, when the larger-than-life newspaper tycoon William Randolph Hearst died. Among Hearst's countless possessions was one of the largest collections in private hands of painted Greek vases, hundreds of them. Bothmer had heard of them when he studied at Berkeley but had never seen them; indeed, only five scholars had since they'd been swallowed up into the famous Hearst estate, San Simeon, in California, in 1935. As Bothmer came to understand it, Hearst had promised them to the Smithsonian but didn't actually own them; the Hearst Corporation did. They were among the few possessions that had survived a massive sell-off of his collections when his finances went awry in the late 1930s. Late in 1956, Bothmer became the sixth scholar to see them when he pulled off a coup and bought sixty-six of them (along with fifty pieces of majolica), chosen from photographs, for $75,000, and then traveled to Hearst's castle to pack and ship them to New York.

Accompanied only by the Hearst estate's secretary and caretakers, he dislodged the vases from atop bookshelves in the publisher's hundred-foot-long library, where they'd been secured with piano wire to protect them from earthquakes. Each vase was checked and double-checked, at least until the secretary let one fall and was so chagrined she shut herself in her office and never emerged again. Back home, Bothmer cleaned and restored many of them himself and then mounted an exhibition in the spring of 1957. His eye was good; only one had proved to be a forgery. Simultaneously, the Hearst Foundation gave the museum a number of things, including three British period rooms and a marble statue of Hermes. Two years later, on the very same day in July 1959 that Rorimer named Thomas Hoving, fresh out of graduate school at Princeton, the assistant curator of the Cloisters, Bothmer was promoted to curator of Greek and Roman art following Christine Alexander's retirement.

Although Rorimer didn't want a vice director, he listened when Both-

mer suggested he hire Joseph Veach Noble, who'd come to ask his opinion of a Greek vase and since become a friend and traveling companion. They would hunt vases together in Greece that Noble would buy, and through him Bothmer had the vicarious pleasure of collecting. Bothmer's encouragement resulted in a suggestion that Noble apply for a job supervising the museum's operations, security, and gift shop. Rorimer met him and hired him immediately. Despite his amateur's interest in Greek pottery—he'd not only collected it but also performed spectrographic analysis of glazes, and attempted to reproduce ancient fired pots in a shop, complete with kiln, in his Maplewood, New Jersey, basement—Noble had no museum background, so curators called it the Noble Experiment.

In fact, while Noble was hired to spare Rorimer from quotidian administrative tasks, his art-science avocation proved to be his greatest strength. In 1959, he decoded and reproduced the recipe for the glazes used on Greek pottery, and later Noble's research and investigations would help uncover the greatest frauds in the museum's collection, the three monumental terra-cotta sculptures, allegedly Etruscan, bought four decades earlier by Gisela Richter, that sat near the museum entrance. Unfortunately for Noble, the museum gave him sole credit for the discovery, when in fact it wasn't entirely his.

Iris Cornelia Love was a great-granddaughter of Isaac Guggenheim, the mining magnate whose brother Solomon founded the Guggenheim Museum, and the granddaughter of a wealthy stockbroker. Raised by a British governess in a Park Avenue apartment and on a seventy-five-acre farm in Goshen, New York, she rarely saw her cultivated but emotionally distant parents. She'd spent her youth hunting for Indian artifacts in the country and, when she was in the city, visiting the Greek and Roman galleries of the Met, where many friends of her parents' worked. She studied classical art and archaeology at Smith College and told one of her professors of her childhood suspicion that two of the much-beloved Etruscan warriors were modern fakes—there was nothing else resembling them in the field—and made their stylistic anomalies the subject of her senior thesis.

Harold Parsons, an American art adviser living in Rome, had come to the same aesthetic conclusion and wrote privately to Rorimer in 1958 say-

ing he would soon provide definitive proof that the statues were phony. But
the museum, aware that Parsons had a grudge against a competing adviser
who'd been Richter's agent on the purchase, made no public acknowledg-
ment of his suspicions and left the sculptures on prominent display; after
all, the great Gisela Richter had said they were real, and sporadic claims to
the contrary in 1937 and 1954 had never gained traction.

Iris Love moved on to graduate school at the Institute of Fine Arts,
where she continued her investigation into the statues, eventually conclud-
ing that they were indeed fakes. In 1971, she told an interviewer from the
New York Times that she'd told Rorimer she was going to publish her paper on
February 15, 1961, in an NYU magazine. In response, she said then, Ror-
imer preempted her, tersely announcing the truth in the Times of February
14. "I wrote a detailed responsible press release and Roland Redmond
squashed it," says Don Holden, who worked in the museum press office but
would quit over this episode. "Redmond said, 'Let's dodge it.' The museum
did not look good." And it made an enemy by giving no credit at all to Iris
Love.

Thirty-five years later, Love, whose subsequent archaeological finds in
Turkey and Greece burnished her reputation, offers a more detailed version
of the events, which still rankle her, saying that Rorimer had gotten wind of
her paper and tried to get a copy through her father, an old friend. When
that failed, Rorimer invited her for lunch, tested her knowledge of antiqui-
ties, and tried to tease a copy out of her directly. But he obviously already
knew what it said. "Never mind," he responded when she said she didn't
know where it was. "I don't need it."

Then he summoned Joe Noble. "My interests were such that I would
try to verify ancient things and raise questions that needed to be raised,"
said Noble. On learning from Rorimer that the warriors were under stylis-
tic suspicion, he scraped some of the glaze off the rear end of one of the
statues with a penknife and sent it to an outside lab for analysis. Its tests
showed a chemical in the glaze that had not been used until the nineteenth
century. Noble's findings formed the basis of the museum's terse an-
nouncement on February 14.

Eight days later, Parsons revealed that he'd found the surviving mem-
ber of the group of Roman forgers who'd created Richter's statues sixty

years before—even better, he'd signed a confession. Bothmer immediately flew to Rome to investigate, carrying "a shoe box with a plaster cast of a hand missing a thumb," says Holden. The forger had broken it off and saved it. "It fit the hand and that was the end." Gisela Richter, who was in Rome, cried when Bothmer gave her the news. A year later, the three statues, and seven slabs decorated with reliefs made by the same forgers, were moved to a study gallery referred to as "a kind of morgue."[12]

According to Bothmer, Love soon insisted that she should get the chance to print her findings in a museum publication. Instead, Bothmer and Noble published their findings that December, infuriating Love by mentioning her only in passing.

THE ETRUSCAN WARRIOR DEBACLE, EMBARRASSING THOUGH IT was, was no Cesnola scandal. For once, the museum was ahead of the press, if not of Iris Love. And the museum's relations with the city were far better than they'd been in either the Cesnola or the Moses era. Gifts and purchases continued to arrive with the regularity of the seasons; a massive wrought-iron screen from the cathedral at Valladolid, Spain, for instance, came from Hearst's foundation. And in June 1960, Rorimer and Rousseau proved their knack for cloak-and-dagger stealth hadn't been left behind in wartime Europe when they announced the acquisition of *The Fortune Teller*, a rare painting by Georges de La Tour.

"Charlie Wrightsman, asserting his philistine habit, wanted to buy it," says Hoving. The dealer Georges Wildenstein wanted "half a mil, a lot of money back then, and Charlie said 250, and Georges, not happy, said, 'Screw you.' Charlie said he would give the Met 250 if they would put up the rest. Wildenstein came down to 350 from 500, and the Met bought it."

At that time, only about twenty paintings by La Tour, who worked during the reign of Louis XIII, were known to exist, and there were only nine in America, of which only three were considered absolutely authentic. When the news that the Met had bought another one was announced, with no details or price given, journalists and art scholars scurried to find out both, and an outcry just like that which had defeated Rorimer's Cloisters

years earlier stirred Paris again, as art experts and politicians railed against this latest blow to French patrimony. Only this time, Rorimer had already won.

The paintings curator Rousseau had had a previous run-in with a foreign government, when he and Redmond acquired a painting of Saint Sebastian by the Florentine Renaissance artist Andrea del Castagno in 1948. By the following spring, the Italian government was claiming it had been improperly exported, but Taylor insisted he'd seen an export license before buying it from the art dealer Knoedler. An investigation led to the arrests of a lawyer and two employees of the Italian government's art export office and futile demands for its return. Eventually, the damaged and overcleaned canvas would be reattributed to a lesser artist, Francesco Botticini.

Rousseau had learned a lesson and was disingenuous, at best, when he told the press that the La Tour painting had "just turned up in France" and been sold by a family of country nobility to the dealer Georges Wildenstein, who had exported it according to French law.[13] While none of that was false, it obscured a much better story. The French family had likely acquired it in 1802, when they bought a fully furnished château in the Loire region. Its provenance was forgotten as it was passed down through the generations to a General de Gastines, who died in 1948. The next year a Benedictine monk recognized it for what it was and brought it to the attention of the Louvre, which tried to buy it but was outbid by Wildenstein, though he was said to have paid only about $20,000 for it. In 1950, the painting was allowed to leave France briefly on loan, but the Louvre's paintings curator made sure it was returned. Wildenstein then held it for years until the paintings curator retired and Redmond and Rousseau learned it was available. How? "Reporters don't reveal their sources and neither do we," Rorimer later told *Time,* though he admitted such news came via "a letter, a phone call, a whisper," and even from American diplomats, all part of "a business fraught with difficulties—wiretapping, fraud, forgeries."[14] Most likely, the source was Wildenstein himself.

Don Holden, as museum press manager, knew the truth was not his business. "People who understood museums said, 'You must understand, there's a lot of skulduggery and payoffs and smuggling and this is normal procedure,' " he says. "Rorimer, who had been [in the war], understood that, too."

After an investigation led by the French minister of culture, André Malraux, it emerged that the painting had actually left France two years earlier, right after Wildenstein donated a fragment of a Claude Monet painting to the Louvre. At the time, the Education Ministry had responsibility for French museums, and the minister's chief administrative assistant had signed a document authorizing export, apparently in thanks for the Monet. It was thought that this trip, like the last, would be temporary. Eighteen months later, however, the painting reappeared at the Met, leading *Le Monde* to deem the affair "exceptional, strange and troubling." Eventually, the outrage died down enough that another La Tour would be allowed out of France, and Wildenstein would be elected a member of the prestigious Academy of the Beaux Arts for his contributions to French culture. *The Fortune Teller*, on the other hand, remained controversial and was denounced several times as a fake—and forever after, rumors that he took kickbacks from Wildenstein would dog Rousseau. Despite all the questions and complaints, *The Fortune Teller* is still attributed to La Tour and considered one of the museum's masterpieces.

Rorimer had truly calmed the waters at the Met from the roiling seas of Taylor's time. No one complained about the Hearn Fund anymore, now that Robert Beverly Hale was spending it. And then Rorimer hired him an assistant. Born in 1935 to a family of Belgian diamond brokers, Henry Geldzahler was a young fan of the American Museum of Natural History, which was near his home, until he switched his allegiance to the Met at age twelve, when art became "a consuming interest," he said. At age fifteen, he was sickened and yet riveted by an Arshile Gorky exhibit at the Whitney Museum, and so began a lifelong love affair with contemporary art. He returned to the Whitney often and got "terrible headaches because I hadn't sorted out anything about quality yet . . . It took five or six years of doing that before I was able to walk in and say . . . that amuses me; that revolts me; and so on."

His next stop was Yale, where he studied Byzantine art and decided on a museum career, believing that his multicultural background—bouncing between "an orthodox Jewish Hebrew environment" and "a privileged New York environment"—was a perfect preparation. "I was a European in America," he said. "I was a Jew at Yale . . . I think that kind of experience in

a funny way also helped me at the Museum with the trustees and artists because there also I'm mediating between seemingly irreconcilable forces: the avant-garde on the one hand and the totally entrenched Hudson Valley trustees on the other. It's the kind of thing I'm able to do ... Ellsworth Kelly in the morning and Brooke Astor in the afternoon ... I consciously decided that it would be better for me to go to Yale and learn how to deal with American aristocracy ... Trustees are nothing but older Yalies."[15]

After his second year at Yale, Geldzahler volunteered at the museum and in the summer of 1954 got a job working in the Paintings Department. Rousseau was away, but he got to know Rorimer and Hale, whom he considered a gruff, silky, and eccentric patrician. He spent several late afternoons talking to Rorimer at length about his dream of a museum job. "I told him that my parents said that since I was Jewish it would be hard for me to advance myself in a field like that," he recalled.

"Don't ever again tell that to anybody" was Rorimer's touchy reply. Despite Blumenthal and Lehman, and despite his own success, Rorimer knew that there was truth in what Henry's parents had told him; he could be whoever he wanted, but there was no need to discuss it. As Henry told the story some years later, Rorimer was named director shortly after this conversation and responded to Henry's note of congratulations with one reading, "Now you see what I mean." (Rorimer's penchant for secrecy also led some to think he was a repressed homosexual and sponsored the homosexual Geldzahler and other promising young men as a way of acting out his taboo desires.) Geldzahler grew to feel that Rorimer lived a tragic "fantasy that he owed his success to his concealment of his Jewish origins."[16]

For Geldzahler, who'd grown up in the postwar world, his religion proved to be an advantage. "The trustees at the Met still have a bit of an anti-Semitic cast to them," he wrote. "Even though there are some Jews on the board of trustees they're always clean Jews. Money gets clean if it's washed by inheritance taxes a few times ... Lehman was on the board ... and people like that ... because they came over in 1848. But I think as far as the staff goes it's not much of an issue anymore ... Most of the great collectors of contemporary art are Jewish. It's natural to have a Jew as curator ... There are certain assumptions of humor and of background that you take for granted."

Rorimer kept his eye on young Geldzahler. After a junior year in Paris at the Sorbonne and the Institut du Louvre, Henry graduated magna cum laude from Yale in 1957 and went on to Harvard to get his Ph.D. He summered in Provincetown, where he met Franz Kline, Hans Hofmann, Robert Motherwell, Helen Frankenthaler, and Ivan Karp, a dealer who worked for Leo Castelli, getting his first sniff of the art rat pack. Henry was working as a teaching assistant at $1,200 a year, frustrated over a recent failure to get an entry-level job at the Whitney in the fall of 1959, when Rorimer visited Harvard and, out of the blue, offered him a job.[17]

When he said he really wanted to work at the Whitney, Rorimer "turned gray with rage," Geldzahler would recall in a 1991 lecture, but then promised the younger man he would hear from him soon.[18] A month later, Rorimer sent a letter and asked him to come to the Met on his Christmas break. Again, he offered the young scholar a curatorial assistant's post attached to Hale in the American art department at $5,000 a year. Accepting the job meant abandoning his doctoral thesis on Matisse sculpture and his Ph.D., but Geldzahler didn't care. When his father agreed to pay his rent for a year, Henry accepted. But there was a condition: he had "rather a disgusting little beard," he said, and Rorimer told him to shave.

"Why?" he asked.

"You haven't earned it," said Rorimer. Once he shaved, he was said to resemble a cross between the actor Charles Laughton and Porky Pig.

Rorimer warned that his new job would be a challenge. "There's nothing for you to do here," he said. "We don't expect to be seeing very much of you at the museum because your job is contemporary art and we don't have any." Geldzahler took him at his word—and never regretted it. He went back to Provincetown that June with a new sense of purpose.[19]

"For the first four or five years my job at the Met was to continue my education at their expense," he later said. It was essentially on-the-job training. But first there was on-the-job hazing. His first day was July 15, 1960, and like any new employee he showed up at 9:00 a.m.—and found himself alone. An hour later, the associate curator and museum archivist Albert Ten Eyck Gardner wandered in, called Henry into his office, and began giving him assignments, all concerned with nineteenth-century art.

The new employee started trembling and, gathering up his courage, re-fused. "I was hired by Mr. Rorimer to work with Mr. Hale," he told the much older man in a shaky voice. Gardner never bothered him again. He felt he'd saved himself from being kidnapped by the forces of the past.[20]

At first, Hale was unsure. When Rorimer told him he'd hired Henry, "Bobby said, 'God in heaven,' " says his wife, Niké. "But they got along very well." After a couple months of going through the storerooms, rehanging a few galleries, adding a slightly more contemporary point of view, the pudgy, blond-haired, blue-eyed assistant curator started going out—visiting galleries and studios and doing what would later be called networking. He never stopped. "The word got out that I'd go anywhere," he said. Soon enough, he seemed to be everywhere.

The New York school Hale had championed in the 1950s had become the establishment. Geldzahler sought out younger artists. "And within a couple of months, I had met Frank Stella, Roy Lichtenstein, Andy Warhol, Dan Flavin, Donald Judd . . . it went on like that," Geldzahler recalled of his days as a self-described little twerp from the Met. "My entrance coincided with a reshuffling of the cards, as it were, or a reinvention of the game. Abstract Expressionism was dominant, but in 1960, the color field painters and a new abstraction, Kelly, Reinhardt, Albers, Stella were coming along . . . and of course, the unpredictable media craze that erupted around Pop Art began the following year. It was possible, by going around the studios with [the art dealers] Ivan Karp and Richard Bellamy, in '59, '60 and '61, to meet these guys and introduce them to each other . . . Many of them didn't know each other."[21] Warhol, in turn, introduced him to David Hockney, who became a close friend and frequently drew and painted him. "I never thought I was beautiful until David started doing my picture," Henry once told a friend.[22]

Most mornings, Geldzahler would go to the office to report in to Hale. "I'd say, yesterday I saw a young artist named Andy Warhol or Frank Stella or Larry Poons or Jim Rosenquist and this is what their work looks like," Henry recalled. Now and then, he'd bring Hale with him to meet an Ellsworth Kelly, Rosenquist, or Jasper Johns. But he didn't buy much art—yet. "I learned a lot from [Hale] about patience," Geldzahler continued.

"When I got to the museum I was really raring to go. I wanted to build a collection and put on shows. He said, 'Henry, just take it easy. We're here to put out fires. We're not here for anything else.' "[23]

In fact, by networking so relentlessly, Geldzahler was collecting kindling to set future fires. "America realized it had missed Abstract Expressionism, American art was drifting away from America, and then along came Pop . . . that market just boomed from the beginning," says Niké Hale. "I remember our first cocktail party at [the noted Pop collector Robert] Scull's house. Everyone was in black tie. Bobby said, 'My God, something has changed.' " American art had come into its own.

Geldzahler grew particularly close to Warhol. At their first meeting, he'd carefully eyed Warhol's own collection of art and objects, then offered him the chance to see paintings by the American primitive artist Florine Stettheimer stored in the Met's basement. "Anyone who'd know . . . that I loved Florine Stettheimer had to be brilliant," recalled Warhol, who went to the Met the very next day. "Henry was a scholar who understood the past, but he also understood how to use the past to look at the future. Right away we became five-hours-a-day-on-the-phone-see-you-for-lunch-quick-turn-on-the-'Tonight Show' friends." Geldzahler inspired Warhol's Death and Disaster paintings by showing him a tabloid front page about a jet crash. "A few years later," Henry recalled, "I said, 'It's enough of disaster; it's time for life again.' " He picked up a magazine off Warhol's floor, flipped to a picture of flowers, and said, "Like this, for instance." Warhol's signature flower paintings were the result.[24]

In 1964, Henry sent Rorimer a memo analyzing the Met's contemporary art holdings and needs. He recommended a separate department of international contemporary art, increased funds for purchase of important missing European moderns and sculpture, to supplement the Hearn bequest (deemed insufficient to buy art in the new market), and increased courting of collectors. Rorimer told him it was the best memo he'd ever gotten and then "put it away and I never heard of it again," Geldzahler recalled. "I never really thought he understood exactly what I was doing but I know that he believed in me. And that seemed more important. He was like a father or uncle figure that sort of patted you on the shoulder and said 'Fine work, my boy,' but didn't really know."[25]

By 1965, the *New York Times* would be describing Geldzahler, by then an associate curator, not as a curator but as an "art-world luminary."[26] That year, he was allowed to help hang his first show, Three Centuries of American Painting, a five-hundred-painting survey of American art from Colonial times to Jackson Pollock. Henry was put in charge of the twentieth-century portion of the exhibit and wrote part of the handbook for the show as well. He recalled that Hale let him have his way and he ended up doing most of the work. "A total disaster," counters Niké Hale. "Bobby had to rehang it. Henry knew nothing about museums, had no qual-ifications. He'd been geared for the academic world until Rorimer showed up. He was a total innocent in that world."

"Henry liked being a fish out of water," says Robert Littman, a curator friend. At the Met, Henry could swim in exotic waters uptown and down.

Out on the Pop scene, roly-poly Henry, dressed in double-breasted jackets, riding boots, leather ties, and sunglasses, with a cigar clenched in his still-babyish face, became a star, moving seamlessly from Claes Oldenburg's Happenings of 1960 into the Warhol films of four and five years later, pop-ping up at gallery openings and readings in between. Indeed, it sometimes seemed he was in the newspapers more than he was in the museum. "There was a little bit of talk in the middle sixties about how 'he never shows up,' " he acknowledged, but added that "it was a marvelous way into the irrational workings of the art world." Unbeknownst to him, though, some of the trustees wanted his head.

In 1966, *Life* magazine had run a spread, "Henry Here, Henry There . . . Who Is Henry?" that included a photo of him in a bathrobe smoking a cigar; *Time* called him "a quasi-somnambulant rotundity in prison stripes afloat in a rubber raft in an Oldenburg Happening mounted in the swimming pool of a Manhattan health club."[27] Some trustees, already wary, called Rorimer, "saying, isn't it time to let me go," Henry recalled. "And he felt that it wasn't, thank goodness." Even though his artists were confined to a single gallery that, it was later said, "moved from area to area like un-claimed baggage," Rorimer protected him and gave him regular promotions and raises.[28]

That year, Geldzahler, though only thirty, asked Rorimer for a one-year leave of absence. He'd been asked to curate the American art to be

shown at the next Venice Biennale international art festival, but couldn't participate in a commercial venture as a museum employee. Rorimer agreed to let him go. So he left, accepting a one-year appointment as program director of the National Endowment for the Arts. First, though, was Venice, where he made a splash announcing his opposition to art prizes just before they were given out. None of the Americans won. "Venice was political and social hell," he wrote to a friend.[29] He came home and was diagnosed with an ulcer.

The festival also lost him Andy Warhol's friendship when he didn't choose to include the artist, some of whose paintings he owned and whom he'd been in daily contact with for six years. Henry appeared in a number of Warhol's films, including *Henry in Bathroom* in 1963, *Couch* and *Batman Dracula* in 1964, *Tiger Hop* in 1966, and most famously the July 1964 film *Henry Geldzahler*, in which he sat in Warhol's Factory smoking a cigar for over an hour. Not only that, Geldzahler was close to Warhol superstars, including Edie Sedgwick and the handsome Paul America, who gave him his first dose of LSD.[30] "I tried everything once or twice," he said. When asked how he survived the Warhol scene, Henry said, "I can't be manipulated. If anything, I suppose I'm a manipulator. I'm like one of them, but I hope with a kinder heart. And my position is that people are handkerchiefs, not Kleenex, to be used again and again, not used once and thrown away."[31]

Warhol was not destined to be one of Henry's handkerchiefs. After the *Life* article, Henry decided that if he took Warhol, then just entering his Velvet Underground phase, to Venice, it would have turned into a media freak show. "It was just a career decision I made . . . to cool my relationship with him for a while," Geldzahler said. He knew that Bob Hale was about to retire (which he would in June 1966) and he'd lose his shot at Hale's job if he didn't play his cards right. But instead of being honest about it, he didn't even tell Warhol he'd been chosen to curate the Venice exhibit; his friend read it in the paper instead. The next time someone asked Warhol about Henry, he replied flatly, "Henry who?"[32]

GELDZAHLER WAS STILL AT HARVARD WHEN TWO OTHER, EQUALLY consequential new arrivals stuck their noses under the Metropolitan's tent. Charlie Wrightsman and his wife, Jayne, had made their first gift of money to the museum and loans of art (a Savonnerie carpet and a recently acquired Vermeer) in the spring of 1955, their quiet entrance belying the profound influence they would soon have. By 1956, Charlie's name was in play for a board seat; he was elected that fall, and years later would be replaced by his wife. Though she stepped back to become a trustee emerita in 1998, Jayne still served on the acquisitions committee and as an advisory member of the executive committee at age eighty-eight.

Charles Bierer Wrightsman was born in 1895, the son of Charles John Wrightsman, an Oklahoma oilman, lawyer, and politician. One of the nineteenth century's original oil wildcatters, the first Charles drilled wells, hit gushers, and built an oil company. As a lawyer, he helped create the oil depletion allowance, a tax credit to encourage exploration. He'd begun his political career when Oklahoma was a territory, served as the Pawnee County attorney, and would run for the U.S. Senate several times but lose, once due to an apparently unwanted endorsement by the Ku Klux Klan, the second time losing to Thomas P. Gore, a blind ex-senator.

Young Charlie's sister drove the only Rolls-Royce in Oklahoma.

After an elite education (Exeter, Stanford, Columbia), Charlie became a navy pilot and met his first wife, Irene Stafford, a socially prominent girl from Wilkes-Barre, Pennsylvania, in the winter of 1921 in Miami. By then, Wrightsman, who'd been an asthmatic child, had grown up into a professional polo player who flew his own planes. "He made money scouring the Southwest, buying up property and mineral rights," says his great-grandson Dana Dantine. "He was a genius; he had a vision, and he accomplished it."

Charlie and Irene were married in Tulsa that June. They promptly sailed for a two-month tour of Europe, including a sojourn at a château in Deauville. The trip was marred by the announcement in July that he'd cheated in an airplane race the year before and been ordered to return a $3,000 prize. That wasn't the only time that Charlie behaved badly. When his father fell ill a few years later and transferred his oil well titles to him for safekeeping, Charlie refused to return them when his father recovered; he

was disinherited.* No matter; he had the money and by 1927 had moved to a ranch in Santa Monica, and his wife gave birth to the first of two daughters, whom they named Irene. In 1932, he fought a proxy war for control of Standard Oil of Kansas and became its president.

Tom Hoving's stepmother knew Wrightsman in Tulsa, where he was known as "a brash, foul-mouthed, hard-drinking guy who was famous for flying a small plane upside down under bridges and cheating at polo," Hoving says. "My stepmother got him to stop swearing, invited him to parties, cooled him down. He had a flaming crush on her the whole time. I don't think they ever consummated it, but she told me stuff about Charlie which alerted me, before I got to be director, about how this guy's mind worked. I knew he would cheat if he could, he'd do anything, backstab anybody to get his way."

In 1936, he shipped his thirty-one polo ponies and his team, the Texas Rangers, to England for a tournament. On that same trip, the Wrightsmans visited Lake Como, Switzerland, and Cannes and had a private audience with the pope. The pope saw him because he was rich and powerful, not because he was kind or generous or religious or good. Wrightsman has been described as ruthless, swaggering, brusque, intolerant, philandering, and tyrannical. Says Stephanie Wrightsman, a granddaughter, "He was *not* a nice man. When he bought Standard Oil, he fired all the employees. A lot of people ended their own lives."

The Depression was not as easy or chic for the future Jayne Wrightsman. Born in 1920 in Flint, Michigan, where her father, Frederick "Fritz" Larkin, an architect who worked as a construction contractor, built offices and factories for the burgeoning automotive and steel industries, she had a comfortable childhood; Fritz and his wife, Aileen, were well-off and lived with their four children in a good neighborhood with a live-in cook. But in 1930, Aileen left town and settled in Phoenix, Arizona, with Jane, as she then spelled her name, and her siblings; their father stayed behind, moving

* After his father died of a heart attack at age ninety, Charlie sued the estate, claiming his father was unduly influenced by a nurse to whom he'd left money. Two years after that, the estate settled, giving him $750,000 that his father had earmarked for charity. Not long after that, he put his mother in a nursing home.

into Flint's Durant Hotel. There is no record of a divorce in Flint, and what happened is unknown. "The family fiercely doesn't talk about things," says Jane Larkin, a cousin. "We try to search and end up with a brick wall."

Fritz Larkin was rarely spoken of again, but he was hardly a cipher. In 1935, at fifty-three, he moved to Washington, D.C., to work as an inspection engineer in the Public Buildings Branch of the Treasury Department. Two years later, he was named chief of the Foreign Service Buildings Office of the State Department, charged with building U.S. embassies and consulates abroad. From his office, he built a real estate development empire fueled by unlimited government money and protected by members of Congress. "If an ambassador wanted something, anything," one of his successors remembered, he had to get along with Larkin. Among his purchases were building sites in Accra, Ankara, Marseilles, and Tehran, a villa in Nice, a Rothschild family *hôtel particulier* in Paris, a manor house in Dublin, a palace in Prague, and two Roman palazzi, one built on land once owned by Julius Caesar. In a black fedora, living out of a suitcase, he traveled the globe until his retirement in 1961. "I tried to find out if Fritz was the OSS or CIA," says Jane Loeffler, author of *The Architecture of Diplomacy*, which told his later story, "because he had an unbelievable ability to get around the world, and they used the Federal Buildings Office as cover. I had a hunch he was."

A *Vanity Fair* profile by Francesca Stanfill next places Jayne-with-a-y in a Los Angeles public school in 1933. Her mother, nicknamed Chuggy Larkin, was a whiskey-voiced southern-accented nightclub habitué, "a dipso," or dipsomaniac, according to some, who had settled her broken family on the unfashionable outskirts of Beverly Hills. Whether she was groomed, or, as some told Stanfill, neglected, Jayne Larkin followed her mother into that fashionably decadent demimonde.

After high school, Jayne took the sorts of jobs a pretty girl could get in Depression-era Hollywood, working in retail, modeling, and nibbling at the edges of filmdom. Years later, she would entertain a dinner partner with the tale of a visit as a teenager to Hearst's San Simeon, where his mistress, Marion Davies, took her to the bathroom to sip from a bottle of liquor she kept hidden in the toilet tank.

Jayne first made the *Los Angeles Times* when she was seventeen in 1937. She was spotted in a nightclub at the Beverly Wilshire Hotel with the pro-

ducer Hal Roach Jr., whose father had made movies starring Harold Lloyd and produced the Our Gang serials and then more sophisticated features like *Topper*. (The young Roach would later take over his father's studio and lose it to creditors.)

Jayne's gossip-column mentions came fast and often in 1938. That spring, after she'd been spotted at a benefit and a bridal shower at the home of a young, handsome Hawaiian sugar plantation heir and wannabe actor, Richard Smart, and his wife, Patricia, a society girl, the column *Chatterbox* championed her, often running a photo of her with a toothy smile in a sombrero. She became a regular at the Smarts', rubbing shoulders with the wives of Melvyn Douglas and Otto Preminger, and she was linked romantically to Pat DiCicco, cousin of the future James Bond producer Albert "Cubby" Broccoli. Usually described as an agent, DiCicco was a gangster, bootlegger, and pimp who was known as Lucky Luciano's man in Hollywood and was rumored to have helped kill his ex-wife, the actress Thelma Todd, a few years before. Her death was ruled a suicide.

But Jayne wasn't a one-man teenager. Ed Sullivan said Burgess Meredith had eyes for her, and in 1939 she'd be linked in the columns to Broccoli himself; Reginald Gardiner, a comic actor; Townsend Netcher, a Chicago retail heir who'd been divorced by two actresses, most recently Constance Talmadge; and any number of others. That October, her name and Charlie Wrightsman's appeared in *Chatterbox* on the same day for the first time. He'd divorced his wife, Irene, in 1937 (giving her a paltry $100,000, though by then he had tens of millions) and begun making the columns himself as he started playing the field.

In 1940, Charlie fell for Shirley Cowan, an instructor at the Arthur Murray dance school, but even though he supported her, "she was cuckoo for Errol Flynn," says another girl-on-the-town of that time. His legal residence was Houston, but Wrightsman, who was of medium height with gray hair parted down the middle and a fashionable wisp of a mustache, had taken a bungalow at the Beverly Hills Hotel. His wife and daughters, Irene and Charlene, kept the ranch in the divorce. He lived in California when he wasn't flying his Grumman (one of only eleven in private hands) to New York or Texas, where he would hunt antelope. In 1941, he was said to be "really serious" with the actress Alice Faye.

Meanwhile, Jayne Larkin had fallen for a film editor at MGM, Phil Kellogg, but lost him to Gloria Vanderbilt, the heiress, who'd come to Hollywood at age seventeen. "Jayne was crazy about him," says the girl-about-town, who partied with a crowd of Europeans, including one Beppe Bellini, who also went out with Jayne. (Vanderbilt would later marry and divorce Jayne's early suitor, Pat DiCicco.)

Jayne was close to two other eligible young women, Esme O'Brien and Lillian Fox, a former model—and the three had a bet as to "who would marry a rich man first," says the girl-about-town. Lil Fox won in 1940, bagging Philip Ickelheimer (later Isles), Bobbie Lehman's cousin. In 1942, Esme O'Brien married Robert Sarnoff, son of the president of RCA. Both would divorce and remarry happily, Lil to a Bulgarian author, and Esme to John Hammond, the music producer. Jayne Larkin came in last in their marital horse race—more men intervened before she found her Prince Charming—but in the end won the richest, though not necessarily the best, prize.

Not even their grandchildren know how Charlie and Jayne met. But they've heard the same story that has circulated in society ever since: that Jayne waited on Charlie in a Beverly Hills department store. More likely, as *Vanity Fair* reported, they were introduced at a dinner by Townsend Netcher. Jayne was only three years older than Charles's elder daughter.

Stanfill wrote that at the time, Charlie was two-timing another girlfriend, the recently divorced wife of the actor Victor Mature. When Charlie was hospitalized with lip cancer in Palm Beach and summoned them both, Jayne, encouraged by the gift of a mink coat, glued herself to his side, while her rival hit the social circuit. "Charlie needed someone to look after him," a Palm Beach heiress remembered fifty years later. "He thought he was dying, so he married Jayne. Well, he didn't die then. The poor girl."[33]

They married in March 1944 and took up residence in Palm Beach. Three years later, they bought a house that Charlie had coveted the first time he saw it (his credo was that everything was for sale for a price)—a white stucco 1917 estate on six acres decorated by Syrie Maugham. The seller was the utilities mogul Harrison Williams and his wife, Mona Strader Schlesinger Bush Williams, better known as the best-dressed woman in the world. Before *they'd* bought it, it had been leased by Barbara Hutton, and the Duke and Duchess of Windsor.

Aileen "Chuggy" Larkin remained in West Hollywood until her death many years later, financed to the end by Jayne's new husband on condition that she keep her distance. Three years after their marriage, the Securities and Exchange Commission accused Wrightsman of defrauding Standard of Kansas stockholders by buying back most of the common stock in the company, worth $5 million, for a mere $100,000 by withholding information about the company's appraised value. Wrightsman denied the charges but agreed to never do it again. He didn't need to. He was one of the wealthiest men in America.

For the next few years, as Charlie recovered from his cancer, the Wrightsman spotlight fell on his two daughters, neither of whom pleased their prickly, demanding dad. In 1946, just after her debut, Charlene accepted a marriage proposal at the Stork Club from a Finnish party boy—her father disapproved, and she soon broke it off, only to elope to Tijuana with an Austrian actor. Wrightsman gave that merger his blessing, but two and a half years later, she sued for divorce, calling her husband a worthless fortune hunter.

Thirteen days later, after a failed attempt at reconciliation, his other daughter, Irene, divorced her first husband, a reprobate playboy, leaving her daughter, Stephanie, with him. Stephanie would return to her mother in 1951 after her father and his next wealthy wife died when the crew of his yacht mutinied and he drowned off Casablanca. Not long after, Irene began an affair with the film star Kirk Douglas (who was at the time inconveniently married to a former model) at the ranch her mother got when Charlie divorced her.

"At dinner, [Irene's] mother drank more than she ate," Douglas would recall of that meeting in his autobiography. After dinner, he and Irene went to the library, where she locked the door and they both stripped and started making love on the floor before a fire. Her mother began pounding on the door. "Fuck her," Irene said. "Or better yet, fuck me."

After his divorce in 1951, Douglas went to meet Wrightsman, who'd just liquidated his oil company, collecting $1 million and all its oil. "He was one of the richest men in the country and one of the meanest," Douglas recalled. "He was cruel and selfish, and demanded that his two beautiful daughters be ornamental and obedient." When they behaved, he bought

them couture gowns. When they didn't, he cut them off. Wrightsman told Douglas, "I don't want you to even consider marrying my daughter." Stephanie Wrightsman has said he gave Irene $1 million in exchange for a promise not to marry the Jewish movie star. The pair would break up and get back together again before finally ending it when Douglas came home from a film set and found her in bed with Charlie Chaplin's son.[34] Both Wrightsman girls would have further matrimonial adventures—Charlene with the gossip columnist Igor "Ghighi" Cassini, twelve years her senior and the brother of Oleg Cassini, a fashion designer; Irene with a New York marketing man—but Charlie, over his cancer and newly arrived in New York, by then had other things on his mind.

The museum's courtship of the Wrightsmans was intense but not one-sided. Charlie had decided to storm the gates of society. "He always wanted to be considered an old-line aristocrat," Ghighi Cassini once said.[35] He decided that collecting would be their ticket in and that his wife should make that her new hobby. He played Pygmalion with the willing Jayne, hiring tutors to teach her both French and proper English, table manners, interior decor, and art. He frequently slapped her down in public and warned her not to speak to others, lest she make a fool of herself. He brutalized her into becoming the wife he wanted. Instead of revolting, she acquiesced, buckled down, and turned herself into a vision of culture and elegance.

She'd begun with imitation, then studied with many mentors. One was John Walker, the chief curator and then director of the National Gallery of Art. He met them in Venice during the 1951 Biennale at a Brandolini palazzo and afterward at cocktails on Charlie's yacht. The slim, chic Jayne riveted him with her gray-blue eyes and quickly drew him out. When he told them he knew Bernard Berenson, they asked to meet him, and Jayne became one of the old man's last disciples.

When Walker told them of his regret that Berenson was too old to travel and would never see the then new National Gallery, Charlie offered to photograph every piece so he could. Walker provided laborers, stepladders, and lights, and after closing, Charlie and Jayne would arrive and set to work, he holding the lights, she taking pictures, thousands of them, and later editing them as well. "Charles's impulsive decision," Walker would recall in his memoirs, "made both of them look very hard at a great collection.

Connoisseurship can be developed only in this way."[36] They delivered the pictures to Berenson personally in 1954, and a friendship blossomed.

Following the traditional path of the new rich, Jayne befriended the contemporary equivalent of the Duveens, two expatriate antiques dealers, distant cousins in the extended Rothschild clan. They sold FFF, Fine French Furniture, the latest thing in *décor retrouvé*, to American arrivistes— Berenson would soon dismiss it as "the Louie, Louie craze"[37]—out of a grand full-floor apartment at 820 Fifth Avenue, where, starting in 1950, they entertained lavishly to lure their guests into becoming clients. Through them, Jayne met the decorator Stéphane Boudin of Maison Jansen, a fashionable Paris interior design firm, who redecorated their twenty-eight-room Palm Beach house, started taking her to museums and galleries, and introduced her to collectors and curators.[38] Jayne studied diligently and realized that connoisseurship would not only give her and Charlie the respectability they so craved but also give her room to breathe within her privileged, suffocating marriage. Beginning in 1952, she not only spent Charlie's money on what would become one of the great FFF collections of her era but sought out experts and read and memorized every fact she could gather on the subject.

In 1955, having sold off their stock, the Rothschild cousins decamped for Europe, and the Wrightsmans, who'd kept a suite of rooms at the Pierre hotel, bought their apartment and shifted their focus to New York. Charlie, in his youth, had been cheated by an art dealer and was initially loath to get involved in Jayne's new pursuit. But in 1949, after they visited a loan exhibition at the museum of porcelains collected by Irwin Untermyer, a retired judge with a world-class collection of decorative arts, Wrightsman sought him out and set up a meeting, and "in a short time the judge and his two neophytes were visiting all the porcelain dealers on both sides of the Atlantic," Walker wrote. With Untermyer's guidance and friendship, Charlie, too, became an avid porcelain collector and then moved into rugs and paintings. Untermyer also taught the Wrightsmans the value of a close relationship with a museum and nudged them toward the Metropolitan.

Irwin Untermyer's life trajectory was set by his father, the lawyer who ran the money-trust investigation that drove J. P. Morgan to his grave. "He made the money," says Ann Carmel, a granddaughter. "Irwin never made any." Samuel Untermyer was a progressive reformer and a zealous Zionist. On his death in 1940, he would be mourned as a champion of the world's Jews. But he'd also made a fortune, pulling in the highest legal fees in New York as well as big profits in the deals of his corporate clients.

Irwin Untermyer "grew up in the shadow of his father," wrote the scholar Stephanie Lake in "With Pride and Prejudice," an unpublished study of Untermyer.[39] It was quite a shadow. The year Irwin was born, Samuel tried more cases than any New York lawyer. Their 171-acre Yonkers estate, Greystone (originally built by another corporate lawyer turned reformer, the failed presidential candidate Samuel J. Tilden), boasted twenty-nine rooms and twelve servants. Both parents were promiscuous spenders; they collected paintings by Whistler, Gainsborough, Monet, and Corot and overpowering furnishings. Samuel commissioned a mosaic inscribed with his initials for their entry hall. A chauffeur brought him a fresh boutonniere from his garden at midday whenever he was in court. Irwin did not approve; he considered his parents enthusiastic but undiscriminating collectors. And he felt no love for his father, a scary, irritable man. "His father was brilliant but unkind to his children," says a cousin, Nina Untermyer. In that, at least, Irwin would take after him.

Long before his father's death, Irwin began receiving his inheritance as income from trusts Samuel had set up—and used the money to carve out his own identity. Despite a fortune a fraction the size of Samuel's, he was driven to top his father somehow. But he didn't manage that in twenty years as a lawyer, or even after he was elected a justice of the New York State Supreme Court in 1929. He retired in 1945 without making much of a mark legally. But beginning in 1912, when he and his wife got a set of Queen Anne chairs as a wedding gift, he distinguished himself by forming world-class collections in several narrow specialties of the decorative arts: embroidery and needlework, English furniture and silver, English and German porcelain of the eighteenth century, and medieval and Renaissance bronzes, 2,129 pieces in all. Governors and mayors may have attended his father's funeral; curators, collectors, and connoisseurs would be among Irwin Untermyer's mourners.

There was little real feeling in that equation, however, as Untermyer cared for nothing but his objects, which he called his children. The only other thing he loved was what Tom Hoving would call "the chase, the capture." Untermyer loved to tell the stories of his acquiring, as opposed to those of the acquisitions themselves. Lake would describe them as his "material autobiography."[40] She speculates that he was inspired by his father's arch nemesis, Morgan, whose famous collection came to New York at the same time Untermyer started his. But unlike both his father and Morgan, Irwin collected with precision and economy rather than voracity.

Though his small trust grew substantially after his mother died in 1924, Untermyer never had unlimited funds like his father, so his purchasing was governed by necessity. He would regularly buy through others, tell dealers he could only be tempted by irresistible prices, and spend years if necessary dickering over a single item. Once, when customs tried to collect duty on what it deemed to be the modern embroidered backs of some antique chairs, he insisted they be detached and returned to the dealer in Europe.

The Untermyers lived on West End Avenue in a cultured, German-Jewish neighborhood, but in the late 1920s, as he passed age forty, Untermyer began to widen his circle of acquaintance, approaching collectors like Jules Bache and befriending titled Europeans. Simultaneously, his collections threatened to take over his home, even though he'd already bought a second floor in his building so he could install two oak-paneled Tudor rooms and glass display cases—his own private museum. His children, something of an afterthought, shared that floor. His distance from his family was profound. "Everything was about buying things for the museum," says Carmel.

Untermyer bought English furnishings after World War I, when England's great estates were broken up, switched to porcelain in the 1930s, when Jews escaping Hitler were selling the stuff for ready cash, and moved on to silver in 1939 and 1940, his interest piqued by the Hearst auctions. His life changed dramatically after his father's death in the latter year. His judgment of Samuel's taste was vindicated when the state of New York refused his dying offer of his Yonkers estate. Irwin and his sibling sold their father's art and belongings shortly afterward. Assuming his own collections

would meet the same fate from similarly disinterested offspring, Untermyer promised them to the Metropolitan Museum in December 1941 and in explanation urged his children to read a Balzac novel, *Cousin Pons*, about a man who feels no one can love his collection as much as he does. His disdain for children was palpable. "He made us anxious when we were in the apartment," says Carmel. "It was like living in a museum." Untermyer's son Frank pointed out that Irwin's greatest complaint about museums was that they catered to children.[41]

Just after he offered his things to the museum, Untermyer moved his family to an apartment a few blocks away on Fifth Avenue, closer to the auction galleries and art dealerships he now haunted daily. The apartment's interiors were designed to store and display his treasures. The windows were shaded so sunlight couldn't damage the delicate rarities. The rooms were so crowded his children were forced to eat off TV trays when they visited. His wife hated the new apartment. She likely hated him, too. "He cheated all the time," says Nina Untermyer. "He didn't pay any attention to his wife." Adds Lake, "She was miserable in her marriage and suffered in silence." Finally, she fell into a deep depression and killed herself in March 1944. One of his daughters, a daughter-in-law, and a grandson would later kill themselves as well.[42]

Untermyer's gifts to the Metropolitan began in the late 1930s. In order to equal and surpass his father, he'd decided to create and donate a collection to guarantee his immortality, choosing to buy objects the museum needed to fill out its collections. As he grew more sophisticated, the donations continued, carefully structured to produce the highest tax deductions possible under the law while allowing Untermyer to retain possession of the objects until his death. These practices, his son Frank said, were encouraged by the museum, which lobbied for the creation and protection of such tax breaks.[43]

Collecting, preparing the collection for the museum, and giving it became Untermyer's occupation for the rest of his days. A year after his wife's death, he retired from the bench to devote himself to it full-time, and four years after that he hired a private curator, Yvonne Hackenbroch. She'd found out about the job from James Rorimer; Untermyer's gifts had attracted the museum's attention, and Rorimer wanted somebody to influ-

ence his buying. Two years after hiring the museum-sanctioned curator, Untermyer was elected a trustee.

Hackenbroch would be Irwin's closest companion until his death in 1973. Unlike his late wife, she shared his enthusiasm and knowledge. Together, they visited New York and London dealers on a regular basis. "She devoted her life to him," says Carmel. "It's unclear what their relationship was." Frank Untermyer thought he knew, though; he told Lake she was "a complex, difficult woman in love with my father."

At her apartment in London, Hackenbroch, a tiny, perfectly coiffed ninety-six-year-old in tinted glasses, lives up to that description. She begins by confirming that Untermyer drove several women in his life to suicide. "He tried it on me, too," she says. "He made you so miserable; it seemed the only way out." Asked how he made her miserable, though, her response is blunt: "You will hear nothing else."

Years later, Tom Hoving would paint their relationship as resembling that between a master and a slave, with Untermyer forcing his curator, on threat of dismissal, to cut his toenails weekly. Relatives of the judge confirm that; Hackenbroch will not discuss it. "His intelligence impressed me," she says. "I didn't stay for the pay; it was miserable. I suffered every day, but to be with such an intelligent man, winning his confidence, that kept me there. I stayed for his knowledge of English literature. And the wonderful chance to touch every object. That's how one learns. In a private collection, you can take it and turn it and know it. That, too, was a great attraction. The human qualities you can *just leave out.*"

Together, they collaborated on seven scholarly catalogs, beginning with one on Untermyer's Meissen porcelain in 1956. The books cemented his reputation. "My publication and the judge's enormous intellect caused interest," Hackenbroch says. "The prices went so high, and people begged to see it." She agrees with his family that he was canny about finances. "He always inquired about the deductions," she says. "If one gave desirable objects, the deductions were enormous." Asked if they had a love affair, she smiles. "That would have been too expensive for him."

As time went on, they grew even closer as Untermyer became more estranged from everyone else in his life. "He was frightfully mean," says Hackenbroch. "Nobody liked him. Nobody wanted him. He was extremely

useful to Rorimer. Rorimer came every weekend. Hoving didn't like him. He came rarely. Rorimer was a far greater museum person. Think of the Cloisters and how he got on with the wealthiest family in America. That's not easy. So he came every weekend to Irwin Untermyer because that was part of the game."

Hoving visited Untermyer after he replaced Rorimer as director because he knew that there was nothing binding about the judge's pledge to give the Met his collections. But Untermyer had already written his will, and shortly after Hoving got the top job, he also wrote a letter addressed to "My dear children" to explain it to them. Under New York state law, they were entitled to half his estate, but he'd already pledged more than that to the museum, he explained in the letter dated May 17, 1967, which paved the way for a later request that they sign waivers agreeing to relinquish their rights to his estate.[44]

Untermyer's greatest gift—of 192 gold and silver objects and 35 bronzes—came in 1968. He died five years later, in October 1973. His decline was rapid after he fell out of bed one night and Hackenbroch was summoned by his cook; his doctor had refused to make a house call. She took him to the hospital, where he had a stroke, and finally, two weeks later, he went home to die. "I sat with him," Hackenbroch says. "The children wouldn't come, which is what he deserved." After his death, the museum contacted his children, who had agreed to his terms, even though, as his son Frank said, it meant their lifestyle "changed very much"—and not for the better.[45] His cousin Nina Untermyer offers an apt epitaph for the judge. "Proximity to treasure breeds certain forms of cruelty," she says.

THROUGHOUT THE 1950S, THE WRIGHTSMANS' TREASURE HOARD grew—Jayne picking things out, Charlie negotiating their purchase. By 1966, an inventory of their possessions, their makers, and their previous owners would have boasted such names as Louis XV and XVI, Madame de Pompadour, Madame du Barry, Marie Antoinette, the duchess Marie Feodorovna, Meissen, Tiepolo, Vermeer, La Tour, Canaletto, Poussin, Lotto, El Greco, David, Renoir, and Houdon. Acquisitions didn't equal re-

spect, though, and the Wrightsmans remained slightly suspect. When they first opened the doors of their redone Palm Beach house, it wasn't the Florida colony's snooty in crowd that passed through them so much as imports like the Windsors, the Shah of Iran, and the flotsam and jetsam of international society, among them Roland Redmond, whose 1957 marriage to Princess Lydia di San Faustino (celebrated with a luncheon chez Wrightsman) gave him entrée into that dubious social circle. But the Wrightsmans had one other advantage that would change their social fortunes forever. It is summed up in that old real estate adage, location, location, location. Among their Palm Beach neighbors were Joseph and Rose Kennedy.

Though Charlie was a Republican, proximity, money (he by then had $100 million), and dinners that started with a pound of caviar helped them bond. The Wrightsmans entertained all the Kennedys and invited them to their annual New Year's Eve parties and on their regular summer cruises in the Mediterranean. In 1958, Charlie sent a letter to the interior designer Boudin to introduce him to Jacqueline Kennedy, who'd married Jack five years before. Though he said she was unlikely to be a major customer, Charlie added a postscript: "But who knows—she may some day be First Lady."[46]

As Jayne and Charlie ascended in society, they risked running into his first wife, who'd taken to calling herself Mrs. Stafford Wrightsman. Irene had a full social life in New York, attending benefits, serving on charity committees, and seeing her daughters. But in November 1960, she died. Though the official account is that she suffered an aneurism after falling off a ladder while changing a lightbulb, it's generally believed in her family that she drank herself to death, her alcoholism worsening as a result of Charlie's cruelty to her during and after their divorce.

Irene's death didn't slow Charlie down, though; thanks to John F. Kennedy, he and Jayne were moving into the first circle. "Each could help the other," says Kennedy's White House social secretary, Letitia Baldridge. "Charlie was a source of money for Jack's campaign." In return, the Kennedys gave the Wrightsmans an aura of "glamour and excitement," she continues. "Jackie was a bridge" to real society, and "Jayne was thrilled" to walk over it.

Just after Kennedy's election in November 1960, Jayne joined a committee to restore and redecorate the White House and would shortly

donate $500,000 worth of tapestries and furniture to the effort. The Wrightsmans' relationship with the Kennedys became broadly known in May 1961, when the president and Jackie were their houseguests in Palm Beach. In June, Kennedy, suffering from the back pain that had plagued him since he'd almost been killed in World War II, returned to the Wrightsmans', saying he needed to swim in Charlie's heated saltwater pool for therapy.

Their friendship notwithstanding, in 1963 Wrightsman sued the Internal Revenue Service for a $34,000 tax refund, saying their $5.5 million worth of art and furniture was an investment, and expenses for the collection should be deductible. They even wrote off flowers sent to curators.[47] And the Wrightsman-Kennedy romance withered when scandal hit Ghighi Cassini, Charlene's husband. In February 1963, he was indicted on federal charges that he'd worked as an agent for the Dominican Republic's corrupt leader, Rafael Trujillo—a public relations firm he co-owned had attracted the attention of Bobby Kennedy's Justice Department by taking $200,000 to improve Trujillo's image. Charlene was shocked to discover that she and her husband were immediately dropped, not only by the Kennedys, but by her father as well. She took an overdose of sleeping pills and died that April.

Marina Cassini, Igor's daughter by an earlier wife, never liked the Wrightsmans, even though she was flown to Palm Beach on private planes for holidays with them. She found Charlie "extremely cold," she says. "He'd flip silver dollars in the pool and we'd dive and get them." Jayne struck her as bizarre. "Very affected and always very subservient to Charlie, but also very poised and very controlled, very distant, very smooth. She never showed emotion, but then neither did he. They were cold, calculating, creepy people." At Charlene's funeral, Marina continues, neither Charlie nor Jayne spoke to or acknowledged Ghighi and his children.

The Wrightsmans ducked for cover after that and remained below the media's radar in November of that year, when the president was gunned down in Dallas, Texas. The following summer, though, the Wrightsmans were back in the spotlight when, in rapid succession, it was reported that Jayne had helped the president's widow find a new home at 1040 Fifth Avenue, just a few blocks from the Metropolitan, and that Jackie planned to emerge from seclusion to join them on an August cruise of the Adriatic on-

board a 188-foot, 690-ton yacht, *Radiant II*, rented from the Greek shipping tycoon Basil Mavroleon. Though it flew a British flag, the Stars and Stripes were raised when Mrs. Kennedy, clad in a black dress, boarded in Venice. The other passengers included her sister, Lee Radziwill; the British ambassador to the United States, Lord Harlech, and his wife; and James, Kay, and little Louis Rorimer, who'd been invited along to keep Charlene's son Dana company.

"When Kennedy was shot, she nearly died of anguish," Kay Rorimer said of Jackie. "After the funeral, she couldn't face the world for six months. Jayne and Charles said, 'Stop this, come with us.' She would come up on deck and sit with Louis, and then she'd disappear." After the visit to Dubrovnik, where they were mobbed, she didn't leave the boat again.

Tom Hoving, who would take Rorimer's place on the yacht in years to come, described its luxury in his memoir. "To cruise with the Wrightsmans was to live in a floating, high-tech Versailles," he wrote. "One was surrounded by modern technology but expected to play at an eighteenth-century pace, sedate and dreamy... There were so many maids that I'd leave a sport shirt on my bed for a fifteen-minute swim and by the time I returned, it would be laundered and ironed."[48]

Life was not so easily ordered. A year later, in October 1965, Charlie Wrightsman's surviving daughter died, although this time, instead of scandalous headlines, there was only silence and a small paid death notice in the *New York Times*. Her last days were spent in her New York apartment, where, her lover Kirk Douglas wrote, "she graduated from alcohol to dope."[49]

"She was tougher than Charlene, but eventually Charlie broke them both," says a close friend. Even as she lay dying, she drank scotch and milk "to fool her nurses." Finally, "her liver collapsed." Charles and Jayne "were completely dry-eyed, cool as a cucumber" at her memorial service, says an attendee.

THOUGH HE WAS A REPUBLICAN AND A MAN DEFINED BY PREJUdice, Charlie Wrightsman, friend of the New Frontier, was a harbinger of things to come at the Met. A slow but steady turn toward more socially lib-

eral, less outrageously patrician, results-oriented management types had begun. As the *New York Times* would note, "The city's arts patrons, once a tight little body bounded by social position and great wealth, are being transformed into an expanding group that would have surprised, and perhaps even shocked, grandmother." The new Medici were mostly businessmen, "new faces, new money and new ideas," and "a segment of the establishment that is not obsessed with personal publicity and, in fact, prefers to stay in the background."[50] Or at least were still en route to the foreground.

The September 1964 board meeting was a turning point at the Met; the next generation of ruling trustees emerged that night and would soon shake the museum to its core. Roland Redmond also stepped down as president; he later claimed that at seventy-two, he felt he would be too old to train Rorimer's successor when the director would have to retire eleven years hence. Though he was still social, "he didn't have any money," says Nancy Hoving, which made him odd man out among the new trustees. So he was "forced out," recalled Tom Hoving, by "exasperated peers," but maintained some of his power as he'd "somehow wheedled his successor," Arthur Houghton, into letting him remain on the board.[51]

Houghton, born in 1906, was a bridge between the past and the future. Like Redmond, he was an American aristocrat: a descendant of a Revolutionary War general and the great-grandson of Amory Houghton, who founded Corning Glass in 1851. Katharine Houghton Hepburn, the movie star, was a distant relation. His education followed the well-worn path of American Episcopal aristocrats from St. Bernard's to St. Paul's to Harvard. His uncle Alanson was the U.S. ambassador to Germany and England in the 1920s.

But Arthur was also a hard-nosed new-breed manager. In 1933, he'd taken over Steuben Glass, and reinvented the company after personally destroying its entire inventory of twenty thousand "blinding-colored glass monstrosities" with lead pipes and going full steam into modernist design.[52] After divorcing his first wife in the mid-1930s, he married Ellen Crenshaw Gates, a descendant of a seventeenth-century royal governor of Virginia and a Dutch patroon, in 1939. More significantly, she had been the wife of his partner and managing director at Steuben, John Gates, who'd destroyed all that inventory with him. Though Gates continued working there, his

family bore Houghton ill will; one Gates relation calls him "a dedicated, cruel son-of-a-bitch."

The marriage didn't last long; Houghton and Ellen were divorced in Reno in 1944 while he was in the army air force. She charged him with desertion, and a week later he married a woman he'd met on a train. They, too, would divorce, in the 1970s. A serial marrier whose new wife was always younger than his last, he was philanthropically promiscuous, too, a member of more than a hundred organizations in education and the arts, and a crusader for racial equality. Not long after graduating from Harvard, he paid for the Houghton Library there, a repository of rare books and manuscripts, which were also his collecting enthusiasm.

Frances Mason, Houghton's longtime assistant, thinks his philanthropic endeavors, like those of Irwin Untermyer, were motivated by family competition. A great Anglophile and fan of English literature, he thirsted for what his uncle already had. "He would have loved in his bones to be ambassador to Great Britain," Mason says. "He wanted to be the big cheese in the cultural life of New York." His generous and public philanthropy paid off when he was elected, at age fifty-seven, as the Met's new president.

Like Houghton, the other new faces at board meetings were both more of the same and something new, or at least younger. In 1961, J. Richardson Dilworth, forty-five, the nephew of a former mayor of Philadelphia but more pertinently the senior financial adviser to the Rockefeller family and former managing partner in the "Our Crowd" investment bank Kuhn, Loeb & Co., and a collector of English decorative arts, took what might be called the Rockefeller board seat, immediately donated $2,000, and soon replaced Dev Josephs atop the finance committee. In 1962, Arthur K. Watson of IBM, forty-three, took his father's seat. In 1963, Robert de Forest's descendant Sherman Baldwin, a lawyer, joined, too.

In 1964, new members included two young bankers, Richard Perkins, fifty-four, of First National City, and the thirty-eight-year-old Daniel Pomeroy Davison of Morgan Guaranty Trust; the latter qualified as fresh *and* blue blood: his grandfathers were the Reverend Endicott Peabody, founder of the Groton School, and Henry P. Davison, the J. P. Morgan partner. His father, F. Trubee Davison, had been an aviator in World War I, an

assistant secretary of war, president of the American Museum of Natural History, and the first director of personnel of the Central Intelligence Agency. If Jack Morgan's son Henry symbolized the family's past status at the museum, Davison was the museum's future.

The self-made Roswell Gilpatric, fifty-eight, a former head of the Cravath, Swaine & Moore law firm, Rockefeller aide, deputy defense secretary in the Kennedy and Johnson administrations, Pentagon critic, and a key figure in defusing the 1962 Cuban missile crisis, was elected at the same time. Gilpatric had grown up lower-middle-class near John D. Rockefeller Jr.'s summer compound in Maine and "would just walk up to Mrs. Rockefeller and start a conversation," according to a daughter, Betsey Lewis. Pushed by a grandmother who'd married a lawyer, he went to Hotchkiss and Yale on scholarships, then rose to the top of the establishment. He was said to have had "more connections than an IBM computer."[53] One of them was Houghton, a longtime friend. A serial womanizer, too—he would be married five times and was romantically linked to Jackie Kennedy before her marriage to Aristotle Onassis—Gilpatric wasn't particularly wealthy; he wasn't natural trustee material. But the qualities sought in a trustee were clearly changing.

Though there was no clean break with the Hudson River valley crowd so ably represented by Redmond, no threat to the established order, the new trustees were the leading edge of a new class of civic leaders. "I will not recommend a person to be a board member solely because he has money," Houghton explained, "but I won't hold it against him . . . There is an increasing realization that business and industry are a part of society and have a responsibility to society . . . You have a type in this city and other cities, the trustee type. You put them on a board of any institution and it will be well-run . . . You do not pick them because of a special knowledge of the field . . . They know where to turn to get the answers."[54] A year later, the new inner circle would be complete when C. Douglas Dillon returned as an active trustee. The banker, Rockefeller intimate, and Impressionist collector had left the board in 1953 to serve as Dwight Eisenhower's ambassador to France and undersecretary of state, and then as secretary of the Treasury in the Kennedy White House.

Unfortunately, Houghton's election served to alienate another power-

ful trustee, and almost lost the museum the greatest art collection still in private hands in America. For reasons then unstated, in the spring of 1961 Bobbie Lehman, sixty-nine, decided to remove his paintings from the museum and install them permanently in what had once been his father's home, a five-story Beaux Arts house Philip had built in 1900, just across the street from John D. Rockefeller's town house. The decision followed a loan of three hundred pieces of the collection to the Louvre in 1956, where they caused a sensation at the Orangerie. In the first two weeks, over seventeen thousand people came to see them. Lehman was similarly hailed in 1959 when a selection of the paintings left the Met again and joined hundreds more objects from his collection in Cincinnati.

The removal of Lehman's art was finally revealed months after it happened, in January 1962. Some went into his eighteen-room Park Avenue apartment, some into his office, but most (estimates of the collection varied from one thousand to three thousand art objects and antiques) were installed in twelve rooms of the old house, which had been redecorated and repurposed as a private museum. They were shown publicly only once a year, at benefits for the Institute of Fine Arts and other charities. After that, the Lehman collection was rarely seen at all. Sometimes, Bobbie would entertain there, sometimes he would admit scholars, and sometimes, Stephen Birmingham wrote, he would prowl "the great, silent rooms like a solitary Croesus contemplating all that he has amassed."[55] The art critic Emily Genauer later called it the only American counterpart to Europe's private-palace museums and bemoaned that it was "hidden and virtually unknown, behind the locked doors on 54th Street."[56]

Lehman denied any unhappiness with the Metropolitan ("I miss the pictures" is all he said[57]), and the board passed a unanimous and fulsome resolution of gratitude for his loan, but his action spoke louder than words. Privately, he would admit that at his very first museum board meeting, the main topic of conversation had been the dispersal of J. P. Morgan's collection. "It all got broken up," says Lehman's son, Robin. "That was the example that really upset him . . . the basis of his adamancy that [his collection] be kept intact." But the immediate cause of his unhappiness was Redmond.

It began when Redmond refused Lehman an even better deal than the ones given to Benjamin Altman and Jules Bache, whom Lehman had

known: essentially a Lehman wing within the Metropolitan. "Redmond was a real prick, a heavy-handed SOB," says a family friend. "It wasn't Rorimer. He was too good a museum man and had already run what was in essence a Rockefeller branch of the museum." So even as he teased other museums with the possibility they might get it, Lehman still talked to Rorimer almost daily, remained on the Met's board, and even ran its executive committee meetings when Redmond couldn't.

Rorimer didn't push the matter. "Jim knew very well that Lehman loved his collection and didn't want to think about having to die and not be with it," said Kay Rorimer.[58] So it is unlikely he spoke up in 1964 when Redmond handed the presidency to Houghton, passing over Lehman. "He felt slighted" is all that Robin Lehman will say. "No Jew was going to run Redmond's museum," says the Lehman intimate. "Bobbie never felt an iota of animus toward Houghton. He just thought he should have had the job."

But it was easy enough to ignore the ill feelings; the museum was doing fabulously well. In its annual studies in the mid-1960s, the Rockefeller Brothers Fund found that the Met's financial condition was "rather healthy, perhaps even robust," with its assets approaching $100 million and attendance soaring to new heights thanks to popular exhibits, the most popular of those being a visit in 1963 from Leonardo da Vinci's *Mona Lisa*, on loan from the government of France.[59]

Jacqueline Kennedy, much beloved in France for her style and beauty, had cooked up the loan with André Malraux the previous spring. At first, *Mona* was to travel only to the National Gallery, but the Met was added to its itinerary, and after a month in Washington it "opened" in New York on February 7 in the Medieval Sculpture Hall, where it was mounted on red velvet in a red brocade niche in the center of the massive Valladolid screen, protected by bulletproof glass, two Secret Service men, museum guards, and the police. The installation, overtime, and a celebratory gala for trustees and swells cost $32,000. A line began forming at 4:30 on opening morning, 16,000 people saw it that day, and after twenty-seven days in the building *Mona Lisa* was said to have attracted 1,077,521 visitors, far more than in Washington. Another 810,000 people passed through the turnstiles that month but passed up the chance to see it. Or so the Met said.

Hoving claims he later found that Rorimer systematically inflated at-

tendance figures. "They had a thumb clicker," he says, "and they'd always do three to one. And we figured out that they had over-clicked to please Jim Rorimer." Rorimer used those attendance figures to justify ever-increasing demands on the public purse. To a reporter questioning the value of the *Mona Lisa's* visit, he was blunt about the importance of blockbusters: "The public will be more interested in voting for state aid to museums, cities will more willingly support cultural undertakings."

❖

ON JULY 4, 1965, RORIMER NAMED HOVING, THEN THIRTY-FOUR, curator of medieval art and the Cloisters. But the Cloisters was no longer the red-hot center of the museum, so Tom's eye was already wandering. "I was being interviewed by the Wadsworth Atheneum to become the director," he says, "and I was toying with that, because I'd become rather bored at the Cloisters. I'd been there six years, and it was kind of routine. I'd gotten over the thrill of collecting because I'd pretty much gone through the money."

Throughout the early months of 1965, John V. Lindsay, a handsome, popular patrician who represented Manhattan's Upper East Side in the U.S. Congress, flirted with the idea of running for mayor. That May, after Governor Nelson Rockefeller urged him to run, he decided to do it. Not long after the Hovings, who'd met Lindsay while giving out leaflets for his 1960 congressional run, volunteered for the campaign, a Lindsay aide who'd gone to Princeton with Tom called to ask the young curator to write a position paper for the mayoral hopeful on the subject of cultural affairs. Hoving suggested he write a paper on parks and recreation instead. The parks were a mess, and morale among Parks Department workers was terrible.

His proposal, developed after he toured the city on his Jawa motorcycle, speaking to artists, community activists, architects, and park users, was that the city's dangerous and run-down parks could easily be improved enough to fulfill their mission to teach, enrich, relax, and inspire, to be, in other words, works of art, just as Frederick Law Olmsted had intended when he laid out Central Park. His big idea was to make noise, attract crowds, make the parks welcoming again. Lindsay loved it, and Tom was

awed by him. So in September, having used up all his accrued vacation days, he asked Rorimer for a leave of absence without pay to continue campaigning. "I'll *give* you the pay, but you're killing yourself," Rorimer replied. "You're going to destroy your whole life, going to work for someone who may not even win."

But win Lindsay did on November 2, and seven days later Hoving was summoned to the mayor-elect's office and offered the job once held by Robert Moses, commissioner of parks. Walking out into the maelstrom of rush hour afterward, Hoving looked up at the skyline as every light in New York City—indeed, every light in the entire Northeast—went out in the largest power failure in history. "It was a sign from God Almighty," he thought, but still he didn't say yes for days—and then only after another Lindsay aide called to demand a decision, adding that if he said yes, he'd get a city car and driver.

"My mother always said Dad was devastated when Hoving left," says Anne Rorimer. "He'd put a lot of faith and time into him." But Hoving was impatient with both Rorimer's deliberate managerial style and the slow pace of the museum world. He was certain Rorimer, who was only sixty, wouldn't retire for at least five years, and having tasted glory when he acquired the Bury St. Edmunds Cross, he wanted more. The Cloisters was a backwater compared to the Arsenal, the Parks Department headquarters twenty blocks south of the museum and just across the street from the Wrightsmans' apartment building. And as parks commissioner, Hoving would, in a vital way, be getting a museum promotion; though he wouldn't have a vote, as an ex officio trustee he would be Rorimer's boss. Hoving appreciated the role reversal. "I was a junior curator who overnight became the landlord."

Hoving started at the Parks Department on January 1, and almost immediately sought to expand his turf to include the arts, asking to bring the city's cultural affairs office under the Parks umbrella and proposing more art in parks, mobile museums, and longer hours at the museums before his first month in office was out. "Times have changed," he said. "We're going to open it up and have a little bit of—how shall we call it—Central Park a Go Go."[60]

In 1966, of course, everything was a-go-go. New York was Fun City.

Life was a party, and everyone wanted in. In an attempt to get things done with more alacrity, Arthur Houghton had changed the composition of the museum's executive committee. No longer would city officials like Hoving be welcome in its meetings. And it was much smaller than it had been in 1964, with only nine members (including Gilpatric, Wrightsman, and Lehman), instead of the thirteen who'd served under Redmond. It was that smaller group that decided, in 1965, to begin planning a celebration of the museum's hundredth birthday five years hence.

Late that October, Houghton, Rorimer, Hoving, Rousseau, Bothmer, Geldzahler, and Harry Parker, Rorimer's new assistant, met to discuss the centennial. "I vividly recall that the atmosphere seemed tense between Rorimer and Houghton," Hoving wrote in an early draft of his museum memoir. "Houghton found free-wheeling discussion sessions exciting." Rorimer preferred structure. After dispensing with wild ideas like official U.S. stamps and gold coins, Hollywood movies, and a new model car called the Sarc, short for "sarcophagus" (Geldzahler's suggested slogan: "The family that drives together dies together"), they proposed that the birthday incorporate major exhibitions and new scholarship, several books (a coffee-table tome by *Vogue*'s Leo Lerman and Calvin Tomkins's history), and community outreach. "It was decided that the principal goal," Hoving wrote, "should be the *next* hundred years, the creation of a truly international art education entity."[61]

Ros Gilpatric was named the head of an ad hoc committee to start planning the event. A core group of trustees—including Daniel Davison, Dillon, Dilworth, Lehman, Watson, and Houghton—and five outsiders—the adman David Ogilvy, the CBS chairman Frank Stanton, Marietta Tree, Jayne Wrightsman, and Frederick Adams Jr., director of the Morgan Library—filled out the committee. Seven months later, tragedy gave them the chance to turn the centennial into a crucible for revolution.

There is no record in Parks Department files that Tom Hoving attended meetings of the Metropolitan board in his first months in office. But he was there on May 10, 1966, when the trustees met at the museum at 4:00 p.m. In his memoir he tells a story about that meeting that no one else will confirm, as it comes close to accusing Roland Redmond of killing James Rorimer. At the meeting, he wrote, Redmond laced into the director for ac-

cepting a small gift—an enameled Christmas card—from a German auctioneer. Rorimer wanted "to give it to the Medieval Department," Hoving says, "so young people coming up through the ranks could see a modern enamel in the style of the late twelfth century as part of the forgery measuring stick. Redmond went into a tirade about, one, accepting gifts from dealers, and, two, trying to palm it off on the Met. Totally outrageous! But Dick Dilworth stepped in, cut Redmond off in the middle of his tirade, and said, 'Moot! I move acceptance!' And Redmond was shut up."

After the meeting adjourned at 5:30, several trustees lingered to see the new French period rooms paid for by the Wrightsmans, which had just opened. Rorimer asked Hoving to wait until the trustees left and then launched into a tirade of his own. "That's been happening to me for years!" Hoving quotes him saying, his face turning purple, veins popping. "Chipping away at me, chipping away at me. I can't take it anymore. I can't stand this." He concluded by accusing Redmond of anti-Semitism, then, turning pale, ran out of steam. Finally, Hoving says, he went home and died of a heart attack, the latest in the line of directors felled by the job of running the Metropolitan.

No one will confirm the specifics of Hoving's story. The official version of Rorimer's death has him in rare form that day, laughing and joking at a friendly board meeting. Dietrich von Bothmer said that Joe Noble walked Rorimer to his Cadillac that night and that nothing was bothering him except, perhaps, Hoving's presence as an ex officio trustee at the meeting.

Kay Rorimer bore no ill will toward Redmond, who she felt shared her husband's devotion to the museum, and never mentioned that the two had fought that day. But some fresh insight is provided by the young man Rorimer had hired two years previously, Harry S. Parker III. A student at the Institute of Fine Arts, or IFA, when he took a course taught by the director, Bothmer, Hoving, and other curators, Parker became Rorimer's assistant in 1964 and quickly bonded with his boss. Among his jobs were coordinating the presentations of curators seeking permission from the trustees to acquire art, ensuring that scientific tests were run, and compiling whatever else Rorimer needed to know to make a case for purchase. Parker, who helped Hoving overcome Rorimer's profound skepticism about the Bury St.

Edmunds Cross, came to admire both men, though he considered them op-
posites, Rorimer methodical, Hoving spontaneous and inspirational.

During that 1965 blackout, which started just after a board meeting,
Rorimer and Parker had helped Redmond get Mary Whitehouse, a trustee,
out of a stuck elevator. Then Rorimer nudged the trustees out of the mu-
seum and into cabs, got his loaded gun from a locker behind his desk, and
walked the galleries all night with Joseph Noble until the power came back
on. "You couldn't rule out that it was a plot to steal," Parker explains. "He
was a housekeeper extraordinaire with a feeling of personal responsibility
for everything."

A few days later, when Hoving announced he was quitting, "it was a
real blow to Rorimer," Parker says. "There was a deep sense of betrayal."
And it was exacerbated when Hoving joined the board. "Tom's treachery,
the disappointment, was a truly disturbing thing," says Parker. "Another was
Roland Redmond. He shadowed Jim" on his summer travels around Eu-
rope, demanding to see anything Rorimer wanted to acquire. "Redmond
had no right to vet," says Parker. "He was an amateur meddling in the world
of professionals." So Rorimer worked out a charade with his secretaries,
who would send false cables to ensure that Redmond would only hear about
a potential purchase in, for instance, Rome after he'd left for the next city
on his itinerary. "Redmond way overstepped and really pissed Jim off. Jim
had been diplomatic his whole life, he'd coped with Rockefeller, he'd sup-
pressed his own ego. Roland had no business screwing around and telling
him what to do." Many museum employees agree.

Rorimer suffered from labile, or wildly varying, blood pressure. So be-
ing dressed down again by Redmond—in front of Hoving!—may have been
more than his heart could take. Jessie McNab Dennis, then a young curator,
believes that Hoving's behavior and betrayal (by leaving the museum) may
have contributed to Rorimer's heart attack.

Whatever or whoever the cause, the facts are that Rorimer came
home, had dinner, and went to bed as usual, then, during the night, Kay
Rorimer "heard a noise and he was gone," their daughter says. Kay called
Parker at six the next morning to tell him her husband had died and sum-
moned him to a meeting in their apartment with Rorimer's secretary and
Houghton, who saw the director's death as his chance to complete his

takeover of the museum. "Houghton hadn't asserted himself yet, but once Jim died, he really stepped up," says Parker. "He said, 'There are many, many, things we have to take care of.' I'm thinking, undertaker. He sits down and drafts telegrams to all the directors of the world's museums."

"It is with profound sorrow that we inform you that our director and friend James J. Rorimer died in his sleep in the early hours of this morning," said the telegram sent to Tom Hoving at the Arsenal later that day. Two days later, another cable invited him to a special board meeting on May 19, where Houghton named a search committee of Young Turk trustees including himself, Danny Davison, Doug Dillon, Dick Dilworth, and Ros Gilpatric to find a successor for Rorimer. Nominally, the architect Francis Day Rogers was in charge, but Davison actually ran the search, nodding at continuity while setting a course for radical change.

Houghton would later say that he sought a man like Francis Henry Taylor, burning with the "fire of genius," to replace the "sound housekeeper" Rorimer. Though he was actually a composite of both, a showman and big-picture dreamer like Taylor *and* an object-loving scholar like Rorimer, Hoving isn't even willing to give Rorimer much credit. "The place was sinking, going down the drain," he says. "Maintenance was deferred. It was dark, it was dingy, it was gloomy, it was not sexy. They knew the place was dying."

Houghton also named a four-man administrative committee to run the museum during the search, consisting of the vice director Joseph Noble as chairman, J. Kenneth Loughry, the treasurer, and two curators, Ted Rousseau and John G. Phillips, who ran the Western European Arts Department. Then he asked Parker to spy on them for him. He also asked Parker, then twenty-six, to recruit and head a group of curator-ushers for Rorimer's memorial service to be held in his beloved Spanish apse at the Cloisters three weeks hence.

A crowd of one thousand filled the Cloisters for Rorimer's send-off, which featured speeches by Houghton, Rousseau, and Rorimer's friendly competitor Sherman Lee of the Cleveland Museum of Art. Recalling Rorimer's unique combination of sensitivity, connoisseurship, patience, discretion, sacrifice, wile, diplomacy, and charm, Rousseau suggested that the Cloisters, filled with his presence, should be Rorimer's memorial. In his

memoirs, John Pope-Hennessy wrote a different sort of epitaph, noting the "widespread regret that a man of such capacity and distinction had been impaled on museum administration."[62]

Two of the four interim administrators were in the running for the job. But Ted Rousseau turned it down, having seen what it had done to Taylor and Rorimer. Joe Noble, on the other hand, wanted the job, even though he knew that he lacked the necessary scholarly credentials. "He wanted to be somebody," says his assistant, Carolyn Aller. And he was. He was the hero who'd unmasked the Etruscan warriors; he had the backing of Bothmer, whose stock had risen two weeks after Rorimer died when he married a Humble Oil heiress (Joyce Blaffer, the ex-wife of Marquis Jacques de la Bégassière, who would soon begin making big donations to the museum). Noble also had a good relationship with Houghton, who appreciated his discretion.

"He tried to keep things out of the news and the museum looking squeaky-clean," says Noble's granddaughter Katie Gamble. When a disturbed visitor stabbed herself in the jugular with an ice pick in a bathroom in the early 1960s, Noble kept it quiet. "The board felt I was honest and trustworthy and always backed me," Noble said before his death in 2007, denying he wanted the job. Harry Parker says differently, recalling a meeting with Houghton in Rorimer's empty office, when he heard a noise in a side room where Rorimer kept books and a cot for catnaps—and yanked open its door. "We found Noble in there, listening," he says. The vice director claimed he was looking for a book.

The search committee first looked outside, researching Evan Turner, the director of the Philadelphia Museum of Art, approaching Sherman Lee, who wanted to stay in Cleveland, and actually offering the job to a more conservative candidate, from the board's Morgan camp, Frederick B. Adams Jr., the longtime director of the Morgan Library. He also said no.

Other trustees made informal overtures. The Wrightsmans had lunch at Pope-Hennessy's home, where Charlie asked to make "the Pope" his candidate. But feeling unsure of "the legal and social context in which the Metropolitan Museum operated," he demurred, even though Wrightsman offered the added inducement of a professorship at the IFA if things went awry. Pope-Hennessy later wrote that he was one of a "vast number" of peo-

ple consulted and offered the directorship, but believed the "appropriate" choice was the "compulsive, highly articulate...confident, overconfident indeed" Hoving.[63]

Hoving certainly needed no introduction to either the museum staff or the public. Within days of assuming his Parks job, he'd become a superstar, in constant motion across the city, injecting new life into a tired department by hiring outsiders and grabbing the spotlight by swimming in public pools, biking in Central Park and banning cars on weekends to make it safer, clowning around in playgrounds, redesigning old parks, opening a café that made Bethesda Fountain one of Manhattan's great pickup scenes, staging what were dubbed Hoving Happenings, where people painted, played, and partied in the parks, and raising money from neighborhood groups, local businesses, and the wealthy to pay for it all. "He brought joy into the parks again," the columnist Pete Hamill would say.[64]

If Hoving is to be believed, he knew he was in the running for the job the day of his mentor's funeral, when Brooke Astor gave him a ride to the Cloisters in her limousine. He'd known her since he was a teenager visiting the Berkshires. The daughter of a career military officer, Astor had suffered through an unhappy first marriage to a wealthy but brutal man who surrounded her with luxury but also beat her. Her second husband and the love of her life was Charles "Buddie" Marshall, who died in 1952, leaving her without an inheritance.

Six months after Buddie's death, she was seated across from Vincent Astor at a springtime dinner party, caught his eye, and afterward accepted a ride home with him and his second wife, Minnie. During the short drive, they induced her to visit them the following weekend at their home on the Hudson River. According to a niece, Minnie wanted out of the marriage and was looking for her replacement. Brooke fit the bill. By the end of the weekend, Astor had proposed to Brooke and all through that summer peppered her with love letters to convince her to accept. In September, Minnie got a divorce (and later married an artist, James Fosburgh). Around that time, says Nancy Hoving, Tom watched Brooke "dancing alone in her living room because she'd captured this Astor guy." He'd inherited $87 million when his father, John Jacob Astor IV, went down with the *Titanic* and by the time Brooke met him had nearly doubled it.[65] Astor's lawyer, Redmond,

arranged not only the secret wedding but also, at the groom's insistence, for Brooke to be tested for syphilis.[66]

The marriage that followed was, to be kind, a trial, but there was a pot of gold at the end of it, and luckily for Brooke it came soon; Astor died in 1959, leaving her the sole heir to an estate worth $134 million ($900 million today), half of it in trust for Brooke and the rest earmarked for the Vincent Astor Foundation, which she promptly decided to run herself. On getting married, she'd joined the boards of several local institutions, but avoided those where her predecessor, Minnie Fosburgh, served. But after Vincent's death, advised by Nelson and John D. Rockefeller III, she decided to get personally involved with any causes she supported, and within a few years was considered a catch by every major philanthropic institution in the city. In 1963, she was asked to join the board of the Met; her money far outweighed the awkwardness of two Mrs. Astors on one board.

One of the foundation's first projects under Brooke's leadership was what she called outdoor living rooms, small parks in housing projects. The first, designed by the architect and community activist Arthur Rosenblatt and the landscape architect Paul Friedberg, opened in 1963, and a second in 1966, with both first lady Lady Bird Johnson and Mayor Lindsay in attendance. "Tommy" Hoving, as she called him, gave Brooke credit as "the absolute leader" of the latest trend in recreation design.[67] "She was funding tons of stuff, and she gave me a huge amount of money to build playgrounds," he says. "We were quite friendly, and she was very amused about the fact that I was parks commissioner. She said she never would have imagined that I would attain such a lofty role."

Astor told Hoving he was resented by Lindsay and his staff for being too public, too popular—and that since Lindsay's fortunes were bound to change, he should jump ship before they did and return to his real career in art. She was backing him to become the youngest director in the museum's history (Taylor had been a year older when he got the job). At first, Hoving claims, he didn't want it, but he changed his mind when his name disappeared from published lists of potential successors and he felt a chill from Houghton at board meetings. "I was so egotistical, I thought, why the hell aren't I even being considered?"

Rousseau summoned him to lunch, demanding to know whether he

wanted the job. In a second meeting, Rousseau told him that the curators had formed an informal group to lobby for his appointment. Typically, Hoving makes himself central to a story that was considerably larger than he was. Shortly after Rorimer's death and over Houghton's very vocal objections, a committee had been formed called the Curators' Meeting. Led by the head of the American Wing, James Biddle, himself a candidate for the directorship, it included Rousseau, Bothmer, and ten others. Its purpose was to force the trustees to first hire the sort of director they wanted and then create and empower a staff committee to advise him. At their lunch, Hoving says, "Ted all but begged me to accept the directorship if asked." It was only then that Hoving decided to campaign. He kept meeting with Rousseau, discussing what he might do if he got the job. And Rousseau lobbied trustees like Wrightsman. His argument was likely simple: Hoving fit the clubby, patrician museum profile but was a man of the future, not more of the same.

After a summer slowdown, the search picked up again. Davison called Hoving in October "and asked would I come up and give them a little advice on who to look for," Hoving says. In the ten days before that meeting, "I had my chief hatchet man, Henry Stern, who would become parks commissioner twice, dig up everything on the Met. Everything. And he did an incredible job. So I knew every goddamn thing about it."

Entering that meeting, Hoving told the committee he'd made some notes while driving uptown from City Hall. "Of course I'd prepared for days," he says, and his pitch "totally flattened them." His big idea was to do for the museum what he'd done for the parks: modernize, popularize, and evangelize, bringing the museum to the public. But he also addressed some immediate concerns. Ever since Redmond had put down a staff revolt in 1962, dissatisfaction had grown. "The word was that the head of the Human Rights Division of New York State was about to go after us, penalize us for paying women distinguishably less than men," Hoving says. "I went after the trustees, accused them of being bum second-raters with no idea how to run a modern institution! The building was deteriorating. The entire institution had stopped. They were completely flabbergasted."

A few days later, Hoving continues, he was summoned to Houghton's neo-Georgian mansion on Sutton Place—bought from J. P. Morgan's

daughter Anne—and offered not just the $50,000-a-year job as the museum's seventh director but also a duplex apartment loaded with art, rent-free, that the museum had just bought at 1172 Fifth Avenue as well as a car and chauffeur. Hoving said yes so fast he surprised himself. "I was inflated—bloated is a better word—with pleasure," he wrote. "I wanted to be accepted into the prestige and power of the Metropolitan far more than I really cared about the institution."[68] They agreed he would take up the post the following April, in 1967.

In the lull between Tom's acceptance and its announcement, the Hovings sat down and "assessed who we were and what we wanted," Nancy says. Though she initially resolved to become "a museum wife," they quickly decided the apartment "would constitute golden shackles, and with it I would never be able to stand up to the trustees," Hoving says. Houghton was first furious, but then managed to sell the apartment for a profit. "The one good thing I did for the Met!" chortles Nancy, who never did become a good museum wife.

"She had a full-time life of her own, which was unusual then," says Michael Botwinick. "But that was part of Tom being part of a new age. His wife wouldn't be like Kay Rorimer."

IN THE MEANTIME, LIFE IN THE PARKS WENT ON. ON HALloween, Hoving presided over a party for twenty thousand children in the Central Park Sheep Meadow. And in November, reports of his unhappiness with Hoving notwithstanding, Lindsay, who knew he'd accepted Houghton's offer, gave him a promotion in a reorganization of city government, making him head of a new department that merged parks, recreation, and cultural affairs, with a raise to $35,000 a year. Part of his new duties involved carefully studying all the cultural institutions that got money from the city, a situation that might have chilled the board had it not already known he was theirs. But Lindsay had to show his annoyance at having his Parks boss poached; three weeks later, in mid-December, after the museum let it be known that a new director would be named at the next trustees'

meeting, Lindsay preempted them and leaked word that Hoving already had the job.

So the announcement on December 20 in the Vélez Blanco patio was an anticlimax. But it included a surprise for Hoving. Joe Noble was simultaneously named his vice director for administration. Hoving had been annoyed by him ever since 1959, when he'd admonished the young curator for sloppiness. Hoving soon began plotting to get rid of him.

"I feel like I have lost one of my arms," Mayor Lindsay moaned at the press conference. Asked his plans, Hoving replied carefully, "I hope to communicate in a greater way the excitement one finds in a museum." In an editorial the next day, the *Times* predicted "a noticeable shift in the Cultural Scene . . . it is likely that the treasure house will be considerably shook up."[69] Truer words had rarely been written. The combination of "the hipness of Hoving and the hauteur of the Metropolitan" promised a reign as colorful and controversial as that of Luigi di Cesnola.[70]

Controversy seemed to come naturally to all the new leaders of the Metropolitan. On February 16, a month before he started at the Met, Hoving was woken by a 6:30 a.m. call from Houghton: "Tom, please forgive me for what you'll be reading in the *New York Times* this morning. Bye." *Ramparts*, a radical leftist magazine, had published an exposé of covert CIA funding of an anti-Communist student organization. Houghton ran a private foundation that served as a CIA front and subsidized the group. Houghton was shocked to discover that Hoving the populist didn't care.

Through the winter and spring, Hoving did both jobs, even though it was certainly improper and probably illegal. After Lindsay named August Heckscher the new Parks chief in February, Hoving's start date was advanced by a month, but he was already considered the director-elect, not an ex officio trustee. He'd grabbed the reins and started whipping his new horse to see what it could do. He wanted to increase showmanship, scholarship, and cooperation with other museums, reach out to the community, make the museum more relevant, and expand into multimedia. He asked each head curator to write a report on his department. And even before they were through, he announced his first blockbuster, a conceptual exhibition of treasures with royal associations to open almost immediately. The

museum was calling it In the Presence of Kings. Putting the Hoving spin on it, he called it "Things for Kings."

Stuart Silver, a graphic artist who had joined the Metropolitan at age twenty-five as a poster designer in 1962, had ascended the ranks quickly to become an exhibition designer and was put in charge of the Kings exhibit. For him, Hoving's arrival changed everything. "The place instantly went on high alert," Silver says. "He insisted on the Presence of Kings show to celebrate his arrival." Normally such a show would take years to prepare, but Hoving demanded that it open in a month. "It covered eighteen departments," says Silver. It would have been impossible had it not been for Hoving, who was "absolutely crazy and brilliant, the quickest absorber of impressions and information I've ever come across," Silver says. "He was like lightning, and he gave me the opportunity, which I profoundly appreciated, to be who I am," a set designer using the museum as a stage.

The show was a huge hit and introduced other innovations. Hoving hung banners touting it over the front steps of the museum—the first since Francis Henry Taylor was stopped from hanging them. He recorded a walking tour of the exhibit himself—the first time a director had done that since Acoustiguides were introduced four years before. And to Silver's knowledge, it was the first time a museum exhibition designer ever got credit in reviews of a show.

Silver was a Rorimer-era employee who emerged as a star under Hoving. Others preferred to work behind the curtains. First among those was George Trescher, who'd been recruited to coordinate planning for the centennial just before Rorimer died. Just as Hoving inspired Silver to create a new style of museum show, Trescher inspired Hoving's reinvention of the museum, developed new ways to pay for parties and improvements, and let Hoving take credit for many of his innovations. If the centennial was the big bang that marked the beginning of a new museum universe, Trescher and the young trustees who hired him were the ones who lit the fuse.

"I understood very young that I had the attention span of a demented fruit fly," the dapper, soft-spoken, and witty Trescher once said.[71] As a young man in New York in the late 1940s, the Berkeley graduate and former naval supply lieutenant immersed himself in the glamour of the city, winning a job at Time Inc., where he would work for nearly two decades as a mer-

chandising and promotion man at *Life* and *Sports Illustrated*.⁷² When the publisher's job at *Sports Illustrated* became vacant in the mid-1960s and he didn't get it, he put himself on the market.

Shirley Clurman, wife of a top editor at *Time*, knew the museum's rising power trio, Ros Gilpatric, Doug Dillon, and Brooke Astor, and heard that the Met needed a marketing genius. She recommended Trescher. He met Rorimer, they hit it off, he accepted, and, says Duane Garrison Elliott, who would soon go to work for him, "Rorimer died the next day." Though he was worried that Hoving might succeed Rorimer—Trescher's mother, an old friend of Walter Hoving's, had heard awful things about Tom—Trescher decided to sign a one-year contract and see how things went.

A few months later, he "met Hoving and was not taken with him," says Trescher's sister Susan, but the canny marketing man knew how to deal with the new director. "He had no respect for Hoving, but they never fought openly. He had to kowtow. Giving him credit was the only way to get along with him. Half of what he did was contrary to Hoving's wishes, but Doug and Brooke pushed through what he wanted."

Which is not to say that Hoving lacked savvy or clout of his own. "I watched him blatantly pandering to Brooke," says one staff detractor. "He was courting her." And he did the same, encouraged by Rousseau, when he decided to finally put an end to Bobbie Lehman's estrangement from the museum. In preceding years, Lehman, then in his mid-seventies, had been quite generous, endowing a chair in art history at Yale and giving large sums to the Institute of Fine Arts and Lincoln Center, but nothing to the museum where he remained the longest-serving vice president. In their regular meetings, Rousseau urged Hoving to bring Lehman's art home.

"As soon as I was elected, I called Lehman and said, 'I'd like to come down, have ten minutes of your time, and give you my views of what I'd like to do,'" Hoving recalls. When he arrived at 1 William Street, he was stunned to be sent to "the smallest office I've ever been in." Lehman's office was famously small, nine by fifteen feet, and shaped like a sloppy slice of pie; it made the diminutive financier seem both humble and more powerful.

"For an hour and a half, I'm pitching to him, making it up as I go because I didn't know anything," Hoving says. "Finally it's 5:30. He said, 'You know, I was dead set against you becoming director. I didn't know that you

were the same young man that I so admired at the Cloisters. I'm really deeply apologetic. I thought you were just another Lindsay hack left-wing politician. I would really like to make it up to you.' And I looked at him, being thirty-six and brash, and said, 'Why don't you make it up to us by giving us your collection?' He went, 'What? Nobody has ever dared, in the twenty-one years I've been trustee, to even bring it up! You know, it's gonna be fun to be a trustee again.' "

Hoving claims that Lehman and he developed an almost father-son relationship. "We'd go to galleries together, art shows, I went to his apartment all the time." And he says that Lehman opened up to him. Hoving was shocked when, after he suggested nominating the CIT Financial founder, Henry Ittleson, to the board, Lehman said, " 'We don't want a kike like that.' I said, 'Mr. Lehman, how can you use a word like that?' He said, 'You gotta know something about the Jewish community. There are the Episcopalian Jews, and then there are the kikes.' " Hoving said, "I've learned more about the Jewish community in ten seconds than I knew in my lifetime."

Hoving finally asked the financier why he'd been estranged from the museum. He says Lehman answered, "They never made me president, even for a day." So he asked if Lehman still wanted to be president, and he visibly paled. "Would I have to speak at meetings?" he asked tremulously. Seeing his distress, Hoving claims he invented the office of chairman on the spot.

Lehman's son takes umbrage at Hoving's version of these events, claiming his father never really liked the new director. Robin says the return of the Lehman collection, and his father's appointment as chairman, only came about after another prized cache, that of the New York financier Joseph Hirshhorn, was given to the Smithsonian and Congress agreed to build a separate museum to house it.

When Robin told his father about the nascent Hirshhorn Museum, "he said to me that he would really like to have his art collection go to the Met," Robin says, "and did I think that they would build a building to house it? My reaction was, why not?" But Lehman *was* still smarting at being passed over for Houghton and adamant that his collection remain intact. So after Hoving's first visit, he had his passionate son call the new director. Robin says he told Hoving "they would need to make him chairman of the

board and find some way to build a building. From then until the consum-
mation of the deal, I served as a go-between. On a few occasions, when the
negotiations broke down, I would step in and smooth the way. My dad
really wanted the collection to go to the Met, and my role was to remove as
many stumbling blocks as possible."

Regardless of whose idea it was, Hoving agreed to Lehman's condi-
tions and that summer contacted Ros Gilpatric to make a case for giving
him what he wanted. Valuing the collection at $100 million, he warned that
the museum's image would be harmed if it ended up elsewhere and, since
Lehman's only real gripe was that the board had slighted him, suggested giv-
ing him "a unique and important position"—like chairman, which didn't
exist—announcing it with suitable fanfare at the next annual meeting, and
then letting him chair meetings. Which is exactly what happened.

Suddenly anything seemed possible. At the same board meeting
where Lehman was made chairman, Houghton and Gilpatric announced a
constitution rewrite that made "the new director chief executive, with not
just a voice [on the board], but a vote, which was a major step," says Hov-
ing. They also decreed "that no trustee over seventy-five years of age could
serve another term. So that automatically got rid of all the old guys."

The old guys, led by Redmond, had run the museum like a club, not a
business. Redmond's rule that trustees should never ante up money had
hobbled their ability to act. That was about to change. Visiting committees
associated with each department were established, each headed by a trustee
reigning over interested outsiders, supposedly a farm system feeding the
board, but also raising funds. And new classes of honorary and emeritus
trustees were established to flatter the influential and keep the elderly on
the reservation yet out of power; invited to one board meeting a year, they
could flaunt their trusteeship, and even be heard, without becoming trou-
blesome. Or that was the theory.

Immediately, Hoving announced the centennial (claiming, disingenu-
ously, that it would "be deeply scholarly"[73]) and introduced longer hours,
live drama in galleries, and the new Department of Contemporary Arts,
which he used as a lure to keep Geldzahler on as a replacement for Robert
Hale. Hale had effectively been sidelined by the trustees ever since his con-
tentious purchase of Pollock's *Autumn Rhythm* and spent his days staring at

an eye chart opposite his desk, or else indulging his fascination with draw-
ing human anatomy; he kept a trunk of human bones behind his desk. He
eventually left in 1966.

The politics of a museum department can be byzantine. The Met's
American departments—Paintings and Sculpture and the American Wing,
which encompassed decorative arts—were particularly so; they shared of-
fices shaped like a dumbbell with the nineteenth century at one end and
Hale and Geldzahler at the other. James Biddle, the American Wing cura-
tor, was "an arch, nose-in-the-air Philadelphia snob," says Hoving, and was
widely disliked. Albert Gardner was a lonely closeted homosexual with a
drinking problem. And Stuart Feld, who arrived in 1961, was an ambitious
American paintings scholar who left the museum after Hoving played him
off against Geldzahler; both men had hoped to replace Hale.

Geldzahler had come back to the museum in early 1967 and when
asked how he'd deal with modern art handed Hoving his 1964 memo to
Rorimer. He thought that under Hoving he had a chance to make the Met-
ropolitan preeminent in contemporary art, leaving the Modern a frozen-
in-amber "jewel box museum like the Frick."[74] In Geldzahler's telling,
Hoving just loved his memo, and he went "from nothing to pseudo
power."[75] At first, they functioned like brothers. But they were soon at odds.

In years to come, people would whisper that Henry was taking kick-
backs from dealers, but if he'd made money under the table, he wouldn't
have needed the many freelance gigs he took (he wrote movie reviews for
Vogue) and consulting deals he made that required Hoving's and the board's
approval, leading the director to wonder, "What does he do for *us?*"[76] He was
so good at getting his way it took him only a year to get his department
name changed—he thought it sounded too much like "temporary"—to
Twentieth-Century Art.

Almost immediately, Hoving put him back in his place by deciding to
show *F-111* by James Rosenquist, a painting owned by the Pop Art collector
Robert Scull, without consulting Geldzahler. Adding insult to injury, Hov-
ing showed it not as contemporary art but as a historical painting, juxta-
posing it with Emanuel Leutze's *George Washington Crossing the Delaware*,
Jacques-Louis David's *Death of Socrates*, and Nicolas Poussin's *Rape of the Sabine
Women*. "I totally crunched him," says Hoving. "He threatened to resign."

The ever-savvy Geldzahler didn't mean it. Like Hoving, he knew a good publicity opportunity when he saw one. But this, like many of Hoving's early moves, was a harbinger. "Culture Gulch"—Hoving's affectionate nickname for the *New York Times* arts section—"was infuriated," Hoving crowed. One of its art critics, Hilton Kramer, decried *F-111* as slick, overblown commercial art and said the exhibit showed "stunning vulgarity and insensitivity."[77]

What Kramer left out was that in putting *F-111* on display, Hoving had also shown stunning insensitivity to one of his trustees. During his career in the Defense Department, Ros Gilpatric—whom Hoving considered "slick, smooth, and manipulative"—had not only been an advocate of the real F-III, a fighter-bomber that had proved to be a fiasco, but, in what some called a conflict of interest, had helped steer the contracts to build them to a company he'd once represented. Arthur Houghton simply hated the painting and would have to twist himself like a pretzel to defend the exhibit, telling aghast museumgoers that showing it as he had, Hoving had demonstrated its utter lack of the sort of quality the museum sanctified in its permanent collection.[78]

HOVING HERALDED AN AGE OF FAST AND FURIOUS, AND IT CAME on fast indeed. In the same organizational revamp that gave Henry his new job, Hoving created a new curatorial title, chairman, for his biggest guns and gave it to Rousseau and Parker, opening up new curatorial positions beneath them. In 1968, he would promote Rousseau and Parker again, naming each vice director, making the former his curator in chief and the latter his head of education.

He was remaking the administration in his image. In 1969, he brought in a new chief financial officer, Dan Herrick. His predecessor, Loughry, "was a green-eyeshade accountant," Herrick says. "All he could say was no." Loughry took a nap every day, let bills pile up, and took an instant dislike to Hoving. Herrick introduced automated payroll and sophisticated accounting practices to a business being run on a cash basis.

Redmond and "a couple of ladies [on the board] who weren't enam-

ored with the major changes" would become constant trustee-critics, "a pain in the ass, but not a formidable obstacle," Herrick says. "Redmond used to write letters. He'd send them to me, then to Dilworth, then to Houghton or Dillon. His problem was, he wasn't in charge anymore. His motive was to represent himself and his era as better than Hoving's." He would even break the boardroom's code of silence and complain to the newspapers.

Redmond came to consider Hoving a duplicitous, delusional, unethical, and profligate publicity whore who commercialized the museum, turned it into a tacky merchandise mart, played accounting tricks to cover his tracks, and manipulated the trustees for his own purposes, denying them information that could be used to short-circuit his misadventures. He also considered Hoving's every action a rebuke to or a theft from *his* directors, Taylor and Rorimer. Out of the loop, he assailed Hoving for pulling the wool over everyone's eyes. Redmond had retired from the law, and the museum was his life. And now it didn't need him anymore.

When Dillon finally began enforcing the new mandatory trustee retirement age, "Henry Morgan said, 'Good idea. I'll be the first to go,'" Herrick says, and left the board in 1973. Redmond followed a year later. But both remained honorary trustees, and Redmond's constant complaints led Hoving to think of him as an "old grouch" slithering around the museum like a ghost muttering about declining standards and morale.

Hoving also hired a new in-house lawyer, Ashton Hawkins, a former assistant attorney general, and named a host of new curators and department managers, too, Hoving-izing the museum, from the library to the conservation department. "He was a fresh breeze but also a strong wind," says the former sailor Herrick.

Hoving also cultivated potential donors like C. Michael Paul, "a hustler," according to someone who knew him, "complex, and an astute collector, if emotionally shriveled." Paul came to Hoving's attention through Charlie Wrightsman, who lived one door down in Palm Beach. Though some had their doubts about Paul's personal provenance, it would be repeated as fact in his obituaries: A musical prodigy from Outer Mongolia, Paul fought as a Cossack cavalryman in World War I as a teenager and was

decorated before being captured by the Germans. He later made his way to America, where he played violin in uniform to sell war bonds, and became a trader in bullion, precious stones, art, and oil. In 1959, he married Josephine Holt Perfect Bay, widow of a pharmaceuticals and oil millionaire who'd been Harry Truman's ambassador to Norway; when her first husband died in 1955, she'd taken over his business interests, his charitable foundation, and his racehorse stable.

Like their neighbors the Wrightsmans, the Pauls sometimes loaned their Palm Beach mansion to President and Mrs. John F. Kennedy; Josephine was an old friend of Joe Kennedy's. But in August 1962, she died, and Paul, who was known as Colonel, though he'd only attained the rank of corporal, took over her foundations and ran them for the next seventeen years. The museum became one of his favorite causes, and in the fall of 1967 the trustees accepted more than $325,000 from him, or rather, from the foundations his late wife had funded, for the purchase of eighteenth-century sculpture. He'd arranged to buy sculptures from Wrightsman, who'd been unable to get them out of France. "Paul got them cheap because they were stuck," says the person who knew him. Paul got them out somehow.

The Met asked no questions. After many more six-figure donations, Paul was named a benefactor and an honorary trustee. He promised millions more to build a garden court and gallery Rousseau would nickname Paul Mall. Unfortunately, he never delivered, and after his death in 1980 his estate ended up in a lengthy legal fracas—"the largest file I've ever seen," says a clerk in Palm Beach probate court—when it turned out he'd mingled corporate, personal, and foundation assets, including a number of great paintings. Most of these were given to the Met by Paul's sister in the mid-1980s, and Paul's foundation sued the museum, claiming she'd given away its assets. In a settlement, the Met sold half of the paintings, and now the Paul foundation uses its $7 million share of the proceeds to support education.

Hoving had to stroke existing benefactors as well as new ones. So in July, after annoying Jayne Wrightsman by dithering two weeks over her invitation, he flew to Europe for a cruise with the couple, who felt ignored

and had been complaining to Rousseau. "Charlie was puffing up his chest, indicating to Ted that the new director had to suck up," says Hoving. "Which I did on the cruise."

Hoving's account of that trip is a tragicomic masterpiece, beginning with Charlie threatening to leave without them while the Hovings searched for Tom's misplaced passport in a Venice hotel. A few days later, Hoving saw his host's scary side when they discussed their children and Wrightsman said his had "turned out badly," blaming "their mother's bad blood." Though "chilled," Hoving decided he had to continue "playing the role of the proper museum toady." Luckily for them, the Six Days' War broke out while they were at sea, and their cruise was cut short.

On board, too, were Katharine Graham, owner of the *Washington Post*, and Cecil Beaton, the prolific photographer, artist, writer, and designer, whom Hoving considered "a living encyclopedia of social small talk."[79] In his diaries, Beaton would note Charlie's difficult, bossy personality and Jayne's insistence that since moving to New York, she'd never been happier, though she would twitch whenever Charlie was in a bad mood.

Jayne was defined by her contradictions. In 1966, she and Charlie had been lovingly profiled by *Vogue* as the consummate collectors of their age. "Her face is beautiful. The clear, high brow, the serene gaze . . ."[80] Four years later, Beaton, who'd photographed the *Vogue* spread, captured a remarkable change. "It is tragic to see how aged she has become," he wrote, "shrunk and wrinkled, and one wonders whether it is worthwhile suffering for so much of her life. Yet if she left him, she could be penniless."[81]

Beaton also captured Hoving's contradictions, his "tremendous physical vitality, gestures, gesticulating . . . alert insect eyes . . . [a] phenomenon," but also "a non-stop 'show-off,' ruthless to his pathetic wife, a go-getter mixed up in the world of art and high-powered business, a troublesome combination."[82] Hoving's effort worked, however; henceforth, Wrightsman, in league with Rousseau, would both scout for and bid on art for Hoving, as he had for Rorimer.

Nancy Hoving tolerated the Wrightsmans, but only barely. After she asked them to give to her favorite cause, the drug rehabilitation center Phoenix House, and Jayne replied that they didn't give "to pauper institu-

tions," Nancy decided they were a "cold, greedy, selfish pair of racists and fascists" and never sailed on *Radiant II* again.[83]

Conversely, Tom fell hook, line, and sinker for what Beaton called "the milk of luxury" that poured from the pair—and eagerly accepted future invitations on the *Radiant,* to Russia, to Palm Beach, to concerts and dinners.[84] "I'd become thoroughly seduced by the high life," he admitted. Rousseau, more skeptical, considered Charlie an amusing poseur and Jayne a "brave and somewhat pathetic courtesan." Behind her back, he and Hoving nicknamed her the American Geisha, "both a contrivance and a caricature," who had "sold out to wealth, power and what she realized was going to be the highest rank of society she would ever achieve. He gave her everything she wanted but paid her back constantly by forcing her to attend to his every demand . . . Jayne, slim to the point of anorexia with dark hair and knife-like pretty face with crooked little teeth and a mouth slightly askew, had long before given up her fresh good looks," crafting herself into a Jackie Kennedy clone, copying the first lady's hairdo and her girlish, whispery voice.[85]

Hoving says he knew he was worth more to Wrightsman as a tax deduction than as a friend or even an unpaid guide to art. Eventually, the *Wall Street Journal* would reveal what Hoving had known since Charlie sued the government in the early 1960s, that for years he had been writing off his $8.9 million art collection and all attendant expenses as an investment, including almost $17 million in insurance and a $10,000 loss on his never-delivered Goya. "He had tried to write off every cheesy little thing because he was an art collector," says Hoving. Finally, in July 1970, a federal court ruled that since they clearly enjoyed and lived with their art, it couldn't be a tax deduction.[86]

By then, the Hovings had ceased to be invited—but that put them in good company. Also banished at the same time was Sir Francis J. B. Watson, who'd spent years compiling and editing a lavish five-volume scholarly catalog of the Wrightsman collection, published by the museum (though paid for by Charlie). Rorimer had arranged the deal in 1959, after introducing the couple to Watson, then the leading authority in England on fine French Furniture. "They fall over for catalogs," Rorimer told the young Hoving, explaining that the lavish books would consecrate the Wrightsmans.

When they met Watson, he was married, but after his wife died in 1969, he came out of the closet as a gay man, adopting his lover, who'd worked for his wife. Society's rule then was that all sexual behavior was acceptable, but only so long as it remained invisible. "Francis was absolutely brazen about the relationship," says John Harris, an architectural historian who was close to him. On a visit to Watson's country home, Charlie and Jayne "saw two sarongs neatly laid out on the bed," says Desmond FitzGerald, the Knight of Glin, another decorative arts collector and friend of Watson's. Though he'd been in their entourage for more than a decade and Jayne had "learned everything from Francis," FitzGerald continues, at Charlie's insistence "Francis was dropped."

WATSON WAS UNPERTURBED, AND HOVING ALSO DID JUST FINE without his Wrightsman invitations. In 1967, his museum pulled off a coup. The first hint the Met might acquire the ancient Egyptian Temple of Dendur from Nubia came to the executive committee in December 1965, when the Egyptian government offered to give it to America in exchange for help salvaging monuments about to be drowned by the Aswan Dam. The estimated cost of disassembling Dendur, which Egypt could not afford, was $150,000, and Henry Fischer, the Egyptian curator, felt that if the museum offered to pay it, it could win the prize. The trustees agreed to offer the money if a deal was made within eighteen months.

Egyptian art, for so long the focus of the museum's attentions, had fallen out of fashion since the great days of tomb openings when Herbert Winlock and Albert Lythgoe made headlines with their finds. But the tall, dark, and handsome Egyptian curator, Fischer, found a friend in Charlie Wrightsman, who'd just taken a cruise on the Nile, seen the monuments about to be inundated, and asked Fischer if he thought it possible to salvage one for the museum.

Fischer cruised the Nile with his wife in a sailboat in the spring of 1967, all expenses paid by Wrightsman, and fell head over heels for Dendur. Aware that there had been talk of placing the temple on the shores of the Potomac (one Kennedy aide seriously suggested protecting it with an invis-

ible force field), Fischer feared the temple would end up in Washington. But when Congress refused to earmark $12 million for Egypt, he agreed to serve on a committee to raise the money privately. One of the first to respond was Lila Acheson Wallace, the co-chairman with her husband, De-Witt, of *Reader's Digest.* DeWitt had no interest in the visual arts, but his wife owned a "first-class" Renoir, a "really good" Cézanne, and a Monet, says their lawyer, Barnabas McHenry. Lila's first love, though, was Egypt, an interest inherited from her father, who'd done relief work there after World War I. "She adored Egypt, and she adored Henry Fischer," says Hoving. Her first donations to the Metropolitan were to the Egyptian Art Department.

The battle for Dendur heated up when the Smithsonian chimed in, successfully urging the U.S. Senate to vote funds to save Abu Simbel, one of the monuments most threatened by the dam. As a result, in 1965 Egypt formally offered Dendur to America and began dismantling it—and Fischer despaired that it would go to Washington. But the Johnson administration, mired in Vietnam, didn't make the tiny temple a priority, so early in 1966 Fischer convinced Rorimer to make a bid to erect it in a new wing adjacent to the European galleries at the northwest corner of the museum. In March, the executive committee agreed to reimburse Egypt (then called the United Arab Republic) for the cost of disassembling Dendur and to meet the conditions set to ensure the temple's safety and place it in an appropriate environment. Lila Wallace sweetened the deal by donating $1 million to save Abu Simbel.

Requests for the temple came from twenty cities, from Phoenix, Baltimore, Philadelphia, Albuquerque, and the appropriately named Memphis and Cairo, Illinois. "Illinois wants to put it on the shores of the Mississippi, the Boston museum wanted to put it on the Charles, there was a movement in New York to put it on the shores of Coney Island because of its proximity to sand, and the Smithsonian was going to put it on a lagoon in Washington," the Parks Department architect Arthur Rosenblatt recalled. Those proposals so offended the scientific-minded Joseph Noble that he launched a campaign to discredit them and approached Hoving, then still at the Parks Department, to ask if the city would pay to enclose it, trumping the Smithsonian. But Washington still wanted it, and the tug-of-war continued.

In the meantime, Hoving moved to the Met and began questioning

Rorimer's agenda for museum remodeling and expansion, particularly his plans for redoing the entrance plaza. "The mandate was to finish the plaza for the Centennial in 1970 and also to produce a master plan for the completion of the museum," said Rosenblatt.[87]

Hoving came up with his plan while sailing off Massachusetts that summer. "I got up at about five in the morning one day, first light, and I started writing down what it would take to get the Metropolitan Museum completely finished. I stopped when I had a list of 175 things to do, and when I got back to work a week later, we started on the 175 things."

Hoving wanted to announce it all at once and push it through fast to ensure that it wouldn't be stopped by community activists. Rosenblatt suggested hiring Kevin Roche, the modernist architect Eero Saarinen's professional successor, whom Henry Geldzahler had suggested to Rorimer early in 1966 to design a new American wing. His firm had just finished building a museum and gardens over a highway and multilevel garage in Oakland, marrying nature to structure in a way Rosenblatt greatly admired. In May 1967, Hoving asked the trustees to hire Roche to work not just on the facade but on another comprehensive master plan. Rosenblatt joined the museum staff, and the first renovations began.

Hoving had known Lila Wallace's lawyer, Barnabas McHenry, since their prep school days. When McHenry heard of the plan to rehabilitate the Great Hall and Fifth Avenue facade, he suggested showing it to Wallace, who wanted to finance a project that would beautify New York. Rosenblatt had already won city approvals and a $470,000 subsidy for Roche's plan to renovate the museum's Fifth Avenue entrance with widened steps flanked by oval fountains circled by driveways, to turn it into a monumental terraced plaza, one of New York's greatest public spaces. "We gave her a presentation with models you could put your head in and see cardboard figures," Hoving recalls, "and she said, 'How much?' I said, 'Seven million.' She said, 'Send the bills to me, I'll pay them.'" Two days later, McHenry called. "I'm afraid we can't see our way to seven million," he said.

"Why don't you start off with a family membership. Forty-eight dollars a year, and we'll work up from there," Hoving snapped.

"No," said McHenry, "we don't think you're asking for enough. So

we're going to give you $10 million." Typically, Hoving is exaggerating. Wallace actually gave $3.6 million to pay for reconstruction of the stairs, facade, and Great Hall, including a $1.1 million endowment to pay for floral displays and upkeep in perpetuity. She soon decided that she would also finance a reinstallation of her beloved Egyptian galleries (earning herself a seat on the board). After that, says Hoving, he had lunch with the "lovely, funny, sweet, bright as hell" Wallace every Wednesday at the River Club. "For years, she kept saying she was putting stock away, and nobody knew what the stock was worth because it was a privately owned company." Shortly before she died in 1984, she made donation history by giving the Met an income-producing fund filled with Reader's Digest stock that would be worth $424 million when the company later went public.

Early in 1967, her favorite Egyptologist, Fischer, put together a detailed proposal for the panel judging what was called the Dendur Derby—that is, deciding where the temple would end up—putting Noble's scientific analysis front and center. Hoving had two huge architectural renderings made showing the temple under glass by day and night. He and Roche would both claim the idea that the temple be placed in a double-layer-glass vitrine. Roche began designing the wing in January 1969 and within three months was making his first presentations for new Egyptian galleries. Despite the opposition of Jacqueline Kennedy—she wanted it in Washington as a tribute to her husband—the panel decided for the Met.[88]

Not even the Six Days' War between Israel and Egypt that June, and the subsequent suspension of diplomatic relations with Egypt, could stop Dendur. In the fall of 1967, Fischer went to Cairo to make arrangements, and the Met asked the city for $1.68 million to erect the temple, and by the following February it was being crated—in 660 cases weighing eight hundred tons—for transport from Egypt to New York. It arrived in August. "We housed it in a bubble on the south parking lot," said Rosenblatt. The first air-filled structure ever approved by the building department, the nylon-reinforced vinyl canvas balloon cost $30,000.[89]

THE YOUNG DIRECTOR WAS ON A ROLL. ATTENDANCE WAS HIGHER than ever in the museum's history except for *Mona Lisa.* Membership hit an all-time peak, too. Hoving's successor at the Parks Department, August Heckscher, had approved charging admission for special exhibits. In November 1967, engraved cards and letters went out from Arthur Houghton to top donors, inviting them to become sponsors of the centennial for $1,000. Nelson Rockefeller anted up immediately. Brooke Astor would soon give $1 million.

In December 1967, Hoving and Rousseau made headlines when they bought Monet's *La Terrasse à Sainte-Adresse,* a great Impressionist painting, at a London auction for $1,411,200; the seller was a Pennsylvania pastor who'd bought it in 1926 for $11,000. Hoving and Rousseau had rounded up five trustees to pay for most of it (Astor, Joan Payson, Dillon, and Houghton each gave about $200,000, and Minnie Fosburgh kicked in $5,000—the rest came from the Fletcher Fund). It was the third-highest price ever paid for a painting and nearly tripled the record for a Monet, setting off a predictable uproar. A bigger one was in the wings.

The Congress of Racial Equality demanded that Dendur be erected in Harlem or Bedford-Stuyvesant, neighborhoods that needed culture and were ethnically more suitable. But Hoving had other plans for Harlem. In June 1967, he suggested a show called Harlem on My Mind. He saw himself as a proponent of Marshall McLuhan, the media professor whose graphics-stuffed book *The Medium Is the Massage* was a best seller that year. Hoving wanted to yank the museum into the same state of hip relevance. Having sniffed the winds of change at the peace marches and Central Park rallies his Happenings inspired, Hoving, like many liberal politicians, had become increasingly vocal about the issues then roiling America: racism, commercialism, and the Vietnam War. So in his pitch to donors to pay for the $250,000 exhibit, he spoke of the urgent need for dialogue between the races, to display the achievements of blacks, to educate whites, and to bring new audiences to the museum and the museum to a new audience.

Early in his tenure, Hoving had proposed placing mobile museums in trailers. But unsatisfied with that medium, he suggested to Parks that the museum buy a fifty-foot geodesic dome, fill it with art by day and

planetarium-style projections at night, and move it from place to place by helicopter. Parker hopped a plane to Expo 67 in Montreal to see a dome the futurist Buckminster Fuller had built there. "There was no idea too outrageous to consider," Parker says, and soon Hoving erected an inflatable—in the parking lot of a Bronx hospital. "We were so well-intentioned, yet so naive," Parker says. "All the kids came and watched it rise, then they came back at midnight, knifed it, and watched it fall. We put Band-Aids on it, and it looked like a wounded veteran. But Tom always bounced back."

Hoving wasn't alone in aspiring to relevance. The Rockefeller Brothers Fund and the Henry Luce Foundation signed on as backers of Harlem on My Mind. The show debuted eighteen months after it was conceived and, for better or worse, set a tone for the Hoving era.

All the contradictions that Hoving embodied were on display when the trustees met on January 14, 1969, the same day as the press preview of Harlem on My Mind. George Trescher reported that he'd signed up 987 centennial sponsors at $1,000, and thirteen corporations at $25,000 each were backing plans for an ambitious but traditional exhibition, Masterpieces of Fifty Centuries, that Rousseau had dreamed up. The idea was to show the greatest art in the world, loaned by its greatest museums in homage to the Met. Hoving, Rousseau, and the Wrightsmans had dashed around Europe for months to make it happen—a trip that sealed a burgeoning friendship and led to many more as Ted and Tom escaped New York to fly the world at the Met's expense. "We laughed for hours, we partied, even, at times, womanized together," Hoving wrote. "Perhaps one reason I was so fond of him was because I yearned to be him."[90]

Rousseau was the curator in charge of charming women donors to the museum. "That's what the Paintings Department did," says Hoving. Joan Payson's donation of $100,000 in 1969, earmarked for whatever purpose Rousseau chose, is but one example of his powers of persuasion.[91] Less well known is the extent to which he charmed women in his private life. "He loved screwing women," says Hoving. "We'd go to the lowest bars and strip clubs in Vienna and grab girls together and go back to our hotel." But Rousseau didn't charm only working girls. Hoving claims, and friends confirm, that aside from his lifelong affair with Berthe David-Weill, his lovers included the infamous Margaret, Duchess of Argyll; Shirlee Preissman, a

California socialite; and Alicia Markova, the ballerina who co-founded London's Royal Ballet.

Rousseau met the future duchess—Cole Porter's Mrs. Sweeney, who would gain a dubious fame due to her world-class promiscuity—after her first marriage, and kept seeing her after she married the duke. She said Ted proposed to her and she rejected him, but when the duke divorced her, in a case that included photos of her fellating another man, the loyal Rousseau gave her a needed alibi.[92] Preissman was cheating on a much older husband, a Beverly Hills real estate developer who lived in a house built by the film stars Constance Bennett and Gilbert Roland and was "rich, rich, rich," says a younger woman in their circle. "It was an open marriage—on her side only. She was a very sexy girl. Ted loved beautiful girls with substance, but he was a terrible snob. He was like JFK, he always wanted connections."

"No man in the world had better taste or more knowledge," says another of Ted's lovers, who asks to be anonymous. "Every sentence was a pleasure, no conversation was ever ordinary. With him, you'd see every gallery for the first time." This lover is unsure if David-Weill knew about her. "If she knew, she turned her eyes away; she epitomized the refined Frenchwoman. She served only pink champagne because it was more beautiful. She had pajamas and robes made for him in Venice." And when he was mugged, gave him a new black alligator briefcase. Perfect for a man "for whom everything was art," says the lover. "He wasn't going to see an unattractive woman."

David-Weill had many attractions. Every year, she'd take a table at the Diamond Ball, a society gala, and invite all his friends, even letting Ted bring a girlfriend. "She was clever as all Frenchwomen of that kind are," says the lover.

Hoving and Rousseau complemented each other. "You could see a mutual dependency," says the lover. Tom needed Ted's eye and was titillated by his lifestyle, the women, and the limousines that provoked whispers as they whisked him off to dinner. "Ted would appear and disappear like royalty," says the art dealer Klaus Kertess, who worked as an intern in Rousseau's department. "He knew people everywhere," says another of his lovers. "Tom hoped some of that would brush off on him. Ted loved Tom's quick thinking; he was always ready to do something *now*."

Ted served the man he called Our Leader to ensure that this lifestyle would continue.[93] Despite all the glamour, he lacked money of his own and lived in a small apartment in a building without staff and a modest cottage on a lake in Connecticut, where he and David-Weill would cocoon on weekends and Ted would kayak, ride his BMW motorcycle, and practice yoga.

Ted was equally adept at courting couples like the Wrightsmans. "Social life was on a much higher plane than now," says the lover. "Now it's how much money you have. Then it was intellectual achievement. That's why they loved Ted. It wasn't chitchat. He could tell them what they wanted to know. He was functioning at the highest level himself. And of course, Berthe had a name. People loved to have them to dinner."

If the appearance that he was escorting an older married woman led some to assume that Rousseau was secretly gay (as it did), so what? That was camouflage a former spy could appreciate. Rousseau didn't want a high profile. "He had all he wanted materially, intellectually, and sexually," says his lover. "He was happy, I think." At least until Hoving's lust for the spotlight dragged Rousseau into it, too.

THE HARLEM ON MY MIND SHOW WAS CONTROVERSIAL BEFORE it opened. Harlem's cultural council dropped its support, claiming it had been used as window dressing. Two days before the press preview, the *New York Times* art critic John Canaday wrote about it, making glancing reference to Hoving's "appetite for showmanship," which would soon become a stick the world would hit Tom with. Another critic took a hands-on approach, defied security, and, using a knife, scratched the letter *H* into ten paintings around the museum, among them a Rembrandt and a Guardi. A guessing game began. Did *H* stand for "Harlem" or "Hoving"?

Picket lines sprang up around the museum ("That's White of Hoving," said a sign), black artists were outraged, and Mayor Lindsay condemned the show catalog and demanded it be withdrawn because an introduction penned by a seventeen-year-old schoolgirl called Jews, the Irish, and Puerto Ricans obstacles to racial progress. ("Behind every hurdle that the Afro-American has yet to jump stands the Jew.")

Some thought the controversy a positive. "Whatever else it may or may not be, the *Harlem on My Mind* exhibit is jam-packed," a Luce Foundation official wrote to the Rockefeller Brothers Fund, inviting its staff to a private viewing to avoid the crowds.[94] "It showed how alive the museum was suddenly," says Rosie Levai, who worked for Rousseau.

Then it emerged that the introductory essay, written as a term paper, had been edited by the show's curator, an outsider, who'd asked the author to remove quotation marks and footnotes and rephrase thoughts and concepts she'd taken from *Beyond the Melting Pot*, a sociology book written by the future U.S. senator Daniel Patrick Moynihan and Nathan Glazer, a Jewish Harvard professor. The curator, who was also Jewish, felt his ethnic background would head off accusations of anti-Semitism (and presumably paternalism and condescension). "The best of intentions can lead to hell," he said after the scandal broke.[95]

"Lindsay said Tom should pull it, or the rabbis would kill him," Harry Parker recalls. "Hoving was fit to be tied." Initially, a statement of regret from the schoolgirl was inserted in every catalog. Then, when the outrage didn't die down, Hoving penned another insert himself. In response, the city's comptroller, an ex officio trustee, wrote to the board demanding they pull the catalog, "lest their silence be construed by the people of the City of New York as an assent to this most unfortunate development."[96] Arthur Houghton responded with a fulsome apology.

Finally, at the end of January, after concerns over racism and anti-Semitism spread across the city and a bill was introduced in the City Council proposing to withhold the city's subsidy, Hoving pulled the remaining twenty thousand copies of the catalog from the museum shop, although Random House continued to sell it in bookstores, trying to recoup what its chairman described as "a whopping loss on the project."[97] Nothing tamped the furor. Two weeks into the show, the *Times* reported that when a museum guard had tried to stop "a young Negro with a small beard and long hair, wearing a gray, striped overcoat," from writing "Fuck H" on a staircase wall, the "vandal" threw him to the ground and slashed his hand.[98] "There were phone calls at night," said Rosenblatt, "threatening calls . . . We had guards set up on the mezzanine to protect [us from] anyone who would come in and threaten Hoving."[99]

The executive committee met in mid-February, with seven trustees and three representatives of the city in attendance, to discuss Harlem on My Mind. Houghton, Dilworth, Dillon, Josephs, Gilpatric, and Francis T. P. Plimpton, the lawyer, diplomat, and father of the writer George Plimpton, who'd joined the board in 1965, were worried that they'd given Hoving too much rope and he'd hung the museum.

The damage proved to be minimal, the defaced paintings were repaired, some letters of complaint came in, some members resigned.* And an anti-Hoving board faction, represented that night by Plimpton and Josephs, but also including Redmond and Wrightsman, demanded change. The group concluded that it needed to restate the purposes of the museum to avoid radical deviations in the future and accepted a suggestion made by a wavering Brooke Astor to save Hoving's scalp by creating a new committee to oversee exhibitions, headed by Gilpatric.

In his memoirs, Hoving claims he offered a spirited self-defense, retreated to his office, learned his fate from Houghton in private, and refused to comply. But according to the meeting minutes, Hoving, Rousseau, and other senior staff were summoned back to the boardroom, informed of its decision, and ordered to keep publicity about Harlem on My Mind to a minimum for the six weeks left in its run. Hoving considered it "a sock in the face" and says that his relationship with Houghton ended. However it went down, soon thereafter the president effectively stepped back from running the museum.[100]

It seems appropriate that just a few days after Hoving's comeuppance, the election to the board of Terence Cardinal Cooke, the recently named archbishop of the Roman Catholic Diocese of New York, was announced. There were so many new trustees, the board had decided to issue them ID cards: Peter H. B. Frelinghuysen, a New Jersey congressman and Have-

* There were about five thousand letters in all, and "no one planned to reply," says Dorothy Weinberger, who headed the Membership Department. "I took them home in a suitcase and broke them down into categories." One category had already been created. "Another Jewish letter" had been written across the top of one of them. Houghton "wrote an absolutely inspired letter" that went to every member who'd resigned, Weinberger continues, leaving the door open for their eventual return. Harlem on My Mind attracted "no new black members," she adds. "Maybe six."

meyer descendant; John Irwin II, a son-in-law of IBM's Thomas Watson; Arthur Ochs Sulzberger, who took his father's seat and was expected to keep the *Times* in line; André Meyer, who held a Lazard Frères seat; R. Manning Brown Jr., an executive with New York Life; and Mrs. McGeorge Bundy, a former dean at Radcliffe whose husband had been a colleague of Gilpatric's and Dillon's in the Kennedy White House before heading the Ford Foundation. Unlike most of them, Cooke lived up to the promise made in the press release announcing his appointment, to "broaden the museum's sphere of reference in order to meet with effectiveness increasing demands being made on it."[101]

FROM THEN ON, HOVING WOULD SEEM LIKE A PUNCH-DRUNK fighter lurching from crisis to scandal and back while driving the museum into the red. When a stock market wobble followed his ambitious first years in office and the city proposed cutting the Met's stipend, Hoving threatened to shorten opening hours, and the cuts were restored. The museum still foresaw a $1.3 million deficit for 1969. But what he memorably termed "kerfuffles" couldn't overshadow what he accomplished, most of it traceable to the centennial, the defining act of his tenure.

The museum's birthday party began with a ball honoring its 103 living benefactors on September 25, 1969, and continued for eighteen months, encompassing twelve exhibitions, the publication of eighteen books, five television shows, countless special events, lectures, concerts, and films. Five of those shows were blockbusters: New York Painting and Sculpture: 1940–1970; The Year 1200; 19th-Century America; Before Cortés: Sculpture of Middle America; and Masterpieces of Fifty Centuries. Cortés was supposed to open the festivities, but its complexity caused delays, and it was postponed. Hoving called Geldzahler on a Saturday and said the New York Painting and Sculpture show was up first instead and Henry had nine months to set it up. Henry's show provoked lots of controversy, and for once that reflected well on the museum. And once again, the drama was all about contemporary art.

Henry was asked to do the show so fast that New York Painting and

Sculpture: 1940–1970 opened in October 1969. The thirty-five second-floor paintings galleries were emptied of everything from Giotto to the Impressionists, and filled instead with 408 works by forty-three artists—only 12 of them owned by the museum. Henry felt it was the perfect moment to synopsize the New York school and bring it into the canon. His choices covered the bases from Joseph Cornell to Abstract Expressionists, color-field painters and Pop Art. But Henry's omissions—Cy Twombly, Larry Rivers, Jim Dine, and Louise Nevelson—drew flack. "You get grades for exclusion," he replied.[102]

Hoving called as Henry was putting the show together and asked him to include a black artist. "Which one?" Henry asked. "Maybe you're right," Hoving answered.[103] Asked later why he included so many works by Frank Stella, Henry responded, "He's my best friend. He teaches me the most. Therefore, I respect him the most." It became known as "Henry's show," even though, Hoving claimed, George Trescher actually created the catalog over a long weekend, using bits and pieces of Henry's magazine writing, "when the over-rated Geldzahler could not finish it on time."[104] Canaday publicly branded Henry the museum's Achilles' heel.

The opening was a circus, immortalized in *The New Yorker* by Calvin Tomkins for the see-through blouses and pot smoke wafting among the two thousand guests, while Henry, in a blue velvet dinner jacket, chatted with Andy Warhol atop the grand staircase. Asked why he didn't go in and see the art, Warhol said, "I am the first Mrs. Geldzahler."[105] Henry was burned in effigy outside the museum that night. "Or was it hung?" he wrote in a note to himself.[106]

Hoving later joked that he wished he'd written down the names of all the pot smokers. But young art lovers found it a revelation, the most important show the museum ever mounted, and a gesture of openness to communities the museum has always spurned.

The critics were harsh, inside and out. One day, a Geldzahler assistant found that someone had put an egg beneath the rooster that topped Robert Rauschenberg's *Odalisk*.[107] The *New York Post*'s Emily Genauer called the Met irresponsible and Henry part of a "coterie of taste-and-value-makers," implying grubby commercial and personal motivations.[108] "It will bring lasting discredit on the Met's standard of judgment," Hilton Kramer wrote. *Time*

called Geldzahler "the museum's most controversial acquisition in the last decade."[109] Hoving realized that the more the museum was criticized, "the more the crowds stream in!"[110]

Henry already knew what he'd done; he let his beard grow back in.

MICHAEL BOTWINICK WAS BROUGHT INTO THE CLOISTERS AS its lowest-ranking curator just as the centennial was getting started. But the Medieval Department's centennial show, The Year 1200, was Hoving's baby, so Botwinick was in the right place at the right time. Just as installation was beginning, his boss left on a trip and assigned the new kid to handle the most complex medieval art show in history.

With that as basic training, Botwinick was promoted to assistant to the curator in chief, Rousseau, running the Masterpieces of Fifty Centuries show—at $18,000 a year. He earned it. Botwinick realized that Rousseau's success arranging loans had created a problem: already running on fumes from Hoving's expenditures, the museum couldn't afford to insure the countless objects it had been promised. So Hoving canceled the loans and ordered Rousseau to start all over, showing only the best works owned by the Metropolitan as an overwhelming demonstration of the museum's might and of the centennial's larger purpose: not just to summarize the past, but to look to a future in which the collection was refined and its usefulness and ability to inspire and delight increased immeasurably.*

Hoving, Rousseau, and several assistants "went shopping in the galleries for a month," says Botwinick. "It was like reinstalling an entire museum. Those three years shaped the last quarter century of American museums. Masterpieces was the first full expression of what you can do with creative museum education. It was the first time we all understood the potential."

* The Masterpieces show also inspired Herrick to approach the federal government to insure loans from foreign museums. "That's how the blockbusters came into being," says Hoving, "because we couldn't afford the insurance. No company would ever do it, so he [Herrick] invented the Arts Indemnity Act" later signed into law by Gerald Ford.

Botwinick also figured out the museum's system of sultanates and satraps, the curators who disdained the administrators, the lesser lights who thought they should be kings. "Joe [Noble] was impossibly difficult, pompous, insecure," he says. "He was never happy until he became a museum director." Early in 1970, Hoving caught Noble complaining to Houghton behind his back—and soon after that, Noble left to take the top job at the much smaller Museum of the City of New York. Noble thought Hoving unprofessional and a liar; Botwinick saw the lie as the man. "There's almost no difference between the real Tom and the character, the drama of Tom," he says. "He was totally inhabited by that personality and persuaded of its power and effectiveness."

To Botwinick, Hoving had seized the museum as no one had since Cesnola. "The Met had nineteen departments, eight hundred employees," he says. "The canvas was huge. The staff was complex. The pattern was curators as giants. They enjoyed remarkable independence. Before Tom, all they had to do was take care of their galleries. You weren't expected to do; you were expected to be. There were no grand plans." Now the curators were either standing firm in opposition or else rushing to keep up with Hoving's demand that they be showmen as well as scholars.

The Greek and Roman curator Dietrich von Bothmer was a paradigm of the old school. "He tormented everyone, he was driven, a martinet, he accepted the authority of no one," says Botwinick. When Hoving asked him to produce a guidebook to his department, a pilot for a museum-wide program, Bothmer simply ignored him.[111] "The cataclysm of Hoving was that he took the museum away from them," Botwinick says. "All of a sudden it all funnels through a director who is setting the identity." Some curators felt diminished, but the best, "like Henry," were "elevated by Tom's letting them do star turns that made them rock stars." Curators had to adapt or die. Bothmer, having just married into money and enjoying his new wealth, would soon get with the program.

As iconoclastic and progressive as he was, Hoving understood that the bottom line was money. To get it, you had to get to the people who had it. Until the centennial, corporate donations had mostly come from companies associated with trustees, like the Watsons' IBM and Houghton's Corn-

ing Glass. But under Hoving and Trescher, corporate benefactions began to be systematically courted.

"I credit Trescher with the invention of the blockbuster," says Barbara Newsom, a public affairs consultant who'd met him years before at Time Inc. and followed him to the Met. "In 1967, he already had it all worked out." By conjuring excitement, experimenting with new styles of presentation and promotion, tying events, scholarly and popular publications, and exhibits together, broadening the museum's audience, and especially tapping new donors, Trescher saw a way for the museum to reinvent itself via this celebration of its past.

Trescher launched modern corporate exhibition sponsorship with a pre-centennial show of frescoes from Florence, which had removed them from churches after a flood. Local officials offered to lend them to the Met to thank America for helping the city recover. Trescher decided to find a sponsor tailor-made for the show, offering ample public credit and private events in return. Advised by Italian diplomats, Trescher focused on Olivetti-Underwood, an Italian electronics firm making a push into the American market. Briefly, Hoving worried that he'd catch flack from art purists. But when Olivetti offered $600,000 and an ad campaign, he was sure it would be worth it.[112] It was. The show was a hit, and other companies wanted in on the action. Xerox pledged $350,000 to pay for Henry's show.

Hoving and Trescher also saw the need to develop the museum's social side—that is, bringing the wealthy and connected in for parties—and in 1968 they hired Duane Garrison Elliott, who'd once worked at Tiffany for Hoving's father, to run events. "They wanted big, splashy events," she says. "They'd had about eight a year before that. I, alone, did ninety." Thanks to the fiasco that was the Harlem on My Mind opening, where many of the guests seated at Hoving's table didn't show up and others, like the Harlem politician Percy Sutton, refused to sit, she was taken seriously when she came in.[113] She developed a party checklist with rules for everything from seating ("You would never see Tom Hoving at Table No. 1") to what kinds of cigarettes to have on hand (Viceroy for Hoving, Benson & Hedges for Houghton). "I made it scientific," she says.

Trescher created the museum's first donor list with the names, ad-

dresses, businesses, and special interests of the first thousand centennial contributors, then expanded it with what he dubbed future favorites, people who might be cultivated to give money or art. Mixed feelings about social life notwithstanding, Hoving brought in fresh faces, too, like Estée Lauder, recruited to host a dinner for Florence Gould, the widow of the railroad tycoon Jay Gould's son, in November 1968. "She was a potential benefactor," says Elliott. "She had a lot of paintings." The party was French themed with menus printed on handkerchiefs embroidered with red petit-point roses. Lauder worried aloud when she saw that the silver Elliott had chosen didn't all match. "It's from the French Revolution!" Duane replied. "There isn't that much!" Lauder invited the heads of department stores, installed her signature products in the ladies' bathroom, and showed up an hour early with her own photographer to record the table settings.

The sudden explosion of semiprivate events was something new. The Metropolitan had always "done its best to keep its social doings to itself," wrote Charlotte Curtis, the New York Times social reporter. "But things seem to be changing."[114] Semiprivate fund-raisers, often held in the Lansdowne dining room, became increasingly common. In November 1969, Jayne Wrightsman held a dinner to celebrate the opening of their two latest French period rooms. She had Monet's Terrasse taken out of its frame and leaned on an easel for the delectation of her guests.

The Centennial Ball on the museum's birthday, April 14, 1970, was the culmination of months of hoopla—and Elliott's crowning achievement. Tickets were $125 ($40 for young people known as juniors and $20 for museum staff). After the elaborate invitations were mailed and there were only seven replies, Elliott realized they'd been held up by a postal strike, and Brooke Astor, head of the Centennial Ball Committee, suggested sending everyone on the invitation list a telegram signed Mrs. Vincent Astor. At Elliott's urging, they were signed Brooke Astor instead. In a way, it was her coming-out party.

Two nights before the ball, First Lady Pat Nixon attended the opening of the 19th-Century America exhibit. The donor Joan Payson toured it in a wheelchair (Hoving would soon buy a golf cart to speed her tours of the museum). The next morning Mayor Lindsay turned on the hundred jets in the new reflecting fountains outside the museum in a ceremony that began

a daylong open house complete with a receiving line of museum officials, free coffee, a birthday cake, a medal stamped with the Met's new logo, an *M* designed by Frank Stella, and a free family membership for every hundredth visitor.

A night later, twenty-eight hundred guests, including various Rockefellers, Lauders, Loebs, Vanderbilts, Whitneys, Wrightsmans, and Brooke Astor, were invited to climb the museum's new steps at ten o'clock to party in four galleries turned ballrooms, redone by society decorators in various styles of the preceding hundred years. The Egyptian galleries became a 1930s supper club; the Arms and Armor Hall, a Viennese ballroom; the Blumenthal patio was made over Belle Epoque style; and at midnight, the Dorotheum opened as a modern disco. As they left (the last stragglers at 4:00 a.m.), each guest was given a copy of Calvin Tomkins's museum history, published over the vociferous objections of old-timers like Redmond and Kay Rorimer.

"To sip champagne under the watchful eyes of the Great Masters, to mingle with the greatest celebrities, to eat fresh strawberries amid a Gay Nineties atmosphere, to feast on crepes, to swing to the Charleston in the Egyptian Court, to rock to psychedelic lighting around the pool, to waltz beneath Viennese royal splendor and to dance all night!" one guest raved in a letter to Doug Dillon. "Never has there been a birthday party so grandiose, so spectacular and so fitting."[115]

Elliott's favorite touch was the donut machine. She'd first rented one when Lila Wallace threw a party for the workmen who'd renovated the Great Hall. Joe Noble hated the idea, but its two best customers were Doug Dillon and Tom Hoving, who sat near it all evening. "The next day Dillon called to ask where I got the machine," she says. He wanted to use it at a party for one of his daughters. Thanks to him, it also got an encore at the Centennial Ball. The only sour note was the $15,000 papier-maché birthday cake Trescher placed atop the octagonal information booth; Hoving declared it ghastly and had it removed just before the doors opened.

Met veterans argue to this day over who—Trescher or Hoving—deserves the most credit for the centennial's success at dragging the museum out of the past and reinventing it for its second century. But even though there's no question that they achieved many of their long-term goals, in the

short term they lost money and left the Met in a financial hole. By 1971, a recession had set in, and after a party paid for by Astor for retiring employees, Duane Elliott left the museum. The party was over—for a few years at least.

<div align="center">❖</div>

THE PUBLIC VERDICT ON THE CENTENNIAL, WHICH ENDED WHEN Masterpieces of Fifty Centuries came down in March 1971, was mixed. "What began as a thank you to the ancien régime devised by a new generation came to be seen as bread and circuses," says Botwinick. In a wrap-up article, the *Times* called it "a giant promotional stunt, a cheapening of the institution, an extravaganza whose funds [the final cost came to $4 million] were better spent elsewhere, and in the words of one biting critic, 'an ego trip for the museum and its director.' "[116]

Within the walls of the museum, though, there was little doubt of its success a view history would support as most big museums began operating in permanent centennial mode. The hard sell had attracted hordes of new visitors, not only increasing audience, but burnishing the Met's international image and status. If the noses of a few purists were out of joint because their private treasure house had been turned into a public pleasure palace, that was a small price to pay.

The centennial "put Harlem away," says Botwinick. Even though Hoving had to cancel the international loans for Masterpieces of Fifty Centuries, the fact that they'd been offered proved "we could command the monuments of Europe to come here. It gave a grand sense of what the museum could be. Everyone was taken by the brilliance and scope of it. The centennial put the trustees in the same role as their forebears, a hundred years earlier. It made them realize we needed a temple equal to our ambitions." But truth be told, Harlem on My Mind was not behind Hoving, and the Roche master plan, which Hoving had announced at the centennial opening, threatened to drown all the good feelings in a tsunami of acrimony.

Hoving's first priority in making his dream museum real was ensuring that Bobbie Lehman's art collection would come to it. Even after Lehman

wrote his will, in the spring of 1968, Hoving couldn't count on anything; first he had to come up with a plan for housing it that would satisfy Lehman and his son, Robin. Roche had tried but failed to find an acceptable way to incorporate or duplicate the Lehman house in the museum as Bobbie wanted. "There are mountains of drawings that Kevin produced," said Arthur Rosenblatt, "of putting the whole house, reproduced, on the back lot of the museum."[117]

As Lehman lay dying, the architects finally came up with a plan everyone liked, removing the grand stairs from the Great Hall and cutting a new boulevard west through the museum's medieval court, ending in a glass-roofed octagonal pavilion—most of it hidden by a steep landscaped lawn so it was hardly visible from the park—housing the Lehman Collection in a series of rooms that duplicated those in the town house. Looking back toward the Great Hall, one even caught a glimpse of the redbrick facade of Calvert Vaux and Jacob Mould's original building.

In June 1969, Lehman agreed to it—but swore Hoving to continued silence. So immediately after Lehman's death in August, Hoving pushed to announce (and so sanctify) what was by then estimated as a $100 million gift at the September ball that was to kick off the centennial. Weeks of tortured negotiations with the foundation and family followed to make that happen. And though Robin Lehman announced the gift that night, it would take many more months to nail down the details and almost thirty years to end the niggling and lingering bitterness between the interested parties over the precise terms of the bequest.

Hoving spends pages of his memoir painting Robin Lehman as obstructive and irrational. That seemed to be confirmed the following spring, when Robin suddenly challenged his father's will in court. Ultimately, all the disagreements, like Bobbie Lehman's own with the museum, boiled down to ego and hard feelings magnified by wealth. "There was art, money, and estrangement involved," says Michael M. Thomas, the former curator, who'd gone to work for Lehman Brothers and become a trustee of the Lehman Foundation. "Bobbie was a cold man, and Robin hadn't been close with him for some time. He was at odds with his stepmother. There was nothing sinister about it. It was about his share." Which finally did get a little bigger. In a complex transaction in 1971, Robin got a Renoir nude, a

Canaletto of the Grand Canal in Venice, a batch of drawings, his father's stamp and coin collections, and his great-grandfather's desk. In the end, he says, all that matters is that his father's will was done. "The stuff lives on. The name is still there. I don't personally think he's around to enjoy it, but who knows."

<center>✦</center>

IN THE VERY SAME SEASON THAT HE'D SEALED THE DEAL FOR THE Lehman art, Hoving claims he decided, urged on by Rousseau, to convince Nelson Rockefeller to give the museum his collection of primitive art. Actually, he was just there to catch it when it came his way.

Rockefeller had first proposed a museum of what he called indigenous art to the Museum of Modern Art in 1942 as part of his effort to improve ties with Latin America. He'd begun collecting it himself and felt it was undervalued. When the Modern proved reluctant, he, Rene d'Harnoncourt, the Modern's director, and others incorporated it as an independent entity in 1954, and renovated one of the family's town houses on West Fifty-fourth Street to hold it. In 1956, its name was changed to the Museum of Primitive Art, because Rockefeller worried that few understood the word "indigenous." Though he knew that Mexicans, among others, objected to the word "primitive," he wrote to Kelly Simpson, a former Met curator who'd married into his family and become a primitive museum trustee, that every catalog it issued would refer to the greatness of its contents to make clear that no insult was intended.[118]

The museum opened in February 1957 and attracted a thousand visitors a month to its display of about 250 objects, mostly loaned or given by Rockefeller. In coming years, Rockefeller, then New York's governor, would occasionally add to its holdings. But he was careful: in the late 1960s, when the Guatemalan government alleged that a stela in the collection had been looted from its soil, he returned it, claiming he didn't know it had been taken from a Mayan temple, though in truth he did.[119]

Rockefeller's enthusiasm for his collection began to wane after the disappearance of his son Michael, twenty-three, off the coast of New Guinea, where he was studying and collecting himself. The governor and

Michael's twin sister, Mary, flew there to join the ultimately fruitless search for the missing youth. Soon, Rockefeller began selling parts of the collection.[120] A money crunch had coincided with Michael's death. With attendance small and expenses large, Rockefeller began thinking about alternatives to continuing to subsidize the museum's operations.

Late in 1967, d'Harnoncourt met with Hoving and proposed incorporating the MPA into the Met and paying for a wing to house it in memory of Rockefeller's son. Hoving was noncommittal, but asked if he could do an exhibit of MPA art during the centennial. The talks faltered during Rockefeller's abortive run for the Republican nomination for president in the spring of 1968, even though Houghton offered to pay for a small collection of Eskimo art, one of his enthusiasms, to demonstrate that the museum was serious.

Tragedy struck again when d'Harnoncourt was killed in a car crash that summer, and more than ever Rockefeller wanted to be rid of the burden of his private museum. Late that year, though, Hoving made it clear there would be no show without money to pay for it. Finally, it was agreed that a Met show of the MPA's best holdings would take place in the spring of 1969, simultaneous with exhibits of Rockefeller's private collection of Mexican art at the MPA and of his twentieth-century art at the Modern. Roche quickly developed a proposal for a Michael Rockefeller wing at the museum's southern end, and Brooke Astor offered to cover half of its cost, $2 million.[121]

Things happened fast then; three weeks later, a draft merger agreement was on Rockefeller's desk, and scale models of the wing were finished. Two weeks later, a day before the primitive show opened, the Metropolitan board announced it would absorb the Museum of Primitive Arts, and Michael Rockefeller was posthumously elected a benefactor, though fine points of the deal were still being hammered out. Dudley Easby, the Met's secretary, resigned his job to become consulting chairman of the new department. Mary Rockefeller was named to the visiting committee along with Arthur Houghton, who promised to try to hire Rockefeller's curators as well. Houghton considered the deal, which filled a huge gap in the Met's collection, the crowning achievement of his years there.[122] Unlike the

Lehman deal, Rockefeller's donation proceeded smoothly and quickly. Partly, that was because Rockefeller had passed a new tax law that made it vital to effect transfers of the MPA's real estate and his primitive art objects before the year ended.[123] By the end of 1970, not only were the details worked out, but the Rockefeller family had also pledged another $500,000 toward the new wing that would hold the Temple of Dendur.[124]

In March 1969, the MPA art went on exhibit at the Met and caused yet more trouble for the museum. What Tom Wolfe would soon dub radical chic was the rage in that season of discontent, and the Metropolitan, bastion of the establishment, was hardly immune. Though a post–Harlem on My Mind security survey had shown that the Met ran a tight ship, the fear of radicals was pervasive and real: a few months later, the New York Public Library would be bombed.

The black artists who'd picketed the Harlem on My Mind exhibit had inspired a radical group of artists to form and picket the opening of the New York Painting and Sculpture show. The group's goals were both specific—to bring in outsider art by blacks and women and move museums out into deprived communities—and vague: to end institutional disdain for living artists, oppression, sexism, racism, and war. The radicals wanted museums to be more relevant; the fact that Hoving did, too, merely made him more of a target, since the radicals were sure that a liberal Republican lackey to the rich was, at best, an appeaser.

Hoving started feeling pressure. That summer, rumors surfaced that he was being pushed out, and he began hinting that he would quit, perhaps to run for office, after the centennial; when that was published, he was forced to deny it and assure the board that he intended to stick around to see through his building plans.

On January 12, 1971, after over a year of trying, albeit halfheartedly, to work with the radicals, even funding their research into the feasibility of cultural centers in ghetto neighborhoods, the museum was embarrassed again. The board's acquisitions committee meetings tended to be long, as curators made their pitches, then left the room while the trustees deliberated and finally made decisions on buying and selling art. So they sometimes met over dinner and, that night, even wore black tie as they dined in

splendor in the Louis XVI Wrightsman gallery. Arrayed around the board-room table were Dillon, Brooke Astor, Minnie Fosburgh, Charlie Wrights-man, André Meyer, Hoving, Parker, Herrick, Rousseau, and other curators.

To save on the expense of guards, the meetings were held on nights when the museum was open late. A group of radicals snuck down a back stairwell close to the room where the committee met cordoned off behind screens. Decoys distracted the guards long enough for eleven of their co-horts to invade the dinner. They circled the table chanting slogans and emptying a jar of dead cockroaches onto the table. (They were supposed to be alive, but had suffocated.) Doug Dillon turned red faced, screaming as the invaders were rounded up, taken to Ashton Hawkins's office for a scold-ing, and expelled. But Hoving was unfazed by the incident. He took Botwinick back to his office, where he "opened a bottle of booze and just *roared* with laughter."

DILLON HAD CHAIRED THE MEETING THAT NIGHT, ARTHUR Houghton having handed over the presidency to him in 1969 after finding Hoving "hard to control," says Parker. But Dillon wasn't good at confronta-tion. Years later, he'd tell Hoving how Lyndon Johnson would humiliate him by dressing him down while sitting on the toilet. "He said he couldn't take that kind of thing," says Hoving. "He couldn't stand up to bullies." In-stead of keeping Hoving in line, Dillon became his lead defender.

George Blumenthal, Robert Lehman, and Irwin Untermyer had rep-resented the first wave of assimilated Jewish-American patricians at the Met. Dillon, the grandson of a Polish immigrant, led the second. He'd run a major investment bank and served as Dwight Eisenhower's ambassador to France and then as Treasury secretary in the Kennedy administration. He also owned Château Haut-Brion, one of the finest vineyards in France, which he'd inherited from his father, a Francophile. He was, in other words, another "clean" Jew and, thanks to his financial and diplomatic experience, just what the Met needed in 1969.

Dillon's grandfather Sam Lapowski had run a department store in Abilene, Texas. In 1901, he changed his son Clarence's name to Dillon, the

maiden name of Sam's French Catholic mother. After graduating from Harvard, Clarence Dillon became a partner in a brokerage firm, Dillon, Read & Co. By 1957, his fortune was estimated at $150 million.[125]

Douglas went to primary school in New Jersey with Nelson, Laurance, and John D. Rockefeller III, graduated from Groton and Harvard, joined his father's firm in 1931, and followed him as chairman in 1946. Seven years after serving as a naval officer in the southwest Pacific in World War II, the tall, blue-eyed American was named ambassador to France. He was admired in Paris for his lavish entertaining and later served as the Republican undersecretary of state for economic affairs; he then made history when he segued to the Democratic cabinets of John Kennedy and his successor, Lyndon Johnson. In a cover story, *Time* called him "the custodian of the world's richest treasury."[126] Dillon was also a trustee of the Rockefeller Foundation and a passionate collector of French paintings, which hung in his homes in New York; Hobe Sound, Florida; Dark Harbor, Maine; Far Hills, New Jersey; and Versailles, France.

Hailed as able, logical, and diligent, the sixty-year-old Dillon's first charge as the new museum president was clear: stabilizing the museum's shaky finances by finding new income—fast. But with more background in art than either Houghton or Redmond, Dillon was also seen as the perfect choice to carry through the building plans Houghton had initiated and to begin refining and completing the collections those buildings held. And as one of the Young Turks who'd pushed to install Hoving, he also had to restore the trust between the damaged director and his worried trustees.

Dillon's close relationship with the equally generous Brooke Astor—they shared a love of Asian art and built up that underdeveloped part of the museum together—made them a formidable team. Bylaws were rewritten to strengthen his control, allowing him, for instance, to get decisions approved by telephone.[127] The Doug-and-Tom show would run for seven years. They were a balanced pair. "Tom was wild and had to be reined in," says the CFO, Herrick, but Dillon was the opposite, "quiet and reserved, and that satisfied the board."

FROM THE MOMENT HOVING ANNOUNCED HIS BRICK-AND-mortar plans for expansion in the fall of 1967, demands that the museum decentralize—break itself up and spread mini-museums throughout New York City—rose up in counterpoint, as protesters noted the irony that the former parks commissioner now sought to "deprive the very people he has helped bring into the park of a substantial part of it."[128] With the likelihood of new Lehman and Rockefeller wings added to the mix in 1969, the results were explosive. Even before Hoving announced his master plan, neighborhood activists were writing to city officials, predicting a snatch of thirty acres of park and a cost to taxpayers of $25 million. Though the new plaza had been approved by four city agencies, nothing else had yet been proposed or officially considered.[129]

To curry favor with local politicians—or "to suck up with the planning commission and Ada Louise Huxtable" (the *Times* architecture critic), as Arthur Rosenblatt put it—in October 1969 the museum loaned galleries to the Urban Development Corporation to show models and plans for what would soon become Roosevelt Island in the East River.[130] Centennial openings were used as lobbying opportunities. When the Year 1200 exhibit opened, Trescher suggested inviting all the city's religious leaders. Rosenblatt, whom Hoving considered "the wiliest man on earth," said that they should also invite every single politician who might oppose the master plan, beginning with "the City Council ruffians."

One of the ruffians was anything but: S. Carter Burden Jr., the newly elected councilman from the Met's neighborhood, was a Vanderbilt heir.[131] Bad blood between Hoving and Burden went back to 1965. That June, the New York senator Robert Kennedy had announced a summer antipoverty program that would turn a rubble-strewn strip of Harlem into a park. A month later, Mayor Lindsay and his parks commissioner declared that they, too, would turn empty lots into "vest-pocket parks" around the city. The idea had actually been floating around for years. But unfortunately for Hoving, when he and Lindsay opened one first, Burden, a just-hired Kennedy aide, took umbrage at a liberal Republican's appropriation of what he deemed his boss's idea.

Despite all the politicking, as details of the Roche plan emerged that winter, the volume of protest rose. Parks activists dubbed the planned ex-

pansion a "glass disaster."[132] The *Village Voice* coined the term "Metaphobes" for the alliance of park people (that is, residents of the museum's immediate neighborhood, practicing not-in-my-backyard politics) and decentralization activists who wanted to bring museums "to the people," even though, as Hoving and Rosenblatt pointed out, the "people" rarely went to the outer-borough museums that already existed.

The leftist paper also allowed that theirs was a quixotic battle because the Met was run by the same small group of trustees "that controls every other moneyed monolith in the city, a crusty, patrician, elitist claque that looks at New York through the tinted glass of a Lincoln Continental."[133]

The *Voice* didn't know how right it was; the museum had already stacked the deck with the city. Because the Lehman and Rockefeller wings would be privately paid for but owned by the city, the museum took the position (and city lawyers agreed) that they could be accepted by Mayor Lindsay as a gift, technically avoiding the need for approval by the city's Board of Estimate. So the only hurdles to be overcome were the approvals of the city's Parks Department and Art Commission, which had to rule on the building's exterior (and included four museum trustees among its nine members). But in February 1970, Parks Commissioner August Heckscher put the brakes on, telling Hoving he wouldn't send the Lehman proposal to the Art Commission out of context; he wanted the entire master plan to be revealed and publicly discussed all at once. Thus challenged, Hoving reverted to imperious type; aghast at this attack on his prerogatives, he argued against public hearings. This time the city's lawyers agreed with Heckscher.

For many in New York, the formal announcement of the master plan in April 1970 was a gauntlet thrown down on Fifth Avenue. First revealed at a staff meeting, then by Dillon at a centennial lunch for museum professionals, it brought picketers out again, many in evening clothes this time, on the night of the big ball. And once again, their message was personal. "Dillon Don't Do It," one sign read. Brooke Astor, arriving after entertaining the Rockefellers, the Dillons, the William Paleys, and others at a dinner at home, dismissed the protest as "a tempest in a teapot."[134]

In truth, there was much to recommend the master plan. It represented a great step forward by finally rationalizing the museum's helter-skelter galleries and making its oft-improvised layout equal to its contents.

Not only would the new museum present, as Dillon put it, "an almost un-broken line through 5,000 years of civilization in all parts of the world," but, assuming a visitor had the stamina, it would finally be seen "in sensible and accessible order... together, in relation to each other."[135] And put in perspective, the museum's plan to expand was long overdue. As Dillon pointed out, it hadn't grown at all in forty-four years.

Despite its desire to grow by more than a third at a cost of about $50 million (which would eventually rise to $75 million), the museum wasn't asking for that much. The Dendur wing had already been approved, and $1.3 million in public funds had been allocated to build it (though that wouldn't come near to covering the projected $7 million cost). The Rockefeller and Lehman wings were to be privately financed. The projected expansion of the American and European decorative arts wings would allow the museum's holdings in both fields, more than half of it hidden in storage, to be properly shown for the first time. Most of the construction would be over existing parking lots. And the museum claimed that although new construction would take thirty-eight thousand square feet of parkland, it would return two to three times more, a net gain, *and* restore the museum's relationship to the park by making its western-facing wall more attractive and opening new entrances through two proposed glassed-in garden courtyards.

The museum would eventually renege on that last promise: neither courtyard has ever been used as an entrance or as parkland. ("Their excuse was they didn't have enough money," recalls the parks activist Evelyn Lauder.) And the grand staircase was never replaced with that wide passage flanked by escalators leading to the Lehman pavilion. "The price of getting the Master Plan approved was to sacrifice that," Rosenblatt said.[136] But many found the big picture, as a *New York Times* editorial put it, "rational, thought-ful and architecturally sensitive."[137] Unfortunately, not everyone agreed.

August Heckscher called for a public hearing and said his approval would hinge on what happened at that meeting, held at the American Mu-seum of Natural History on June 4, 1970. In the days leading up to it, a whole new set of museum opponents emerged, foremost among them the city councilman Carter Burden.

Hoving underestimated him; it was an easy mistake to make. Raised as an American prince in Beverly Hills, the Vanderbilt heir was the hand-

some, privileged son of a starstruck investment banker turned photographer who'd been kicked out of the *Social Register* when he married Flobelle Fairbanks, an actress and the niece of Douglas Fairbanks Sr. Burden dated Geraldine Chaplin as a teen, then went to Harvard (he wrote his thesis on the author Henry Miller) and was studying law at Columbia in 1964 when he married Amanda Jay Mortimer, herself a beautiful über-aristocrat; her father's family traced its roots to Colonial times, and her mother, known as Babe, was married to the founder of CBS, William S. Paley. Her middle name honored the same John Jay who inspired the founding of the museum.

The Carter Burdens became immediate stars of the city's social scene, giving parties at their apartment in the famed Dakota, being photographed by fashion magazines, flaunting their wealth and taste; dubbed Young Locomotives, they were among the first people in contemporary society known for being known. By 1967, they were the most beautiful of New York's Beautiful People; though still in their twenties, they had even inspired a roman à clef, *The Moonflower Couple,* by the *Women's Wear Daily* publisher, John Fairchild. But despite their frivolous image, they had a serious side. Though she'd dropped out of college after her marriage, Amanda was a volunteer teacher in Harlem, and in 1969, inspired by his work for Kennedy, Carter took his first step up the political ladder, moving to an apartment just north of the museum to run for a seat on the City Council representing New York's Upper East Side. After outspending his opponent, Burden won in a landslide. Amanda would later say that soon after they met, he'd confided his dream to be president.[138]

Burden's father had been a trustee of the Modern, and Carter had played a role in the birth of the Studio Museum in Harlem and collected contemporary art (he owned a Pollock and a Bacon), so Hoving, who disdained him as a "richie," thought he would be easily charmed, and at the urging of the museum secretary, Ashton Hawkins, invited him in for a master-plan dog-and-pony show, and Hoving was sure he'd been snowed. But Burden wasn't seduced. "He thought Hoving was a bit of a lightweight," says the lawyer Bartle Bull, his Harvard roommate, business partner, and campaign manager.

Four months later, Burden wasn't among the speakers against the

master plan at the four-hour Parks Department hearing before an audience of six hundred. They demanded to know every detail of the Lehman bequest, hailed decentralization, called the museum monstrous, and hissed at the plan to remove the grand staircase. Hoving was outraged—most of all when he learned that museum employees had applauded the anti-master-plan forces.

Hoving was caught between two staff factions, neither of which liked him. On one side were the conservative curators led by Bothmer and appalled by Hoving's ambition, hubris, and especially his disdain for them. They thought Hoving was playing a zero-sum game; for him to win, his curators would have to accept second place. On the other side were those Bothmer disdained almost as much, less-lofty staffers who reflected the turmoil in the larger world.

The Met may have been behind the times, but it was not exempt from them. At the same time Hoving was fighting for his master plan, a battle was beginning on another front as well. In 1970, the educational material coordinator, Judith Blitman, who'd just turned thirty, started to feel frustrated that women staffers were paid less and promoted more slowly than their male counterparts. She was not alone. Other women had come up against arcane and unfair policies regarding maternity leave, and discontent galvanized them. "People started asking, does the museum need a staff association?" says the curator Jessie McNab Dennis. Though the guards and maintenance staff paid by the city had a union, no other employees did.

Early in 1969, Blitman read about a young lawyer who'd taken Time Inc. to court for discrimination against women—and won. To the Met's chagrin, he was hired to represent the nascent women's group and that summer asked members to write memos that he could boil down into a list of demands. By the time of the meeting at the American Museum of Natural History, he was issuing them. McNab Dennis was there that night and applauded when a speaker deplored the sort of architecture championed by the museum's board. "When I looked up, there was Hoving," she later said.

"I've been watching you," Hoving said ominously.

The lawyer, Dominick Tuminaro, found that "women with equivalent backgrounds took three to nine times longer" to win promotions, he says. After the museum lawyers proved unwilling to negotiate with him, he took

his case to New York's attorney general, and after a brief investigation the museum denied it had broken the law but agreed not to do it again, and to set up a women's forum to hear charges of sex discrimination. "There was an easing," says McNab Dennis, "but no one was really pleased."

The grumbling and organizing continued, and a staff group met outside the museum and insisted that if Hoving wanted to treat them like a university senate, then they wanted job protections equivalent to tenure, salaries comparable to those in universities, and the right to know about major policy decisions in advance. Summaries of what was said at the meeting were soon on Hoving's desk. His reaction was likely not expected.

In May 1972, Hoving announced layoffs and blamed them on a $1.5 million budget deficit. The museum had run in the red for four years. The trustees had only raised $21 million from themselves and their friends to pay for the master plan. Admission was down, the city was retrenching, a strike at a plant had cut into merchandise revenues, the Dorotheum's sales were down. The trustees insisted that Hoving balance the budget and agreed when he decided to cut staff and programs, though they feared that decision would land them in trouble again. They were right.

When a list of forty-three names of those who'd quit, retired, or been laid off hit Hoving's desk, he scrawled across the top, "Why not more?" Sixty-three people were finally let go. The ax was aimed at the primarily female education and catalog departments. None of Hoving's inner circle lost their jobs of course. Sympathetic curators like John Walsh wrote an open protest letter and joined a picket line in the pouring rain. The line went up as the board arrived for a meeting. "Brooke Astor's car pulls up," recalls a striker. "She gets out, hair done, in a beautiful raincoat, hears the chants, stops, looks, and goes in." Dick Dilworth paused long enough to tell the *Times* he was sorry, but the layoffs were long overdue.[139]

The new staff association complained to the National Labor Relations Board, and in May 1973 the museum settled for some back pay with some of the fired, a vote on whether the staff wanted to join the municipal employees' union (they did not), and again, no admission of wrongdoing. Two years later, the sex-discrimination deal with the New York attorney general was amended, and the museum promised to hire more minorities and women. The first female guard in the museum's history, a former cos-

metician, was finally hired in March 1975. Tuminaro, who'd won the first agreement, now feels it was a token victory. "It shook things up a little bit, but there's always a question of what you accomplished and whether more could have been," he says. "There's an incentive to settle with a public institution and a very powerful board of elite individuals."

Which likely explains why, that same summer, Heckscher agreed to let the museum start charging admission, after the board said it was facing its third straight year of deficits. Henry Ittleson, who'd been made an honorary trustee even though Bobbie Lehman objected to him, came up with a way to increase revenue without running afoul of the museum's lease or state law, which mandated free-admission days. Immediately, the museum began experimenting with a pay-what-you-wish-but-you-must-pay-something policy for two special exhibits (for which it already had permission to charge a $1 entrance fee) and found that the average contribution was about seventy cents. Hoving extended the policy to the Cloisters that summer and the main building in the fall. The colored buttons still used today were suggested by one of the fifty-four letters the museum received about the experiment; half the writers were opposed to it, but many of the rest were supportive. Early in 1971, Dillon told Heckscher the extra income was paying for extended hours. "So every year or so we'd raise the suggested price," says the CFO, Herrick. The policy remains in effect today (although the museum's signs play up the $20 fee, not the pay-what-you-wish part, and foreign-language signs omit that suggestion altogether). Ever since, protesters have sporadically come to the museum to hand out pennies, "suggesting" a one-cent admission.

IN THE WEEKS FOLLOWING THE MEETING AT THE AMERICAN Museum of Natural History, the master-plan debate continued throughout the city. In advance of a Landmarks Preservation Commission hearing, Rosenblatt drew up lists of potential supporters and opponents (noting such details as their ethnic and religious affiliations and political debts to Hoving).[140] One of the names on that list of potential supporters was Carter Burden. Hoving was sure he'd won the young councilman over.

As summer turned to fall, and the new fountains outside the museum were turned on, the battle heated up. The landmarks commission approved the Dendur enclosure but rejected the Lehman Wing. It was on to the City Council hearing, where Hoving counted on Burden's support. But the hearing was contentious, with Hoving accused of hypocrisy, the trustees of elitism, Nelson and Michael Rockefeller of exploitation of African artists, and museum donors of making Central Park a monument to their own egotism. The anti-museum forces were led by Burden, who the *Times* said played the role of "grand inquisitor," questioning the museum's good faith, calling its outreach plans window dressing and the board members present (Dillon and Gilpatric) unrepresentative, accusing it of catering to a cultural elite, and comparing the Lehman Wing to a monument to a Roman emperor. Before the meeting was over, Hoving admitted that the trustees were "almost totally unrepresentative of the people we serve," and Dillon had promised to do something about that and to take no more land in Central Park—even if the museum could proceed.[141]

In the weeks to come, the battle continued in dueling letters to the editor from Burden and Dillon. At the end of October, Burden introduced a bill demanding Heckscher withhold his approval until more questions were answered. Instead, in January 1971, Heckscher approved the Lehman pavilion conditioned on the trustees' agreement to add the two garden court entrances, to make more loans to neighborhood institutions, and to never again ask to build outside the borders of the master plan.[142] Burden and a number of others announced plans to sue to overturn Heckscher's "illegal act."

On the surface at least, Hoving seemed to relish the fuss. But behind the scenes, some trustees were lobbying to fire him—and do the unthinkable, replace him with George Trescher. Trescher had descended into a funk after the end of the centennial. When he got wind of the rumors, he decided to go for it, making little power plays for the job, including setting up a private event for Charlie Wrightsman after Hoving ordered him not to.

Hoving won the fight with Trescher, who left the museum in 1971 to set up his own events and marketing firm, which he ran to great success until his death in 2003. But Hoving lost the last remnants of Wrightsman's patronage. "He said, 'Eighty-five percent of the time you're really a genius;

15 percent you're a piece of shit and I can't stand you,' " Hoving recalls. "I said, 'Charlie, I'd reverse the percentages when I think of you.' And he slapped me on the back." Trescher was replaced by Edward Warburg, a grandson of the investment banker Jacob Schiff who'd made the arts his life's work after studying under Paul Sachs at Harvard. Dillon stuck by Hoving through it all. Dillon also backed Hoving's decision to alter the Great Hall plan and build two large shops there (they opened in 1979), "transforming the Met—subtly and gradually, so as to blunt the inevitable flak—into a retail store of the finest quality," Hoving would later recall.[143] Dillon was wholeheartedly in favor of the expansion of the reproduction "factory" developed by Brad Kelleher, the Met's resident retail genius. "When curators turned up their noses," Herrick says, "I told them, 'This helps pay your salary.' " Sadly, Kelleher's success caused more problems between Tom and Walter Hoving, after Tom approached some of Tiffany's vendors to make museum merchandise. Walter was furious.

But it was in the big things that Dillon really excelled. And the biggest were writing checks to cover the deficit, year after year, and directing traffic at the intersection of Hoving, the board, and the public. With a manner the museum historian Karl Meyer called "emollient," Dillon "came to the aid of his besieged director and adroitly quelled criticism both from within and from without."[144]

Three months after Trescher's departure, the lawsuit brought by the Municipal Art Society and the Parks Council to stop the Lehman Wing was finally thrown out of court, the museum's 1878 lease was upheld, and the way was cleared for construction to begin. Good as their word, Dillon and Hoving fulfilled several of their promises that year, allotting a board seat to a representative of each of New York's five boroughs. Redmond sent Dillon a long letter griping that it was a hasty, unsound decision. But it brought the museum its first black trustee, Arnold Johnson, owner of a women's clothing store in Harlem, where he was a civic leader (Johnson would eventually make it onto the executive committee).* Dillon also sent Heckscher a letter stating the museum's intention to never expand its perimeter again.

* The borough trustee program was abandoned under the Montebello administration. But by then, the museum had had more, if not many, nonwhite trustees.

Though budgeted at $8 million, the Lehman pavilion came in for less due to a slowdown in the construction industry. The same week that a crew began clearing its site behind a fence painted with murals to discourage anti-museum graffiti, Dillon began the museum's latest capital fund-raising drive—an effort to raise $75 million, half to pay for buildings, the rest for curators, a documentation center (never realized), and various education and outreach efforts, sending a fund-raising firm out to see major donors like the Rockefeller Brothers Fund. A Rockefeller fund official sharply criticized the high-handed rhetoric in the proposal and noted it was unlikely that the fund would make any more large gifts. That may be because Hoving had just called Governor Rockefeller "a cheap grifter" when he refused to pay $2 million for the Michael Rockefeller Wing, blaming his decision on the cost of his failed presidential run in 1968.

Luckily, Nelson's stepmother had just died and left the museum $5 million, with $1 million earmarked for the wing. Brooke Astor had stepped in to cover the rest, and an additional $1 million was raised when Hoving proposed building a profit-making parking garage beneath the wing. Construction began in the spring of 1973, with the museum advancing the $3.75 million cost out of its endowment. The garage paid for itself in three years and after that made "huge amounts of money," Rosenblatt said. When he left in 1986, it was netting $1 million a year.[145]

Though it had financial problems of its own, the city's contributions to the museum's operations had continued to rise to $2.3 million, and that would provide the peg for Carter Burden's next beef with the museum; though that sum covered only a fifth of the cost of operating the museum, it represented a quarter of all the money allocated to fifteen city-supported cultural institutions, and Hoving estimated that the Met would need close to $3 million a year by 1976, when the new wings were to be finished. Despite Burden's protests, after his election as Lindsay's successor as mayor, Abe Beame "left the money in the capital budget even though the city was going bankrupt," says Hoving. "I hit him where he lived and opened my presentation with a slide of a big American flag and a line I stole from *The Godfather,* 'It's time to honor America.' "

In fact, the political wind had changed with Beame, and the funds to build came fairly easily. Decisions about the museum's budget were no

longer political footballs. "We had a duty to support [museums] as orna-
ments of a world capital of culture," says Beame's comptroller, Harrison
"Jay" Golden.

Private donors felt the same, but still there were difficult negotiations
over the money for the wing to hold the Temple of Dendur—and repercus-
sions from them would shake the museum in years to come. The root of the
problem was buried deep in the secretive Rorimer years. In November
1963, Dr. Arthur M. Sackler—the creator of modern drug marketing whose
company would later develop and market the opium-based painkiller Oxy-
Contin[146]—offered to pay for new galleries to house Chinese art, donate
part of his collection of Chinese jades and porcelain, an area in which the
museum was weak, and buy four large Chinese sculptures it had purchased
decades before at cost and then give them back to the museum, all in ex-
change for naming the new galleries for his family.[147] In that sleepy era, bag-
ging Sackler was a coup.

In 1966, he negotiated a second deal with Rorimer, who gave him a
cavernous storage room above the museum's auditorium for the storage and
cataloging of his private collection by a private curator. The deal gave Sack-
ler free guards and fire protection, saved him the cost of insurance, and was
so secret only top museum officials knew about it. The enclave even had its
own phone number that bypassed the museum switchboard. Rorimer
hoped it would induce Sackler to give the majority of the five thousand ob-
jects stored there to the museum. Curiously, the stickler Redmond didn't
object to that unusual deal.

Sackler had just taken possession of his secret room when the newly
installed Hoving invited him in for a chat and asked for more money. Then,
in 1972, after Lila Wallace refused to pay for the Dendur enclosure, Dillon
and Hoving asked Sackler for $3.5 million, using his well-known interest in
Middle East peace as a lure to get him to pay for a home for the Egyptian
temple. In 1973, the lengthy negotiation was still going on when the Art
Commission approved the structure. Only then did Hoving realize he
needed another $1.4 million to build the foundation. Dillon ended up foot-
ing that bill, anonymously.

Excavation was well under way when a deal with Sackler was finally
signed in June 1974, just after the Board of Estimate and the City Council

held their final vote on the master plan, approving Beame's $3 million allocation for a new American wing. By the time ground was broken for that in July (Joan Payson kicked in $5 million and got the ceremonial shovel, $5 million more had been promised from individuals and foundations, and businesses like AT&T, Corning, Exxon, and IBM committed $1.4 million), the shell of the Lehman wing was finished, the garage beneath the Rockefeller Wing was under construction, and the Dendur foundation—which would eventually hold employee parking, loading docks, storage, a vault, an environmental chamber, and a hydraulic lift topped by a concrete platform for the temple itself—had been laid. Though work on the American Wing would be frozen for a year by political opposition—Hoving came to think that Carter Burden and Carol Greitzer, a liberal in the City Council, would have voted against the Garden of Eden had he supported it—all would eventually proceed.

Sackler and his brothers finally agreed to pay for not only the Dendur temple enclosure but also Asian art and archaeology galleries, offices, and laboratories. But they drove a hard bargain: The wing was to be named the Sackler Wing, the temple enclosure the Sackler Gallery for Egyptian Art, and the galleries the Sackler Galleries for Asian Art, with each of the three Sacklers' names listed. "They insisted on having the M.D.'s on there," said Rosenblatt, who would later joke that all that was missing was a note of their office hours.[148]

The museum also promised that whenever any of those spaces were referred to, individual nods to each of the three brothers would be included; that if the Sacklers chose to give more Asian or Egyptian art, space would be cleared for its permanent exhibition; that catalogs of the Sackler collections would prominently feature their names; that their beneficence would be mentioned whenever there was an event in the wing or an object from it mentioned in the Bulletin; that all photographs and reproductions would reference the Sackler name; and that any press releases would be subject to their approval. Unfortunately, the donation was to be paid out over twenty years, so in the end the museum had to raise construction money elsewhere. The true value of the gift was far less than it first seemed.

Though they gave in to them, Sackler's demands rubbed the trustees the wrong way. He also wanted a seat on the board and, when one wasn't

forthcoming, he decided he was a victim of anti-Semitism—even though, as Rosenblatt later observed, in the Dillon era "they ran out of WASPs with money, so now they have every rich Jewish real estate mogul on the board."[149]

In 1978, just after Hoving left the museum, Sol Chaneles, a criminal justice professor at Rutgers University, uncovered the existence of the Sackler enclave, inspiring another investigation by New York's attorney general. This time, the museum got off with a mild scolding, and Sackler was cleared of any wrongdoing, and his art remained in the enclave for several more years. Dillon and company "weren't entirely distressed" by the investigation, the journalist Jesse Kornbluth wrote, hoping the bad publicity would nudge Sackler closer to donating his treasures to the Met. But instead, the opposite occurred. Sackler started thinking of cheating on the Met two years before his wing opened. And if revenge is a dish best served cold, then Washington, D.C., would soon taste a gourmet feast, losing Dendur but getting more out of Sackler than New York.

In 1982, Hoving's successor, Philippe de Montebello, would be rocked by the news that Sackler, then sixty-nine, was giving $4 million and a thousand of his best Asian objects to the Smithsonian Institution—which had offered to build what would become the Washington Mall's Arthur M. Sackler Gallery to house them—and another big batch of art and money to Harvard's Fogg.

Even after Sackler's betrayal of the Met was announced, Montebello gave lip service to his desire to get some of what remained of Sackler's collection. But in the months that followed, Sackler's grievances against the Met piled up. In 1982, he approached Hoving, who'd gone to work as the editor of *Connoisseur* magazine, to publish an exposé aimed at getting rid of Montebello.

Sackler presented Hoving with a litany of the complaints that had led to his deal with the Smithsonian. He thought Ashton Hawkins, who'd made the Dendur deal, had kept him off the board and obscured his own role in the negotiation by claiming Sackler took advantage of the museum; he was furious over the way the museum was using the "sacred" Dendur enclosure for parties, calling a recent private dinner for the fashion designer Valentino "disgusting"; and he thought a photo of Montebello in a fashion magazine denigrated the museum.[150]

Sackler seemed particularly vexed by the preponderance of homosexuals on the museum staff. Tuminaro, the labor lawyer, had noted the museum's gay mafia and felt it partly explained the pattern of discrimination against women there. At one point, Dillon asked Hoving to institute a secret gay quota for curators. "I roared with laughter when he left," he says. "All the big gays were in the *administration,* and he had no idea who they were! We loved having gays around. They were smart and funny as hell."

Sackler had a terrible relationship with Montebello—and a quarter century later, his lawyer still betrays the ill will. "Philippe decided he didn't have time for Arthur," Michael Sonnenreich says. "If you're a director and you have a donor, you spend time." It didn't matter that Sackler was abrasive. "So what?" Sonnenreich says. "Do you think most people who give money are easy to get along with?" So the Met lost the Sackler collection. "That's life," Sonnenreich barks.

In the end, the Met got Asian art of its own from Dillon and a couple of his neighbors, Charlotte and John Weber (she was a Campbell's soup heiress), whom Dillon recruited to buy a collection that rivaled Sackler's. But Sackler got more: not just a museum of his own, but respect. Though he was called controversial, manipulative, and demanding, museum directors competed to see who could lavish more praise on him, and by the time he died, his donations had transformed his reputation. Instead of reporting on him for their obituaries in 1987, both the *New York Times* and the *Washington Post* focused on his generosity, basing their accounts of his life on a biography the *Post* admitted was provided by Sackler's office.

TOM HOVING'S METROPOLITAN MUSEUM WOULD BE A LONG, slow reveal. The Lehman Wing opened in May 1975 to a fierce round of criticism of the museum's wrongheaded pandering to a donor's desires. New Islamic galleries opened that fall, followed by new Egyptian galleries and, in September 1978, the Sackler Wing, which was both condemned as a barren gymnasium and hailed as an instant landmark. Then came the Rockefeller Wing, the new European paintings galleries above it named for the Lazard Frères trustee André Meyer, and the American Wing—all open

by 1980—and only then, the museum's southwest corner. When the $26 million Lila Acheson Wallace Wing opened there in 1987, repurposed from a decorative arts wing to a modern art wing, Hoving's museum would be virtually complete, its three mismatched sides wrapped in limestone and glass.* The master plan "seems to make real sense at last," the critic Paul Goldberger wrote.[151] Its success was the greatest accomplishment of Hoving's tenure as director, yet it was Montebello who presided over it.

Hoving's mistakes leeched a lot of the joy from his accomplishments. His biggest mistakes, he thinks, began after the master plan was approved and he started looking for new worlds to conquer. Hoving had always seen himself as a Grand Acquisitor, not a builder—and knew that acquisition was not a game for the weak. "Art collecting is all about greedy social-climbers and parvenus who virtually steal the stuff away from weaker people and countries," he wrote.[152] Over the next few years he would help hide the circumstances of one great purchase, known as the Lydian Hoard, found just before he became director, and preside over another, the Greek antiquity known as the Euphronios krater, that would plague the museum for thirty years. By 1975, when Hoving's reign began to wind down, the trustees likely longed for the days when their biggest problems were radicals and roaches.

Hoving's successes led to scandals. In November 1970, he bought the Diego Rodríguez de Silva Velázquez painting *Juan de Pareja,* "a dignified portrait of a black man [technically, a mulatto], a free, fully formed individual," says Botwinick; what better way to show the Met was a champion of equal rights. Dillon approved it without consulting the board—the $5.592 million purchase was presented as a fait accompli.

How would the museum pay for such an extravagance when it had been running up deficits for nearly four years? Six members of the acquisitions committee contributed, but only $750,000. The rest came from the principal of an acquisition fund. Of that, $2 million was to be repaid over

* In 1973, Arthur Rosenblatt did manage to expand the museum one more time, buying two adjacent town houses on East Eighty-second Street that would be used by the museum's merchandise development and publishing departments for about $475,000. Hoving opposed the deal, but Dillon talked him into it. "You've heard the term edifice complex?" Rosenblatt said in his oral history. "He loved it."

fifteen years from the income of another fund—a move that required an amendment to the museum's bylaws. Redmond, as usual, was outraged. *Time* magazine called it a mortgage on the museum's buying power. But a plan was already under discussion to pay it off and had been announced in general terms in Dillon's introduction of the master plan, though it slipped by unnoticed. Acutely aware that "art had to be disposed of now that the finite limits of physical growth had been set by the Master Plan," Hoving had "instructed each curator to comb through *all* his or her holdings with an eye to what secondary and duplicate material [could] be weeded out."[153] There was about to be a mass sell-off of museum property.

Deaccessioning had been going on for years. It was made easier in 1968, when the purchasing committee was renamed and given power to accept and reject gifts and to sell things worth under $25,000. By the spring of 1971, the process had begun, each item noted in the minutes of the acquisitions committee along with its value, whether it was a purchase or a gift, and who'd given it; the March list included gifts from Morgan, de Forest, Rockefeller, and Blumenthal, as well as three Claude Monet paintings valued at $40,000 to $50,000 apiece. In June, the trustees decided to sell a collection of about ten thousand coins the museum owned, worth more than $1 million.

That fall, Hoving and Rousseau saw a Francis Bacon retrospective in Paris and decided the Met had to have one. "Tom desperately wanted one," says Rosie Levai, Rousseau's assistant; her husband's family controlled the Marlborough galleries, Bacon's dealer. Geldzahler's acquisition budget was meager, though, so he suggested selling a batch of paintings, among them *The Tropics* by the painter known as Le Douanier Rousseau (no relation to Ted) because the Met had two similar works. Geldzahler was so desperate to acquire modern art he'd once listed the items the trustees had caused him to lose: a Matisse cutout, a drawing by Arshile Gorky, a Jasper Johns white flag, a Brancusi, Rauschenberg's *Rebus*. "It was crushing, crushing, but it didn't stop me," he said.[154] Now, he wanted a Bacon.

In November, Rousseau, the chief proponent of the cull, added fortyfour paintings to the sell list, many quite valuable, including the museum's first Cézanne, *View of the Domaine Saint-Joseph*, bought by Bryson Burroughs from the 1913 Armory Show; works by Corot, Courbet, Sisley, Pissarro,

Manet, Redon, Renoir, Seurat, Signac, Picasso; a Vuillard that had been a gift from Bobbie Lehman; and a van Gogh worth at least $1 million. The public was in the dark about the sell-off.

But soon, word leaked of the museum's intention to invite sealed bids from a handful of dealers for some of the paintings and to sell others at auction. Private expressions of outrage came from curators at the Modern, from scholars like Francis Watson, and even from dealers who felt that whether the paintings were expendable or not, the impulsive Hoving was heading down a slippery slope. In mid-May, the *New York Post* printed a rumor that Ted Rousseau was being interviewed to replace him.

But the sell-off wasn't just Hoving's doing. The acquisitions committee, chaired by Houghton and including Astor, Fosburgh, Wrightsman, André Meyer, Frelinghuysen, Dillon, Payson, the banker Walter Baker, and Sulzberger, the *New York Times* publisher who was known as Punch, had approved the sales. After news of the deaccessioning reached the denizens of Culture Gulch, the *Times* culture writers seemed determined to test the boundaries of their freedom to annoy their publisher.

John Canaday drove the story. A former museum education man in Philadelphia, he was alternately charmed and appalled by Hoving and his "extremely disarming" but simultaneously arrogant and transparent attempts to manipulate him. Like Burden, he found Hoving condescending— but compelling. Late in February, without named sources or comment from the museum, Canaday published a Paul Revere–like call to arms, "Very Quiet and Very Dangerous," in his Sunday *Times* column, decrying the idea of painting sales. Citing the tax deductions donors take, and clearly offended by the secretive process, he called the move a betrayal of public trust. Hoving demanded the right to rebuttal and a week later, in the same space in the Sunday paper, set out the case for, and the history of, deaccessioning. He titled it "Very Inaccurate and Very Dangerous." John Hess, a hotheaded reporter who would soon join the chase, later claimed Punch Sulzberger insisted on the unprecedented article by a news subject, and held the presses to run it.[155]

Punch was considered quiet, conservative, and unostentatious, though he did fly in a company jet. His aspect was bland, but he was forward-thinking and possessed of a certain heroism: the first attribute was ex-

pressed in his creation of the paper's popular lifestyle sections, the second in the bravery it took to print the Pentagon Papers. Despite this, Punch was not perceived as a business genius, an intellectual, or a cultural savant; he would have been the first to say he was none of those.

Sulzberger's election to the Met board still puzzles the former *Times* critic Hilton Kramer. "He didn't have a clue what the museum was doing," Kramer says. "His interest in art was nil." Clearly, Hoving and the trustees hoped that like his father, Punch would keep the *Times* off their backs. Despite the *Times*'s insistence on the separation of church and state, of editorial and advertising and of news and opinion, Punch was interested in what his paper printed and proved willing to edge close to those inviolable lines.

During the Lehman Wing fracas, Punch had sent his cousin John B. Oakes, editor of the *Times* editorial page, two memos, the first asking him to refrain from publishing an editorial opinion until the Met board had reached a decision, and the second informing him the wing would be built and that he agreed it should be. "I would like us to come out positively for the construction," Punch suggested. But Ada Louise Huxtable, the architecture critic who sometimes wrote for the editorial page, sent Oakes a memo, too, warning that Culture Gulch was unanimous in its opposition to the plan.

It wasn't long before Punch wrote again, asking if he'd missed a pro-wing editorial and offering to write it himself. Oakes recorded what happened next in a memo for his files in April 1971: "In a conversation with AOS today, I persuaded him to drop his editorial idea on two basic grounds—1) as publisher he should not force an editorial through against the strong advice of the editor of the page and the latter's colleague, 2) as trustee of the institution involved, he has an obligation over and above that just mentioned to separate the responsibilities of trustee from those of publisher of the *New York Times*. After hearing me out patiently, he agreed to drop the proposed editorial." The moment passed. "I think that speaks very well for him," Oakes concluded.[156]

So, in hindsight, does Sulzberger's role in the deaccessioning story, and all that followed. Despite the insistence of some that his presence on the acquisitions committee indicates complicity in museum misdeeds, nothing Sulzberger did ever put the museum's interests ahead of the *Times*'s,

unless, of course, as seems possible, he was actually trying to bring Hoving down by letting his reporters chip away at him. If true, he was in good and growing company. Francis Steegmuller, the author and Flaubert scholar, wrote Canaday after his column to say that Hoving had just told his wife, the novelist Shirley Hazzard, of a plan to "dispose of fourteen routine Monets." Routine Monets, she'd replied, was a contradiction in terms.[157] Brooke Astor must have agreed. She told an art historian friend she was thinking of buying one, even though, as a trustee, that would have been illegal.

Virginia Lewisohn Kahn, whose mother gave the Gauguin, was angry, too. "It was not her intention to give the Metropolitan a negotiable security," she wrote to the *Times*.[158] *Art in America* decided it was vulgar to trade away a painting like another donor's van Gogh and put the name of its donor on "a painting she never saw and for which she might not have cared."[159]

Reporters generally mistrust powerful, secretive institutions. And those organizations often mistake the press's pursuit of them for vendetta. In the spring of 1972, such tendencies were magnified. And by slapping Canaday in public, Hoving had made it personal. Given the climate of the times—just a few months earlier, the Nixon White House had formed a secret leak-plugging unit after the *Times* published the Pentagon Papers; three months after Canaday's first Hoving articles, those same plumbers were arrested breaking into Washington's Watergate—it's probably no wonder that Hoving began to think that Culture Gulch was determined to lynch him for *something*. Ted was also blamed; a joke went around that the museum had deaccessioned the wrong Rousseau.

And it wasn't only the *Times* complaining. Hoving's critics were out for his scalp for changing the terms of the art world, for his "brutal disregard for custom, truth and even law,"[160] for the populist centennial hoopla, for the imperial landgrab, for letting Henry turn the Great Hall into a dope den, all of it magnified by the joy and ego lift Hoving so obviously got from it all. The press had a good story and wouldn't let go. And Sulzberger showed no inclination to stop them. "He understood the limits," says Grace Glueck, another *Times* culture section writer. Riding in the elevator with her one day, he joked, "Are you trying to get me in trouble with the boys over there?"

WAS THE MUSEUM FOR SALE? IT SEEMED SO IN SEPTEMBER 1972. Though Canaday had saved that first batch of paintings, Hoving wasn't deterred. First the coin sales were announced, then an October auction of 12 paintings, with another 123 to follow.

Then Canaday dropped another bomb: the museum had already started secretly selling paintings to the Marlborough Gallery, though the buyer remained anonymous for the time being; Geldzahler had also been secretly trading out items from his department, picking up a David Smith sculpture and a Diebenkorn painting. The Art Dealers Association declared this kind of transaction a breach of trust.

More secrets emerged early in 1973, when John Hess, the dogged *Times* reporter, took the story over and in a series of nine articles published over three weeks showed what a can of worms it all really was. The Marlborough, an international network of galleries based in tiny Liechtenstein, was deeply involved in the Met's secret paintings sales. It was something new on the scene, huge, well financed, international, and sharp elbowed; it was being sued at the time for conflict of interest by the heirs of Mark Rothko, and would later pay a large settlement to his estate.

The gallery was unpopular. So was the man who ran it, Frank Lloyd (who would be convicted of tampering with evidence in the Rothko lawsuit). Hess revealed that museum staffers had started calling Rousseau's department Marlborough Country. Another critic called Geldzahler's department a virtual branch of the gallery. "It is scandalous for public monies, indirectly siphoned via tax credits, to sustain dealers some of whom, voracious and conscienceless, demean the business," wrote Eleanor Munro in the *New Republic*.[161]

Hess next revealed that the Met had breached bequest conditions when 34 pictures left to the museum by the eccentric collector Adelaide Milton de Groot had been sold; that an Ingres painting, *Odalisque in Grisaille*, had been secretly shipped to Wildenstein in Paris for sale; that 147 more paintings, this time old masters, would shortly be auctioned; and that the

catalog staff had been decimated by layoffs, leaving museum records incomplete (the department would never recover).

When the disappearance of the Ingres was revealed, the museum claimed it had only been sent to Paris for study by experts. Rousseau had decided it was not an Ingres, even though the painting had been bought in 1938 from the artist's widow's family. (It was returned, and its downgrade was ultimately reversed; *Odalisque* remains in the collection, attributed to Ingres and his workshop.) Years later, Hoving admitted that he *had* tried to sell it.[162]

Hess's next story revealed that the museum had given Marlborough art worth about $400,000 in trade for works worth only $238,000 at retail. Hess thought Marlborough had gotten a sweetheart deal; Rousseau countered that his valuations were exaggerated. Was Ted taking kickbacks, as some thought? "I never trusted curators," said Rosenblatt. "They were never well paid and their alliances with dealers [were] always so close." He suspected "most curators, at some point in their lives, have received some form of remuneration from dealers . . . They have private collections of art that they couldn't possibly afford."[163]

An art insider even wrote to Canaday to say that Ted and Tom were on the take, and that Rosie Levai's employment at the Met was a "telling" detail that had been overlooked.[164] Levai and Rousseau were also having an interoffice affair. But Levai says neither she nor her husband, who only played a supporting role at the gallery, knew about the art swap, "thank goodness"—at least until she joined Ted's damage-control team. "Every morning, we had to answer the articles because they were full of inaccuracies," she says. "I was called in one Saturday to write up statements for Ted and Dillon. Every day you had to do battle. The press was hounding us."

After ten days of battering, the museum blinked and gave Hess a list of all the objects it had recently sold and copies of appraisals for some of them. A leading group of art historians, teachers, and curators met with Rousseau and rebuked the museum for the sales. On the same day, Hess's work inspired another attorney general's investigation. Rousseau accused the *Times* of leading "a campaign against us." Instead of stopping, Hess continued to skewer the museum.

By mid-February, the *Washington Post* declared the Met under seige. "Though the museum seems to expect awe, it often gets resentment," the paper wrote. "Provoked by all its vices—its ancient arrogance, its snobbery, its aura of infallibility—and not just by the disclosures, large segments of the art world have risen in rebellion. Some of the attacks are full of glee, of righteous indignation, and long-stored resentment. That largest, richest, most imperiously patrician of American art museums is getting its come uppance."[165]

All that was missing was Carter Burden, who'd taken a time-out after separating from Amanda, who sued him for divorce for cruel and inhuman treatment. Burden didn't get back on his high horse until the Hess series had run its course. Prompted, he said, by the "public deceit and dissimulation" of the deaccessioning, he introduced a bill in the council to force city-subsidized museums to disclose their finances and give advance notice of sales and exchanges and punish those that didn't with loss of subsidies. As the museum lobbied against him, Burden kept up his attacks, comparing Hoving to Richard Nixon. Finally, the museum won, and Burden lost interest, first in the museum, and then in politics, after unsuccessful bids for City Council president and for Congress. In the 1980s, he sold his contemporary art collection at a profit and began buying rare twentieth-century American books. In 1990, he bought an apartment across the street from the Metropolitan that he filled with twelve thousand volumes. After his death from heart disease in 1996 at age fifty-four, his family gave those and thousands more to the Morgan Library.

The paintings-sale drama ended, too, not with a bang but with a white paper. Hoving, Gilpatric, and Dillon all wore dark suits and white shirts as they presented it to the public in June 1973. As usual, the board promised to mend its ways, pay more attention to donors, stick to public auctions, get outside appraisals, and generally be more transparent. "It's a new era of disclosure," said the adaptable Hoving. The attorney general dropped his investigation, but said he'd be watching. And for once, the board admitted that it had made "a mistake" in trying to pull switcheroos on dead donors.

Dillon concluded his speech absolving the *Times* but accusing Hess of

pursuing a vendetta. The reporter was transferred. "It wore thin after it went on for weeks and weeks, and next thing you know, Hess was writing about food," says another *Times* reporter.* But anyone who concluded that the *Times* was done picking on the museum wasn't paying attention.

IT ALL STARTED WITH DIETRICH VON BOTHMER. IN 1967, HE complained that export laws in what are called source countries—the places where antiquities are dug up—had grown too restrictive. Masterpieces were the air his department breathed, but recently they'd been lost to limited purchase funds; and those it owned, like a bedroom with wall paintings from Boscoreale near Pompeii, had been out of sight for years due to lack of gallery space. Privately, though, Bothmer was still buying the sorts of pieces he was talking about. One curator thinks that his rich wife gave the museum so much money he could do whatever he wanted.

Beginning in 1966, just before Hoving returned, and into 1969, Bothmer bought a collection of more than two hundred artifacts in three batches from J. J. Klejman, a Polish-born New York dealer; it included gold and silver jewelry and objects, marble sphinxes, and wall paintings. Hoving's troubles with Bothmer may have begun when he told the board the objects were of dubious origin. Klejman, who was elected a museum benefactor that year, would later claim the stuff had first surfaced as "junk," bought from ignorant villagers who didn't know what it was. Hoving and Bothmer agreed that the purchases would not be announced or even displayed (except for a brief exhibition in which they were not identified). "It was a big joke between Dietrich and Tom that they called it the East Greek Treasure," says Michael Botwinick. There was in fact every reason to obscure what it was, where it came from, and how they'd gotten it.

The Turks called it the Lydian Hoard, and it came from Usak, in the

* In his memoir, Hess would claim he asked to be taken off the story, but after his transfer he continued to write about Hoving relentlessly over the years, railing in particular about the hypocrisy and mendacity of Hoving's books, which Hess considered "auto-hagiography," while admitting that despite all the exposure "nothing basically changed."

ancient Lydian region of Turkey; the treasure was discovered in 1966 by grave robbers in several sixth-century-B.C. burial mounds constructed long before the Greeks conquered the area. The tombs had been plundered in a series of raids that year, and though some of the looters were arrested, most of the loot disappeared, smuggled out of the country. Klejman sold it to Bothmer for about $1.5 million. Among the donors who paid for it were Joyce von Bothmer ($114,000), Joan Payson ($49,351), Doug Dillon ($48,154), Houghton ($15,456), and Brooke Astor ($10,000).

Acquisitions committee meetings were fun, especially so back in the days when drinks were served during the deliberations. At one, Joan Payson and Brooke Astor pushed a $19,000 Islamic bowl back and forth, debating who should buy it. "What would I do with it?" Payson asked. "Wear it as a hat?" Egged on by Astor, she put it on her head and ended up paying for it. After that meeting, drinks were delayed until the committee's business was done. The night the so-called East Greek Treasure was approved must have been great fun, as the modern heirs of King Croesus, who reigned when the loot was made, discussed whether it had once been his.

It was a unique, incomparable collection. And even if it had to be locked away in storage until it cooled off, Bothmer could treasure it whenever he wished. He likely felt sure that his find would eventually see the light of day. Problem was, the hot properties never cooled off, because the looters left a lot behind, stole from each other, and then started pointing fingers, giving Turkish authorities a trail to follow.[166] Burhan Tezcan, then Turkey's deputy director of antiquities, who had done excavations in the area, had been called in by Usak's mayor and realized what the stuff was. That led to a dealer in Izmir who called himself Ali Baba, who'd rounded up the treasure from the various looters and sold it to Klejman. But with the loot hidden in the bowels of the museum, the trail went cold. Tezcan wrote to the Met. No one responded.

Hoving and Bothmer knew they were in the wrong. "They knew from day one that it came from Turkey," says Oscar White Muscarella, a curator and archaeologist in the Ancient Near Eastern Art Department, who was asked to examine two frescoes from the hoard and write a memo describing them. "I knew it was plundered from a Turkish tomb," he says. A curator from the Greek and Roman Art Department was sent to Turkey to

examine the site, and he, too, wrote a memo about the criminal source of the hoard; both documents were buried in museum files.

Bothmer had plenty of experience with dicey dealers. Between 1950 and 1968, he had bought eight pieces from Robert Hecht, who would earn himself something of a shady reputation. In 1961, Italian authorities charged Hecht and others with receiving stolen property; fifteen years later, two of them were found guilty, but Hecht was acquitted. In 1962, Hecht was briefly arrested and later barred from Turkey for years after he flew from Izmir to Istanbul with a pocketful of Roman coins. And in 1963, his Italian residence permit was revoked after he was accused of equipping looters with electric saws to strip frescoes from tombs.[167] Late in 1972, Hecht contacted Bothmer to say he'd come across something very special, so special that Bothmer didn't hesitate to pursue it.

The object in question was a large, two-handled jug from the sixth century B.C., originally used by ancient Greeks and Etruscans to mix wine and water. Many such jugs, known as kraters, exist, but this one was special; it had been made by the potter Euxitheos and painted by Euphronios, one of the greatest vase painters. Euphronios's technique, painting pictures that can't be seen until a pot is fired, was almost magical.

In the mid-1960s, several Euphronios works appeared on the market, the first in a century. Hecht got his hands on at least three of them. One came with a provenance, albeit a shaky one: Hecht claimed he'd bought it in August 1971 from a somewhat mysterious Armenian art dealer in Beirut—a city known for being a laundry for smuggled goods. Another krater and a cup were almost certainly looted, late in 1971, from an Etruscan tomb near Cerveteri, north of Rome. Knowing Bothmer would kill to acquire a work by Euphronios, Hecht let him know he had an item of interest several months before the looted krater was dug up; he already had the Armenian's vase.

A few months later, the *tombarolo*—or tomb robber—who'd found the second krater sold it, and it ended up in a dealer's Swiss bank vault, where Hecht saw it, bought it, and gave it to a Swiss restorer to reconstruct (for it had been broken, likely to facilitate smuggling out of Italy). The following February, Hecht wrote letters offering a krater to Bothmer, who wrote back that he and Hoving were interested. In April 1972, Hecht flew to New York

and showed photos of the restored vase to Bothmer, Hoving, and Rousseau. In June, the group met Hecht in Zurich to see it in person. Hoving heard what he deemed "an imaginative tale" about the krater's provenance and demanded all the proof Hecht could offer. Years later, Hoving admitted that he knew instantly it had been looted and made a silent pact with Bothmer to avoid any knowledge of where it really came from.[168] Rousseau, by Hoving's account, smelled a rat but didn't prevail. This was Bothmer's moment.

Back in New York, Dillon gave his okay, and by summer's end Hecht had accepted $1 million, the highest price ever paid for an antiquity. At the end of August, he got on a plane and brought the krater to New York. Two weeks later, keeping his suspicions to himself, Hoving assured the board the vase was legitimate, and the trustees agreed to buy it.

The museum put it on display on Sunday, November 12, the day the purchase was announced in a story raving about the acquisition in, of all places, the *New York Times*. Hoving claims Sulzberger saw it as a perfect example of the rationale for deaccessioning, and a great cover story for his Sunday magazine, and somehow a freelancer got the assignment, instead of one of the Culture Gulch crew.

In that story, Hoving was vague about where the krater came from, saying only that it had been in a private collection in England before World War I; the writer joked that the pot must have sprung from the head of Zeus. Initially, Hoving thought he'd pulled off a coup, since Canaday had been sidelined and the Euphronios story announced with all the importance and gravitas that the *Times* could convey. But Canaday was indignant, and not, like many, because of the huge price tag on the vase; he suspected that Hoving had paid it precisely because he knew he'd done something unethical, if not illegal.

Canaday and another reporter, David Shirey, started sniffing around and soon heard that in the antiquities field, the assumption was that the krater had been illegally dug up and smuggled out of Italy. People were so angry, Bothmer was denied election as a trustee of the Archaeological Institute of America. But the culture reporters could get no further, so their editor, Arthur Gelb, decided to enlist an investigative reporter and put Nicholas Gage, a Mafia specialist, on the story. Gage approached it as a

crime and in less than a month, traveling from Switzerland to Italy to Lebanon, put together most of the case that would send the krater home more than thirty years later.

Punch Sulzberger never raised an objection as, beginning on February 19, damning revelations emerged twelve days in a row, in as many as four *Times* stories a day. Hoving complained the coverage was more extensive than that given the bombing of Hanoi, but admitted, "I was convinced that the *Times* team had rooted out the straight story." A triumphant Canaday, who simultaneously revealed the Met's purchase of the Lydian treasures, joked that Euphronios was the only artist to ever make the front page of the *Times* ten days in a row.

Hecht met with Hoving, Rousseau, and Ashton Hawkins, the museum's in-house lawyer, to assure them that the krater was on the up-and-up, and offered them $1.1 million if they wanted to return the vase. They didn't, but Hoving went home and burned the relevant pages from his diary. Not long after that, Oscar Muscarella told the *Times* he agreed with the Italians, and began giving lectures on looting. Hoving and Hawkins tried to fire him.*

Hecht stuck to his story, even after the Italians issued a warrant for his arrest in June 1973, having decided the *Times* was right. New York's attorney general announced another investigation of the museum, too. Hoving dismissed what he termed "the hot pot" affair as "a lot of hot air," but to many it was another example of mind-boggling arrogance.[169]

Unfazed, Dillon pronounced the hot pot "legal" in March 1973, even as he ordered up an in-house investigation. Several months later, Hoving received a letter from a modern art collector in Chicago, Muriel Newman, corroborating the authenticity of the pot. She claimed she had once seen it at the home of the Armenian dealer from whom Hecht said he'd

* Represented pro bono by the firm of the radical lawyer William Kunstler, Muscarella won an injunction, and an independent fact finder named Harry Rand was appointed to investigate. After Rand held hearings, Muscarella was exonerated, eventually reinstated, and remains at the museum today, a perpetual thorn in its side, but in a sort of limbo, without raises, promotions, cost-of-living increases, or much contact with his colleagues.

bought it.* With that, the museum had a story line that couldn't be broken, even if it still engendered skepticism. A few weeks later, the warrant for Hecht's arrest was voided for lack of evidence (he was still declared persona non grata in Italy for almost a decade).

In March 1974, the museum declared itself innocent in a letter to its members, though, as the *Times* noted, questions remained unanswered and Hoving remained defensive. Doubts aside, he was unapologetic, even publishing a book in 1975, *The Chase, the Capture,* celebrating the museum's pursuit of art and seeming to thumb his nose at his critics.

Years later, Hoving would present a theory that conveniently tied up a lot of loose ends and exonerated the museum from complicity. He'd concluded that there were really two pots—one hot and one not—and thinks that when he demanded proof of provenance, Hecht simply grafted the Armenian's story onto the more valuable, looted pot. Hecht adamantly denies that. But if, as Hecht's wife says, Hoving invented the two-pot tale to try to "fend off accusations he was involved in something fishy," the question remains, what was he involved in that he hasn't already admitted? While he's waving his magician's wand before our eyes, what's Tom hiding behind his back? That remains unknown. And it isn't the only remaining hole in the hot-pot saga.

After the Euphronios krater story ended, Nicholas Gage segued to a four-part series on antiquities smuggling. One part, he says, related to the Metropolitan, and his editor predicted he'd win a Pulitzer Prize. One of Gage's last calls was to Dietrich von Bothmer, who said, "My comment is no comment. Your story will never run."

"Punch didn't stop us, but he didn't contribute," says James Green-

* In 1980, Newman announced her plan to give her collection of sixty-three modern paintings, including works by Pollock, de Kooning, Kline, and Rothko, to the museum on her death. Instead, it arrived in 2007, when she turned ninety-three, when it was shown together and then dispersed throughout the modern art collection. Though it came during Philippe de Montebello's directorship, Hoving takes credit for it. "We were so sweet to Muriel, because we needed her so desperately," he says. "We got her deposition, and she decided she'd give all her stuff to the Met because we treated her so well." She died in 2008.

field, a *Times* editor who is certain that Sulzberger didn't interfere. But after the pieces were edited, Gage was summoned to see the paper's managing editor, A. M. Rosenthal, who asked if it was true that he'd used a researcher who was in the federal witness protection program. He had, to interview Hecht, who wouldn't speak to Gage. Rosenthal said that was tantamount to paying a government employee for information and killed the story. "It was the only thing I ever wrote that never ran," says Gage, who quit the *Times* six months later—and politely declines to say what went unpublished.

ANTIQUITIES OFTEN CAME WITH ISSUES. IN ABOUT THE YEAR 1522, Shah Tahmasp, the son and founder of the Safavid dynasty, which ruled Persia for two hundred years, commissioned artists and calligraphers to create a *Shahnameh,* a traditional history of Iran's rulers from prehistory to the arrival of Islam, told in about thirty thousand couplets. Twenty years later, the elaborate book, containing 759 sheets or folios and 258 hand-painted illustrations, was finished and bound in lacquered covers. In 1568, the Shah gave it to the reigning Ottoman sultan, and it remained in the library of Topkapi Palace for almost 350 years, treasured as one of the two greatest examples of this ancient epic, the Persian equivalent of a Gutenberg Bible or the Irish Book of Kells.[170]

Today, that precious book is in pieces, and its miniatures scattered in what scholars decry as an act of deliberate, high-end vandalism and "one of the saddest events to have happened in Persian scholarship."[171] Seventy-six of those sheets have been in the Metropolitan Museum since December 1970, a gift from the man who had the *Shahnameh* taken apart, then the museum's new chairman of the board, the bibliophile and library benefactor Arthur A. Houghton Jr. The travels and the travails of what was by then known as the Houghton *Shahnameh* have since been used to illustrate the fate of Islamic art in the West, the arrogance and hypocrisy of art collectors, and even, as an Iranian art expert, Dr. Habibollah Ayatollahi, wrote, the destruction of the world's artistic heritage. The fate of the illuminated manuscript also sheds light on the contradictory impulses of the philanthropist who once owned it.

Houghton bought his *Shahnameh* in 1959 for $360,000 from the dealers Rosenberg & Stiebel, who'd sold it on behalf of Baron Edmond de Rothschild, whose grandfather acquired it around 1900 and displayed it in a 1903 exhibition of Islamic art at the Musée des Arts Décoratifs in Paris—the first time its existence was revealed.

When it came on the market, curators at Harvard University asked Houghton to acquire it for them, but once the deal was done he decided to keep it for himself, though he offered a Harvard scholar the chance to unsew the binding, photograph it in its entirety, and publish it. That took years, and when it was done, Houghton decided not to put the *Shahnameh* together again. He had some pages matted and framed and decorated his homes with them, and donated what he considered lesser miniatures to the museum.

In the spring of 1972, Houghton decided to donate more folios and the book's binding to the Metropolitan, explaining that though he was keeping some for his own enjoyment, he eventually planned to reunite the masterpiece.

But then a dispute with the Internal Revenue Service over the value of the gift inspired Houghton to sell other pages to establish their market value. After a deal to sell the manuscript to the Shah of Iran fell through in 1975, Houghton started selling off pages both at auction and privately. The most important page in the manuscript sold to the Aga Khan for a reported $2 million.

In the meantime, Houghton had essentially retired from his philanthropic endeavors after meeting the woman who would become his fourth wife. Nicknamed "the Seal Lady" by museum staffers, she became "the talk of New York," says Harry Parker. One day in the spring of 1971, a neighbor of Houghton's in Florida had found a sea lion flopping around beside her swimming pool and asked Houghton's help getting rid of it. His staff discovered that nine days earlier, a sea lion that belonged to a couple who did research on diving mammals had swum off and disappeared. Houghton chartered a plane to pick up one of the owners—who turned out to be a "tall blonde in boots" who "had a bad marriage," Houghton's assistant recalls. After he got a divorce and they married in May 1973, he wanted to spend all his time with her.

Houghton retired from the Met board in January 1974 and took emeritus status. The museum's eighteen new galleries for Islamic art, for which he'd paid $500,000, opened in September 1975 and were declared glorious by John Russell, the latest *New York Times* critic, whose view of the Met would prove less jaundiced than his predecessors'. After that, Houghton returned to private life. His name only appeared in the newspapers rarely, most often when he sold more pages from his *Shahnameh*.

After Houghton's death in 1990, his son and namesake, Arthur Houghton III, a former antiquities curator and diplomat in the Middle East, was asked what could be done to dispose of the pages that had remained in his father's possession. Aware that if he sold them separately, he might cause their value to plummet, he insisted on an en bloc deal for what remained of his father's *Shahnameh*: the cover, some five hundred pages, and 118 painted miniatures. He turned to a London dealer, Oliver Hoare—the world would soon find out that he'd just broken off a relationship with Princess Diana—who approached Iran, by then ruled by Islamic ayatollahs. Devastated by a war with Iraq, and unwilling to buy what was to them a holy relic, they finally agreed to a transaction that would be above reproach, a trade for an equivalent item.

After the Shah was deposed, most of his art purchases had been buried in storage in the Tehran Museum of Contemporary Art, declared anathema to Islamic sensibilities. Hoare identified one of those works, Willem de Kooning's *Woman III*, a full-frontal nude painted in 1953, as having a market value similar to the $20 million he thought the remains of the *Shahnameh* were worth. In the summer of 1993, the trade was done in great secrecy on the tarmac at the airport in Vienna. The *Shahnameh* went to Tehran, the de Kooning to the producer David Geffen, and the proceeds to the Houghton Foundation. Geffen sold it in 2006 to the hedge fund manager Steven A. Cohen for $137.5 million.

BACK AT THE MUSEUM, THE TOP STAFF WAS IN FLUX YET AGAIN. In September 1973, Anthony M. Clark, the director of a Minnesota museum, was named chairman of the European Paintings Department after

Ted Rousseau suddenly retired. Some thought he was bitter. "Tom had promised him the Lehman Collection as a retirement job and he couldn't deliver," the exhibition designer Stuart Silver says; the Lehman Foundation had insisted on installing its own man. "That broke Ted's heart."

But in fact, Rousseau's health was broken. Earlier that year, after suffering for months from a stomachache that wouldn't go away, he was diagnosed with inoperable pancreatic cancer. When he decided to retire, Rousseau was elected a trustee—the first professional curator ever so honored, effective the first of the year. But Ted fell into a coma and died on December 31 "in [his longtime lover] Berthe [David-Weill]'s bed two minutes before midnight, of cancer, and therefore was not the first trustee of the museum to come from the staff. Two minutes before . . . ," Tom Hoving says, and then his voice breaks off. He'd lost his best friend.

One curator wrote to the *New York Times* to complain about Ted's obituary, which failed to mention his exhibitions, the art he'd acquired, and the collectors he'd seduced and stressed scandals instead. Another curator wrote to Punch and called it disgraceful. Apologies flew back. The paper soon ran a corrective article.

Hoving was the executor of Ted's estate. The museum got two Chinese statues, a Cézanne watercolor, and other objects on condition it would never dispose of them. Ted also endowed a curatorship in perpetuity. Hoving had to dispose of eighteen bottles of 1961 Dom Pérignon, twelve bottles of 1962, seven bottles of Dillon's Haut-Brion 1962, and seventeen bottles of brandy and cognac. At Ted's request, Rosie Levai burned his cache of love letters.

Hoving's support system was failing. "Dillon had him on a tighter leash," says Harry Parker, who left to become director of the Dallas Museum of Art just after Rousseau retired. But even on a leash, Hoving managed to find ways to offend his curators and art world conservatives. Early 1975 was supposed to be another triumphal season, beginning with a show celebrating the hundredth birthday of Impressionism, followed by exhibits of Japanese art, Francis Bacon, Scythian gold from the Soviet Union, the opening of the Lehman pavilion, and, finally, a major scholarly exhibit of French paintings, organized with and first seen at the Louvre. Instead, it became another season of discontent.

The Impressionism show was unprecedented, attracting a record-breaking 500,000 visitors in its ten-week run and bringing in six-figure sums from sales of catalogs, posters, and food in the museum restaurants. But Hoving's crowing—on the heels of a report that named the Met New York's new No. 1 tourist attraction, he called it "the hot place to see" and bragged about broadening the audience and "packaging" exhibits to attract crowds—brought down fresh wrath from critics like Hilton Kramer of the *Times*.[172] Kramer attacked Hoving for succumbing to a box-office mentality and "compromising standards of scholarly integrity in the interest of crowd-pleasing spectacles" because the "cynically-conceived" exhibit only included forty-two paintings, which, Kramer concluded, "was anything but adventurous."[173]

A few weeks later, unhappy curators echoed him, complaining that Hoving had unilaterally cut down the size of the upcoming French paintings show, eliminating 25 percent of the pictures, sacrificing scholarship for box-office appeal. Though Hoving countered that his motives were financial—he either had to cut shipping and insurance costs or cancel the show altogether—that explanation was dismissed.

The two top European paintings curators promptly resigned, one after the other. One took his grievances to the press, where he said Hoving cared about neither art nor art professionals, and had proved his disregard by unilaterally rearranging the Impressionist show the day before it opened, loaning fragile paintings to Russian museums to get the Scythian gold, and embarrassing the head curators by gutting the French paintings show. Soon, the Met got its sixth head of European paintings in three years, Sir John Pope-Hennessy.

Though he'd spurned Wrightsman in the past, by the spring of 1975 Pope-Hennessy, then the British Museum's director, was longing "to be released from the ghost-haunted atmosphere" of London, he would later write. His brother, James, a writer and a homosexual with a penchant for what was called rough trade, had just been murdered—bound, gagged, and left for dead by three men, one his lover. John decided he needed a change. He has said he quit the British. A member of his circle says he left "because he was caught in flagrante with one of the museum's warders." What's cer-

tain is that he moved to Tuscany and almost immediately was offered positions at both the National Gallery and the Metropolitan.

After "a doubt-ridden week" with the Wrightsmans in Palm Beach in April 1976, the Pope, as he'd be called in New York, headed north to Washington and New York, where Hoving impressed him with his "incomparable skill" and the offer of a dual role as professor at the Institute of Fine Arts and consultative chairman at the museum, a fancy way of saying he would not be burdened with administrative duties at the Met.

Even though each had attained a lofty level of professional success, and found the other useful, Hoving and Pope-Hennessy sniped at each other. "He was always interested in living well," says Hoving. "He was a suck-up to the rich, particularly Americans, totally brownnosed his way through life. But he was a divine guy, I hired him, I saved his career." Pope-Hennessy would later claim that the trustees first offered him Hoving's job, but he chose the lesser post of chairman, as he longed to set the "discredited" Paintings Department right again. He felt the European galleries were all wrong and blamed Rousseau, who had "a defective sense of quality . . . did not believe in knowledge, and . . . was a poor administrator." He took up the post in January 1977.[174]

THE HIRING OF POPE-HENNESSY WAS TOM HOVING'S LAST HURrah as director. Though he'd begun planning for what was arguably the greatest museum blockbuster of all time, the King Tut show, it wouldn't open until 1978, by which time he'd be gone (and Henry Kissinger, who initiated it, would be on the museum board). During the planning of Tut, Hoving had another crisis of confidence. He'd been at the Met for eight years, he'd lived through the centennial, survived his scandals, and now he thought, what next? "I was tired of the boring routine," he says.

Hoving denies it, but close associates at the museum say he had a fantasy of becoming America's André Malraux, a national culture minister in the president's cabinet. But when Nixon quit the presidency in August 1974 and was replaced by Gerald Ford, who named Nelson Rockefeller his vice

president, that dream flew out of reach. It wasn't likely the man he'd called a cheap grifter would relish sitting in a cabinet room with him.

By then, Hoving had become openly contemptuous of many of the trustees. "A lot of them hated each other," he says. "They were Wall Street people who were competitors. On the board they had to be friendly, but you could see they didn't like each other. Redmond hated Wrightsman. Wrightsman thought Redmond was a piece of shit. They'll go to each other's dinner parties, but they don't like each other. It's a bunch of extremely rich, egotistical, ambitious, highly polite people. Get six of those in a room and they're gonna act as if they love each other. But boy, three minutes out, it's 'Did you see what that cunt was wearing?' "

The board kept evolving of course. In 1974, Jane Engelhard, the wife of a precious-metals magnate, joined, and the next year Jayne Wrightsman replaced Charlie. He'd managed to hang on until age eighty, but, says Hoving, "he was getting old and in bad health and wanted Jayne to have her day." Hoving says he had to force a reluctant Dillon to give her Charlie's seat. "She was known as spoiled and, despite the bullshit, ignorant when it came to the history of the fine arts," Hoving says. "Plus the Wrightsman demands over the years had begun to pall."

By the early 1980s, when Charlie had the first of a series of strokes that left him incapacitated, Jayne was already asserting herself. She hired nurses to care for him, sold the Palm Beach house and its contents, and began emerging from his dark shadow. As Charlie declined, she finally had the chance to shine. Like Brooke Astor, she came into her own as a widow; when Charlie died, aged ninety, in 1986, he left her everything—reportedly $150 million.

The new trustee who had the most impact on Hoving, and would play a crucial role in his departure from the museum, was Walter H. Annenberg. Walter had inherited his father's publishing empire—which included the *Morning Telegraph*, the *Daily Racing Form*, and the *Philadelphia Inquirer*—in 1942. His father had died after spending two years in prison for tax evasion. Walter righted the business, restored its luster, and created *Seventeen* and *TV Guide*. He didn't hesitate to play politics with his newspapers, and used the power and wealth that flowed from his business to punish his enemies (he

was said to keep a blacklist of people his publications couldn't mention) and connect his family name to good causes.

He established two communications schools, at the University of Pennsylvania in 1959 and at the University of Southern California in 1971. He and his second wife, a niece of Harry Cohn, a Hollywood mogul, weren't high society, but when Richard Nixon became president, he named Annenberg ambassador to the Court of St. James's, effectively leapfrogging them over the judgmental swells of New York City and into the upper echelon of international society. They and their extraordinary art collection moved into Winfield House, the ambassador's residence in London's Regent's Park, from 1969 until 1974. Over the years, he made canny contributions that made him popular in London society.

Hoving had met Annenberg at an IBM board meeting—both were directors—and the relationship deepened when he was elected to the Met board just after leaving London. The beginning of the end came when Hoving asked Annenberg for a contribution to build a new museum orientation center designed by Charles Eames. His prey had bigger ideas. Annenberg admired Sir Kenneth Clark's 1969 television series *Civilisation*, a multipart survey of European art. "Why can't *we* do that?" he asked Hoving.

Later, several key trustees would say they'd decided the time had come to toss Tom Hoving under a train, and even some of Hoving's closest allies at the museum came to believe he was, if not fired, then nudged sharply toward the exit. As with the Euphronios krater, there's an official story of Hoving's end, but it's riddled with holes big enough to let almost any interpretation through.

He'd often said he would keep the job for seven years—but instead, in March 1976 he'd celebrated his ninth anniversary as museum director by writing a letter to Annenberg, outlining a strategy to create an Annenberg center within the museum, dedicated to the visual arts. "To record, in the most permanent way, every work of art on earth," Hoving says. The tentative idea—approved by Dillon and turned into actual plans by Roche and Eames that spring—was announced to the executive committee at its June meeting. Annenberg promised $20 million to build a southwest wing, redesigned to house the Western European and twentieth-century art de-

partments and the proposed Annenberg Center. He pledged $2 million a year more to run it for at least a decade. Though his name wasn't mentioned, Hoving says that Annenberg always wanted him to run it.

"He was looking for an excuse" to quit, says Nancy Hoving, and the executive committee gave him one at that very same meeting. He'd decided to buy another masterpiece, a *Crucifixion* by Duccio, the great Sienese painter of the early fourteenth century, whose work wasn't yet in the collection. Then, thinking that Dillon had agreed to bid on it at an auction, he flew to Bermuda for a sailing race and was out at sea when the executive committee canceled the purchase a few minutes before it agreed to proceed with the Annenberg Center. Back on dry land, Hoving learned the purchase approval had been rescinded and "had a hissy fit," he says.

He decided to say yes to Annenberg; went to Maine for a long talk with Dillon; met with the inner circle of Dillon, Gilpatric, Dilworth, and Davison in New York in September; and finally wrote Dillon a month later, saying that he would resign effective the end of 1977 at the November board meeting. He announced himself satisfied with his tenure, reminded Dillon he'd always favored term limits, and finally said that someone else would be better suited to preside over the era of consolidation that was on the horizon. Dillon didn't tell the other trustees he'd quit, and when the *Times* reported Hoving's departure a week later, along with rumors that he planned to head a new communications "venture" financed by Annenberg, the trustees felt blindsided, and all hell broke loose.

Gilpatric had studied the legalities and reached the conclusion that Hoving's negotiations with Annenberg presented a conflict of interest. Several other trustees were furious when they learned that the center had been planned in secret over the course of many months. Nevertheless, the board agreed to let Tom continue planning with Annenberg so long as he no longer negotiated for the museum.

A day after the November meeting, Charlotte Devree, the widow of a *New York Times* art critic who represented New York's City Council president on the Met board, expressed her doubts about the arrangement. "I can't see that museum trustees have the right unilaterally to sign away city-owned space," she wrote. When she asked whether the center would pay rent to the city, it "infuriated Hoving," she said, and he "declared it outra-

geous ... like asking rent from birds in the trees of the zoo." Sure that Hoving hoped to "achieve worldwide personal recognition," she worried how his successor would deal with him "in one corner of the museum, directing," who would pay for curators working on Annenberg projects, whether the museum would share in the profits, and what would happen if Annenberg decided to bail out. "I think Hoving is helping himself to city-owned museum space," she concluded, "and I think he should be stopped."[175]

What were the trustees thinking? Harry Parker thinks they'd bought Hoving off with what he loved most—a new opportunity for self-aggrandizement. Michael Botwinick decided they went along with the Annenberg plan so he would leave quietly. "There was no second act for Tom," he says. Hoving insists it was all his idea. "They might have wanted to can me and perhaps I richly deserved it, but I headed them off at the pass," he says.

The controversy mounted, and by January 1977, the same forces Hoving had been fighting for seven years had been roused again. The Parks Council urged the latest commissioner to ban the center from the museum. Pete Hamill, the columnist, railed against it in the *Daily News*, offending Annenberg by dredging up his father's gangland connections and jail stint. And someone leaked documents to Barbara Goldsmith, a member of the Parks Council, who began reporting a story for *New York* magazine. When it appeared in March, it was clear several trustees had spoken to her, including one who worried that Hoving had crowned himself emperor.

Finally, the City Council, the New York attorney general, the Manhattan borough president, and a new cultural advisory group all started investigating the proposed Annenberg Center. Hoving flew to California to discuss the situation with Walter. The risk-averse publisher bought a quarter page in the *Times* warning that he'd take his money elsewhere unless the trustees and "those responsible in civic affairs in New York City" immediately and overwhelmingly approved his plan. The very next day, Annenberg abruptly withdrew his offer anyway.

A month later, after desperate pleas by city officials failed to get Annenberg back to the table, arguments still raged over who'd actually killed the center, leaving some Hoving friends wondering if it wasn't all a Machiavellian plan by Dillon to get rid of Tom. Many think it was. "When

they cut that limb off the tree, Tom was sitting at the end of it," says the CFO, Dan Herrick. Fifteen weeks after Annenberg's withdrawal, Thomas P. F. Hoving cashed in his vacation and sick days and left the Met "on sabbatical" at full pay. Instead of a gold watch, he got a dinner, a replica of the Tut goddess Selket, and, best of all, a free parking space for life in his garage beneath the Rockefeller Wing. He says Annenberg offered him $3 million to start a production company, and at his wife's urging he refused and opened a consulting firm instead. Looking back, thirty years later, many see the Annenberg Center as a good idea expressed too soon—for private money would shortly become the mother's milk of the Met again—and Hoving, the man who tried to sell it, as tragic. None consider his later jobs in television and magazines, his books, or his role as a perennial gadfly anything more than anticlimax.

So, did Hoving jump or was he pushed?

"I don't think it was voluntary at all," says Barbara Newsom, who'd left her job under George Trescher to work for the Rockefellers. Hoving "was maneuvered out because the trustees suddenly got very nervous about him running the Annenberg Center and dominating the museum, . . . and they forced his retirement. Tom floundered after that."

"He was cleverly maneuvered out," insists a friend of Doug Dillon's, who quotes the exasperated museum president saying, "We let him run with [the Annenberg idea], and once he was committed, we said you can't have both jobs, and that was the end of it."

Hoving managed to "walk out before they fired him," says Nancy Hoving, whose compulsive honesty balances her husband's sophistry. Her final words on what happened?

"*Tant pis.* Didn't matter."

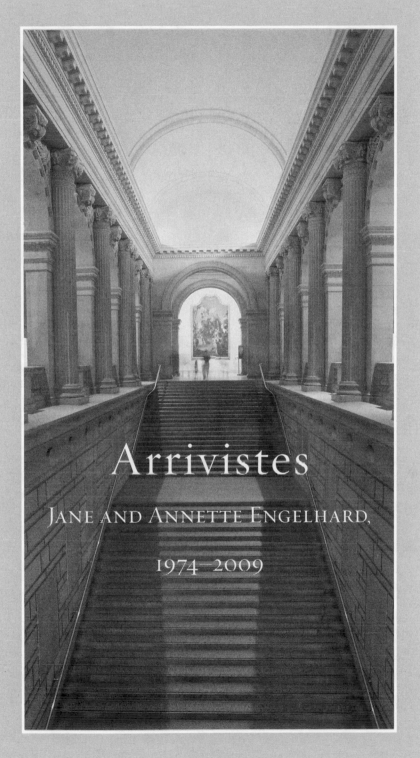

Arrivistes

JANE AND ANNETTE ENGELHARD,

1974–2009

It was the summer of 1973, and the socially savvy fashion designers Bill Blass and Kenneth Jay Lane were having lunch at the Connecticut weekend home of the Oscar de la Rentas. She was the former Françoise de Langlade, a onetime editor in chief of French *Vogue,* he was a suave, Dominican-born fashion designer with ties to international society. They'd married a few years earlier, Oscar for the first time, Françoise for the third, just after she'd exiled herself from Paris in the wake of an affair with a married member of the Rothschild banking family. Over lunch, the conversation turned to the Metropolitan Museum's latest acquisition, Diana Vreeland, a friend of them all. Fired as editor in chief of American *Vogue* two years earlier, the grandly grotesque fashion eminence, who was given to red lacquer rooms and advising readers to wash their hair with champagne, had been rescued by Ted Rousseau, who'd made what at first appeared a face-saving gesture, offering her a part-time job as a consultant to the Costume Institute.

Vreeland got off to a slow start. Her first show failed to materialize;

her second, a retrospective of clothes by the late Spanish couturier Cristo-bal Balenciaga, was praised within the fashion world but ignored outside of it. And instead of one of the institute's famous balls, The World of Balen-ciaga kicked off with a mere black-tie preview in March 1973, albeit one at-tended by hundreds of the Seventh Avenue regulars and a small crowd of swells, among them Andy Warhol, the model Apollonia, the Pop Art patron Ethel Scull, and the Washington socialite and Wrightsman pal Deeda Blair.

Press coverage of the affair was modest, too, at least by Hoving-era standards, and Vreeland was worried. Her contract was about to run out, and her designer friends knew that she was eager to have it renewed. The diners at the de la Rentas that summer day resolved to ensure that by mak-ing a commercial trade group, the Council of Fashion Designers of Amer-ica, the institute's benefactor. De la Renta, just named president of the decade-old dressmakers' lobby, set to work.

The Party of the Year, revived by the CFDA, returned in force in 1974, to coincide with the opening of Vreeland's next exhibition, of couture of the years 1910 to 1940. The party committee was a social who's who, in-cluding Gianni Agnelli, Leonore Annenberg, Pat Buckley, Jacqueline Onas-sis, and her sister, Lee Radziwill. "From then on, it was the hot party of the season, always held the first Monday in December," says a friend of Vree-land's. "It was because of Diana that all the stars came: Babe [Paley] and Betsey [Whitney] and Jane Engelhard, full of rubies."[1] Though they didn't know it at the time, that fashionable crowd would soon evolve into the Metropolitan Museum's most visible ruling clique and would reign into the next century.

TED ROUSSEAU, COURTIER OF THE WEALTHY, HAD SOMETHING like that in mind from the start of his seduction of the sixty-eight-year-old Vreeland. By the late 1960s, the Costume Institute, subsumed into the mu-seum as a department in 1959, had lost its pizzazz as haute couture was el-bowed into the gutter by street fashion. After one last ball in 1967, the Party of the Year and the institute itself shut down for a face-lift.

Vreeland, a minor socialite and longtime fashion editor, had been

widowed in 1966, so her sudden dismissal from *Vogue* late in 1970 came as a financial as well as an emotional shock. Fortunately, Peter Tufo, the lawyer she hired to negotiate her exit, would be the bridge to her next career. Tufo had worked at a law firm with offices near Rousseau's favorite restaurant, the Veau d'Or, and they had a passing acquaintance. "I don't remember if she, he, or I had the idea," Tufo says, but somehow, during the five months before Vreeland's firing became publicly known, he ended up talking to both Rousseau and Ashton Hawkins, who'd met Vreeland and her husband, Reed, through Jane Engelhard and become a regular guest at their dinners. Rousseau knew all about Vreeland and her treatment by *Vogue*'s owner, the Condé Nast publishing company. He told Tufo he thought it awful and wondered if he and Vreeland couldn't help each other. He was unsatisfied with the institute's operation and wanted to find a way to "elevate" it.

"They wanted to put it on the map," Tufo says, "but he wasn't clear how to do that."

Vreeland, Rousseau, and Tufo had lunch at Quo Vadis, where the editor reeled off ideas on how to make over the Met's fashion operation. Then she and Ted set out to make their marriage happen. Rousseau asked the then head of the institute, Adolph Cavallo, if he might be able to use Vreeland somehow. To press the point, he had Dillon invite Vreeland to join the institute's visiting committee. The problem was, Vreeland needed a salary, and the Met had no budget to pay her. So unbeknownst to Cavallo, Ashton Hawkins started raising money to pay for a salary. Vreeland worked her connections, too—and social leaders like Engelhard, Jacqueline Onassis, Pat Buckley, and C. Z. Guest all worked behind the scenes on her behalf. "She was beloved, but also direct when she wanted something," Tufo says.

In the one-year contract Vreeland finally signed in July 1972, she was charged with generating and organizing exhibitions, expanding the costume collection, and working with the fashion press and industry to raise consciousness of and money for the museum. Her ability to do the last was proven before she signed on.[2] The museum agreed to give her a secretary and private office, and pay her $25,000 and $10,000 in expenses. "Her expense account was to be kept the utmost secret," says Rousseau's assistant, Rosie Levai. Also secret was the fact that 40 percent of that sum was subsidized by social figures: Marella (Mrs. Gianni) Agnelli contributed $3,000;

Mrs. Umberto de Martini (who, as Mona Williams, had not only owned the Wrightsman house in Palm Beach but shopped in a lingerie boutique Vreeland ran in London in the 1930s) gave $2,500; Phyllis (Mrs. Douglas) Dillon, Frederick Melhado, a banker, Babe Paley, Jacqueline Onassis, Bunny (Mrs. Paul) Mellon, the insurance magnate Frank Schiff, Berthe David-Weill, and Lily Auchincloss each kicked in $1,000; and Mary Cutting (Mrs. Watson) Blair gave $500.[3] Along with the generous settlement Tufo won from Condé Nast (severance, a $20,000-a-year pension, later doubled, hefty consulting fees that continued until her death, a clothing allowance, and contributions toward her rent), she would never worry about money again.[4]

Initially, she was "ecstatically happy," but Vreeland knew she couldn't bank on promises; her perch at the museum felt as insecure as Cavallo's proved to be.[5] Not a favorite of Hoving and Rousseau—he lacked the social razzle-dazzle factor—Cavallo resigned not long after Vreeland flew to Paris, London, and Rome on a $1,039 first-class ticket to try to kick-start her first big idea, a show of clothing worn by the Duke and Duchess of Windsor. That was politically incorrect; though well dressed, the couple were disdained as snobs, and the duke, who had just died, was despised as a Nazi sympathizer and a laughingstock after his decision to abandon the throne of England—he was briefly King Edward VIII—to marry an American divorcée.

The full weight of the museum was nevertheless put behind the Windsor show. Doug Dillon personally contacted the duchess, who agreed to the idea. Hawkins, who had a cousin in the royal household, became Vreeland's comrade-in-arms, negotiating with the duke's longtime secretary and plotting with her to get "the men's cosmetic industry and wholesale tailors, John Weitz–Oscar dlRenta–Bill Blass–etc. [sic] . . . to put up the money for the show."[6] Vreeland contacted a Japanese industrialist who owned licenses for Saint Laurent and Dior cosmetics to ask if he could make mannequin heads that would be "abstract, perhaps like a wonderful baroque pearl with no trace of hair or features but with a definite expression in the carriage of the neck, the tilt of the head."[7] Though she would feature active brands in many of her exhibits, she wanted to be sure the displays didn't look like retail stores, full of "rather creepy and unattractive" mannequins.[8]

She also discussed them with a young photographer and jewelry designer who'd asked for work; Robert Mapplethorpe suggested she simply drape store dummies with fabric to "eliminate the obvious identification problem."⁹ Mapplethorpe didn't get the job, though he did continue to consult on the mannequins. Vreeland didn't get her Windsor show, either; though the duchess was willing to loan their private clothes, England's royal family, which never forgave the duke or accepted the duchess, refused to loan ceremonial garments, which shut the project down.

That didn't stop Vreeland. Working from a room at the posh Hôtel de Crillon in Paris with the covert help of a British *Vogue* staffer, she began cajoling, charming, and flattering the best-dressed-list types whose clothes she hoped to borrow for the Balenciaga show while plotting another featuring Cartier jewelry, firing off memos about how to get corporations, publishers, cosmetics firms, and "the rich on my list" to subsidize her activities, finding new work for some of her old *Vogue* staffers, and consulting with designers.¹⁰ She also began compiling a list of her accomplishments for Hufo to use in seeking a contract renewal. Her savior Rousseau's health was failing. She knew she would soon be on her own. Just in case things didn't work out, Vreeland also returned to her retail roots, running a little side business as a personal shopper for a handful of wealthy women, among them the *Washington Post* publisher, Kay Graham, and Jane Engelhard.¹¹

IN HIRING VREELAND, THE MET WAS SHOWING A WILLINGNESS to move in new directions. As it did again in 1974, when Engelhard joined the board; she was something new, and so was the intriguing route she took to get there.

Jane Engelhard was born Marie Annette Jane Reiss in 1917, in either Qingdao or Shanghai, China (sources differ on the place and her exact birth date). She was the third daughter of Hugo Reiss, a thirty-seven-year-old black-haired, gray-eyed Jew from Michelfeld, Germany, and Ignatia Mary Valerie Murphy, a dark-haired twenty-five-year-old Irish-Catholic beauty from San Francisco. Reiss's family had an import-export business in Manchester, England, in the nineteenth century. Reiss Brothers did busi-

ness in China as early as 1889. Hugo carried a Brazilian diplomatic passport; he served as Brazil's consul in Shanghai while running his family's company. He met and married the much younger Mary after her parents died and she moved to Shanghai to live with a sister who was married to the American consul. But within seven years of Jane's birth, Mary Reiss had left Hugo and resettled with her three daughters in the fashionable sixteenth arrondissement in Paris. In November 1928, she gave birth in nearby Neuilly to another daughter she named Marie Brigitte. Hugo was not the father.

"Miss Mary Murphy was a beautiful lady," says Patricia "Bébé" Bemberg, the younger of Jane's two half-sisters. "She fell in love with a handsome man, and she had an affair with him, I suppose." A merchant just like Reiss, Mary's new lover, Bébé's father Guy Louis Albert Brian, had the added attraction of claimed noble French descent, although that can't be confirmed. Hugo Reiss's fate is a mystery, too. No record of his consular service or of his death can be found. He last appears in American immigration records in 1930 at age fifty. By then, he and Mary had divorced. "I'm not sure if they divorced before or after Brigitte was born, but they'd lived together since they met," says Bemberg. Mary and Guy Brian were married "in 1928, I think," Bemberg, who was born in 1930, continues. Brian adopted Mary's girls. Jane was enrolled in the Convent des Oiseaux, a fashionable Catholic school in Neuilly.

Though the oldest, Barry, never married, the other four snared husbands who make them the Parisian equivalent of the famous Cushing sisters who grew up to be Babe Paley, Minnie Astor Fosburgh, and Betsey Whitney. In 1949, Brigitte would marry a descendant of La Rochefoucauld. Bébé's husband, Jacques, was from a famously wealthy German-Argentine textile, banking, and brewery family in Buenos Aires; a distant relative, Philippe de Noailles, duc de Mouchy, would connect her to both the Dillon and the Montebello families. Another sister, Huguette, married a British army major who claimed an ancestry tracing back to William the Conqueror. But Jane would hit a bigger jackpot—twice.

Jane's first husband was Fritz Mannheimer, a Jew from Stuttgart. When they met in the 1930s, he was in his forties and the most important banker in Europe. Since then, his name and story have mostly been forgotten, in part due to Jane and their daughter, the future Annette de la Renta,

who have repeatedly rebuffed researchers and historians. "What I have learned about Mannheimer, I learned through other people, because neither Annette nor her mother ever talked about it," says Annette's husband, Oscar de la Renta. But Mannheimer left a colorful trail through the history of society, art, finance, and war.[12]

After studying law at the University of Heidelberg, Fritz Mannheimer trained as a broker in Paris and Amsterdam and during World War I bought foreign wheat, as well as metal for the German weapons industry. In 1920, the thirty-year-old Mannheimer, with his pale brown hair and gray eyes magnified by thick glasses, set up an independent branch of the 125-year-old German-Jewish investment bank Mendelssohn & Co. in Amsterdam. He ran it for the next nineteen years, trading money and driving down the value of the German paper mark to help his defeated country pay off its massive war reparations as cheaply as possible. Instead of taking commissions from the government, he used the information he gleaned to make a fortune of his own, which bought a country home in Holland and a late-nineteenth-century villa called Monte Cristo in Vaucresson, France, near Versailles.

In 1924, J. P. Morgan & Co. refinanced Germany and stabilized the mark,* and Mannheimer began arranging loans, trade credits, investments, and partnerships with Dutch and foreign banks to help Germany rebuild. It was moving in on territory that had been controlled by Morgan, which had "ruled the world until it was deposed by Mannheimer," says Patrick Hannon, an American lawyer and former banker who has researched American banks and the Nazis. Fritz physically entered Morgan territory, too, traveling to America on a diplomatic passport like Hugo Reiss, living in luxury at the Ritz Tower or the Waldorf-Astoria, accompanied by his valet.

In 1931, the German economy ground to a halt, the government froze the mark and stopped paying reparations, and the Weimar Republic began to teeter. Mendelssohn Amsterdam was Germany's vital link to other economies, which made Mannheimer Europe's de facto central banker. "At one time he worked simultaneously for the German, Austrian, Czech, Pol-

* The Dawes Plan was administered by S. Parker Gilbert, whose son would later become a vice chairman of the Metropolitan Museum.

ish, Hungarian, Yugoslav and Rumanian Central Banks," *Time* magazine would later say.[13]

Which may explain how Mendelssohn Amsterdam, though Jewish owned, thrived in close collaboration with the German government even as the Nazis, led by Adolf Hitler, took power in 1933 and began to institutionalize anti-Semitism as the cornerstone of their social and economic policy. Mendelssohn & Co. was one of the last Jewish banks to do business with the Nazis, and was hardly alone in proceeding with business as usual. Ethics and morals were not priorities of finance capitalism.

For the moment, the Nazis needed Mannheimer, too. Right until the start of World War II, Nazi anti-Semitism was ignored outside Germany. Some Jews viewed working with the Nazis as self-protective, an insurance policy: the best way to deal with them was to deal with them. The prevailing indifference to, indeed concurrence with, the Nazis by the capitalist world was reflected in *Time*'s profile. Mannheimer, the so-called king of flying capital,[14] had been playing both sides, secretly helping German Jews get themselves and their assets out of the country, but the magazine stereotyped him as a "fat-lipped, mean, noxious, cigar-chomping" creep who gave one of his mistresses a gold bathtub and who, "after 20 years in The Netherlands, could not speak enough Dutch to boss his chauffeur."[15]

Time's opinion was shared in Calvinist Amsterdam, where Mannheimer was disdained for a lifestyle that included a Rolls-Royce when most bankers walked or took streetcars. He also owned a huge paintings collection, including works by Canaletto, Watteau, Chardin, Ingres, and Ruisdael, some bought from various Rothschilds and other wealthy collectors, several sold to him via Wildenstein by David David-Weill during a liquidity crisis at Lazard Frères, some sold out of the Hermitage and Kremlin collections by Joseph Stalin, and others whose provenance traced back to German museums. He also had thousands of antiques, valuable German decorative arts objects, and flashy jewelry.

"His extravagantly ostentatious expenditure [was] aimed explicitly at recreating the life of a banker of the France of Honoré de Balzac and Alexandre Dumas," wrote the historian Harold James.[16] Though some thought he had charm, flair, and taste, Mannheimer's flamboyance ran against the grain of both Dutch and private banking culture. He even

flaunted his mistresses. One girlfriend, a swimmer, competed in the 1928 Summer Olympics in Amsterdam, and he shocked polite society by sitting at the edge of the pool and cheering as she won a medal.[17]

Despite his usefulness to the regime (in 1933, he'd launched another speculative attack against the franc on behalf of the Nazis[18]), as a Jewish banker he had dim prospects in Germany. Mannheimer sought Dutch citizenship in the 1920s and was stopped by German bankers. He tried again in the early 1930s but was stymied by his detractors. In 1936, he gave some paintings to Amsterdam's Rijksmuseum, and influential friends pushed his naturalization through parliament. In the meantime, he'd hit some rocks on what had otherwise been a pleasant cruise.

In 1934, Mendelssohn discovered that his art collecting had been funded by the bank and forced him to transfer all his purchases to a British holding company, Artistic and General Securities Ltd., created for that purpose, and to stop spending their money. In exchange, the company rented his art and objects back to him. Unbeknownst to the partners, Mannheimer continued his obsessive collecting, spending another 13 million guilders of the bank's money, about $7 million. No one cared because, backed by a huge loan from Belgian interests, he'd moved Mendelssohn into underwriting bonds to finance whole countries.

Despite his indispensability, by 1937 the pressure on Mannheimer was growing, as the German government started cutting off economic relations with its neighbors and forcing the last German Jews out of banking. The next year Mendelssohn's Berlin-based operations were liquidated, and though it was never officially "Aryanized," its operations, accounts, and assets were taken over by Deutsche Bank. In Amsterdam, Mannheimer, still independent, abruptly switched geopolitical sides and started openly serving France's new anti-German government, allying himself with its finance minister, Paul Reynaud, in a scheme to prop up his destitute country by manipulating the stock market to shore up French credit in the run-up to an inevitable war.

Mannheimer formed a syndicate to underwrite $265 million in short-term French state and railroad bonds, and offered more loans in a vain attempt to lure Spain's fascist dictator, Franco, away from the Axis. All that would earn Fritz a nomination to France's Legion of Honor and praise as "a fi-

nancier of Napoleonic ability,"[19] but it proved to be the last straw for the Nazis, who declared him an economic traitor and, after taking over Austria and Czechoslovakia in 1938, "began to coerce banks in the occupied territories into refusing to conduct financial transactions with Mannheimer's bank."[20]

Though the details of Mannheimer's life in that fraught period are sketchy, one fact seems beyond dispute. Mannheimer married the German-Brazilian–Irish-American Marie Annette Jane Reiss-Brian, usually described as a Brazilian beauty, in France on June 1, 1939. He was forty-eight, she was twenty-two and two and a half months pregnant. *Vogue* would later say she was "16 or so, black-eyed, confident and competent beyond her years."[21]

However old she was, in every respect, this was an odd turn of events in the life of a conservative, convent-educated Catholic girl. And the ceremony was odder still. Before Paul Reynaud, Fritz's best man; Sir Charles Mendl, a British diplomat in Paris, and his wife, the decorator Elsie de Wolfe; and the mayor of Vaucresson, the groom suffered a heart attack during the ceremony, which only continued after he was revived with several injections.[22]

Later reports added provocative detail. Mannheimer had had a heart attack two years earlier, had been ailing, perhaps with syphilis, was addicted to drugs, possibly morphine, had lost nearly half his 250 pounds, and could barely walk up steps. Yet he'd somehow met Mary Murphy Brian, who'd introduced him to her beautiful daughter, Jane, who became his lover and the mother of his child. The most thorough published account of Mannheimer's death, *Kunsthandel in Nederland* by the late Dutch journalist Adriaan Venema, says Mary had met him some years earlier and, aware of his failing health, written to him in 1938, offering Jane, who'd had experience as a nurse, to care for him, an offer he was persuaded to accept.[23] (Though she would remain with Guy Brian until his death, some Mannheimer researchers, and some of Jane's friends in later life, believe that Mary had had an affair with Mannheimer first.)

Regardless of how they met, Jane's new rich husband was about to be poor, though the precarious state of Mendelssohn was, for the moment, unknown. Sixty-nine days after the wedding, on August 9, 1939, Fritz died "suddenly," said the *Times* of London, of "a heart attack but many rumors as to the cause of his death caused French police to assert that death was nat-

ural," said the *Washington Post,* which added that he'd "looked quite healthy" at his Paris home, presumably Monte Cristo, one day earlier when he met some Dutch visitors. Which contradicts another unsourced account that has him taking a phone call that day in his Amsterdam office—caller and content unknown—leaving immediately for Vaucresson, and dying on arrival. His burial in the rain two days later attracted a mere four mourners— his pregnant bride among them—and a rabbi.

Questions linger over Mannheimer's death. There was no medical investigation. Officially, it was a heart attack. But Jane told friends he'd killed himself and once told someone that he'd died in the firebombing of Rotterdam. Hannon thinks Mannheimer may have been killed by Gestapo agents with an overdose of arsenic, which was used as a treatment for syphilis. But that would make Jane, his nurse, a suspect.

The case for suicide is strong. A day after Mannheimer's death, Mendelssohn suspended payments on its obligations; the Dutch bond market had proved unwilling or unable to absorb its loans to the French, leaving the bank insolvent, and it collapsed. Mannheimer's personal fortune, which had been holding it up, proved an illusion, too. His estate was declared bankrupt nineteen days after his death, and a French administrator prepared to sell his villa in Vaucresson.[24] Jane Mannheimer fled for the Côte d'Azur, and on Christmas Eve 1939 their daughter, Anne France, was born in Nice.

Mannheimer's actions just before his death also point to suicide. Around the time he married Jane, he secretly shipped many of his finest works of art and antiques out of the Netherlands.[25] Some went to London, where they were stored in a vault, and dozens of paintings and drawings went to France, many to an art storage firm that had once been Marie Antoinette's royal packer. It is impossible to know the extent of Mannheimer's holdings outside of the Netherlands. Under French privacy laws, documents on his estate and bankruptcy are sealed. And official files on the case in England "have all been destroyed," says Ian Locke, a researcher into Holocaust-era assets.

A multinational search for his and Mendelssohn's assets and liabilities ensued. Several oil companies owed Mendelssohn millions borrowed to build pipelines in Libya and Iraq. Mendelssohn owed money to Dutch,

Swiss, Belgian, Swedish, Canadian, and the largest American banks. Lazard Frères was another creditor, owed 1.5 million guilders, the equivalent of $11.6 million today. Lazard and Mendelssohn were entwined in business and personally. In 1930, both banks were involved in the creation of an international credit organization that facilitated the cross-border movement of funds. Their relationship deepened when Mendelssohn began working with the French; André Meyer and Mannheimer became friends.[26]

But the cause of the bank's failure is still argued. "There is no doubt in my mind that Mannheimer was a swindler," says a researcher at the University of Amsterdam. "His bank did not collapse. There was a lot of money missing when he died. He had been cheating on his partners for years. He died when the bad news about his fraud was about to become public." Hannon, who thinks the bank and Mannheimer were solvent, believes the truth is lost in a fog of pro- and anti-Nazi propaganda designed to obscure the role of international finance in the Third Reich.

Had Mannheimer hid his assets in art to move them out of reach of both the Germans and his creditors? Jane's travels as the war started suggest that he did, and that she was determined to get at them. But this brief, defining period of her life will always remain a mystery. She never spoke of it, and though she considered opening up the Pandora's box of her past in later years, after she'd made her way back to the heights of wealth and influence, she would ultimately flinch and slam the lid closed again.

Sometime after giving birth to Anne France—the future Annette de la Renta—Jane left her daughter with her mother and sailed to Buenos Aires.[27] France had become a dangerous place for the widow of a German-Jewish banker who'd been condemned as a traitor to his homeland. A month after Mannheimer's death an anti-Semitic German journal, *Die Judenfrage* (The Jewish Question), published what it called "A Closer Look at a Jewish Financial Mastermind," claiming Jewish financial crooks had taken over Holland and charging that if Mannheimer had any assets left, only "his Jewish wife" knew where they were.[28]

The Nazis invaded France and the Netherlands five months after Annette was born. Holland surrendered in five days. On June 3, the Germans began bombing Paris, and they entered the city eleven days later. France's Third Republic, headed by Mannheimer's best man, Paul Reynaud, col-

lapsed, and a new government was installed and signed an armistice, agree-ing that Germany would control northern and western France, while French officials based in the southern spa town of Vichy would administer the re-mains. A day later, on June 23, Adolf Hitler rode in triumph into Paris.

It's unclear how or when Jane Mannheimer got to Argentina, but her father had, of course, been a South American diplomat; there was also a large German community there, and one of Jane's lifelong friends, Monique Berthier de Wagram, the illegitimate daughter of the 4th Prince de Wa-gram and a Rothschild descendant, was then married to an official in Chile's legation to the Vichy government. Like Jane, lots of looted art ended up in Buenos Aires, according to the Office of Strategic Services, which singled out Brazil and Argentina as hot spots for "the disposal of looted pictures."[29]

Jane's months in Buenos Aires are mostly a mystery. "We had nothing with us except our passports and our personal belongings," she once said.[30] But an aging Argentine socialite remembers her having a little more than that. Like Jayne Larkin in Hollywood at the same time, she was part of a pack of "adventuresses," he says. "Ah, she was unbearable, but she had this huge diamond ring she was desperately trying to sell." She succeeded, sell-ing it to a Brazilian friend of Mannheimer's decorator, Elsie de Wolfe. She also befriended an Argentine writer, editor, arts patron, and proto-feminist, Victoria Ocampo, who was related by marriage to the same Bemberg dy-nasty that Jane's half sister would marry into.[31]

In September 1941, Jane appeared at the American consulate in Buenos Aires, where she registered as an alien seeking permission to take a two-month pleasure trip to America. She flew to Miami in October, spent a week in New York, then returned to France, where she collected her daughter, a few weeks shy of her second birthday. She arrived in New York again via Lisbon on the SS *Excalibur* nine days after the attack on Pearl Har-bor and America's entry into the war. Their visas had been issued a month earlier in Madrid, and they said they were in transit to Brazil and had tick-ets to prove it. Their passage through America wasn't smooth, though; they spent at least a day as "Aliens Held for Special Inquiry."

As with so much of Jane's story, what happened isn't clear, but their ship's manifest of foreign passengers offers some clues. Annette was ini-

tially recorded as Spanish. That was later crossed out and changed to Dutch, though she held a Brazilian passport. Her mother, whose passport was also Brazilian, was also first noted as Spanish, but that was replaced by Portuguese, even though Jane was half-American and half-German, and her daughter's late father had been German, but also a citizen of France and the Netherlands. By then, Germany, France, and the Netherlands were all American enemies.

Handwritten notations on the manifest indicate that their projected length of stay, originally "in transit," was revised to two days and their immediate destination, originally the home of Beth "Bijie" Wardener, an American heiress to the Maxwell House coffee fortune who worked for the Iowa-born couturier Mainbocher, was changed to the Hotel Gotham a block away. But after they entered America, at 10:55 a.m. on December 18, they did not, in fact, leave after two days. Rather, they stayed at least a year and likely longer. Jane didn't pay the head tax due on entry until summer 1942.

"Like so many others at that time, they'd probably come here as visitors and overstayed," says Marian Smith, an immigration historian, after examining the manifest. Their overnight detention indicates that someone suspected that was Jane's plan. "They'd say they were changing ships, but didn't board," Smith continues. "With friends and lawyers, you could get your status changed." It appears to have taken Jane six months to do that. But proof can't be found. "It would be in her file," says Smith. But it isn't. Use of the Freedom of Information Act turns up a raft of documents about her quest, seven years later, to be naturalized as an American citizen, but there are no references to what happened in December 1941 in Jane's immigration and naturalization files. Oddly, on another official document she filled out seven years later, Jane gave her father's name as Hugo P. Reis (with one *s*) and in later years often claimed her maiden name was Pinto-Reis. Pinto is a Portuguese name. Bébé Bemberg is certain it has "nothing to do" with her sister.

WHO GOT JANE OUT OF DETENTION AND INTO AMERICA? FRITZ Mannheimer's powerful Lazard Frères associates are likely suspects. Over

the years, several authors have posited that her escape from Europe was engineered by André Meyer, whom she'd known since 1936.[32] But another international banker and close friend of Mannheimer's, George Murnane, an American who would join Meyer at Lazard in New York a few years later, was more likely her savior—even arranging a job for her with a wealthy business associate, John Jakob Raskob, who'd built the Empire State Building, the tallest building in the world.

In 1968, Jane would claim she'd inherited an American microfilm company from Mannheimer, sold it to Raskob, and gone to work for him after she got to America. Family lore also has it that on meeting Raskob, Jane boldly announced that the Empire State Building was badly run, and she could do it better, and oh, by the way, she happened to own a microfilm patent. As that story goes, she sold him the patent and started managing the building for him, even collecting rents. Both claims are dubious.

Raskob's company, Holbrook Microfilming, was named for John Knight Holbrook, an inventor who'd patented a microfilm viewer six months before Fritz Mannheimer's death. Incorporated in November 1942, it made microfilms of War Department and other confidential U.S. government records into 1947.[33] Had Mannheimer or his widow somehow come to own that patent, or the company that held it, it is almost certain it would have been frozen or confiscated by the American government as an asset of an enemy alien and Jane investigated by the FBI before she was given access to military records.

Jane did, however, go to work as a vice president of Holbrook shortly after Raskob created it.[34] And she'd clearly stabilized her finances by then; at the same time she took the job, she joined a group that included a Baroness de Zuylen de Nyevelt backing a Broadway musical. Where did the money come from? A note in Raskob's papers shows that he drew a check for $49,500 to the order of an M. A. J. Mannheimer.[35]

Jane hadn't forgotten the assets she'd left behind in Europe, either. In the summer of 1941, two objects her husband had sent to England in her name—a gold-enameled German tankard (ca. 1590) and a painted silver gilt and enameled ostrich egg cup (ca. 1608)—were seized by the British as enemy property. Jane brought suit to recover them, and while no record remains of that action, in 1943 Christie's in London sold both for £1,775, not-

ing on the cover of the auction catalog that they'd been taken from Jane. The Dutch journalist Venema wrote that the paintings Mannheimer sent to London were destroyed in the Blitz, Germany's bombing campaign against England in 1940–1941.

The art that Mannheimer left in the Netherlands and sent to France survived and attracted even more attention, and not only because it was his only remaining asset. Before leaving for Buenos Aires, Jane had moved many paintings to the south of France, where a lawyer kept them out of reach, for the time being, of her pursuers. But the collection nonetheless became the focus of a struggle between Adolf Hitler and his second-in-command, the air force Reichsmarschall, Hermann Göring.[36]

When the Nazis took the Netherlands, Hitler appointed an administrator, Arthur Seyss-Inquart, to run the country. He promptly bought Mannheimer's wine cellar. A few months later, the official who'd been put in charge of the Mannheimer bankruptcy heard that two top Nazi art dealers wanted Mannheimer's art collection. The first, representing Hitler, was Sturmbannführer Dr. Kajetan Mühlmann, a commander in the elite paramilitary SS, Hitler's Praetorian Guard, and head of Dienstelle Mühlmann, a bureau formed to "secure" through purchase and seizure Jewish-owned art in the Netherlands and Belgium on behalf of the Nazi elite. The other, representing Göring, was Alois Miedl, who planned to give his boss some of the loot and sell the rest. It was decided to encourage them to bid against each other. Meanwhile, Mannheimer's less valuable jewelry, books, and furniture were auctioned on behalf of the creditors. *The New Yorker* reported that Seyss-Inquart "pocketed" $3.4 million from that sale, which included a life-sized bird carved from a single emerald and a gilt-bronze miniature of Houdon's statue of Voltaire.

In February 1941, Mühlmann appealed to Berlin for help, and Seyss-Inquart was ordered to obtain the entire collection for Hitler's planned Führer Museum in Linz. Despite Mannheimer's unfortunate religion and economic betrayal, Hitler appears to have admired his taste, and his private secretary, Martin Bormann, informed the Dutch that he wanted the collection—intact. Mühlmann later told Allied interrogators (Ted Rousseau among them) that he considered it "the most valuable collection of ancient *objets d'art* in private hands."[37]

The cocky dealer, who had planned to break it up, had already published a 215-page catalog of the best art and porcelain in the part of the collection that remained in Holland, titled *Guaranteed Artworks from the Occupied Netherlands (Collection Mannheimer)* and emblazoned with the official symbol of the Third Reich, a German eagle atop a swastika ringed with oak leaves. Copies still trade on the rare-book market. Annette de la Renta has one.

The argument over Mannheimer's art was finally settled after Seyss-Inquart and Mühlmann threatened to confiscate it all as enemy property, and the bankruptcy administrator sold it to Hitler at a steep discount, including the works in England and France, which Hitler would pay for once they were retrieved.[38] Decades later, the Rijksmuseum's *Bulletin* said the purchase price came from "money confiscated from the Jews."[39] Late in 1941, the art in Amsterdam was carefully packed and sent to Munich, then to a monastery in Czechoslovakia, and finally, in 1944, to Altaussee, the Austrian salt mine. By then, another Nazi official had managed to seize the art stored in southern France and shipped it to the mine as well.[40]

Eleven months later, victorious Allied troops began to uncover the priceless hoards of looted art. But long before the Third Army's art recovery team got to Altaussee and found the Mannheimer paintings, Jane's stepfather had launched an effort to recover them. After Paris was liberated in the summer of 1944, Guy Brian hired a lawyer to track down the art "pillaged by the Germans during the occupation."[41] He submitted a detailed list and photos of the art that had been hidden in France—it named Crivelli's *St. Madeleine,* Miereveld's *Child with Parrot,* Fragonard's *A Woman Reading,* Ruisdael's *Ferryman,* and works by Watteau, Ingres, Greuze, Chardin, Guardi, and Canaletto—in the hope that the U.S. military would hand it all back to Jane, cutting out the French and Dutch bankruptcy officials. But he was foiled when a Monuments, Fine Arts, and Archives officer responded: the recovered art had not been sorted, but when it was, it would be turned over to France, which would determine ownership.[42]

That brought Jane back to Paris in the fall of 1945. Again using a powerful connection, she hired the president of the Paris bar to represent her and soon made a deal. In exchange for renouncing her claims, she got a Fragonard, the Miereveld, and Chardin's *Soap Bubbles.* Years later, Jane told a friend that the Chardin—which she sold to Wildenstein, who in turn sold

it to the Met—had financed her first days in New York. Yet another friend recalls her saying of that Chardin, "Art has always been my savior."

Only one Mannheimer object is known to have survived the London bank bombing, a tiny fourteenth-century enamel-on-gold triptych, originally the private traveling altar of Mary, Queen of Scots. After passing through other hands, it had spent more than three centuries with the Wittelsbach family, the rulers of Bavaria, before it was sold in 1933 to a Munich dealer, who sold it to Mannheimer. An English sailor allegedly looted the miraculously intact altar from the rubble of the bank where Mannheimer stashed it, only to trade it away for drinks in an Irish pub. The pub keeper gave it to a convent, it somehow passed to a local collector, and he traded it to a dealer for some chairs. The dealer showed it to Martin Cyril d'Arcy, an influential Jesuit priest, who had tried to buy it years earlier but had been outbid by Mannheimer.

In about 1948, after somehow deciding that Jane was the rightful owner, the dealer and d'Arcy somehow induced her and her new husband to give the triptych to d'Arcy for Campion Hall, a private Jesuit-run residence at Oxford University where he was master. What, if anything, the dealer got for the piece is unrecorded. D'Arcy's "claim on their gratitude is said to have been that he received Charles Engelhard into the Catholic Church and helped in resolving some canonical problem over his marriage," claimed H. J. A. Sire in *Father Martin d'Arcy*. Five years later, after it was put on public view to celebrate the coronation of Queen Elizabeth, the Dutch government claimed the altar and then wrangled with the Jesuits for years. "It is thought that Mrs. Engelhard eventually resolved the problem by paying the Dutch government the price of this immensely valuable piece," wrote Sire. D'Arcy remained a close friend and companion of the Engelhards—and the devout Catholic Jane's personal confessor.[43]

Annette de la Renta has said her mother kept fighting for her other pictures for years, even enlisting the aid of Herman Baruch, America's postwar ambassador to the Netherlands, but finally gave up when she was threatened with confiscatory taxes. Annette has also said her mother got a frame that belonged to Catherine the Great; it and at least one of the Mannheimer paintings are said to be in Annette's Park Avenue apartment today. The rest of the "French" art went to Holland, where the Rijksmu-

seum and other institutions were given pick of the litter. What they spurned was sold at auction.

Questions linger to this day about the collection. "What was in it?" the researcher Ian Locke asks. "And what happened to it?" Though it doesn't entirely answer those questions, a 1971 letter to Jane from Ted Rousseau is intriguing. Her second husband had died three months before, and, needing money for taxes, she'd asked the paintings curator to evaluate her art and recommend paintings to sell. Eager that some of them might one day come to the museum, Rousseau suggested she hold on to more than three dozen, including a number of masterpieces she'd purchased after her remarriage. But the list he compiled also mentions one of Mannheimer's Fragonards and a Miereveld he called *Portrait of a Child*, which Rousseau found charming.[44] Jane also held on to a 1929 Kees van Dongen portrait of her mother.

In about 1980, urged on by friends who understood that coerced sales of art to the Nazis were a gray zone and that she might make a case to re-open her claim and recover more, Jane, her butler, and one of her art advisers went to Europe to meet with Dutch authorities. But on arrival, Jane changed her mind. "She couldn't abide the idea, gave up her claim, and came home," says someone who heard of the aborted journey. "She had greater concern for her reputation and image than justice. The idea of being candid about who Mannheimer was didn't fit her image of herself."

THROUGH SMARTS, AMBITION, SPUNK, GOOD CONNECTIONS, AND good fortune, Jane Mannheimer had survived her husband's death, bankruptcy, and World War II, and seemed to be thriving in its immediate aftermath, even if most of the loot her husband had hidden for her had gone back to Holland. Before leaving America for her 1945 trip to France, she filled out a form for immigration authorities that sketched out her place in life. She listed assets of $33,300, only $3,200 liquid. She'd lived at the Hotel Gotham for three years, spent nine months on East Seventy-ninth Street, and the summer of 1945 in another hotel, before moving into a three-bedroom apartment in a building designed by Rosario Candela, the

city's best apartment architect, at Sixty-sixth Street and Madison Avenue. She was making $12,000 a year at Holbrook. The government said she could reenter America while awaiting naturalization.

She began assembling the documents she needed to formally apply to become a citizen: birth and marriage certificates, proof of her employment and bank account, and a certificate of good conduct from the New York police. In November, she had to leave the country and reenter in order to establish legal residency. Again, notes in her file indicate friends in high places were watching. An assistant commissioner in Washington asked local immigration officials to expedite her paperwork.[45] She was issued a visa in June 1946, left for Montreal, and returned to Burlington, Vermont, setting the citizenship process in motion.

She and Annette left again in December, and her application for reentry said she would be visiting Portugal, Spain, France, and Switzerland "to settle my husband's estate." She spent the holidays in Europe and returned in late January, alerting the INS that she'd lost their reentry permits. New ones were issued. The next time Jane left the country, in May 1948, she filled out her latest reentry application with a new name. Marie and Annette are crossed out on the handwritten form. "JANE M. ENGELHARD" is written in strong capital letters and underlined. Her reason for going to France and England? "ACCOMPANY MY HUSBAND," she wrote. "CHARLES WILLIAM ENGELHARD—U.S.A. CITIZEN."[46]

Once again, George Murnane had been present at a vital juncture in Jane's life—only this time, it was she doing him a favor. André Meyer's arrival in New York at the beginning of the war had wreaked havoc on Lazard Frères. One of Meyer's first deals—wiring money to Switzerland that ended up in Nazi-controlled Paris—attracted the attention of the U.S. government, which suspected him of breaking trading-with-the-enemy laws. In June 1943, Pierre David-Weill admitted as much to the Treasury Department, and federal officials swooped in to monitor the investment bank's activities.[47] Its managing partner was forced out, Meyer and Pierre David-Weill took over, immediately hiring Murnane, who brought with him priceless connections to corporate America. Together, they would remake Lazard—and their old friend Jane would help them by bringing Charles Engelhard into their lives for the benefit of all concerned. He soon became

her husband and one of Lazard's key clients. And as all their fortunes rose, they would all get involved with the Metropolitan, forming a faction on its board whose influence would rival J. P. Morgan's.

Charlie and Jane were a match many claimed to have made. But it was Jane herself who engineered their first meeting. In her first years in New York, she often had dinner with a young couple, a granddaughter of Cornelius Vanderbilt and her husband, an Austrian count who worked for Engelhard's father, a wealthy dealer in precious metals. One night, Jane suggested they bring his boss along to dinner. Expecting an eighty-year-old, she brought Murnane as her date. "Imagine my surprise when this young man of 25, looking like Paul Newman with intense blue eyes, walked in," she would later recall. "It was love at first sight."[48]

THAT YOUNG MAN'S FATHER, CHARLES ENGELHARD SENIOR, WAS the son of a German jeweler and diamond merchant. He first came to New York in 1891 to open and run a branch of his future in-laws' smelting company. In 1901, after a trip home to marry, Charles senior and his new wife moved to New Jersey, where he bought a small wire business with the dowry her family provided and built it by mergers into the Hanovia Chemical and Manufacturing Company, the world's leading refiner of platinum, gold, and silver, its largest precious-metals smelter, and a pioneer in the development of decorative liquid gold. Like Jane's parents, they had a mixed marriage: Charlie's mother was part-Jewish (several of her siblings ended up in concentration camps); their son was raised Episcopalian.

The Engelhards lived quietly, though they didn't deny themselves pleasures. They lived in Craigmore, a twelve-bedroom mountaintop estate in Bernardsville, New Jersey, and, even in the depths of the Depression, vacationed at the society resort in White Sulphur Springs, West Virginia, earning regular write-ups in social columns. Despite his low profile, Engelhard senior was also frequently quoted on the state of the precious-metals market. He was a presidential elector for Franklin Roosevelt and by 1940 was considered a solid enough citizen that his company won contracts from the War Department as it geared up to enter the latest conflict. One

German-American business associate of Engelhard's did go to jail in 1943 for engineering shipments of American platinum to Nazi Germany. A descendant, who asks to be anonymous, marvels that Engelhard's name never came up at the trial.

Jane dropped an *s* from her father's name on her license to marry Charles Engelhard Jr., and gave "Hugo Reis" a promotion to Brazilian minister to China in the announcement of the wedding, held in August 1947 in Murnane's Park Avenue apartment. Jane and Charles moved to Fifth Avenue, and Jane's mother sailed to New York for a visit. Coincidentally, Roger André de Montebello, the father of the future director of the Metropolitan, was on the same boat.

Charles senior wasn't close to his son. Charlie would later say that he never had a single personal conversation with his "very Germanic" father.[49] And both Engelhards looked askance at Jane. It's said that when Charlie introduced her to his parents, he didn't let them beyond the first room in her apartment. "It looked really odd" that it was so big, says a New York socialite who knew all concerned. "She'd had a past." Worse yet, "she was Catholic," says Jane's New Jersey friend, "and they thought she lived too grandly." He adds that Jane signed a prenuptial agreement, not with Charlie, but with his parents, "promising she'd raise the children as Protestants. But they were all raised as Catholic as can be, with priests and cardinals around every minute."

Children came along quickly. Less than eight months after the wedding, in April 1948, Jane had her second daughter. Thirteen months later, she swore an oath of allegiance to the United States on May 9, 1949, and became a citizen. She would soon have three more daughters in rapid succession, and Engelhard would adopt Annette, who finally became an American citizen in 1966. By then, both she and Jane had established themselves atop American society. "As far as I was concerned, my father was Charles Engelhard," Annette has said.[50]

The Engelhards got their foothold when Charlie bought a house of his own not far from his parents' in New Jersey horse country in 1949. Though he worked out of a nondescript building in Newark, he lived a bit higher, in Cragwood, a pillared Georgian Colonial on 172 acres above a lake. Cragwood was decorated by Sister Parish, born Dorothy May Kinnicutt, a

legend in the field of interior design who would become a vital link in the Engelhards' social ascent. Charlie and Jane kept the house a secret from his father, who would have considered it all proof of his worst suspicions about her.[51]

Slowly, Jane started inching into society. In 1949, she hosted a luncheon for a committee planning a benefit for Bellevue Hospital. Her pace quickened after Engelhard senior died at eighty-three in 1950, leaving Charlie with a $20 million company that he soon built into an industrial giant worth a dozen times as much.

Just before his father died, Charlie had decided to expand the family business into mineral-rich South Africa. Among his advisers was Robert Fleming & Co., a London bank, where he met Ian Fleming, a former British naval intelligence officer and the founder's grandson, who was soon to write his first James Bond novel. Auric Goldfinger, the pudgy villain of Fleming's seventh novel, published in 1959, was based on Charlie, and a key plot point was inspired by Charlie's first trip to the African nation in 1948. Because of export restrictions, gold bullion could only leave that country if it had been made into art objects or jewelry. Engelhard cast it into small trinkets—including religious objects—that could be easily melted down once outside South Africa. It was the first of Charlie's many business triumphs.

Any number of Jane's friends say she was an engine of his success. She "built the business," says one, pushing him into South Africa. She knew the value of diamonds. "She saw Charlie's potential," says Horace "Woody" Brock, a philosopher-economist and close friend of Jane's in her later years. "Jane had intelligence, values, character, charm, sophistication, languages, and warmth. As an admiring young man, I would watch her at her remarkable dinners outperforming everyone—men and women—at the table. Anyone who observed her, as I was fortunate enough to do, would agree that she could have only been an asset to Charles Engelhard or any husband. She was by far the most interesting woman in America."

With Jane by his side, Charlie came into his own. In 1955, he made a brief foray into politics, running for the New Jersey state senate against a neighbor, the Republican incumbent, Malcolm S. Forbes. Both were Princeton graduates and sons of successful fathers; Forbes had founded the eponymous magazine. Engelhard, a lifelong Democrat, lost by 370 votes (he

demanded a recount, but the vote didn't change). He would remain friendly rivals with Forbes and later sold him a private plane, a gold-painted Convair turboprop that Forbes named the *Capitalist Tool.*[52]

After that, Engelhard devoted himself to business, which made him enough money that he could buy political power, a taste he indulged for the rest of his life with large contributions to the Democrats. In 1961, Jane won a place on Jacqueline Kennedy's White House redecoration committee thanks to their friendship with Sister Parish and generous contributions, which went beyond money; they gave the White House an antique desk and a nineteenth-century dining table, serving table, and cupboard for the family's dining room, which they also paid to refurbish.

But Charlie was a supporter of Lyndon Johnson, the vice president, not Kennedy. In 1959, when he'd learned of one of Kennedy's affairs, he hired a private eye to photograph him in flagrante and hurt his chances of running for president, not knowing the detective was a Kennedy fan. After the detective told Kennedy what Engelhard was up to, the politician understandably held a grudge and refused requests to appoint him an ambassador. Charlie remained out of favor until Kennedy's death.[53] But at the 1964 Democratic National Convention in Atlantic City he chaired the host committee, and a month later, three thousand guests descended on Cragwood for a fund-raising barbecue for the new president. Johnson later named Jane, who'd become a rare-book collector, to the Library of Congress Trust Fund Board, and she and her husband were regulars at White House dinners.

In 1958, Charlie reorganized all of his holdings into Engelhard Industries, with $200 million in annual sales of "atomic reactor components, nuclear instruments, aircraft and missile parts, dental and medical devices, and a wide range of equipment for the petroleum, chemical, pharmaceutical, plastics, automotive, jewelry, ceramics and electrical industries."[54] Three years later, he took the company public, selling 6 percent of its shares in a public offering underwritten by Dillon, Read and, of course, Lazard Frères. Henceforth, Lazard would be involved in most of Engelhard's financial maneuvers—most significantly, a merger with several mining and metals companies that gave the successor firm, Engelhard Minerals & Chemicals, an iron grip on international mineral and metal mining, refining, and trading.

Within ten years, it would have revenues of $10 billion.[55] Charlie controlled 43 percent of the company.*

Engelhard outdid Fritz Mannheimer in making the most of his wealth. Over the years he added a Quebec fishing camp; a walled compound on the Gulf of Mexico in Boca Grande, Florida; a home in Dark Harbor, Maine; and apartments in Rome, New York's Waldorf Towers, and Grosvenor House in London to his residential portfolio. He also owned a fleet of planes and a helicopter, several thoroughbred racehorse stables (his best-known horse, Nijinsky II, would sell for a record $5.4 million after winning the English Triple Crown), and a menagerie that included a lion, peacocks, house-trained parrots, and championship golden retrievers.

Though he professed to hate his nickname, the Platinum King, Charlie more than lived up to it. He "ran the company like Louis XIV," said a board member, Robert Zeller. "He would hold meetings . . . propped up in bed, just like the Sun King, with his retinue all around him."[56] And as his business grew fat, so did he; he guzzled so much Coca-Cola and ate so many Hershey's Kisses that he ended up obese and suffered from a severe case of gout.

Although her early years had been fraught, Anne France Engelhard was a privileged child when she entered the Foxcroft School in Middleburg, Virginia, arguably the most exclusive finishing school for American society girls. The boarding school prized horsemanship, proper behavior, and bloodlines. Anne, though pudgy and unathletic, was well liked. Although she didn't have her own horse, and didn't take part in the school's equestrian competitions, Anne did ride, as Sister Parish discovered when they met on the decorator's first visit to Cragwood. "She was a wild little girl," about eleven years old, Sister recalled. "Apparently, she wanted to make an impression about something, so she rode her horse right into the house and right up the red-carpeted staircase—swearing so hard the whole time that a truck driver's hair would have stood on end."[57]

* Years later, Engelhard's investments in South Africa would cause some to brand him a supporter of its apartheid system, picket his public appearances, and protest plans to honor him. Though he said he opposed that policy of racial separation, supported liberal Democrats in America, and eventually dialed down his investments in South Africa, Engelhard generally put his business interests ahead of social concerns.

Her cussing would end her days at Foxcroft, says another schoolmate who asks to be anonymous. "You wouldn't recognize her!" this Foxcroft graduate says of today's skin-and-bones Annette de la Renta. "She weighed about 160 then." And she managed to get herself thrown out by calling the headmaster "a fucking bastard," the student continues. "The family gave a gym to Foxcroft," the Engelhard Activities Building, "so the rest of the girls could get in." That gesture apparently won Annette belated recognition as a member of the graduating class of 1957. Only her first wedding announcement exists to set the record straight. The *New York Times,* a stickler for such things, called Annette an "ex-student" who had "studied" at Foxcroft, and then at the Villa de l'Assomption, a Catholic school near the Champs-Élysées in Paris, whereas her husband "graduated" from Deerfield Academy.[58]

That marriage came shortly after Annette made her debut into society, first at the Morristown Debutante Assembly in June 1957, next at the sixty-ninth Autumn Ball in Tuxedo Park that October, then at New York's prestigious Debutante Cotillion at the Waldorf-Astoria in December, and finally at a party at Cragwood. "I was a fat little Foxcroft thing," she'd recall a few years later, "and I didn't enjoy it at all."[59] But she got what she came out for. Debutante parties were designed to market eligible young women to the sorts of men they were destined to marry. Annette, or Anne France, as she was still known, managed to make a most attractive match a little more than a year later.

Samuel Pryor Reed's bloodlines were considered as good as it gets. He was a grandson of the chairman of Remington Arms, the weapon maker, and a son of Joseph Verner Reed, who was the founder of the American Shakespeare Festival and the owner of Hobe Sound, a.k.a. Jupiter Island, Florida. Reed developed that elite, well-guarded enclave of wealth north of Palm Beach into the wealthiest town in America, selling property through his Hobe Sound Company only to those he approved of (among them members of the Bush family, Joan Payson, and Doug Dillon).

Sam's mother, Permelia, the Remington heiress, was renowned for running Jupiter with an iron fist wrapped in black cashmere; an apocryphal story had it that if a visitor to the island displeased her, she would send the person a black cashmere sweater with a note that read, "You are going to need this up North." It was said to be her polite way of saying, "Get off my

island."⁶⁰ In truth, she'd given someone a sweater only once, to urge a woman in a revealing dress to cover up, but she allowed the tale to spread because it kept visitors in line.⁶¹ Annette had made an interesting choice. She and Reed married in March 1960. Ashton Hawkins was an usher at their wedding. Sam soon went to work for Engelhard Industries.

In 1961, Jane was co-chair of the Diamond Ball, a high-society gala sponsored by Engelhard's diamond-mining interests. It benefited the Institute of International Education, where Arthur Houghton was chairman of the board. His nephew Jamie, who would eventually follow him as chairman of the Metropolitan Museum, was married to Sister Parish's niece May, better known as Maisie, yet another descendant of the Met's godfather, John Jay. For more than a decade, the Diamond Ball would be Jane's big annual event, "always glamorous and prestigious," the society gossip Suzy would write.⁶² Jane also toiled for such diverse causes as the Newark Museum (the Engelhards gave it more than sixty works of art), the New York Zoological Society, and the Alliance Française.

With their increasing wealth and political and social connections, Jane and Charlie's public profile rose. In 1963, Charlie was written up in the *New York Times*, and Jane was regularly lionized in the pages of Diana Vreeland's *Vogue* and newspaper social columns. A 1967 profile in the *Washington Post* chronicled her quotidian existence: her daily exercise hour; her "little" luncheons and dinners "for anywhere from 50 to 80"; her "two Pekingese dogs from whom she is inseparable"; her unmarried sister, Barry, who'd moved in with Charlie's mother; her daily visits to St. Patrick's Cathedral for afternoon mass; and her three butlers, chauffeur, and Swiss governess, without whom "I don't think I could manage."⁶³

In the midst of all that, their midnight-to-dawn 1965 coming-out party for their second daughter, Susan, attracted the cream of society, including the new Metropolitan chairman, Doug Dillon, and reporters who tallied up the 7,050 feet of tent, 560 feet of floral garlands, 3,500-square-foot dance floor, 98 pairs of draperies, 50 gallons of *émincé* of chicken, 60 pounds of rice pilaf, and 1,500 pancakes the Engelhards laid on for their guests. Three different spokesmen refused to say how much they'd spent.⁶⁴ Mary Murphy Brian, who must have been proud, died six months later.

Even her grandchild, now calling herself Anne Reed, was getting fa-

mous, profiled in the *New York Times* in 1967 as one "of the current crop of switched-on matrons." Having dieted down to a size 6, she was photographed on the street outside her ten-room apartment in a mink coat and fur beret, hailed as a local fashion icon, dressed by the hot new designer in town, Oscar de la Renta, and more interested in her family (she'd had a son and daughter) than in society. Though she went to charity balls, the young Mrs. Reed called them "a bore."

Luckily for Jane, though, their brood wasn't famous outside society, for around that time Charlie had an affair that shook their marriage to its core. Though discussed within their circle, it was years before the story spread. Carroll McDaniel was a southern belle who came to New York at eighteen at the end of World War II and became a fashion model and party-girl regular at the glamorous nightclub El Morocco. There, she befriended an aging Argentine shipping magnate, who took her around the world, ending up in Paris in 1949, where she was spotted at Maxim's by the 17th Marquis de Portago, known as Fon, a race-car driver and inveterate playboy, who promptly proposed.[65]

By 1953, their marriage was fraying when Fon met the married American supermodel Dorian Leigh and started sleeping with her. Late in 1954, Leigh got a Mexican divorce from her husband, the son of the gossip columnist Suzy, and immediately married Portago. It didn't last, in large part because he was still married to Carroll, so after he got Leigh pregnant, he hightailed it to Paris and reconciled with his first (and legally only) wife. The affair with Leigh continued through an abortion, the birth of a son by Carroll, another pregnancy for Dorian, and another dalliance on Fon's part, this time with Linda Christian, an actress and the former Mrs. Tyrone Power. Finally, Fon filed for divorce from Carroll, who'd moved back to New York, into an apartment just across the street from the Metropolitan. Before the divorce was finalized, he died in a race-car crash in 1957.[66]

Sometime after that, Carroll found herself at a birthday party Jane was throwing for Charlie. She'd been invited as an extra woman for an unattached male guest. But at some point during the party, "Charlie and Carroll disappeared," says a socialite. "Everyone knew he wanted to divorce" Jane and marry Carroll, the man-about-town John Galliher told the gossip columnist Charlotte Hays, in her book *The Fortune Hunters*. "Even Engelhard

said so." And "Carroll was telling everyone she was going to marry Charlie," a friend of hers confirms. "He was mad about her, and she was crazy for him."

But Jane wasn't giving him up easily. After learning he'd invited Carroll on a safari, she hired a private detective, who allegedly caught Carroll trying to sell a sapphire ring Charlie had given her.[67] With the marriage hanging by a thread, Charlie's mother "told him to ditch Carroll or think about inheriting a whole lot less," says a New Jersey neighbor. Charlie ended the affair, drowning his sorrows with cake and Coke (he had a special fridge that held twenty-four bottles built into the armrest of his seat on his latest jet), growing visibly more obese and arthritic. Soon, he could only walk with canes, wheezing.

In the spring of 1971, a few days after the Lyndon Johnsons spent a weekend at Pamplemousse, his Florida home, Charlie died suddenly there at age fifty-four. His obituaries said he'd died in his sleep of a heart attack after a day of fishing; one society wit claimed his last words were "Give me a Coke." Lyndon Johnson, Hubert Humphrey, Ted Kennedy, and Doug Dillon were among the nine hundred mourners at his funeral.

Jane inherited a portion of Charlie's fortune, but after paying taxes on her inheritance, she had far less than people assumed. She continued to live as if she were one of the richest women in America, but only managed that by using up her capital and slowly and methodically selling off possessions. One of those was the Fragonard painting of a girl reading a love letter, which she'd retrieved from France after World War II. Fritz Mannheimer had bought it from David David-Weill. His grandson Michel (who would become a Met trustee himself in 1984) had long wanted to buy it back, and finally did.[68]

Jane also proved herself capable of public philanthropy large and small. She built a pool for the local YMCA, gave $1 million to the Newark Museum, and was one of the top donors to congressional Democrats, but the Met became her favorite cause, and in 1974 she joined the board, taking a seat just vacated by her friend André Meyer, who was ailing and also embroiled in another financial scandal. She took his place on the acquisitions committee, too.

That same year, Jane reemerged in society with a profile in W, the society broadsheet. She was described as "a sculpturesque blonde with classic

features and a regal manner." She was interviewed at Pamplemousse, where the reporter approvingly noted her unpretentious eight-year-old Chevrolet station wagon, customized with a stripe in the Engelhard racing colors, the eclectic decor by Sister Parish, and the fishing yacht named after Nijinsky. "Ms. Engelhard makes short work of biographical details," Agnes Ash wrote. "She wants to stay in the present."[69]

Eighteen months after her election to the museum board, she served as chairman of the revived Party of the Year for the museum's Costume Institute, joining Tom Hoving and Oscar de la Renta on the receiving line in a long wine velvet dress as 550 guests previewed Diana Vreeland's latest exhibit, American Women of Style. Planned as a celebration of the American bicentennial, the show featured clothes worn by ten of America's most stylish women. Jane's reaction to the inclusion of Elsie de Wolfe, decorator of Mannheimer's Monte Cristo, went unrecorded.

The following summer, through the Charles Engelhard Foundation, she pledged to give $2 million in five annual installments to the museum, which she earmarked for the long-delayed new American Wing. In 1976, she was named to the executive committee, and the next fall the board agreed that the enclosed courtyard in front of the new American Wing would be named in memory of her husband.

BY THEN HER FRIEND TED ROUSSEAU HAD DIED, SETTING THE stage for the next great era in the Metropolitan's history: the ascension of Philippe de Montebello to its directorship. In many respects, Montebello seemed born to direct a great museum. Philippe's great-great-great-grandfather Jean Lannes, the son of a stable boy, rose to become one of Napoleon Bonaparte's generals. After he won an important battle in the town of Montebello, Italy, Napoleon gave him the title duc de Montebello.* His death in battle in 1809 was said to have made Napoleon cry.[70]

* Though he has often been referred to as a French count, Philippe is not; as the second son of a duke, his father was a baron, and that title passed to Philippe's now-deceased older brother, Georges Roger, and then to Georges Roger's sons.

Philippe's mother, Germaine Wiener de Croisset, was the daughter of a Belgian playwright and, by marriage, a relative of the wealthy American Woodward and Bancroft families. More significantly, perhaps, she descended from the brother of the infamous Marquis de Sade. The character of the Duchess of Guermantes in Marcel Proust's *Remembrance of Things Past* was based on Philippe's great-grandmother. His aunt Marie-Laure, Vicomtesse de Noailles, an erudite, eccentric, witty, and highly sexed daughter of a Belgian banker, was a figure of considerable artistic sway in Paris. She was a patron and friend of Pablo Picasso, Salvador Dalí, Balthus, and Jean Cocteau (who was briefly her lover), and she and her estranged husband financed films by Man Ray and Luis Buñuel, and entertained all of the above at their mansion, decorated by Jean-Michel Frank, at 13 Place des États-Unis.

Philippe was born in Paris in 1936 and raised in a villa with a cloister, gardens, and a view of the Mediterranean in the southern French town of Grasse, but his life changed during World War II when German officers commandeered the family's house and they had to move out. He has said his father was the head of the Resistance in southern France. It is more likely he was a member. Regardless, Philippe continued his schooling in Paris, where his aunt introduced him to art, and later, at a bullfight, to Pablo Picasso.[71]

After the war, Philippe's father invented a process for 3-D photography but, when he couldn't find financing to develop the process in France, moved to America, crossing paths en route with Mary Brian. After two years in Montreal waiting for permission to join him, his family arrived in 1951. The Montebellos brought a little bit of France with them; Philippe's father was listed in the New York phone book with his title "Baron" alongside his name.[72]

The family's Napoleonic titles have cachet, though some look down their noses at the postrevolutionary nobility, referring to it as *noblesse d'empire, c'est de la merde* as opposed to *vraie noblesse*. Montebello takes his heritage more seriously. An apocryphal story has it that early in his tenure as the Met's director, he took offense when his name was mispronounced *di* Montebello, explaining that his family was not *from* Montebello, rather his great-great-great-grandfather had won the battle *of* Montebello. Thirty years later, at

his retirement dinner in November 2008, he "obviously didn't like it" when his youngest brother, Henry, one of several speakers, repeatedly called him Phil instead of Philippe, says a guest, the former museum CFO Dan Herrick. Montebello turned it into an awkward joke, predicting that some on his staff would follow suit, which would help him identify who should lose their jobs in layoffs stemming from that fall's financial collapse. In doing so, he neatly bookended his career as the museum director; early on, he was forced to deny an equally Bourbonic quotation attributed to him in which he described himself as "essentially a royalist" who wished "the French Revolution had never taken place."[73]

After his father, a sometime painter and art critic, convinced Philippe that he lacked the talent to be an artist ("I believed him," Philippe would say[74]), he decided to channel his love of art into scholarship and went to Harvard to study art history with a mind to working in a museum. After a break to serve in the army, where he rose to second lieutenant, he graduated from Harvard magna cum laude in 1961 (his thesis was on Delacroix), married a Radcliffe student, Edith Myles, a great-granddaughter of the Supreme Court justice John Marshall Harlan and a debutante in Anne Engelhard's season, and then spent two years at New York University's Institute of Fine Arts, just across the street from the Metropolitan.

Although he has said that he was on the verge of earning a doctorate in art history, and his *Who's Who* listing says he got his master's in 1963, he hadn't actually finished his master's thesis (which was on the French Fontainebleau school artist Jean Cousin the Elder) or fulfilled other requirements for the lesser degree when Ted Rousseau, then still head of the European Paintings Department, brought him across Fifth Avenue as a curatorial assistant in 1963. Montebello saw his future unfolding. "I knew then that I wanted to be sitting where he was," he said of that meeting with Rousseau.[75] He would finally take his last exam and collect his master's in 1976.

Hoving noticed him shortly after his return as director, and in 1967 and 1968 Montebello was assigned to organize the summer loan shows; this required him to deal with collectors who wanted to safely "park their stuff" in the museum while they went "off to Bar Harbor and East Hampton," Hoving says. Montebello's job was to gather the art and write the catalog

entries and an introduction. It was appalling, Hoving says. "He had a couple of statements in there like 'Now the great unwashed can see art.' I said, 'What the fuck is this?' " Ordered to rewrite it, Montebello did, "but he was kind of stiff about it," Hoving says.

The director wasn't the first to reach that conclusion. Though Philippe thought himself friendly, a fellow graduate student at the IFA recalls him as "a pompous ass." So although Montebello won steady promotions, researched sixteenth-century French artists, and wrote a monograph on Rubens, he also won a reputation as standoffish and self-assured to a fault and lost the confidence of Rousseau, who became "convinced he had no eye," Hoving would later write.[76]

Rousseau might have also noted and feared Montebello's ambition. "He had bravado," says Rousseau's longtime lover, "he thought he had as good an eye as Ted, and he wanted desperately his job. Philippe was aggressive. He wasn't going to sit around. He saw that Ted didn't want to be number one and he thought, 'Why not me?' "

By then, Montebello was thirty-one and had two children and a home in the upper-crust suburb of Locust Valley, and though his wife worked at a private school, his $13,000 salary was stretched thin. So, shortly after Rousseau was promoted to chief curator and Claus Virch arrived to replace him, Montebello went to Hoving "for a real heart-to-heart" about his future, Hoving says.

"What are my chances of becoming head of the department?" he asked.

"Not very stellar," Hoving says he replied. "It seems to me your real skills are in administration. My advice is to become a museum director as quickly as you can, someplace where nobody's done anything for years so no matter what you do, it will look like you've done an incredible job. I'll support you; I'll give you a lot of help and any recommendations."

On a single-page résumé he prepared that December ("Age 32, 6 feet 2, 205 lbs., Health excellent"), Montebello listed his accomplishments: he'd mounted those loan exhibitions and a show of another private collection at Brandeis University three years earlier. He'd written a book on Rubens and articles for the museum *Bulletin* and catalogs, attributed "certain works" to the French artist Jean Cousin, and given some lectures. He also mentioned

being a collector "on a small scale" of old master drawings, an enjoyment of chess, bridge, and tennis, and his lack of advanced degrees "as I was employed by the Metropolitan before completion of my thesis. (Still hope to finish it some day.)" Within weeks, Montebello was back in Hoving's office. "I've been offered Houston," he said.

Montebello later told Calvin Tomkins that at the time, spring 1969, he didn't know where Houston was, let alone how to run its Museum of Fine Arts. "I had never done a budget or formally organized an exhibition," he said. "They were interested in modern art, which was not my forte. But I took it."[77] He had some understanding of Texas and dropped the Guy from his name on arrival that fall. But he quickly came to regret his first chat with the *Houston Chronicle,* in which he described the museum's collection as modest, made it clear he expected donors to cough up cash to improve it, and hinted that if they didn't, he wouldn't stay. He had no intention, he declared, of being "merely a concierge."[78]

In a later interview, he seemed to suggest a contemporary sculpture near the museum's door as a good receptacle for gum wrappers, a remark interpreted by Houstonians as expressing his disdain for their taste in art. The sculpture had been bought with funds from the de Menil family, Houston's most prominent art-collecting philanthropists. He later said he was joking. In the same interview, he expressed his nostalgia for the France of the Bourbon kings, the remark he later denied making.[79]

"He didn't like his time here," says a current executive at the Houston. And the feeling was mutual. The *Houston Chronicle* would soon say he was "tall, handsome, proud, sometimes called arrogant by his critics," and could "be volatile if provoked." He was promptly nicknamed Mr. Five Names, and a story went around that a neighbor said he was so stiff he wore a suit when he sat by his backyard swimming pool. "Socially, he and Houston were worlds apart and he didn't adapt," says a Houston art dealer.

He did succeed, though. Having inherited a museum with almost no money and a pool of old families interested mainly in building monuments to themselves, he offered them named endowment funds for acquisitions instead, setting a pattern that would reinvent the museum. "He did remarkable things," says David Warren, who briefly succeeded him. "There

were no curators when he came. His predecessor liked to do everything himself. He hired professionals."

His predecessor had hired Ludwig Mies van der Rohe to design an addition to the museum, a curved glass box that was not to Montebello's taste and proved less than ideal for showing art, a problem he had to solve. There was also no money to operate it. "Nobody gives Philippe credit for putting the museum on a professional footing," says Warren. His tendency to speak bluntly didn't help matters. "He has foot-in-mouth disease sometimes," says Warren's successor, Bill Agee.

Montebello has said that negative local press drove him away, but a review of his coverage in the *Houston Chronicle* doesn't bear that out. Reporters stressed his desire to build up and better showcase the museum's permanent collection rather than mount flashy temporary exhibits, but other than noting that he was conservative for someone so young, their coverage was hardly critical. He was, for instance, hailed for spotting a valuable bronze in a gift shop and buying it for a twentieth of its value.

Warren finally decided that Montebello's arrogance and high self-regard were a cover for an awkwardness rooted in the difference between the way he'd been raised and how things were done in Houston. "He was not a good fit. He was never comfortable here." And he left bad feelings behind when he left just as the new van der Rohe building opened. "Houston was hurt," Warren says. But the dealer adds, "He had a sense of destiny," and it wasn't in Texas. Montebello would later wax eloquent about "the unmitigated joy of boarding my last flight out of there, without a return ticket."

TOM HOVING ENGINEERED MONTEBELLO'S RETURN TO THE MET as he had his departure. Shortly after learning that Ted Rousseau had terminal cancer, Hoving was at a meeting of museum directors when Montebello turned up at breakfast. "Philippe sits next to me, and I said, 'It's time for you to come back. I need a replacement for Teddy, who's dying.' He was very eager to take my offer. He wasn't charmed by Houston." In the midst of his kerfuffles, Hoving saw Montebello not only as a buffer between him

and the curators but also as a potential successor. After a visit to Maine that summer to be vetted by Doug Dillon, Montebello returned as vice president for curatorial affairs in September 1973. A few months later, Harry Parker left and Montebello took over education as well.

"He was quite astoundingly good at his job," says Hoving. "There were a lot of really prickly curators and a lot of wars." He also proved to have skills Hoving needed, particularly a fluency in Russian, which came in handy while negotiating for the Scythian gold show, the opening shot in Hoving's landmark cultural exchange program with the Soviet Union.

Hoving, who was bored with his job, let Montebello take charge of most acquisitions and exhibitions as well as the staff of about ten dozen curatorial employees and found him quite capable, if a bit of an elitist. Indeed, one of the few times Montebello made the newspapers in the next three years was when he was gently mocked for writing a memo suggesting museum staff refrain from calling the output of students in museum workshops "art" to "avoid confusion with the high art displayed in the museum's galleries."[80] More often, he was dutifully defending Hoving's decisions. "We're better off with one beautiful rooster than three ugly chickens," he said during the deaccessioning contretemps. "We'll always go after the big bird whenever we can."[81]

A year later, shortly after accepting Hoving's resignation, Douglas Dillon had a thought that would shape the next twenty years of Montebello's life. The Metropolitan, he decreed, would no longer be ruled by one big rooster. Instead, henceforth Hoving's job (and a large part of Dillon's, too) would be split between two smaller birds, the museum director and a new paid president to whom the director would report, though the board would guarantee the director's creative autonomy.

The search for Hoving's replacement began. Hoving suggested two other museum insiders to replace him. But one was a woman, which Dillon didn't want, and the other didn't want the job. "So they picked Philippe," Hoving says. "But it wasn't immediate." At the June 1977 executive committee meeting, Hoving asked to leave his post early, so as to put his papers in order for the museum archives (and make a set for himself) and consult for Walter Annenberg. Montebello—who'd only gotten a lukewarm en-

dorsement from Hoving, who warned the board that he was a bit dim—was named acting director. It would be almost a year before he got the job.

The search committee's first assignment was to plan the dual-head structure. All concerned understood that it wouldn't work unless the president and the director got along. The loudest objection was lodged that August by Roland Redmond, still grumbling on the sidelines. He found the plan unsound and took his case to the *New York Times* in a letter to the editor in which he reprised all his arguments against the way the museum was being run and worried that Dillon would hire a retail executive, having already turned the museum into a store.

A response from the museum followed, finally throwing its cranky ex-president overboard, suggesting that Redmond was living in the past. At a board meeting six weeks later, the trustees approved the proposed constitutional changes and referred them to the corporation's fifteen hundred members—people who had donated $25,000 or more—for final approval. They accepted the proposal by a wide margin in October 1977.

Five years later, Redmond died in his sleep in his own bed at age ninety. Though he'd written a memoir for Simon & Schuster, it was never published. Ironically, seven months before he died, his last published comment on the museum he'd run with such dedication concerned another Simon & Schuster book, Hoving's first museum memoir, *King of the Confessors,* about his quest to buy the Bury St. Edmunds Cross. Hoving's tales out of school were "disgraceful" and "shocking," Redmond said. "It's even more shocking that he comes out with it." Revealing secrets was Hoving's worst sin of all.

THE AGE OF THE MET'S LETTING IT ALL HANG OUT WAS OVER. On May 12, 1977, Nelson Rockefeller's daughter Mary Morgan, who'd taken the family's board seat, wrote a letter of complaint to Douglas Dillon. Two days earlier, at an executive committee meeting at the Cloisters, she'd hit the roof after Hoving's plan to leave early and Dillon's to rewrite the constitution were revealed. At the end of the meeting, Morgan proposed a mo-

tion urging greater candor on the part of the museum's officers toward the board.[82]

In an attempt to appease her, Dillon and Gilpatric called her into a meeting. After that, her specific unhappiness with the officers, in their telling, was transformed into a more general concern about trustee behavior and a suggestion that new board members get tutorials on how to behave and clear instructions on what to do when contacted by the press. And the executive committee decided to bar nonvoting trustees—that is, ex officio representatives and trustees emeriti—from its meetings, limiting the possibility of leaks. At the September board meeting, the dual-head vote went by so fast it "conjured up recollections of a steamroller," one unenlightened trustee told the *Daily News*.[83]

Other trustees were agitating to have the city representatives barred from regular board meetings, too. Three weeks later, the *New York Post*'s Page Six gossip column reported on the compromise approved by the Met board: henceforth, city representatives would no longer be seated at the board table with the trustees; instead, they'd be segregated in the back of the room. The museum, the paper concluded, "doesn't want us interfering in its affairs."[84]

In fact, after Ed Koch was elected mayor in November of that year, the two new administrations, the city's and the museum's, would begin to make peace with each other—and the ex officio trustees would be invited back to the board table, though not to the executive committee. Koch named Henry Geldzahler, then forty-two, head of the Cultural Affairs Department, which had taken over control of the city's cultural subsidies from the Parks Department. Geldzahler's comment on his old job was priceless. "It's a pleasure to get out of politics," he said, comparing the museum to a confederacy of eleventh-century French dukedoms. Geldzahler soon named another friend of the museum, Lila Wallace's lawyer, Barnabas McHenry, chairman of the Commission on Cultural Affairs, an unpaid advisory board that helped set municipal arts policy. (Geldzahler spent five years as commissioner, saved his department from budget cuts in 1980, and resigned in 1982, just in time to take part in the next wave of New York art as an independent curator. He died in 1994.)

The détente between the museum and its city patrons was also aided by the appointment of William Butts Macomber Jr. as the Met's first paid

president in April 1978. A native of Rochester, where his grandfather had been a state supreme court justice, Macomber had served in the OSS during World War II, parachuting into France to work with the Resistance and seeing action in Burma. He then joined the CIA, became an intelligence specialist and congressional liaison in the State Department, and served as ambassador to Jordan in the Kennedy and Johnson years and as Gerald Ford's ambassador to Turkey. He was known as a reformer and a champion of women and minorities.

Announcing Macomber's unanimous election, Doug Dillon stressed his résumé, his political experience, and the value of his inexperience in the art world, as the board feared that an art-savvy president might second-guess or dominate a director. He did not mention Macomber's sole, tenuous connection to the Met: his sister-in-law was a granddaughter of Junius Spencer Morgan. So he was a member of the Met's extended family.

Though Macomber improved the museum's relationship with city officials, inside the museum his lack of art credentials and hail-fellow-well-met personality generated scorn. And years later, Montebello would admit that the decision to make Macomber chief executive "enraged" him.[85] The seeds of breakdown were sown a month later, as the board of trustees considered the search committee's recommendation that Montebello's appointment as director be made permanent. While awaiting the board's decision, Montebello kept a brave face on at work, but couldn't always sustain his facade. Barbara Newsom, the former museum employee, would take the Fifth Avenue bus with him mornings and listen as he poured out his woes. "He was nervous, in limbo, not very happy," she says. "They wouldn't make up their minds."

Initial reports said that Montebello wasn't popular with all on the curatorial staff. He'd already rubbed some curators the wrong way. Some considered him Hoving's creation. Others, perhaps aware that he had no advanced degrees, disdained his scholarly credentials. Redmond told a reporter that some trustees felt he lacked stature. The consensus was that Montebello had performed well so far and deserved a chance. But on May 25, when the board was called to order at a special meeting to confirm the choice, something went awry.

Montebello was "all dolled up in his suit and vest," ready for his coro-

nation, says a museum officer whose office was near the boardroom. But after cooling his heels outside for ninety minutes, "he was back in his office, tie undone, because it wasn't a fait accompli," the official continues. "There was some discussion. I could see him sweating. We kept him company."

The exhibition designer Stuart Silver thinks Brooke Astor opposed him. "She threatened to resign," he says. "There was a very powerful and pronounced opposition, but Dillon absolutely insisted." Despite that, another trustee bucked him. Mary Morgan held up the decision with her misgivings and ultimately abstained from what was reported to be an otherwise unanimous vote in favor.[86] Though she's never revealed her reasons, a Rockefeller family insider says they were simple. Montebello's tenure as acting director coincided with the installation of the primitive art wing named for Mary's twin, Michael Rockefeller, a process that, according to the insider, led to hostility.

Though Nelson Rockefeller had been briefly mentioned as a possible president of the museum, it was his daughter on the front lines when the Met "pulled the rug out" from under one of her pet projects, a series of orientation films about the sources of the objects in her family's collection, says Arthur Rashap, a family adviser. The filmmaker they'd hired believed the museum was siphoning money from his budget, making it impossible to finish the movies.[87] Nine days before the vote on Montebello, Morgan got personally involved, trying—futilely—to save the films. "We had an understanding that something would happen, and it didn't," says Rashap. Mary's refusal to approve Montebello "could have been a protest vote. I would speculate there was no love lost with Philippe," who, it was assumed, had little or no interest in primitive art. Finally, as the opening date of the wing kept being delayed and costs continued to rise, Nelson Rockefeller called his old friend Dillon and offered one last check for $150,000, about a tenth of the budget shortfall, on condition that the museum never ask the family for capital contributions to the wing again.[88] Morgan's presence on the board for another nine years was likely an irritating reminder of the family's power.

That rough start was just the beginning of Philippe de Montebello's trial by fire. His relationship with Macomber—wags called them Cucumber and the Count of Monte Cristo—would prove to be a huge irritation.[89] In-

stead of collaborators, they were and remained oil and water. Already arrogant and awkward around people, Montebello now felt humiliated by the board, and overwhelmed by his job, which, though downsized, was still much larger than the one he'd held in Houston. He also felt insecure at having to prove himself again while competing with fresh memories of the larger-than-life Hoving. Initially, he tried too hard. "He tried to have the wit and pizzazz of Tom and the elegance of Ted Rousseau combined, but . . . he couldn't pull it off," says the CFO, Dan Herrick. "Philippe was stepping into a big pair of shoes, and he just couldn't fill them the same way. That created resentment." Things "changed dramatically," said Arthur Rosenblatt, who tangled with Montebello over the remaining master-plan projects. The new director wanted to fire Kevin Roche and hire an architect of his own. "I cannot work with Hoving's old, dirty linen," he said.[90]

Seeking his own identity, Montebello took Rousseau as his model, even moving into his old office (Macomber took Hoving's) and using his ormolu-encrusted Louis XIV desk by Boulle. But Rousseau had used charm to distance himself from things he chose not to deal with. Some thought Montebello replaced Ted's charm with Gallic petulance. He refused to go to weekly staff meetings if his titular superior would be there and refused to consult him, visit his office, or even mention his name in public.[91]

Rousseau's former deputy Michael Botwinick puts a positive spin on that, insisting that Montebello, descendant of a war hero, studied the battleground before him and decided to play a waiting game until the way was clear for him to simply walk through it. "The board said they weren't cutting down the job, but freeing him from distractions so he could be the museum's intellectual and spiritual leader," Botwinick says. "From the first day, Philippe decided to take that literally. He said, 'Okay, don't bother me with this budget shit. You go to meetings. You deal with it. I have a museum to run.' And because he was so good at it, no one could take issue with what he did in his patch, and inevitably they did manage the museum, the labor force, the city, the fund-raising, the maintenance, so he could do his job."

Simultaneously, in the 1980s, the cultural pendulum swung. Post-Watergate, institutional arrogance became less of a hot-button issue than the content of the messages institutions conveyed. In that arena, Monte-

bello proved a deft defender of high culture. Though he presented himself as an opponent of Hoving's revolutionary innovations—blockbuster exhibits, high-profile acquisitions, and the attendant glamour—he actually used them all to restate and revitalize the museum's standards.

"Hoving was a classic entrepreneur," says a museum staffer who watched the transition. "Montebello was a corporate emperor. Hoving was a big bang. Montebello was going to straighten things out." He immediately won praise as a canny, calming consolidator who, in his own words, redirected the museum's focus so it became "a place to visit repeatedly . . . and not simply when a new banner is hoisted on the façade."[92] And with his Acoustiguide tours, he quickly established himself as "the authoritative voice of the Metropolitan itself," Grace Glueck of the *Times* would soon write, "graciously undertaking to repair my esthetic deficiencies."[93]

Nonetheless, all the tensions were evident and affected the troops. Many Hoving-era staffers like Herrick, Levai, and Silver left. Montebello was also tested by several time bombs laid during the Hoving era. The first, which had been ticking for years, blew up while he was still acting director. After Joan Whitney Payson died in the fall of 1975, her husband and children got first crack at the art hanging in her four homes; each was allowed to choose $500,000 worth of pictures. An inventory of what remained was then sent to the museum, which had been willed its pick of what was left, up to an appraised value of about $4.3 million. Key curators checked out the pictures and made suggestions to Hoving and Montebello, among them important works by Picasso, Manet, Degas, Rouault, Wyeth, Corot, Toulouse-Lautrec, Winslow Homer, and Thomas Eakins, and in June 1976 Dillon formally requested thirty-one works from Payson's executors. Simultaneously, the museum reminded them of an oral promise Payson had made to Dillon to contribute another $1.5 million in cash for the American Wing (bringing her total contribution to the wing to an even $5 million).

The Payson estate balked, claiming the alleged pledge was not enforceable; it also raised serious tax issues. The museum took the estate to court; the presiding judge suggested that the parties negotiate a smaller settlement, but the museum refused, sticking to its guns. Which is where things sat when Montebello took over.

In the background was a family squabble over money. Though each of

Payson's children received $7.5 million trust funds from their mother (whose fortune it was), and expected to get almost as much when their father died, they had reason to worry about the second installment of their inheritance. Charles Payson, who received the bulk of his wife's $100 million estate, had kept mistresses for decades.[94] He "then had the ill grace, in his children's view," to marry a much younger woman in 1977, the *Washington Post* would report, and "in the eight remaining years of his life, to continually rewrite his will in her favor," eventually leaving her "the lioness' share of the estimated $70 million estate."[95] Shortly after his 1985 death, Joan's children would contest his will but lose after a vitriolic court fight. Three months later, Joan's son John would auction off Vincent van Gogh's *Irises,* one of the twenty-eight paintings he'd received from his mother. Due to changing tax laws on donating art and the rising price of insurance, "he couldn't afford to give it away; he couldn't afford to keep it," said Sotheby's chairman, John L. Marion, who sold it for almost $54 million, a record auction price for a painting.[96]

That had yet to happen in the spring of 1978, when the Met sued Payson's estate. Dillon testified that though their mother had made no written pledge, the museum had relied on her promise. The estate argued that the paintings covered her promise. Though the judge chastised the museum for its imprudence, it won and got its cash.

Thirty years later, when the American Wing was about to be closed for renovations, Montebello invited each of Payson's children to the museum to fill them in on the plans and reassure them that prominent signs would acknowledge their mother's contributions, regardless of whether the family gave the museum more money. John Payson says he did not believe Montebello was angling for more cash.

If so, that may be because of what happened between the museum and the Lazard chairman, André Meyer, and his family. Meyer had begun collecting art while living in France before the war, but his collection was seized by the Nazis and was never recovered. He started collecting afresh when he moved to New York, following the lead of the David-Weills and Robert Lehman. But one of Lehman's partners, who knew them both, thought that Meyer collected only for effect. "It was like hunters hanging antlers on the wall," he told the Lazard chronicler William Cohan. Still,

Meyer managed to acquire a respectable collection that included works by Rembrandt, Picasso, Manet, Renoir, Cézanne, Degas, Rodin, and van Gogh, as well as Greco-Roman bronzes, Asian objects, and Louis Louis furniture. On his death in 1979, it emerged that he'd given $2.6 million to the Metropolitan to pay for new European paintings galleries above the Michael Rockefeller Wing, which would open in 1982.

In 1991, Walter Annenberg, who'd obviously forgiven New York for doubting him, bequeathed his entire collection of Impressionist and Postimpressionist paintings, watercolors, and drawings to the museum. The art critic Robert Hughes predicted that the existing European paintings galleries—considered badly designed by both critics and curators—and Meyer's name would soon vanish in a much-needed renovation. He was right. Gary Tinterow, the Engelhard Curator of European Paintings, helped design new rooms that met Annenberg's condition that his paintings remain together, and Annenberg agreed to pay half the cost of building them. In 1993, the Meyer Galleries were replaced with a new, unnamed suite of old-fashioned rooms. The public liked them, but behind the scenes there was private indignation.

There are still two rooms named for André Meyer in the Met's European galleries (which were enlarged and reopened in December 2007). They hold British and French Romantic paintings and works by Ingres and Delacroix, "though you would be hard-pressed to find them," says Laurent Gerschel, one of Meyer's grandchildren. "Apart from his name on one wall," in beige letters on a beige wall above a doorway, "the gallery is basically lost." Meyer's family believed that his galleries would bear his name in perpetuity. But perpetuity, in Meyer's case, lasted only about a dozen years. "Then," says another relative, "various Mr. This-and-So's" approached them and asked them "to refinance the wing at a cost of $10 million for another ten years." The family considered litigation but finally decided against it. "How should I say this?" Laurent Gerschel concludes. "I respect the priorities of the institution, but perhaps it could have been done with slightly more class."

As far as the Met was concerned, though, it was Meyer who'd been classless. "He knifed us by selling the best part of his collection," says Tom Hoving, who assumed the museum would get the art—until Meyer's will was read. Consigned to Sotheby Parke Bernet shortly after his death, the

thirty-two paintings and drawings and ten sculptures attracted the largest crowd in Sotheby's history for an auction that netted $16.4 million, well above the initial $10 million estimate, and set records for works by Renoir, Degas, Daumier, Fantin-Latour, Gris, and Bonnard.

Even when he got a collection, Montebello could be less than deft in handling donors. In 1984, he hailed a gift of ninety works by, and a library of books about, Paul Klee from Heinz Berggruen, a retired art dealer who'd organized Klee exhibits at his Paris gallery and acquired the works from, among others, the estates of the surrealist André Breton, the MoMA's founding director, Alfred Barr, and Nelson Rockefeller. Berggruen's generosity made the Metropolitan the second most important Klee repository in the world, after the Kunstmuseum in Klee's native Bern.

A Swiss citizen, Berggruen got no tax deduction for his gift; his sole reward was introducing Klee to Americans. But after the Lila wing and its Berggruen gallery opened in 1987, it was Berggruen who felt knifed; he considered the mezzanine space badly situated and ill suited. Only a small percentage of the Klees could be shown there. "I gave the works without conditions and I learned my lesson," he said. Though a relative says he'd planned to give more to the Met, in 1990 he loaned seventy-two paintings and drawings by Cézanne, Seurat, van Gogh, Picasso, Braque, and Miró to London's National Gallery for five years instead. Then, after the city of Berlin offered an entire museum to receive them, he first loaned and then sold it more than a hundred works for about a tenth of their market value. So pleased was he that he kept an apartment atop Berlin's Berggruen Museum and sometimes gave tours to visitors.

As a Jew, Berggruen had fled the city in 1936. His gesture of reconciliation to his hometown made him "a celebrity outside the world of art," the *International Herald Tribune* said on his death in 2007.[97] Shortly afterward, his family auctioned off two more van Goghs and five Cézannes for $71 million. An auction catalog essay by the art historian John Richardson pointedly noted that Berggruen was "so disappointed" by the Metropolitan "that he never gave the museum another thing."[98]

JANE ENGELHARD SUFFERED A DISAPPOINTMENT OF ANOTHER sort early in 1980, when Harrison Williams, a senator from New Jersey (no relation to the industrialist Harrison Williams), whom she and Charlie had supported for years, was revealed to be the top-ranking target of an FBI investigation called Abscam probing influence peddling by members of Congress. Williams said he'd been entrapped by agents posing as Arab sheikhs, but a year later he was convicted on nine counts of conspiracy and bribery and sentenced to prison, and in 1982 he quit the Senate just before he was expelled. The revelation of his involvement came just a few weeks after a weekend-long series of sixtieth birthday parties for him, among them a brunch at Cragwood hosted by Jane. A friend says the shock of almost daily revelations about Williams, followed by his indictment that Halloween, was a real blow to her.

It should have been a moment of triumph. Though the museum had missed the American bicentennial by four years, the reopening of the American Wing that June—six times the size of its predecessor and fronted by the Charles Engelhard Court—was a cause for national celebration. The courtyard quickly became one of the most beloved spots in the museum, incorporating plantings, a reflecting pool, nineteenth- and twentieth-century sculpture, and grand architectural elements old and new.

The Branch Bank of the United States was transformed into an entrance to the new galleries, "imbued," Ada Louise Huxtable wrote, "with the drama of an architectural stage set within the concrete and steel-framed, glass and limestone courtyard."[99] Initially, curators wanted to clean its dirty white Tuckahoe marble facade. But after blasting a portion of it with pressurized water, turning it sparkling white, a conservator carefully painted the dirt back on.

The museum had salvaged great architectural elements and incorporated them into the courtyard: the flower-columned loggia from Louis Comfort Tiffany's own home, a Tiffany mosaic fountain, a mantel by Augustus Saint-Gaudens and John La Farge from the entrance of the home of Cornelius Vanderbilt II, a pair of Louis Sullivan staircases from the Chicago Stock Exchange, a set of Frank Lloyd Wright windows.

Many of them had been stored in the old water tunnels under the mu-

seum during the construction. Luckily, there were photographs of the Sullivan staircase in situ, because it was in pieces when the Met's curators and conservators began installing it. A New Jersey firm of third-generation ironworkers that had built the Statue of Liberty and Ellis Island reconstructed it. The copper plate over the cast-iron stair structure was peeling away: special tanks were built to reverse the plating process, remove the copper, and then replate it, first with nickel and then with the original copper to reduce the risk of corrosion. Since the staircase had come to the Met without landings, they were copied from elevator grilles.

The Tiffany fountain was missing a panel from its frame, pieces of its base, and the fountain itself. The donor, a dealer, wouldn't name her source at first, says a reconstruction team member, but finally revealed that it had come from a Mrs. L. Groves Geer, who lived on a horse farm in Maryland. "She had tons of Tiffany in her living room and her barn," he says. "She gave us huge drinks and took us into the barn. The fountain was there in its original crate." One small mosaic in the loggia was re-created with the aid of the son of Tiffany's stained-glass-studio foreman, who'd saved bits of original glass. When the conservators couldn't get granite from the original quarry to replace missing elements of the columns, they had them cast from concrete and painted to match the existing ones.

Jane Engelhard's life could not be refreshed as easily as those artifacts. The next year, approaching sixty-five, she retired from the museum board, passing her seat to her daughter Annette and entering the final phase of her life, a long and increasingly reclusive decline. At first, Jane kept up appearances and would still turn up at museum events like the 1982 opening of the $9.6 million Astor Chinese Garden Court, Brooke Astor's most beloved gift to the museum, and one of her most expensive gestures ever, inspired by the traditional architecture she'd loved during her childhood in Peking. Jane even co-chaired the gala 1983 opening of The Vatican Collections: The Papacy and Art, also attended by Nancy Reagan and a host of Vatican officials, but she'd clearly begun to let herself go, her once slim form growing fat, her bad habits—drinking and popping pills—multiplying.

"She'd done it," says a close friend, "she was getting old and she wanted out." In the late 1980s, she was still capable of stirring up some fun, invit-

ing the heavyweight champion Mike Tyson to a society lunch after he bought a house near Cragwood in 1988, but by then she was mostly absent from the New York social scene. Annette had taken her place there, too.

❖

IT WAS A MOMENT OF GENERATIONAL CHANGE, AND ANNETTE became its symbol, not just taking her mother's position, but leaping at the chance to show what she could do for the museum. Some friends say her dedication was limitless; several tell the same story of her personally painting the walls of a stairway used only by museum employees. But others think she was just trying to outdo her mother. "There was a strange dynamic between them," says Jane's friend from New Jersey. "They were very much alike and they admired each other, yet there was a rivalry, too." The friend chuckles when asked if Annette inherited her mother's affinity and eye for art. "No," he says. "None." Neither did she exhibit any interest in politics or finance.

What she did inherit—her intermittent protests notwithstanding— was her mother's taste for social stature. Through the New Jersey society she'd grown up in, she knew many of the families involved with the Metropolitan. The Engelhard winter home was in the same Florida town as Arthur Houghton's. Doug Dillon's daughters, Phyllis and Joan, though older than Annette, were neighbors and fellow Foxcroft students. Jane, Phyllis Dillon, and Jayne Wrightsman were all on the Kennedy White House redecoration committee. They all spent summers together in the old-money enclave of Dark Harbor, Maine, alongside Annette's close friends Maisie and Jamie Houghton and not far from Brooke Astor.

The Engelhards' arrival in the late 1960s caused a frisson in insular Dark Harbor, which "didn't know what to make of them at first, 'new people,' you know," Sister Parish recalled, "but soon everyone grew to love them as much as I did . . . They were a terrific addition to the island." And they saw it in its last glory days, said Maisie Houghton, who returned there in 1969 after a long hiatus, just after she married. "That was the last gasp of the old era," she said, "when people still wore black tie to dinner parties." To Annette, "it was just a magical world."[100]

In the 1970s, Brooke Astor had emerged as New York's most impor-
tant philanthropist and gathered a coterie of young acolytes, many, like Tom
Hoving, associated with the Metropolitan. Among them were the Met
lawyer Ashton Hawkins, the son of a friend, who became her frequent
walker, and the paintings curator Everett Fahy, whom she met through the
Wrightsmans. Astor admired her fellow striver Jane Engelhard, who, like
her, had grown up in China, been widowed young, married well, and culti-
vated serious interests while also enjoying unserious high society. "Jane's the
power," she told the centennial planner George Trescher. "I walk in her
wake." Then she met Annette, who became her protégée and, Astor's biog-
rapher Frances Kiernan wrote, "the daughter she never had."[101] When As-
tor hosted a dinner for seventy in her apartment to celebrate Ronald
Reagan's election to the White House, Annette and Sam came along with
Jane, the Dillons, the Sulzbergers, the Kissingers, and Oscar and Françoise
de la Renta.

Annette was "under Brooke Astor's wing," says a friend of Jane En-
gelhard's. "She was being groomed. It was well-known." Annette, says a for-
mer friend, "saw Jayne Wrightsman and Brooke Astor as her godmothers
and herself as a torch relay for their sense of style and living. At forty, she
had old ladies for friends. The only person her own age she hangs out with
is Mercedes [Bass, the Texan Sid Bass's wife, who plays a role parallel to An-
nette's at the Metropolitan Opera]." Bass, an Iranian, had the misfortune to
have bolted from a well-liked first husband, leading many in society, Jayne
and Annette among them, to snicker about her past, which allegedly in-
cluded liaisons with wealthy Europeans like Sir Jimmy Goldsmith and Hans
Heinrich von Thyssen-Bornemisza.

But dangerous liaisons aren't limited to youngsters in the social set.
Hoving suspected that Dillon had a brief affair with Jane Engelhard in the
1970s after Charlie died and Dillon's first wife grew ill. Not long after Phyl-
lis Dillon died in 1982, Doug turned his attentions to Astor. They'd
planned her garden court together as part of Dillon's last pet project at the
museum, the creation of a world-class wing for Asian art. "She just stood
out," he'd say, "she charmed you utterly . . . It's a great gift."

"There is a whole chapter to be written about their relationship,"
Hawkins told Astor's biographer. Dillon "wanted to marry her." Unfor-

tunately, she didn't want to marry him. Which, wrote Kiernan, left Astor wondering why she was abruptly asked to retire from the museum's board that year and become a trustee emerita. An Astor Foundation trustee insists that her rejection of Dillon had nothing to do with that. "She was not aware that at a certain age she was supposed to get off. She thought she was a trustee for life."

Though Ashton Hawkins, who delivered the news, said she took it with grace, "she did not," Kiernan wrote. "And she did not become resigned to it." Instead, she made the sudden, dramatic announcement that she was resigning from every board she was on except the New York Public Library's. Montebello begged her to reconsider. Her announcement was "damaging" and "caused great consternation," Kiernan wrote, and she relented, "albeit quietly," accepting her emeritus position, remaining on the acquisitions committee, sitting in on executive committee meetings, and endowing not only the Astor Court, but also a chair for a Brooke Russell Astor Chairman of Asian Art.[102]

Finally, in 1997, Astor decided to give away the remaining assets of her foundation in one last blast of charity, and the Met got another $1 million to endow an annual catered holiday lunch party for the museum's staff and volunteers. She'd not only paid for the party since 1993; she was the first trustee who had ever attended, walking from table to table in the Temple of Dendur, greeting many staffers by name. In return, she was made an honorary member of the staff association, a status she adored. She took it so seriously, Kiernan wrote, that when Annette de la Renta once made an appearance at the holiday party dressed in weekend clothes, Astor quietly chastised her, saying that "next time something less informal might be preferable."[103]

Astor's departure coincided with other changes at the top of the museum hierarchy. In the spring of 1983, Douglas Dillon announced he would step down as chairman at age seventy-four. His first wife had died after her long illness the preceding June, and he'd quickly married again and wanted to spend time with his new wife. His final years at the museum had been satisfying. Though it couldn't have pleased him that Macomber and Montebello still weren't getting along, in his last year in office he'd managed to defuse one last crisis with the city and attract one of the last great collections of art and antiques in private hands.

✼

DESPITE VAST IMPROVEMENTS IN THE BEHAVIOR OF BOTH SIDES, the museum's relationship with the city remained rocky through the early Koch years. At the end of 1978, after a preview of the King Tut exhibit, Gordon Davis, the parks commissioner, "noticed something odd," he says. The museum garage under the Rockefeller Wing was supposed to have its entrance facing south, so it couldn't be seen from Fifth Avenue. "But the entrance was a gaping hole facing Fifth," says Davis, who did some research the next day and found that the museum had made the switch without asking or telling the city. Ashton Hawkins and Arthur Rosenblatt had "decided it was too expensive to build it as approved," says Davis, "so this horrible open scar faced Fifth." He summoned them, and "by the end of the meeting they were pouring sweat. They knew Ed Koch liked to throw his weight around." Davis ordered them to cover it up and suggested doing so with a teardrop-shaped traffic island. When they balked at the cost, he snapped, "I don't give a shit." The island was built. "That was my little accomplishment," Davis says proudly.

Davis rarely missed a Met board meeting, considering them one of the best shows in town, and decided that Dillon had ended "the reign of terror of Tom Hoving" by replacing him with a "total novice," Macomber, and the equally untried Montebello. "I always sat with Henry, because he was so much fun," Davis says of his fellow commissioner Geldzahler. "He'd write me mocking notes about Philippe, who'd pronounce words in ways nobody ever had before. Philippe was a baby with a terribly complicated personality, and the only reason he had the job was that Dillon had picked him to assure his own control." Which was almost absolute. "People didn't say anything," says Davis. "That was astounding to me. Three reports. Boom. Adjourned."

Late in 1981, Geldzahler and Barnabas McHenry cooked up a plan that redefined the city's financial relationship to the museum. In his role as bursar for Lila Wallace, McHenry offered to pay for most of what would become her wing, but only if the city would match her contribution. "I can't do it," a city budget officer told them at a meeting at City Hall. "These are

dark days. I can't fix my bridges, the schools are falling down." But, says a Geldzahler aide, the matching funds finally proved irresistible. In 1982, the museum got $8 million, the largest capital contribution by the city to its master plan, and McHenry got a seat on the board, which he held through 1986, when he became a trustee emeritus.

Macomber's diplomatic background didn't prepare him for the moment when Ed Koch threatened to create an international incident to embarrass the museum. In 1973, Dillon had postponed a show of Jewish, Christian, and Islamic archaeological artifacts from a museum in the disputed West Bank in Jerusalem out of fear of sabotage by newly emboldened Arab terrorists. Several years later, the idea was raised again, and in 1980 Montebello visited Jerusalem to discuss the loan and make a preliminary selection of objects. Two years later, in February 1982, an early edition of the next day's *New York Times* was delivered to Mayor Koch, featuring a front-page story saying that Montebello, just back from his latest trip to Jerusalem, was worried about "the security risk from radical elements" and had decided to cancel the show.[104] Koch went ballistic.

"Montebello had consulted Henry Kissinger," says Gordon Davis. "He, of course, advised them that they were risking an international incident." Furious, Koch wrote Dillon, lambasting him for subordinating "curatorial considerations to political hallucinations and speculative fears" and demanding a complete accounting of the decision. It's unlikely Dillon missed the meaning of Koch's unsubtle reference to New York's large Jewish community or his blunt mention of the city's $10.6 million annual subsidy.[105]

Two days later, the cancellation was reversed after a Koch aide forced a reluctant State Department to insure the show, which was finally held in 1986. That incident "was the great divide," says Gordon Davis. "After that, Koch became totally enamored with the museum. He was more secure because they knew who was boss." Davis thinks it was also an important watershed for the board; after that, "the question of Jews on the board became a nonissue," he says. "Nobody was counting heads anymore."

In fact, the museum's policies on board members had been loosening for years as its need for new sources of funds grew acute. By the early 1980s, it boasted both local and international business committees, charged with

attracting donations from corporations, and had begun aggressively court-
ing more donations from its members, hosting more paid benefits, and
sponsoring a series of partly tax-deductible international art cruises, which
would grow into a huge business over the years, combining, as the museum
puts it, "curatorial expertise and behind-the-scenes viewing arrangements
with spectacular itineraries and interesting companionship."

"Historically, it was status, not wealth, that ran the board," says the
representative of another of the Koch-era ex officio trustees. "They came to
realize that by excluding people without social pedigree they were missing
out on potential donors. They began to expand their outreach. They were
slow, but they realized."

"The board appeared to get larger, the table got longer," adds Henry
Stern, who replaced Davis as parks commissioner in 1983, when there were
thirty-seven elective trustees. The new trustees were obviously pleased to be
there. "I don't remember a single divided vote in fifteen years," Stern says.

"They'd organized it so no business was transacted by the board," says
another city official. "Technically, of course, it all was, but they were ratify-
ing decisions already made by the people with real power. The meetings
served the purpose of informing the board through the director's famously
elegant presentations. They observe the ritual because if they disagree, they
probably wouldn't be renewed or would be shunned."

The museum's board was finally tamed by the simple expedient of in-
clusion.

NEITHER JACK NOR BELLE LINSKY EVER SAT ON THE MET'S BOARD,
but in March 1982 Belle gave the museum a collection of old master paint-
ings and European objects worth about $60 million that Montebello had
"coveted," he said, "for at least 20 years."[106] Jack Linsky, a Russian immi-
grant to New York, had started his career in the stationery business as a
messenger at fourteen. In 1925, he saw his first stapling machine the day he
got a license to marry Belle, another Russian-Jewish refugee. They made a
deal to distribute them, got married, sold out their stock on their honey-
moon, decided they could make a better gizmo, and formed the company

that would become Swingline, the stapler maker. Every time a piece of paper got stapled, they got a little richer.

The Linskys started collecting porcelain on Saturdays during the Depression; Belle's first purchase—for she did the buying, he went along—was a $400 Fabergé snuffbox. By the 1950s, they'd begun giving art to museums, but after James Rorimer ridiculed their taste, they sold everything they had. Neither had any training in the arts; they assumed Rorimer was right. But when some of their Fabergé objects turned up in a museum show, they started over, trusting their own taste, buying in their spare time on business trips. Since they'd come out of nowhere, were Jewish, collected for pleasure, not social advancement, and didn't entertain, "nobody knew," says a museum curator who courted them years later.

In 1959, they took Swingline public and began buying more expensive pieces. In 1961, a few weeks after another share sale, they picked up a Crivelli *Madonna* at the same sale where Rorimer bought Rembrandt's *Aristotle*, and three years later paid $176,400 for a Louis XVI commode from Versailles at a London auction, then the highest price ever paid for a piece of French furniture. They broke that record when they bought a matched pair of Louis XV tables in 1967 for $241,000. That same year, though they'd never heard of the artist, they spent $244,000 for a tiny panel by Juan de Flandes, painted for Queen Isabella from Spain, outbidding the National Gallery in a London auction and gaining the attention of museum directors worldwide. They also once outbid John Paul Getty for a writing table made for Madame de Pompadour. Their trick was simple: if they wanted something, they just kept bidding. And they only wanted things of "staggering quality," says the curator.

The Linskys sold Swingline in 1970 for $210 million. Ten years later, Jack died, and museums and auction houses swarmed Belle when they learned that she was tired of caring for the collection and might give it away. No fool, though, Belle also considered selling it and played her suitors off against each other. Christie's would be walking out of her apartment when the Met's curator was walking in, and the National Gallery would be in Linsky's lobby when he left. None expected what they found upstairs. "She was one of the toughest ladies I've ever dealt with, and I've dealt with some

tough broads," says the curator. "She was the toughest, the meanest, the rudest."

All Belle wanted to know was what her things were worth, and by then they were worth plenty. The talks went on for months. "What about this?" she'd ask. "What's it worth?" It was a ritual she loved to repeat, and they all performed for her. "What do you think of those chairs? Sotheby's said they're worth more. You're not doing too well." It was as if she was paying them all back for the way Rorimer had treated her. All she wanted was respect for her taste.

The Met finally brought in Montebello, and though impressed, Belle wasn't cowed. She insisted her things be shown together. Finally, it came down to Dillon. "Everyone else dawdled around," Belle later told *ARTnews*. "Not him. He just came over here, sat on the sofa, had a drink and said, 'This collection belongs in the Metropolitan and that's where I want it.' After I agreed, the wheels started turning the next day." Belle wouldn't pay a penny for the installation, either; the board only went along after Dillon agreed to cover the $3 million cost.[107]

With the museum over a barrel, William Zabel, Belle's trusts and estates lawyer, negotiated with Hawkins and drew up a contract the museum would sign but later come to regret. It contained what Zabel called a Sword of Damocles clause that said if anything about the Jack and Belle Linsky galleries were ever to change, if a single item was moved or deaccessioned, "we can take it all back and give it to a different museum," Zabel says.

As the museum emptied her parlors of their precious treasures, Belle began to suffer from donor's remorse. One day, the Juan de Flandes painting vanished. A curator noticed its absence as well as the disappearance of the key that locked a commode. Where was the painting? Belle said the maid must have moved it. And the key? What key? Finally, the commode was unlocked and the painting was inside.

"Do you have to take it?" she asked. "I'm so fond of it."

Montebello and Dillon were thrilled with their coup, but at least one trustee was not. Jayne Wrightsman had opposed accepting Belle Linsky's conditions, fearing the Linsky galleries would draw attention away from the nearby Wrightsman rooms. When her reaction got back to Belle, "it made

her feel very good," says someone who knew her. Wrightsman's pique was the ultimate affirmation.

⊹

DOUG DILLON LEFT HIS SUCCESSOR WELL POSITIONED FOR THE future. The "big" board had been neutered, and by 1983 the museum had a well-oiled fund-raising apparatus; within a year of the announcement of a $150 million campaign to increase the endowment and eliminate deficits, two-thirds of that sum had been pledged. And with Macomber in place, if not entirely in charge, Dillon was able to cut his job down to size before installing his vice chairman J. Richardson Dilworth in it that fall. At sixty-seven, Dilworth was a transitional figurehead in the evolution of the museum's management that had begun with Macomber. And Dillon remained on the board and the executive committee, "a godlike figure," according to one city official. So on the surface, nothing much changed in Dilworth's tenure.

Dilworth accomplished little of note in his years atop the Met, and never had to defend the museum in a scandal, and so rarely made the newspapers. But behind the scenes, he played a key role in attracting new donors to the museum, speeding up the change in emphasis on the board from bloodlines to money. "He was a great ecumenicalist," says John C. Beck, who became an adviser to the board's investment committee in 1984. "He felt strongly that all groups should be represented" and "was skillful enough to keep it in balance." Unfortunately, Dilworth lasted less than three and a half years; suffering from acute depression, he resigned as chairman early in 1987.

The other important development in the Dilworth years was the arrival of a stronger, more suitable president who forged a working relationship with Montebello. William Macomber, suffering from Parkinson's disease, announced his retirement in the spring of 1985 and spent the rest of his life as a high school teacher and football coach on Nantucket until his death in 2003. He was replaced by William Henry Luers, another ex-diplomat.

The son of an Illinois banker, Luers served in the navy in the 1950s, then entered the foreign service, dedicated to fighting Communism. He

worked in Italy, the Soviet Union, and Washington before Jimmy Carter appointed him ambassador to Venezuela in 1978. In 1983, Luers was named Ronald Reagan's ambassador to Czechoslovakia and was in that job when he was hired by the museum. Though his art and museum credentials were as weak as Macomber's, he had similar skills in dealing with public officials.

Luers was called president and chief administrative—not executive—officer, and Montebello reported to the board, not to him, which gave them parity and made his political situation a bit more palatable for the director. In public, both denied any friction. But the "language barrier," as one city official describes it, remained, and the two-head arrangement stayed strained. "Inevitably, we had moments of disagreement," Luers would later admit, though he declined to be specific.[108]

Luers's forte was fund-raising. He and his wife functioned smoothly as the Met's outside ambassadors. They moved into the apartment at 993 Fifth, where, unlike Macomber, they took full advantage of the restaurant-quality kitchen Rosenblatt had installed and entertained trustees and potential donors "breakfast, lunch and dinner, seven days a week," a trustee would later say.[109]

"He pretty quickly built his own constituency, and that was a problem for Philippe," says a well-placed museum watcher. "The lines of demarcation weren't clear, so there was a rivalry. Who had the most sway in deciding about galleries? Who had the most contact with the trustees?"

That became increasingly important as Dillon's role at the museum waned. "Every December, Dillon wrote a check to cover the deficit," says John Beck. "When they brought Luers in, I'm not sure he completely grasped the seriousness of the financial implications."

The Met's Old Guard held on. In 1991, S. Parker Gilbert Jr. came onto the board and the investment and finance committees and quickly became "the real force" behind the museum's investment decisions. Gilbert was the latest Morgan trustee, the son of a Morgan partner and undersecretary of the Treasury who'd administered German reparations between the world wars. After his father's death, Gilbert's mother married Harold Stanley, another Morgan partner and a founder of Morgan Stanley, formed when J. P. Morgan shed its investment banking operations during the Depression. After graduating from Yale and serving in army intelligence, Gilbert junior

joined the family firm and in 1983 was named its chairman. Gilbert would quickly rise in the museum's hierarchy; after taking over the investment committee in 1993 and joining the executive committee in 1995, he was named a vice chairman in 1999. But the old families were increasingly overshadowed by much newer money.

Its arrival coincided with the Lila wing's completion. As the final touches were being put on the museum within a museum for modern art, Luers was readying a campaign to get this new generation of donors to pay for the last puzzle piece of the master plan—the only part conceived as well as executed under Montebello. Hoving's plan had called for a second garden courtyard of about the same size as the Charles Engelhard Court to occupy an empty notch between the new Rockefeller and Wallace wings and Theodore Weston's 1888 Wing B, containing the old Medieval Sculpture Hall and the existing decorative arts galleries. But his promise of a beautiful, new public garden behind a glass facade incorporating a sculpture gallery and a park entrance to the museum was about to be broken. At the end of 1986, ground was broken instead for what was called the ESDA wing, a $35 million home for European sculpture and decorative arts, which had been left adrift when Geldzahler effectively seized the museum's southwest corner for modern and contemporary art.

Kevin Roche designed this new space, which would also contain a conservation center, new executive offices, a restaurant, a 240-foot-long sculpture courtyard with a pyramidal skylight, and temporary exhibition galleries. Planning for the five-story, 141,000-square-foot behemoth, larger than the Lila wing, was carried out in secret, and the drastic change in plan was only revealed after excavation had begun. That news, which once would have certainly stirred discussion if not outrage, was received without criticism (except from Dietrich von Bothmer, still mourning the loss of his Greek and Roman galleries), buried deep in the arts pages of Punch Sulzberger's *New York Times.*

Five months later, Punch was revealed to be the successor to the ailing Dick Dilworth as the museum's chairman. "It was a very shrewd move," says a former curator. "Immediately, the museum was no longer held to certain standards." Sulzberger's role in his newspaper's coverage of the museum is a subject of debate. It is undeniable that after Hoving, the *Times* was

less critical, but under Montebello there was far less to criticize. Montebello was not a risk taker. Rather, he was a caretaker—a brilliant one, but a maintenance man nonetheless.

The last master-plan construction job proceeded without a peep of protest, and the ESDA wing galleries opened over the course of four years, from 1988 to 1992. Its Central Park entrance, which the museum was still promising in the summer of 1987, was never mentioned again. At first at least, construction proceeded slowly; money for the building's shell came from $11.2 million in bonds issued by the Dormitory Authority of the State of New York, a quasi-public branch of state government that finances and manages construction of buildings for the public good. Luers had to find the rest. He carried on Dilworth's strategy of bringing in new money, its age and pedigree notwithstanding. "Bill Luers was a fantastic success in smoothing things out and bringing in big donors," says his predecessor's brother, John Macomber.

More funds eventually came from the city. Ed Koch credits his chief of staff, Diane Coffey, and his representative on the Met board, Ronay Menschel, for that. "I was constantly pushed by the two of them to protect the museum's budget," he says. Sulzberger's comment on the latest city grant rewrote history somewhat, but did reflect the new conflict-free reality. He said the money "underscores once again a partnership that has long existed between City Hall and this great institution. Our bonds of unity have become a standard and model for the rest of the nation, demonstrating the harmonious interdependency that can exist between the private and public sector."[110]

Ronay Menschel credits "a mayor who appreciated the importance of the museum more than his predecessors" for this, but also "the improvement in the economic climate" in the Reagan years. The new business titans who climbed from that crucible were the next generation of potential museum benefactors. Many were willing, but some proved unable to break into that charmed circle.

One who tried was Saul Phillip Steinberg, who'd bought John D. Rockefeller Jr.'s 740 Park apartment in 1970 as the first step of a long campaign to storm the bastions of New York finance and society. A feisty and brilliant outsider, a Wharton-trained financial operator (whose failed 1969

attempt to take over Chemical Bank made him a pariah in WASP banking circles), and the central figure in a scandalous tabloid divorce, in which his wife charged him with financial shenanigans and cocaine addiction, Steinberg was disdained by the sorts of people who'd long run the Metropolitan, even after he sold an early collection of German Expressionist paintings and started buying old masters in an attempt to reposition himself as a man of wealth and taste.

"To a shocking extent, the people who've assembled art have had other or parallel agendas, which is very depressing," says a former museum director. "You deal with it. If they can help us, we can help them." But Steinberg's interest in art and the museum seemed to transcend mere utility. The relationship began in 1973, encouraged by a friend who developed the Met's merchandise. Steinberg's Reliance Group Holdings, an insurance-based conglomerate, paid for a survey of attitudes about the museum that showed it was New York's top tourist attraction. In return, Reliance got to hold its annual meetings in the auditorium. In years to come, Steinberg and Reliance underwrote exhibitions and the $500,000 cost of creating and publishing a comprehensive guide to the collections, and even paid to install the museum's popular Christmas tree and crèche.

But Steinberg didn't get what he wanted. "Of course, he wanted to be a trustee," says a lifelong friend of his. "It was appropriate considering the amount of money he gave. He was captivating, brilliant, successful. He was a serious, knowledgeable collector. He gave money, paintings, endowed galleries. His name was all over the museum. And he made no demands. You don't ask, but of course it was known what he wanted. But they couldn't handle him. He was too smart, he'd made his money too quickly, and they didn't have the money he had. And he just kept giving. I thought he was a schmuck to keep giving. They did nothing for him. He was an arriviste, an upstart. The museum simply shafted him." Steinberg's art dealer, Richard Feigen, "was outraged," says Steinberg's friend. "He thought it was pure anti-Semitism." (Feigen, who now has a good relationship with the museum, denies this.)

Still, Luers proved willing to engage the sorts of donors the museum had previously disdained. The first donation for the ESDA wing came from CBS's chairman, Larry Tisch, and his brother, Bob, the postmaster general

of the United States, whose $10 million donation in June 1987 got their name on the Tisch Galleries for loan exhibitions. Another new benefactor was A. Alfred Taubman, a Michigan shopping center developer who made a big splash in New York in the fall of 1983 by buying Sotheby Parke Bernet. The previous year, he'd made the first Forbes 400 list of the richest Americans with a fortune estimated at $525 million. He soon added two Met trustees, Ann Getty and Baron Thyssen-Bornemisza, to Sotheby's board and began offering to buy art for the museum.

Taubman was approached to make a big donation after he hosted a benefit for the museum in Sotheby's salesroom in September 1984 to celebrate the hundredth birthday of the auction house. The evening was a watershed; the first time in anyone's memory that the commercial art trade had been so closely linked to the art temple. But the $50,000 Taubman raised and another $50,000 he gave himself were enough to assuage any concerns among the guests, who epitomized New York society in the mid-Reagan years: in the crowd were Tisch, Estée Lauder, William Paley, Guy de Rothschild, Mercedes Kellogg (the future Mrs. Sid Bass), Nancy Reagan's favored escort, Jerome Zipkin, and the Doug Dillons.

Not long afterward, Taubman and the Met began negotiating a much bigger gift. The museum wanted another $10 million for the ESDA wing and offered to name it for him. "Taubman made the negotiations for 'his' wing so awful they actually told him to take a hike," says an Ashton Hawkins intimate. Taubman is said to have argued over how many times his name would appear in and on the wing and even how high off the ground it would appear. "Ashton called it the most unpleasant experience of his career."

Taubman is evasive about the episode and simply says he gave about $15 million to Harvard instead. Bill Luers won't talk about it either, but does say that he quickly replaced Taubman's money with $10 million from another up-and-coming financier, the leveraged-buyout mogul Henry Kravis, who not only got a wing named after him—ESDA became the Henry R. Kravis Wing for European Sculpture and Decorative Arts—but in 1989 was elected to the Met's board, too. Though he was a Jew from Tulsa, Oklahoma, Kravis, who'd worked for Bear Stearns before forming a private equity firm with two of his co-workers, was deemed more socially compatible than Steinberg and Taubman. He had a philanthropic track

record, having created an investment fund to encourage inner-city job de-
velopment. As important perhaps, he had one generation of connections
behind him; his father, Ray Kravis, partnered with Joseph P. Kennedy in the
oil business in the late 1940s.

Another new face in society, and on the Met board, in 1989 was one
that could not have pleased Jane Engelhard or her daughter Annette. Mrs.
Milton Petrie, wife of an aged retailer who, like Kravis, was part of the Bear
Stearns circle, joined the board at the same time Kravis did, a little over a
year after her husband pledged $10 million to pay for the sculpture court in
the new wing. Milton Petrie, then eighty-seven, owned Petrie Stores, a
women's clothing retail chain. But his fourth wife was the former Marquesa
Carroll de Portago, who had briefly been Charlie Engelhard's lover. Her
fourth marriage had proved charmed. Petrie, the son of a Russian immi-
grant pawnbroker, who'd gotten his start before the Depression with a
hosiery store financed from his winnings at craps, was worth about $890
million, according to the latest *Forbes* rich list.

After the Engelhard affair and another failed marriage, Carroll was
left with a Fifth Avenue apartment, a small house in Lyford Cay in the Ba-
hamas, and an empty bank account. Acquisition minded as always, she went
looking for another wealthy husband and hit the jackpot when she went on
a blind date with Petrie, twenty-some years her senior. He didn't look like
much—he wasn't handsome, smoked cigars, and worked out of a drab New
Jersey office—but he bought her expensive jewelry and stopped drinking
for her, and within months they were married in a 1978 civil ceremony.

Together with Carroll, Petrie embarked on an extraordinary second
career in philanthropy, giving away more than $100 million in the next ten
years, much of it to Jewish charities, but also giving quiet aid to individual
accident and crime victims he read about in the papers, particularly
wounded policemen and the families of others who'd been killed in action.
But those were his causes; the Met was Carroll's. "She wanted to be on the
board," says a close friend of hers—and Milton bought the seat for her at
the then-going rate of $10 million. It "was a big 'fuck you,' " a friend of Car-
roll's told the author Charlotte Hays. Whenever Jane or Annette or any of
their friends entered the museum, "they can't avoid seeing the Carroll and

Milton Petrie European Sculpture Court," the counterbalance, both architecturally and socially, to the Charles Engelhard Court.

Milton Petrie died in 1994, leaving his wife a $150 million trust fund, $5 million in cash, all their possessions, and a foundation with an endowment of about $350 million. In the years since, she stayed on the museum board, eventually becoming emeritus. She refuses to discuss the museum or Engelhard, but she's already had the last word.

BY 1985, PHILIPPE DE MONTEBELLO HAD SETTLED INTO HIS JOB ("part diplomat, impresario, courtier and lawyer," he'd say). He'd won back some of the directorial prerogatives that he'd at first been denied, the approval of the press ("His tenure so far has been impeccably correct," said the *Times*), and also something more important to the smooth functioning of the museum—the respect and confidence, if not always the admiration, of his staff.[111] The Louis Sullivan staircase in the Charles Engelhard Court became a symbol of curatorial preeminence over the Met's administrators. When William Macomber decided its installation would be too costly, Montebello fired off a memo ordering him to stay out of matters of art and find the money to install the stairs. He did.

Soon after he was made acting director, Montebello made his first high-level curatorial appointment, replacing Henry Geldzahler with Thomas B. Hess, a former editor of *ARTnews,* in February 1978. Five months later, though, Hess collapsed at his desk and died of a heart attack.

It took eleven months for Montebello to replace him with a chain-smoking, alcoholic workaholic, a committed bachelor and Paul Sachs—trained curator who liked to be called Uncle Bill. Authoritative, urbane, intimidating, concise, and famously difficult ("I can't hear you" was a favorite refrain), William S. Lieberman was a thirty-five-year veteran of the Museum of Modern Art, where he'd been the protégé of Alfred Barr and famously bought Gertrude Stein's art collection over the course of one frantic weekend. Shortly after that, he lost a political battle to become chief curator of paintings and found himself sidelined in the prints and drawings

department. So he leaped at the chance to move to the Met, where he would not only be in charge of hanging its modern collection in the Lila wing but also have the chance to show up his MoMA rival.

Lieberman proved a mixed blessing, but a great character. Arthur Rosenblatt felt he was a good man with a blind spot for architecture and installation. "The unfortunate layout" of the Lila wing, he said, "is entirely Bill Lieberman's fault."[112] Though the galleries he designed and hung inspired "lots of complaints," an art dealer agrees, Lieberman's brilliance at "convincing people to buy and then give art" was unparalleled. His knowledge of twentieth-century art and his single-minded ability to romance donors and attract treasures finally drowned out the critics who said his buying was old-fashioned, promiscuous, uncritical, and political.

Immediately after his arrival, great collections started coming to the Met. Lieberman was peripheral to the first two, Muriel Kallis Steinberg Newman's collection, which came in 1980, and 450 works from the estate of Scofield Thayer, including paintings by Picasso, Braque, Munch, and Matisse and drawings by Gustav Klimt and Egon Schiele. The second had been willed to the museum in 1925, though nobody knew until Thayer died in 1982. He had assembled his collection while editing the *Dial,* a maverick literary magazine that published T. S. Eliot, Ezra Pound, W. B. Yeats, and William Carlos Williams. An early patient of Sigmund Freud's, Thayer had severe mental problems and quit his job in 1926, just after he loaned his collection to the Worcester Art Museum in his Massachusetts hometown and saw his taste excoriated by local critics—apparently a traumatic event. Afterward, he was institutionalized, and his art stayed in place for more than fifty years. Only when his will was read was Thayer's reaction to Worcester's provincialism revealed: he'd left his entire collection to the Metropolitan.

Lieberman was responsible for luring many of the gifts that came after that. In 1996, he reeled in the collection of the art dealers Klaus and Amelia Perls, including Cubist masterpieces by Picasso and Braque and the museum's first Modigliani statue, and half of the collection of the May Department Stores heiress Florene May Schoenborn, who was a trustee of MoMA, making her gift that much sweeter for Lieberman.

His greatest catch was his last, the Jacques and Natasha Gelman col-

lection, though he almost lost it before the gift was saved by Montebello. Like each of the donations he'd won before, the Gelman gift—valued at $300 million and consisting of eighty-five pieces by Degas, Matisse, Braque, Balthus, Bacon, Giacometti, Picasso, and Modigliani—was hailed for filling gaping holes in the Met's modern holdings. Montebello even agreed to keep it together.

Jacques Gelman was a Russian-born producer who'd made a fortune making Mexican movies. He and Natasha, a multinational beauty from what is now the Czech Republic, used his fortune to buy art, becoming patrons of Frida Kahlo and Diego Rivera and gathering one of the best private collections extant of French modernist paintings.

The Gelmans had known Lieberman since the 1950s but had fallen out with him by the mid-1980s over Lieberman's blossoming friendship with another wealthy international, the Mexican billionaire collector Emilio Azcárraga. Natasha had already decided to give their school of Paris paintings to an American museum; they'd long kept an apartment in New York. Though she'd had a relationship with MoMA, she felt it didn't need her art. The Met did—desperately—but somehow Lieberman found himself competing with the Guggenheim, whose director, Thomas Messer, was also a Czech, and the National Gallery. When Montebello heard that Natasha and Lieberman were on the outs, he invited her to lunch at a private club near her apartment. What they discussed isn't known, but the result is: there was a rapprochement, Lieberman curated a show of their art at the Met in 1989, and Natasha promised the museum her collection, endowed a curatorship, and was named an honorary trustee.

Lieberman wasn't finished. After Azcárraga died in 1997, and Natasha Gelman followed in May 1998, the coast was clear for Uncle Bill to take up Azcárraga's blond, blue-eyed ex-wife, Paula Cussi, and get her involved with the Met, too. The Mexican mogul had met Cussi, "his third or fourth wife, depending on the source," the New York Observer reported, "while she was working as a weather reporter . . . Although his marriage to Ms. Cussi ended in divorce, he reportedly was generous to her in his settlement and in his will," leaving her a stake in his business that she sold for a nine-figure sum.[113]

Just after Natasha's death, seemingly out of the blue, Cussi was named co-chairman of the next Party of the Year, along with Miuccia Prada, the

fashion designer, and Pia Getty, an heiress and socialite. Cussi was also named and remains a Met trustee, a status that eluded Natasha Gelman. In 1998, Cussi was among the donors who paid an estimated $20 million so the Met could buy *White Flag,* its first painting by Jasper Johns, filling what Montebello called "a cruel gap" in its collection. Montebello had visited Johns, who'd kept it since it was painted in 1955, and convinced him to sell. Lieberman was so thrilled he gave the museum another, smaller *Flag* that his mother had bought in 1958.[114]

Lieberman's last big coup came in 2003 when the Met got a hundred works from the collection of his friend Pierre Matisse, the artist's son, and his wife. In 2004, he defied a serious illness at age eighty-one and came back to work, only to be elbowed aside. His fief, renamed the Department of Modern Art in 1999, was renamed again, this time oddly as Nineteenth-Century, Modern, and Contemporary Art, encompassing European painting after 1800 and international art and decorative arts of the twentieth century. Gary Tinterow, a protégé of John Pope-Hennessy's, was installed as its chairman—the new boss. Uncle Bill was made chairman emeritus and special consultant, reporting not to Tinterow but to Montebello.

Lieberman's dedication to the museum was unwavering; art was his life. "He was eighty years old, but he still went to work every day, and had lunch at the same spot in the Trustees Dining Room," says a friend. "He came home from work one night and died" in his sleep in 2005. At his memorial, some of his greatest acquisitions were displayed onstage, so he was sent off by his best friends: Picasso, Matisse, Balthus, Léger, Modigliani, de Kooning, Freud, Pollock, and Warhol.

DUE IN NO SMALL PART TO THE GLAMOUR OF THE EUROPEAN Paintings Department, the Pope and his court of curators were—arguably—the focus of more attention, fascination, and gossip than any group of art experts in the world. Promised anonymity, many say that they were a kind of harem surrounding their leader and that curatorial fortunes rose and fell based on his enthusiasms, sexual and professional. "John was certainly not an angel in that respect," says a former colleague at the Victoria and Albert.

And Pope-Hennessy did end up retiring to Florence in 1986 with a male intern from the museum who was his partner until his death in 1994. The fact that several of his most important hires are demonstrably heterosexual does nothing to stop the rumors.

The Pope loomed large, "but it was a matter of talent," argues William Hood, an Oberlin College art historian who knew him. "Generally, people backbite when they're envious. That's human nature."

Some of the most persistent backbiting has concerned Gary Tinterow, one of Pope-Hennessy's last hires, who would emerge as his most powerful protégé, briefly touted in 2008 as the only in-house candidate to succeed Montebello. A handsome native Houstonian, the son of a violinist and bandleader who toured with the Artie Shaw and Tommy Dorsey orchestras in the 1940s, Gary trained in art history at Brandeis and Harvard, before passing through a number of museums in America, Israel, and England. He'd come to the Met as a Ted Rousseau fellow in 1982 and was named Engelhard Curator the next year, shortly after he co-curated The Essential Cubism at London's Tate Gallery with Douglas Cooper, the former Nazi art chaser. It was Cooper who'd brought Tinterow to Pope-Hennessy's attention. The Pope apparently took one look and hired him. And Tinterow never looked back.

Keith Christiansen arrived in the European Paintings Department after earning a Ph.D. from Harvard in 1976 and became another Pope protégé, known for his photographic memory of art and its owners, and another favorite of wealthy collectors. Named the Jayne Wrightsman Curator in 1989, he has published often and has coordinated exhibits on Italian painters like Caravaggio, Correggio, Mantegna, and Carracci to great acclaim. But what *Apollo* magazine once called his three-decade pursuit of the Renaissance painter Fra Carnevale began with a tussle that still rankles the young art scholar he crossed swords with thirty years ago.

In 1978, Christiansen was an associate curator, assisting the Pope, when Monica Strauss, now a private art dealer, was at the nearby Institute of Fine Arts, writing a dissertation on Fra Carnevale. She dug up convincing evidence that two panel paintings—one in the Metropolitan and the other in the Museum of Fine Arts in Boston—that had been the subject of fierce attribution debates were actually Carnevale's, and her adviser told her

to go to the Met and tell Pope-Hennessy what she'd learned since he would be reading her dissertation anyway. According to Strauss, Pope-Hennessy asked Christiansen to sit in on the meeting, where he asked for a photocopy of her references but seemed to reject her theories. She left the meeting "upset and insecure," she says.

Friends and professors advised Strauss to publish her finds as fast as possible in order to lay claim to them, but Christiansen published first. Strauss felt he'd used her discoveries without credit. "I was devastated," she says. She complained to the IFA—but to no avail.

In 1994, Strauss did get some credit in a scholarly publication on the Renaissance. And in 2005, when Christiansen curated a Met show on Fra Carnevale, Strauss got proofs of the catalog and found that though she wasn't mentioned in Christiansen's essay, she was "cited in all the articles by others," she says, "which was a big relief." She wasn't invited to the opening, but did attend a private viewing of the show. When she saw Christiansen there, she says, "we both looked away."

BY THE EARLY 1990S, PHILIPPE DE MONTEBELLO HAD GAINED respect for his ability to manage both up and down, throwing credit bones to his curators and keeping key trustees happy. Many thought he'd restored the Met's standards. Others felt he'd simply put the museum back to sleep. "He was Hoving's Brutus, dancing on his grave," says a journalist who has covered the Met for decades, "a dull status-quo man, an old fogy, snooty, deeply aware of his own dignity, posing as a statesman, the worst of both worlds, stifling the museum's dynamism so he could climb on its corpse in solitary power." And Montebello's grace under pressure sometimes failed him. The 1993 publication of Tom Hoving's museum memoir *Making the Mummies Dance* was one of those occasions. In it, Hoving gleefully bit the hand that had fed him, revealing lots of those naughty little secrets Montebello says the museum doesn't have. Shortly after the book came out, Arthur Rosenblatt bumped into Montebello on a bus and the next day taped a session of his own oral history of the museum.

"He chatted about Tom Hoving [and] used language that is inappro-

priate and . . . rough," Rosenblatt reported. When Rosenblatt observed that the museum store was selling *Mummies,* Montebello said, " 'I don't read fiction . . . It's all lies . . . He's a schmuck,' and he repeated it several times." Rosenblatt wasn't surprised. He, too, had been a target of Montebello's ire—and believed it lost him several museum jobs after he left the Met.[115]

Montebello also came up against Bill Luers. And ironically, he did it defending actions taken by Hoving. By the time Montebello took over the Met, the fights over the Euphronios krater and the Lydian Hoard had mostly been forgotten. The assumption was that they would be part of the Met's collection forever. So there was no hesitation on the museum's part to buy, in several transactions beginning in 1981, yet another batch of Greek antiquities from the dealer Robert Hecht, nor to accept the explanation that this "hoard of silver vases and utensils," as Dietrich von Bothmer described it when they were first exhibited in 1984 as A Greek and Roman Treasury, had "presumably [been] found together a generation ago." A museum official claimed they'd come from Turkey and been legally imported from Switzerland.[116] As the Met spokesman Harold Holzer put it many years later, "Our curators do not buy on the illicit market."[117]

Malcolm Bell, a professor of classical art and archaeology at the University of Virginia, thought he knew better, and was sure of it when he came face-to-face with some of the silver at the Met a few years later. After Bell began directing excavations at Morgantina, an ancient Greek city in central Sicily, he "heard rumors of the discovery of a silver service there," which had subsequently disappeared. Among the objects he'd heard were looted—for clandestine tomb robbing was a fact of life at Morgantina—were two distinctive miniature silver horns. So when he saw them in a display case at the Metropolitan in the fall of 1987, he "recognized them immediately," he says, and "put two and two together and notified the Metropolitan of that fact."

Bell and Bothmer exchanged several letters over the course of the next year. Bothmer "asked a mildly curious series of questions about the evidence we had," which "in retrospect were probably edited by legal counsel," Bell says, "then, silence. When I proposed that some be returned, he didn't respond."

The catalog for that 1984 exhibit included about fifty pieces of the Lydian Hoard. They'd also been spotted at the museum by Ozgen Acar, a

Turkish journalist, who wrote an article about them, attracting the attention of the government in Ankara, which launched an investigation aided by Acar and another writer, Melik Kaylan, who was assigned to the story by Tom Hoving at *Connoisseur*. Once they were convinced that the "East Greek Treasure" and the Lydian Hoard were one and the same, the Turks approached the Met, seeking its return. Montebello and Hawkins stonewalled.

The Turks enlisted the aid of several social figures in New York. One was Ahmet Ertegun, the Turkish-born music business mogul who'd become one of New York's leading social figures, running in the same circles as Annette and Sam Reed. "Ahmet talked to Ashton," recalls his widow, Mica Ertegun. "He was trying to find a solution agreeable to both sides" and suggested the Met give title to the Turks while retaining possession. The museum refused.

Iris Love, the archaeologist who uncovered the fake Etruscan warriors, tried next. When she heard that the Turks were so upset they refused to speak to Montebello or Hawkins again, she proposed an end run to Luers, the Met's chief diplomat; surely he would see the light. He did and enlisted the help of Dick Dilworth, who brought the matter to the trustees.

"They were well on the way to a resolution," says John Macomber. But Hawkins insisted that the pressure would pass, as it always had, says an antiquities collector with family ties to the Met's ruling circle, and the board backed down. Montebello and Hawkins "wouldn't budge," says someone Luers later confided in. Unfortunately, the Turks weren't inclined to give up, either. They hired Harry Rand, the lawyer who won the first case in an American court in which a sovereign nation recovered stolen art. "[The museum] talked to us and said they wouldn't give the objects back," says Rand's then associate Lawrence M. Kaye. "They were courteous but skeptical about the claim, and they said it had no merit and wouldn't honor it." So in May 1987, Turkey sued the Met.

After turning back a motion to dismiss the suit, Rand began the process known as discovery in 1990 and gained access to the museum's basement, where some of the hoard was still hidden in storage. An international team of archaeologists was allowed to examine all the material, which included wall paintings torn from tombs and an incense burner virtually identical to another that had been left behind by the *tombaroli* in 1966. In

Turkey, the team discovered that the paintings in the basement fit the walls of one of the looted tombs like pieces from a jigsaw puzzle. Fresh identifications of the objects in the Met by the looters themselves were another nail in the museum's coffin—Melik Kaylan brought one of the looters to the museum with a British TV crew, and on camera he identified the very pieces he'd found there.[118] The Met delivered the coup de grâce itself when, in response to discovery demands, it handed over internal documents, most crucially, acquisitions committee minutes indicating that the museum knew the hoard was looted from Turkey. Those, Kaye says, "motivated the Metropolitan not to go to trial."

In 1992, museum officials suggested a settlement. They were willing, they said, to return some of the objects, but not all of them. The Turks refused. Finally, more than a year later, the Met accepted the inevitable. That fall, Sulzberger signed an agreement with Turkey that acknowledged its ownership of the Lydian Hoard, agreed to pay its legal fees, later estimated at $40 million, and promised to work together in the future to advance scholarship and cultural goodwill. A month later, the objects were returned to Turkey and put on display in Ankara.

Montebello was on the wrong side of history, but, still, he didn't back down. His imperious dismissal of the Turks was more than a defense of decisions made in the Hoving era; it was a betrayal of arrogance worthy of Hoving himself. Even after the loss of the Lydian Hoard, which he might have taken as a lesson in changing circumstances, his stiff-backed refusal to give so much as an inch when next confronted with cultural property claims was Hoving-esque, too. In his new role as journalist, Hoving himself had evolved, becoming an eager advocate for the source nations. Montebello felt he had to defend not just the Metropolitan but the Platonic ideal of the cosmopolitan museum as the protector of all mankind's past. He wasn't going to give things back—even if Hoving had bought them.

Finally, though, the truth did come out about Hoving's acquisition of the Euphronios krater and that mysterious silver service acquired right at the start of Montebello's reign. In *The Medici Conspiracy*, the journalists Peter Watson and Cecilia Todeschini recount how, in September 1995, Italian carabinieri and Swiss officials investigating the smuggling of ancient loot raided warehouses in the free port of Geneva that belonged to Giacomo

Medici, a middleman dealing in antiquities that ended up in museum and private collections like those of the Met and of Leon Levy and his wife, Shelby White, who'd become a trustee in 1991. The raiders found thousands of artifacts and a trove of documents and photographs that confirmed a vast and lucrative trade in looted antiquities.

A year later, the head of the Carabinieri Art Squad wrote to William Luers, asking for the return of the Morgantina silver. Ashton Hawkins replied, politely refusing. Copies of that correspondence somehow ended up in the hands of Robert Hecht, the dealer who'd sold the Met both the Morgantina hoard and the hot pot.

In 1993, the Metropolitan had refused the archaeologist Malcolm Bell's request to closely examine the Morgantina objects. But four years later, working with the Italians, Bell discovered two fresh pits in the floor of an ancient house at the dig site in Morgantina—clear evidence of modern looting. He also found two coins in those pits: one dating back to 211 B.C., the year Morgantina was sacked by the Romans, when the silver would have been buried; the other, a 100-lira coin minted by Italy in 1978, the year it was dug up. With that evidence in hand, the Italians asked again if Bell could see the silver. "Again the Met refused," Watson wrote, "describing Bell as 'biased' and his arguments as 'untrustworthy.' " Finally, in 1999, Bell was allowed to see the hoard, and found more evidence that it came from Morgantina. Simultaneously, the carabinieri produced a chain of ownership from the *tombaroli* who'd found the silver and sold it for about $27,000 to a Swiss middleman who'd sold it to Hecht for $875,000, and on to the museum, which paid $3 million.[119]

In 2000, Italian police raided Hecht's apartment in Paris, finding the two versions of Hecht's memoirs, with their varying accounts of the famed krater. More raids followed, including one at Medici's house north of Rome in 2002, where searchers found an album of photographs with images of the Euphronios krater. The Met refused an Italian request to interview Bothmer, who'd officially retired in 1990 but remained at the museum. It ignored a similar invitation to Ashton Hawkins. But the investigation was gaining steam. In 2002, a U.S. court gave the Italians an important lever when it ruled that foreign governments could claim undocumented antiquities if they had laws barring their export and trade.

The prosecutors weren't looking only at the Met; they also investigated the Getty Museum in California, where Bothmer's counterpart was Marion True. Eight years after the investigation began, Giacomo Medici went on trial in December 2003, and eighteen months later was found guilty of all charges and sentenced to ten years in prison, the forfeiture of his antiquities, and tens of millions of dollars in fines and damages. His appeal is still pending. A few months after that, Hecht and True were put on trial, too, charged with conspiracy to traffic in looted objects. That case would continue even after the Getty agreed, late in 2007, after two years of negotiations, to return more than forty contested antiquities.

Simultaneous with that trial's start, Montebello finally opened talks with the Italians. Though several objects purchased by the Met figured in Medici's conviction, Montebello called the evidence inconclusive.[120] Less than three months later, though, he did an about-face, "conceded that the standard of evidence he had demanded was unrealistic," in Watson's words, and agreed to return the krater, fifteen Morgantina objects, and four other vases to Italy.

Next, the Italians turned their attention to the Met trustee Shelby White, whose collection included many pieces from Medici's inventory. White's first husband, an investment banker, had drowned on a fishing trip, and she subsequently married his boss, Leon Levy, the co-founder of Oppenheimer & Co., who became a pioneer in hedge funds. They started collecting antiquities in 1975, displaying them in their home on Sutton Place, where female guests were sometimes asked to leave their purses at the door.

Their willingness to share their art with others had the unintended effect of making White and Levy easy targets. After a 1990 show at the Met called Glories of the Past: Ancient Art from the Shelby White and Leon Levy Collection, two British archaeologists did a study that concluded that 93 percent of the objects in that show lacked provenance. At best, that meant a loss for scholarship as no one would ever know where they came from or be able to place them in cultural context. At worst, it meant that they had been looted.

In 1995, when Levy turned seventy, he and White gave the museum $20 million toward new Greek and Roman galleries around the former Dorotheum, which was to be turned into a courtyard named for them; they

also promised the loan of many of their antiquities. Levy died in 2003, so when the Italians turned the heat up just before the opening of those galleries in April 2007, White stood the pressure alone.

At the time, Michel van Rijn, a former smuggler turned anti-looting gadfly, said that secret talks were under way, and White was being pressured to make a deal in order to ensure that high-ranking diplomats of Italy and Greece appeared and blessed the opening of the new antiquities galleries with their presence. "Shelby has taken a firm stand," said van Rijn. "She wants to go down in history as a great philanthropist, not a looter." White's interests were not in sync with the museum's, though. They negotiated separately.

High-ranking diplomats did not, in fact, appear at the Met opening, and it took nine more months before there was any resolution, but in January 2008 White returned nine objects from her private collection to Italy, including her Euphronios vase, and agreed to eventually send back a tenth, while continuing to insist she had purchased them in good faith. In return she won praise for her "great sensitivity" and a promise that Italy would henceforth leave her alone.[121] But soon Greece came calling, demanding the return of some of its property; White conceded, giving up a broken marble sculpture and a bronze vase. Was White's capitulation a confession of sorts? She has never fully explained her decision, beyond saying that she felt it appropriate.

PHILIPPE DE MONTEBELLO'S REIGN AT THE MET ENDED AS IT began—tangled up in the legacy of his predecessor. It's hard to follow anyone into a high-profile job, harder still to follow someone like the larger-than-life lightning rod Hoving. Long before he wrote his memoirs, Montebello had ample reason to resent him. But that wasn't Montebello's biggest Hoving problem. Despite his predecessor's role in creating the conditions that allowed him to become the museum's eighth director, Hoving was also responsible for the emasculation of that job, for the master plan that made it impossible for Montebello to build any monuments to himself, and, finally, for the antiquities mess, Montebello's own Waterloo.

Montebello was rightly hailed for his decision to return the Euphronios krater and other objects to Italy. Though he finally prevailed, Malcolm Bell, the excavator of Morgantina, felt Montebello had proceeded "with reluctance and ill grace." But how could it have been otherwise?

After yielding, Montebello sounded alternately defensive and peevish about his decision, disdainfully attacking cultural property activists—the people demanding the return of ancient art—as atavistic, sectarian hypernationalists and giving lectures and talks in which he declared himself a high priest of the Napoleonic religion of enlightened cosmopolitanism, defending the universal museum's role as the only proper guardian of the world's most precious relics. (Even if it happens that they were illegally looted.)

"True, things are not always done, and have not always been done, correctly in the past," he admitted at a 2007 lecture at the Met. "Still . . . [the] issue here is not the law, which must be obeyed, or fiefs that must be preserved; it is the current modus vivendi in cultural matters which is beholden to a new political correctness born of a fierce nationalism, and which has dramatically changed the natural order. Those of us who believe in the benefits of cosmopolitanism, interconnections, and the cross-fertilization of ideas, which is of course what the world's cultures reflect, see this new chauvinism doing a great disservice to mankind." He was convinced it had done him a disservice, too. And that obviously gnawed at him. Earlier, at a meeting of a society of museum directors in the summer of 2006, Montebello was overheard lamenting, "I'll be known for only one thing, giving things back, giving things *back*."

To his credit, though, Montebello did proceed, however reluctantly. And to *his* credit, William Luers, though furious over the way he'd been treated and the cost to the museum, never said, "I told you so." But neither did he forgive Montebello and Hawkins for sidelining him when diplomacy was called for. In 1998, as Malcolm Bell's new evidence came to light, Luers announced his retirement. A few months later, having secured a new position as chairman of a support group for the United Nations, he accelerated his departure and left the premises, vowing never to attend another museum party.[122]

"Philippe never gave him an inch of credit," says John Macomber. History likely will.

❖

IT MUST HAVE RANKLED BILL LUERS WHEN ASHTON HAWKINS, his nemesis in the antiquities struggle, threw his hat into the ring for Luers's job. Hawkins felt he'd put in his time and, as the Met's best widow walker since Ted Rousseau, deserved the position. "Dilworth told him he couldn't have it because he was gay," says a former Geldzahler aide.

Some felt Hawkins had sabotaged his own ambitions. Not only was he gay, but he broadcast that fact "among sophisticated worldly people who thought it was fine to be gay as long as you never talked about it," says one of his lovers, a little bitterly. "Ashton wrecked his own chances," the Geldzahler aide agrees, noting what others confirm: "He was drinking a lot in those days," and word got around. He took to showing up at private parties with "three, five, ten gay men" in tow; they were dubbed the Ashtonettes. On the subject of Hawkins, the centennial planner George Trescher would paraphrase the poet Lord Alfred Douglas: "The love that dare not speak its name won't shut up." But others believe that another gay man could have had the job. Hawkins, whose bloodlines ran back to Colonial times, who had gone to the right schools and had waited his turn, "had been there too long," says the Met watcher. "He was a throwback to the era when the job was about lunch and coddling."

Hawkins was kicked upstairs to executive vice president. He stayed at the museum until 2001, but friends say he paid less attention. "He'd spend five weeks in Greece," at a house he shared with the Cloisters curator Tim Husband, "take three-day weekends, summer was from April until Thanksgiving," says a city official. "They screwed him, so he could do what he wanted."

Luers and Punch Sulzberger both retired on November 11, 1998. Sulzberger was replaced by James "Jamie" Houghton, Arthur Houghton's nephew, who'd been a classmate of Montebello's at Harvard. Luers was succeeded by David E. McKinney, the first non-diplomat to take the paid presidency. A thirty-six-year veteran of IBM and right-hand man of Thomas J. Watson Jr., the son of its founder, McKinney, sixty-four, had retired from the computer giant in 1992. "Other than taking art classes and visiting mu-

seums," Sulzberger's newspaper noted, McKinney had no background in art. Like McKinney, Houghton was a colorless manager. Simultaneously, Montebello was named chief executive officer, putting him firmly in charge of the museum after two decades as its director. It was a tribute to his patience, as much as to his skills, that he finally restored the director's traditional power.

ASIDE FROM DEALING WITH MONTEBELLO, THE GREATEST DIFFI-culty William Luers faced in his tenure as museum president was the huge cut in public funding that followed the stock market crash of 1987 and continued into the recession of the early 1990s. In June 1991, when Ed Koch's successor, David Dinkins, kicked off a museum festival on Fifth Avenue, the Metropolitan Museum of Art sat unlit and closed down, having withdrawn in protest against a staggering $3.5 million cut in city funding, set to take effect in the 1992 fiscal year, with more cuts expected.[123] That year, New York State reduced its support of the museum, too, as conservatives in Congress attacked the National Endowment for the Arts. Luers worried that public financing for the museum might disappear altogether.[124]

Deficits at the Met were climbing. Though the board had raised enough capital funds to cover its debt service and the museum had posted surpluses in the 1980s, in the 1989–1990 fiscal year it had a $2.6 million shortfall before debt payments. With those factored in, the deficit nearly doubled. To stanch the bleeding, the Metropolitan began shutting galleries, instituted a hiring freeze, and halted salary increases for nonunion employees. Luers told the *Times* that the Metropolitan would do without washing its windows, a $120,000-a-year luxury it could no longer afford.[125]

But as so often in the past, private money rode to the rescue. In 1992, gifts and grants for non-exhibition purposes rose almost $2 million, to $18.4 million, while funding for special exhibitions increased by $1.1 million, to $6.3 million; private gifts topped city support for the first time and have remained the main funding source ever since. Annual giving through the Corporate Patron Program was $2 million in 1987. In 1992, the last year for which figures were broken out, the committee raised $2.41 million. In

return, the corporate committee hosted benefit dinner dances for patrons. Brooke Astor was feted in 1989, and in 1991 the benefit honored the chairman of the Lila Wallace—Reader's Digest Fund.

Another innovation was an aggressive international fund-raising effort. In 1989, Dr. Rokuro Ishikawa, head of the Kajima Corporation, a big Japanese construction company, was named to run the museum's International Business Committee. In February 1993, Luers accompanied Mayor Dinkins on a goodwill visit to Japan. The Metropolitan's annual report that year notes a continued focus on "a more global approach to fund-raising." Ishikawa was ensnared in a bribery and bid-rigging scandal after it was revealed that his company had given tens of millions of yen to government officials in return for preferential treatment in the awarding of public works projects. Ishikawa was never charged, but he resigned from his posts at the Tokyo Chamber of Commerce and Industry and the Postal Service Council in disgrace.[126] He remained chairman of the museum's International Business Committee, however, and then chairman emeritus until his death in 2005.

City funding of the museum eventually inched back up, but less than one-third of the 1992 cuts were restored. In August 1993, the Met issued $63.8 million in tax-exempt bonds to refinance the outstanding $40.5 million debt left from an earlier bond, saving $700,000 annually in interest payments and providing an additional $22.1 million in financing for capital projects. In the same period, private gifts continued to rise, nearly doubling the museum's endowment but, more significantly, returning the museum to what it had been at its founding: a private club.

The displacement of public capital by private funds was reflected in decreasing transparency. As public funding declined, so did the museum's obligation to accountability. Annual meetings of the corporation became public relations exercises; at one recent board meeting before the annual charade, Jamie Houghton suggested trustees attend only if they wanted to be thoroughly bored. So, aside from the handful of NIMBY neighbors upset by traffic, crowds, and noise and fearful of more surreptitious expansion, there was no one left to call the museum to account.

Emily Rafferty would shortly replace David McKinney and become the Met's first woman president; her fortunes rose in lockstep with the mu-

seum's new focus on fund-raising. Her mother, she once told a *Vogue* reporter, was related "to the Livingstons and Peabodys and all that."[127] Her Irish-Catholic father had grown up in society during the Depression and became a senior partner at the law firm Carter Ledyard & Milburn. In 1958, when its client John Hay "Jock" Whitney took over the *New York Herald Tribune*, he was named to its board of directors. Emily was raised in a large family on Park Avenue and attended the chic Convent of the Sacred Heart and Chapin schools. Montebello's wife, Edith, was her ninth-grade math teacher. A 1967 debutante, she went to Pine Manor Junior College and graduated from Boston College in 1971.

Though she majored in African and Middle Eastern history, she went to work as an assistant to David Rockefeller Jr., a Boston arts philanthropist. After a brief stint at Boston's Institute of Contemporary Art, she moved to the Met in 1976 as a secretary in the still-new development (that is, fund-raising) department, shortly before marrying an accountant, John Rafferty. She was promoted to manager in 1981, the museum's first female vice president in 1984, senior vice president in 1996. She was energetic, efficient, driven, and a natural at fund-raising. "It . . . helps if the person doing the fund-raising comes from a social or a money background that allows you to sit at the table as a quasi-equal, which she can do, which I can do," an admiring Montebello has said.[128]

When Luers retired, Rafferty's domain was renamed external affairs, encompassing development, sponsorships, and memberships, and she was made staff liaison to a trustee committee chaired by Michael Bloomberg, the information-technology billionaire and future mayor of New York, and put in charge of the Internet task force developing the museum's Web site.

THERE HAD BEEN A CHARISMA VACUUM AT THE TOP OF THE Metropolitan's hierarchy for years, and in the Montebello era Diana Vreeland and company filled it, adjusting the tone of the place, changing the face it showed to the world, altering how people perceived it subtly but steadily. The writer William Norwich would cleverly dub the phenomenon Club Met. This latest iteration of the museum as a social center of gravity

emerged in the early 1980s and remains in place today, a by-product of the Met's ever-more-elaborate fund-raising process.

Down in the basement, Diana Vreeland had been running a semiautonomous operation ever since her first shows in the early 1970s. When Montebello took over, Vreeland's friends fretted that he would disdain her frivolity. "Wrong!" says Katell le Bourhis, who would shortly become her chief aide. As she came to understand his concept of balancing scholarship, accessibility, and "events to bring in enough money to support all the costly endeavors," Vreeland grew comfortable with her place in his "modern museum," Bourhis says. "Tom Hoving had a vision, but he couldn't realize it. Everyone was pulling in a separate direction. Philippe had the capacity to bring it together." The Costume Institute would be central to that process.

"The moment she arrived, she was the editor of *Vogue* again," says Stuart Silver, who watched as Vreeland secured her position with a series of blockbuster shows, beginning in 1974 with Romantic and Glamorous Hollywood Design, which Silver designed. "Talk about the opposite of the curatorial mentality! She had an open bottle of scotch on her desk, she lacquered her hair once a week, she had a red smear of a mouth. And that voice! I thought she was a clown, but she was very smart and very wise and just went full out."

Emboldened by her initial success and surrounded by a group of eager volunteers whose only payment was the chance to be in her presence, Vreeland ignored Stella Blum and her scholarly ways, calling her chief curator "the old one," and set out to get people talking by having American designers secretly reconstruct famous screen dresses that had long since disappeared. "She didn't have any curatorial sense," the Council of Fashion Designers of America founder Eleanor Lambert told Vreeland's biographer Ellie Dwight. "No curator of an art exhibition would ever put a fake in it." But the crowds didn't care, and neither did the press. The costumes had "been worn by the stars of the silver screen," the gossip Suzy wrote, reporting on Jane Engelhard's opening-night party for "500 hand-picked people," Mick and Bianca Jagger among them. They dined in a salon decorated by the power wives Mica Ertegun and Chessy Rayner before they were joined for cocktails by another 1,300, among them Cher, "who made dead sure she was noticed by wearing nothing under her transparent chiffon pajamas."[129]

"She invited her friends, her world," says Bourhis. "It was international café society." Vreeland unveiled her most powerful weapon at her 1976 show, The Glory of Russian Costume. Jacqueline Onassis, just widowed for the second time, had always shied away from public display, but she not only served as chairman of that Party of the Year; she published the exhibition catalog, the first book she commissioned in her new job as an editor at Viking Press. The former first lady not only accompanied Vreeland to the Soviet Union while she was preparing the show (one of the five exchange exhibits negotiated by Hoving); she also helped overcome Soviet resistance to loaning objects once owned by the czars. A year later, Onassis wrote an introduction to the catalog for Vanity Fair: Treasure Trove of the Costume Institute, a sort of greatest-hits show. Surveying the two thousand guests at that Party of the Year, Stella Blum sagely observed that "fashion cannot exist without a leisure class."[130] Neither could museums.

The fates of fashion and the Metropolitan were increasingly entwined. Vreeland's 1980 show, The Manchu Dragon: Costumes of China, followed by a mere three months a China-themed promotional blitz by Bloomingdale's, the trendy New York department store, where several of the robes the Met later showed were first displayed, reprising the 1947 Costume Institute show, when garments moved from the store to the museum.[131] A Valentino fashion dinner followed in the fall of 1982. After a couture show for a thousand guests in the museum restaurant, a third of them stayed for lobster at the Temple of Dendur. The crowd included Muhammad Ali, Mikhail Baryshnikov, Raquel Welch, Placido Domingo, several American designers, Pat Buckley, Doris Duke, and Nadine de Rothschild. As they left, they could visit a display of Valentino's ready-to-wear, set up near the museum shop.

Two years later, Vreeland dragged the Met even closer to commerce when she mounted her first exhibition of the work of a living, breathing designer, Yves Saint Laurent, who toured the exhibit hand in hand with Vreeland. That was the last show she organized herself—tragically for a visual genius, her eyesight was failing. But not even Montebello, who approved the Saint Laurent show, could chart the tricky path ahead.

The 1984 Costume Institute show, Man and the Horse, was a watershed. Vreeland turned up for the opening and again toured it with a de-

signer, Ralph Lauren. Though he was quick to point out that he didn't have so much as a blazer in the exhibition, this time the criticisms were louder; Lauren's company had paid $350,000 to underwrite the show in a deal "masterminded by the museum's chief fundraiser, Emily K. Rafferty," the author Debora Silverman reported. In return for his donation, "the Met agreed to affix Lauren's own name and the sportswear logo, Polo, to all the publicity associated with the show, from poster to invitations to catalogue and postcards, as well as to the walls of the exhibition galleries."[132] It was the last Party of the Year that Vreeland would attend. She skipped the next, The Costumes of Royal India, pleading a cold. In truth, after dressing, she decided against going.[133]

Vreeland died in 1989. But it was her spirit as much as Montebello's plummy voice that set the tone of the modern Metropolitan. Its new glamour and continued high profile were her doing, and she was praised for it— and blamed. Since 1978, Pat Buckley, an Auntie Mame–like character of great wit and eccentric style, had served as chairman of the Party of the Year. Buckley, of course, was the wife of William F. Buckley Jr., the founder of the conservative National Review, a casting choice by Vreeland that helped inspire Selling Culture, Silverman's scathing critique of Vreeland, the museum, and the Reagan-era elite that sustained it. The book was published in 1986, midway through Reagan's second term in office, shortly after a White House dinner where the guest list included the Buckleys, the Montebellos, and the museum trustees Leonore Annenberg, Drue Heinz, and Brooke Astor. The author accused all concerned of debasing the purpose of the founders and promoting a cult of wealth committed to distorting history in favor of producing nothing less than an amoral, inauthentic culture that celebrated not obligation but "aristocracy as posture."[134] Not the message the Metropolitan had been founded to advance.

Yet for the rest of the decade, it was the subtext at 1000 Fifth Avenue. In 1989, the journalist John Taylor would summarize the decade's Met in a devastating New York magazine cover story called "Party Palace." Sometimes private (like Sid Bass's fiftieth birthday party), sometimes honoring donors (like a 1988 dinner for Gianni Agnelli, who'd given $300,000 to restore and display seventeen Pompeian frescoes), sometimes commercial (a

Catherine Deneuve perfume launch), sometimes semipublic like the Costume Institute parties and the museum's annual spring gala, the parties provided the hoi polloi with near-weekly glimpses of how the city's better half lived, dressed, ate, and accessorized themselves; the great museum plaza became a runway for the era's aspirational role models.

In 1988, with the public tiring of all the display, Pat Buckley sought to distinguish between two eras and two sets of scene makers. "It's the new people," she insisted, worrying aloud she'd be mistaken for Marie Antoinette. "They're getting *us* mixed up with *them*."[135] She was right; us and them were all mixed up. What to make of Annette Reed, who was newish and part-Jewish but married to old money? A *New York Times* spread on an Indian art opening in 1985 featured Reed, Dillon, Dilworth, Jacqueline Onassis, Barnabas McHenry, Oscar de la Renta, and the maharaja of Jaipur, who was quoted telling Annette, "I am descended from the sun."[136] Now, *that's* old.

At one real estate council dinner in the Temple of Dendur, the trustee Frederick Rose called it the Temple of Din-Din. That was because donors who pledged $25,000 or more to the museum could buy the chance to host parties there. The *New York Times* attempted a joke about the limits of the museum's "drift toward commercialism," which was epitomized, it said, by "the sale of van Goghmania at the entrances and exits" of the latest blockbuster exhibit. That had inspired the relatively liberal art critic John Russell to describe the ringing cash registers as "the single most offensive sound that I have ever heard in a great museum."

"Critics might well ask—and have—'What next?' " the *Times* wrote with a snicker. "Wedding parties in the Temple of Dendur?"[137]

The joke became a reality two years later. In April 1988, Saul Steinberg and his third wife, Gayfryd, rented out Dendur for $30,000 and spent another $3 million on a French Directoire–themed dinner for five hundred guests, celebrating the wedding of his daughter to one of Bob Tisch's sons. Nine months later, Sid Bass's parents entertained 166 guests in the Medieval Hall for cocktails and the Charles Engelhard Court for a dinner celebrating his marriage to the former Mercedes Kellogg. In tune with the times, details of the decor (Christmas trees surrounded by white narcissi),

the entertainment (eighteen strolling violinists), and the menu (poached lobster in caviar sauce, pheasant bouillon, roasted quail with foie gras, and a toast with Krug Rosé champagne) appeared in *W* magazine.

Also published, the last word of Bass's toast to the bride: *"Yahoo!"*[138]

In between the two wedding parties, Henry Kravis hosted a party, too, for no reason other than to show he could, and afterward treated his guests to a private viewing of the latest museum blockbuster, a Degas show in the Tisch Galleries in the Kravis Wing. "It is their own Palace in the Park," Taylor would shortly write. "After all, their names are on the wings and the galleries and on the plaques lining the walls of the main staircase . . . They, not Philippe de Montebello, decide on the important acquisitions . . . They celebrate their birthdays and their weddings and their triumphs here. It is theirs. *Theirs!*"[139]

Private parties would continue. Gianni Agnelli's seventieth birthday, hosted by Henry Kissinger and Oscar de la Renta, would attract 180 in 1991. But not long after Taylor's article was published, the museum banned weddings from the premises. Which probably annoyed Annette Engelhard Reed no end. For she was about to get married—again.

WHILE STILL LIVING WITH SAM REED, ANNETTE HAD BEGUN shopping for a new husband. "She was unhappy," says a lifelong acquaintance. "Sex had gone, as it does. Sam was not much fun." But she couldn't marry just anyone; her mother's daughter, she had to be *bien mariée*. "You could see her ambitions," says her mother's friend from New Jersey. She dated William Paley and took a run at a Rothschild. "She always wanted to be one of *those* people," says another friend of Jane's. "Everyone knew she wanted to marry one of her mother's friends. In her eyes, they were the epitome of international power and social position."

Jane, no fan of Sam Reed's, "disapproved of Oscar," too, says her New Jersey friend.

"I know that tango type," she said.

In 1989, Oscar de la Renta was one of America's top fashion designers and a leading member of café society. Fifty-seven years earlier, he'd been

born Oscar Aristides Renta Fiallo, the only boy among seven children in his middle-class family. Though detractors claim his name change was an act of self-invention, both his parents did come from distinguished families. His father's forebears were landowners in today's Dominican Republic; a branch of the family moved to Puerto Rico, where they established the city of Ponce, where the designer's paternal great-grandfather, José Ortiz de la Renta, was mayor through the first half of the nineteenth century. His mother was the youngest sister of General Federico Aladio Fiallo Perez, the right-hand man, army commander, secretary of state, and chief of military intelligence under Rafael Trujillo, the Dominican dictator from 1930 to 1961. Fiallo would shoot himself in 1962 as a mob surrounded his house on the morning he was to be charged with the ambush and massacre of eight of Trujillo's political enemies.

Luckily for Oscar, he was long gone. He'd moved to Spain in 1952 at his uncle's urging to study painting, and would later say he was so lonely there he cried himself to sleep every night—until he discovered Madrid's famous nightlife. When he refused to go home and join his family's insurance business, his father cut him off. He was rescued from penury and, by his own account, malnutrition by an Estonian-born baroness with White Russian ties.

Aino de Bodisco was *not* a catch; she had bad skin and wore heavy makeup. But she was wealthy and well connected. After two divorces—one of which a relative describes as "Armageddon; it went to the Supreme Court"—she moved to Madrid with her daughter in 1948, which is where she met Oscar in February 1955. A proposal for a book about him, written years later at the instigation of her heirs, says she was "alone, rich, rattling around in a grand old palazzo and just waiting for a 23 year old handsome man in need."

Bodisco fell in love with him, installed him in an apartment, bought him clothes and food, and began "a close social, personal and business relationship" with him. She later told friends that she'd not only "kept" him but created him, convincing him to turn his artistic skills to fashion design and winning him an apprenticeship at a Madrid fashion house, which led to work for the renowned couturier Balenciaga.[140] In apparent thanks, in 1956 Oscar offered her half of any money he made for the rest of his life and into

eternity if she would continue to support him. The deal seemed to pay off not long after that when she took him to a cocktail party at the American embassy in Madrid, where he met Francesca and John Davis Lodge, the American ambassador to Spain. Bodisco wore a dress he'd designed, the Lodges' daughter borrowed it, wore it to the White House, ordered three more, and asked him to design another for her debutante ball. *Life* magazine photographed the fittings, and his fashion career was launched.

In 1961, Aino and Oscar moved to Paris, where he worked as an assistant to Antonio Castillo, the couturier at Lanvin. A year later, Elizabeth Arden offered Oscar a job in New York. Three years after that, he launched his own label as Oscar de la Renta. Friends of Bodisco's say the restoration of the "de la" to his name was her idea. It does not appear on his 1962 application for a U.S. visa.

After the move to New York, he left his sugar mommy. "The moment he received a livable salary, he dropped me," she wrote to the Lodges. "His excuse for using, abusing and disposing of me was that he had fallen in love with someone else," a devastatingly handsome American man who would soon become well-known in New York's gay underground.[141] For the next thirty years, the spurned Aino would shadow Oscar, sometimes appearing as a friendly supporter, sometimes as a needy specter from his past, sometimes demanding money, sometimes taking gifts of dresses, and, finally, hiring the notorious lawyer Roy Cohn to sue him, unsuccessfully, for $2 million in 1979.

In the meantime, Oscar had prospered—in part due to a strategic marriage. In 1966, he'd been seated next to Françoise de Langlade, French *Vogue*'s editor, at a dinner party at Maxim's in Paris for the Duke and Duchess of Windsor. Slightly older than he, Langlade was also the child of an insurance salesman. She was twice divorced, and her latest affair, with a Rothschild, had ended messily after his wife discovered the dalliance and confronted Langlade in public, according to Aino. She was looking for a face-saving exit from Paris.

By the summer of 1967, Oscar and Françoise were engaged and globe-trotting with the likes of the William Paleys. In society, it was generally assumed that Françoise, like Oscar, was bisexual. That fall, Oscar won a Coty award and gave a dinner dance at the St. Regis Roof to celebrate. The cou-

ple were the toast of New York. They bought a Fifth Avenue duplex, in-
stalled her maid from Paris, and got married a few days later on Halloween.
A day after that, they had cocktails with Jane Engelhard and then headed
off to a country weekend highlighted by Drue Heinz's luncheon in their
honor—their every move chronicled by the fashion columnist Eugenia
Sheppard.[142] With his new wife promoting him, Oscar's career took off, and
their enviable marriage and perfect homes were featured in newspapers and
glossy magazines around the world—until Françoise died of cancer in 1983.
"My wife died at four A.M. and I called Annette at six A.M. and she didn't
leave my side for twenty-four hours," de la Renta told Meryl Gordon, au-
thor of a book on Brooke Astor.[143] He and Annette were first publicly linked
in the fall of 1984, when they co-hosted a benefit concert commemorating
Bach's three hundredth birthday. By 1988, Annette had left Sam Reed for
Oscar, and they married after she and Sam were divorced in 1989.[144] The
only resistance came from her family. Before the wedding, Jane's New Jer-
sey friend was at Cragwood with several of Annette's sisters when the talk
turned to Oscar's rumored bisexuality. "Jane said that wasn't the point. He
could give her the life she wanted."

Annette and Oscar were wed at his home in the Dominican Republic
on December 26, 1989, two days after Annette's fiftieth birthday. Their
wedding announcement, which didn't say if her mother attended, described
her as Charlie Engelhard's daughter; her biological father had vanished. Her
mother would soon as well. Although the magazine of her husband's friend
and former political rival Malcolm Forbes continued to list Jane as one of
its four hundred richest Americans with a fortune estimated at $365 mil-
lion, she actually had far less than that left. After André Meyer's death, the
asset sales became more frequent. "She had to get rid of houses and horses,
which she did very efficiently," says her New Jersey friend.

Eventually, everything went. In October 1995, she sold most of her
books at Christie's; they fetched about $1 million. The next June, she sold
Cragwood and the best of her remaining paintings. Christie's considered
them so desirable it took them on tour to Singapore, Tokyo, Paris, and
Zurich and published a hardbound catalog, even though there were only
nine artworks in the sale. But given their quality—the sale included a
Monet *Water Lilies* that had once belonged to Mrs. George Blumenthal, an-

other Monet of his garden, a rose-period Picasso, and a Boudin view of the jetty at Deauville—and the $25 million estimate placed on them, that wasn't really so surprising. The bet paid off; the auction netted almost $31 million. Multiple bidders drove two Monets up to $13.2 million each.

A few months later, Christie's sold Jane's copy of the presidential proclamation of the Louisiana Purchase for $772,500—well under its estimate but impressive nonetheless. "She got enough money to live in a place that she actually liked," says a friend, and moved permanently to an eighteenth-century brick mansion on Main Street in Nantucket, where she lived out her days. She gave more objects away, too; a Houdon bust of Benjamin Franklin went to the Morgan Library.

"When she left Cragwood, it all ended," the New Jersey friend says. Long a user of prescription drugs, in her later years she became an abuser. She had multiple doctors who gave her multiple prescriptions. And she exacerbated her condition by drinking. "She was embarrassed by her problems," says her friend. "She just got weary. Everyone said she'd given up." No wonder they thought so. "She saw no one."

Annette's attitude toward her mother in her last years is a subject of debate among those who know her. It's said that she did her best to manage her decline but also was glad that her mother had exiled herself. "When there's that much money at stake, people on all sides swear they're telling the truth," says a friend of the younger Engelhard daughters. "As Jane got more alone and isolated, it seemed people were moving in, making decisions for her. You didn't talk to Jane anymore. You talked to people in Far Hills who were selling off her land." This friend wonders if she wasn't being psychologically manipulated. "She sat there like furniture, getting all kinds of confused medical messages." At one point, some years earlier, Jane had tried rehab at St. Mary's Hospital and Rehabilitation Center in Minneapolis. "But if you're hurting and something helps, you'll do it again," he says sadly.

WITH PAT BUCKLEY AND KATELL LE BOURHIS PRESIDING AND Annette and Oscar pulling strings in the background, the Costume Institute's parties and exhibits went on as before as Diana Vreeland lay dying.

But in the early 1990s, a new restraint dimmed the proceedings. As the museum searched for a replacement for Vreeland, and fashion lost direction after the giddy 1980s, the Costume Institute lost its fizz. Its exhibition space was cut down by almost two-thirds to make way for a new employee cafeteria. Two new curators were hired, Richard Martin and Harold Koda, who'd put on widely admired shows at the Fashion Institute of Technology, but their first few Met shows were tentative as they tried to find a middle ground between Vreeland's way and the museum's. "There is no razzle dazzle," complained the *Times*. "A little would help."[145]

Though the usual suspects still paid $900 a head to attend, and Blaine Trump, a pretty and popular new socialite, signed on as co-chair, even she admitted that the soufflé had gone flat. A 1993 tribute to Mrs. Vreeland's "immoderate" style failed to pick things up. The Party of the Year was "ailing" and "no longer an exclusive evening," a critic said.[146] So the next year, Oscar, sixty-two, and Bill Blass, then seventy-two, replaced Trump as the co-chairmen, albeit without much enthusiasm.

Annette de la Renta had been named a vice chairman of the museum in 1993, though, and it wasn't long before her influence was felt; she and Oscar were about to turn the museum into a vehicle for their social ambition. In 1995, there was a bloodless coup at the Costume Institute, and Pat Buckley and her older society crowd were nudged aside, replaced by Annette, Anna Wintour, the editor of *Vogue*, and Clarissa Bronfman, the wife of a liquor heir who'd recently invested in a fashion line. A year later, in what appeared to be an attempt to spread the work and the wealth fairly, the baton was passed to Wintour's chief competitor, Elizabeth Tilberis, the editor of the rival *Harper's Bazaar*, for the opening-night party for a show on Christian Dior, the first since Man and the Horse that gave off the scent of overt fashion promotion. "Just another tedious, overtouted soirée," wrote the *New York Times*, which added that not even an appearance by the Princess of Wales could "lift the crowd above a certain dutiful enthusiasm."[147]

After that, Emily Rafferty and Annette gave the chairman's role back to Wintour—and the long-playing cast of society characters was permanently replaced by fashion high jinx and low commerce, to the delight of the crowd. In years to come, Wintour's co-chairmen would include socialites old (Jayne Wrightsman), new (Mrs. David Koch), and in-between (Caro-

line Kennedy and Stephanie of Monaco), but more often they would be the ruling class of the new, commercialized simulacrum of society: fashion marketers like Tom Ford, Tommy Hilfiger, and Aerin Lauder and movie stars like George Clooney, Julia Roberts, Nicole Kidman, and Sienna Miller. In recognition of her success, Wintour was named an honorary trustee in 1998. Though her importance to the museum was often dismissed by art lovers as negligible, her effect on its image was incalculable. Like fashion, the cast of characters now changed annually and grew ever less exclusive. The Party of the Year, though still a fund-raiser, was now also a marketing opportunity for all concerned.

In 2000, the fashion takeover of the museum seemed complete when a show featuring Chanel was announced, to be paid for by the brand and guest curated not by curators but by Chanel's designer Karl Lagerfeld, who communicated with the museum through a friend, Ingrid Sischy, then editor of *Interview,* a magazine fixated on novelty and fame. Worse in many minds, it would be staged not in the basement institute but in the Iris and B. Gerald Cantor Galleries, steps from the museum's European paintings. But shortly after the show was announced, Montebello abruptly canceled it. Some said he did so because Richard Martin had recently died and would not be there to stand up to Lagerfeld. Others posited that Lagerfeld and Montebello fought over the meaning of the word "contemporary."

Michael Kimmelman, the latest art critic at the *Times,* suggested that the cancellation was actually caused by a show called Sensation, held the year before at the Brooklyn Museum. An exhibit of new British art from the collection of the advertising man Charles Saatchi, it was condemned as too commercial by museum purists, who accused Saatchi of trying to raise the value of his collection, and as sacrilegious by New York's mayor, Rudolph Giuliani, who objected to a portrait of the Virgin Mary adorned with elephant dung. The mayor's opinion was supported in an Op-Ed piece by Montebello, who insisted, under the headline "Making a Cause Out of Bad Art," that the mayor had a perfect right to judge the show "either repulsive or unaesthetic or both."[148]

But a mere five years later, Chanel and Lagerfeld infected the Met after all, in a show that Kimmelman called "a fawning trifle that resembles a

fancy showroom." The critic also intimated that by reversing course, Montebello was trafficking in moral hypocrisy. The same week Kimmelman's critique ran, New York magazine put the Chanelized Party of the Year on its cover. No longer was the magazine criticizing the museum; instead, it lionized the planners and participants, most especially Anna Wintour and Emily Rafferty, who'd just replaced McKinney as president. "The sponsors"—Chanel and Condé Nast had paid the estimated $2 million cost of that year's party—"give a lot of money," Rafferty told the magazine, "and we make sure they're satisfied." Anna's Party—as it would henceforth be known—struck a new balance between art, commerce, and society. "At the Costume Institute Ball, it is real taste that counts," New York wrote. So "in the end, the Met is happy to overlook the implicit commercialism. After all, it gets to play host to a lot of those super-rich benefactors. And amid all the bedazzlement and air-kissing, who would be so crass as to mention a little thing like commercialism?"[149] Certainly not Montebello or the de la Rentas, who knew that their product, too, was being sold.

But at the ball celebrating the May 2006 opening of a show of British designs called AngloMania—attended by Charlize Theron, Lindsay Lohan, Sarah Jessica Parker, Drew Barrymore, Jennifer Lopez, Jessica Alba, Victoria "Posh Spice" Beckham, Scarlett Johansson, the fashion-challenged Olsen sisters, and the odd man out, the Duke of Devonshire—a lone voice in the crowd did suggest that the emperors had no clothes. John Lydon, a.k.a. Johnny Rotten of the Sex Pistols, was determined to make a mockery of the moment.

According to the New York Times, the "oafish" Lydon, who "was itching for a good fight . . . wobbled around the edges of the party," insulting guests, offering the sweater off his back—which he'd designed—to Wintour (she "quickly handed it off to a museum officer"),[150] and for his finale, which was not reported by the Times, walked around giving museum guards Nazi salutes and barking "Fashion!" in a tone that made it abundantly clear he meant "fascist." It was performance art worthy of Sensation.

❖

JANE ENGELHARD DIED OF PNEUMONIA ON NANTUCKET IN FEB-
ruary 2004. Just as she'd taken her mother's board seat at the Met, Annette
immediately took charge of her mother's departure and her legacy. She'd al-
ready shocked some of her mother's friends by having her papers, stored in
a New Jersey warehouse, "carted off to be shredded," says one.

Her sisters, Charlie's four daughters, had long since "opted out" of her
mother's orbit, says a friend of Jane's. They'd lived free, wild lives compared
with Annette. "They ran as far and fast as they could," says their friend,
adding that they were running not only from Jane but from lots of "painful
memories." In Jane's last years, they let Annette, the one who cared, inherit
her mantle and the attendant responsibility.

Annette was quick to take the lead, running Jane's funeral, even bar-
ring one of her mother's closest friends. Though few people are willing to
be quoted by name when criticizing Annette, longtime family friend
Woody Brock will because he was outraged by that. "Annette couldn't resist
turning the funeral into yet another one of her staged B-string social-
climbing events," he says. "As her mother would have said in her inimitable
way, summarizing matters in one pithy word: '*Incroyable!*' There was a time
when bad character and poor behavior of this kind would have cost you
your perch in society. But that time has gone."

Annette didn't stop there. She also tried to dictate what would be said
in her mother's obituary, leaving out what friends consider some of her
greater accomplishments: helping to gain landing rights for the Concorde,
which won her a Legion of Honor from France; her work with the Library
of Congress; her appointment as the first female commissioner of the Port
Authority of New York and New Jersey; and, says one friend, quietly help-
ing Henry Kissinger with his first diplomatic overtures to Communist
China.

Annette "refuses to talk about her mother," says a baffled friend of
Jane's. "She doesn't want her mentioned. And though Jane was extremely
generous when she was alive," after her death, "lots of friends got no re-
membrances at all."

Sam Reed died a year after Jane, and again Annette had to run a fu-
neral, but she did it in style for the father of her three children. "She'd
nursed him," says her lifelong acquaintance, "kept him alive with the best

doctors." And then she "gave a party for him at one of those swell clubs on Fifth Avenue," recalls an attendee, "and everyone came."

Not long after Sam died, when Jane's remaining furniture, jewels, and more of her famous book collection were auctioned off at Christie's, *Vogue*'s William Norwich declared it Annette's coronation before a court that stretched "from museum curators to Park Avenue decorators." The queen is dead. Long live the queen. Among the items sold were a signed copy of the Duke of Windsor's memoirs, which brought $420, well under the low estimate, and a set of stemware from the Houghtons' Steuben Glass, engraved with what the catalog called the Engelhard crest of an armed, crowned angel above a coronet. The 105 glasses sold for $9,000. A big furniture sale brought in almost $4.5 million and included a gilt wood table made for Napoleon's uncle that sold for $168,000.

Following the stock market crash of 1987, economic fear and bad publicity drove New York Society underground, and by 1991, when the *New York Times* asked who might succeed Brooke Astor at the top of the city's philanthropic pecking order, the answer was no one. The live wires of the 1980s—the Kravises, Trumps, Steinbergs, Perelmans, and Gutfreunds—had lowered their profiles. Public posturing had gone out of fashion. But still, there was Brooke Astor. And always nearby was Annette de la Renta.

As these words were being written, the last chapter of the Brooke Astor saga was still playing out. Her decline was slow but steady, and finally, in the summer of 2006, when she was 104 years old, all that was left was waiting for her death. It was then that one of her grandchildren, backed up with affidavits from Annette de la Renta, David Rockefeller, and Henry Kissinger, sued to have his father, Brooke's only son, Anthony Marshall, removed as her guardian and replaced by Annette and the JPMorgan Chase bank. Among the ugly charges made: Marshall had fired Brooke's longtime butler and forced her to sleep "in chilly misery on a couch that smells of urine," according to the *New York Times*.[151]

Those accusations of elder abuse, apparently inspired by complaints from Astor's household staff, set off a fierce legal and public relations battle that would continue for more than two years, first in state supreme court, then in Westchester Surrogate's Court and New York Criminal Court, over her care and then her estate. Annette was portrayed as Astor's

protégée and protector, Astor as "something of a surrogate mother" with "an intensely firm bond" to her.[152] Marshall, then eighty-two, a onetime marine and minor diplomat, was disdained by his mother's social friends, who found him dull and accused him of looting his mother's assets.

Annette was made Brooke's temporary guardian, and promptly re-hired the dismissed butler. In September 2006, Marshall, who'd joined the museum board twenty years earlier, attended his last meeting as a trustee emeritus; fourteen months later, the executive committee would quietly vote to suspend him.[153] That October, Marshall acquiesced in a settlement, returning about $1.3 million, art, and jewelry and giving up his right to make health and financial decisions for his ailing mother; in return, he was allowed to keep millions of dollars JPMorgan Chase maintained he'd siphoned off while managing her finances—even though her assets had grown from $19 million to $82 million while he was in charge.

In December 2006, with considerably less fanfare, the state supreme court judge overseeing the case said that the claims of elder abuse "were not substantiated."[154] In the interim, however, it had emerged that Marshall and his second wife (who was cast as "a penny-pinching gold-digger"[155]) had taken control of a great deal of his mother's property, sold her favorite painting, *Flags, Fifth Avenue* by Childe Hassam, and misstated the profits on her tax return. Soon, Marshall and a lawyer were accused of inducing his incompetent mother to sign two codicils to her will and, allegedly, forging her signature on a third, in order to move vast bequests away from the Metropolitan and other organizations and into Marshall's hands. The Manhattan district attorney opened an investigation. As the months passed, and Astor lay dying, the intimate secrets of her life became fodder for gleefully salacious tabloid stories. Her assets and finances were revealed, as well as what was being spent on her care. She had only $816 in her checking account, but somewhere around $131 million (later upped to $198 million) altogether. This was just the sort of exposure that well-bred wealth abhors.

Astor finally died of pneumonia at 105 in August 2007. Within days, Annette and JPMorgan Chase filed papers challenging her will and asking that they be appointed co-administrators of her estate. Marshall would soon object to that, asking for a "disinterested, impartial, independent administrator," rather than Annette, who was pursuing a "vicious and self-

aggrandizing vendetta," according to his lawyer.[156] Two months later, Annette's request would be denied, and the bank and a retired judge Marshall
had suggested were appointed to oversee the estate.

The sparring even spoiled Astor's funeral. Marshall ran it, but a few
days later the gossip columnist Cindy Adams reported that Astor's real
friends would hold a memorial of their own, co-hosted by "her favorite
charities, the New York Public Library and the Metropolitan Museum,"
and the Marshalls would not be invited.[157]

A few days after the funeral, so many lawyers crowded into the
Westchester court at one of the first hearings on her will it was clear the legal profession would be the only certain winner in the contest. Among
them were attorneys representing the museum and the library, both of
which had seen their original $16.5 million bequests shrink to $5.28 million
under the terms of the contested codicils. As the skirmishing continued
into the fall, the surrogate pushed for a settlement, warning that the alternative would "cost the charities a lot of money." The assembled lawyers, he
predicted at another hearing, "will be happy to litigate this matter to the
very end of this stream of money."

That seemed even more likely after settlement talks stalled when
Marshall was indicted on criminal charges including fraud, grand larceny,
conspiracy, and criminal possession of stolen property. But several wealthy
New Yorkers who remain close to him insist that regardless of what people
think about Marshall, Annette was a bad actor in the drama, too. In a version of events promoted by Marshall's advocates, Annette's behavior during
Astor's last days was said to mirror her earlier treatment of her mother
during her self-exile in Nantucket. They suspect Jane was manipulated—
convinced to sell everything she owned, sent to Nantucket, and isolated
there—to assure Annette's inheritance, both financial and social. And they
feel Astor was manipulated, too, and for the same reasons. "She kept as close
as she could because she wanted to be the next Brooke Astor," Marshall said
in an interview with *Forbes* magazine.[158]

Some say Annette wanted even more than that, always bringing
Brooke little presents and talking about which pieces of Astor's jewelry she
wished she could have (all she was left in Astor's will were four paintings,
all of dogs). "She was pushing herself, demanding jewelry, diamonds, emer

alds," says a Marshall supporter. Brooke finally gave her a gold-and-diamond necklace and matching earrings.[159] Tellingly, Marshall said, she did that a day after signing the very codicil redirecting her fortune that Annette would later challenge, saying Astor had been incompetent at the time.

"Brooke would have no more wanted Annette to step into her shoes than Tony would," says another Marshall advocate. But newspaper reports acted as if her ascension were fait accompli. By protecting her mentor, she'd claimed her place. "Annette certainly wasn't upset by being named the guardian of Brooke Astor," sniffs a man who was once close to both of them. But the way she got there, he adds, "was unbelievably invasive." And to those who care about propriety, that is the problem. Forevermore, they fear, Brooke Astor's legacy will be as stained as the sofa her son allegedly forced her to sleep on.

PHILIPPE DE MONTEBELLO'S LAST YEARS AS THE MET'S DIRECTOR— cultural property disputes notwithstanding—were immensely satisfying. Finally in complete control, he'd amassed a record of considerable achievement but did not rest on his laurels. He was justly praised for smoothing the ruffled feathers of trustees, curators, and art purists by setting the museum back on a steady course and keeping it on an even keel longer than any of his predecessors. He'd acquired around eighty-four thousand works of art during his tenure, including one artist that got away from Hoving; Duccio di Buoninsegna's *Madonna and Child,* purchased for about $45 million, was Montebello's *Juan de Pareja.** He'd also more than doubled the museum's endowment from $1.36 billion when he arrived to $2.9 billion in 2007 and completed the master plan when he presided over the reopening of the stunningly restored Greek and Roman galleries in 2007. And despite the limitations on building, that wasn't the last of Montebello's brick-and-mortar triumphs. Not only did he finish what Hoving had left undone; he added to it, too. The antiquities museum within a museum was followed in

* The Duccio was as controversial as *Juan de Pareja*, too; several scholars continue to question its authenticity.

rapid succession by the opening of a refurbished Oceanic art and Native North American art wing, refreshed and relit Wrightsman rooms, new galleries for nineteenth-century European paintings and sculpture, the Joyce and Robert Menschel Hall for Modern Photography, the revamped Ruth and Harold D. Uris Center for Education, and rehabilitations of the museum's American Wing and its entrance plaza.

His last year in office seemed as perfectly choreographed as the finale of a fireworks display, when everything goes off at once, in perfect harmony, lighting up the skies and bringing smiles to all who observe. Midway through it, the New York Times ran an article about his irreplaceability topped with a headline that called him the Sun King. Not long after that, the New York Sun front-paged an article quoting the director calling it an "annus mirabilis." And a few days later, another article in the Sun lauded the museum's "Memorable Year," citing such shows as Lorenzo Ghiberti's Gates of Paradise; The Age of Rembrandt, which featured Dutch paintings from the permanent collection; Tapestry in the Baroque; the exhibit of the Clark brothers' early modern and Impressionist paintings; a show of the newly acquired Muriel Newman modern art collection; and others focused on Venice and Islam, the art of Barcelona, central African reliquaries, and American silver. When it emerged, late in 2007, that Montebello's $4.7 million compensation made him the highest-paid nonprofit executive in America that year, few blinked. He'd earned it, as he demonstrated a year later with his last show, The Philippe de Montebello Years. The museum's only major exhibition in Montebello's lame-duck season, that attention-grabbing survey of the greatest acquisitions of his tenure was both hailed as a triumph and derided as resembling a rummage sale, but most of all it was a display of directorial ego that demonstrated just how far Montebello had come, personally and professionally, from his awkward, insecure start in the job thirty-one years before. "Almost without exception," the Sun noted approvingly, "art was put ahead of everything else" in the Montebello era.

The latest exception was Damien Hirst's Physical Impossibility of Death in the Mind of Someone Living, better known as the dead shark in formaldehyde, purchased for $8 million and loaned to the museum by Steven A. Cohen, the secretive hedge fund operator (who had previously been associated with

the Museum of Modern Art). Which may be why Montebello let Gary Tinterow announce its arrival. If the public was revolted, Tinterow would take the heat; if the shark proved more than a momentary sensation, it would be another boon for the Montebello museum.

"You go where the money is," observes the curator, banker, and journalist Michael M. Thomas. "Anything can be justified in the name of fundraising. You put on circuses to put bread on the table of van Gogh."

Hirst's shark symbolized the museum's latest dilemma. The Metropolitan is the sort of institution that should be run by well-seasoned wealth and taste and should stand for conservative values like Montebello's. Yet it also needs regular challenges, challenges balanced on the edge between the bracing and the abrasive—the very sort posed by a Francis Henry Taylor, a Hoving, or a Hirst—to ensure it doesn't tumble into irrelevance. And it needs money, gobs of it. In the early years of the twenty-first century, it was contemporary art that attracted the big money and generated so much buzz that it threatened to overshadow all the art that came before it. Thanks to the museum's long-established fifty-year rule, which says that a piece of art must have survived half a century of scrutiny before it is deemed worthy of a permanent place in its collection, the Met had cut itself out of that market and, in the minds of some, made itself irrelevant—again. They fear that contemporary art collectors, the latest new Medici, many of them from fast-paced financial and digital businesses, will bypass traditional museums in favor of less hidebound ones, or open their own like the Gap's founder, Donald Fisher, Alice Walton, and Ronald Lauder—drawing attention and funds away from universal museums like the Metropolitan. After all, why should they support an institution that doesn't respect what they collect?

But it is just as likely that as they mature, the new rich will seek the same validation of status and taste that the Morgans and Rockefellers did before them, that which is conferred only by great, established cultural institutions. And their unprecedented financial clout notwithstanding, many will learn that the ultimate prize, secular immortality, requires more than cash. Which seemed to be the subtle point of the snarky *New York Times* editorial that greeted the loan of the Hirst shark. It pointed out that the deal was not about art but rather about "money and reputation":

It may appear as if Mr. Cohen is doing the Met a favor by lending this work. In fact, it is the other way around. The billionaire, number 85 on the most recent Forbes 400, has been collecting art at a furious rate since 2000, and he is being courted by museums in the way that prodigiously wealthy collectors have always been courted. Part of that courtship is, of course, endorsing and validating the quality of the collector's eye. The only defense against the skewing of the art market created by collecting on Mr. Cohen's scale is to appropriate the collector himself.[160]

Hirst's shark—as well as the challenge it represented—was the elephant lurking in the back of the room at the press conference early in January 2008 where Montebello's unprecedented retirement (for Cesnola, Robinson, and Rorimer had died in office; Clarke, Winlock, and Taylor fell ill and resigned; and Hoving quit under pressure) was announced. After revealing that Annette de la Renta and Parker Gilbert would head the search for a new director, the board chairman, Jamie Houghton, praised Montebello's "absolutely incomparable legacy of accomplishment," his "giant intellect . . . fierce devotion to this place, and . . . tireless thirst for perfection," and then gave the stage to the outgoing director.

Montebello began by expressing pleasure that the "announcement of my impending retirement has not been met with jubilation but with genuine sadness, distressed anxiety, all the emotions that go with the notion of change." Describing the moment as one of wrenching ambivalence, he said, "I do think the time is right . . . There's an old adage that before you flub it, get out, so I'm following it . . . I'm also perfectly aware that society, the world, people, change, sometimes faster than people in positions such as mine, and the Met should never risk becoming a museum of itself. It should adapt."

He was asked what his proudest accomplishment was. His "absolute dedication to excellence, faithfulness to integrity, and the courage to maintain institutional authority," he said. "I think far too many institutions, in a misguided sense of democratic ideal, fail to exercise their authority and tend to do things in a muddle." What next? "I certainly will be speaking out

in the future." What about? "Well, standards, principles . . . the primacy of art." Finally, a questioner wondered if he would write his memoirs. "I have not been approached, and whoever approaches me is making a futile gesture," he said sternly. "I have no intention whatsoever, wonderful as my career has been, to relive it in paper, on a tape, or otherwise, I will not write a book about my experiences at the Met—that I know." Sitting beside him, Jamie Houghton burst into laughter. Then, in an odd coda, Montebello added, "Although a true one is necessary at this point."

Speculation about who would replace Montebello had begun even before the announcement. It was generally agreed that he would be a tough act to follow. "Philippe's retirement really does mark the end of the cultural ancien régime," says Michael M. Thomas.

The history of the Metropolitan surely demonstrates that the more things change, the more they stay the same, but change and the need to confront it are also eternal. Like the art on its walls, the Met's ruling trustees and its donor pool are old and getting older (de la Renta was sixty-nine when Montebello retired, Gilbert seventy-four, and Houghton seventy-two), whereas the art world, like the rest of American society, seems to grow younger by the day and is thoroughly consumed with the sort of living, contemporary art the Metropolitan has long kept at arm's length. Gary Tinterow, who was generally considered the leading in-house aspirant for the director's job, had thrown a spotlight on that dilemma when he procured that loan of Hirst's shark and hailed it as "an amazingly powerful work of art." It takes nothing away from Hirst's creation to say that that is an arguable opinion.

What *is* truly powerful is the continuing ability and willingness of the world's wealthiest to give art and money to the museum. And that, finally, was what was at stake in the director sweepstakes. "When the managerial class took over museum boards, they built buildings as evidence of success," says a top art dealer. "Acquisitions don't impress them." But the Met can't build like that anymore. And it's an open question whether its social magnetism matters at all to the nation's new wealthy, the technology and financial billionaires who have, among other things, turned the contemporary art market into a frenzied, seemingly unstoppable juggernaut, where the advisers of choice are dealers, not curators, and artworks are viewed as invest-

ments rather than as holy objects. If they don't care about old art, will they ever care about the Metropolitan, where a curatorial staff used to being protected by Montebello "doesn't think about the audience"? a prominent art dealer asks. "They do shows for themselves and their colleagues now." Will a group of trustees lulled into happy complacency by their brilliant caretaker Montebello be able and willing to let the pendulum swing and encourage another revolutionary like Hoving or Taylor to yank the museum into an uncertain future?

Annette de la Renta was said to be ill disposed toward Tinterow for a variety of reasons. One of them may have been his taste in art. "Mr. Tinterow has gone out of his way to demonstrate how . . . willing [he is] to compromise aesthetic excellence for the sake of appealing to whatever trashy 'genius' the art market happens to favor this season," the *New Criterion* opined. "How disquieting it must be for Mr. de Montebello, who has spent more than thirty years holding the line and upholding high standards. Like Louis XV, he has reason to mutter, '*après moi, le déluge.*' "[161]

Even if the Met hired someone conversant with the current art scene, it was unclear there would be anyone for that person to talk to. "There are major moguls out there, buying art, but is Steven Cohen giving anything away?" asks Klaus Kertess, the dealer who once worked at the museum. "He's spent hundreds of millions, but he's really not given anything at all. And there are countless people like that. I consulted with one young Wall Street titan who bought great art. I kept saying, 'Think about museums.' He said, 'I'm not ready.' That's pretty typical."

The social status the Met conveys means much less than it used to. Once, new generations of yearning-to-be-swells would have stood in line to see their names carved on the museum's grand stairway. But the latest wave of wealth has broken that long, heretofore-uninterrupted act of succession, in which patronage greased the wheels of social ascendancy. The new Morgans and Rockefellers just don't care, and if they do, it's about forward-looking institutions, not those that only look back. For them, the end of history is already an old story. All they want to know is, what's new? Elon Musk, for instance, who made millions as a founder of PayPal, put his profits into developing a private spaceship and an electric car, not an art collection. The idea of following the traditional trajectory of wealth, climb-

ing from nouveau to noble, and taking the place of people like Gilbert and Houghton "fills me with dread," Musk has said.[162] And if his ilk doesn't care if Annette de la Renta inherits Brooke Astor's social throne, she may find herself a queen without a country.

EVEN IF THE NEW TITANS OF FINANCE AND CYBERSPACE FINALLY do decide they want in, the question remains, will the likes of de la Renta and Jayne Wrightsman, still active after all these years, find their ilk acceptable? One young New York heir offers up a cautionary tale of his courtship by those grandes dames of Metropolitan society. "I briefly rose to glory as their cat toy," says David Netto, grandson of Frank Cosgrove Sr., who himself rose from fourteen-year-old errand boy to the treasurer of Johnson & Johnson after working as its founder Robert Wood Johnson's personal assistant and confidant. His reward for his lifelong devotion to J&J was stock options that made him, at his death in 1970, the largest holder of its stock outside the Johnson family; he'd never sold a single share. Cosgrove wanted his fortune to stay in his family, but his troubled and ultimately childless son, Frank junior, left his half to the Met in a will he'd made in secret, to the dismay of his sister, Kathryn Netto, and her son, David.

When they found out about the will on Frank junior's death in 1992, the Nettos hired a lawyer who made a deal with the Metropolitan. For the next fifteen years, the museum kept most of the money and used the interest it generated, but in 2007 a healthy share of it reverted to Netto. He also got his name carved into the staircase as a museum benefactor, and Frank Cosgrove Jr.'s inscribed on the wall at the entrance to the new Greek and Roman galleries, which his money paid for. (It also endowed a fund for the purchase of American Impressionist paintings.)

"Since the Met wanted to be friends, I asked to be brought into their world," Netto says. "I wanted to see Jayne Wrightsman's apartment." So in 1995, he was invited to a $25,000-a-ticket fund-raiser featuring cocktails at 820 Fifth and dinner in the museum's Wrightsman rooms. Though Wrightsman was short with some of her guests ("Get these people out of my house," he heard her say), she invited Netto back, and he was soon

adopted by Wrightsman and de la Renta, "her best friend," he says. "Annette runs the joint. It's her club. And these people know how to work their prestige and power. I was just out of college. I thought I was there because we had mutual interests, but they just wanted to sniff me, like some eighteenth-century countesses looking for a new Pekingese.

"They're irresistible, if that's your thing," Netto continues. "They're living treasures, and you don't meet people like that every day. If you care about the 'top people,' you'll want to hang on. There's something about them that's pure magic. I wouldn't trade seeing how they live and what they're about for anything."

Netto hung on for a long time, becoming a regular, even at private parties with no connection to the museum. "My mother knew it would end in tears," he says. "But I was gullible. I wanted to know people like this my entire life." Then, at a dinner for a Rothschild at Wrightsman's apartment in 1998, the tables suddenly turned on him. When he was still in architecture school, he'd written an article for an obscure architecture journal about Sid and Mercedes Bass's apartment—and years later had shown it to Annette, who always did the seating for Wrightsman's dinners and placed him next to Mercedes that night, at a table that also included Barbara Walters and Anna Wintour. "Annette sat down and said to Mercedes, 'He published your apartment,' " Netto recalls, shuddering at the memory. Though the article didn't say who owned the apartment, he immediately realized what was going on. He'd broken the rules. "A rant ensued. Annette had seated the dinner in order to start something, to watch me squirm or to see someone stand up to Mercedes or to expel me from their orbit. She's just so bored she wanted to stir the pot. But I was defiant, impertinent, which I don't think she'd counted on. When you go down on your knees with people like that, you never get up again." Wrightsman later sent a letter of apology. "But I never heard from her again."

He did hear from the museum, though, after an eight-year silence, shortly before the fifteen-year agreement expired and he finally got his inheritance. He was again invited to what he calls "inner circle" dinners but now knew why he was there. "Fifty million dollars later," he says, "I was being courted to give more. I realized it was useless to try to please them. I could never give enough to make them happy. So I designed a way to termi-

nate the relationship without causing bad feelings. I gave them $100,000—proudly—in my mother's name to pay for child-friendly guides to the collection. It was a sum so negligible I knew I would never hear from them." In fact, he did, but he'd been downgraded to the status of a minor donor; on the few occasions where he gave in and wrote checks to attend dinners, "nobody talked to me," he says, "proving my theory correct." He recently stopped giving money to the Met and gave $300,000 to the American Museum of Natural History instead. "They are so nice to deal with," he says.

Though he came to genuinely like and respect Emily Rafferty, David Netto finally decided that all de la Renta and Wrightsman care about is their own aggrandizement. "They run [the museum] to settle scores and control New York socially as much as to exhibit art," he says.

Finally, Netto was chastened by his experience. "In my wide-eyed way, I really thought they were my friends," he says. "But I was lucky to get out. Jayne earned it and cares so much about it, but she can't enjoy it. If that's what you have to look forward to, why climb?" But looking ahead, he sees a brighter future. "One day, this won't be the way it is anymore," Netto says. "Really, it only exists in a few people's minds."

And they're a dying breed.

A DAY AFTER MONTEBELLO ANNOUNCED HIS RETIREMENT, THE search committee set to work, seeking his successor. It faced two serious challenges: about twenty other American museums were simultaneously seeking new directors, and the pool of interested, qualified candidates was small.

The qualifications, as spelled out by the search committee, were daunting. They included

a commitment to the Museum's mission and the primacy of the collection; ability to embody its standards of scholarship and curatorial excellence and to articulate and uphold the values of the institution; passionate connoisseurship with a broad, informed appreciation of art or the facility to acquire it beyond an area of specialization; respect for

and strong support of curatorial talent; able to represent effectively the institution to its constituents and play a leadership role in the international art world; capacity to lead a large institution and to develop and articulate its strategic course; ability to engage a sophisticated board of trustees; enthusiasm for and effectiveness at cultivating donors, collectors and other supporters; excellent interpersonal skills with the ability to motivate, direct and hold accountable a highly skilled staff in a notably collegial environment; effective abilities delegating and communicating expectations; experience setting rigorous standards and inspiring others to achieve them; record of recruiting and mentoring exceptional professional talent; a practiced, effective and confident decision maker who inspires trust; a doctorate is desirable but not required. The individual will be: a person of unassailable integrity, diplomatic and tactful; a strong leader who is decisive, fair and a confident and wise delegator; a broad-minded humanist who inspires institutional pride; highly intelligent; a good communicator and an even better listener; flexible and in possession of a sense of humor.[163]

Eight months later, on September 9, 2008, the museum announced that the new guardian of its sacred premises would be Thomas P. Campbell, forty-six, a relative unknown. The British-born, Oxford-educated Campbell was a museum insider with thirteen years' experience at the Metropolitan. A curator in the European Sculpture and Decorative Arts Department and a specialist in European tapestries, he had administrative experience as the supervisor of the Met's Antonio Ratti Textile Center, where textiles from every museum department (except the Costume Institute) are held; in that job, which required him to deal with curators from almost every museum department, Campbell had proved his mettle and made important alliances. Though he was, some said, untested, he was an insider like Montebello. So he was thought to be unlikely to rock the boat and likely to be accepted by the staff he would soon supervise and, as an art historian and scholar, have the immediate respect of his colleagues in the museum field; so the immediate reaction to his appointment was generally positive. But he is also something of a wild card.

Regardless of whether Campbell turns out to be a revolutionary or another caretaker, it will take all those carefully delineated skills to deal with the biggest challenge he will face, which is nothing less than defining the museum's place in a challenging, fast-changing world. "What really is a museum?" Montebello wondered rhetorically in one of his farewell interviews. "Is a museum really useful in today's world?"[164] The new director will have to find answers to those questions. The beauty of the situation is that at age 138, the Met is still a work in progress.

When he got the job, Montebello was charged with counter-programming Hoving and chose to do it by turning the Met inward, quieting things down, and reminding all concerned what the core values of a great museum should be—and he did that with intelligence, if not always grace, for thirty-one years. But today, the museum audience has grown and changed beyond recognition, and wealth has come to a new class of characters who are rewriting the roles of philanthropic benefactors and cultural patrons.

Ownership of art once conferred "a kind of automatic status," Karl Meyer wrote.[165] Just as the Romans invented their line of descent from Olympus, he said, "a similar obsession with continuity often afflicts Americans with more money than pedigree, and the art museum can be seen as . . . a means by which wealth is gilded with antiquity."[166] Though their houses were often fakes—fake châteaus, fake Palladian villas—the old new rich bought authentic art, certified by provenance, scholarship, and the approval of curators who were members of the same social class as those who'd endowed the museums, the very class that, through collecting, the up-and-coming sought to join. But now most curators come from academia, not old collecting families, the most valuable art in the marketplace is so new the paint might as well be wet, and the people who collect it are not in thrall to the established cultural order.

"Once, even if they didn't come from a prominent social background, museum patrons and collectors aspired to a knowledge and appreciation of art of the past" and "like Jayne Wrightsman studied hard to attain it," says Guy Stair Sainty, a London dealer in old masters. "Now many museum patrons lack real culture, they aren't interested in learning, and they collect contemporary art because it is unnecessary to know anything about art, cul-

ture, religion, iconography, history, or literature to do so. Sadly, the great museums—founded to collect, conserve, and educate—are now more and more dependent on people like this! They make a great mistake in trying to be cutting-edge."

Today's collectors and potential patrons too often see art as an investment rather than as an end in itself. "If you added up the value of the art people gave in the 1930s through the 1950s and compared it to their net worth, it was a small portion," says Alan Salz, a New York dealer. "Now the art is 90 percent. Art dealers aren't saying, 'You should buy this because the Metropolitan wants it.' They're not going to give it to the museum! It's going back on the market, unfortunately."

Museums are more focused than ever on money, too. With its meager annual acquisition budget—reportedly $30 million for all seventeen curatorial departments, which is a third less than what Montebello paid for his Duccio—the Metropolitan can't possibly compete freely in the contemporary marketplace with the new New Money.[167] "Wouldn't it be nice if Steve Cohen gave the museum a few hundred million?" Salz asks. The social status museums once conferred in exchange for donations has been devalued, too. If the people you know and admire don't care about the Metropolitan's holdings, why would you? The museums hope that as this new base of potential donors age, their interests will change and mature, but there are no guarantees.

Campbell learned that the hard way in the days just after his appointment, when the director-elect watched, as the world did, as the sort of credit the museum depends on vanished, Wall Street swooned, and then the world economy collapsed, taking with it key museum patrons like John Rosenwald's old firm Bear Stearns, which was gobbled up by JP Morgan Chase, Lehman Brothers, which went bankrupt, and Merrill Lynch, which ceased to exist as an independent entity after selling itself to Bank of America, and decimating the fortunes of old and new money alike. The sorts of "deep-pocketed executives from real-estate firms, financial institutions and hedge funds" who now fill museum boards faced not just shrunken portfolios and personal and corporate fortunes but a very uncertain future, the *Wall Street Journal* reported. "We know from history the bell curve of support goes down," the museum's president, Emily Rafferty, said. "But as far as the

corporate world is concerned, we've never seen anything like this. We need to navigate a very, very difficult time."[168]

Some, though not all, of the looming difficulties were plainly evident in the museum's 2008 annual report, released that December. It had gone from a $2.6 million surplus in 2007 to a $3.2 million deficit in a year. But, clearly, the museum had no more thought through its new reality than many of its patrons and benefactors had theirs. The only cost-saving steps the latest CFO mentioned in the report were the elimination of vacant staff positions and cutbacks in temporary employees, messengers, newspaper and magazine subscriptions, the image library, and the editorial and education departments. Further retrenching was almost certain. Just a month later, *The Art Newspaper* reckoned that if it tracked the market, the Met's endowment would have already declined from the $3.5 billion touted in the report to $2.75 billion. It also noted that a cash-strapped New York City had trimmed the Met's 2009 subsidy by 2.5 percent, with additional cuts of up to 7 percent in the works for 2010.[169]

Before the Panic of 2008, many museums had sidestepped fundraising problems through expansion, throwing their creative energy into raising money for and constructing new buildings, appealing to the edifice complex so common among the rich. But the Metropolitan couldn't build; all it can do is remake and remodel, give old galleries face-lifts and sell them to new names. The Met is hardly a fly caught in amber, but neither is it a buzzing hive of construction activity. So Tom Hoving thinks it's no wonder that during the search for a new director, the leading candidate, the British Museum's director, Neil MacGregor, turned the Met down. He said he preferred running a public museum to one dependent on private funding. But Hoving adds that the director of the British is supervising a nine-figure expansion of its nineteenth-century building in London, which will debut in 2011. The Metropolitan, hemmed in by Hoving's promises, must have looked like a straitjacket in comparison.

So it's likely that Thomas Campbell's focus, like Montebello's, will of necessity be building from within, only now the job will also entail building a new image for the twenty-first-century Met—one that attracts a new generation of Morgans and Rockefellers (whose wealth, though shrunken, re-

mains relatively large) by injecting fresh excitement into the massive enter-prise without compromising its art-historical standing. In essence, it needs a shot of speed.

At first, though, it's likely that there will be more questions than an-swers. Is the Met a temple of knowledge? A community center? A private party palace? Or all of the above?

Is the museum an altruistic institution dedicated to conserving and displaying historic art? Should it dabble in the marketplace and confer re-spectability on new art? Should it allow itself to be used as a vehicle for self-ish social ambition in order to keep the machine running? Or should it be above such potentially tricky alliances? (The brief, embarrassing relation-ship of the Tyco tycoon turned jailbird Dennis Kozlowski to the Whitney is a case in point.)

In a multicultural, hyper-nationalist world, how does the Metropoli-tan defend its retention of the spoils of what the rest of the world sees as an obsolete jingoism? MacGregor doesn't want to return the British Museum's Parthenon marbles, either. Can the Met continue to buy things it may later have to give back?

Is the blockbuster syndrome a permanent condition? If it is, how does connoisseurship survive in a museum crammed with thousands of people chasing the latest passing sensation?

Is the contemplative connoisseur an anachronism? And what of the comprehensive historical museum? Vienna reinvented itself by adding new museums that appeal to new audiences, not adding to existing ones.

Where does contemporary art fit in a historical museum, if at all? If it does, should the permanent collection remain sacrosanct—or could some of it be winnowed out and sold to create a purchase fund that would make the museum more competitive in the art market, more able to act when one of the rare masterpieces still in private hands suddenly pops up for sale? Fi-nally, is the Met a white elephant, unequipped to compete in a world of shrinking attention spans, shrinking interest in history, shrinking leisure time—and so many easier-to-digest competing diversions?

To Guy Stair Sainty, the answer to most of those questions is to re-invent cultural education. "How does one get the context across?" he asks.

How can anyone imagine how and why art was created without some understanding of the cultural background and historical context in which its creators lived and worked? You have to find a way to explain this. How does one communicate successfully with three and a half million people? The raison d'être of museums has changed from preserving and helping people understand and enjoy the art of the past. Today, success is judged by the numbers of visitors who attend traveling exhibitions rather than how many enjoy the permanent collections. Empty galleries are perceived as a sign of failure, so people are enticed through the doors with gimmicks; but when, for example, they exit the temporary exhibits at the Metropolitan Museum into the splendid baroque galleries, they are likely to walk straight out without even pausing to admire the Caravaggios, Guido Renis, Velázquezes, or Zurbaráns. That's a larger failure. One needs a flashing red light and a sign that says, "Stop and gaze with wonder at what's around you." If visitors neglect the masterpieces in the permanent collection . . . then the museum has truly failed in its mission.

It was not Philippe de Montebello's fault that on a typical day, his $45 million Duccio sat in a gallery as empty as the one that Edith Wharton's Newland Archer and Ellen Olenska visited in Luigi di Cesnola's time. But it was Montebello's failure, and that of his museum, that on one recent Sunday, that Duccio sat alone and unloved while crowds jostled at a Costume Institute exhibit of superhero costumes and fashions based on them, before exiting into a shop selling $30 pink and green T-shirts sporting the word "Pow!" in a cartoon bubble. The museum Web site justifies such merchandise with semi-obtuse artspeak. But the pretense is pretty thin.

And while it's true that contemporary art must be a part of the solution of the Met's dilemma, it isn't an answer in itself. The museum's traditional hostility to new art was clearly a mistake, but it is just as wrong to go to the other extreme to court potential patrons like Cohen. New art has an audience, and it is one the Met must cultivate in order to survive, but it needs to have a conversation with what's current, not give it a solo. With apologies to Henry Geldzahler, Hoving was right when he showed Rosenquist's *F-111* with historical paintings.

And the Met should probably try to avoid obvious conflicts of interest like the one on display at the opening reception for its recent rooftop show of three of Jeff Koons's delightful sculptures (two of them loaned by Cohen), which was underwritten by the artist's dealers. "It is a mark of the deterioration of elementary museum standards of behavior that galleries are now permitted to fund exhibits of artist they handle," wrote Marty Peretz of the *New Republic*. "To this chintzy enterprise, the Metropolitan has now given its honor, its reputation and its name. Shame."[170] Peretz doesn't like Koons, either, which is his right, but had those sculptures been shown in the same way at the Modern or the Whitney, it is unlikely he would have spanked those more contemporary-minded museums in the same fashion.

Institutions like those, formed for the express purpose of displaying new art, are better equipped to deal with the present as well as its commercial temptations. The Met's edge in this transaction is that nothing remains avant-garde forever; so inevitably, everything that survives a few decades of viewing and still has an admiring audience has a chance to become part of the pantheon of sanctified art that the Met was created to collect, conserve, and communicate to generations to come.

So Thomas Campbell faces daunting challenges: to make visitors want to walk through the always-empty permanent galleries as well as the crowded one-season-only ones, not by shocking with sharks, but by luring them on the more difficult but rewarding journey through culture into history. Campbell must also reinvent patronage for a new breed of wealth, uninterested in the well-trod bridle path of American upward mobility. It may be that Annette de la Renta and Jayne Wrightsman are obsolete. Many think so. Their ways are "byzantine," says Nancy Richardson, the ex-wife of a Met trustee and, like David Netto, another discarded member of their court. The Metropolitan, she continues, is "a great big ball of lies with some beautiful art. It's run for their purposes, they really are unchecked, and it has nothing to do with civic-mindedness."

Their way of playing the social game notwithstanding, the broader roles those two, and the other leading trustees play are as eternal as the art entrusted to their care as the public's guardians. Even if the Met's art is frozen in time, its leaders can't afford to be. They may not feel themselves accountable to anyone but themselves, but the public has proven time and

again that it can and will pierce the curtain that shrouds the Metropolitan's operations and remind the trustees that they occupy the people's building on the people's land and hold "their" art in trust for the citizens of the state of New York and, through them, the world.

"Growing the endowment, getting richer donors, having people believe that they should give money to support this wonderful thing, so they don't have to do frivolous exhibitions," is the challenge that Campbell faces, says Sam Sachs, a nephew of the museum educator Paul Sachs and a former director of the Frick Collection and the Minneapolis Institute of Arts. "One of Philippe's great gifts [was] to keep in balance with the seismic shift in board constituency [during his tenure as director]. The character of the board changed over time from caretaker trustees who had social and fiscal responsibility. Today's board is more [interested in] trying to prove their social standing. To whom they're trying to prove it is an open question . . . But it's a terrible mistake to assume that these people are involving themselves, their time, their money, their effort, in an organization just for frivolous purposes . . . For the most part, they seriously believe in its mission."

So among its myriad virtues and delights, the Metropolitan Museum of Art is proof that the highest social power in New York derives from the ability to raise and spend money for the public good. Eventually, one must hope, some of the new New Moneyed will see this and support the museum through the next phase of its evolution, rather than destroying it in a misguided attempt at reinvention.

Some institutions deserve the chance to be as eternal as great art.

Acknowledgments

IN MY PAST BOOKS, OUT OF BOTH GRATITUDE AND DILIGENCE, I have listed and thanked the hundreds of people who typically help me with interviews, information, and pointers to others. With this book, however, I felt the need to balance my desire to do the same against the clear perception that identifying those who helped me might put them at risk of retaliation from a very powerful institution and the individuals who run it.

The Metropolitan Museum of Art has been overtly hostile to this project since its inception. Members of its board, administration, and staff have made its opposition widely known. To protect their livelihoods or their social positions, many of my sources insisted on remaining anonymous. Others said they didn't care or were willing or proud to defy the museum, and some of those are quoted by name in the text or acknowledged in the notes. But rather than try to decide which of the hundreds of people who helped me might be at risk, I concluded it would be best to thank them all here collectively for their commitment to the idea that independent inquiry into powerful institutions and individuals has value.

That said, some have been so very generous of their time and resources that I must single them out. Thanks to Tom and Nancy Hoving, for their memories and for the unlimited access they gave me to their papers; to the various members of the Johnston, de Forest, Marquand, Taylor, Rorimer, Redmond, Lehman, Wrightsman, and Houghton families who were willing to speak to me; to Jerri Sherman, Ellie Dwight, William Cohan, Murielle Vautrin, Stephen Yautz of SMY Historical Services, and

Stephanie Lake for their generosity with their own research; to Melik Kaylan and Engin Ozgen for their help on the Lydian Horde story; to Marian L. Smith, immigration historian of the Department of Homeland Security; to the Rockefeller family, and their creation the Rockefeller Archive Center, and Darwin Stapleton and Ken Rose, who run it; to Leonora A. Gidlund and the New York City Municipal Archives; to Calvin Tomkins and the Museum of Modern Art Archives; to the library of the Rijksmuseum Amsterdam; to the Center for American History at the University of Texas; to Christine Nelson and the Morgan Library; to the New York Public Library; to the Beinecke Rare Book and Manuscript Library at Yale University; to the Columbia University Rare Book and Manuscript Library; to the Hagley Museum and Library; to Jane C. Waldbaum, president of the Archaeological Institute of America; to Norm Turnross of the Baillieu Library at the University of Melbourne; to the Leo Baeck Institute; to ArtWatch; to Barbara Niss and the Mount Sinai Archives; to Pat Nicholson, Samuel Peabody, and the Metropolitan Museum Historic District Coalition; to the Smithsonian Institution and its Archives of American Art; to the Altman Foundation; to the New-York Historical Society; to Ian Locke, Gary Combs, Nilüfer Konuk, Dan Weinfeld, Anja Heuss, Anna Marangou, and Arthur Oppenheimer; to Harold James of Princeton University, Johannes Houwink ten Cate of the University of Amsterdam, and Jonathan Petropoulos of Claremont McKenna College; and to my journalist comrades-in-arms Charles Finch, Walter Robinson, Jean Strouse, Marianne Macy, Russell Berman of the *New York Sun,* Autumn Bagley of the *Flint Journal,* Laura Harris of the *New York Post,* and Tom Mooney at the *Wilkes-Barre Times Leader.*

The researchers who helped me are beyond compare. Thank you to Ryan Hagen, Kerrie Lee Barker, Asli Pelit, Amanda Rivkin, Alexandra Schulhoff, Cynthia Kane, Eric Kohn, Laila Pedro, Lisette Johnson, Raymond Leneweaver, Zachary Warmbrodt, and Sarah Shoenfeld, and to Bouke de Vries, Gerard Forde, Benedetta Pignatelli, Oliver Hubacsek, Radhika Mitra, Laila Pedro, and Ewa Kujawiak for their skilled translations.

Finally, personal thanks to my wife, Barbara, my sister, Jane, Peter

Gethers, Kathy Trager, Claudia Herr, Bette Alexander, Ingrid Sterner, Christina Malach, and Brady Emerson of Random House, Dan Strone of Trident Media, Maria Carella, Robert Ullmann, Ed Kosner, Roy Kean, and Barry and Karen Cord. My gratitude to each of you is limitless.

Michael Gross
New York City

Notes

ARCHIVE SOURCES

Frank Altschul Papers, Rare Book and Manuscript Library, Columbia University, New York

John Canaday Papers, Archives of American Art, Smithsonian Institution, Washington, D.C.

Henry Geldzahler Papers, Yale Collection of American Literature, Beinecke Rare Book and Manuscript Library, Yale University, New Haven, Conn.

Oral History of Robert Beverly Hale, Archives of American Art, Smithsonian Institution, Washington, D.C.

John Davis Lodge Papers, Hoover Institution Archives, Stanford University, Stanford, Calif.

Oral History of A. Hyatt Mayor, Archives of American Art, Smithsonian Institution, Washington, D.C.

Pierpont Morgan Papers and J. P. Morgan Jr. Papers, Morgan Library Archives, New York

Reminiscences of John B. Oakes (1978), Oral History Research Office of the Columbia University Libraries, Columbia University, New York

Parks Department General Files and Parks Commissioner Series, New York City Municipal Archives, New York (hereafter cited as PDGF)

Rockefeller Family Archives, Rockefeller Archive Center, Sleepy Hollow, N.Y. (hereafter cited as RAC)

Calvin Tomkins Papers, Museum of Modern Art Archives, New York

Diana Vreeland Papers, Manuscripts and Archives Division, New York Public Library, Astor, Lenox, and Tilden Foundations, New York

OTHER SOURCES

Thomas Hoving Papers, New York (they are his personal papers located in his home, not an institution)

The Metropolitan Museum Oral History Project interviews I gained access to were provided by James Rorimer, Dietrich von Bothmer, and Arthur Rosenblatt or their heirs, and not via the Archives of American Art, where they are housed.

INTRODUCTION

1. Judith Dobrzynski, "Oral History of Met Revised," *New York,* May 20, 2007.

2. Thomas Hoving, *The Second Century: The Comprehensive Architectural Plan for the Metropolitan Museum of Art* (New York: Metropolitan Museum of Art, 1971).

3. Feigen, *Tales from the Art Crypt,* p. 109.

4. PriceWaterhouseCooper, "Report of the Chief Financial Officer" and "Report of Independent Auditors," *Metropolitan Museum of Art Annual Report, 2007,* pp. 59–77.

ARCHAEOLOGIST:
LUIGI PALMA DI CESNOLA, 1870–1904

1. Author's correspondence with Louis Mendola, publisher of www.regalis.com.

2. *Times* (London), July 7, 1866.

3. Taylor, *Taste of Angels,* p. 95.

4. Burt, *Palaces for the People.*

5. Ibid., p. 79; Howe, *History of the Metropolitan Museum of Art,* pp. 3–93.

6. Robert Hendre Kelby, *New York Historical Society, 1804–1904* (New York: New York Historical Society, 1905), p. 53.

7. Ibid.; and Rosenzweig and Blackmar, *The Park and the People,* p. 350.

8. *New York Times,* May 21, 1866.

9. *New York Times,* April 2 and 4, 1864.

10. *New York Times,* April 23, 1864.

11. Whittredge, *Autobiography of Worthington Whittredge,* p. 62.

12. John K. Howat, "Founding Friends," *Magazine Antiques,* Jan. 2000.

13. "An Act to Incorporate the Century Association," March 7, 1857.

14. The account of Cesnola's youth and military career is based on McFadden, *The Glitter and the Gold.*

15. Marangou, *Life and Deeds,* pp. 145, 160, 164, 285.

16. *Revue Archéologique* (1905), p. 1.

17. Marangou, *Life and Deeds,* p. 137.

18. Howe, *History of the Metropolitan Museum of Art,* p. 124; and Sherman, "The Classes vs. the Masses."

19. Sherman, "The Classes vs. the Masses."

20. de Forest, *John Taylor;* and de Forest, *John Johnston of New York, Merchant.*

21. Letter to author from Derek Mali, one of Johnston's great-grandsons.

22. Priscilla de Forest Williams, "Our Grandparents: Robert and Emily de Forest," talks to the visiting committee of the American Wing, 1997, provided to the author by Helen Taylor Burke; and Samuel Willard Crompton, "Johnston, John Taylor," in *American National Biography Online,* Feb. 2000.

23. Tomkins, *Merchants and Masterpieces,* p. 35.

24. Suzaan Boettger, "Eastman Johnson's 'Blodgett Family' and Domestic Values During the Civil War Era," *American Art* (Autumn 1992), pp. 50–67.

25. Robert W. de Forest, "William Tilden Blodgett and the Beginnings of the Metropolitan Museum of Art," *Metropolitan Museum of Art Bulletin,* Feb. 1906, pp. 37–42.

26. Jeannie Chapel, "The Papers of Joseph Gillott," *Journal of the History of Collections,* Sept. 4, 2007.

27. Howe, *History of the Metropolitan Museum of Art;* Tomkins, *Merchants and Masterpieces;* and *New York Times,* Feb. 18, 1872.

28. Madeleine Fidell Beaufort and Jeanne K. Welcher, "Some Views of Art Buying in New York in the 1870s and 1880s," *Oxford Art Journal* (1982), pp. 48–55.

29. Ibid., pp. 138–39.

30. Sherman, "The Classes vs. the Masses"; and Osborn, *American Museum of Natural History,* pp. 12–13.

31. "In Memoriam, Joseph Hodges Choate," *Metropolitan Museum of Art Bulletin,* June 1917, p. 126.

32. de Forest, *John Johnston of New York, Merchant.*

33. McFadden, *The Glitter and the Gold,* pp. 115–19.

34. Marangou, *Life and Deeds,* p. 125.

35. Ibid., p. 63.

36. Ibid., pp. 273 and 278.

37. Hoving Papers.

38. Strouse, *Morgan,* p. 175.

39. "Masterpieces and Mummies—II," *New Yorker,* March 23, 1940.

40. *New York World,* March 30, 1880, quoted in Howe, *History of the Metropolitan Museum of Art.*

41. Lerman, *Museum,* p. 48.

42. Harry Jackson, "Fifty Five Years in Retrospect 1938," Tomkins Papers, IV.B.6.

43. Tauranac, *Essential New York.*

44. Jackson, "Fifty Five Years in Retrospect 1938"; and Tomkins, *Merchants and Masterpieces,* p. 61.

45. Tomkins Papers, IV.B.8.

46. Marangou, *Life and Deeds,* pp. 66–67.

47. Ibid., p. xix.

48. Wharton, *Age of Innocence,* p. 312.

49. Lee Sorensen, "Cesnola, Luigi Palma di," in *Dictionary of Art Historians,* www.dictionary ofarthistorians.org/wittkowerr.htm.

50. The account of the Sunday-opening issue is based on contemporary newspaper clippings and Sherman, "The Classes vs. the Masses."

51. de Forest, *John Johnston of New York, Merchant,* p. 139.

52. Tomkins, *Merchants and Masterpieces,* p. 59.

53. Morgan Library Archives, ARC 1196, letters to Morgan, 1881, 6–41.

54. Marangou, *Life and Deeds,* p. 69.

55. Ibid., p. 130.

56. Danielle O. Kisluk-Grosheide, "The Marquand Mansion," *Metropolitan Museum Journal* (1994); and Burt, *Palaces for the People,* pp. 100–101.

57. "Art Collections in America," *Times* (London), April 22, 1895.

58. William Churchill, "A Walloon Family in America," *Bulletin of the American Geographical Society* (1915), p. 454.

59. James A. Hijiya, "Four Ways of Looking at a Philanthropist," *Proceedings of the American Philosophical Society,* Dec. 17, 1980, pp. 404–18.

60. *New York Times,* May 7, 1931.

61. *New Yorker,* March 23, 1940.

62. Tomkins Papers, IV.B.4.

63. McFadden, *The Glitter and the Gold,* p. 244.

64. *New York Times,* Nov. 30, 1904.

CAPITALIST:
J. PIERPONT MORGAN, 1904–1912

1. Taylor, *Pierpont Morgan as Collector and Patron,* pp. 8–9.

2. J. P. Morgan Jr. Papers, box 205, folder 340.

3. Morgan to Cesnola, March 8, 1888, Morgan Library.

4. Strouse, *Morgan,* p. 273.

5. Seligman, *Merchants of Art,* p. 33.

6. Tomkins Papers, IV.B.10.

7. Constable, *Art Collecting in the United States,* pp. 67–74.

8. Secrest, *Duveen,* p. 25.

9. Constable, *Art Collecting in the United States,* p. 113.

10. Secrest, *Duveen,* p. 27.

11. Esmée Quodbach, "The Age of Rembrandt, Dutch Paintings in the Metropolitan Museum of Art," *Metropolitan Museum of Art Bulletin* (Summer 2007).

12. J. Watson Webb Jr., interview in *Merchants and Masterpieces* video, Metropolitan Museum of Art and WNET/Thirteen, 1989.

13. Weitzenhoffer, *Havemeyers,* p. 47.

14. Saarinen, *Proud Possessors,* pp. 144–54.

15. *Merchants and Masterpieces* video.

16. Ibid.

17. Weitzenhoffer, *Havemeyers,* p. 184.

18. Ibid., pp. 62–63.

19. Morgan Library Archives, Correspondence, ARC 1310.

20. Taylor, *Pierpont Morgan as Collector and Patron,* p. 113; and Morgan Library Archives, Correspondence, Bill of Sale, April 27, 1901.

21. Secrest, *Duveen*, p. 49.

22. Weitzenhoffer, *Havemeyers*, pp. 66–69.

23. Ibid., pp. 156–57.

24. Shriner, *Random Recollections*, p. 8.

25. *Paterson Guardian*, July 3, 1901, p. 1.

26. *Washington Post*, July 7, 1901.

27. *Washington Post*, July 3, 1901.

28. Tomkins Papers, IV.B.9.

29. Shriner, *Random Recollections*, pp. 18–19.

30. Morgan Library Archives, ARC 539; and *Chicago Daily Tribune*, May 28, 1901.

31. Strouse, *Morgan*, p. 485.

32. Ibid., p. 377.

33. Ibid., pp. 489–90.

34. Taylor, *Pierpont Morgan as Collector and Patron*, p. 3.

35. *New York Herald*, March 31, 1903.

36. Taylor, *Pierpont Morgan as Collector and Patron*, pp. 28–30.

37. The account of the Etruscan *biga* is based on an author interview with Tito Mazzetta and articles in the *Daily Telegraph* (London) on March 3, 2005, and Sept. 4, 2007, and the *New York Times*, April 5, 2007.

38. *New York Times*, Feb. 25, 1905.

39. The account of the Ascoli Cope is based on Strouse, *Morgan*, p. 502; and the *New York Times*, Aug. 18 and 21, Nov. 4, Dec. 4, 1904, and Aug. 18, 1907.

40. The account of the Dino collection is based on the *Chicago Tribune*, April 16, 1904; and Tomkins, *Merchants and Masterpieces*, p. 152.

41. "J. Pierpont Morgan," *McClure's Magazine*, Oct. 1901.

42. "Museums and Art Schools," *Independent*, March 2, 1905.

43. Strouse, *Morgan*, p. 497.

44. Walker, *Self-Portrait with Donors*.

45. Strouse, *Morgan*, pp. 556–57.

46. The account of Bashford Dean is based on Tomkins, *Merchants and Masterpieces*, pp. 149–53; Constable, *Art Collecting in the United States*, p. 67; Strouse, *Morgan*, p. 495; *New Yorker*,

March 30, 1940; and Lee Sorensen, "Dean, Bashford," in *Dictionary of Art Historians*, www.dictionaryofarthistorians.org/wittkowerr.htm.

47. Morgan Library Archives, Correspondence, ARC 1310.

48. Ibid.

49. *New York Times,* May 9, 1909.

50. Strouse, *Morgan,* p. 609.

51. Ibid.; Meyer, *Art Museum,* p. 31; Seligman, *Merchants of Art,* p. 75; and Howe, *History of the Metropolitan Museum of Art, Volume II.*

52. "Address on the Opening of the American Wing," *Metropolitan Museum of Art Bulletin,* Dec. 1924.

53. Saarinen, *Proud Possessors,* pp. 107–8.

54. Morgan Library Archives, Correspondence, ARC 1310.

55. Strouse, *Morgan,* p. 633.

56. Morgan Library Archives, Correspondence, ARC 1310.

57. "Oral History Interview with A. Hyatt Mayor," March 21, 1969.

58. Tomkins Papers, IV.B.11.

59. *New Yorker,* March 16, 1940.

60. Strouse, *Morgan,* pp. 641–42.

61. Seligman, *Merchants of Art,* p. 76.

62. Shipping records from Morgan Jr. Papers, ARC 1216, box 191, files 273.1–273.4; Robinson to Morgan, Morgan Library Archives, Correspondence, ARC 1310, file MMA-2.

63. Morgan Library Archives, Correspondence, ARC 1310, file MMA-2.

64. Strouse, *Morgan,* p. 638.

65. Morgan Library Archives, Correspondence, ARC 1310, file MMA-2.

66. Mahoney and Sloane, *Great Merchants.*

67. Secrest, *Duveen,* pp. 56–57.

68. Constable, *Art Collecting in the United States,* p. 113.

69. Simpson, *Artful Partners,* p. 135.

70. Secrest, *Duveen,* p. 96; and *New York Times,* Oct. 14, 1910.

71. New York Community Trust, "Benjamin Altman, 1840–1913," n.d.

72. Tomkins Papers, I.V.B.26.

73. "Last Will and Testament and Codicil of Benjamin Altman," May 2, 1912.

74. Strouse, *Morgan*, pp. 672–73.

75. Ibid., pp. 675–80.

76. Morgan Jr. Papers, ARC 1216, box 221, file 411; and *Metropolitan Museum of Art Bulletin*, Nov. 1957.

77. Morgan Jr. Papers, ARC 1216, box 205, file 340.

78. Ibid., box 63, file 55.

79. Ibid., box 205, file 340.

80. Ibid., box 160, file 194.

81. Ibid., box 205, file 340.

82. Ibid., box 168, file 225.

83. Ibid., box 160, file 194.

84. Ibid.

85. Ibid.

86. Saarinen, *Proud Possessors*, p. 87.

87. Ibid., p. 88.

88. Morgan Jr. Papers, box 220, file 390, and box 168, file 223.

89. Ibid., ARC 1216, box 121, file 41.

90. Ibid., Metropolitan Museum of Art Correspondence.

91. Ibid., box 168, file 223.

92. Ibid., box 221, file 400.

93. Ibid., box 160, file 194.

94. Morgan Library Archives, Correspondence, ARC 1310, file MMA-3.

95. Burt, *Palaces for the People*, p. 315.

96. Morgan Library Archives, Correspondence, ARC 1216, box 160, file 194.

97. Ibid.

98. Taylor, *Pierpont Morgan as Collector and Patron*, p. 36.

PHILANTHROPIST:
JOHN D. ROCKEFELLER JR., 1912–1938

1. Dalzell and Dalzell, *The House the Rockefellers Built*, pp. 22–23; and Hugh J. McCauley, "Visions of Kykuit: John D. Rockefeller's House at Pocantico Hills," *Hudson Valley Regional Review*, Sept. 1993, pp. 1–51.

2. Dalzell and Dalzell, *The House the Rockefellers Built*, p. 89.

3. Fosdick, *John D. Rockefeller Jr.*, p. 336; and Saarinen, *Proud Possessors*, pp. 345–46.

4. Simpson, *Artful Partners*, p. 146.

5. Fosdick, *John D. Rockefeller Jr.*, p. 337.

6. Rockefeller Family Archives, RAC, Record Group 2, Office of the Messrs. Rockefeller, Homes/Pocantico series, folders 189 and 190, box 21.

7. Ibid., Cultural Interests series, folder 328, box 32.

8. RAC, III 2E 32 328.

9. Ibid.

10. Fosdick, *John D. Rockefeller Jr.*, pp. 324–25.

11. RAC, Homes series, folder 157, box 16.

12. Ibid., folder 190, box 21.

13. Tomkins Papers, IV.B.31.

14. Geoffrey T. Hellman, "The American Museum," *New Yorker*, Nov. 30, 1968.

15. Tomkins Papers, IV.B.26.

16. Metropolitan Museum of Art Annual Report, 1914–1920.

17. *New Yorker*, March 30, 1940.

18. RAC, Harkness to Rockefeller, Jan. 24, 1919.

19. Ibid., Rockefeller to Duveen, Dec. 18, 1919.

20. Ibid., Cultural Interests series, folder 278, box 27.

21. Ibid., folders 273–76, box 27.

22. Ibid., Homes series, folder 157, box 16.

23. Ibid., folder 191, box 21.

24. Ibid., Cultural Interests series, folders 328–30, box 32.

25. Ibid., folder 157, box 16.

26. Ibid.

27. Ibid.

28. Fosdick, *John D. Rockefeller Jr.,* pp. 330–32.

29. Tomkins, *Merchants and Masterpieces,* pp. 252–53.

30. RAC, Cultural Interests series, folder 158, box 16.

31. Ibid., folder 329, box 32.

32. Ibid., folder 158, box 16.

33. *New York Times,* May 31, 1923; and Secrest, *Duveen,* pp. 218–20.

34. *New York Times,* June 4, 1923.

35. Simpson, *Artful Partners,* pp. 188–89.

36. Secrest, *Duveen,* p. 223.

37. Ibid., p. 218.

38. Ibid.

39. RAC, folder 331, box 32.

40. Ibid., memorandum for Mr. Fosdick, Oct. 25, 1922; memo to Mr. Fosdick, Jan. 10, 1923; and "Report: The Metropolitan Museum of Art," Jan. 1923, all by Beardsley Ruml.

41. Peter M. Kenny, "R. T. H. Halsey: American Wing Founder and Champion of Duncan Phyfe," *Magazine Antiques,* Jan. 2000.

42. Ibid., p. 187.

43. Emily Johnston de Forest, "My Memories," an undated manuscript written for her children, provided to the author by her great-granddaughter Helen Taylor Burke.

44. Priscilla de Forest Williams, "Our Grandparents: Robert and Emily de Forest," talks to the visiting committee of the American Wing, 1997, provided to the author by Helen Taylor Burke.

45. Ibid.

46. *New York Times,* Nov. 11, 1924; Amelia Peck, "Robert de Forest and the Founding of the American Wing," *Magazine Antiques,* Jan. 2000; and *Metropolitan Museum of Art Bulletin,* Dec. 1924.

47. Williams, "Our Grandparents."

48. Kenny, "R. T. H. Halsey"; and display ad for W. & J. Sloane, *Los Angeles Times,* April 10, 1939.

49. *New York Times,* Dec. 23, 1925.

50. Ibid.

51. *New Yorker,* March 16, 1930.

52. RAC, III 2E 28 295.

53. Ibid., de Forest Rockefeller, Dec. 23, 1924.

54. RAC, III 2E 28 295.

55. Ibid.

56. Ibid.

57. RAC, III 2E 30 307.

58. PDGF, Metropolitan Museum, 1941; Tomkins, *Merchants and Masterpieces,* p. 219; and *New Yorker,* March 16, 1940.

59. RAC, III 2E 30 308.

60. Saarinen, *Proud Possessors,* p. 227; and Berman, *Rebels on Eighth Street,* p. 172.

61. Weitzenhoffer, *Havemeyers,* pp. 244–45.

62. *New York Times,* Dec. 14, 1919.

63. Weitzenhoffer, *Havemeyers.*

64. Saarinen, *Proud Possessors,* pp. 227–28; and *New York Times,* Sept. 8, 1921.

65. Weitzenhoffer, *Havemeyers,* pp. 251–52; and *New York Times,* Jan. 22, 1929.

66. *New Yorker,* March 30, 1940.

67. Berman, *Rebels on Eighth Street,* p. 263.

68. Author interview with Flora Biddle.

69. Secrest, *Duveen,* p. 369.

70. *New York Times,* Dec. 1, 1912.

71. RAC, III 2E 28 288.

72. *Washington Post,* June 18, 1978; and *New York Times,* Sept. 2 and 26 and Nov. 9, 1931.

73. RAC, Charlyne Gellatly to Rockefeller, Dec. 10, 1937, and Jan. 4 and 31, 1938; Robert Gumbel reply, Feb. 8, 1938.

74. RAC, 2E 30 300; and Fosdick, *John D. Rockefeller Jr.,* p. 325.

75. *New York Times,* Oct. 28, 1930.

76. *Chicago Daily Tribune,* Jan. 28, 1931.

77. Interview with Dr. Joseph Turner by Dr. Albert S. Lyons, Dec. 14, 1965, Mount Sinai Archives, Gustave L. and Janet W. Levy Library, Mount Sinai Medical Center, New York.

78. *New York Times,* Jan. 28, 1950.

79. Howe, *History of the Metropolitan Museum of Art, Volume II,* p. 17.

80. RAC, III 2E 31 318.

81. Undated manuscript by James Rorimer on the Cloisters, Tomkins Papers, IV.B.16.

82. RAC, III 2E 31 327.

83. Ibid., III 2E 30 300.

84. Ibid., III 2E 29 296.

85. Ibid.

86. Moses, *Public Works,* p. 48.

87. Tomkins, *Merchants and Masterpieces,* p. 223.

88. Russ Bellant, *Old Nazis, the New Right, and the Republican Party* (Boston: South End, 1991), pp. 32–33; and William H. Tucker, *The Funding of Scientific Racism: Wickliffe Draper and the Pioneer Fund* (Urbana: University of Illinois Press, 2002).

89. RAC, III 2E 29 296.

90. Ibid., III 2E 30 312.

91. Tomkins Papers, IV.B.15.

92. Heckscher, *Alive in the City,* pp. 57–58.

93. PDGF, 1934, folder 37.

94. RAC, III 2E 30 300.

95. Ibid., III 2E 29 296.

96. Undated manuscript by James Rorimer on the Cloisters, Tomkins Papers, IV.B.16.

97. RAC, III 29 300.

98. Ibid., III 2E 20 311.

99. Ibid., III 2E 30 310.

100. Ibid.

101. Ibid., III 2E 29 297.

102. Ibid.

103. Ibid., III 2E 30 312.

104. Ibid., III 2E 29 297 and III 2E 30 300.

105. Tomkins, *Merchants and Masterpieces,* p. 266.

106. Winlock to Rockfeller, Rockefeller to Winlock, March 23, 1938, RAC, III 2E 31 323.

107. RAC, III 2E 32 329.

108. Ibid., III 2E 32 330.

109. *New York Times,* April 25, 1938.

110. RAC, III 2E 29 297.

CATALYST:
ROBERT MOSES, 1938–1960

1. PDGF, 1934, folder 37.

2. "Oral History Interview with A. Hyatt Mayor," March 21, 1969.

3. Redmond to Tomkins, Sept. 8, 1969, Tompkins Papers, I V.B.25.

4. Tomkins, *Merchants and Masterpieces,* p. 273; and George M. Goodwin, "A New Jewish Elite: Curators, Directors, and Benefactors of American Art Museums," *Modern Judaism,* Feb. 1998, pp. 47–79.

5. Meyer, *Art Museum,* p. 103.

6. *New Yorker,* March 30, 1940.

7. Tompkins, *Merchants and Masterpieces,* p. 302.

8. PDGF, 1944.

9. Seligman, *Merchants of Art,* p. 146.

10. PDGF, Jennings memo to Moses, April 16, 1940.

11. RAC, III 2E 31 324.

12. Ibid.

13. Ibid., Ivins memo, March 25, 1940.

14. Murielle Vautrin, "Government and Culture: New York City and Its Cultural Institutions, 1870–1965" (Ph.D. diss., Brandeis University, 1997), p. 201.

15. PDGF, Budget folder, Moses to Osborn July 21, 1939.

16. Ibid., Moses memo to Jennings, May 2, 1938.

17. RAC, II 4 L 121 1189.

18. PDGF, Osborn to Moses, July 20, 1939.

19. Ibid., Moses to Osborn, July 21, 1939.

20. Ibid., Moses to Blumenthal, Oct. 14, 1939.

21. Vautrin, "Government and Culture," pp. 193–94.

22. Coleman, *Museum in America,* p. 403.

23. *Time,* Dec. 29, 1952.

24. Burt, *Palaces for the People,* p. 323.

25. *Time,* Dec. 29, 1952.

26. "Oral History Interview with A. Hyatt Mayor," March 21, 1969.

27. Ibid.

28. Jayne to Tomkins, April 29, 1969, Tomkins Papers, IV.B.25.

29. Kay Rorimer oral history, read to the author by Anne Rorimer.

30. RAC, III 2E 31 324.

31. *New Yorker,* March 16, 1940.

32. Tompkins Papers, IV.B.26.

33. Ibid., IV.B.19.

34. *New Yorker,* March 30, 1940.

35. RAC, III 2E 31 325.

36. PDGF, 1940.

37. *New York Times,* July 14, 1940.

38. *New York Times,* July 7, 1940.

39. *New York Times,* May 5, 1940.

40. PDGF, margin comment on open letter to Moses, March 23, 1942.

41. RAC, III 2E 31 325.

42. PDGF, 1942, folder 15.

43. Except where otherwise noted, the account of Robert Moses and the museum is based on documents contained in the Parks Department General Files on the Metropolitan Museum.

44. "Museums: Report to the Mayor of the City of New York by the Commissioner of Parks," March 3, 1941.

45. PDGF, 1942, folder 20.

46. Ibid., Moses to J. G. D. Paul, April 5, 1941.

47. Ibid., Taylor to Moses, April 19, 1941.

48. RAC, Rockefeller to Osborn, July 16, 1941.

49. PDGF, Moses to Osborn, Sept. 10, 1941.

50. Ibid., 1942, folder 16.

51. Moses to Hoving, March 9, 1977, Hoving Papers.

52. PDGF, 1941, 1942 folder 34, and 1943 folder 9.

53. Berman, *Rebels on Eighth Street,* p. 431.

54. RAC, III 2E 31 324.

55. Berman, *Rebels on Eighth Street,* p. 421.

56. *Washington Post,* Dec. 2, 1962.

57. *New York Times,* March 22, 1947, and Aug. 10, 1969.

58. *New York Times,* Aug. 10, 1969; and Birmingham, *Our Crowd.*

59. PDGF, Moses to La Guardia, Nov. 13, 1942.

60. Ibid., Dawson memo to Moses, Sept. 9, 1941.

61. Berman, *Rebels on Eighth Street,* pp. 444 and 448.

62. PDGF, Moses to Taylor, Oct. 28, 1943.

63. Berman, *Rebels on Eighth Street,* pp. 451–53; and PDGF, Crocker to Redmond, June 22, 1943.

64. Berman, *Rebels on Eighth Street,* p. 469 (from Lloyd Goodrich interview by Harlan Phillips, Archives of American Art).

65. RAC, III 2E 29 297.

66. Ibid.

67. Ibid., III 2E 29 301.

68. Ibid., III 2E 29 297.

69. Ibid., Taylor to Rockefeller, Oct. 27, 1942.

70. Ibid., Rockefeller to Taylor, Dec. 22, 1942.

71. Ibid., Rorimer to Rockefeller, Feb. 18, 1943.

72. Ibid., John D. Rockefeller to Nelson Rockefeller, Feb. 23, 1943.

73. Kay Rorimer oral history.

74. Rorimer, *Survival*, p. 108.

75. Ibid., p. 110.

76. Ibid., p. 161.

77. Ibid., pp. 198–202.

78. RAC, III 2E 29 298.

79. PDGF, Moses to George Spargo, May 2, 1942.

80. PDGF, 1942.

81. Ibid., Moses to Spargo, May 2, 1942.

82. Ibid., 1942, files 14 and 16, and Metropolitan Museum of Art executive committee, minutes of a special meeting, Sept. 30, 1942.

83. Ibid., Osborn to board of trustees, Dec. 29, 1943.

84. Ibid., 1944, file 8, Metropolitan Museum of Art board resolution, Jan. 5, 1943.

85. Ibid., Francis Henry Taylor, *Where Is the Metropolitan Museum Going?* Jan. 1943.

86. Ibid., Spargo memo to Moses, Oct. 18, 1943.

87. Ibid., Moses to Taylor, Oct. 25, 1943.

88. *New York Times*, Jan. 18, 1944.

89. Eleanor Lambert interview with Eleanor Dwight, n.d.

90. PDGF, Moses to Osborn, Dec. 31, 1943.

91. Ibid., Moses memo to Spargo, Jan. 4, 1944.

92. Ibid., Arthur S. Hodgkiss memo to Francis J. Cormier, Feb. 10, 1944.

93. Ibid., Cormier memo to Hodgkiss, Jan. 9, 1945.

94. Ibid., Moses to Webb, Feb. 27, 1945.

95. Ibid., Moses to Webb, March 13, 1945.

96. Ibid., Moses to Webb, March 21, 1945.

97. Ibid., Moses to Webb, March 23, 1945.

98. Ibid., Cormier to Hodgkiss, Oct. 2, 1945.

99. RAC, "The Metropolitan Museum of Art 75th Anniversary," brochure, hand-dated April 7, 1946.

100. PDGF, 1946, folder 48.

101. Ibid., Cormier memo to Hodgkiss, April 8, 1947.

102. RAC, III 4 L 121 1197.

103. Ibid., III 2E 29 301.

104. Ibid.

105. *New York Times,* Sept. 16, 1947.

106. *Newsweek,* Oct. 11, 1948.

107. Berman, *Rebels on Eighth Street,* pp. 495–505.

108. Tomkins Papers, IV.B.19.

109. PDGF, Redmond to Moses, Aug. 5 and 24, 1948, and Moses to Redmond, Aug. 19 and 25, 1948.

110. Ibid., Moses to Redmond, Dec. 22, 1948.

111. Ibid., Cormier memo to Hodgkiss, April 23, 1947.

112. Tomkins Papers, IV.B.30.

113. Ibid.

114. RAC, III 2E 30 299.

115. Ibid., III 2E 30 303.

116. Philip Hamburger, "All in the Artist's Head," *New Yorker,* June 13, 1977.

117. Forrest Selvig, "Oral History Interview with Robert Beverly Hale," Oct. 4, 1968.

118. *New York Times,* Dec. 7, 1948.

119. Hamburger, "All in the Artist's Head."

120. PDGF, Rosenberg to Moses, Dec. 10, 15, and 22, 1948.

121. Ibid., James N. Rosenberg, "Nine Open Letters to Roland L. Redmond," Jan. 6–14, 1949.

122. Ibid., 1949, Webb to Moses, n.d.

123. *New York Times,* Jan. 18, 1949.

124. *New York Times,* Jan. 23, 1949.

125. PDGF, Biddle, "Open Letter to Ronald [*sic*] L. Redmond," Feb. 1949.

126. RAC, III 4 L 121 1189.

127. PDGF, Moses to Biddle, March 22, 1949.

128. Ibid., Moses to Redmond, May 13, 1949.

129. Hamburger, "All in the Artist's Head."

130. Saarinen, *Proud Possessors,* p. 266.

131. *New York Times,* Dec. 11, 1949.

132. Tomkins Papers, IV.B.28.

133. *Smithsonian,* May 1987.

134. Niké Hale interview.

135. Tomkins Papers, IV.B.30.

136. PDGF, Moses to Board of Estimate, Oct. 25, 1950.

137. RAC, III 2E 30 299 and 306.

138. Rorimer postcard to Kay Rorimer, June 7, 1952, courtesy Anne Rorimer.

139. Saarinen, *Proud Possessors,* p. 349.

140. Pope-Hennessy, *Learning to Look,* pp. 231–32.

141. Roland Redmond report, 1966, Tomkins Papers, IV.B.19.

142. Jayne to Tomkins, April 29, 1969, Tomkins Papers, IV.B.25.

143. PDGF, Moses to Redmond, July 21, 1953.

144. Ibid., Moses to Redmond, Oct. 26, 1953.

145. Ibid., Redmond to Moses, Nov. 18, 1952.

146. *ARTnews,* Jan. 1954.

147. RAC, III 4 L 121 1196.

148. PDGF, April 29, 1955.

149. Pope-Hennessy, *Learning to Look,* pp. 231–32.

150. RAC, III 2E 30 299.

151. Ibid.

152. Undated typescript by A. Hyatt Mayor provided by Anne Rorimer.

153. *Metropolitan Museum of Art Bulletin,* Jan. 1958.

154. RAC, Rockefeller Brothers Fund Archives, 310-1.

Exhibitionist:
Thomas P. F. Hoving, 1959–1977

1. John McPhee, "A Roomful of Hovings," *New Yorker*, May 20, 1967.

2. Hoving, *King of the Confessors*, p. 4.

3. Ibid., p. 18.

4. *New Yorker*, Dec. 2, 1961.

5. PDGF, 1961, folder 23.

6. Kay Rorimer oral history, read to the author by Anne Rorimer.

7. *New York Times*, Nov. 17, 1961.

8. *Washington Post*, Dec. 1, 1961.

9. PDGF, Lewis N. Anderson memo to Moses, Dec. 13, 1955.

10. *New Yorker*, Aug. 28, 1948.

11. Ibid.

12. *New York Times*, Jan. 22, 1962.

13. *Newsweek*, June 13, 1960.

14. *Time*, Sept. 25, 1964, and Aug. 1, 1960; *New York Times*, June 8 and 9, 1960; and *Burlington Magazine*, Aug. 1981.

15. Interview with Henry Geldzahler by Paul Cummings, Jan. 27, 1970, Archives of American Art, Smithsonian Institution, Washington, D.C.

16. Ibid.

17. Ibid.

18. Henry Geldzahler, "The Sixties: The Way We Were," lecture at Guild Hall of East Hampton, Sept. 22, 1991.

19. Warhol, *POPism*, p. 15.

20. "Now and Then in Focus," book outline, Geldzahler Papers.

21. Ibid.

22. Author interview with confidential source.

23. Geldzahler interview with Cummings.

24. Untitled transcript of interview with Henry Geldzahler, Jan. 6, 1973, Geldzahler Papers.

25. Geldzahler interview with Cummings.

26. *New York Times,* April 24, 1965.

27. *Time,* Oct. 24, 1969.

28. *Smithsonian,* May 1987.

29. Geldzahler to Michael and Ruth Fried, July 5, 1966, Geldzahler Papers.

30. Warhol, *POPism,* p. 74.

31. Untitled transcript of interview with Geldzahler, Jan. 6, 1973.

32. Geldzahler interview with Cummings.

33. Khoi Nguyen, "Gilt Complex," *Connoisseur,* Sept. 1991.

34. Douglas, *Ragman's Son,* pp. 176–79 and 187–88.

35. Nguyen, "Gilt Complex."

36. Walker, *Self-Portrait with Donors,* p. 259.

37. Ibid., p. 256.

38. Abbott, *Jansen,* pp. 30–31.

39. Stephanie Lake, "With Pride and Prejudice: Motives and Meanings in Judge Irwin Untermyer's Embroidery Collection," unpublished manuscript, 2000. Lake originally wrote under her maiden name, Stephanie Day Iverson.

40. Stephanie Lake, "The Formation of a Collection: Examining the Motives Behind the Irwin Untermyer Collection," unpublished manuscript, 1999.

41. Frank Untermyer interview with Stephanie Lake, Nov. 16, 1999.

42. Author interview with Ann Erdmann Carmel.

43. Frank Untermyer to Stephanie Lake, Nov. 24, 1999.

44. Irwin Untermyer letter, May 17, 1967, provided by Frank Untermyer to Stephanie Lake.

45. Frank Untermyer letter, Aug. 21, 2001, provided by Frank Untermyer to Stephanie Lake.

46. *New York Times,* April 1, 1961.

47. Meyer, *Art Museum,* pp. 189–90; and *Wrightsman v. United States,* U.S. Court of Claims, 428 F.2d 1316.

48. Hoving, *Making the Mummies Dance,* p. 113.

49. Douglas, *Ragman's Son,* p. 188.

50. *New York Times,* March 8, 1965.

51. Hoving, *Making the Mummies Dance,* p. 18.

52. *Time,* Sept. 25, 1964.

53. Hess, *Grand Acquisitors,* p. 32.

54. *New York Times,* March 8, 1965.

55. Birmingham, *Our Crowd.*

56. *New York Post,* Aug. 16, 1969.

57. *New York Times,* Jan. 30, 1962.

58. Kay Rorimer oral history.

59. RAC, Rockefeller Brothers Fund Archives, 310-3.

60. *New York Times,* March 28, 1966.

61. Unpublished draft manuscript of *Making the Mummies Dance,* Hoving Papers.

62. Pope-Hennessy, *Learning to Look,* p. 232.

63. Ibid., p. 154.

64. *New York Post,* Dec. 17, 1966.

65. Kiernan, *Last Mrs. Astor.* pp. 105–13.

66. Ibid., p. 125.

67. *New York Times,* June 16, 1968.

68. Hoving, *Making the Mummies Dance,* pp. 34–35.

69. *New York Times,* Dec. 21, 1966.

70. *Newsweek,* Dec. 26, 1977.

71. *New York Times,* May 5, 1998.

72. Author interviews with Susan Trescher and Duane Garrison Elliott.

73. *New York Times,* March 15, 1968.

74. Geldzahler interview with Cummings.

75. Ibid.

76. Hoving memo to Ashton Hawkins, Jan. 28, 1974, Hoving Papers.

77. *New York Times,* Feb. 17, 1968.

78. Houghton to Dr. Rudolph J. Heinemann, March 4, 1968, Hoving Papers.

79. Beaton, *Unexpurgated Beaton,* p. 114.

80. *Vogue,* Oct. 1, 1966.

81. Beaton, *Unexpurgated Beaton,* p. 107.

82. Beaton, *Beaton in the Sixties,* pp. 237–45.

83. Hoving, *Making the Mummies Dance,* pp. 112–16; and unpublished manuscript dated March 1, 1990, Hoving Papers.

84. Beaton, *Unexpurgated Beaton,* p. 439.

85. Hoving, unpublished manuscript dated March 1, 1990, Hoving Papers.

86. *Wall Street Journal,* April 20, 1969, July 29, 1970, and May 4, 1989.

87. Rosenblatt oral history.

88. Except where noted, the account of the acquisition of the Temple of Dendur is based on Sophy Burnham, "A Little Bit of Egypt on Fifth," *New York,* Nov. 18, 1968; and Henry G. Fischer, "The Temple of Dendur Comes to New York City," *ARAMCO Magazine,* undated copy in Hoving Papers.

89. Rosenblatt oral history.

90. Hoving, *Making the Mummies Dance,* p. 118.

91. Minutes of the board of trustees, Metropolitan Museum, Jan. 1969.

92. Argyll, *Forget Not,* pp. 113 and 193.

93. Nora Scott to John Canaday, Feb. 18, 1973, Canaday Papers.

94. RAC, Rockefeller Brothers Fund Archives, 310-3, letter dated Jan. 23, 1969.

95. *New York Times,* Feb. 1, 1969.

96. Mario Procaccino to Arthur Houghton, Jan. 28, 1969, Hoving Papers.

97. Bennett Cerf to Hoving, Aug. 26, 1969, Hoving Papers. The catalog would be reissued without protest in 1995.

98. *New York Times,* Feb. 2, 1969.

99. Rosenblatt oral history.

100. Hoving, *Making the Mummies Dance,* p. 180.

101. RAC, III 4 L 121 1196.

102. Geldzahler, "Sixties."

103. Geldzahler, "Now and Then in Focus."

104. Thomas Hoving, "The Artful Tommy," unpublished manuscript, Hoving Papers.

105. *New Yorker,* Nov. 6, 1971.

106. Geldzahler, "Now and Then in Focus."

107. *Smithsonian,* May 1987.

108. *New York Post,* undated clipping, Hoving Papers.

109. *Time,* Oct. 24, 1969.

110. Hoving, centennial manuscript, Hoving Papers.

111. *New York,* Aug. 18, 1969.

112. Hoving, *Making the Mummies Dance,* pp. 148 49.

113. Author interview with Duane Garrison Elliott.

114. *New York Times,* Sept. 26, 1968.

115. George C. McDermott III to Dillon, April 10, 1971, provided to the author by Duane Garrison Elliott.

116. *New York Times,* Dec. 30, 1970.

117. Rosenblatt oral history.

118. RAC, III 4 L 161 1642.

119. Ibid., III 4 L 161 1654.

120. Ibid., III 4 L 161 1643 and 1656.

121. Ibid., III 4 L 161 1645.

122. Ibid.

123. Ibid.

124. RAC, Rockefeller Brothers Fund Archives, 310-4.

125. Henry Young, letter to the editor, *Abilene Reporter-News,* Oct. 25, 1952, Center for American History, University of Texas at Austin; *Abilene Reporter-News,* Oct. 31, 1957; and *New Yorker,* Oct. 20, 1928.

126. *Time,* Aug. 18, 1961.

127. Meyer, *Art Museum,* p. 120.

128. *New York Times,* Oct. 12, 1968.

129. Estelle Wolf to Percy Sutton, Manhattan borough president, Aug. 7, 1969, Hoving Papers.

130. Hoving, centennial manuscript.

131. Ibid.

132. Ibid.

133. *Village Voice,* Feb. 12, 1970.

134. *New York Times,* April 14, 1970.

135. Remarks of Douglas Dillon at centennial luncheon, April 13, 1970.

136. Rosenblatt oral history.

137. *New York Times,* April 13, 1970.

138. *New York Times,* Nov. 7, 1971; and *New York,* Jan. 19, 1970.

139. *New York Times,* May 10, 1972.

140. Rosenblatt oral history.

141. *New York Times,* Sept. 16, 1970.

142. "A Statement on the Metropolitan Museum of Art Issues by Parks, Recreation, and Cultural Affairs Administrator August Heckscher, January 20, 1971."

143. Hoving, centennial manuscript.

144. Meyer, *Art Museum,* p. 120.

145. Rosenblatt oral history.

146. Meier, *Pain Killer,* p. 9.

147. Hoving, *Making the Mummies Dance,* p. 94.

148. Rosenblatt oral history.

149. Ibid.

150. Tom Hoving file memo, Dec. 29, 1982, and memos to Phil Herrera, Jan. 1 and 2, 1983, Hoving Papers.

151. *New York Times,* May 11 and 19, 1980.

152. Hoving, centennial manuscript.

153. Ibid.

154. *Smithsonian,* May 1987.

155. Hess, *My Times,* p. 135.

156. Reminiscences of John B. Oakes, pp. 222–32.

157. Steegmuller to Canaday, March 7, 1972, Canaday Papers.

158. *New York Times,* March 19, 1972.

159. *Art in America,* Jan.–Feb. 1973.

160. *New Republic,* June 1, 1975.

161. Ibid.

162. Hoving, *Making the Mummies Dance,* p. 298.

163. Rosenblatt oral history.

164. Boleslaw Mastai to Canaday, Oct. 16, 1972, Canaday Papers. Mastai was the publisher of a directory of art and antiques dealers. "The Metropolitan Museum would not need to sell any pictures if its director and curator had not grown used to modest little creature comforts like week-ends in Moscow at the drop of a hat," he wrote.

165. *Washington Post,* Feb. 18, 1973.

166. Melik Kaylan, "Who Stole the Lydian Hoard?" *Connoisseur,* July 1987.

167. Watson and Todeschini, *Medici Conspiracy,* p. 165.

168. Thomas Hoving, "Super Art Gems of New York City," www.artnet.com, June 29, 2001.

169. *Time,* March 5, 1973.

170. The account of the Tahmasp *Shahnameh* is based on a confidential interview with a Houghton relative; an interview with András Riedlmayer of Harvard's Fine Arts Library; Feigen, *Tales from the Art Crypt,* pp. 205–24; *Burlington Magazine,* June 1983; Dr. Habibollah Ayatollahi, "Tahmasbi Shahnameh," on www.iranchamber.com; *New York Times,* Nov. 18, 1976; *International Herald Tribune,* April 27, 1996, Oct. 18, 1997, April 22, 2000, and April 24, 2004; and *Art Newspaper,* Oct. 1994.

171. Klaus Graf, ExLibris e-mail list, Jan. 23, 2005; *Harvard Library Bulletin* (Fall 2003), pp. 3–7; and *Art Newspaper,* Oct. 1994.

172. *New York Times,* Feb. 8, 1975.

173. *New York Times,* March 2, 1975.

174. Pope-Hennessy, *Learning to Look,* pp. 229–30.

175. PDGF, Devree to Paul O'Dwyer, Nov. 23, 1976.

ARRIVISTES:
JANE AND ANNETTE ENGELHARD, 1974–2009

1. Author interview, confidential source.

2. Diana Vreeland Papers, Vreeland contract, July 18, 1972, box 10, folder 2.

3. Ibid., unsigned memo, Dec. 4, 1972, box 7, folder 14.

4. Ibid., Perry Ruston to Vreeland, May 11, 1972, Si Newhouse note to Vreeland, Aug. 1986, box 7, folder 14.

5. Ibid., Vreeland to Rousseau, Aug. 10, 1972, box 10, folder 4.

6. Ibid., box 14, folder 5.

7. Ibid., Vreeland to Masatake Katamoto, Aug. 28, 1972, box 10, folder 4.

8. Ibid., Vreeland to Stella Blum, Sept. 25, 1972, box 12, folder 1.

9. Ibid., Mapplethorpe to Vreeland, Sept. 7, 1972, box 11, folder 3.

10. Ibid., undated memo, box 10, folder 2.

11. Ibid., Vreeland notes, box 10, folder 4.

12. The account of Fritz Mannheimer's life and career is based, except where noted, on J. P. B. Jonker, "Mannheimer, Fritz (1890–1939)," in *Biografisch Woordenboek van Nederland,* www.inghist.nl/Onderzoek/Projecten/BWN/lemmata/bwn5/mannheimer; the Herkomst Gezocht/Origins Unknown database, www.herkomstgezocht.nl/eng/collecties/content .html; and Venema, *Kunsthandel in Nederland.*

13. *Time,* Aug. 21, 1939.

14. *New York Times,* Aug. 11, 1939.

15. *Time,* Aug. 21, 1939.

16. James, *Deutsche Bank and the Nazi Economic War Against the Jews,* p. 71.

17. Author interview with Johannes Houwink ten Cate.

18. James, *End of Globalization,* p. 190.

19. Author interview with Ian Locke.

20. Harclerode and Pittaway, *Lost Masters,* p. 13.

21. *Vogue,* May 1968.

22. *Time,* Aug. 21, 1939.

23. Venema, *Kunsthandel in Nederland,* pp. 172–76.

24. Ibid.; Meyer to Frank Altschul, Feb. 7, 1940, Altschul Papers.

25. Author interview with Mary Murnane.

26. Testimony of Mrs. Charles Engelhard, June 20, 1975, file no. HO-536, official transcript of proceedings before the Securities and Exchange Commission, in the matter of International Telephone and Telegraph Corporation.

27. Author interview with Mary Murnane; Jane Mannheimer U.S. immigration records.

28. "Ein jüdisches Finanzgenie bei Lichte betrachtet: Feststellungen zum Fall Mannheimer," *Mitteilungen über die Judenfrage*, pp. 5–6; and *Juden in Niederlanden*, Sept. 1939, pp. 7–10.

29. Office of Strategic Services Art Looting Investigation Unit, "Art Looting Investigation Unit, Final Report," National Archives, Washington, D.C., provided to the author by Jonathan Petropoulos.

30. *House and Garden*, March 1987.

31. Ibid.

32. Testimony of Mrs. Charles Engelhard, June 20, 1975.

33. John Jakob Raskob Papers, files 1096 and 1549, Hagley Museum and Library, Wilmington, Del.; and *New York Times* ad for Holbrook, Oct. 20, 1946.

34. *Kenyon v. Holbrook Microfilming Service, Inc.,* Circuit Court of Appeals, 2nd Circuit, 155 F.2d 913, June 27, 1946.

35. Raskob Papers, file 416, Horace J. Clement.

36. The account of Fritz Mannheimer's art during World War II is based, except where noted, on Venema, *Kunsthandel in Nederland.* Translated for the author by Gerard Forde.

37. Office of Strategic Services Art Looting Investigation Unit, report on Dr. Kai Mühlmann, n.d., National Archives, provided to the author by Jonathan Petropoulos.

38. Nicholas, *Rape of Europa*, pp. 111–14.

39. "Mannheimer, the Unknown Collector," *Bulletin van het Rijksmuseum*, Jan. 22, 1974; and Office of Strategic Services Art Looting Investigation Unit, Consolidated Interrogation Report No. 4, Dec. 15, 1946, National Archives, provided to the author by Jonathan Petropoulos.

40. Office of Strategic Services Art Looting Investigation Unit, Consolidated Interrogation Report No. 4, Dec. 15, 1946; Harclerode and Pittaway, *Lost Masters*, p. 16; and Kajetan Mühlmann, "Report Concerning the Mannheimer Collection," Nov. 18, 1947, National Archives, courtesy Jonathan Petropoulos.

41. "Cultural Property Claims," Monuments, Fine Arts, and Archives Section of the Military Government, Record Group 260, claim F132C, filed by Jane Mannheimer, National Archives.

42. Ibid.

43. Sire, *Father Martin D'Arcy: Philosopher of Christian Love*, pp. 147–49; and Alexander and Binki, *Age of Chivalry*, pp. 460–61.

44. Rousseau to Mrs. Charles W. Engelhard, June 12, 1971, Hoving Papers.

45. Handwritten notation on letter from Raoul Desvernine to Ugo Carusi, commissioner, INS, May 3, 1946, INS file C-6882787, U.S. Citizenship and Immigration Services, Department of Homeland Security.

46. Application for reentry permit, May 19, 1948, U.S. Citizenship and Immigration Services.

47. John W. Pehle to Randolph Paul, June 7, 1943, provided to the author by Patrick Hannon.

48. *W,* May 3, 1974.

49. *New York Times,* March 3, 1971.

50. Gordon, *Mrs. Astor Regrets,* p. 97.

51. Bartlett and Crater, *Sister,* p. 239.

52. Jones, *Malcolm Forbes,* p. 140.

53. Hersh, *Dark Side of Camelot,* pp. 110–11.

54. *New York Times,* Jan. 6, 1958.

55. Reich, *Financier,* pp. 68–69.

56. Ibid., p. 69.

57. Bartlett and Crater, *Sister.*

58. *New York Times,* Nov. 5, 1959.

59. *New York Times,* April 1, 1967.

60. Liz Smith, *Dishing* (New York: Simon & Schuster, 2005), p. 68.

61. "Jupiter Island Marks 50 Years of Exclusivity," *Palm Beach Post,* Nov. 30, 2003.

62. *Chicago Tribune,* Jan. 10, 1973.

63. *Washington Post,* Nov. 19, 1967.

64. *New York Times,* June 19, 1965.

65. Hays, *Fortune Hunters,* pp. 11–19.

66. Michael Gross, *Model* (New York: Morrow, 1995).

67. Hays, *Fortune Hunters,* p. 25.

68. Cohan, *Last Tycoons,* p. 475.

69. *W,* May 3, 1974.

70. "Biographies: Jean Lannes," www.napoleon.org; "Jean Lannes," www.napoleonguide.com; "Jean Lannes, Duke of Montebello," *Encyclopaedia Britannica* (2007).

71. Danny Danziger, *Museum: Behind the Scenes at the Metropolitan Museum of Art* (New York: Viking, 2007), pp. 148–49.

72. "Will de Montebello Make It the Met?" *ARTnews*, Sept. 1978, pp. 82–84.

73. Ibid.

74. Calvin Tomkins, "The Importance of Being Élitist," *New Yorker*, Nov. 24, 1997.

75. *New York Times*, Nov. 3, 1985.

76. Hoving, *Making the Mummies Dance*, p. 185.

77. Tomkins, "Importance of Being Élitist."

78. *Houston Chronicle*, March 30, 1969.

79. *Houston Chronicle*, May 19, 1969; and "Will de Montebello Make It the Met?"

80. *New York Times*, March 23, 1975.

81. *New York Times*, July 27, 1975.

82. PDGF, Devree to Paul O'Dwyer, May 19, 1977.

83. *New York Daily News*, Sept. 27, 1977.

84. *New York Post*, Dec. 27, 1977.

85. Tomkins, "Importance of Being Élitist."

86. "Will de Montebello Make It the Met?"

87. RAC, Rockefeller Brothers Fund Archives, 310–4, 1977–78, Bill Dietel memo to Barbara Newsom, April 23, 1978.

88. Ibid., Dietel to Newsom, June 27, 1978.

89. *New York Times*, April 8, 1979.

90. Tomkins, "Importance of Being Élitist."

91. Rosenblatt oral history.

92. *Current Biography* (New York: H. W. Wilson Company, 1981).

93. *New York Times*, March 18, 1984.

94. *Forbes*, Oct. 26, 1987.

95. *Washington Post*, Nov. 12, 1987.

96. Ibid.

97. *International Herald Tribune*, Feb. 26, 2007.

98. John Richardson, "Heinz Berggruen, Collector and Dealer," Phillips, de Pury & Luxembourg catalog, for a sale held May 7, 2001.

99. *New York Times,* May 25, 1980.

100. Bartlett and Crater, *Sister,* p. 247, 308, 316.

101. Kiernan, *Last Mrs. Astor,* p. 172.

102. Ibid., pp. 214–17.

103. Ibid., p. 247.

104. *New York Times,* Feb. 23, 1982.

105. Koch to Dillon, Feb. 26, 1982; Dillon reply, Feb. 28, 1982, courtesy Ed Koch.

106. *New York Times,* March 4, 1982.

107. Rosenblatt oral history.

108. *New York Times,* Jan. 7, 1999.

109. Ibid.

110. *New York Times,* June 30, 1987.

111. *New York Times,* Nov. 3, 1985.

112. Rosenblatt oral history.

113. *New York Observer,* Aug. 31, 1998.

114. *New York Times,* Oct. 29, 1998.

115. Rosenblatt oral history.

116. *Metropolitan Museum of Art Bulletin* (Summer 1984), as quoted on www.lootingmatters.blogspot.com.

117. *Atlanta Journal and Constitution,* April 18, 1998.

118. Ozgen and Ozturk, *Heritage Recovered,* pp. 12–13; and Watson and Todeschini, *Medici Conspiracy,* pp. 102–3.

119. Watson and Todeschini, *Medici Conspiracy,* pp. 105–6.

120. Ibid., p. 327.

121. www.lootingmatters.blogspot.com, March 31, 2008.

122. *New York Times,* Jan. 7, 1999.

123. *New York Times,* June 12, 1991.

124. *New York,* Feb. 3, 1992.

125. *New York Times*, June 12, 1991.

126. "Kajima Chairman Resigns; from Govt Postal Council," *Yomiuri Shimbun*, July 31, and Nov. 3, 1993, and July 6, 1994.

127. *Vogue*, March 2005.

128. Ibid.

129. *Dallas Morning News*, Nov. 22, 1974.

130. *Dallas Morning News*, Dec. 16, 1977.

131. Silverman, *Selling Culture*, p. 31.

132. Ibid., pp. 126–27.

133. Dwight, *Diana Vreeland*, p. 280.

134. Silverman, *Selling Culture*, p. 20.

135. *New York Times*, Dec. 31, 1989.

136. *New York Times*, Sept. 11 and 17, 1985.

137. *New York Times*, Nov. 3, 1985.

138. *W*, Jan. 9–16, 1989.

139. *New York*, Jan. 9, 1989.

140. Proposal for "Oscar: An Intimate Biography of Oscar de la Renta," provided to the author by Aino de Bodisco's sole heir, Jonathan Rogers Clark.

141. Bodisco to John and Francesca Lodge, Feb. 21, 1982, Lodge Papers, box 196, folder 55.

142. *Los Angeles Times*, Nov. 12, 1967.

143. Gordon, *Mrs. Astor Regrets*, p. 101.

144. *Manhattan Inc.*, Sept. 1988.

145. *New York Times*, Dec. 8, 1992.

146. *New York Times*, Sept. 25, 1994.

147. *New York Times*, Dec. 11, 1997.

148. *New York Times*, Oct. 5, 1999.

149. *New York*, May 9, 2005.

150. *New York Times*, May 4, 2006.

151. *New York Times*, July 27, 2006.

152. *New York Times*, July 30, 2006.

153. Gordon, *Mrs. Astor Regrets,* pp. 213 and 272–73.

154. *New York Times,* Dec. 6, 2006.

155. *New York Post,* July 30, 2006.

156. *New York Times,* Aug. 23, 2007.

157. *New York Post,* Aug. 22, 2007.

158. *Forbes,* Oct. 9, 2006.

159. *New York Post,* Aug. 23, 2007.

160. "Dumping the Shark," *New York Times,* July 20, 2007.

161. *New Criterion,* Feb. 2008.

162. *Talk,* Dec. 2000.

163. CultureGrrl blog, May 23, 2008.

164. *W,* Sept. 2008.

165. Meyer, *Art Museum,* p. 28.

166. Also, as those who followed Morgan are well aware, art given to a museum is deductible in the amount of its fair market value at the time of the gift, and the donor is not taxed for gains in value, which he would be if the art was sold. No other country allows this, said Meyer, so the taxpayer is ultimately the biggest benefactor of art museums.

167. *Los Angeles Times,* Sept. 4, 2007.

168. *Wall Street Journal,* Oct. 30, 2008.

169. *The Art Newspaper,* January 8, 2009.

170. blogs.tnr.com/tnr/blogs/the_spine/archive/2008/04/12/jeff-koons-and-the-end-of-western-civilization. aspx.

Bibliography

Abbott, James Archer. *Jansen.* New York: Acanthus, 2006.

Alexander, Jonathan, and Paul Binski (eds.). *Age of Chivalry: Art in Plantagenet England 1200–1400.* London: Weidenfeld and Nicholson, 1986.

Argyll, Margaret Campbell, Duchess of. *Forget Not.* London: W. H. Allen, 1975.

Astor, Brooke. *Footprints: An Autobiography.* Garden City, N.Y.: Doubleday, 1980.

Bartlett, Apple Parish, and Susan Bartlett Crater. *Sister: The Life of Legendary American Interior Decorator Mrs. Henry Parish II.* New York: St. Martin's, 2000.

Beaton, Cecil. *Beaton in the Sixties.* New York: Knopf, 2004.

———. *The Unexpurgated Beaton.* New York: Carroll & Graf, 2002.

Berman, Avis. *Rebels on Eighth Street: Juliana Force and the Whitney Museum of American Art.* New York: Atheneum, 1990.

Biddle, Flora Miller. *The Whitney Women.* New York: Arcade, 1999.

Birmingham, Stephen. *Our Crowd: The Great Jewish Families of New York.* New York: Harper & Row, 1967.

Booker, Christopher, and Richard North. *The Great Deception.* New York: Continuum, 2005.

Burnham, Sophy. *The Art Crowd.* New York: David Mackay, 1973.

Burt, Nathaniel. *Palaces for the People.* Boston: Little, Brown, 1977.

Callow, Alexander B. *The Tweed Ring.* New York: Oxford University Press, 1966.

Chernow, Ron. *The House of Morgan.* New York: Grove, 1990.

Cohan, William D. *The Last Tycoons: The Secret History of Lazard Frères.* New York: Doubleday, 2007.

Coleman, Laurence Vail. *The Museum in America: A Critical Study.* Washington, D.C.: American Association of Museums, 1939.

Constable, W. G. *Art Collecting in the United States of America.* London: Thomas Nelson and Sons, 1964.

Craven, Thomas. *Modern Art: The Men, the Movements, the Meaning.* New York: Simon & Schuster, 1934.

D'Alton, Martina. *The New York Obelisk; or, How Cleopatra's Needle Came to New York and What Happened When It Got Here.* New York: Metropolitan Museum of Art/Abrams, 1993.

Dalzell, Robert F., Jr., and Lee Baldwin Dalzell. *The House the Rockefellers Built.* New York: Henry Holt, 2007.

de Forest, Emily Johnston. *John Johnston of New York, Merchant.* New York: privately printed, 1909.

———. *John Taylor: A Scottish Merchant of Glasgow and New York, 1752–1833.* New York: privately printed, 1917.

di Cesnola, Louis Palma. *Cyprus: Its Ancient Cities, Tombs, and Temples: A Narrative of Researches and Excavations During Ten Years' Residence in That Island.* New York: Harper & Brothers, 1878.

Doheny, David A. *David Finley: Quiet Force for America's Arts.* Charlottesville: University of Virginia Press, 2006.

Douglas, Kirk. *The Ragman's Son.* New York: Simon & Schuster, 1988.

Dwight, Eleanor. *Diana Vreeland.* New York: William Morrow, 2002.

Feigen, Richard. *Tales from the Art Crypt.* New York: Knopf, 2000.

Feldman, Gerald. *The Great Disorder: Politics, Economics, and Society in the German Inflation, 1914–1924.* New York: Oxford University Press, 1993.

Fosdick, Raymond B. *John D. Rockefeller Jr., a Portrait.* New York: Harper, 1956.

Fry, Roger Eliot. *Letters of Roger Fry.* London: Chatto & Windus, 1972.

Gelb, Arthur. *City Room.* New York: Putnam, 2003.

Gordon, Meryl. *Mrs. Astor Regrets.* Boston: Houghton Mifflin Harcourt, 2008.

Haden-Guest, Anthony. *True Colors: The Real Life of the Art World.* New York: Atlantic Monthly Press, 1996.

Harclerode, Peter, and Brendan Pittaway. *The Lost Masters.* New York: Welcome Rain, 2000.

Hays, Charlotte. *The Fortune Hunters.* New York: St. Martin's, 2007.

Heckscher, August. *Alive in the City: Memoir of an Ex-commissioner.* New York: Scribner, 1974.

Hersh, Seymour M. *The Dark Side of Camelot.* Boston: Little, Brown, 1997.

Hess, John L. *The Grand Acquisitors.* Boston: Houghton Mifflin, 1974.

———. *My Times: A Memoir of Dissent.* New York: Seven Stories Press, 2003.

Hibbard, Howard. *The Metropolitan Museum of Art.* New York: Harrison House, 1980.

Hoving, Thomas. *King of the Confessors.* New York: Ballantine, 1981.

———. *Making the Mummies Dance: Inside the Metropolitan Museum of Art.* New York: Simon & Schuster, 1993.

Howe, Winifred. *A History of the Metropolitan Museum of Art.* New York: Metropolitan Museum of Art, 1913.

———. *A History of the Metropolitan Museum of Art, Volume II, 1905–1941.* New York: Columbia University Press, 1946.

James, Harold. *The Deutsche Bank and the Nazi Economic War Against the Jews: The Expropriation of Jewish-Owned Property.* New York: Cambridge University Press, 2001.

———. *The End of Globalization: Lessons from the Great Depression.* Cambridge, Mass.: Harvard University Press, 2001.

Jones, Arthur. *Malcolm Forbes: Peripatetic Millionaire.* New York: Harper & Row, 1977.

Josephson, Matthew. *The Robber Barons.* New York: Harcourt, Brace, 1934.

Kelley, Kitty. *Jackie Oh!* Secaucus, N.J.: Lyle Stuart, 1978.

Kiernan, Frances. *The Last Mrs. Astor.* New York: Norton, 2007.

Klein, Edward. *All Too Human: The Love Story of Jack and Jackie Kennedy.* New York: Pocket Books, 1996.

Lerman, Leo. *The Museum: One Hundred Years and the Metropolitan Museum of Art.* New York: Viking, 1969.

Lisagor, Nancy, and Frank Lipsius. *A Law unto Itself: The Untold Story of the Law Firm Sullivan and Cromwell.* New York: Morrow, 1988.

Loebl, Suzanne. *America's Art Museums.* New York: Norton, 2002.

Loeffler, Jane C. *The Architecture of Diplomacy.* New York: Princeton Architectural Press, 1998.

Lossing, Benson John. *History of New York City: Embracing an Outline of Events from 1609 to 1830, and a Full Account of Its Development from 1830 to 1884.* New York: Perine, 1884.

Mahoney, Tom, and Leonard Sloane. *The Great Merchants.* New York: Harper & Row, 1974.

Marangou, Anna G. *Life and Deeds: The Consul Luigi Palma di Cesnola.* Nicosia: Cultural Center of the Popular Bank Group, 2000.

McFadden, Elizabeth. *The Glitter and the Gold.* New York: Dial, 1971.

McNall, Bruce. *Fun While It Lasted.* New York: Hyperion, 2003.

Meier, Barry. *Pain Killer: A "Wonder" Drug's Trail of Addiction and Death.* New York: Rodale, 2003.

Meyer, Karl. *The Art Museum: Power, Money, Ethics: A Twentieth Century Fund Report.* New York: Morrow, 1979.

——. *The Plundered Past: The Traffic in Art Treasures.* New York: Atheneum, 1973.

Miller, Sara Cedar. *Central Park: An American Masterpiece.* New York: Harry N. Abrams, 2003.

Moses, Robert. *Public Works: A Dangerous Trade.* New York: McGraw-Hill, 1970.

Nasaw, David. *The Chief: The Life of William Randolph Hearst.* Boston: Houghton Mifflin, 2000.

Nicholas, Lynn H. *The Rape of Europa.* New York: Vintage, 1995.

Osborn, Henry Fairfield. *The American Museum of Natural History: Its Origin, Its History, the Growth of Its Departments.* New York: Irving Press, 1911.

Ozgen, Ilknur, and Jean Ozturk. *Heritage Recovered: The Lydian Treasure.* Istanbul: Ugur Okman for the Republic of Turkey, 1996.

Pertinax. *The Gravediggers of France.* Garden City, N.Y.: Doubleday, Doran, 1944.

Petropoulos, Jonathan. *The Faustian Bargain: The Art World in Nazi Germany.* New York: Oxford University Press, 2000.

Picon, Carlos, et al. *Art of the Classical World in the Metropolitan Museum of Art.* New Haven, Conn.: Yale University Press, 2007.

Pope-Hennessy, John. *Learning to Look.* New York: Doubleday, 1991.

Reich, Cary. *Financier.* New York: Morrow, 1983.

Renfrew, Colin. *Loot, Legitimacy, and Ownership: The Ethical Crisis in Archaeology.* London: Gerald Duckworth, 2000.

Rorimer, James J. *Survival: The Salvage and Protection of Art in War.* New York: Abelard, 1950.

Rosenzweig, Roy, and Elizabeth Blackmar. *The Park and the People: A History of Central Park.* Ithaca, N.Y.: Cornell University Press, 1992.

Russell, John Malcolm. *From Nineveh to New York.* New Haven, Conn.: Yale University Press, 1997.

Saarinen, Aline Bernstein. *The Proud Possessors: The Lives, Times, and Tastes of Some Adventurous American Art Collectors.* New York: Random House, 1958.

Samuels, Ernest. *Bernard Berenson: The Making of a Connoisseur.* Cambridge, Mass.: Belknap Press, 1979.

Schuker, Stephen. *The End of French Predominance in Europe: The Financial Crisis of 1924 and the Adoption of the Dawes Plan.* Chapel Hill: University of North Carolina Press, 1976.

Secrest, Meryle. *Duveen.* New York: Knopf, 2004.

Seligman, Germain. *Merchants of Art: 1880–1960.* New York: Appleton-Century-Crofts, 1961.

Sherman, Jerri. "The Classes vs. the Masses: The Struggle to Open the Metropolitan Museum of Art on Sunday (1870–1891)." Master's thesis, New York University, 2005.

Shriner, Charles A. *Random Recollections.* Paterson, N.J.: privately printed, 1941.

Silverman, Debora. *Selling Culture: Bloomingdale's, Diana Vreeland, and the New Aristocracy of Taste in Reagan's America.* New York: Pantheon, 1986.

Simpson, Colin. *Artful Partners: Bernard Berenson and Joseph Duveen.* New York: Macmillan, 1986.

Sire, H. J. A. *Father Martin D'Arcy: Philosopher of Christian Love.* Herefordshire: Gracewing, 1997.

Smith, Sally Bedell. *Grace and Power.* New York: Random House, 2004.

Strouse, Jean. *Morgan: American Financier.* New York: Random House, 1999.

Tauranac, John. *Essential New York.* New York: Holt, Rinehart & Winston, 1979.

Taylor, Francis Henry. *Babel's Tower: The Dilemma of the Modern Museum.* New York: Columbia University Press, 1945.

———. *Pierpont Morgan as Collector and Patron, 1837–1913.* New York: Pierpont Morgan Library, 1957.

———. *The Taste of Angels.* Boston: Little, Brown, 1948.

Tomkins, Calvin. *Merchants and Masterpieces: The Story of the Metropolitan Museum of Art.* New York: Henry Holt, 1970. Revised and updated, 1989.

Towner, Wesley. *The Elegant Auctioneers.* New York: Hill & Wang, 1970.

Turpin, John K., and W. Barry Thompson. *The Somerset Hills.* Far Hills, N.J.: Mountain Colony Press, 2004.

Unger, Irwin, and Deb Unger. *The Guggenheims: A Family History.* New York: HarperCollins, 2005.

Venema, Adriaan. *Kunsthandel in Nederland, 1940–1945.* Amsterdam: Uitgeverij De Arbeiderspers, 1986.

Visson, Vladimir. *Fair Warning: Memoirs of a New York Art Dealer.* Tenafly, N.J.: Hermitage, 1986.

Vreeland, Diana. *D.V.* New York: Knopf, 1984.

Walker, John. *Self-Portrait with Donors: Confessions of an Art Collector.* Boston: Little, Brown, 1974.

Warhol, Andy. *POPism: The Warhol '60s*. With Pat Hackett. New York: Harcourt Brace Jovanovich, 1980.

Watson, Peter, and Cecilia Todeschini. *The Medici Conspiracy*. New York: Public Affairs, 2006.

Weitzenhoffer, Frances. *The Havemeyers: Impressionism Comes to America*. New York: Harry N. Abrams, 1986.

Wharton, Edith. *The Age of Innocence*. New York: Appleton, 1920.

———. *A Backward Glance*. New York: D. Appleton-Century, 1934.

Whittredge, Worthington. *The Autobiography of Worthington Whittredge, 1820–1910*. New York: Ayer, 1969.

Woolf, Virginia. *Roger Fry: A Biography*. New York: Harcourt, Brace, 1940.

Index

About the Author

MICHAEL GROSS is the bestselling author of *740 Park: The Story of the World's Richest Apartment Building, Model: The Ugly Business of Beautiful Women,* and other books. A contributing editor of *Travel + Leisure,* he has also written for major publications, including the *New York Times, Vanity Fair, New York, Esquire,* and GQ. He lives in New York City.